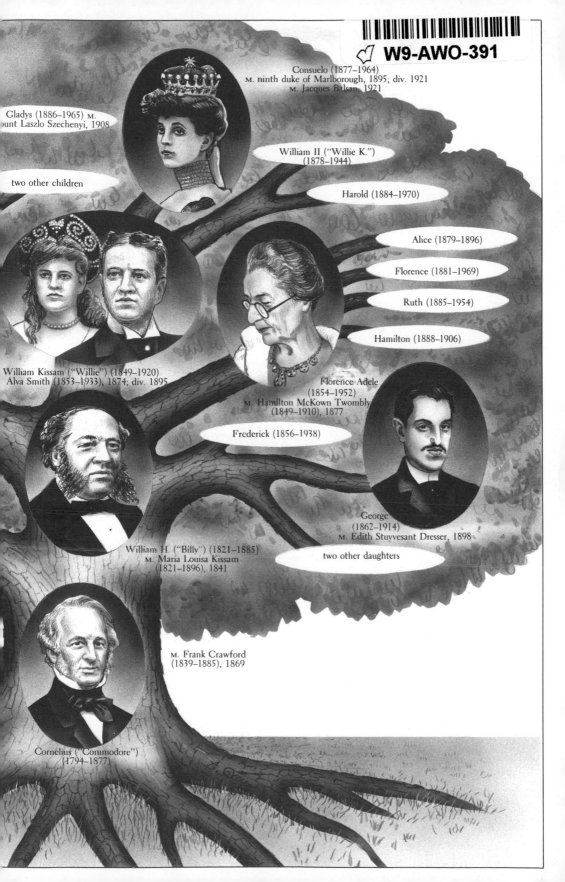

Consuelo (1877–1964)
M. ninth duke of Marlborough, 1895; div. 1921
M. Jacques Balsan, 1921

Gladys (1886–1965) M.
unt Laszlo Szechenyi, 1908

William II ("Willie K.")
(1878–1944)

two other children

Harold (1884–1970)

Alice (1879–1896)

Florence (1881–1969)

Ruth (1885–1954)

Hamilton (1888–1906)

William Kissam ("Willie") (1849–1920)
Alva Smith (1853–1933), 1874; div. 1895

Florence Adele
(1854–1952)
M. Hamilton McKown Twombly
(1849–1910), 1877

Frederick (1856–1938)

George
(1862–1914)
M. Edith Stuyvesant Dresser, 1898

William H. ("Billy") (1821–1885)
M. Maria Louisa Kissam
(1821–1896), 1841

two other daughters

M. Frank Crawford
(1839–1885), 1869

Cornelius ("Commodore")
(1794–1877)

FORTUNE'S CHILDREN

The Fall of the House of
VANDERBILT

FORTUNE'S CHILDREN

Arthur T. Vanderbilt II

WILLIAM MORROW
and Company, Inc.
New York

Library of Congress Cataloging-in-Publication Data
Vanderbilt, Arthur T., 1950–
Fortune's children : the fall of the house of Vanderbilt / Arthur
T. Vanderbilt II.
p. cm.
ISBN 0-688-07279-8
1. Vanderbilt family. 2. United States–Biography. 3. Upper
classes–United States–Biography. 4. Wealth–United States–
History. I. Title.
CT274.V35 1989
973'.08'621–dc20
[B] 89-32421
 CIP

Printed in the United States of America

First Edition

1 2 3 4 5 6 7 8 9 10

BOOK DESIGN BY RICHARD ORIOLO

CONTENTS

INTRODUCTION

I magine waking up one morning to learn you had won the lottery. You are informed that the jackpot is $10 billion. You, the sole winner, have become the richest person in the world! The lottery officials tell you that you will receive all of the prize money in one lump sum, tax free, that morning. As a condition of receiving the money, you must never give away any of it to charity.

A close approximation of this unlikely event occurred an astonishing number of times during the Gilded Age, that heady time from the

INTRODUCTION

end of the Civil War to the turn of the century, the height of the Industrial Revolution in the United States, when great fortunes were made and spent overnight in a way that had never been seen before and will probably never be seen again.

The nation's first great industrial fortune was won by the Vanderbilt family, and for a while this family could claim the title of the richest in the world. Subsequent fortunes surpassed it, but by then great wealth was decried. The unique opportunity that confronted the members of this particular family was the freedom to use their fortune just as they damned pleased, to create whatever reality they wanted, to give free rein to their every impulse without any sense of the social responsibilities that great wealth confers.

For the Vanderbilts lived in a day when flaunting one's money was not only accepted but celebrated. What may have started as playacting, as dressing up as dukes and princesses for fancy dress balls in fairytale palaces, soon developed into a firm conviction that they were indeed the new American nobility.

The bits and pieces of history that chronicle the four-generation saga of the Vanderbilt family are scattered everywhere like a broken string of pearls: in wills and court transcripts, letters, memoirs, journals, newspaper clippings, magazines, scrapbooks, photographs, and auction catalogs. But nowhere is that curious combination of magnificence and absurdity that was the Gilded Age more palpable than in the great country homes that still stand today as monuments to their dreams and fantasies: Idlehour, Marble House, The Breakers, Biltmore, Florham. These country estates were not just bigger or more ornate than other millionaires' mansions. They rivaled the most magnificent country houses of England and the châteaus of France that had been passed down to titled descendants, generation to generation, since the Middle Ages. They were built to become precisely the American equivalent of these Old World palaces, great ancestral homes that would proclaim for centuries, for all time, the prominence of the Vanderbilts.

But it did not work out that way. Far from becoming ancestral homes, these monuments to limitless wealth, built for eternity, were hardly used for a lifetime. None was occupied by the next generation.

These great estates were but the family's country retreats, built

INTRODUCTION

after the Vanderbilts had achieved social prominence. Their main residences on Fifth Avenue in New York City were designed to so startle the world with their size and splendor that they would secure the family's preeminent position of social leadership. Dominating the prime real estate of what was even then one of the greatest cities of the world, the ten Vanderbilt mansions that lined Fifth Avenue were examples of epic extravagance. Yet these homes, too, failed to become the family seats their builders had envisioned. One by one, the Vanderbilt mansions on Fifth Avenue fell to the wrecker's ball, their contents to the auctioneer's gavel. The first of these Fifth Avenue mansions was completed in 1883, the first was demolished in 1914, and by 1947 every one had been broken to rubble.

This fabled golden era, this special world of luxury and privilege that the Vanderbilts created, lasted but a brief moment. Within thirty years after the death of Commodore Vanderbilt in 1877, no member of his family was among the richest people in the United States, having been supplanted by such new titans as Rockefeller, Carnegie, Frick, and Ford. Forty-eight years after his death, one of his direct descendants died penniless. Within seventy years of his death, the last of the great Vanderbilt mansions on Fifth Avenue had made way for modern office buildings. When 120 of the Commodore's descendants gathered at Vanderbilt University in 1973 for the first family reunion, there was not a millionaire among them.

What had happened? What had gone wrong with the Vanderbilts' plans to found a family dynasty? There is no easy answer. The ratification in 1913 of the Sixteenth Amendment to the Constitution, which gave Congress the power to tax incomes; rising property taxes; the imposition of estate taxes; the Depression; the fecundity of a family: All splintered the fortune. But taxes, depressions, and reproduction had posed no burden to the establishment of other family dynasties founded in the same era. The most recent listing in the Forbes Four Hundred of the richest people in the United States includes three Fords, with combined fortunes of over $1.5 billion; five Rockefellers holding net assets of over $3 billion, with another $2 billion spread among the rest of the family; and twenty Du Ponts, worth a total of $5 billion, in addition to another $2 billion held by other family members.

What happened to the richest family in the world is a remarkable

story that no novelist would dare invent. What began as that peculiarly American dream of rags to riches—in this case, the dream of a Staten Island water rat who turned his ambition and energy, his frugality and hard work into an astounding fortune—became for the Commodore's descendants an unusual nightmare as they discovered what they could do with the money and what the money could do to them. If ever Scott Fitzgerald needed evidence to substantiate his aphorism that "the very rich . . . are different from you and me," it was here in spades in this portrait gallery of extravagant crazies that is the unique saga of the Vanderbilt family.

Today, you can wander through some of the remaining architectural relics of this other world, these homes of baronial opulence whose extraordinary lack of human proportion and perspective says so much about the Gilded Age, and listen to the echoes of the past. What did you think, Alva, as you were building Marble House? Did you think that the world you created would go on forever, that the ball would last past dawn? As they sat in the quiet of the upper loggia of The Breakers and watched the sun rise over the ocean, what dreams did Cornelius and Alice Vanderbilt dream? What was the power of the dream that led to the creation of their "summer cottage"? Did this bizarre monument to a fortune make them happy? How did it feel to be rich enough to build Biltmore, that 250-room French Renaissance château set on 146,000 acres in the hills of Asheville, North Carolina, a house so large, its proud architect noted, that the surrounding mountains "are in scale with the house"? What was it like to have more money than anyone else?

The Fifth Avenue mansions, alas, are long gone. But today, if you stroll down Fifth Avenue and if the light is just right and you half close your eyes, you might spot a red carpet being unrolled from the door of a limestone château down the steps to the curb, watch as a burgundy Rolls-Royce stops in front and guests walk up to the door flanked by maroon-liveried footmen, and hear coming from inside the faraway sounds of an orchestra.

Generations pass while some tree stands,
and old families last not three oaks.

–SIR THOMAS BROWNE

1

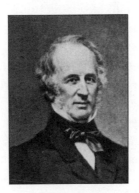

THE COMMODORE

1794 – 1877

1.

That Wednesday morning, May 10, 1876, reporters from every New York City newspaper gathered in front of the townhouse at 10 Washington Place, waiting for some sign that eighty-two-year-old Cornelius Vanderbilt, the Commodore as he was called, had passed away.

During the last few days, no one had seen the aging millionaire at any of his favorite haunts. He had not come to his office to oversee his railroad empire. He had not driven his fine team of trotters in the warm

spring afternoons while nursing a tumbler of gin laced with sugar. He had not gone to the Manhattan Club for an evening game of whist. Something was wrong. Something had happened.

All morning, the reporters paced up and down Washington Place, a fashionable street until the city's elite had begun moving up Fifth Avenue. Some ate sandwiches and drank beer. Others played cards. Now and then, one would leave to file a bulletin: The Commodore was dead! The stock market plunged. The Commodore was still alive! Wall Street rallied.

Finally, Frankie, the Commodore's ravishing thirty-seven-year-old wife, invited the reporters to come in, leading them over threadbare rugs to the large parlor. As they milled about, admiring a bust of the Commodore, and an oil painting of the Commodore in a road wagon driving his favorite team, and the small solid-gold model of one of the Commodore's steamships, a voice roared down from the upstairs hall, spewing forth a string of obscenities mixed with a message for the reporters:

"I AM NOT DYING!"

The house shook. The reporters froze.

"The slight local disorder is now almost entirely gone! The doctor says I will be well in a few days! Even if I was dying," the voice bellowed, "I should have vigor enough to knock this abuse down your lying throats and give the undertaker a job!"[1]

It was vintage Vanderbilt. The reporters quickly departed, convinced the richest man in the world was alive and obviously well.

Alive, yes, but not feeling very well. After the reporters left, the Commodore summoned Dr. Jared Linsly, his physician for the past forty years.

"Doctor," he told him, "the devil has been after me."

"Well, don't let him catch you for if you do, you will not be Commodore Vanderbilt any longer for Commodore Vanderbilt never suffered anybody to catch him!"[2]

"Doctor, if all the devils in hell were concentrated in me I could not have suffered any more. I want you to make a thorough examination of my case. I think I have neglected myself too long already. I have difficulty in urination, the efforts being protracted and painful. I have hernia and I have piles."[3]

He was also suffering from chronic indigestion, he told his elderly physician, accompanied by excessive belching and flatulence.

After examining him, Dr. Linsly advised the Commodore that the difficulty in urination, which was causing the excruciating pain, was the result of an enlarged prostate gland. And what had caused that? the Commodore asked his doctor.

"The authorities considered it might be due, either to stricture, gonorrhea, horse-back riding or excessive sexual intercourse," Dr. Linsly answered. "It drives the victim of it into venereal excesses; it produces a species of lascivious mindedness; this is what the authorities give as the tendency of that disease."[4]

Well, that explained a lot. The Commodore winked at his doctor and asked no more questions about the cause of his troubles. Now all he had to do was get better. He told Dr. Linsly that he "and the Lord were fighting the devil, and were going to whip him."[5]

Every day, Dr. Linsly stopped by to visit. When the crusty Commodore was in pain, he lashed out at his physician in terrible fits of temper. "Has the old Doctor come?" he yelled to Frankie. "Is the old Doctor here? Is the old granny here yet?"[6] "Blatherskite!" he exploded as Dr. Linsly entered his bedchamber, hurling his favorite epithet for anyone the Commodore considered a dolt. "Bloxhead!" Do something for the pain![7]

Uneducated, barely able to read (if a letter was longer than a paragraph or two, he would throw it down in disgust and have his clerk read it to him), superstitious, the Commodore believed in mysticism and the occult and, much to Dr. Linsly's dismay, was willing to try anything suggested by anyone promising a cure. Believing they were "health conductors," he even had four pans of salt placed under the four posts of his bedstead, just as a spiritualist advised.

The Commodore had frequently told his friends that he never made a business decision without advice from the spirits, so it was not surprising that now he summoned mediums to his aid.

"I have a communication from your dead wife," a spiritualist murmured to him during a seance in his darkened bedchamber.

"I don't care for that now," the Commodore snapped. As long as he had made contact with the other side, he wanted to take full advan-

tage of the practical aspects of the opportunity. "I want to know about the price of stocks,"[8] he told the medium. "Business before pleasure. Let me speak with Jim Fisk."[9] He was clearly feeling better.

The spiritualist obediently conjured up the wraith of his deceased business rival, who began forecasting the prices of railroad stocks. Not agreeing with the predictions he was hearing, the Commodore argued with the spirit, until the medium convinced him he was interfering with the communications from the other world.

Reporters, Wall Street operators, doctors, and occultists were not the only ones interested in the state of the Commodore's health. His ten children had grown old waiting for this moment. His oldest child was sixty-one; his youngest, forty. Now, like vultures, they swooped around 10 Washington Place, consumed by the vision of picking over his sumptuous estate. The Commodore was not keen to see any of them, for when they entered his room, each one inevitably asked about his will.[10] He told them he "had done the best he could for all" in his will and that if he had made a hundred more wills he could not make a better one.[11] When he refused to see them, these birds of prey would gather in an adjoining room and, scared to death of the sick old man who was their father, peek through the crack in the open door, staring, waiting.

He felt especially indifferent toward his eight married daughters. They were all right as women went, but, he complained, "they are not Vanderbilts. They do not bear the name of Vanderbilt."[12] One of his daughters had sold her house and given her father the money to invest for her. After he had doubled it, he refused to give any back to her. "Women are not fit to have money anyway," he explained.[13]

And he wanted nothing to do with his namesake, Cornelius, the younger of his two sons. Two or three times a day, Corneel would stop by the house, asking to see his father.

"Your son Cornelius is downstairs and wishes to see you," a servant would tell the Commodore.

"Where is he?"

"In the reception room."

"Well let him stay there! Why does he come down here? He ought to stay home in Connecticut; he has no business here. I don't want to see him. Go down and tell him not to come in here again while I am living, or after I am dead."[14]

THE COMMODORE

Only fifty-five-year-old William, his older son, was permitted to enter the Commodore's room unannounced when he stopped in to see his father twice a day.

When Dr. Linsly told the Commodore he was well enough to see all of his children, the Commodore responded in a sudden rage, "No, damn them, they are all bastards but Bill."[15]

Alone in the large, sunny second-floor room at the southeast corner of the house, propped up in his bed in the middle of the chamber where he could gaze out the window or at his safe in the corner, the Commodore dozed and dreamed, drifting in and out of consciousness.

Fantastic recurring visions disturbed the octogenarian's sleep. He felt himself falling, falling to the bottom of the sea. Only the full power of one of his old steamships, the *Vanderbilt,* was able to pull him slowly to the surface. In another dream, he had a vision of a roadway shaped like a horseshoe stretched around his bed. At one end of it gathered a large number of his acquaintances, his business associates and rivals from his steamship and railroad days. He traveled with them along the road around his bed, watching as on occasion one of them walked to the edge of the road and dropped off, never to be seen again. Several times during the journey he recalled going to the edge of the road and coming back again, and then continuing on. Now he felt he was standing on the edge once more. He could not tell in what direction he would go.

2.

His journey had begun sixty-six Mays before, on a sunny day on Staten Island when he was about to turn sixteen.

Cornelius had been born on May 27, 1794, in a small farmhouse at Stapleton, Staten Island, a stone's throw from the waters of New York Bay. He was the fourth of nine children. His mother, Phebe, was a bright, shrewd woman of English ancestry who was the head of the family. She once saved the family farm from foreclosure by opening the grandfather clock in the kitchen and pulling out $3,000 she had squirreled away. His father, Cornelius, was descended from Dutch farmers who had come to the New World from the village of De Bildt, in the

highlands of Holland, and settled near Brooklyn, moving to Staten Island in the early 1700s. Plodding and lazy, he supported his large family with some farming and fishing.

A big, healthy, vigorous boy, young Cornelius had no patience for school. He roamed the waterfront by the hour, watching sailing ships from all over the world tack back and forth through the Narrows as they approached New York Harbor and the island of Manhattan, hazy on the horizon. By the age of eleven, he was spending all his time working with his father around the waterfront farm and, whenever he was allowed, helping him sail his periauger—a heavy two-masted barge constructed like those that were used on the Dutch canals—as he took loads of hay, farm crops, fish, and an occasional passenger over to Manhattan, five miles across the Narrows. Cornelius could barely read or write, let alone multiply or divide, but he had mastered the channels and kills around the islands, and knew the ways of the currents and tides and the wind upon the water.

On that first day of May in 1810, a few weeks before his sixteenth birthday, Cornelius announced to his mother that he was running away to sea. His mother protested: He was too young; he was needed to work in the fields and to help his father bring the produce to market. Phebe Vanderbilt knew her son well enough to sense that he did not really want to run away to be a sailor; he was negotiating. What he truly wanted was a boat of his own so he could become a boatman on New York Harbor. After a while, they struck a deal: If Cornelius successfully completed what seemed an impossible task, his mother would loan him $100 to buy a boat.

"On the 27th of this month is your birthday. If by that time you have ploughed, harrowed and planted that field with corn," she said, pointing to an eight-acre tract that had never been cultivated, so full of rocks and stumps was its poor soil, "I'll give you the money."

"It's a bargain. I'll do it."

"No boat if you don't do it."

It seemed like a good deal to both of these tough traders.

"All right. I understand; and I'm going to do it."

He did. His mother went to the grandfather clock in the kitchen and counted out one hundred old dollar bills. "Mother thought she had the best of me on that eight acre lot," he recalled many years later, "but

I got some boys to help me, and we did the work, and it was well done, too, for mother wouldn't allow any half way of doing it. On my birthday I claimed the money, got it, hurried off, bought a boat, hoisted sail and was the happiest boy in the world."[16]

What dreams and visions swirled through his thoughts that warm spring day as he took the tiller and hauled in the sail and felt his flat-bottomed periauger, which he named the *Swiftsure*, buck through the waters of New York Bay!

With boundless energy and ambition, Cornelius went to work. The tan, six-foot teenager, broad-shouldered and strong, with a shock of sand-colored hair and bright blue eyes that squinted from the sun on the bay, soon became a familiar sight on the waterfront, as he hustled for business, racing the other ferryboats back and forth to the Battery. The boatmen laughed at this eager kid, who swore and cursed like an old sea dog as he poled his scow across the waters of the harbor. They nicknamed him Commodore in jest, but the moniker stuck for life. Tough, boisterous, profane, he earned a reputation for being fair and, above all, capable and reliable. Whatever the weather, whatever the winds, passengers could count on Cornelius Vanderbilt's periauger being first to the city, whether he sailed it or, if the wind died down, poled it.

By his next birthday, he had ferried enough passengers at eighteen cents a trip (a round trip for a quarter) to repay his mother the $100. And since he was still a minor, he turned over to her his profits for the year—$1,000—a rather satisfactory return on her wise investment.

A year later, during the War of 1812 when the British fleet blockaded New York Harbor, Cornelius's business boomed. He transported workmen and building supplies to construct fortifications and won a contract to carry provisions to the six military garrisons around the harbor and the Narrows. When he had a few spare hours, he brought food down from farms on the Hudson River and sold it from his boat to the starving city. He promptly bought an interest in two other periaugers with his profits.

At the age of nineteen, Cornelius married his eighteen-year-old neighbor and cousin Sophia Johnson, the daughter of his mother's sister, on the evening of December 19, 1813. To Cornelius, Sophia was more than a woman, more than a wife. Quiet, plain, a prodigiously hard worker, Sophia in his eyes was as good as an employee, a servant, a slave,

someone willing to labor endless hours to further his consuming ambitions. Early the next morning after the wedding, he was back down at the docks waiting for passengers.[17]

At the end of the war, Cornelius bought a condemned flat-bottomed schooner from the government for $1,500. His decrepit vessel was the first to arrive at the oyster beds of Chesapeake Bay at the start of that year's harvest. Loaded dangerously full of oysters, it was the first to return to New York City. The profits from that one cargo paid for his schooner. This was better than ferrying passengers at eighteen cents a trip! He put his periaugers under the supervision of a friend and concentrated on the coastal trade, carrying cargoes of oysters, watermelons, whale oil, and shad, and trading cider and beer with the ships anchored in the bay. Frugal Cornelius did not fritter away his money like other boatmen. By 1818, at twenty-four, he had saved $9,000 and owned interests in several periaugers and coasting schooners.

Like most of the boatmen who worked in New York Harbor and on Long Island Sound, Cornelius had no use for the awkward, newfangled steamboats that emerged after Robert Fulton's remarkable feat in 1807 of running his *Clermont* up the Hudson, against the current, from New York to Albany, at a steady four miles an hour. But when his income suddenly dropped because a steamboat outran his periauger between Staten Island and the city, he was clever enough to foresee that this new mode of transportation—"b'ilers," he always called them, for the steam boilers that powered them—was the wave of the future. In 1818, he sold his schooners, put his father in charge of his periaugers, and, to learn all about this modern method of transportation, began working for Thomas Gibbons, who owned a small steamboat.

A wealthy sixty-year-old Georgian attorney and plantation owner, Gibbons had purchased a summer residence in Elizabeth, New Jersey, and, as a hobby, had acquired a little steam ferry, the *Bellona*. It ran from Elizabethtown Point up the Raritan River to New Brunswick, completing the transportation network that brought passengers from New York City to Elizabethtown Point and, once they had been taken along the river to New Brunswick, overland by stagecoach from New Brunswick to Trenton and then across the Delaware River to Philadelphia.

Gibbons agreed to pay Cornelius Vanderbilt sixty dollars a month, plus half of the profits from the ship's bar, to serve as "captain, pilot and engineer."[18] In addition, Gibbons agreed to give him a run-down wayside inn, Bellona Hall, located right at his New Brunswick landing. Cornelius put his wife in charge. Sophia went to work with a vigor equal to her husband's, cleaning and fumigating the old structure and running a tavern that became known for its good food and courteous service.

Sophia had her hands full at Bellona Hall. Not only did she do all the cooking and cleaning and serving, but she was also raising several young children, and more often than not was pregnant with her next. Between 1815 and 1839, she gave birth to thirteen children. The older ones helped around the inn as soon as they were able, carrying travelers' bags and waiting on tables. Frugal, parsimonious, downright miserly, her husband never gave her a penny for the children's necessities. Sophia fed them, sewed their clothes, and bought them shoes with money she earned at the inn.

Once he had learned the tricks of operating a steamboat, Cornelius was no longer satisfied with taking the *Bellona* up and down the Raritan estuary, and began running Gibbons's steamboat as a ferry from Elizabethtown across the Kill Van Kull and New York Bay to the Battery. The trouble was that this run was illegal: Robert Fulton and Robert Livingston had secured a monopoly to operate steamboats on New York waters from the New York legislature. Not only did Cornelius Vanderbilt begin running Gibbons's steamboat on the same route without any authorization from the monopoly, but he also cut his rates from the four dollars the monopoly was charging to one dollar a trip, covering his losses by raising the price of food and drink at the steamboat's bar.

Day after day, every day for two months, the New York monopoly sent out constables to arrest him. He outwitted them every time. His passengers loved the thrill of watching him challenge the law. One time he left his crew in New Jersey and tied up at the New York wharf with a woman at the helm while he managed the engine belowdecks. On many occasions he hid in a secret closet he had built in the steamer's hull. One day as he was preparing to pull away from the New York wharf, an officer came up behind him and tapped him on the shoulder. Corne-

lius spun around. "Let go the line!" he ordered his men.[19] The officer, afraid of being carried away to the New Jersey side where he, in retaliation, would have been imprisoned, jumped ashore.

This cat and mouse game might have continued indefinitely had not Aaron Ogden, another New Jersey steamboat owner who had purchased a license to run steamboats between Elizabethtown Point and Manhattan from the monopoly, sought an injunction against Thomas Gibbons to prevent him from running his line. The New York courts upheld the monopoly. Gibbons appealed to the United States Supreme Court, where Daniel Webster argued his cause, challenging the constitutionality of the monopoly. In deciding this case of *Gibbons* v. *Ogden,* Chief Justice John Marshall established the principle that only Congress had the authority to regulate commerce on the navigable waters of the United States, a landmark decision that helped build a unified nation and a national economy, and that, incidentally, helped Cornelius Vanderbilt become an independent steamboat operator.

In the eleven years under Vanderbilt's management, the Gibbons line had grown from the twenty-five-ton *Bellona,* running up and down the Raritan River, to seven three-story steamboats of two hundred tons each, working the New York–New Brunswick run as well as a new line on the Delaware. By 1829, thirty-five-year-old Vanderbilt had saved $30,000 and wanted again to be working for himself. He sold Bellona Hall, moved his family to a modest house on Stone Street in Manhattan near the Battery, bought one of the older steamboats from the Gibbons family, and set off on his own, immediately slashing his rates for the New York–Philadelphia run. The other steamboat operators blanched. He was, of course, bluffing; he was competing with established lines that easily could have outlasted any rate war this upstart chose to commence, but everyone assumed that the Gibbons fortune was still behind him, an assumption that he did nothing to dispel and quite a bit to encourage. Before long, several lines joined together and paid him handsomely not to compete on their route.

With his steamboat, his new extortion capital, and his limitless ambition, Cornelius Vanderbilt was quite happy to shift his operations to the Hudson, establishing a line from the city up the river to Peekskill. Here he came up against another grasping, sharp-witted young man,

THE COMMODORE

Daniel Drew, who had made himself some money driving cattle from the Hudson and Mohawk valleys to New York City. It was Drew's scheme to salt the feed of his herds and deprive them of water until just before they reached the city, when he would let the cattle drink their fill, thus adding to their weight, and his profits, when he sold them to unsuspecting purchasing agents in Harlem. Seeing how much money steamboat operators like Cornelius Vanderbilt were making, Drew decided to see what he could do. He acquired a small steamboat, the *Water Witch*, and launched a competing line. Vanderbilt immediately cut his rates. The *Water Witch* lost $10,000 in its first season.

"You will soon fail in this business," the Commodore warned Daniel Drew. "You don't know anything about running boats. You know a good deal about judging cattle. That's your line. Boats is my line. You don't understand it."

Drew responded by cutting his rates.

"Do you think, Commodore, that I understand the steamboat business?" Drew asked him some weeks later.

"I don't think anything about it, Uncle Dan'l. You do."[20]

The Commodore thereupon purchased the *Water Witch* to eliminate a pesky competitor whom he was beginning to admire as an equally ruthless operator.

So began a strategy that the Commodore would follow throughout his career: cut rates, drive away the competition (or sell out), raise rates, cut service, cut expenses (he never insured his boats, and life preservers were never considered a necessary safety precaution), raise profits. It was a winning strategy.

Vanderbilt took on the powerful Hudson River Steamboat Association, a consortium of steamboat owners that controlled the route up the Hudson River from New York to Albany. He immediately cut the fares for the twelve-hour run aboard his two steamboats from three dollars to one dollar, and then to ten cents, and finally to nothing. Free passage for all! (The price of meals was increased.) Vanderbilt's People's Line, as he called it, was obviously losing money, as was the Hudson River Steamboat Association, which had been forced to cut its rates to the bone, though the association, with many more steamboats, was losing money faster. After prolonged negotiations, Vanderbilt was delighted to

agree to leave the Hudson River for ten years. For being so amenable, he was paid $100,000 on the date the agreement was signed, and $5,000 a year for the next ten years.

On a warm hazy day in September of 1609, the *Half Moon,* a small ship owned by the Dutch East India Company under the command of Henry Hudson, had poked along "the River of the Steep Hills," exploring the broad waters of the Tappan Zee, sailing past the Catskills up to Albany, trying to locate the fabled Northwest Passage to the riches of Cathay. Two centuries later, the Hudson River, which had frustrated the Dutch East India Company, yielded up its riches to a young Dutch entrepreneur, the Commodore. Now being paid not to operate a New York–Philadelphia route and a New York–Albany route, the Commodore established lines on the North River, the East River, the Connecticut River, around Long Island Sound, up to New Haven, Hartford, Stonington, New London, Providence, Newport, Boston; south along the coast to Washington, Charleston, Havana. By the 1840s, when he was in his mid-forties, he operated a fleet of more than one hundred steamboats, which employed more men than any other business in the country. The Commodore was now worth several million dollars.

3.

This steamship millionaire was difficult to ignore yet even more difficult to accept. It was hard to know what to make of this rough-hewn character, perennially dressed in an out-of-style costume consisting of a long frock coat, high collar, and luxurious white cravat, with top hat, cane, and cigar. (He always carried his cigars loose in a side pocket rather than in a cigar case. "When I take one cigar out of my pocket, my friends don't know whether there are any left," he explained, and therefore he never had to share them.[21]) Henry Adams wrote that the steamboat king was "not ornamental" and "lacked social charm."[22] Adams was exceedingly charitable. When the Commodore was invited to the home of one of the city's leading families, his startled hosts discovered that he used atrocious grammar, interlaced his talk with the profanity of the wharves,

always had a plug of Lorillard's tobacco in his mouth, expectorated a stream of tobacco juice on his hostess's rugs, and pinched the bottoms of whichever of the pretty maids caught his fancy. The Staten Island water rat never received a return invitation to the same home. Polite society banished him.

Spurned by the social elite of New York City, he returned to Staten Island when he was forty-five, the local boy coming home after making his fortune. On a tract of land on the farm where he had grown up, he built a mansion with a commanding view of the bay and the flags of his fleet. It cost $27,000. With a Grecian facade set off by six enormous fluted columns, entered through a front door in whose colored glass was etched the outline of his favorite steamer, the *Cleopatra,* revealing an interior decorated with mantelpieces of Egyptian marble, plate glass from France, and a grand staircase with carved mahogany rail, the Vanderbilt mansion became the great house of Staten Island. Here the Commodore received the respect and accolades he needed.

The Commodore had built his fortune by his single-minded devotion to business. Other than as captive workers, his wife and ten living children were extraneous to his life.

His first three children, Phebe Jane, Ethelinda, and Elizabeth, shared a tragic flaw: They were girls, and would marry and no longer be Vanderbilts.

His fourth child and first son, William, born on May 8, 1821, at Bellona Hall, was a disappointment, too. He did not have the Commodore's sturdy frame and robust constitution, or handsome appearance. Heavyset, slow, and clumsy, Billy had a large head; the features of his broad Dutch face were coarse, his complexion red and rough, his eyes small and dull. He often squinted. He looked slow-witted, and so his father concluded that he was.

The Commodore had a choice collection of epithets he barked at his son whenever something went wrong. "Blatherskite!" he would yell. "Sucker! Stupid blockhead! Chucklehead! Beetlehead!" Terrified of his apoplectic father, William never spoke back to him. "I never saw William resent any of the many ill-natured speeches of his father," a friend noted many years later. "He would call him a *blatherskite* and a *sucker;*

that word *sucker* was a very common epithet with the Commodore. William said nothing, and took it with meekness, whiningly. Well, there was a falling down of his jaw, peculiar to him, and a peculiar noise of a whine without words."[23] This meek subservience further infuriated his father.

When Billy was twelve, the Commodore sent him to the Columbia College Grammar School, where his dogged, plodding work confirmed his father's belief that there was little hope for the boy. At eighteen he left school and the Commodore placed him in Daniel Drew's new brokerage house, Drew, Robinson and Company, in the financial district of New York. Uncle Dan'l paid young Billy a salary of $150 a year.

The next year, Billy informed his father that he was going to marry. Although the Commodore had wed Sophia when he was nineteen, he believed his son was too young and too weak to marry and raise a family. It was bad enough that the woman he had chosen to be his wife, Maria Louisa Kissam, was poor, the daughter of a clergyman of the Dutch Reformed Church. Even worse, his son was poor. How did he think he would support himself on the pittance Uncle Dan'l was paying him?

"What are you going to live on?" the Commodore demanded of Billy.

"Nineteen dollars a week."

"Well, Billy, you *are* a fool, just as I always thought!"[24]

If there was one person harder to work for than his father, it was Daniel Drew. Night and day, Billy pored over the books, adding columns of figures, learning his trade. Three years later, Drew offered him a partnership in his brokerage house. The Commodore assumed that his son would spend the rest of his life seated on an accountant's stool, but Billy declined Drew's offer. His health had been broken by three years in the counting house; not surprisingly, with a father like the Commodore and a boss like Uncle Dan'l, he was suffering from chronic dyspepsia. Billy's doctor advised him to move to the country.

Blatherskite! What could the Commodore do with such a disappointing son? He certainly wasn't about to give him a job with his steamboat lines; Billy was too dumb for that. The Commodore told a friend that "Billy was good for nothing but to go on a farm."[25] He bought him a worn-out seventy-acre farm on Staten Island near New Dorp, between the old Moravian church and the bay, with a small

two-story house and attached lean-to kitchen, gave him an allowance of $3,000 a year, and sent him into exile.

One day Billy went to see his father. He needed manure to use as fertilizer to improve the sandy, barren soil of his farm. He knew his father would never give him the horse manure from his Fourth Avenue stables since he was selling it to other farmers. So Billy offered to buy the manure for four dollars a load.

The Commodore was delighted. Billy's offer was well above the going price of manure. What a blockhead! He shook hands with his naïve son; a deal, after all, was a deal.

The next day down at the docks he saw his son with a scow piled high with manure, ready for the trip across the bay to his Staten Island farm.

"How many loads have you got on that scow, Billy?" he asked him, already multiplying the number of loads he thought were aboard by the four dollars he would make on each load.

"How many?" William asked. "One, of course! I never put but one load on a scow."[26]

A worker who was at the docks and overheard the conversation remembered that "the Commodore wa'n't no gret hand to stan' around, and I never seen him stan' so long before as he stood that afternoon on the dock, looking at that scow goin' across the harbor."[27] The Commodore was speechless, grinning with a new pride in his son who had just pulled one over on him. Maybe there was something to that blatherskite after all.

After carefully surveying his land and weighing his options, Billy decided that he would have to buy more acreage and make substantial improvements to the farm to make it pay. The land and improvements would, of course, cost money, something that he didn't have, but of which his father had a surfeit. William complained to his friends about his father's treatment of him, telling them that "the old man treated him harshly," that he had asked the old man for money and been refused, that the old man was niggardly toward him and it was hard work to get money out of him.[28] He dreaded the scene he knew would ensue if he asked his father to loan him money for the farm, so he had a friend intercede on his behalf. When the Commodore was approached, his answer was very simple: no. So Billy mortgaged his farm and used the

$6,000 he received to buy surrounding acreage and to purchase the equipment he needed.

The Commodore was furious when he learned what his son had done, telling a friend that he could not believe William would do such a thing. William had "told him he was making $10,000 a year off that farm, now what has he done with that money?"[29] The Commodore sent for his son and took him for a drive.

"William, you don't amount to a row of pins anyway. You won't never be able to do anything but bring disgrace upon yourself, your family and everybody connected with you. I've made up my mind to have nothing more to do with you."

William was stunned. What had precipitated this latest outburst?

"Didn't you mortgage your farm for $6,000?" his father asked him.

"I did. I had to do it. The farm required considerable investment and I had no money. My object in life has been always to please you, and I am profoundly grieved to see that I am unable to do so. I can assure you of one thing, and that is, not one cent of this money has been diverted to my personal comfort. The transaction is perfectly business-like. I engaged to pay the mortgage off at a certain date. I shall do so. I cannot see that I have done anything to be ashamed of."[30]

The next morning, the Commodore had delivered to his son a check for $6,000, ordering him to pay off the mortgage that day. "There's something in that boy, Bill, after all," the Commodore told his friends.[31]

Billy often began his day at five o'clock in the morning, setting out for the city and returning to the fields by seven o'clock. He planted crops of timothy, corn, potatoes, and oats for the New York market. Dressed in blue-jean overalls, heavyset Billy rarely did much plowing himself. He hired farmhands and sat on a fence watching them closely during their first day on the job when they tried to make a good impression. Then he required them to do the same amount of work on every succeeding day. None of them ever balked at this or felt that Billy was taking advantage of them. He "was a downright square man," one of his farmhands who had worked with him for twenty years recalled, "social, reliable, honest, prompt to pay, quick to recognize merit."[32]

Possessing those Dutch Protestant virtues of industry, frugality, and sobriety, Billy increased his fields to 350 acres, developing Staten Island's

most profitable farm, and there raised his four sons and four daughters, seeing to it that each received a good education. The Commodore, however, could not have cared less about what his son had accomplished, and never considered offering Billy a position with his profitable steamboat operations. In his eyes, his son wasn't bright enough to work with him. He belonged on the farm; once a blatherskite, always a blatherskite.

After Billy was born, the Commodore suffered through the birth of four more daughters before Sophia presented him with another son. This boy he named for himself—Cornelius. If Billy was a disappointment, Cornelius Jeremiah was an embarrassment.

Unlike his older brother, Corneel, according to acquaintances, "asserted his rights to his father manfully."[33] This, to a limited extent, the Commodore admired. He often stated that Corneel had more brains than Billy. But those brains could easily get Corneel into trouble with his father, who on occasion became fed up with his defiant son and beat him with a horsewhip. Once, in a rage, the Commodore caught hold of him and tried to hurl him over the banister and down the stairs. Corneel eluded his father's grasp and fled bareheaded from the house into the woods until things quieted down.

Though Corneel was not strong or handsome—he was tall and lanky and always looked a little undernourished—his intelligence might have carried the day with his father, except for one problem. When he was eighteen, Corneel had his first epileptic seizure, an affliction that his father regarded as an inappropriate weakness for a Vanderbilt, if not a clear sign of mental derangement. (Every so often, the Commodore was seized with guilt, believing his son's epilepsy to be a punishment for having married his cousin, Sophia.[34]) When Corneel collapsed in a convulsion, his face twisted and red, his arms and legs jerking violently, his father was convinced that he belonged in a lunatic asylum. "He's a very smart fellow, but he's got a cog out," he would tell his friends.[35] "I'd give a hundred dollars if he'd never been named Corneel."[36]

To try to make a man out of him, in 1849 the Commodore sent nineteen-year-old Corneel off as a sailor on a three-masted schooner that was rounding the Horn to the gold fields of California. Corneel was sick when he arrived in San Francisco and drew a draft on his father to pay his expenses for a return voyage to New York. Drawing a draft on the

Commodore! Never was there a clearer sign of insanity! When his son reached home on November 20, 1849, the Commodore had him arrested and committed to the Bloomingdale Insane Asylum. His records there stated: "Form of mental disorder—dementia. Supported by father."[37] He was discharged from the asylum on February 20, 1850.

The Commodore believed his son would never be able to earn a living on his own, and so gave him an allowance of $100 a month. This, for Corneel, was just a beginning. Realizing that he could never win his father's respect and that, despite repeated entreaties to give him a chance to show what he could do, his father would never let him work with him, Corneel turned to his wiles to find his way. He bragged to his friends that he could make a living out of the name Cornelius Vanderbilt, Jr., and set about showing them how. He talked his way into procuring free passes on his father's lines and traveled widely. With his name and glib talk and flattery, he borrowed money for gambling from the Commodore's friends and from complete strangers, writing checks on banks in which he had no funds and forging his father's name. That he would forge his father's name and expect him to pay was a clear indication to the Commodore that his son was demented. The Commodore sent word out to all his business acquaintances: "There is a crazy fellow running all over the land calling himself my son. If you come in contact with him, don't trust him."[38] On January 24, 1854, he again had his son arrested on the grounds of "confusion" and "loose habits,"[39] and taken again to the Bloomingdale Insane Asylum. "Mr. Vanderbilt," Dr. Brown, the director of the asylum, said to Corneel after talking with him a while that evening, "I have received your commitment. I am satisfied that you are no more crazy than I am. You may go home."[40] Corneel left the asylum the next morning and rode to town to get a writ of habeas corpus, since under the terms of the commitment he could be arrested again at any time and sent to another institution. Appearing against him in the court proceedings was brother Billy on behalf of their father. "William told me that he had only had this done to save me from State Prison. I told him that I would rather be considered a damned rascal than I would a lunatic."[41]

Corneel could always count on a loan, no questions asked, from his friend Horace Greeley, editor of the *New York Tribune*. When the Commodore learned that Greeley was lending his son large amounts of

money, he dropped what he was doing and hurried to Spruce Street to the Tribune Building, storming up the narrow creaking wooden stairs to Greeley's office.

"Greeley," he bellowed, "I hear you are lending Corneel money."

Greeley raised his head from the high desk at which he was writing and looked at the Commodore. Then he went back to his work, remarking, "Yes, Commodore, I've let him have some money."

"You have, eh? You have! Well, I want you to understand that I ain't responsible for it, and I shan't pay you a cent of it."

Greeley stopped writing, pushed his spectacles up on his forehead, and stared at the Commodore.

"You won't, eh? Well, who the devil asked you to pay it? I didn't, did I?"[42]

He went back to his work, as the Commodore stomped out of the office.

When the Commodore learned that another friend of his had loaned money to Corneel, he was flabbergasted. "Why, I didn't think you was such a damn fool as to invest your money that way. Now you'll have to wait for your money until after I am dead, then Corneel will pay you. Corneel has many indiscreet friends and the only revenge I can take is to let you all wait for your money until after I am dead."[43]

What, the Commodore wondered, was such a son good for? He had worked in a law office copying papers and then quit. He had worked for a while in a leather business and left. Hoping to see as little of him as possible, the Commodore bought Corneel a ten-acre fruit tree farm— not on Staten Island, but rather in East Hartford, Connecticut.

The Commodore was pleased when at the age of twenty-five, Corneel told him that he was going to marry Miss Ellen Williams, the daughter of a Hartford minister. "I have a divine mission to save that young man,"[44] Miss Williams had told her friends in explaining why she had agreed to marry the charming young hustler, and the Commodore believed she could. He had such respect for the young lady that he felt duty-bound to make sure she knew just what she was getting into. The Commodore went to call on her father.

"Has your daughter plenty of silk dresses?" the Commodore asked Mr. Williams.

"Well, my daughter, as I told you, is not wealthy. She has a few

dresses like other young ladies in her station, but her wardrobe is not very extensive nor costly."

"Has your daughter plenty of jewelry?" the Commodore continued.

"No, sir. I have attempted to explain to you that I am in comparatively humble circumstances, and my daughter cannot afford jewelry."

"The reason I ask you is that if she did possess these articles of value, my son would take them and either pawn or sell them, and throw away the proceeds at the gaming table. So I forewarn you and your daughter that I can't take any responsibility in this matter."[45]

When Corneel came to his father to ask for money to build a house in Hartford for his new bride, his father was adamant. "No, Corneel, you've got to show that you can be trusted before I trust you."

Several days later, Corneel's wife tried her luck with her new father-in-law.

"How much can you get along with?" the Commodore asked her.

"Ten thousand dollars."

He wrote a check, advising her to stretch it as far as possible, since there would be no more.

Several months later, she again went to see her father-in-law. The Commodore braced himself, knowing what was coming: a request for more money.

"Well, what now?" he demanded.

"Nothing, papa; only I've brought back $1,500. It was more than we needed, and I've brought you what's left."[46]

The Commodore could hardly believe it. Corneel had been saved. He raised his son's allowance to $150 a month, and then $200 a month. But unlike his brother, Corneel was never able to make his farm pay. He continued living well beyond his means, frequenting gambling dens and brothels in Manhattan, borrowing money from professional gamblers, assigning his allowance as security, writing bad checks, landing in debtors' prison on a number of occasions and depending on his mother to bail him out, until it reached the point that the Commodore would not give Sophia any money, in the belief that she would simply turn around and give it to her wanton son. Finding himself in 1868 with outstanding indebtedness of $80,000 and no assets, Corneel declared bankruptcy.

* * *

THE COMMODORE

Faithful wife and tireless worker Sophia fared no better than her children in the Commodore's eyes.

In the summer of 1846, when the Commodore was fifty-two and Sophia was fifty-one, he fell in love with his children's comely young governess, the latest of an endless series of dalliances, but the first within his house. It was difficult having Sophia at home, so he sent her on a trip to Canada with one of his daughters. When the beleaguered governess quit, it fell to obedient Billy to secure another buxom maid to fill her position.[47] "I'll find some woman to take her place," Billy noted. "The old man is bound to fall under the influence of some woman, and I'll have that woman appointed."[48]

While his wife was away, the Commodore was busy indeed. Having decided that he had to be closer to the center of business, he began constructing a four-story brick and brownstone townhouse in New York City at 10 Washington Place, a quiet street between Washington Square and Broadway. Complete with stables in the rear, the house cost the Commodore $55,000. Upon her return, Sophia for the first time in her life stood up to her husband and refused to leave her home on Staten Island and move to the city. The Commodore could not believe what he was hearing. Clearly the poor woman was out of her mind! The Commodore told his children that their mother, who steadfastly refused to leave her friends on Staten Island, was in poor health and "was at the change of life," which obviously had affected her sanity.[49] Against the protests of all his children—all except Billy—he had her committed to Bloomingdale Insane Asylum. When the physicians at the asylum insisted upon her return, Sophia reluctantly gave in once again to the wishes of her domineering husband and left her home on Staten Island.

4.

From his small office on Battery Place, the Commodore watched during 1848 as hundreds of ships sailed from New York, packed with adventurers racing by way of Panama to California, where gold had been discovered in the Sacramento Valley. For hours, he stood examining large colored maps of Central America spread on the table before him. There,

smack in the middle of Nicaragua, lay Lake Nicaragua, 100 miles long and 50 miles wide. From the Caribbean, the San Juan River snaked 119 miles to the lake. Between the lake and the Pacific coast lay but 12 miles of jungle. The logic seemed irrefutable. If this route across Central America through Nicaragua was passable, the eager prospectors racing to the gold fields could cut 500 miles and several days off their trip, and avoid the disease-ridden isthmus of Panama. In 1851, the fifty-seven-year-old Commodore organized the Accessory Transit Company, and for $10,000 secured from the Nicaraguan government a charter to cross the country by river and lake.

To test his new route, the Commodore sailed to Nicaragua aboard one of his new large steamships, the *Prometheus,* with a small steamboat, the *Director,* in tow. The San Juan River, the natives warned him, was filled with rapids and rocks, boulders, fallen trees, and hidden bars, and was navigable only by dugout canoe. The Commodore took the helm of his steamer and announced that he was going up to the lake "without any more fooling." One of the men on board remembered that on this first trip "the Commodore insisted upon 'jumping' all the obstacles, and tied down the safety valve, put on all steam, and compelled the little steamer to scrape and struggle over the obstructions into clear water again."[50] What was the matter with these natives? Of course the river was navigable! He arranged for part of the San Juan River to be dredged and for obstacles to be blasted out, for docks to be built at the Atlantic and Pacific ports, and for twelve miles of macadam road to be laid through the jungle from Lake Nicaragua to the Pacific.

On July 3, 1851, the papers advertised "the New and Independent Line for California, via Nicaragua." Every two weeks, one of the Vanderbilt steamships sailed from New York, headed for San Francisco by way of Nicaragua. It was a horrendous journey of 4,531 miles that took four weeks to complete. Large steamships brought the passengers down the Atlantic coast through the Gulf of Mexico and Caribbean to the mouth of the San Juan River. Smaller iron-hulled steamboats then transported them up the river to Lake Nicaragua. A lake steamboat took them across the lake, and then stagecoaches drawn by mule teams brought them through the jungles to San Juan del Sur, the small port Vanderbilt had built on the Pacific coast, from which another steamship took them up the coast to the gold fields. The trip itself was hard enough; conditions

aboard the Vanderbilt ships made it agonizing. A group of passengers who had traveled on his line from California to New York purchased space in the *New York Times* to vent a number of their criticisms:

> There are a few trifling items which we in kindness submit to you as being unworthy of your generally enlarged views and most liberal, humane intentions toward those under your care and protection. For instance, all the meats set before us at our meals were so tainted as to be positively offensive to the smell, and, of course, unfit as food for any civilized creature. . . . Our eyes were never feasted by the appearance of a clean cloth on the table, nor did we, on the voyage . . . luxuriate upon a clean sheet or pillow case. Not a bathroom on the ship, and a spittoon is not an article of furniture to be found in the establishment. We regret, sir, to mention these little inconveniences as having a tendency toward complaint—yes, even instilling in the minds of passengers a thorough disgust and most perfect contempt toward you, as the controller of the magnificent institution composing this company. In conclusion, our very dear friend, we promise you that we will never burden again your superior steamer *Champion* with our presence on board; and in preference to another such voyage, we would each get a wheel barrow, carry our provisions on it, and thus plod across the plains back to our homes on the Pacific—and there we will teach our children to revere your name as the most successful, most penurious and most heartless millionaire that ever disgraced our country.[51]

Those willing to endure these conditions reached California several days ahead of their less stalwart brethren, and for less money. Vanderbilt cut his first-class fare from $500 to $300, eventually reducing the cost of a trip from New York to San Francisco to $50. The line was profitable from the start. His operation carried two thousand passengers a month for nine years, and he made a profit of more than $1 million a year from it.

With the success of his Nicaraguan venture, the Commodore had stashed away a great fortune, and now was just about as rich as anyone, as rich as A. T. Stewart, the department store owner; the Lorillards, who

had made their money in tobacco; the Goelets, who owned valuable Manhattan real estate. He was almost as rich as the heirs of John Jacob Astor, the New York City real-estate tycoon. "I have got $11,000,000 better invested than any $11,000,000 in the United States," he told his good friend Jacob J. Van Pelt in 1853 when he was almost sixty. "It is worth 25 per cent a year and there is no risk on it." His children would be well provided for if something happened to him. "I have a large family and none of them were brought up to do anything," he told Van Pelt. "If they have it as I have left it to them they can live on the interest and they will all have plenty as long as they live."[52]

Sixty years old. His affairs in order. His children provided for. The Commodore decided to do something he had never tried before. He would take some time off to relax. He left his California route in charge of two trusted directors of his company, Charles Morgan, who had operated a steamship business in the Gulf of Mexico, and Cornelius Garrison, who had established a banking house in Panama during the gold rush, and commissioned a Long Island shipyard to build for $500,000 a 270-foot steam yacht.

The ship was thirty-eight feet amidships, equipped with paddle wheels with a diameter of thirty-four feet, four coal-fed boilers, and two masts for auxiliary sails to help steady it in rough seas. The *North Star* he called her, the first oceangoing yacht ever built for a private citizen, and in her he would tour the capitals of Europe. As his expedition took shape, the Commodore came to see himself, as did the American press, as something of a diplomat, an example for the European aristocracy of what American businessmen had achieved. "The real character of our people has been misunderstood," wrote the *New York Herald* in April 1853, several weeks before the *North Star* sailed. "What can the Czar of Russia know of our social life—of the general prosperity which prevails throughout the country—of the intelligence and comfortable condition of our industrial classes, and the refinement of those whose enterprise, industry and genius have placed them at the head of the social scale? It is only by personal observation that he and the other crowned heads can obtain a true knowledge of these facts; and though he may not visit us to obtain the required information, yet he will, in a very few months, have the opportunity of seeing one of

our most distinguished and wealthy citizens in his own capital. . . . Although it is solely a personal matter, it partakes somewhat of a national character."[53]

As befit the yacht of a colossus of capitalism, the *North Star* was royally outfitted. It had a satinwood-lined grand saloon, rosewood furniture carved in the style of Louis XV and covered with green velvet plush, positioned around a circular crimson-plush sofa that could seat twenty. The walls of the dining saloon were of highly polished marble that glistened like a mirror. Its white ceiling was covered with scrollwork of purple, light green, and gold surrounding medallion paintings of famous Americans: Webster, Clay, Calhoun, Washington, and Franklin. Each of the ten staterooms sported a different color scheme and was furnished with a large French armoire and lace curtains.

To witness his world conquests, the Commodore invited Sophia and his children to accompany him on the grand cruise (Corneel did not receive an invitation; the Commodore did not want to be embarrassed by one of his son's epileptic seizures) along with six sons-in-law, one daughter-in-law, and one granddaughter, as well as his personal physician, Dr. Jared Linsly, and chaplain, John Choules.

The *North Star* pulled away from the wharf in the East River at 10:30 on the morning of May 19, 1853. As it passed the shores of Staten Island and the cottage of eighty-six-year-old Phebe Vanderbilt, the Commodore ordered a military salute to his mother, who had made this all possible by loaning him $100 for a periauger years before.[54]

Burning forty-two tons of coal each day, averaging thirteen knots, the *North Star* plowed across the Atlantic. Within several days, a routine had established itself. "There was discipline on board that ship, sir," the Reverend Choules noted. "Each man attended to his own business. The Commodore did the swearing, and I did the praying. So we never disagreed."[55]

As would be expected, while everyone attended to his or her own business, the Commodore attended to everyone else's business. One evening after dinner, he walked up to his thirty-three-year-old son Billy, who was enjoying a cigar on the deck.

"Billy, I wish you would quit that smoking habit of yours. I'll give you ten thousand dollars if you do."

"You need not give me money, father. Your wish is sufficient." And with that, Billy threw his cigar into the sea.[56]

The Commodore then reached into his side pocket and pulled out a large Havana cigar. Slowly he fondled it and finally lit it, blowing the fine, rich smoke into his obedient son's face.

Ten days after leaving the East River, the *North Star* arrived at Southampton, England, greeted by a cheering crowd. England's aristocracy was curious about this American rustic, but reluctant to get too close. All declined with regret the kind invitation to the banquet to be given in honor of the Commodore on June 13 by Southampton's merchants and tradesmen. Prime Minister Lord Palmerston remarked diplomatically to a friend that it was unfortunate that a man of the Commodore's talents had not had more of an education. "You can tell Lord Palmerston from me," the Commodore responded when this was reported to him, "that if I had learned education I would not have had time to learn anything else!"[57]

"Trouble is anticipated upon the return of Commodore Vanderbilt," the *New York Herald* predicted that summer as the *North Star* was steaming on from St. Petersburg to Marseilles to Genoa to Constantinople. "It appears that when he agreed to put boats upon the route, the Transit Company contracted to pay him twenty percent of the gross receipts of the Transit across Nicaragua. This payment was made regularly to Mr. Vanderbilt up to the time he left in his yacht for Europe. Since, the Company has refused to make payments to Vanderbilt's agent, and there is very little doubt but that upon the Commodore's return, summary measures will be taken to collect his demand."[58] This was a safe prediction.

It did not take the Commodore very long upon reaching New York in September to learn that his agents, Charles Morgan and Cornelius Garrison, had double-crossed him. He penned them a succinct letter, which he published in the papers:

GENTLEMEN
You have undertaken to cheat me. I won't sue you, for the law is too slow. I'll ruin you.

C. Vanderbilt[59]

THE COMMODORE

He organized a new line to California by way of Panama, the People's Independent Line, and, as usual, initiated a rate war, charging only thirty-five dollars for steerage passage from New York to San Francisco. ("For a very small sum passengers will be guaranteed to arrive in San Francisco ahead of the Nicaraguan line," he promised in his advertisements.[60]) By September 1854, a year later, Morgan and Garrison had capitulated and paid the Commodore what he demanded, and purchased his ships, including his steam yacht, the *North Star*, all at the exorbitant prices he set. Within the year, when the price of the stock of Accessory Transit Company dropped due to political unrest in Central America, Vanderbilt bought a controlling interest in the company, got his route back, got his ships back, and threw out Morgan and Garrison. The next year, every other line through Panama agreed to pay the Commodore a total of $40,000 a month not to operate his Nicaraguan line. He was only too glad to enter into this oral agreement to be paid for keeping his ships tied up at the wharf. Shortly thereafter, he came to believe that his withdrawal was worth $56,000 a month to the opposition lines. They quickly saw the wisdom of his reasoning and increased their payments.

By 1862, in the midst of the Civil War, after he had sold the last of his steamships to the Union, the Commodore had accumulated $40 million.[61] What was the secret of his success? he was asked. "Secret? There is no secret about it. All you have to do is to attend to your business and go ahead. The secret of my success is this: I never tell what I am going to do till I have done it."[62]

Surely that was part of it. The other part was, as the Commodore was the first to admit, that the accumulation of money had been a mania with him when he was seventeen and that he had never gotten over it. "I have been insane on the subject of moneymaking all my life."[63] He was never interested in spending his money. His mansion on Staten Island had cost $27,000, and his townhouse on Washington Square $55,000, significant sums in the mid-nineteenth century to be sure, but not for a multimillionaire. He had spent $500,000 on his steam yacht, the *North Star*, but had sold it at a profit the following year. No, it was not what he could do with his money that interested the Commodore. It was the money itself. The money. It was money madness, greed. The

money was the basis of his self-esteem, it was his tally of his wins, of his success, of his self-worth, and there would never be enough to satisfy him.

The stories of his avariciousness were legendary. On one occasion he gave a servant three cents to buy matches. A visitor thought about it, and realized that if he had been as rich, he would have had more than three cents' worth of matches purchased at a time. The mother of a schoolteacher had saved $4,000 and, concerned about the money, had her daughter bring it to Commodore Vanderbilt, with whom she was acquainted, asking him to invest it safely for her. He declined to invest it, but said he would take it and pay her 7 percent interest each year. He paid her 7 percent the first year, but then only 4 percent the second and third years, and refused to give her an accounting.[64]

In an "Open Letter to Commodore Vanderbilt" published in *Packard's Monthly*, Mark Twain, sick and tired of seeing Vanderbilt extolled in the press as the self-made man as hero and compared with Franklin, Jackson, and Lincoln, got a few things off his chest:

> How my heart goes out in sympathy to you! How I do pity you, Commodore Vanderbilt! Most men have at least a few friends, whose devotion is a comfort and solace to them, but you seem to be the idol of only a crawling swarm of small souls, who love to glorify your most flagrant unworthiness in print; or praise your vast possessions worshippingly; or sing of your unimportant private habits and sayings and doings, as if your millions gave them dignity; friends who applaud your superhuman stinginess with the same gusto that they do your most magnificent displays of commercial genius and daring, and likewise your most lawless violation of commercial honor—for these infatuated worshippers of dollars not their own seem to make no distinctions, but swing their hats and shout hallelujah every time you do *anything,* no matter what it is. I do pity you.
>
> All I wish to urge upon you now is, that you crush out your native instincts and go and do something *worthy* of praise—go and do something you need not blush to see in print—do something that may rouse one solitary good example to the thousands of young men who emulate your energy and

your industry; shine as one solitary grain of pure gold upon the
heaped rubbish of your life. Do this, I beseech you, else
through your example we shall shortly have in our midst five
hundred Vanderbilts, which God forbid. Go, oh please go, and
do one worthy act. Go, boldly, grandly, nobly, and give four
dollars to some great public charity. It will break your heart,
no doubt; but no matter, you have but a little while to live, and
it is better to die suddenly and nobly than to live a century
longer the same Vanderbilt you are now.[65]

5.

The Commodore would indeed do something worthy with the remain-
ing years of his life. He intended to do what he did best and what he
had to do: make more money. Hale, hearty, the Commodore at sixty-
eight was erect and vigorous, with ruddy cheeks and bright blue eyes,
snow-white hair and bushy white sideburns. Seeing him dressed in his
old-fashioned black suit with white choker, some thought he looked like
a bishop. At an age when most men were winding down their affairs, the
Commodore was plunging into a new business.

From the day in October 1833 when he had taken his first train
ride, traveling to Philadelphia aboard the Camden and Amboy Railroad,
the Commodore had had nothing but contempt for "them things that
go on land."[66] The train he was riding that day had run off its tracks
near Hightstown, New Jersey, tumbling into a ravine and instantly
killing most of the passengers. His ribs had been driven into his lungs,
his head and face severely bruised, the skin ripped from much of his
body. He was carried to a nearby cottage where he remained for a month,
and then was taken to his home where he was confined to his bed until
the spring. Railroads? No! "I'm a steamboat man, a competitor of these
steam contrivances that you tell us will run on dry land. Go ahead. I wish
you well, but I never shall have anything to do with 'em."[67]

As his steamboat operations became more sophisticated, he began
to appreciate how the rails that served as feeders to steamboat lines
would someday become competitors to the steamboats themselves. In
the winter of 1862–1863, he became fascinated by the potential he saw

in the New York and Harlem Railroad, a short, unprofitable line of just 131 miles (at a time when the total railroad track mileage in the United States was over 36,000), but which did have the distinction of being the only railroad line that entered New York City. He began buying up the Harlem at eight dollars a share and, when he had control, began making improvements to the line. "I've got a few millions lying idle, and the Harlem is going up to par, if we give it time. If I don't get the benefit of it, my children will."[68] His friends shook their heads. His competitors laughed. An old man starting a new venture about which he knew nothing! He was about to lose the fortune it had taken him half a century to accumulate.

Gradually, however, the Harlem's stock rose to 30, and then slowly to 50. On April 23, 1863, at his behest, the aldermen of the common council of the city of New York authorized the Harlem to construct a line along Broadway to the Battery. The day after the granting of this franchise, which would make the Harlem not only the one railroad entering New York City but also the only line running the length of Manhattan Island, the stock jumped from 50 to 75, moving within days to 100.

Now one of the Harlem's directors, Daniel Drew, the Commodore's old steamboat rival, sun-beaten gospel-quoting Daniel Drew, as tightfisted and shrewd as the Commodore ("I had been wonderfully blessed in money-making," he once commented; "I got to be a millionaire afore I know'd it, hardly"[69]), now Drew had a little talk with the aldermen of the common council. Look how the Harlem's stock has risen! If that franchise were, perchance, to be rescinded, think how fast the stock would drop! If the aldermen were to sell the Harlem short—if they were to speculate on an anticipated drop in the stock's price by borrowing shares they did not own, selling them, and then buying them back at a much lower price to replace the borrowed shares—think how much money there was to be made as the stock plummeted! What he said made eminent sense to the honorable aldermen. Led by Drew, they each borrowed as much money as possible and began shorting the Harlem's stock, selling, selling, always selling. Learning of the scheme, the Commodore began buying.

When the council repealed the ordinance on June 25 and the court of common pleas issued an injunction to prohibit construction of the

new Harlem line along Broadway to the Battery, the aldermen gleefully sat back and waited for the stock to dive. As it fell from 110 to 72, they cheered. Their glee, however, turned to terror the next day when, inexorably, inexplicably, horribly, the stock began rising. The Commodore had cornered the market—had bought every outstanding share of the Harlem. By June 26, the stock was at 97¼. The next day it rose again, up to 106. In a panic, the august aldermen repealed their repeal of the franchise to placate the Commodore. That didn't help. The stock continued to rise. All the while, they begged the Commodore to stop, to allow them to buy the stock back from him to cover their short positions. No, the Commodore said. It was important for them to learn their lesson. The stock continued to rise: to 150, to 170, to 179. There was no limit to their losses. The higher the stock rose, the more money they were losing. The only way to stop these terrible losses was to buy back stock to replace their borrowed shares, but there was not a single share available.

By the end of the summer, the Commodore had had his fun. Drew tearfully pleaded for mercy, reminding the Commodore of their common, dirt-poor boyhoods and their years together on the Hudson. The Commodore took a certain pleasure in seeing his old rival grovel, and allowed Drew and the aldermen to buy the stock from him at $180 a share.

The gentlemen of the common council were ruined. The Commodore was $5 million richer. Daniel Drew was poorer but wiser. He composed a little jingle setting forth what he had learned: "He that sells what isn't his'n, must buy it back, or go to prison."[70] Drew was philosophical. He knew there would be opportunities to recoup his losses.

With this invigorating success, the Commodore began buying stock in the Hudson River Railroad, another short line, 140 miles long, running from New York up along the Hudson to Peekskill. Like the Harlem, the road was in disrepair and near bankruptcy.

Early in 1864, Vanderbilt traveled to Albany with pockets full of cash to convince the state legislators of the wisdom of passing a bill to authorize his Harlem railroad to consolidate with the Hudson, creating a through line into New York City. As soon as the Commodore returned home, another director of the Harlem, the ubiquitous Daniel Drew, arrived in Albany with even more money and an interesting proposition.

What if it seemed that the legislature would pass the bill? Harlem stock would rise, right? And then what if at the last moment the legislators were to decide to vote down the bill? The shares would tumble. If the distinguished lawmakers were to sell the Harlem short, there were easy fortunes to be made. So sure were the legislators of the soundness of Drew's scheme that many mortgaged their homes and farms to raise money to sell the Harlem short.

On March 16, 1864, as the legislature debated the bill and its prospects seemed rosy, Harlem stock rose from 89, where it had settled after Drew's last raid, and hit a high of 149. But then, as planned by Drew, the state senate committee refused to approve the consolidation of the Harlem and the Hudson, and in ten days the stock plunged 48 points.

When Vanderbilt realized what was happening, he called his trusted broker. "How do you feel about it? Shall we let 'em bleed us? John, don't those fellows need a dressing down? Let us teach 'em never to go back on their word again as long as they draw breath. Let us try the Harlem corner once more!"[71]

Vanderbilt organized a pool to buy up all the outstanding shares of the Harlem. By April 6, it was back at 150. By the end of April it was at 235. By May 17, it had risen to 280. The legislators waved the white flag of truce, begging him to stop. Vanderbilt ignored them. "Put it up to a thousand!" the Commodore exclaimed. "This panel game is being tried too often."[72]

After he had calmed down a bit and his friends convinced him that if he carried out his threat he would destroy the financial markets, he let the legislators out at 285. He chuckled with glee: "We busted the whole Legislature and scores of the honorable members had to go home without paying their board bills!"[73] Vanderbilt made several million dollars on the second Harlem corner. Uncle Dan'l lost a million.

When these profitable victories convinced the Commodore beyond doubt that "the business of the future in this country is railroading,"[74] he cast a covetous eye at a third line, the New York Central.

The New York Central, with 510 miles of track, was much larger than his Harlem and Hudson combined. It had originated in 1831 as a seventeen-mile road, the Mohawk and Hudson, and had emerged in 1853 as the New York Central, a consolidation of ten railroad companies

that connected the major cities along the Erie Canal, from Albany to Buffalo. The Central was not only the most important line in the east, it was the natural link with Vanderbilt's Hudson River Railroad and Harlem, connecting Manhattan with the heartland of the nation, with the Great Lakes, with the Ohio and Mississippi rivers. The trouble was that the New York Central was shipping all of its freight to the city not on the Commodore's lines, but on the People's Line, Daniel Drew's old steamboat service on the Hudson River. Only when the river was blocked with ice in the winter did the Central rely on Vanderbilt's Hudson River Railroad to make the connection to New York City.

Because the Central was too big for the Commodore to acquire by buying its stock, as he had the Harlem and the Hudson, he devised another plan. After months of negotiations with the directors of the Central failed to result in any agreement satisfactory to the Commodore for the use of his Hudson River Railroad for the Central's through freight to the city, he issued an order to the managers of his road: "Take no more freight from the New York Central."[75] The order was exquisitely timed: The date was January 17, 1867; the Hudson River was choked solid with ice. Not a steamboat was moving. The trains of the Hudson River Railroad stopped in East Albany, just shy of the single-track railroad bridge across the river to the terminal shared with the Central. The Central's connection to New York City was broken. Desperate passengers had to walk two miles through snow and ice, dragging their baggage across the frozen river from where the Central stopped to where the Hudson River Railroad began, if they wanted to get the connecting trains to the city. The Central's freight piled up at its terminal.

Within two days, the directors of the New York Central surrendered, and the Commodore could report in a statement published in the papers that "arrangements satisfactory to both companies for the transactions of their passengers and their freight business have been made."[76] The nature of the arrangements became clear later in the year when the directors of the New York Central sent him a letter:

C. VANDERBILT, ESQ.

The undersigned stockholders of the New York Central Railroad Company are satisfied that a change in the administration of

the Company, and a thorough reformation in the management of its affairs, would result in larger dividends to the stockholders and greatly promote the interests of the public. They therefore request that you will receive their proxies for the coming election, and select such a board of directors as shall seem to you entitled to their confidence. They hope that such an organization will be effected as shall secure to the Company the aid of your great and acknowledged abilities.[77]

On December 11, 1867, seventy-three-year-old Cornelius Vanderbilt was named president of the New York Central.

These curious events troubled the New York legislature. An investigation was initiated and the Commodore ordered to testify. A legislator asked why he had not sued the Central if he had some grievance against it when it had refused to use his railroads for the better part of each year.

"That is not according to my mode of doing things," he replied. "It is not according to my mode of doing things to bring a suit against a man that I have the power in my own hands to punish."

"Were you not aware that in punishing a railroad corporation, you had no right to punish the people of the state or inconvenience them?"

"I did not desire to punish anybody. All I desired was our own rights."

"Did you not know that the law provides a remedy for all wrongs?"

"The law, as I view it, goes too slow for me when I have the remedy in my own hands."

One investigator asked Vanderbilt why he had refused to negotiate the dispute.

"I did not have the time. I went home. Life is not a bit too short for me, and I like to play whist. I will not permit any business to come in and interfere with that."

Could not the Hudson River Railroad enforce its claims through the courts? he again was asked.

"They might. I will not give an opinion on that point. I stated a while ago that I for one will not go to a court of law when I have got the power in my own hands to see myself right. Let the other parties go to law, but by God, I think I know what the law is; I have had enough of it."[78]

THE COMMODORE

* * *

A month later, in January 1868, the Commodore was ready to acquire yet another railroad, this time the Erie, the great line stretching from Nyack to Lake Erie, which, like its rival the Central, connected New York with the Midwest. The Erie would complement the Commodore's growing rail system and eliminate a troublesome competitor that hurt the Central's business by frequently cutting rates. It was controlled by none other than that old drover, seventy-year-old Daniel Drew, who had long been its treasurer and a director. He had made a fortune in manipulating the Erie's stock by leaking rumors, trading on advance information, and withholding shares or flooding the Street with them. Wall Street was aghast to see moves of 20 or 30 percent in the Erie's stock in a matter of days, time and again. "Daniel says up," went the Wall Street wisdom of the day, "Erie goes up. Daniel says down, Erie goes down. Daniel says wiggle-waggle, Erie bobs both ways."[79] Drew was nicknamed by Wall Street the "speculative director," and the Erie, the "scarlet woman of Wall Street."[80]

Strangely enough, when the Commodore began buying Erie, the stock began falling, from 97 to 50. Drew was again taking a short position in his own company, confident that he could manipulate the stock to depress it. Clearly, Uncle Dan'l had not yet learned the risks of tangling with the Commodore. The Commodore kept buying. Just to make sure everything was on the up and up, the Commodore went to court and obtained an injunction against the directors of the Erie, prohibiting them from issuing more stock than the 251,058 shares already outstanding.

Compared to his two young protégés and fellow Erie directors, stealthy Jay Gould and pudgy Jim Fisk, Drew was as moral as the sanctimonious, gospel-shouting Methodist preacher some said he tried to resemble. Thirty-two-year-old Gould, who had made a fortune speculating in small railways, was described by one railroad president with whom he had clashed as "a perfect eel."[81] Thirty-four-year-old Fisk, the son of a tinware peddler from Vermont, had been a salesman for Jordan, Marsh and Company in Boston and a cotton smuggler during the Civil War until he learned there were easier ways to make money on Wall Street. "There goes Jim Fisk, with his hands in his own pockets for a change,"[82] businessmen joked. Gould and Fisk pointed out to Drew that

the Commodore had beaten him at this game twice before, as he would again. There was no doubt that he had the wherewithal to buy every last share of the Erie. Why not let him buy every last share? Gould and Fisk patiently explained to Drew that there was a sure way to humble Vanderbilt. The Commodore wanted to buy Erie stock? Let him buy it. Let him buy as much as he wanted. He was gobbling it up in million-dollar blocks. The more he bought, the more unauthorized stock certificates they would print. On February 19, 1868, the Erie directors met and, in violation of the court injunction, issued fifty thousand new shares, followed in short order by another fifty thousand. The next day, these fresh certificates found their way to Wall Street. "If this printing press don't break down," chortled Jim Fisk, "I'll be damned if I don't give the old hog all he wants of Erie."[83]

Cornering Erie stock was as impossible as trying to corner the ocean. The more the Commodore bought, the more worthless stock the three conspirators dumped on the market, all the while selling the stock short in anticipation of its inevitable collapse.

When the spanking new stock certificates turned up on the market, it was obvious to Vanderbilt what had happened: He had just paid millions of dollars for a bundle of worthless certificates. Enraged, he had a court issue a warrant for the arrest of Drew, Gould, and Fisk for violating the injunction.

Drew had been withdrawing cash from the Erie's treasury, the proceeds from the sales of the worthless stock certificates to Vanderbilt. Learning that a warrant for their arrest had just been issued, the three bundled $6 million of these greenbacks into packages and stuffed them in carpetbags. At ten o'clock on the morning of March 11, 1868, the three directors, Drew, Gould, and Fisk, were seen running from the Erie offices with their bulging carpetbags, dashing straight for the ferry that would take them across the Hudson River to New Jersey, outside of the New York court's jurisdiction.

Safe from the law and the raging old Commodore, the Erie ring holed up in Taylor's Hotel in Jersey City. Around the hotel, which the press dubbed Fort Taylor, they stationed a small army of Erie detectives to protect them. "This struggle is in the interest of the poorer classes especially,"[84] Fisk explained to the reporters inspecting three small cannons mounted on the shore aimed at New York City, and the arsenal

of rifles, shot, and shells meant to protect their $6 million in greenbacks.

All summer the three hid in Fort Taylor, surrounded by their money and an army of thugs, expecting a surprise attack by Commodore Vanderbilt, or at least some treachery by one or more of the three co-conspirators. In the fall, Gould traveled to Albany to induce the state legislators to enact a law that would legalize the actions that had been taken by the Erie in issuing the unauthorized stock. The Albany politicians were pleased to see him. He was, as the *New York Herald* wrote, "a godsend to the hungry legislators and lobbymen, who have had up to this time such a beggarly session that their board bills and whiskey bills are all in arrears."[85] It was rumored that Gould, Drew, and Fisk were willing to spend $2 million in Albany to secure the passage of their bill and hence their safe departure from Fort Taylor. This was quite possible. When Gould was arrested for contempt of court, bail was set at $500,000, an amount he had no trouble posting on the spot in greenbacks so that he could continue lobbying receptive legislators.

One autumn Sunday, when Drew could enter New York without fear of arrest, he went to see his old friend Commodore Vanderbilt and once again offered the peace pipe. A settlement was reached. Drew, Gould, and Fisk agreed to buy fifty thousand of Vanderbilt's Erie shares at $70 a share, to give him $1,250,000 in Erie bonds, and in addition to pay him for his troubles a cash bonus of $1 million. Vanderbilt in return agreed to dismiss all legal actions against the three. Despite the settlement, the Commodore had lost several million dollars in the Erie war. This time, he was the one who had learned a lesson: "Never kick a skunk. From now on, I'll leave them blowers alone."[86]

The Commodore never really minded the Erie setback. At seventy-five, he was having the time of his life.

Before he established his railroad empire, a traveler from New York to Chicago had to change trains seventeen times. By 1869, he had consolidated his Harlem, Hudson, and New York Central lines to create a unified rail system that spun like a spider's web, touching every major city in the growing Northeast. Old iron rails were ripped up and replaced with steel rails the Commodore imported from England. Where the lines had been single-track, the Commodore laid a parallel track; one was dedicated to passenger service, one to freight. Freight cars were rede-

signed to carry not the usual eight tons, but fifteen to twenty tons of precious cargo. Terminals, stock and grain elevators, and bridges were constructed. At Fourth Avenue and Forty-second Street in Manhattan he built the Grand Central Depot, a massive brick-and-granite structure with a glass-domed roof that covered five acres, a building that was, as he planned it, the largest terminal in the world. Pullman sleeping cars, safety couplers, and Westinghouse air brakes, all developed in the last several years to make rail travel safer and more convenient, were installed on all his trains. The New York Central, when consolidated with the Commodore's other lines, created a trunk line between the Atlantic Ocean and the Great Lakes, stretching to the nation's heartland. With its 740 miles of track, 408 locomotives, 445 passenger cars transporting over 7 million passengers each year, and 9,026 freight cars carrying much of the nation's produce, raw materials, and manufactured goods, it was a veritable money machine. Central's stock rose from 75 to 120 in 1867. Despite doubling the number of shares outstanding, the stock jumped to 200 by 1869. The Commodore couldn't have been happier; more money was always more happiness. The Commodore was in paradise.

Vanderbilt's overhead was slim. An English visitor asked to see his "bureaux of affairs."

"What bureaux?" he asked.

"Your departments of business where you conduct your affairs."[87]

The Commodore pointed to his faithful clerk, Lambert Wardell, seated on a stool in the corner of his office in the Grand Central Depot.

But where are your materials for work? the Englishman persisted. Vanderbilt opened the drawer of his work table, which contained nothing but a checkbook and cigars. Everything was recorded in a single small book he carried with him at all times, his "confidential book" he called it, in which he kept a record of all his property.

As had always been his way, he ran his railroads as he pleased. One of his business associates once told him that each of the transactions he had just completed was in violation of the New York statutes.

"My God, John," the Commodore exclaimed in amazement. "You don't suppose you can run a railroad in accordance with the statutes of the State of New York, do you?"[88]

Running his railroads as he pleased often meant cutting expenses

to the bone, as he had with his steamboats, to earn the greatest profit. If travelers could afford to pay extra for seats in a drawing room car, all was well. They would settle into roomy seats behind plate-glass windows, in a well-ventilated car with a washbasin and clean towels, plenty of ice water, a waiter, and a separate compartment for packages. If, however, they traveled at the legal passenger rates, it was quite a different story. The passengers in these stuffy cars sat in a blinding storm of black dust, with their refreshment "of the flavor and attractiveness of bilge water." As the *New York Times* observed, "Commodore Vanderbilt is not unknown to fame as the Poor Railroad King. Those who have had occasion to pass over his lines will not deny that he is the king of poor railroads. . . . Mr. Vanderbilt's roads are great roads, but what are the passengers going to do about it?"[89] "Such cars!" wrote a traveler on his lines. "Old, low-roofed, meanly, dingily furnished, smoky, rickety, crazy, abominable! What an odor! Tombs' stench over again. As we proceeded on our way, the leaky old hulk opened its sides to the rain, and very soon the floor was sole deep in water."[90]

Such criticism never bothered the Commodore. On the contrary, he saw himself as something of a national hero for revolutionizing the nation's transportation system, and contemplated creating a monument 625 feet high in Central Park dedicated to the joint glory of George Washington and Cornelius Vanderbilt.

Yes, the Commodore was having the time of his life and was pretty proud of what a poor boy from Staten Island had accomplished. He named a New York Central locomotive the *Commodore Vanderbilt* and had his portrait painted on its headlights. It pulled a private railroad car called the *Vanderbilt,* which was painted yellow with red trim and decorated with scenes from along the route of the Central. He had his likeness engraved on each of the stock certificates of the New York Central. He told his friends that "numerous ladies bought the stock from him solely for the purpose of obtaining his likeness," never failing to add that the likeness was a very fine one.[91] Over the entrance of the St. John's Park freight terminal on Hudson Street in Manhattan, he had constructed an elaborate fifty-ton bronze frieze of steamships and railroads. In the center was a colossal bronze Cornelius Vanderbilt, standing in a fur-lined overcoat.[92]

The Commodore had always considered his fortune as his real

monument, and now he was at an age when he had to begin considering what to do with it.

The Commodore's thirteenth, and last, child, George Washington Vanderbilt, born in 1839, had been well worth the wait, for here at last was just the type of son the Commodore wanted. He looked just like the Commodore, he had the Commodore's strong physique, and he acted just like the Commodore. What a boy! Here at last was a son to step into his shoes. George was said to have been one of the strongest and most athletic men ever to attend West Point. There, on his twenty-second birthday, he made a name for himself by lifting nine hundred pounds. Commissioned as a lieutenant in the Union infantry during the Civil War, he contracted tuberculosis in the Shiloh campaign. The Commodore sent him to the Riviera to recuperate, accompanied by Billy to look after him. But George never recovered, dying in Nice on January 1, 1864, at the age of twenty-five.

In his grief, the Commodore took stock of what he had left: a bunch of girls and two disappointing sons, Billy the blatherskite and crazy Corneel. This was not much to work with. To found a dynasty to perpetuate his fortune and name, Billy was clearly a better bet, blatherskite or not. The Commodore could trust his elder son, whom he was beginning to see as something of a kindred spirit. "Cornelius is generous but wasteful, and William is, like me, avaricious."[93]

He had to admit that Billy, now in his fifties, was showing some promise. The Commodore had arranged for him to be appointed receiver of the tiny Staten Island Railroad, whose three locomotives and six passenger cars ran along thirteen miles of track on the eastern shore of the island. Billy had very carefully cut its expenses, connected the road with the city by means of a line of ferryboats, and within a couple of years had paid off all the debts of the bankrupt line. Its stock had risen from next to nothing to $175 a share, and was paying a dividend of 10 percent.

The Commodore bought Billy a large stone house at 459 Fifth Avenue and made him vice president of the Harlem and Hudson. While the Commodore planned his market strategies, he set Billy loose managing the day-to-day operation of the lines. "I tell Billy that if these railroads can be weeded out and cleaned up, and made ship-shape, they'll both pay dividends."[94] Billy worked long and hard to master all the

details of running the railroads, studying every train schedule, every bill and voucher, examining each engine, reviewing every piece of correspondence. His father was pleased and made him a vice president of the New York Central.

The Commodore still found it great fun to see if he could take advantage of his son. Once, in casual conversation, he remarked to Billy that it was probably a good time to sell short any stock he was holding in the Hudson Railroad since it looked like the price of the stock was about to fall. Billy knew his father well enough not to take his advice on its face. He did a little investigation of his own and found that even though his father was telling him to sell the stock, he was buying it himself, obviously on the conviction that it would go even higher.

When the Hudson's stock hit 130, the Commodore asked his son how much money he had lost.

"I went in at 110 on 10,000 shares," Billy answered. "That ought to make me $260,000."

"Very bad luck, William, very bad luck this time," his father said, shaking his head in sympathy.

"But I bought and so made," Billy responded.

"Eh?"

"I heard that was your line, and so concluded that you meant long instead of short."[95]

The Commodore beamed.

"I suppose William is doing well, now," a friend said to the Commodore.

"Yes," he replied. "Billy will make a good railroad man."

6.

After his breakfast of six eggs, a lamb chop, toast, and a cup of tea with twelve lumps of sugar, topped off by a cheekful of Lorillard's plug, the Commodore spent four or five hours a day at his office, managing the affairs of his railroad empire. He had no patience for details, leaving all that to Billy and Chauncey Depew, a bright young graduate of Yale who served as general counsel to the Vanderbilt lines. If he received a letter of more than half a page, he would struggle through part of it and then

toss it to his clerk. "Here, see what this damned fool is driving at, and tell me the gist of it."[97]

The rest of the afternoon was devoted to driving a team of his prize steeds while sipping a tumbler of gin mixed with sugar. After a dinner of Spanish mackerel, woodcock, and venison, his evenings were spent at the Manhattan Club playing whist or five-point euchre. (Once he returned from the club chuckling in amazement. "I have just seen the funniest thing. Horace Clark and three grown-up men playing cards for nothing!"[98])

The Commodore was lonely. Sophia had died of a stroke on August 17, 1868, at the age of seventy-three. All his children, married and with their own children, had left home. He was alone in the big house at 10 Washington Place. The Commodore spent each evening at the Manhattan Club with the few remaining friends of his generation whom he had not outlived. He had even taken to inviting home Uncle Dan'l Drew to reminisce about the good old days when they had tried to ruin each other.

Into his world of lonely old age descended two young sirens, remarkably good-looking sisters, Victoria and Tennessee Claflin.

The two sisters were the seventh and ninth children of a white-trash family from Homer, Ohio. Their father, Buck Claflin, was a small-town swindler who passed poor-quality counterfeit money and burned down his gristmill to recover the insurance money. When he was driven out of Homer, he and his illiterate wife gathered up their children and organized a traveling medicine show, enlisting their two beautiful daughters, Victoria and Tennessee, to tell fortunes, call up spirits in seances, hawk cancer cures, and do some faith healing, and if that didn't work, to throw in a little prostitution for good measure. One of their popular patent medicines had Tennessee's picture on the label: "Miss Tennessee's Magnetio LIFE ELIXIR," it was called, "for Beautifying the Complexion and Cleansing the Blood." Each bottle sold for two dollars and the directions instructed that for best results, a teaspoonful was to be taken three times a day, one half hour before each meal. Those two remarkable daughters could sell anything.

The ragtag family never stayed long in any town. Victoria, in one of her trances, was visited, she said, by the Greek orator Demosthenes,

who told her that if she went to New York City, she would emerge from poverty into a life of great wealth and would become the ruler of her country. She faithfully followed these spiritual orders and in 1868 arrived in New York with her sister, Tennessee.

Victoria Woodhull (she, like her sister, had married and divorced) held herself out as a clairvoyant. At seventy-four, the Commodore was at an age when he was thinking more and more of the hereafter, and realized he needed some spiritual assistance. In addition, he was always hopeful that he would receive advice from his beloved mother, or at least learn what the stock market would do in the week ahead. It was therefore inevitable that he met thirty-year-old Victoria, who promised messages from the other world.

An acquaintance with one sister invariably led to an acquaintance with the other. Twenty-two-year-old Tennessee held herself out as a magnetic healer. By touching and massaging a patient's body, she could, she claimed, transmit vital forces, with one hand transmitting positive force and the other hand negative force. This, too, was just what the Commodore needed. The Commodore could feel it, he felt the vital forces enter him, he felt the wonders that Tennessee was able to perform on his tired old body. He began spending more and more time with the young girl, bringing her with him to his office, sitting her on his knee and bouncing her up and down as he talked railroad business with his associates and she pulled on his side whiskers. She called him "old boy." He called her "little sparrow."

There were a couple of things these two young girls wanted, and maybe the Commodore could help them. They wanted to be stockbrokers. Brokers! Well, if that was it, why not? With the Commodore's financial backing, they rented a suite of offices at 44 Broad Street and opened Woodhull, Claflin and Company.

It was quite a sensation. Women were not supposed to be interested in business. Yet here were two striking young women, whose curly brown hair was cut short, who wore their dresses daringly short, ending at their shoe tops, and who sported jackets with a masculine cut set off with bright-colored neckties. The "Lady Brokers of Wall Street," the newspapers called them; the "Bewitching Brokers." The curious mobbed the streets around their office. Those who made it inside saw on one wall a portrait of the Commodore, and on another a sign: ALL GENTLEMEN

WILL PLEASE STATE THEIR BUSINESS AND THEN RETIRE AT ONCE.[99] How
would the ladies make their investment decisions? That was easy, the
Commodore responded. Mrs. Woodhull would go into a trance and
predict the course of railroad stocks. "Do as I do," he told one young
man asking for stock advice, "consult the spirits."[100] The stock of the
New York Central would be rising, he told another. How did he know?
"Mrs. Woodhull said so in a trance."[101]

Whether Victoria Woodhull was receiving stock tips from the
beyond, or whether the Commodore was whispering tips into Tennes-
see's cute little ear, within a few months the sisters had made over
$500,000. Demosthenes had been right! The sisters had emerged from
poverty.

If the first part of Demosthenes' prophecy had been correct, why
not the second? Victoria Woodhull was destined to be the leader of her
country.

With the Commodore's money, the two lively young ladies pub-
lished the first edition of their newspaper, *Woodhull & Claflin's
Weekly*, on May 14, 1870. And what a paper it was! PROGRESS! FREE
THOUGHT! UNTRAMMELED LIVES! BREAKING THE WAY FOR FUTURE GENER-
ATIONS! heralded the masthead. The paper, whose articles were written
by a number of gentlemen admirers, engaged in muckraking, exposed
stock and bond frauds and political corruption, advocated women's
rights, promoted clairvoyant healing and free love, and in each issue
advanced Victoria C. Woodhull's candidacy for the presidency of the
United States. The Equal Rights party nominated her as its candidate
for president in the election of 1872, her running mate being Frederick
Douglass, the black reformer.

Not to be outdone, young Tennessee ran for Congress in the Eighth
Congressional District of New York, but what she really wanted was to
marry her "old boy." The Commodore found the idea appealing and
promised to marry his "little sparrow," telling her he would take care of
her and make her a queen when he died. But before any wedding
arrangements were made, the seventy-four-year-old Commodore fell in
love with an older woman.

The Commodore was infatuated with a relative, Frank Crawford,
the thirty-year-old great-granddaughter of his mother's brother. Tall,
graceful, and well educated, stunning Frankie and her mother had left

Mobile, Alabama, after the Civil War to seek a new beginning in New York City. As distant relatives, they had stopped in to see the Commodore.

The Commodore was hooked. In June of 1868, two months before she passed away, Sophia was planning a trip south. The Commodore issued an order to one of his servants: "Get her out of the way as soon as possible!"[102] Several hours after his wife had left the house, the Commodore, his son Billy, Mrs. Crawford, and daughter Frank were aboard a special palace car of the New York Central headed for Saratoga Springs. The day after Sophia's death that August, the Commodore began squiring Mrs. Crawford and Frank around New York City, and invited them to live at his house, free of rent, as visitors. They accepted his kind offer.

A year later, in August of 1869, the Commodore proposed to Frankie. "You are making a great sacrifice in marrying me. You have youth, beauty, virtue, talent, and all that is lovely in a woman, and I have nothing to give you in return!"[103] Well, yes, perhaps: A seventy-five-year-old grandfather was marrying a beautiful thirty-one-year-old woman. However, a prenuptial agreement giving Frank $500,000 of first mortgage bonds of his Hudson River Railroad Company went a long way toward balancing the match, and the odd couple married on August 21, in Ontario, Canada. "I didn't want to raise a noise in the United States," the Commodore explained, "so I slipped over to Canada and had it done in a jiffy, and I guess the knot was well tied."[104]

When the newlyweds returned to the city, there were many questions. Why hadn't he married Frank's mother, for instance, of whom he seemed fond? "Oh, no! If I had married her mother, Frankie would have gone off and married someone else. Now I have them both!"[105]

He was obviously happy. Frank called him "Com" and fawned all over him. Acquaintances noted in amazement that, quite uncharacteristically, on occasion the choleric old Commodore would "giggle foolishly without provocation."[106]

Frank saw it as her duty to improve her husband's life. She did not approve of cards, so the Commodore gave up his games of whist at the Manhattan Club. A deeply religious woman, she scoffed at his belief in seances and spiritualism, so the Commodore was careful not to talk about his attempts to communicate with the other world. Once, and

only once, he put his arm around Tennessee Claflin's narrow waist and kissed her in front of his wife.

"Did you not promise to marry me before you married your wife?" Tennessee pouted.

"Certainly I did. I intended to have done so, but the family otherwise arranged it. You might have been Mrs. Vanderbilt."[107]

Frankie saw to it that that was the last he saw of the Claflin sisters.

Frank tried to instill some religion in his life and urged him to stop swearing. That was all but impossible after a lifetime around New York's waterfront, but he gave it a good try. Frank's pastor came visiting one day and found the Commodore on the sofa, obviously distraught.

"Why, what's the matter, Commodore?"

"Oh, damn!" he replied. "I've been a-swearing again, and I'm sorry. I'd ought to stop it, my wife being such a pious woman and you and other religious folks coming to see us, and it's a shame that I don't."[108]

Yes, Frank was working miracles with Com, even getting him to loosen up the purse strings a bit for a good cause or two. The Commodore had never had much respect for people who sought charitable contributions. "Let others do as I have done and they need not be around here begging."[109] Clerical beggars were the worst. He once presented a parson seeking a donation for his church with a one-way ticket to the West Indies. Another time, a Catholic priest from Albany came to him with twenty dollars that a parishioner had stolen from the railroad and wished to return. The Commodore took the twenty-dollar gold piece and handed it to his bookkeeper to put into the proper account. The priest remained a while, talking to the Commodore about the poverty of his church. The bookkeeper expected the Commodore to ask for ten dollars back to give to the priest, but no such request was forthcoming. "There's considerable good in religion after all," the Commodore told the bookkeeper after the priest had left.[110]

Despite his feelings about clergymen seeking contributions, Frank convinced him to give $50,000 to her favorite pastor, the Reverend Charles F. Deems, for the purchase of a building for the Church of Strangers.

"Commodore, if you give me that church for the Lord Jesus Christ, I'll most thankfully accept it," the grateful pastor told him.

"No, Doctor, I wouldn't give it to you that way," the Commodore replied, "because that would be professing to you a religious sentiment I don't feel. I want to give you a church. That's all about it. It is one friend doing something for another friend. Now, if you take it that way, I'll give it to you."[111]

When the Commodore again began thinking about the construction of a 625-foot-high monument to be erected in Central Park to the joint glory of his two heroes, George Washington and Cornelius Vanderbilt, his wife plotted with Dr. Deems to dissuade him.

"I'd give a million dollars to-day, Doctor, if I had your education!" the Commodore said to Dr. Deems one evening after dinner.

"Is that your honest sentiment, Commodore?" Dr. Deems asked him.

"It is. Folks may say that I don't care about education, but it ain't true; I do. I've been among educated people enough to see its importance. I've been to England, and seen them lords, and other fellows, and knew that I had twice as much brains as they had maybe, and yet I had to keep still, and couldn't say anything through fear of exposing myself."

"If these are really your sentiments, then you must let me tell you that you are one of the greatest hindrances to education that I know of."

"Why, how so?" the Commodore demanded.

"Why, don't you see, if you do nothing to promote education, to prove to the world that you believe in it, there isn't a boy in all the land who ever heard of you, but may say, 'What's the use of an education? There's Commodore Vanderbilt; he never had any, and never wanted any, and yet he became the richest man in America.'"

"Will they say that? But it isn't true. I do care for education and always have. But what shall I do?"

"Show to the world your true sentiments."

"How?"

"Well, here you are proposing to build a monument to Washington to cost a million of dollars. Such a monument will not add one iota to Washington's fame. A monument on every street corner in America would not do it. Suppose you take that money and found a university."

"A university!"

"Yes, why not?"[112]

One million dollars from the Commodore's fortune was soon on its way to Nashville, Tennessee, where a friend of Dr. Deems and Frank Vanderbilt was raising funds for the Central University of Nashville, quickly renamed Vanderbilt University, a change that struck the Commodore as "very satisfactory."[113]

7.

When he was eighty, the Commodore invited a friend to go driving with him. As an express train of his Harlem Railroad sped toward them down the tracks, the Commodore declared he would beat the train across. He gave the word and his steeds raced across the railroad tracks, with the carriage passing over just before the train sped by, so close that the rush of wind lifted the Commodore's hat.

"There is not another man in New York that could do that!" the exhilarated Commodore gloated.

"And you will never do it again with me in your wagon!" his friend moaned.[114]

The curmudgeon seemed invincible, but at last there came that day in May of 1876 when, feeling every one of his eighty-two years, he returned home, climbed the stairs to his bedchamber on the second floor of the townhouse at 10 Washington Place, laid down his cane, took the cigars out of his pocket, lifted off his overcoat, and untied his snow-white choker, never again to leave the house.

Every other time when he had been ill, the Commodore told Dr. Linsly, he'd seen he would get well: when as a lad he had been poling his periauger so hard that the pole slipped and rammed through his chest; when he'd been in the terrible train accident in 1833; when he'd had those strange attacks in 1849 and again in 1854 during which his heart beat so rapidly it was impossible to count its pulsations. This time was different. As spring turned to summer and summer to fall, and still he lay bedridden, he told Dr. Linsly: "I don't see this now."[115] "I used sometimes to think that the Commodore never expected to die,"[116] Dr. Linsly remembered, but now his patient was no longer talking about whipping the devil.

THE COMMODORE

The reporters from the city newspapers resumed the deathwatch they had begun back in May, renting a room in a house across the street. Fluctuations in the Commodore's condition were reported in daily bulletins in the morning and evening editions as if part of the day's weather report. The reporters' vigil was endless; the old man meant to hold on.

Though confined to his bed, the Commodore maintained a keen interest in the news that was brought to him. When he was told that Daniel Drew, who was three years younger, was also ill, he chuckled. "Aha! Breaking down so young! Well, Dan'l Drew never did have any constitution."[117] At least twice every day, Billy stopped in to report to his father about the railroads, hurrying back to his office at the Grand Central Depot with the Commodore's orders, which were immediately implemented.

Dr. Linsly would read to him the obituary notices that frequently appeared in the newspapers when the reporters, encamped in the house across Washington Place, concluded that he could not possibly live another day. "He was much gratified with them. I did not read anything that I thought would be displeasing to him."[118] When the obituaries estimated the size of his fortune, Dr. Linsly noticed a slight smile cross the old man's face, but he would say nothing. The estimates were all far too low. Sixty-seven years after his mother had loaned him $100, he had increased that loan by a factor of one million. He had accumulated a fortune of $105 million. He was richer, by far, than anyone else in the United States was or ever had been. He finally seemed satisfied with that.

Some days he felt better, some days worse, but he was not recovering his strength. Day by day his stamina ebbed. When the pain became intense, he summoned magnetic physicians. "I have a frightful racking pain in my head," he told Mrs. Helen Clark, one of his favorites. "I am almost insane."[119] She stroked his head where he said the pain was centered, and it then moved down his body. She followed it with her hands until it passed away. He told her he felt like a new man.

Later when she was treating him, he jumped and said sharply, "Why don't you remove that pain as readily as you did before?"

"Remember, Commodore Vanderbilt, you are not to command me! I'm the boss of this job, or nothing at all."[120]

He controlled his temper, for he enjoyed discussing with Mrs. Clark

an admonition in the Bible that was disturbing him: that it was easier for a camel to go through the eye of a needle than for a rich man to enter into the kingdom of heaven.

"How far away do you think heaven is?" he would ask her. "Do you think that the Lord would forgive me and that I shall be washed in the blood of the Lamb?"

"No, I don't," she answered. "What have you done to merit heaven?"

What was necessary? he asked her.

"By their works ye shall know them. Are your works material or are they heavenly?"[121]

The Commodore told her he had prayed. That was not enough, she informed him. When she wanted a loaf of bread, prayer would not get it for her; she must go to work and earn it. And, by the way, she told him, if she had to preach as well as treat every time he called for her, she should charge him double. He persisted. What were the occupations of heaven? She told him that she thought they probably varied as much as in this life. Did she believe in the Judge sitting on the great white throne? No, she answered, the God that she believed in was too great and incomprehensible to be described in that way. Was there hope that he could engage in singing and praying in heaven? "I think you could build a railroad better than you could play on a golden harp."[122]

The Commodore might have been thinking of heaven, but he still had enough spunk to make a hell for those who lived with him at 10 Washington Place. Frankie, Frankie's mother, the servants, Dr. Linsly who had taken up residence in the house—everyone knew well enough to stay out of his way. As had always been the case, no one dared tell the Commodore what to do, to eat his food or take his medicine or move from his bed so that it could be changed. He took his own time and did just as he pleased.

Dr. Linsly suggested that it might help if he was given champagne to sip. The Commodore thought about this for a moment. "Champagne? Champagne! I can't afford champagne! A bottle every morning! Oh, I guess sody water'll do!"[123]

His doctor observed that he was lying on a rubber sheet and told him it was the worst thing in the world for him, that woolen blankets

would be much better. The Commodore's wife informed the doctor that they could not stand the expense of woolen blankets, which had to be changed so often. "Damn the expense!" the Commodore commanded. "Buy a bale!"

Frankie brought him a bowl of soup. He sat up in bed and tasted it, and then flung the bowl against the wall. "Who in hell salted this soup! Don't give me anything except it is home made!"[124]

The members of the household kept their distance, avoiding his room as much as possible. Once when Frankie's mother walked in, he seized her by the hand and squeezed it until she cried out. "Can't I keep some of you damn sluts here?" he complained.[125]

"That old man must die," Frankie muttered. "I can't stand this hell any more."[126]

The Commodore was not planning to make things any easier after he was gone.

"Dan'l," he said to a friend who had come to visit, "when I die, there'll be hell to pay."

"Oh, no, Commodore, I guess not."

"Oh, yes, there will—yes there will. When I am gone there will be trouble, but they can't break the will. There is not a flaw in it. I believe in the way the Astors did. But I shall leave my property more compact. I don't know that I am doing right, but I will not have it scattered. I will leave it as a monument to my name."[127]

One evening it was obvious that the Commodore wanted to talk with his son about something important. Billy stood at the foot of his father's bed. Dr. Linsly got up to leave them alone, but the Commodore ordered him to sit down, pointing to the chair he was to occupy.

"Billy," he said, shaking his finger at his son, "after I'm dead a great responsibility will fall upon you. You will find a piece of paper left to direct you what to do. There are several pieces of paper attached to my will. I charge you to carry out faithfully what I have directed in my will."

Billy nodded.

"Had I died in 1833 or 1836, or even 1854," the Commodore continued, nodding at Dr. Linsly, "the world wouldn't know that I ever lived; but I think I have been spared to accomplish a great work which will remain, and I think I have fixed it so that it cannot be destroyed by

the stock market. If I had given my daughters $3,000,000 or $3,000,000 apiece the first thing they would do would be to put William out. . . . The next thing they would be quarrelling among themselves, and their stock would be thrown on the market until it would not be worth 40."[128]

As the days and weeks passed, his tall frame became bent, his face grew thin and pale, his eyes sank deep behind his brows, but one of his grandsons noticed when he visited that his hands, the hands which long ago had poled a heavy old periauger across the Narrows to Manhattan, still were calloused and hardened.[129]

Early in the morning of January 4, 1877, the Commodore looked at Dr. Linsly. "I think I am nearly gone, Doctor."[130]

A light snow was falling and already the pavement was white when his children and grandchildren began to crowd into his bedchamber.

Dr. Deems knelt by his bedside and said a prayer. The Commodore muttered the benediction with the pastor: "Now may the peace of God which passeth all understanding keep your hearts and minds on Christ Jesus; and the blessing of God Almighty, the Father, the Son and the Holy Ghost."

He turned to Frankie. "That was a good prayer," he mumbled.

"Yes," Frank replied, "because it expressed just your feelings now."[131]

Frankie asked if he would like her to play some hymns on the small organ that had been moved into the room. Yes, he indicated, he would. He tried to join in the singing of his favorite, "Come Ye Sinners, Poor and Needy," whining along as the others sang: "I am poor, I am needy, weak and wounded, sick and sore."[132]

The Commodore looked toward his son Billy, who stood at the head of his bed. "Keep the money together, hey. Keep the Central our road,"[133] he whispered. "That's my son Bill."[134]

At 10:30 that morning, Dr. Linsly announced that there was no sight in his eyes. The old man was dead.

The Commodore lifted a hand and with it closed his eyelids. Within a few minutes, finally, reluctantly, he let go of his life and his fortune.

An autopsy revealed that he should have died long before, that he

had been living for months on willpower and guts. There was not a sound organ in his body. All were atrophied. The liver and spleen were emaciated, he had Bright's disease of the kidneys, his intestines were inflamed and ulcerated, and, perhaps not surprising to some, it was found that "the heart was small—smaller than is usual with men of similar size."[135]

"It was a giant they buried," wrote the *New York Herald*. [136] An old sea captain who had known him well said that it was fortunate that the Commodore had not received any education, for if he had "he would have been a god."[137] And at least one congressman thanked God that men could not live more than one hundred years, for if they could, he feared, "such men as Cornelius Vanderbilt would own the whole world."[138]

His two sons, eight daughters, sixteen grandsons, and seventeen granddaughters could hardly wait to find out just how much of the world he did own. After his burial on Staten Island, they returned to the home of one of the Commodore's sons-in-law. There, in the parlor, former judge Charles Rapallo, the Commodore's attorney for many years, read the will.

The Commodore's young wife, Frankie, whose patience had been so tried in the final weeks of his illness, was rewarded with $500,000 and the house at 10 Washington Place. Each of his eight daughters received a few hundred thousand dollars of his railroad bonds, and the income from trust funds of several hundred thousand dollars. His wayward son Corneel was left only a trust fund of $200,000, the interest from which was to be used for his support. The Commodore's sister and brother, nieces and nephews, assorted faithful employees, and friends received smaller bequests. The grandson who had been named for him, Cornelius Vanderbilt II, Billy's oldest son, received $5.5 million of railroad stocks, and Billy's other three sons each received $2 million.

The eighth clause of the will provided that "all the rest, residue, and remainder of the property and estate, real and personal, of every description, and wheresoever situated, of which I may be seized or possessed, and to which I may be entitled at the time of my decease, I give, devise, and bequeath unto my son, William H. Vanderbilt."[139]

The rest, residue, and remainder left to Billy totaled $95 million. It was a day when the finest French chef could be hired for $100 a

month, a proper English butler for $60 a month, a footman, carriage man, or gardener for less than $1 a day. It was a day when a very successful businessman might earn as much as $10,000 a year.

Ninety-five million dollars. This was more money than was held in the United States Treasury.

Fifty-six-year-old Billy threw himself on the piano in the parlor, weeping profusely.

2

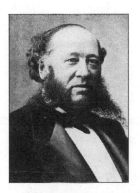

THE
BLATHERSKITE

1 8 7 7 – 1 8 8 3

1.

"**A**ny fool can make a fortune," the Commodore had told his son William, whom he still called Billy, shortly before he died. "It takes a man of brains to hold on to it after it is made."[1]

In his own mind, William had earned every penny of the fortune that was now his, for fifty-six years having put up with a cantankerous, overbearing father who considered him a bumbling fool and treated him like one, exiling him to a small farm on Staten Island and never

letting him participate in his business ventures until he was forty-three. Was William Vanderbilt equal to the challenge of now holding on to the fortune? The head of a great railroad like the New York Central needed the administrative ability to oversee an operation consisting of thousands of employees spread all across the United States. He must be a daring financier as well as a shrewd strategist, ready to seize the best routes for his lines and to take over smaller lines after weakening them by cutthroat competition. And he must be a consummate diplomat and politician in order to secure every conceivable concession from the town councils, legislatures, and governors of the areas his trains would cut through. William Vanderbilt? No. He didn't fit the bill.

William harbored no illusions about his entrepreneurial abilities. The executive titles his father had bestowed on him were meaningless. The Commodore had made all the decisions until the day he died. When faced with a business decision, William's only resource would be to try as best he could to remember how his father would have acted.

The Commodore's business associates shook their heads and predicted it would not be long before the old man's fortune was gone. Bumbling Billy could never hold on to the empire his father had built. Whether he could or not would become clear soon enough, for that empire was now under siege.

Several months after the Commodore's death, a depression that had lasted for most of the decade—the era was known as the "black seventies"—finally affected the railroads. In May of that year, 1877, the Pennsylvania Railroad announced a 10 percent wage cut for all employees, its second cut since the panic that had begun in 1873. This action was immediately followed by similar decrees from the Erie and the Baltimore and Ohio. On July 14, 1877, three days after the Baltimore and Ohio slashed its wages, its firemen walked out. Two days later, its conductors, trainmen, trackmen—every employee—deserted the trains and began rioting. In Pittsburgh, angry mobs of railroad men, joined by other unemployed who had lost their jobs in the business downturn, torched hundreds of boxcars and passenger coaches, destroying scores of locomotives, tearing up tracks, and burning depots. Panicked railroad executives called in the state militia. When the mob overcame the

militia, President Rutherford Hayes sent in troops from the Grand Army of the Republic to quell the nation's first labor uprising.

Did he think the strike would spread to the New York Central? a reporter from the *New York Times* asked William Vanderbilt, who was vacationing at Saratoga.

"Not at all," he responded without hesitation. "I put great confidence in our men. There is a perfect understanding between the heads of departments and employees, and they appreciate, I think, so thoroughly the identity of interest between themselves and us that I cannot for a moment believe that they will have any part in this business. I am proud of the men of the Central road, and my great trust in them is founded on their intelligent appreciation of the business situation at the present time. If they stand firm in the present crisis, it will be a triumph of good sense over blind fury and fanaticism. Our business relations with all our men on the Central are shaped, as they fully understand, by the emergencies of the business situation. Their hope, like ours, is for better times."[2]

William Vanderbilt was right about one thing: The men of the New York Central were intensely loyal to the Vanderbilt family. Hadn't they worked valiantly through the rough winter that year when a series of blizzards and weeks of freezing weather had threatened to stop all rail traffic between Albany and Buffalo? Yet it was difficult for the railroad workers to reconcile all the facts the newspapers were publishing. On the one hand, the New York Central that year had reported earnings of $28,910,555, operating expenses of $16,136,977, and a net profit of $12,774,578, a remarkably healthy profit margin; the Central's 8 percent dividend had never been cut; the Commodore had passed away, leaving an estate of $105 million. On the other hand, the mechanics who worked for the railroad were paid $1.20 a day; the switchmen and trackmen earned 80 cents a day; the average annual salary of most of the Central's employees was several hundred dollars. And now, when the Central faced a slump and its stock was falling, William Vanderbilt was joining the presidents of other railroads by ordering a 10 percent wage reduction for all New York Central employees. "The workman now earns the equivalent of a barrel of flour each day," he had told the shareholders of the Central when justifying this decision, which he implemented just

a few days after his Saratoga interview.[3] It certainly seemed, as one editorial writer noted, that the railroad kings, "having found nothing more to get out of stockholders and bondholders, [have] commenced raiding not only the general public but their own employees."[4]

Their loyalty strained to the limit, workers of the New York Central threatened to strike and destroy the Grand Central Depot. From his hotel room at Saratoga, William Vanderbilt considered bringing in the militia as the other railroad executives had, but instead tried quite a different approach. He issued an announcement to all the workers on the Vanderbilt lines: $100,000 would be divided "among the loyal men of the New York Central & Hudson River Railroad effective immediately."[5] Furthermore, he promised to restore the 10 percent cut as soon as business improved. Loyal engineers would each receive $30 in cash; passenger conductors, $20; switchmen and brakemen, $9; laborers, $7. If his employees had stopped to analyze these measures, they would have realized what a pittance $100,000 was to a man who had inherited $95 million, a man whose company was spinning off profits of millions of dollars each year, good year or bad. But it was a masterful stroke of public relations, and it worked like a charm. Of the 11,000 employees of the Central, 8,904 agreed to share in the bonus. All the lines kept running. By October, half of the wage cuts had been restored, and when good times returned, just as William Vanderbilt had promised, full wages were restored to everyone.

In this first test of his mettle, William H. Vanderbilt had proved he was no blatherskite. It was doubtful the Commodore—with his inclination to fight, rather than compromise—could have done as well.

2.

It was not only business problems that plagued William Vanderbilt.

"When I die," the Commodore had warned time and again, "there'll be hell to pay."[6] As usual, he was right.

Two of William's sisters, Ethelinda Allen (the beneficiary of a $400,000 trust fund) and Marie Alicia La Bau (the recipient of $250,000 of railroad bonds), along with William's brother, Cornelius Jeremiah Vanderbilt (who had been given only the income from a $200,000 trust

fund to be controlled by William), ganged up and decided to contest their father's will. William was able to reach a settlement of several hundred thousand dollars with his sister Ethelinda, but Marie Alicia and Corneel would hear nothing of what they considered to be the crumbs he offered to throw their way. The will was so unjust, so inequitable, they reasoned, that it would be obvious to any court that their father had been insane and clearly under the malicious influence of his son William when he made it. The will must be overturned, and the fortune divided equally among all the Commodore's children.

On the afternoon of November 12, 1877, as the hour for the hearings to commence approached, attendants bustled about Surrogate Delano Calvin's courtroom in the county courthouse on Chambers Street in New York City, straightening the tables and chairs and adjusting stacks of legal documents. Cornelius J. Vanderbilt was the first to arrive, accompanied by his attorneys, former congressman Scott Lord and Jeremiah S. Black, former chief justice of the Supreme Court of Pennsylvania. Affecting a pale and sickly demeanor, Corneel, wrapped in a shabby brown overcoat, sat stooped in his chair, staring straight ahead.

William Vanderbilt came attired in a lavish black beaver frock coat and silk hat bound in mourning crepe. He removed his overcoat and hat, glanced indifferently around the courtroom, and settled his considerable bulk into a chair that faced away from his brother. With him came his entourage: his attorneys—Henry L. Clinton, a famed criminal lawyer, and George G. Comstock, former chief justice of the New York Court of Appeals—three of his sons, Cornelius, William, and Frederick; and the Commodore's brother, old Captain Jacob Vanderbilt.

The four or five rows of chairs in the small courtroom were jammed with spectators eager for some excitement; latecomers stood patiently at the back of the room.

At exactly two o'clock, Surrogate Calvin entered the courtroom from a side door and took his seat on the dais.

"Are you ready, gentlemen?"

"Ready on behalf of the executors," Mr. Clinton replied.

"We're ready, Sir," said Mr. Lord.

"Proceed gentlemen."[7]

Corneel's attorney Mr. Lord took a heavy manuscript from the

table before him and rose to address the court. He read his opening argument slowly and deliberately, teasing the courtroom for nearly an hour with bits and pieces of the case he would try to prove. The Commodore had "offered himself to almost every marriageable woman," he declared, and was clearly "passing into his second childhood." He "was the slave of a vice more exhaustive than any other of the intellectual and moral faculties of the mind." He "acted like a woman in confinement." He was "a believer in spiritualism, not in its higher but in its lowest type." He believed in "clairvoyance and was governed by its revelations."[8]

Mr. Lord spun around to face William Vanderbilt. "This man," he said pointing, "rolling in his nearly $100,000,000, nearly a quarter of a century ago had said that he meant to control his father, showing that he had an eye even then on the disposition of his father's property after death. We have thought it proper to show that Commodore Vanderbilt was in a situation to be influenced, that he had terrible diseases, and that they so operated upon his mind that he might be subject probably at least to undue influence.

"When the evidence which has been collected is all in," Mr. Lord concluded, "we shall confidently assert either that the testator executed his will under a delusion directly affecting those for whom the law provides equality of distribution, or else that his mind, although held to his railroad projects by the force of habit, was by indulgence, delusions and diseases, and the consequent sufferings or medicines, so broken and impaired that he was subjected to, and acted in making the will under, the undue influence and control of the residuary legatee."[9]

William Vanderbilt's attorney Henry Clinton jumped to his feet.

"The counsel has spread in his opening what we believe to be the grossest slanders," he retorted to the surrogate.

"Let counsel put that in his summing up," Mr. Lord argued. "I'll answer him there."

"I do not propose to pass upon the propriety or impropriety of the opening," Surrogate Calvin ruled.

"It was such an opening as I have never heard in all my experience in courts, and hope never to hear again," Mr. Clinton persisted.

"Because he has one hundred millions of dollars behind him the counsel should not travel so far out of his way," Mr. Lord snapped.

"If we possess wealth of money on our side," Mr. Clinton responded, "you possess wealth of imagination on yours."

"I can stand that, considering the source it comes from."

"I can hardly believe that any one outside of a lunatic asylum would credit the statements made in your opening."

"Gentlemen," the surrogate warned, jumping into the fray, "these side remarks had better cease. The case will not be decided upon an opening nor upon a summing up, but upon the facts as given in evidence."[10]

And so began the great trial over the will, which would proceed day after day, week after week, for the next eighteen months, filling more than two hundred days with testimony, as Mr. Lord summoned an extraordinary assortment of characters to the witness stand: the doctors who had performed the autopsy on the Commodore and who chronicled, in gruesome detail that forced William to leave the room, the diseased state of each of his organs; the magnetic healers who had attended the dying man and claimed to transmit electricity and energy into his tired body by touching him; the spiritualists who had helped the Commodore communicate with ghosts from his past; even eighty-year-old Daniel Drew, Uncle Dan'l, who a year later would die a bankrupt, his fortune lost, leaving only his watch, his sealskin coat, a Bible, and his hymnbook.

(William Vanderbilt was able to save himself considerable embarrassment by paying off those two harpies sure to be called as witnesses: Victoria Woodhull and Tennessee Claflin. "It would make a splendid sensational article if we gave the reasons why Commodore Vanderbilt took such an interest in a paper that expressed the most radical of radical views," they wrote in *Woodhull & Claflin's Weekly*, "but our lips are sealed."[11] Indeed they were. When the two sisters expressed their disappointment that the money left to them under the Commodore's will to advance the work of spiritualism was rather inadequate for this great purpose, William Vanderbilt gave them more than $100,000 on the condition that they make themselves scarce during the trial. Off they sailed to England, encamped in six first-class double staterooms, accompanied by a covey of newly hired servants, and there, in a fashionable suburb outside of London, rented an elegant mansion.)

Day after day, the courtroom filled with "loungers . . . numerous,

picturesque and ill-smelling, as usual," as the *New York Daily News* characterized them.[12] They brought their lunches and came to be entertained with new revelations about the world's richest family. The day's proceedings were eagerly recounted in each of the city's newspapers and included transcripts of much of the testimony. It was never really clear what degree of truth lay behind some of the bizarre tales the witnesses spun out, but even if there was just a little, the *Boston Herald* was justified in its conclusion that "the haughty house of the Vanderbilt railway king, which had its origin in a Staten Island cabbage and onion patch, is, for a parvenue race, possessed of quite a respectable collection of family skeletons."[13]

Throughout the hearings, William Vanderbilt reclined in his chair, or stared placidly at the frescoed courtroom ceiling. A slight smile skated across his face when a witness recalled how the Commodore had referred to him as a "blatherskite," a "stupid blockhead," and a "sucker." He laughed out loud when another witness mentioned that the Commodore had said there would be hell to pay when he died; how right he had been. But William's composure slipped when brother Corneel was called to the witness stand. William listened intently, scribbling notes and passing them to his lawyer. Several days of testimony and cross-examination would reveal why Corneel was the black sheep of the family, and why the Commodore had been wary of leaving him anything.

"How much was necessary for the support of your family on the farm in Connecticut?" Mr. Clinton asked Corneel.

"I suppose $200 a month would have kept us from starving, but at the rate we had to live it cost $5,000 or $6,000 a year."

"Did you think it right to live at a rate of $5,000 or $6,000 a year on an income of $2,400? Did you live at that rate?"

"I did."

"Did you run in debt for the difference?"

"I did. I had to. My father rather forced on me that style of living. I could not turn people out of the house when they came, as it was expected of me that I should sustain my family name and my father's honor in a decent shape, which I did."[14]

"You have stated that you never contracted a debt that you did not intend to pay. Now, from what source did you expect to get this money?"

"From the same source that my brother William got his."

"Did you expect to pay them before your father's death?"

"Yes, I expected that he would put me in business and give me an opportunity of earning it."[15]

"Do you remember anybody with whom you have become acquainted casually that you have not tried to borrow money from?"

"Yes, thousands of people."[16]

"Has there ever been a month in which you did not incur indebtedness far beyond what your income was?"

"There have been several months in which I gave no notes, borrowed no money and drew no checks."

"Can you mention any one large city in the nation in which you have not borrowed money and not paid it?"

"Yes, sir, I can mention several of them."

When pressed, Corneel admitted that he had borrowed money (and not repaid it) in Utica, Rochester, Cincinnati, San Francisco, and Philadelphia. In fact, he was at a loss to name a city in which he had not borrowed money.

"Of that $100,000 [Corneel's total debts at that time], you say you owe the Greeley estate $40,000?"

Corneel testified that he had insisted on giving a note to Horace Greeley. "I told him I might die and that in that event father might be so happy that he would be willing to pay off what I owed him."[17]

"Do you owe Mr. Terry, as you believe, $30,000?"

"I know I don't owe him as much as $40,000; my indebtedness to Mr. Terry is for money advanced to me and my wife, and he has notes signed by my wife and myself; he has given me none since my wife's death."

"What did you use that $30,000 for—gambling?"

"I don't think I did; for various things, for paying my debts with."

Through cross-examination, it was revealed that Corneel had been arrested at least thirty times for forgery, writing bad checks, and indebtedness.

"Were you in charge of the criminal authorities?"

"I think I was in jail."

"Don't you know what is meant by criminal authorities?"

"It is hard to tell what is criminal nowadays."

"Were you arrested on a criminal warrant and lodged in jail?"

"I don't know whether it was civil or criminal action."[18]

Corneel admitted that there had been a time when he was addicted to gambling, but claimed that he had given it up after his wife's death in 1872.

"What brought you into the habit of gambling?" he was asked.

"It was a sort of second nature for me. I had seen so much of it in my father—it was a kind of family matter."[19]

"Was not the greater part of this indebtedness caused by your gambling?"

"No, sir, nothing of any amount was caused in that way; merely a few thousand dollars."

"During the last four years did you assign or allow any gambler or gamblers to go and draw your monthly allowance for you and did you generally assign it before it was due to some gambler or gamblers?"

"I never assigned it for that purpose; I sometimes would borrow money, and would assign my allowance as security."

"Did you borrow money from professional gamblers?"

"I have borrowed money at times off what you might call men that played cards. I have borrowed money off different kinds of gamblers—never for gambling purposes to pay gambling debts."

William leaned over to his lawyer. "He's making it up as he goes along," he whispered audibly.[20]

"Did you pawn your wife's jewelry to obtain money to gamble with?"

"I don't know that I did for that purpose."

"Did you pawn your wife's jewelry and dresses?"

"No, never her dresses."

"Did you pawn her jewelry?"

"I have been in debt frequently, and she had given me her jewelry to pay her debts with and my own."

"Did you pawn them when she was unwilling to let you take them?"

"She did not appear to be unwilling."

"Do you remember when your brother George died?"

"I do."

"Do you remember some sleeve-buttons belonging to him which were given to you?"

"I do. They were given to me by my mother."

"Did you pawn them to raise money to gamble with?"

"I pawned them, and when I went to get them I found William had gone and got them and he never had given them back, although I offered him the money for them."

"Were you charged with taking a gold cup from the house of Horace F. Clark and pawning it?"

"I don't know that I did. I won't swear that I did not."[21]

Just when it seemed that Corneel's own testimony about his dissolute life provided the full explanation of the unusual terms of the Commodore's will, his lawyer introduced a theory that raised anew the question of whether William had conspired against his brother. Corneel's lawyer told Surrogate Calvin that William had instigated a conspiracy to discredit Corneel in the Commodore's eyes.

William's mouth dropped open.

Yes, William Vanderbilt had authorized Chauncey Depew of the New York Central to hire detective Frank Redburn and have his men follow Corneel and report their findings to the Commodore. Depew had met Redburn at the Fifth Avenue Hotel, at the intersection of Broadway and Fifth Avenue, to work out the details. How will my men know what Corneel looks like? Redburn had asked Depew. Why, there he is now, Depew had said, pointing to a man crossing through the lobby. How providential! Redburn set his men to work at once.

The detectives discovered that each day followed the same pattern, beginning at the Fifth Avenue Hotel right before noon when their quarry would go to the bar, meet some friends, and have a few drinks. In the afternoon the group would head to Broadway to the gambling houses that opened in the afternoon. Their return to the Fifth Avenue Hotel late in the afternoon for more drinking would precipitate the major decision of the day: whether to go to a gambling parlor for a free meal and a night of gambling, or meet some ladies of the night along West Twenty-fifth Street. Several times a week the observers saw Corneel meet such a lady on Fourteenth Street, vanish into a restaurant with private rooms above, and emerge several hours later looking somewhat the worse for wear. All of this the detectives reported to the Commodore after several weeks. He was suitably shocked. "I wish that this son of mine had never been born; that's what I do wish."[22]

The problem, Corneel's attorney Mr. Lord told Surrogate Calvin,

was that the detectives had been following the wrong man! One of the detectives several years later had been strolling down Broadway with a friend when his friend pointed out Cornelius J. Vanderbilt. That's impossible, the detective said. That's not Cornelius Vanderbilt. I should know what he looks like; I shadowed him for several weeks a few years ago. The detective learned he had not been trailing the right person. The man who had been followed by the detectives, Mr. Lord asserted, had been paid by William H. Vanderbilt to impersonate his brother.

Mr. Lord assured Surrogate Calvin that he could prove these allegations. Yet after weeks of promises and delays, he failed to produce the detectives who could substantiate the story, implying they had been paid by William Vanderbilt to stay far away from New York during the trial.

When Mr. Lord had taken this conspiracy theory as far as he could, he brought Mrs. Lillian Stoddard to the stand, the attractive thirty-five-year-old widow of Dr. Charles Stoddard, a medical clairvoyant the Commodore had met at a spiritualists' meeting in the fall of 1874. Mrs. Stoddard lost no time in getting to the heart of her tale. "It was early in September, 1874, about 11 o'clock in the morning," she testified. "William came up to Mr. Stoddard and says, 'That gentleman is my father and you're his medical clairvoyant that's attending him. I've been wanting to speak to you, but I've never had the opportunity till now.' Mr. Stoddard was surprised and said, 'Any time that you say I can see you—make it at some hotel.' So they made it at the Cosmopolitan Hotel, on the corner of Chambers Street and West Broadway next morning."

The reporter for the *New York Times* looked across the courtroom at William and observed that "Mr. Vanderbilt was flushed so that the bald portions of his head were crimson, and he nibbled on the head of his cane and pulled at his side whiskers." He seemed very upset "and his face underwent a constant succession of changes from burning blushes to his natural complexion."

"Did you see him again?" Mr. Lord questioned Mrs. Stoddard.

"Yes, Sir, the next day at the Cosmopolitan Hotel. Mr. Stoddard and myself and William H. Vanderbilt were the only persons present. The hour fixed was 10 o'clock, and we were there before 10 and it was about 10 when Mr. Vanderbilt came in. William H. Vanderbilt says, 'I want you to control the old man—he has great belief in you and you can do it. I want you to make him think more of me, so I can influence him.'

THE BLATHERSKITE

Mr. Stoddard then said that he didn't know about that—that he should have a day for reflection, and would let him know the next day. They were to meet there again at the same time. So they met there again, and when he came in Mr. Stoddard says, 'I have thought well of your proposition provided you make it satisfactory.' Mr. Vanderbilt then gave him a roll of bills and Mr. Stoddard counted them over and says: 'This will do; this is satisfactory. Now I am ready for business. What's your proposition?' He says: 'I want you to go to the old man's office and tell him you have a message from his dead wife, that she is now in the spirit world and has a much clearer knowledge of affairs than she ever had before, and that he should make his will, and make William H. his successor, and that he'll make no mistake.' And then William was to come in. He said to Mr. Stoddard, 'And you impress upon him that all the rest of them hate him and that I am the only one that should have the business, and that he should only think of me.' "

"You went to the office?" Mr. Lord asked.

"Yes, Sir, Mr. Stoddard and myself."

"Who was there?"

"The Commodore. It was between 12 and 1 o'clock and the Commodore wanted him to give him an examination, so he went into a trance."

"Who went into a trance?"

"Mr. Stoddard."

"State what occurred at the Commodore's office."

"Mr. Stoddard went into a trance and said there was the spirit of an elderly lady around him—the spirit of his wife—and that she in the spirit land had a much clearer sight of things than ever upon earth and that he should make William H. his successor, and that he would make no mistake, and the Commodore said, 'I'll do as the spirit wants me to.' "

"Was anything else said before William came in?"

"No, Sir. Then William H. came in and Mr. Stoddard had come out of the trance, and he looked at him surprisingly and said, 'Who is that man? That's the man I saw in my trance,' and the Commodore said: "That's William H., my son.' And then William H. said he had had a spirit message and had come to tell him about it. He said that he should make him his successor and he says, 'You shall have all, Billy.' Then the Commodore asked Mr. Stoddard if anything was going to happen to

him, and Mr. Stoddard said no, he would live long after his will was made—be easy in his mind, and the Commodore says, 'I believe it.' "

"Anything else that you remember? Anything said on the subject of the children?"

"When Mr. Stoddard was in a trance he said the spirit told him that he was the only one that should be depended on in the business and that all the rest hated him and wished him dead. The Commodore and Mr. Stoddard made another appointment and . . . Mr. Stoddard and me went there again about two days afterward, and the same conversation took place—that he should make William his successor, and that was at the direction of the spirit. This took place about five times and William was present."

"Did you count the money that William gave to Mr. Stoddard?"

"No, Sir. I saw Mr. Stoddard count it, and they were big bills. I saw 10's, 50's, 5's and so on."[23]

Whether or not there was some foundation for the theory of undue influence raised at the trial, this prolonged washing of dirty linen was embarrassing the new head of the House of Vanderbilt. How long must he sit there and hear how the Commodore had put pans of salt under the four legs of his bed as "health conductors" to cure his aches and pains; how he had giggled like a schoolgirl after his second marriage; how his brother had been thrown in jail time and again between his visits to gambling dens and brothels; how he, William H. Vanderbilt, had been conspiring for years to have his brother disinherited? How long must he sit there and listen to doctors testify as to the number of hardened feces they'd found in the Commodore's intestines when they performed the autopsy? He had had enough. In the spring of 1879, a year and a half after the trial began, William reached a settlement with his brother and sister, giving Corneel an extra $200,000 in cash and a trust fund of $400,000 in addition to the income from the $200,000 trust fund he had received under the will. He reached the same settlement with his sister Marie Alicia. For a man who had inherited $95 million and the ownership of the nation's greatest corporation, the New York Central, these sums were scraps. William Vanderbilt had been stubborn enough to fight for eighteen months to preserve his inheritance and he had been wise enough to know when to settle. He had emerged again the victor.

One evening William Vanderbilt set out in his carriage to distrib-

ute the bonds each of his sisters was to receive under the Commodore's will. One of his brothers-in-law counted the bonds and then shook his head.

"William, these bonds fall $150 short of the $500,000 according to the closing prices on this day's market."

"All right," William patiently responded, "I will give you a check for the balance." He wrote out a check for $150 and handed it to him.

Another brother-in-law followed William to the door as he left.

"If there is anything more in this line, I hope we shall not be forgotten."[24]

"Well," William thought to himself, chuckling at what money did to people, "what do you think of that?"[25]

After the settlement, Corneel took a trip around the world in the grand style, returning to New York City in March 1882 to arrange for the construction of a new house in Hartford. He spent most of Saturday night, April 1, 1882, gambling, returning to his room at the Glenham Hotel at 319 Fifth Avenue at six o'clock the next morning. Had his losses that night been staggering? Had he lost all he had won in the settlement? Had he come to the realization that he had wasted his life dreaming of a fortune that would never be his? Was he consumed by envy of his brother's undeserved luck? At two o'clock that Sunday afternoon in his room at the Glenham, fifty-one-year-old Cornelius Jeremiah Vanderbilt, the Commodore's younger living son, took his .38 caliber Smith and Wesson revolver from a bureau drawer and shot himself.

There is no evidence that Corneel's tragedy had any effect on brother William, who by then was preoccupied again with managing the New York Central. Whatever the real story behind the Commodore's will, whatever one might choose to call William Vanderbilt, *blatherskite* did not now seem the right word for a man who, by merit or design or a little of each, had been successful in cutting his brother and eight sisters out of their father's will.

3.

Like the Commodore, William H. Vanderbilt was never shy about letting it be known that he controlled 87 percent of the New York

Central, the nation's biggest business. But unlike his father, he did not revel in the publicity and endless controversy that the ownership brought with it.

By the time of the Commodore's death, the railroads were all-powerful. "These railway kings are among the greatest men, perhaps, I may say, are the greatest men, in America," wrote James Bryce, an Englishman, in his treatise *The American Commonwealth*, which he published after a tour through the United States. "They have wealth, else they could not hold the position. They have fame, for everyone has heard of their achievements; every newspaper chronicles their movements. They have power, more power—that is, more opportunity of making their personal will prevail—than perhaps any one in political life, except the President and the Speaker, who after all hold theirs only for four years and two years, while the railroad monarch may keep his for life."[26]

For one man to control a railroad system as vast as the New York Central was an awesome responsibility. By the routing of his tracks and the setting of his rates, William Vanderbilt could use his power to make or ruin major businesses and entire cities. As an English paper observing the Vanderbilt lines reported: "Their hands are upon the traffic of Northern Canada, and according to their pleasure, for half the year at least, the farmers of the great grain growing and cattle rearing half of the Central and Northwestern States find their occupations profitable or not. In some essential ways the family holds the trade of New York in the hollow of their hands, and no business worth the name can be started anywhere along the railways they command without their support and sanction. They can within these limits bring a meat exporter into a great fortune or strip him bare. It is much a matter of their favor whether a man flourishes or becomes bankrupt."[27]

Having this much power was an uncomfortable experience for a man like William Vanderbilt. He wanted to be liked, this man who, as his friends agreed, "had a heart as tender as a woman and as big as an ox."[28] Because every action of the New York Central had such major consequences, and because he *was* the New York Central, municipal councils and state legislatures assailed every move he made; resolutions were drawn up opposing some action he had taken or urging some action he had not taken; laws were enacted changing the rules under which his

railroads operated. Petitioners pleaded with him; editorials condemned him; cartoonists had a field day portraying the heavyset executive as a rapacious brigand, intent only on satisfying his insatiable appetite for more—more railroads, more business, more money. Even rival railroad tycoons had little trouble lining up public support behind their schemes when they opposed Vanderbilt. When there were train wrecks—when boilers burst, engines derailed, bridges crumbled, drawbridges were left open; when lines of cars burst into flames or engines ran away; when there were head-on collisions or rear-end collisions, which the newspapers featured with sensational coverage, accompanied by graphic artistic representations of the horror and gore and mangled bodies—William H. Vanderbilt was blamed. Regularly, he received threatening letters, informing him of the exact hour and location at which he would be stabbed or shot, though he never changed the established route or times he walked alone between his home and the Grand Central Depot. Once smoke was seen pouring from a leather mail pouch at the Central Post Office. The pouch was emptied out, and there amid the blackened mail was a pasteboard box containing a half-pound gunpowder canister, the top of which had exploded prematurely. This "infernal machine" had been addressed to:

<div align="center">

W. H. Wanderbilt,

Esq.

459 5th Avenue,

City

</div>

Frequently he was called upon by emissaries from Tammany Hall asking for favors.

"Some of the boys need to go up to Albany Wednesday, and we'd like to have a special train."

"I'm afraid I can't promise that," Vanderbilt would explain. "We can give you a private car on a regular train, if you like, but I don't see how we can spare a whole train."

The political emissary would not seem to mind. Several minutes later when he rose to say good-bye, he would say, "Oh, by the way, Mr. Vanderbilt, that ordinance comes up in Council again tomorrow."[29] The ordinance was invariably one that the New York Central had long

opposed. Vanderbilt would rearrange his schedules to provide a train for "some of the boys."

The final straw was added in 1879 when the New York City Chamber of Commerce called on the state legislature to investigate the railroads, and the resulting Hepburn Commission began hearings to look into the workings of the New York Central. It probed secret agreements between the railroads and oil refineries, the frequent gyrations in freight rates, the slow speed of rail service, the difference between long-haul and short-haul rates, even the effect of the railroads on the price of milk in the city. The New York legislature, it was rumored, was about to impose heavy taxes on railroad property in order to cut down Vanderbilt's power.

By that summer, William Vanderbilt had had enough. "We get kicked and cuffed by congressional committees, legislatures, and the public," he complained to Chauncey Depew, "and I feel inclined to have others take some of it, instead of taking it all myself."[30] To take some of the heat off himself, he was willing to do something that never would have crossed his father's mind. He was ready to give up part of the golden goose. He was ready to sell part of the New York Central.

Vanderbilt went to see financier J. P. Morgan of Drexel, Morgan and Company. "A public sentiment has been growing up opposed to the control of such a great property by a single man or a single family," Vanderbilt told Morgan. "It says we rule by might. We certainly have control of this property by right. But no matter, this public feeling exists."[31] Morgan arranged a private sale to English investors of three hundred thousand shares of New York Central stock at between $120 and $130 per share. By November 26, 1879, the stock had been placed. Under the terms of the sale, Vanderbilt agreed that J. P. Morgan would sit on the board of directors, as would representatives of Jay Gould, who had been part of Morgan's syndicate, a startling move to end the competition with the Commodore's old nemesis.

"Some people talk about my getting out of the road—selling my interest—and that sort of thing," Vanderbilt explained. "It's all nonsense. I have sold considerably less than half my interest—considerably less than half. That does not look like getting out of the road, does it?"[32]

Vanderbilt immediately invested the $35 million he made from the sale in government bonds that paid a 4 percent return. With that, the

weary railroad tycoon heaved an almost audible sign of relief. "It can no longer be said that I am the owner of the New York Central."[33]

In his flight to the safety and security of his government bonds, William Vanderbilt had sacrificed the potential for boundless growth that had bewitched his father. A railroad executive with the Commodore's instincts would have continued expanding the scope of operations of the New York Central. Why stop growing just because it was already the biggest and the best? Why shouldn't it buy up more major lines? Why shouldn't the road go right to the west coast, becoming a transcontinental line? Why shouldn't the Central build its own cars, make its own track, have its own iron and coke and steel mills? Why shouldn't the Central integrate its operations just as John D. Rockefeller was doing with his oil business?[34] The simple answer was that William Henry Vanderbilt was tired of it all and didn't want any more. "I would not walk across the street to make a million dollars," he told a friend.[35] All he wanted to do was hold on to what he had in the face of the attacks that seemed to be launched at him from every side. "Any fool can make a fortune. It takes a man of brains to hold on to it after it is made." He was trying to hold what he had with everything in him. What he never understood was that by being concerned solely with preserving his fortune, he was putting an end to the days of risk taking, of expansion and empire building for the Vanderbilt family. He was braking the growth of the fortune.

4.

The sale of the New York Central stock did not, however, bring William Vanderbilt the peace he sought. Another threat to his empire arose when speculators formed syndicates to build railroad lines that paralleled parts of the Vanderbilt system. Since there was never enough business to support two competing roads, the only reason the rival lines were built was to force Vanderbilt to buy them, or if he would not, to engage in a rate war that could break the Vanderbilt line.

Construction began on the so-called Nickel Plate road in 1881. The work was done so quickly and carelessly that in fewer than six hundred days, more than six hundred miles of track had been laid alongside

Vanderbilt's profitable Lake Shore rails from Buffalo to Chicago to St. Louis. Vanderbilt scoffed at the new road, calling it "a poor piece of work" and stating that "no railroad can parallel us that will not starve to death. We will starve it, not maliciously, but by superiority of our position, before it can get in a condition to live."[36]

William Vanderbilt was interviewed about the Nickel Plate several weeks before it first started running. "I don't think much about it at all," he casually told the reporters. "It's no good. It's very poorly built. You can't tell me otherwise because I know. Why, who would want to risk their neck on a road built in the slipshod manner it was constructed? And then they talk about its being built so cheaply! That's nonsense. I'll bet you anything it cost more to build the Nickel Plate per mile of single track than it did the Lake Shore. Do I fear its competition? No, not much. I will bet the Lake Shore will earn at least six per cent on its capital the first year after the new road opens, and the new road will not earn expenses. Why, you ask? Well, I'll tell you. It can't get the business, and it has too many heavy expenses."

"Do you think," Vanderbilt was asked, "that there is any truth in the rumor that the road was built to sell?"

"Yes, I do. That's all it could have been built for, because there is no business which it can get that warrants its construction."

"Have you ever been asked to buy it, or any interest in it?"

"No, I cannot say that I have been asked directly to buy it, but I have been approached by persons who, I think, were to a certain extent authorized, and they gave me to understand that if I wanted to buy it, it could be obtained. I did not want it, however; I have no use for it. My present roads have plenty to do, but I do not know where I could find any business for a road like the Nickel Plate."[37]

The syndicators of the Nickel Plate road knew just what they were doing. They invited Jay Gould to travel on their new road on his return from a western trip. Vanderbilt interpreted this as Gould's inspection tour. To keep Gould from taking over the road and threatening his Lake Shore route, to prevent a rate war, Vanderbilt began buying its stock less than three weeks after the interview in which he had accurately assessed the limited prospects of the Nickel Plate.

"Your road is bankrupt," Vanderbilt told one of its promoters.

"No one knows that better than I do," he replied, "but do you want to compete with a receiver?"[38]

The road was ready for business on Monday, October 23, 1882. By Thursday, October 26, 1882, William Vanderbilt had acquired the Nickel Plate. The price he paid gave its promoters a $10 million profit. "For the price we paid for it, it ought to be nickel-plated!" Vanderbilt commented.[39]

Just as quickly as he had made his decision to purchase the road, he realized he had made his worst business blunder. As he had predicted, the road was facing bankruptcy within a year. Had he waited a little longer, he could have had the road on his own terms, rather than paying the exorbitant price that the speculators had set on their property. He could almost hear the Commodore explode: "Blatherskite! Beetlehead! Sucker!"

William must have wondered what his father would have done. He undoubtedly would have started a rate war to ruin the line and drive it out of business. But times had changed. Railroad peace, an end to rate wars, was worth a certain price. The only hitch in William's theory was that his purchase of the Nickel Plate did not establish the peace he coveted. It instead merely encouraged new groups of speculators to view William H. Vanderbilt as an easy mark.

"Now Commodore," a president of the Erie Railway had once said to Cornelius Vanderbilt, "nothing can hurt the New York Central until somebody builds a narrow-gauge road on the other side of the Mohawk."

"It is impossible," the Commodore snapped. "Such a road will never be built."[40]

In the winter of 1881, four years after the Commodore's death, work gangs, supported by a war chest of $50 million, began blasting out the right-of-way of the New York, West Shore and Buffalo. This new line was commonly called the West Shore because it followed the western bank of the Hudson from Weehawken, New Jersey, up to Albany, where it turned west along the Mohawk through Utica and Syracuse to Buffalo and the Great Lakes—the exact route, through the richest areas of the Northeast, that the main line of the New York Central followed on the eastern side of the Hudson and the opposite bank of the Mohawk.

Not only was there no economic need for the West Shore, it didn't make much practical sense either. All passengers and freight had to be transported by ferry boats from New York City to Weehawken, where the line began, thus increasing the expenses and inconveniences of the new road. No, there was never any doubt as to why Jay Gould and his partners, who included John Jacob Astor III and a group of Civil War generals, were constructing this road, which threatened Vanderbilt's crown jewel. "The West Shore was built as a blackmailing scheme, just as the Nickel Plate was," William Vanderbilt told a reporter.[41] It was nothing but "a miserable common thief caught with its hands in my pocket."[42]

The West Shore began operations on June 4, 1883. This time, William Vanderbilt knew he had to fight. First he cut the Central's freight rates between New York City and Albany from 25 cents a ton to 10 cents. The West Shore had used all of the $50 million it had raised to build the road; there was no money left over to wage battle with the mighty New York Central. Nevertheless, it gamely matched these cuts though its revenues were insufficient to pay the interest on its bonds and it was beginning to fall behind in paying its employees.

By June 1884, after one year of operation, the West Shore had gross revenues of $2,979,331 and expenses of $3,664,294. It declared bankruptcy. Its bonds were purchased by the Pennsylvania Railroad, the New York Central's arch-rival, which Vanderbilt had always believed was behind the West Shore scheme. The receivers of the West Shore decided to go for broke and ruin the New York Central once and for all.

The West Shore cut its passenger rates between New York and Chicago from $12.00 to $10.50. The New York Central matched it. The West Shore cut to $9.00. The New York Central dropped to $8.00. The West Shore gasped, and dropped its passenger rates as far as it dared, to $8.30.

The effects of the rate war on both railroads were devastating. The West Shore was borrowing money to meet its operating expenses. The New York Central's gross revenues fell from $33,770,721 for the year ending September 30, 1883, to $28,148,699 the following year, and to $24,429,411 the next, with net earnings falling to less than half of what they had been two years before. After government bonds, the bonds of the New York Central always had been regarded as the safest investment

for the most conservative investor. All of that changed with the West Shore battle. In June of 1881, the Central's stock was trading at 151½. By June of 1884, it dropped to 99½. In the second quarter of 1884, the Central showed a profit of $733,812, or 82 cents a share. When this was compared to the $2 in dividends the Central paid out to its shareholders that quarter, it was obvious that the rate war could not go on forever. For the first time, William Vanderbilt cut the once inviolate New York Central dividend. The rate war continued, with the West Shore clinging to the logic that for each dollar it was losing, the New York Central had to be losing three; the Central's demise was inevitable. While the receivers of West Shore waited, they eliminated all construction work and cut maintenance to the bone, to the point where equipment began to deteriorate. Vanderbilt again cut the Central's dividend.

Now some of the old Commodore's blood was coursing through his son's veins. Two could play this game.

William Vanderbilt invaded the territory of the Pennsylvania Railroad, organizing a competing parallel line that would run from New York City to Pittsburgh—the South Pennsylvania Railroad, he called it. He was able to interest Andrew Carnegie in the line since it would cross the yards of his Homestead plant. Vanderbilt tossed $5 million into the pot, as did Carnegie, and the Rockefellers threw in another million. The work of laying the bed was pushed at full speed. Thousands of workmen in the Allegheny Mountains began detonating, slashing, grading, boring tunnels, constructing great stone piers for bridges.

Suddenly, the work stopped. When it became obvious that the nation's two largest railroads were engaged in a fight to the finish, J. P. Morgan, anxious to calm the fears of the English shareholders to whom he had sold Central stock, invited George Roberts, head of the Pennsylvania Railroad, and Chauncey Depew, representing the New York Central, for a cruise aboard his yacht, the *Corsair*. As the *Corsair* steamed around the outer New York Harbor and up and down the Hudson, he proposed that rather than threatening the very reputation of American railroads, they call a truce, suggesting that the New York Central buy the West Shore out of bankruptcy and that the Pennsylvania Railroad buy the South Pennsylvania from the New York Central.

By the end of the cruise that evening, a deal had been struck. The Pennsylvania Railroad repaid Vanderbilt for all the money expended on

the South Pennsylvania. And the New York Central bought the West Shore at such a low price that it was doubtful competing roads would again be built for blackmail.

Compared to the savage Erie war between the Commodore and Daniel Drew, Jim Fisk, and Jay Gould, William Vanderbilt's battle with the Pennsylvania Railroad had been a rather civilized skirmish. Who would say that William Vanderbilt had not proven himself to be a sensible businessman in terminating a war his father undoubtedly would have pursued to the finish?

5.

When backed into a corner, William Vanderbilt had shown himself to be as ruthless as his father. But the Commodore's personality didn't fit him. As numerous as the stories of the Commodore's grasping covetousness were the stories of William's quiet kindness and generosity. His wife, Maria, who had raised their eight children, adored him. She once remarked that he had "never said an unkind word to me during all the years we were married."[43] For that matter, no one, no member of his family, none of his business associates, none of his competitors, could remember his ever uttering an unkind remark. When any of his children needed his help, he was there. When his son Willie got caught in a stock market manipulation and lost millions, his father was there to bail him out, handing over to him $5 million in government bonds. Whenever a former employee of the New York Central or an old friend of his father's needed help, William was there, writing a check to give someone a fresh start. Once a bondholder of the defunct predecessor of the Lake Shore and Michigan Southern Railway Company found a few coupons that had been lost in his desk for many years. Every time he tried to turn them in, he was told they were long overdue and could not be honored. Having exhausted his efforts in dealing with the railroad bureaucracy, the gentleman sent the coupons directly to William Vanderbilt. Vanderbilt replied by return mail, stating that the claim was just, and arranged for the immediate payment of the coupons.[44]

The management styles of the Commodore and his son William stood in stark contrast to one another. Where the Commodore had been

shrewd and secretive, his son was open and forthright. Where the Commodore had made all decisions himself, his son delegated responsibility and sought the advice of others. Where the Commodore had wished to ruin all competition, his son was anxious to reach accommodations with his rivals. Where the Commodore had been intent on cutting all unnecessary service to raise profits, his son took pride in the quality of service his railroads provided. Yet as the press would have it, it was William H. Vanderbilt, not the Commodore, who was labeled forever as the archetypal robber baron.

The misunderstanding originated one fall day in October 1882, when William Vanderbilt was touring the western lines of his railroads aboard a private train of the New York Central. As the train was on its way from Detroit to Chicago, a reporter from the *Chicago Tribune* and one from the Metropolitan Press Bureau boarded his car to interview the railroad king.

One of the issues they raised was his new fast mail train to Chicago, a special run from New York to Chicago that took twenty-four hours, twelve hours less than his passenger trains. He was considering discontinuing this special service.

"Why are you going to stop this fast mail train?" he was asked.

"Because it doesn't pay. I can't run a train as far as this permanently at a loss."

"But the public finds it very convenient and useful. You ought to accommodate them."

"The public! How do you know, or how can I know that they want it? If they want it, why don't they patronize it and make it pay? That's the only test I have as to whether a thing is wanted or not. Does it pay? If it doesn't pay I suppose it isn't wanted."

"Are you working for the public or for your stockholders?" the reporter persisted.

"The public be damned!" William Vanderbilt snorted in exasperation. "I am working for my stockholders. If the public wants the train why don't they support it? What does the public care for the railroads except to get as much out of them for as small a consideration as possible? When we make a move, we do it because it is in our interest to do so, not because we expect to do somebody else some good. Of course, we like to do everything possible for the benefit of humanity in

general, but when we do, we first see that we are benefitting ourselves. Railroads are not run on sentiment, but on business principles, and to pay, and I don't mean to be egotistic when I say that the roads which I have had anything to do with have generally paid pretty well!"[45]

"Don't forget the cussword," the editor at the city desk told the reporters when they filed the interview later that day.[46]

As was consistent with his character, William Vanderbilt had expressed a valid business principle in an honest and straightforward manner. But the following headline was telegraphed to every major newspaper across the country the next morning: THE PUBLIC BE DAMNED! Those four words became the battle cry of politicians, preachers, and editors ("A Millionaire's Motto," the New York Sun called them; " 'Billy Be Damned' Vanderbilt" he was labeled by another[47]), expressing the public's growing outrage at the excesses of big business, monopolies, capitalism, and greed. That entrepreneurial spirit, which once had been viewed as the foundation of the nation's industrial growth, by now was seen in a different light: as a threat to the American public. Cartoonists reveled in depicting William Vanderbilt as a bloated plutocrat with flaring muttonchop whiskers, often with a dollar sign on his vest, standing on the backs of his downtrodden employees as he fleeced the public.

The story haunted him on the trip. When he returned to New York, he attempted to set the record straight. "Those who know me and are familiar with my manner of talking do not need to be told that I was greatly misrepresented in that Chicago interview. . . . You ask me about that expression which has been put into my mouth. You say that it has become famous. I never used it, and that is all there is about it. Supposing that the expression which I am reported to have made revealed my real sentiments—do people think that I would publish such an opinion! That is not my way, nor my father's!"[48]

"Nor my father's!" That was an ill-advised afterthought, if ever there was one. Those who remembered the profanity of the hard-bitten Commodore could only smile and conclude, however mistakenly, "like father, like son."

Assailed on every side—by labor problems, by family squabbles, by competition, by the public—William Vanderbilt plodded onward, head down, watching every step. The old Commodore's words reverberated

over and over: "Any fool can make a fortune. It takes a man of brains to hold on to it after it is made." Again and again, William reviewed what might go wrong, what different calamities awaited him around the corner. He carefully divided his annual income into two parts: one for expenses, the other for investment. Distrustful of banks, he spread his money around, making small deposits in numerous financial institutions.

One fine day he must have looked up and concluded he had been doing something right: In January 1883, he confided to a friend that he was worth $194 million. "I am the richest man in the world."[49]

In the six years since his father's death, he had doubled his inheritance. He had made as much money in those six years as it had taken his father seventy years to accumulate. Never had so great a fortune been built in so short a time.

He was correct: He was the richest man in the world. One of the Rothschilds was reported to be worth $65 million and the duke of Westminster had a fortune of $50 million. An issue of London's *Whitehall Review* noted that Vanderbilt's wealth was greater than that of any member of the English nobility, and that he could "buy up all the Rothschilds and still remain richer than any duke."[50] He had $54 million in government 4 percent bonds, $4 million in government 3½ percent bonds, $80 million of railroad bonds, $42 million of railroad stock, $3 million of state and city bonds, $2 million in manufacturing stocks and mortgages, $5 million of real estate, an art collection worth millions. From his government bonds he had an income of $2,372,000 a year, from railroad stocks and bonds $7,394,000, from miscellaneous securities $376,695, a total tax-free income of $10,350,000 annually— over $28,000 a day, $1,200 an hour, $19.73 a minute. His income each day was larger by far than the annual income of most businessmen of the day. He stated that his annual expenses were $200,000. At this rate, his fortune was growing at more than $10 million a year.

The Commodore had died believing that through the occult, he would know what his heirs were doing. Perhaps between playing the harp and singing hymns, the activities that he hoped would occupy his time in heaven, or maybe while trying to figure out how a camel might pass through the eye of a needle, if he was elsewhere, the Commodore noticed what his son had accomplished. Not bad for a blatherskite, he might have said. "There's something to that boy, Bill, after all!"[51]

What did it mean to be the richest man in the world? To William Vanderbilt it meant very little.

He was constantly concerned about preserving his wealth, and was obsessed with scrutinizing his smallest expense. Just after he had invested $50 million in government bonds and was sorting them into stacks on his desk, he called for his private secretary, Isaac Chambers, to come into his office.

"Was I here last Thursday, Mr. Chambers?" he asked.

"No, for I remember having been up to your house that day."

William Vanderbilt picked up a bill from the janitor who supplied him with lunches for forty cents a day.

"Well, do you know that the janitor has charged me with a lunch on Thursday?"

He took his pen and made a correction on the bill, eliminating the forty cents for the lunch he had never eaten, and handed the corrected bill to Mr. Chambers to be paid.[52]

The sheer magnitude of his fortune, he told Chauncey Depew, gave him no advantages over men of moderate wealth. "I have my house, my pictures and my horses, and so do they. I can have a steam yacht if I want to, but it would give me no pleasure, and I don't care for it."[53] On another occasion he spoke of a neighbor saying, "He isn't worth a hundredth part as much as I am, but he has more of the real pleasures of life than I have. His house is as comfortable as mine, even if it didn't cost so much; his team is about as good as mine; his opera box is next to mine; his health is better than mine, and he will probably outlive me. And he can trust his friends."[54]

Being the richest person in the world brought him, he said, nothing but anxiety. He enjoyed having some fine horses that grazed in a pasture he could see from his office in the Grand Central Depot. (One friend noted that he was so fond of horses that he "probably would have slept with them [and did not] only through fear of the newspapers criticizing his eccentricity."[55]) And he was beginning to collect works of art. Other than that, there was nothing he wanted. His fortune was really nothing but a source of headaches.

He believed that his health had been broken by the burden of managing his father's empire. "I feel pretty well," he would tell his doctors, "but can't depend upon myself."[56] "What's the use, Sam, of

having all this money," he said to his nephew, "if you cannot enjoy it? My wealth is no comfort to me if I have not good health behind it." He asked his nephew if he thought he looked old, as old as the Commodore right before he died. That was just how he felt: like an eighty-three year old.[57]

By his early sixties, he was tired and worn out. "The care of $200,000,000 is too great a load for my brain or back to bear," he confessed to his family. "It is enough to kill a man. I have no son whom I am willing to afflict with the terrible burden. There is no pleasure to be got out of it as an offset—no good of any kind. I have no real gratification or enjoyments of any sort more than my neighbor on the next block who is worth only half a million. So when I lay down this heavy responsibility, I want my sons to divide it, and share the worry which it will cost to keep it."[58]

3

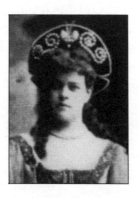

ALVA

1 8 7 5 – 1 8 8 3

1.

Willie Vanderbilt, the handsome twenty-six-year-old son of William H. Vanderbilt, married twenty-two-year-old Miss Alva Smith on April 20, 1875. Alighting from the Commodore's private railroad car in Saratoga Springs for his honeymoon, Willie signed the hotel register: "William Kissam Vanderbilt, wife, two maids, two dogs, and fifteen horses."[1]

Writing of this Victorian age, novelist Edith Wharton noted that "brides knew nothing and expected everything. Brides were plunged

overnight into what people called 'the facts of life.' "[2] In this marriage, however, it was Willie who was plunged into the facts of life. Neither Willie nor the Vanderbilt family would ever be the same again.

It had all seemed so simple at the outset. Willie's parents approved of the marriage. In fact, William H. Vanderbilt seemed as captivated by the charming Alva as was his son. So was the Commodore. On the obligatory visit to 10 Washington Place to meet the family patriarch, Alva found the old Commodore "one of the handsomest, most intelligent, and most interesting men I had ever met. His manner was most overbearing and the family more or less stood in great awe of him. I had never known what it was to be awed by anybody, and I think for that reason he had a great deal of respect for me, and we became quite friendly."[3] Alva and the Commodore seemed to sense at once that they were kindred spirits, both "dreamers of dreams."[4] Even the press applauded this marriage to an "honest American woman." Wrote the *New York World:* "There has been no attempt on either side to connect titles with the family name by means of a wedding-ring. Mr. and Mrs. [William H.] Vanderbilt have not followed the example of the American aristocracy of wealth, and put their daughters up at auction to be bid for by seedy and needy European titles. Their boys and girls have fallen in love and married like the boys and girls of any honest American mechanic. For this both father and mother are entitled to credit."[5]

Like the Commodore's new wife, Frank Crawford, Alva had been born and raised in Mobile, Alabama. Alva was the daughter of Murray Forbes Smith, a successful cotton merchant of Scottish descent. Her mother was Phoebe Desha, the daughter of General Robert Desha who served as a member of Congress from Tennessee, and the niece of Governor Joseph Desha of Kentucky.

"A born dictator,"[6] young Alva enjoyed nothing so much as "tyrannizing over the little slave children"[7] on her father's cotton plantation. She was "of fighting stock,"[8] as she liked to say, her ancestors having fought in every war that had taken place in the United States, and her "combative nature rejoiced in conquest."[9] She recalled discovering at the age of seven that boys looked down upon girls. "I can almost feel my childish hot blood rise as it did then in rebellion at some such taunting remarks as: 'You can't run.' 'You can't climb trees.' 'You can't fight.' 'You are only a girl.' But no young would-be masculine bravado

ever expressed twice such slurring belittlements of me,"[10] for Alva would beat the daylights out of any boy who teased her.

One boy in church school made the mistake of laughing at Alva's Sunday hat. Outside "we fought and I pushed him in the gutter. He never laughed at me or at my clothes again."[11]

That young man should have considered himself lucky. On another occasion, Alva had climbed a large apple tree, using a ladder to reach the first branches. Along came her friend Pepe, whose "masculine superiority was unbearable." Pepe took away the ladder and began to taunt Alva, pelting her with apples. "I came down that tree like a monkey, scaling the rough bark. By the time I was on the ground I think I saw red. I ran after Pepe who by this time felt the approach of a Fury and had begun to make his escape. I caught him and threw him to the ground. I choked him and banged his head upon the ground. I stamped on him screaming 'I'll show you what girls can do.' In my rage I think I would have killed him but for the intervention of some of the spectators who had gathered to watch the fight. Pepe was completely vanquished."[12]

Sassy, with two long braids draped to her waist, Alva was by her own admission "probably the worst child that ever lived," and believed she deserved the regular whippings her mother administered "whenever I did things I should not have done. There was a force in me that seemed to compel me to do what I wanted to do regardless of what might happen afterwards." Later in her life Alva wondered "at the great leniency of my teachers. Perhaps they realized that I was impossible, and thought the best thing to do was to ignore an impossible condition."[13]

Alva's parents, the Smiths, were ruined at the outset of the Civil War and fled to Paris with their five children. Although Alva would later tell her own children that her mother's sister "made her debut at one of the last balls given at the Tuileries by Napoleon III,"[14] when the Smiths returned to the United States after the war, they never recovered their fortune or social standing. Phoebe Smith set up a boarding house in New York City, as her husband struggled to make some money trading cotton to support his family in genteel poverty. It would be up to the Smiths' children to marry well if they would ever live again the life they had known in the antebellum South.

"Youth," wrote Euripides, "is the best time to be rich, and the best

time to be poor." Alva had seen enough of both to know that rich was for her. She realized that she needed a wealthy husband to help her family and to fund her own ambitions.[15] But how to catch one?

No one would have called Alva beautiful. Attractive? Not really. A little too short, a little too plump, her face a little too severe, her mouth a little too set, her long brown hair, which reached the ground, tinged with gray even in her twenties. Some remarked that she looked like a cute Pekingese. But intelligent? Yes, without question. "Her conversational powers are rather remarkable,"[16] one observer noted. Vivacious? Yes, indeed. Pert, sassy, a tease, she was a bundle of energy, "quick at repartee, witty and somewhat sarcastic."[17] Charming? Without a doubt. And "credited with considerable sex appeal."[18] Beneath the southern charm of this cute Pekingese beat the heart of a pit bullterrier. Alva lunged right at what she wanted, grabbed on, and never let go, and no one, no one ever dared stand in her way.

What Alva wanted was Willie Vanderbilt.

Wealthy Consuelo Yznaga, Alva's best friend from her childhood days in Mobile, was spending part of the year in New York City. By all accounts, Consuelo was "beautiful, witty, gay and gifted," a woman who, "wherever she went . . . attracted rich and poor alike, solely through her fascinating personality."[19] Consuelo's brother had married one of Alva's sisters, and Consuelo was determined to see to it that her best friend began moving in the New York social circles of which she was a part. Consuelo introduced Alva to young William Kissam Vanderbilt at a party for one of Commodore Vanderbilt's daughters. And so it came to pass that Alva lunged at Willie.

Willie. Willie was wonderful. Willie had the build of an athlete, just like his grandfather the Commodore. Willie was good-looking. His face had none of the cragginess of his grandfather's or the bloatedness of his father's, but more the beauty of his mother's, with his beveled lips and flashing smile, his short, neatly combed brown hair and humorous eyes. Willie was bright. Willie was polished. He had studied with private tutors and attended school in Geneva, Switzerland. Willie had a good job. The Commodore was convinced that only "hard and disagreeable work" would keep his grandsons from becoming "spoilt,"[20] and had put Willie to work at the age of nineteen at his Hudson River Railroad. Now Willie was second vice president of the New York Central. Willie was

easygoing and a lot of fun. He had "the look of happy expectancy one sees on the faces of those who love life," and "found life a happy adventure."[21] And God, was Willie rich! And his dear old, very old, eighty-one-year-old grandfather was very rich indeed, richer than anyone. In the foreseeable future (it couldn't be long now), Willie would inherit a fortune.

On April 20, 1875, a year after meeting him, Alva married Willie Vanderbilt, with Consuelo Yznaga as her bridesmaid. "I always do everything first," Alva later would brag. "The Smiths of Alabama cut me dead for marrying W. K. Vanderbilt because his grandfather peddled vegetables. I blaze the trail for the rest to walk in. I was the first girl of my set to marry a Vanderbilt."[22]

Alva didn't waste a moment now that she had won a Vanderbilt as her first trophy. First on her agenda was a country house for the early summer and autumn months, an escape from their fashionable brownstone at 5 East Forty-fourth Street, a wedding present from Willie's father. Less than a year after their marriage, they purchased eight hundred acres of peace and solitude in Oakdale, Long Island, on Great South Bay. Richard Morris Hunt, the first American architect trained at the École des Beaux-Arts in Paris, was developing in the United States a new architecture of grandeur that appealed to the rich. It was therefore naturally Hunt, a Francophile just like Alva since her days in Paris, whom Willie and Alva retained to build a large rambling shingled villa overlooking the bay.

The next year, Alva gave birth. She named her daughter Consuelo in honor of her best friend, Consuelo Yznaga, who had just married Lord Mandeville, the son of Britain's seventh duke of Manchester. In marrying him, lovely Consuelo Yznaga became Viscountess Mandeville, Lady Mandeville, a member of a family of English nobility that traced its roots directly to the monarchs of the sixteenth century. Alva regarded Consuelo Yznaga's transformation into Lady Mandeville as wondrous indeed. There was, alas, no American nobility, but there certainly was no reason why the Vanderbilts couldn't live like the English nobility, just like the duke and duchess of Manchester.

Willie had just received $2 million in railroad stocks from the Commodore's will when Alva announced in 1878, three years after marrying Willie, that it was time for a new home. During her teenage

years in Europe, she had marveled at the great châteaus of the Loire Valley. France had its châteaus, England its ancestral country estates, Germany its Rhine castles, Italy its magnificent villas, Venice its Renaissance palazzi, Russia its summer palaces. Where were the American equivalents of these homes? Even as the work was still in progress at Idlehour, their country estate on Long Island, Alva convinced Willie to retain Richard Hunt to design yet a second project, a new town house. And what Alva wanted, Alva got.

Alva and Willie liked the work Richard Hunt was doing for them at Idlehour. They also liked his personal philosophy. "The first thing you've got to remember," the architect once remarked, "is that it's your client's money you're spending. Your goal is to achieve the best results by following their wishes. If they want you to build a house upside down standing on its chimney, it's up to you to do it."[23] Richard Hunt knew his new young clients very well, and he understood the function of architecture as a reflection of ambition. He sensed that Alva wasn't interested in another home. She wanted a weapon: a house she could use as a battering ram to crash through the gates of society.

The house Alva felt would fit her bill was what she called "a little Chateau de Blois."[24] Richard Hunt shared her vision precisely. And there, on a lot at the corner of 660 Fifth Avenue and Fifty-second Street, surrounded by uninspired brownstones "cursed," as Edith Wharton wrote, with the "universal chocolate coating of the most hideous stone ever quarried,"[25] there arose during the next several years with the labor of one thousand workmen and artisans, a fairy tale palace of white Indiana limestone, a palace reminiscent of the Château de Blois in Touraine and the castle at Bourges of Jacques Coeur, the fifteenth-century merchant prince. During its construction, Alva and Richard Hunt made several trips to Europe, scouring the great antique shops of London and Paris, pillaging the ancient homes of impoverished nobility, gathering tapestries, chandeliers, paneling, floors, fireplaces, suits of armor, alabaster bathtubs, and anything else they could find to decorate the interior of her new town house in a way that would complement the splendor of its exterior.

Three years and $3 million later (Alva's constant alterations of the original plans tripled its cost), the Vanderbilts' house was complete. It was hailed as an architectural masterpiece. Even rival architect Charles

F. McKim, of McKim, Mead, and White, said that he liked nothing better than strolling up Fifth Avenue in the evening and gazing at the Vanderbilt palace. "I can sleep better at night knowing it's there."[26]

Everyone was entranced by this château that seemed to have been lifted from the rolling countryside of the Loire Valley and planted on a corner of Fifth Avenue. Everyone except Alva. Alva was disappointed. Society still was not beating a path to her new front door. In fact, the leaders of New York society, the people who meant the most to Alva, were still barring their doors to the Vanderbilts. As always, what Alva wanted was what she did not have. And now, what she wanted most of all was the acceptance of the elite social set, the recognition by society that the Vanderbilts had arrived.

As Oscar Wilde once said of society: "To be in it is merely a bore; but to be out of it is simply a tragedy." It was a tragedy to Alva that she, Alva Smith Vanderbilt, who could trace her ancestors back to the Scottish aristocracy, was being excluded from the finest homes and the most prestigious balls in the city, just because she had married a Vanderbilt.

2.

Mrs. William Backhouse Astor. Mrs. Astor (early on she had dropped the troublesome *Backhouse* as well as the dreary-sounding *William* and was known forevermore as Mrs. Astor) was definitely the problem. Mrs. Astor would have nothing to do with social upstarts like the Vanderbilts, and Mrs. Astor was the undisputed queen of New York society. She had been crowned by a southern dandy named Ward McAllister, a young sycophant who had once curried the favor of Commodore Vanderbilt, and who, in the decade of the 1870s, all but created the rarefied world of New York society.

Very early in his life Ward McAllister had realized that there was little work for which he was suited, and that his greatest happiness lay in living well. The son of a prosperous Georgia attorney, Ward had set out for New York City to make a name for himself. There he lived with "an old maiden lady, my relative and godmother, whom I always felt would endow me with all her worldly goods, but who, I regret to say,

preferred the Presbyterian Church and the Georgia Historical Society to myself, for between them she divided a million."[27]

Before this blow, McAllister found that "as the supposed heir of my saving godmother, the portals of New York society were easily open to me."[28] Receiving an invitation to his "first fancy ball," McAllister promptly went out and spent all of "a legacy of a thousand dollars paid me by the New York Life Insurance and Trust Company" on "fancy dress, which I flattered myself was the handsomest and richest at the ball."[29]

As Ward McAllister "was dancing and reciting poetry to beautiful women," and "breathing soft words to lovely Southern maidens,"[30] his ambitious brother, who had traveled to California during the gold rush, was prospering as a lawyer in San Francisco and urged Ward and his father to join him. The two left for San Francisco in 1850. There, the family agreed that Ward was much better at entertaining the law firm's clients than he was at practicing law, and he was put in charge of these social responsibilities. "Such dinners as I then gave," Ward recalled with fondness years later, "I have never seen surpassed anywhere."[31]

After several years, McAllister left the firm and married an heiress, the granddaughter of Thomas Gibbons, the steamboat entrepreneur who had once employed Cornelius Vanderbilt. Sarah Gibbons was as retiring as McAllister was outgoing, and was more than happy to sit at home and let her husband use her dowry of about a million dollars to fund his avocation of living well. From then on, McAllister's world consisted of a steady round of formal dances, dinners, and cotillions.

The McAllisters bought Bayside Farm, a modest estate in Newport, Rhode Island, which, in the 1870s, was a fashionable seaside resort for wealthy southern planters escaping the summer heat and fever of the Carolinas and Georgia. There Ward went to work entertaining "the most charming people of the country [who] had formed a select little community there."[32] No doubt about it, he was a lot of fun. He liked nothing more than organizing elegant champagne picnics, *fêtes champêtres* as he called them, for the idle rich of Newport, at which they "frolicked . . . to their hearts' content."[33] He explained how his picnics would come about: "Riding on the Avenue on a lovely summer's day, I would be stopped by a beautiful woman, in gorgeous array, looking so

fascinating that if she were to ask you to attempt the impossible, you would at least make the effort. She would open on me as follows:

" 'My dear friend, we are all dying for a picnic. Can't you get one up for us?'

" 'Why, my dear lady,' I would answer, 'you have dinners every day, and charming dinners too; what more do you want?'

" 'Oh, they're not picnics. Any one can give dinners,' she would reply; 'what we want is one of your picnics. Now, my dear friend, do get one up.'

"This was enough to fire me, and set me going. So I reply:

" 'I will do your bidding. Fix on the day at once, and tell me what is the best dish your cook makes.'

"Out comes my memorandum book and I write: 'Monday, 1 P.M., meet at Narragansett Avenue, bring *fillet de boeuf pique,*' and with a bow am off in my little wagon, and dash on, to waylay the next cottager, stop every carriage known to contain friends, and ask them, one and all, to join our country party, and assign to each of them the providing of a certain dish and a bottle of champagne. Meeting young men, I charge them to take a bottle of champagne, and a pound of grapes, or order from the confectioner's a quart of ice cream to be sent to me. My pony is put on its mettle; I keep going the entire day getting recruits; I engage my music and servants, and a carpenter to put down a dancing platform, and the florist to adorn it, and that evening I go over in detail the whole affair, map it out as a general would a battle, omitting nothing, not even a salt spoon; see to it that I have men on the road to direct my party to the farm, and bid the farmer put himself and family, and the whole farm, in holiday attire."[34]

McAllister "did not hesitate to ask the very *crème de la crème* of New York society to lunch and dine at my farm or to a fishing party on the rocks,"[35] and through this entertaining "formed lifetime intimacies with the most cultivated and charming men and women of this country."[36] What he meant was that he came to know the very rich.

"These little parties were then, and are now, the stepping-stones to our best New York society. . . . Now, do not for a moment imagine that all were indiscriminately asked to these little fetes. On the contrary, if you were not of the inner circle, and were a new-comer, it took the combined efforts of all your friends' backing and pushing to procure an

invitation for you. For years, whole families sat on the stool of probation, awaiting trial and acceptance, and many were then rejected, but once received, you were put on an intimate footing with all. To acquire such intimacy in a great city like New York would have taken you a lifetime."[37]

McAllister was an unlikely candidate for the appellation of "Autocrat of the Drawing-Rooms" with his paunch, thinning hair, wispy moustache and Vandyke beard, and ill-fitting, although expensive, clothes. But he was unfailingly courteous, charming, and socially suave. And who else devoted every waking hour to studying etiquette and genealogy, devising guest lists, and planning balls? McAllister's special passion was fine wines and foods, about which he offered Olympian pronouncements to all who would listen. "My dear sir, I do not argue, I inform."[38]

- "Decant all your clarets before serving them, even your *vin ordinaire*. Stand up both wines the morning of the dinner, and in decanting, hold the decanter in your left hand, and let the wine first pour against the inside of the neck of the decanter, so as to break its fall."[39]
- Avoid at all costs "the fatal mistake" of "letting two white or brown sauces follow each other in succession; or truffles appear twice in that dinner."[40]
- Start the meal with a soup "which is attractive to the eye, and, if well made, at once establishes the reputation of the artist, satisfies the guests that they are in able hands, and allays their fears for their dinner."[41]
- "The man who gives salmon during the winter, I care not what sauce he serves with it, does an injury to himself and his guests."[42]
- "*Sorbet*, known in France as *la surprise*, as it is an ice, [can] produce on the mind the effect that the dinner is finished, when the grandest dish of the dinner makes its appearance in the shape of the roast canvasbacks, woodcock, snipe, or truffled capons, with salad."[43]
- "Properly *frappé* champagne" so that "when the wine is poured from the bottle, it should contain little flakes of ice" but "none but a very rich, fruity wine should ever be *frappéd*."[44]

• "In going in to dinner, there is but one rule to be observed. The lady of the house in almost every case goes in last, all her guests preceding her, with this exception, that if the President of the United States dines with you, or Royalty, he takes in the lady of the house, preceding all of the guests."[45]

During the 1870s, New York's new rich were uncertain of themselves, socially inept. It was an age that spawned a host of etiquette books warning dinner party guests against "shaking with your feet the chair of a neighbor," instructing ladies who were traveling to "avoid saying anything to women in showy attire, with painted faces, and white kid gloves," and cautioning "the rising generation of young elegants in America . . . to observe that, in polished society, it is not quite *comme il faut* for gentlemen to blow their noses with their fingers, especially when in the street."[46] When the wealthy encountered Ward McAllister, who spoke with such authority in his affected British accent, his conversations punctuated with "jolly well," "right you are," "frightfully," "don't you know," "don't you see," "do you understand," and "I hope you catch the point," and sprinkled with references to his intimates among the British gentry and America's oldest families, they were relieved to let this fop assume the role of arbiter of good taste and to obey his precepts blindly.

"We here reach a period," Ward McAllister noted of the decade of the 1870s, the beginning of the Gilded Age, "when New York society turned over a new leaf. Up to this time, for one to be worth a million dollars was to be rated as a man of fortune, but now, bygones must be bygones. New York's ideas as to values, when fortune was named, leaped boldly up to ten millions, fifty millions, one hundred millions, and the necessities and luxuries followed suit."[47] Now, McAllister proclaimed, "a fortune of only a million is respectable poverty."[48]

New York society had always consisted of what McAllister termed its "nobs" and its "swells." The nobs were the old-money families, the Stuyvesants, Van Cortlandts, Van Rensselaers, De Lanceys, and Morrises, the aristocrats of America by virtue of their hereditary wealth; the swells were those with new money, trying to break into society. A pleasing mixture of nobs and swells, McAllister felt, was good for society. The trouble was that now, with great fortunes being made overnight,

society could easily become dominated by whoever at the moment had the most money. That would never do. "We thought it would not be wise to allow a handful of men having royal fortunes to have a sovereign's prerogative, i.e., to say whom society shall receive, and whom society shall shut out."[49]

Nothing, Ward McAllister always believed, could solve society's problems so well as a ball. In the winter of 1873 McAllister organized what he called the Patriarch Ball, an event to be attended only by New York's upper crust. He assembled a group of twenty-five "Patriarchs," chosen "solely for their fitness; each of them promising to invite to each ball only such people as would do credit to the ball."[50] McAllister defined *fitness* as being a gentleman, and it naturally took "four generations of gentlemen," a pedigree of four generations, "to produce a gentleman."[51] The twenty-five chosen leaders included Astors, Livingstons, Schermerhorns, Rensselaers, Rutherfurds, and, of course, Ward McAllister.

Each Patriarch had the right to invite four ladies and five gentlemen to each ball. According to McAllister, "we then resolved that the responsibility of inviting each batch of nine guests should rest upon the shoulders of the Patriarch who invited them, and that if any objectionable element was introduced, it was the Management's duty to at once let it be known by whom such objectionable party was invited, and to notify the Patriarch so offending, that he had done us an injury, and pray him to be more circumspect. He then stood before the community as a sponsor of his guest, and all society, knowing the offense he had committed would so upbraid him, that he would go and sin no more. We knew then, and we know now, that the whole secret of the success of these Patriarch Balls lay in making them select; in making them the most brilliant balls of each winter; in making it extremely difficult to obtain an invitation to them, and to make such invitations of great value; to make them the stepping stone to the best New York society, that one might be sure that any one repeatedly invited to them had a secure social position, and to make them the best managed, the best looked-after balls given in this city."[52]

The motto of the Patriarchs was *nous nous soutenons*, which translated as "we stand by one another," but which really meant, "we keep out profiteers, boors, boorish people, people with only money."[53] The

Patriarch Balls would keep the parvenus in their place, and identify who was a part of society and who was not, thereby eliminating many troubling dangers, for as Ward McAllister warned, "You can never be absolutely certain whether people are society or not until you see them at four or five of the best houses. Then you can make advances to them without the danger of making a mistake."[54]

It was during that winter of 1873, the winter of the first of the Patriarch Balls, that Mrs. Astor, who had several daughters for whom she wished to find suitable husbands, first took an active role in New York society.

Mrs. Astor, a nob, had been a part of society "by divine right," as Ward McAllister would decree.[55] When she, Caroline Schermerhorn, had married William Backhouse Astor, Jr., twenty years before, she was convinced she had bestowed on the Astor family an extraordinary gift. For she was a Schermerhorn, of an old Knickerbocker line that traced its roots directly to the original Dutch settlers of Manhattan and so to every prominent New York family. Her husband was an Astor, the grandson of a coarse German immigrant. That immigrant, John Jacob Astor, the son of a butcher who had sailed to New York in steerage, a man who "wrote a wretched scrawl, setting spelling and grammar equally at defiance,"[56] a man who never lost his thick German accent, had died in 1848, a penny-pinching octogenarian who happened to be the richest man in the United States, leaving his family a real-estate fortune of $20 million, a figure that the newspapers found "as incomprehensible as infinity."[57] But Caroline Astor believed it was her distinguished Schermerhorn lineage that brought honor and social acceptance to the Astor name.

Here was a woman whose thoughts about society, about nobs and swells, were just like McAllister's. "Society," McAllister believed, "must have its leader or leaders. It has always had them, and will continue to have them. Their sway is more or less absolute."[58] That winter of 1873 McAllister was brought in contact with this *grande dame* for the first time, and "at once recognized her ability, and felt that she would become society's leader, and that she was admirably qualified for the position."[59]

She was admirably qualified not only because her views on society matched McAllister's to the letter, but also because she was admirably

rich and because her husband was admirably absent. William Astor couldn't have cared less about the world of society into which his wife tried to propel him, and retreated more and more frequently to Ferncliffe, their country estate on the Hudson, or to his yacht, the *Ambassadress,* for prolonged voyages. Mrs. Astor had the wherewithal to fund extravagant social entertainments, and she obviously needed a male escort, social adviser, and confidant. Enter Ward McAllister. It did not bother him one whit that Mrs. Astor, upon being escorted to a dinner, would leave him to fend for himself while she went to sit with the honored guests, or that he would not see her again until the end of the evening when she expected him to take her home. Nor did it bother Ward McAllister that Mrs. Astor treated him like her servant and social secretary, expecting him to organize all the details of her parties. For Mrs. Astor was his entrée into the highest reaches of society, which he, living in "respectable poverty" with "a fortune of only a million," would otherwise never see.

"All admired her," Ward McAllister said of Mrs. Astor, "and we, the young men of that period, loved her as much as we dared. All did homage to her. . . . She was, in every sense, society's queen. She had the power that all women should strive to obtain, the power of attaching men to her, and keeping them attached; calling forth a loyalty of devotion such as one imagines one yields to a sovereign, whose subjects are only too happy to be subjects." McAllister was only too happy to be a subject of the queen he called his "Mystic Rose," for as her court chamberlain, he found he had the influence over high society that he so long had craved. "I well remember being asked by a member of my family, 'Why are you so eager to go to this leader's house?' My reply always was, 'Because I enjoy such refined and cultivated entertainments. It improves and elevates one.' "[60]

Together, Mrs. Astor and her faithful subject defined who constituted society. Their desire to establish in America a society patterned after the European aristocracy was "so ardent, so sincere that it acquired dignity," a contemporary noted; "it became almost a religion."[61] The annual Patriarch Balls became but a dress rehearsal for the great social event of each year: Mrs. Astor's Ball, which was held on the first or second Monday of each January.

The pair spent weeks winnowing through the rosters of New York's

finest colonial families in order to fashion a guest list. They subscribed to the theory that a ball that was exclusive would make invitations sought after by everybody. "The man of fashion," Ward McAllister reminded Mrs. Astor, "should have no business,"[62] so of course tradespeople and all those who actually had to work for their living were excluded from the invitation list, though it was not so long ago that John Jacob Astor had been running advertisements in the local papers offering "guitars, fifes and pianofortes"; that the Manhattan land baron Peter Goelet, selling saddles and pewter spoons, had advertised a special: "a consignment of playing cards"; and that Isaac Roosevelt had been pushing his "loaf, lump, and strained sugar" to the townsfolk. In considering her next-door neighbors on Fifth Avenue, the department store tycoon A. T. Stewart and his wife, who had built a mansion that far outshone the Astors', Mrs. Astor noted that "I buy my carpets from them, but then is that any reason why I should invite them to walk on them?"[63] Although only those who enjoyed a moneyed leisure could be invited to the balls, excluded also were the dreadful *nouveaux riches* like the Vanderbilts. Mrs. Astor did not approve of railroad money.

The ballroom of Mrs. Astor's brownstone at 350 Fifth Avenue at the corner of Thirty-fourth Street could hold four hundred people. Therefore that became the magic number that constituted the cream of New York society. "Why, there are only about 400 people in fashionable New York Society," McAllister patiently explained. "If you go outside that number you strike people who are either not at ease in a ballroom or else make other people not at ease. See the point? These people have not the poise, the aptitude for polite conversation, the polished and deferential manner, the infinite capacity of good humor and ability to entertain or be entertained that society demands."[64] McAllister concluded that society really was but "twenty score of well bred persons, called the world."[65]

Standing before a full-length portrait of herself, Mrs. Astor greeted the chosen Four Hundred once a year. Like Goya's devastating painting of the family of Charles IV, which revealed the Spanish royal family as an assembly of dim-witted grotesques but whose splendor apparently so dazzled them that they never noticed what Goya had done, so did the portrait of Mrs. Astor capture a plump plain woman of bovine countenance, bedecked in a lavish gown and imposing jewelry. "She was really

homely, no looks at all,"[66] recalled one of Mrs. Astor's nieces. Yet dressed in a Worth gown, weighed down with her jewels, a diamond tiara set in her dyed black hair, she appeared more regal ruling over her Four Hundred than Queen Victoria ruling over the British Empire.

Every once in a while, one of her guests who had heard gossip of the wild parties William Astor was throwing aboard his yacht would work up the courage to inquire how the absent Mr. Astor might be that fine evening of the ball. "Oh," Mrs. Astor would invariably reply with calm dignity, "he is having a delightful cruise. The sea air is so good for him. It is a great pity I am such a bad sailor, for I should so much enjoy accompanying him. As it is I have never even set foot on the yacht; dreadful confession for a wife, is it not?

"Dear William is so good to me . . ." she would add, touching one of the ropes of diamonds around her neck and looking over "the spoils of civilization," as Henry James called the treasures of antiquity that adorned her home. "I have been so fortunate in my marriage."[67]

After being greeted by Mrs. Astor, the four hundred guests moved into her large art gallery, which served as her ballroom. There, on an enormous divan set on a raised platform, Mrs. Astor and a few specially favored guests settled for the evening to watch the dancing. Mrs. Astor's friends groveled for a year to win one of the few spaces on the divan for the evening of the ball. Once Mrs. John Drexel, upon discovering that none of the red silk cushion seats of the divan had been allotted to her, ran sobbing through the ballroom and seized Mrs. Astor's daughter.

"Your mother doesn't like me," Mrs. Drexel wailed. "She has given me the most dreadful humiliation. . . . Oh, I have never been hurt so in my life. . . ."

"But what has Mother done?"

"My name is not on the Throne," Mrs. Drexel cried. "She does not love me. I won't stay one minute longer in a house where I am not loved. . . ."[68]

Another lady was denied the privilege of sitting with Mrs. Astor on the throne because of the size of her hips. "How can I have her when you have to allow at least two ordinary seats for her?"[69]

No one ever remembered Mrs. Astor's Ball as being very much fun, but failure to be invited "virtually debars one from eminent leadership in that surpassing coterie known as national and international American

society," the Reverend Charles Nichols once noted.[70] "Not to have received an invitation to an Astor ball; not to have dined at Mrs. Astor's,"[71] this minister of a fashionable church declared, was the equivalent of being banished from society. "There was weeping and gnashing of teeth on the part of those who did not receive the coveted slip of cardboard, 'Mrs. Astor requests the pleasure . . .' " remembered Elizabeth Drexel Lehr, one of the ladies always invited. "Life could hold no more bitter mortification. There remained only one course open to them—to hide the shameful truth from their friends. They did it at all costs. Doctors were kept busy during the week of the ball recommending hurried trips to the Adirondacks for the health of perfectly healthy patients, maiden aunts and grandmothers living in remote towns were ruthlessly killed off to provide alibis for their relations . . . and every excuse was resorted to. Not a man or woman in society would let their friends jump to the dreadful conclusion that their absence from the greatest social event of the year was due to lack of an invitation!"[72]

Mr. and Mrs. William K. Vanderbilt, Willie and Alva, had never received an invitation to Mrs. Astor's Ball.

3.

The Vanderbilts were exactly the sort of objectionable element Mrs. Astor wished to exclude from her ball: people with no background who had gotten too rich too quickly, people who thought that their money could buy everything.

For Ward McAllister, the Vanderbilts presented something of a dilemma. On the one hand, McAllister's purpose in life was to obey the wishes of his Mystic Rose. On the other, in his early days in New York, he had shamelessly cultivated the friendship of the Commodore. "I have always had a great fondness for men older than myself. Always preferring to associate with my superiors than my inferiors in intellect, and hence when brought in contact with one of America's noblest and most cultivated men (withal, the then richest man in the United States, if not in the world)," McAllister noted parenthetically as an appealing characteristic of the Commodore in addition to his fine old age, intellect, nobility, and cultivation, "I sought his society, and he in turn appeared

at least to enjoy mine. Dining with him constantly, I suggested that he should dine with me; to which he readily assented. So I went to Cranston, my landlord of the New York Hotel, and put him to his trumps to give me a suitable dinner. His hotel was then crowded, and I had actually to take down a bedstead and improvise a dining-room. Cranston was one of those hotel-keepers who worked as much for glory as for money. He gave us simply a perfect dinner, and my dear old friend and his wife enjoyed it. I remembered his saying to me, 'My young friend, if you go on giving such dinners as these you need have no fear of planting yourself in this city.' "[73]

McAllister became a "great admirer of this grand old man." "You, Commodore," McAllister told him at one dinner, "you will be as great a railroad king as you were once an ocean king." Vanderbilt grew "very fond" of this young sycophant, calling him "my boy."[74]

When Ward McAllister saw young Willie and Alva Vanderbilt's limestone château rising on Fifth Avenue, he knew there was no longer any holding the family back. On the evening of January 15, 1883, Willie and Alva were Ward McAllister's guests at a Patriarch Ball. Mrs. Astor was also there. But she would not permit her court chamberlain to present the Vanderbilts to her.

"People seem to be going quite wild and inviting all sorts of people to their receptions," Mrs. Astor complained. "I don't know what has happened to our tastes."[75]

How could she continue to ignore the Vanderbilts? McAllister asked his Mystic Rose. Theirs was the richest family in the world. Mr. and Mrs. William K. Vanderbilt had been to the homes of many of Mrs. Astor's closest friends. And they had built that wonderful château just down the street.

That house, Mrs. Astor informed her chamberlain, was absurd. She was sick and tired of hearing about that house. A garish display of wealth, of palace car taste. Leave it to the parvenus to show off like that. It was absurd to have that monstrosity sitting on Fifth Avenue. It simply did not belong there. Surely people should not be able to buy their way into society. That was exactly what she had been fighting, to hold the line. Why, the Vanderbilts were nothing but rich vulgarians.

Alva stormed home that night from the Patriarch Ball. That was it! she complained to her friend Consuelo, Lady Mandeville, who was

spending the winter as the Vanderbilts' houseguest. That did it! This was the final straw! Mrs. Astor would not even say good evening to her. Everyone there had been talking about their invitations to Mrs. Astor's Ball, and again this year the Vanderbilts had not received one. Social acceptance of the Vanderbilts seemed to be receding the closer they approached.

Enough was enough. Maybe the Commodore had been a little rough around the edges. Maybe his talk had contained too many expletives. Maybe he had not always been discreet in his personal life. Maybe he had pinched the pert little bottoms of the maids at the houses he visited. And yes, maybe it was true that he had expectorated tobacco juice onto his hostess's Aubusson rugs. But what about the founder of the Astor fortune, John Jacob Astor? Who was he but the son of a butcher, a German immigrant who had made a fortune killing animals and skinning the stinking carcasses? A fur dealer. An opium trader. Everyone knew that one hostess had reported that he "dined here last night and ate ice cream and peas with a knife,"[76] that at the dinner party given by the United States minister to London, Albert Gallatin, he had wiped his greasy fingers on the white dress of the daughter of the hostess, that one European visitor had watched in horror as he withdrew the chewing tobacco from his mouth and absently ran it over the windowpane as he talked.[77]

Mrs. Vanderbilt and Lady Mandeville put their heads together and decided it was time to act. Alva would hold a little housewarming party in honor of her dear friend Lady Mandeville. This party would be different from Mrs. Astor's boring balls where guests sat and talked quietly of nothing but food, wines, horses, and yachts. "I went to my first society dinner party," a lady confided to her friends after going to Mrs. Astor's, "and I was bored to death. I amused myself by grading the people at the table in terms of dullness from one to ten, with one being the absolute peak of deadliness—and hardly a guest fell below three."[78]

Alva's party would be different. She would throw a fancy dress ball.

Monday nights belonged to Mrs. Astor. Everyone knew that. She had made them her own. Monday nights were Mrs. Astor's nights at the opera. Monday nights were the nights of her Patriarch Balls. It was on Monday nights that Mrs. Astor gave her dinner parties, her receptions, her musicales, her dances. It was on a Monday night that Mrs. Astor

gave her annual ball. So it was of course for a Monday night that Alva scheduled her party.

Alva's house was much bigger than Mrs. Astor's. There was no reason, therefore, to restrict her invitation list to four hundred just because Mrs. Astor's old ballroom could hold only four hundred guests. Early in February, Alva mailed twelve hundred invitations to her fancy dress ball for Monday evening, March 26, 1883, after the completion of the forty days of fasting and penitence of Lent, at the beginning of a new spring. Everyone of importance was invited.

Alva and Lady Mandeville realized that Mrs. Astor's friends would want to show their allegiance to her, but who would be able to resist the opportunity to see the inside of the Vanderbilts' new palace? They would come out of curiosity. And, nothing so much as a title fascinated New York society. Having Lady Mandeville as the honored guest was a sure attraction. Nevertheless, having heard the stories of the heartbreaking balls thrown by the socially ambitious to which no one came, Alva and Consuelo left nothing to chance. Through well-placed leaks to the press, they began a campaign to make the forthcoming ball the most talked-about social event of the season.

"The Vanderbilt ball has agitated New York society more than any social event that has occurred here in many years," reported the *New York Times.* "Since the announcement that it would take place . . . scarcely anything else has been talked about. It has been on every tongue and a fixed idea in every head. It has disturbed the sleep and occupied the waking hours of social butterflies, both male and female, for over six weeks. . . ."[79]

The newspapers caught the excitement and assigned reporters to prepare lists of those who would be going and what costumes they would wear. Those who received invitations began ransacking illustrated books, histories, and novels, and racing through art galleries and museums, to come up with clever ideas for costumes.

One of the city's premier tailors, Lanouette, worked to exhaustion to complete his customers' bizarre requests. He was compelled to refuse many orders "on account of my inability to complete them. I had one hundred forty dressmakers and seamstresses at work night and day for the past five weeks" making over 150 costumes, while "many ladies had their gowns made at home either by their own seamstresses or by dress-

makers hired for the occasion."[80] Amid the rush and excitement of business, the papers reported, "men found their minds haunted by uncontrollable thoughts as to whether they should appear as Robert le Diable, Cardinal Richelieu, Otho the Barbarian, or the Count of Monte Cristo. The ladies were driven to the verge of distraction in the effort to settle the comparative advantages or the relative superiority from an effective point of view of such characters and symbolic representations as the Princess de Croy, Rachel, Mary Stuart, Marie Antoinette, the Four Seasons, Night, Morning, Innocence and the Electric Light."[81] Some reporters speculated that Alva would appear as Cinderella to represent her marriage to the fairy tale prince who had made all this possible.

It soon became quite clear, as the *New York Times* noted, that "everybody who amounts to anything, that is, in the eyes of society, will be present as over 1,000 invitations have been issued and it is not likely that anybody who has been invited will fail to go."[82]

Mrs. Astor, however, still had not received her invitation.

Late one winter's afternoon, Ward McAllister set off to the new château on Fifth Avenue on a most delicate mission.

McAllister admired Alva's new home. He told her how fond he had been of the Commodore, and of all the special dinners he had with him. He told her stories of the first fancy dress ball he had ever attended, given by the Schermerhorns many years before, when all the guests had come in the costume of the period of Louis XV. He pontificated for a while on the importance of planning every detail of her own forthcoming ball, "as a general would a battle," so that the evening would be a success. And then, without a pause in the conversation or a change in his lazy drawl, Ward McAllister began working into the conversation what was on his mind.

His daughter and Mrs. Astor's daughter, young Carrie Astor, and their friends had been practicing for weeks, for weeks! to perfect the star quadrille they would perform at Alva's ball. He had watched them just the other day. Their costumes had been completed and fitted, and refitted. Oh, if Alva could see them! Two of the young ladies would dress in white, two in blue, two in mauve, and two in yellow! The precision of their dance from the hours of practice! The beauty of the girls! It would be spectacular!

Alva sat quietly listening, nodding sympathetically now and then. But inside, she was all but bursting. Her trap had been entered! She felt like running through the period rooms of her home and up the grand staircase, shouting war whoops of triumph as she had as a child in Mobile when she beat her brothers and their friends at some game.

Instead, she hid her hand and played it with the skill of a robber baron.

Alas, what a shame! What a pity! Alva shook her head in sorrow. Oh, what a shame! But obviously neither young Carrie Astor nor her mother had been *invited* to the ball. How could they have been? It was out of the question. The Astors had never paid her a call. Why, she had never even *met* Mrs. Astor. And all that work the poor girls had gone to! It truly was a shame, but there simply was not a thing she could do about it.

She was right, of course. Ward McAllister knew she was right. Those were the rules of society.

As soon as he could leave gracefully, Ward McAllister thanked Mrs. Vanderbilt for a lovely visit and told her how much he was looking forward to the evening of March 26. He then took his hat, walked down the front steps to Fifth Avenue, and hurried down the street to 350 Fifth Avenue.

"Mrs. Astor," it was said, "was always dignified, always reserved, a little aloof. . . . No one ever knew what thoughts passed behind the calm repose of her face."[83] When the news that she had been snubbed by those upstart Vanderbilts was brought to her by her chamberlain, the face of the Queen of Society lost its calm repose.

Mrs. Astor bristled. She was angry. She was furious. She was enraged. Every prejudice she held about the parvenus, every black thought about the Vanderbilts, came boiling to the surface. Who did that little strumpet think she was? What a humiliation! What an embarrassment! Revenge! She would teach Mrs. Vanderbilt a lesson or two!

Somehow, Ward McAllister convinced her that she had been checkmated. The time had come to recognize that the Vanderbilts were a part of New York's high society, if for no other reason than to protect poor little Carrie, Mrs. Astor's last unmarried daughter. The time had come. The time had come. "My dear," Mrs. Astor told one of her friends, "we have no right to exclude those whom the growth of this

great country has brought forward provided they are not vulgar in speech and appearance. The time has come for the Vanderbilts!"[84]

Mrs. Astor called for her carriage and ordered it to proceed up Fifth Avenue to Number 660. There, one of her footmen dressed in blue livery, a copy of the uniform at Windsor Castle in England, got out of the carriage and walked up the steps to the entrance. The great door slid open. Mrs. Astor's footman presented a calling card to the maroon-liveried Vanderbilt footman who had opened the door. Engraved on it were two words: MRS. ASTOR.

A calling card with two words. Yet those two words opened up a new world for Alva Vanderbilt and the Vanderbilt family. They had finally crashed through the gates of society. Mrs. Astor had come calling.

The next morning, Alva ordered her carriage to take her to 350 Fifth Avenue. There, one of her maroon-liveried footmen walked up to the entrance of Mrs. Astor's brownstone and delivered the last of the invitations to her fancy dress ball to the blue-liveried footman at the door.

Between then and the evening of March 26, if Mrs. Astor had reservations about what she had done, Ward McAllister kept reminding her of one of his cardinal rules of conduct: "A dinner invitation once accepted is a sacred obligation. If you die before the dinner takes place, your executor must attend."

4.

Monday, March 26, 1883. A stranger to the city would have noticed that something extraordinary was afoot. Reporters saw "carriages flying about with unusual go, and there was much slamming of front doors as hair-dressers, milliners, costumers and other tradespeople were admitted or let out."[85] All day long, wagonload after wagonload of palms and plants purchased from conservatories all over New York City pulled up to the Fifty-second Street entrance of the Vanderbilt mansion, until it seemed as if the house were being converted into a tropical jungle.

By seven o'clock that evening, reporters assigned to cover the ball spotted "gentlemen returning from the hair dressers with profusely

powdered heads alighting from coupes along Fifth Avenue, and hurrying up the steps of their residences to complete their toilets."[86]

Those who had taken up vigil outside the brownstone at 742 Fifth Avenue saw the workaholic Cornelius Vanderbilt II come home early from the offices of the New York Central in Grand Central Depot. A costumer and hairdresser awaited his arrival. If the sightseers could detect any trace of happiness in his stern visage as he entered his home, it was probably less because of the anticipated pleasure of an evening at his brother's fancy dress ball than it was because shares of New York Central stock closed that day at the satisfyingly high price of 126¾, with an annual dividend of 8 percent.

That evening, Ward McAllister was in his glory. Determined to be costumed in a way that would "live ever after in history," weeks before he had gone "to a fair dowager" to ask her advice as to the best tailor to prepare his costume. "Mapleson is your man," she had told him. "Put yourself in his hands."

Mapleson's female assistant looked McAllister over.

"Why, man alive!" she said. "Don't you see he is a Huguenot all over, an admirer of our sex. Put him in the guise of some woman's lover."

"By Jove," Mapleson said, "you are right, my fair songster! I'll make him the lover of Marguerite de Valois, who was guillotined at thirty-six because he loved 'not wisely, but too well.' Pray, what is your age?"

"Young enough, my dear sir, to suit your purpose. Go ahead, and make of me what you will," McAllister replied.

"Have you a good pair of legs?"

"Aye, that I have! But at times they are a little groggy. Covering they must have."

"Ah, my boy, we will fix you. Buckskin will do your business. With tights of white chamois and silk hose, you can defy cold."

That evening as McAllister dressed for the ball, one of his friends entered his room and saw "two sturdy fellows on either side of me holding up a pair of leather trunks, I on a step-ladder, one mass of powder descending into them, an operation consuming an hour."

"Why my good sir," McAllister's friend remarked, "your pride should be in your legs, not your head!"

"At present," McAllister replied, "it certainly is."[87]

* * *

Early in the evening, a crowd of millionaire-watchers began to gather on Fifth Avenue by Fifty-second Street. The spectators staked out space at the corner or on the steps of houses across the street, each selecting a spot that would offer the best vantage point to spy on the guests arriving at the ball.

The evening was almost mild. It had been one of those winter days that threatened to snow but ended warm, almost springlike, with a hint of showers on the northeast breeze.

The light pouring from every window of the four stories of the Vanderbilt mansion brilliantly illuminated the white limestone château against the darkness. The gathering crowd stared at the magnificent flight of stairs to the main entrance on Fifth Avenue, where workmen were busy erecting a double canopy. Above the doorway was a deep, recessed balcony, and to the left of the entrance rose that wonderful slender turret, carved with fleurs-de-lis, capped by a conical top and finial. Perched on the blue slate roof, watching the scene below, was an almost lifesize statue of a seated stonemason in apron and cap, holding a chisel and mallet. That's a statue of Richard Hunt, the architect of the mansion, someone in the crowd remarked.

What's going on behind those enormous windows? the onlookers wondered. What is life like within? Which room is Mrs. Vanderbilt's? What's in the tower? What does it cost to run a house like that? How many people does it take to clean it? What does it cost to heat it? How many people do you think are coming to the ball? Do they all have to wear costumes?

Perhaps some who stood in the crowd outside 660 Fifth Avenue that evening were neighbors who lived within a mile or two of the mansion in what was another city, a city of poverty-stricken immigrants living in run-down tenements in the slums on the West Side and the Lower East Side, properties owned by the Astor, Rutherfurd, and Schermerhorn families. Below Fourteenth Street was what one writer called "a wretched quarter, which extends westward to Broadway and almost indefinitely in other directions. . . . Drunken men, depraved women and swarms of half-clad children fill the neighborhood, and even the 'improved tenement houses,' as viewed from the outside, seem but sorry abodes for human beings."[88] Privies filled the empty lots around them.

A reporter for the *New York Tribune* described the life of these poor in 1879: "The bedrooms were small and dark with windows 13 by 15 inches in size for ventilation. These opened on stifling hallways and admitted an atmosphere almost as bad as that within. . . . A sick child lay in a rear room gasping for breath while its mother stirred up a fire, the heat of which made the atmosphere terrible. . . . The yard was unclean as were the closets which gave forth terrible stenches. . . . The apartments could not be fouler. The walls were cracked and blackened and there was a squalor visible that was revolting."[89]

If these Irish, German, Italian, and Jewish neighbors from the tenements stood outside the Vanderbilt mansion that evening, it is likely that they saw their dreams come to fruition in the vision before them. It is even likely that they believed that if they were diligent and worked hard enough a similar mansion could be theirs, for the deepening social inequalities of the day had yet to be clearly recognized. If all this could arise from a young man plying a ferryboat back and forth across the harbor from Staten Island to the Battery, what future palaces might result from their own menial labor? The white limestone castle before them sparkling in the night held the infinite promise that they, too, could go from rags to riches.

Suddenly, the front doors slid open to either side, slipping into recesses. Out came a group of footmen dressed in maroon knee breeches, buckled shoes, and powdered wigs, unrolling a maroon carpet from the door of the mansion across the sidewalk right down to Fifth Avenue. The crowd gasped. Paying no heed to the hundreds of people watching them, the footmen straightened and smoothed the carpet, pushing out every wrinkle, then went back into the mansion and slid shut the front doors.

The crowds milled about the street, some peering under the double canopies, others feeling the rich thickness of the red carpet. At nine o'clock, a squad of police officers had arrived to hold back the curious. An express wagon rattled over the cobblestones of Fifth Avenue to deliver eight horse costumes to the mansion; the police directed them to the service entrance.

By 10:30, reporters noted carriages slowly driving by, their occupants "peering surreptitiously under the curtain to see if others were arriving."[90] No one wanted to make the mistake of being first.

A half hour later, elegant carriages and hired cabs with liveried

coachmen and footmen were stopping in front of 660 Fifth Avenue. Through the carriage windows, the eager lookers-on in the street were able to catch glimpses of "flashing swordhilts, gay costumes, beautiful flowers, and excited faces."[91] The maids and valets of the partygoers helping their mistresses alight from the carriages were told by the Vanderbilt ushers that they were not allowed to enter the mansion, which caused some grumbling among the arriving guests. But these were Mrs. Vanderbilt's rules tonight, and the ushers insisted that these orders were "imperative."[92]

By 11:15, the police were no longer able to control the flow of the hundreds of carriages arriving in front of the mansion. Too eager to wait, some guests left their carriages in adjacent streets and walked through the crowds to the canopied entrance of the Vanderbilt home. "Pretty and excited girls," their costumes covered by shawls, and "young men who made desperate efforts to appear blasé"[93] left their carriages with orders to return at four o'clock that morning. The crowds "caught a glimpse of bright color, or the flash of diamonds, or heard the clank of a sword striking the stone steps,"[94] as the guests walked the red carpet, up the ten steps, into 660 Fifth Avenue.

Passing through the front doors, they entered another age, another world, a fantasy, a dream. It was too much to absorb at once. The massiveness of the interior, the intricacy of workmanship, the lavishness and richness of materials, took their breath away.

Handsome maroon-liveried footmen with white silk stockings and gilt buckles on their shoes, and pretty maids dressed in French peasant costumes ushered them on a course designed to take them through many of the rooms of the house.

Ahead of them, like a Gothic cathedral with its arches and vaulted ceiling, was the main hall, sixty feet long, twenty feet wide, brightly lit with a series of crystal chandeliers that sparkled on the floor of polished luminous marble. The first seven feet of the walls was carved Caen stone, which had taken foreign artisans two years to complete,[95] above which hung magnificent Italian tapestries. The ceiling, sixteen feet above them, was of elaborately beamed and paneled oak. And everywhere were roses. The famous French émigré florist Charles Klunder, with his small army of assistants, had been scurrying about the house since Saturday, filling every room with vases and gilded baskets of large dark-crimson

Jacqueminot roses and deep pink Gloire de Paris and pale pink Baronne de Rothschild.

Halfway down the hall on the left, great logs blazed in an enormous stone fireplace. Across from it, the grand stairway of intricately carved limestone rose slowly to the second floor, a stairway that had been called "not only the finest piece of work of its kind in this country, but one of the finest in the world."[96] The "endless upward sweep" of this "long and terrifying" staircase frightened the Vanderbilts' six-year-old daughter, Consuelo, as she climbed to her room every night, "leaving below the light and its comforting rays. For in that penumbra there were spirits lurking to destroy me, hands stretched out to touch me and sighs that breathed against my cheek. Sometimes I stumbled, and then all went black, and tensely kneeling on those steps, I prayed for courage to reach the safety of my room."[97] Tonight, the enormous house was cheery and warm, teeming with the laughter of hundreds of guests, and the spirits were nowhere to be seen as the costumed ladies and gentlemen climbed in safety to the second floor.

There the ladies left their wraps in Mrs. Vanderbilt's boudoir and admired Boucher's erotic *The Toilet of Venus,* painted for Mme. de Pompadour in 1751, as well as the enormous bathroom with marble wainscoting, marble fixtures, mirrored walls, and a bathtub carved for $50,000 from a solid block of flawless Italian marble. The procession then continued up to the third floor of the mansion. At the head of the stairway, grouped around monumental columns on each side of the hall, were tall palms whose trunks were surrounded by masses of ferns and ornamental grasses, with strings of multicolored Japanese lanterns suspended above the columns.

Following the sound of the orchestra's music, the guests entered what looked like a vast tropical forest. Here, in the mansion's gymnasium, a room so enormous that the Vanderbilt children used it "to bicycle and roller skate with our cousins and friends,"[98] the florist Klunder had created his masterpiece. The walls of the gymnasium were completely hidden by an impenetrable thicket of fern above fern and palm above palm; from the branches of the palms hung a profusion of orchids, displaying a rich variety of color and an almost endless variation of fantastic forms. In the middle of the room was a giant palm surrounded by small dinner tables covered with damask cloth, gold service,

and crystal. Fragrant flowering vines trailed from the ceiling, all but covering it. Each door was a solid mass of roses and lillies of the valley. And in the corners of the room bubbled beautiful fountains.

"I have decorated the houses of princes and ambassadors," commented the usually supercilious but now obviously awestruck Charles Klunder, "but never have I seen floral embellishments on a scale of such regal grandeur. Mr. Vanderbilt gave me *carte blanche.*"99

Here in this tropical forest, the one hundred special guests who would dance in the six quadrilles had gathered. The previous Saturday, the six ladies in charge of the quadrilles had drawn lots to determine the order in which these formal French square dances would be performed. Now, to the music of John Lander's twenty-five-piece orchestra, which was hidden by a canopy of roses, the ladies and gentlemen who would dance the hobbyhorse quadrille formed a line and, followed by those who would dance in the other quadrilles and then by the other guests, began to move in a glittering processional down the grand stairway and through the hall. None complained of their circuitous journey through the house, for the secret goal of each guest was to see everything, without appearing to be staring and without giving any indication that the splendor that surrounded them was any different from that of their own homes.

Down the Caen stone staircase swirled a crowd of princes, monks, cavaliers, Highlanders, queens, kings, dairy maids, bullfighters, knights, brigands, and nobles.

Again on the first floor, the guests filed into the Francis I parlor at the front of the mansion, which was wainscoted in carved French walnut and hung in dark red plush, and then proceeded into the white and gold Louis XV music salon paneled with gilded wainscoting wrested from an old French château. Few noticed the three priceless Gobelin tapestries illuminated by glowing candelabra, the black and gold lacquer secretaire and commode that rivaled those in the Louvre's collection, or the circular ceiling painting that represented the marriage of Cupid and Psyche, for there in regal splendor, standing directly beneath her portrait, just as Mrs. Astor received the Four Hundred beneath her lifesize portrait, was Mrs. William Kissam Vanderbilt, greeting her guests as the butler called out their names.

Thirty-year-old Alva looked very young and she looked very rich. She was dressed as a Venetian Renaissance princess, her costume pre-

pared by a Parisian couturier, copied from a painting by Alexandre Cabanel, noted for his *Birth of Venus.* Her gown was of white and yellow brocade, shading from the deepest orange to the lightest canary, with figures of flowers and leaves outlined in gold stitching and white iridescent beads, and with sleeves of transparent gold tissue. The train was light blue satin embroidered in gold and lined with Roman red. The gown was cut low, and looped around her neck, dropping to her waist, were strand after strand of pearls, the pearls Willie had given her that once had belonged to Catherine the Great of Russia and Empress Eugénie of France. On her head was a Milan bonnet covered with gems that outlined a peacock, a splendid complement to the long brown curls flowing to her shoulders.

Receiving the guests with Mrs. Vanderbilt was Lady Mandeville, seated near the doorway of the salon.

I'd like you to meet Viscountess Mandeville. This is Lady Mandeville. Lady Man-de-ville. The name certainly had a royal ring to it, as Alva introduced her best friend to each of her guests. Lady Mandeville's costume, the papers noted, provided a "most fortunate contrast with the toilet of Mrs. Vanderbilt."[100] Lady Mandeville wore a black gown copied from a painting by Vandyke of the princess Marie-Claire de Croy: black velvet ornamented with heavy jet embroidery, large puffed sleeves, and a stand-up collar of Venetian lace. Her blond hair was crowned by a black Vandyke hat set with jewels.

Nearby stood obedient Willie, dressed as the duc de Guise after a painting in his father's art gallery. The duc de Guise, Willie explained to his guests, had been stabbed to death in the chambers of Henry III in the Château de Blois in France, and his spirit still haunted that French château after which the Vanderbilt's town house had been fashioned. If Willie was a little self-conscious in his yellow silk tights, yellow and black trunks, yellow doublet, black velvet cloak embroidered in gold, black velvet shoes with silver buckles, and white wig, he dared give no sign of embarrassment, at least not in Alva's presence.

One by one, the thousand guests stepped forward to greet their hostess. Alva was amazed "at the perfection and fidelity of the fancy dress in which each guest appeared."[101] There was Joan of Arc with helmet and gauntlet of solid silver mail, a barefoot monk with hood and sandals, a Spanish muleteer, "Mary, Mary, quite contrary" wearing a

yellow satin skirt trimmed with silver bells and cockleshells, Bluebeard, the young duc de Morny in court dress of plum velvet embroidered with rubies and with buttons of diamond, Mme. le Diable in a red satin gown with a black velvet demon embroidered on it, the entire gown trimmed with a fringe ornamented with the heads and horns of demons, and the Daughter of the Forest, wearing a green velvet dress trimmed with real ferns, ivy, wild roses, and shells, with ferns and butterflies in her hair and a necklace of jeweled lizards.

Onward they came to greet Mrs. Vanderbilt: King Lear, a Persian princess, a Dutch maiden, an Arab sheik, the goddess Diana, Egyptian princesses, a Hungarian Hussar, courtiers of Louis XV and XVI, Christopher Columbus, a Gypsy queen, the Evening Star.

Everyone was there: Mr. and Mrs. Hamilton Fish, Mr. and Mrs. August Belmont, Mr. and Mrs. D. Ogden Mills, Mr. and Mrs. J. R. Roosevelt, Mr. and Mrs. Stuyvesant Fish, Mr. and Mrs. Robert Goelet. All of society, all of the Four Hundred, had come to Alva's party.

Here was Miss Amy La Farge dressed as the Huntress, wearing a tiger skin lined with red satin, clutching a bow, a quiver of arrows hanging on her back and on her hair a crescent of diamonds.

And there was Senator Wagstaff as Daniel Boone, in a suit of leather, with leggings, moccasins, and a coonskin cap with protruding porcupine quills, a bowie knife stuck in his belt.

As Ward McAllister, costumed as the Huguenot comte de La Môle, lover of Marguerite de Valois, embraced Alva, Alva thought that his arrival was a good omen. With the Autocrat of the Drawing-Rooms in attendance, surely Mrs. Astor could not be far behind.

"Mrs. Pierre Lorillard!" the butler announced.

A phoenix! Dressed in a Worth gown of gray silk bordered by an irregular band of crimson cashmere on which leaping flames were embroidered, bedecked in diamonds and rubies, Mrs. Lorillard, the wife of the tobacco and snuff manufacturer who had made his fortune "by giving them that to chew which they could not swallow,"[102] walked up to greet Alva, scattering tinsel sparks and ashes represented by bits of fluffy gray down.

"Mr. and Mrs. Cornelius Vanderbilt the Second!"

There was Cornelius dressed in fawn-colored brocade trimmed with lace of real silver, with a jabot and ruffles, and bearing a diamond-hilted

sword: King Louis XVI of France, a fitting costume on this Gallic evening for the man who considered himself the heir apparent as head of the Vanderbilt family. If the Commodore could have seen his grand-sons now! Cornelius's wife, Alice, the former Sabbath morning instruc-tress of the children of St. Bartholomew's Parish, came as that new invention the Electric Light torch, dressed in white satin lavishly trimmed with diamonds and with her head, Ward McAllister noted, "one blaze of diamonds."[103] With the couple were their three children, one dressed as a rose, one as Sinbad the Sailor, and the third as a little courtier.

"Miss Ada Smith!" One of Alva's sisters stepped forward, wearing a peacock costume of blue satin, the front of her dress, her cap, and train covered with peacock feathers.

And here were several of Willie's sisters: Mrs. Seward Webb as a hornet, wearing a waist of yellow satin, a brown velvet skirt, and brown gauze wings, with antennae of diamonds; Mrs. W. D. Sloane as Bo-Peep, with jeweled poppies; Mrs. Hamilton McKown Twombly in a pale blue brocade gown embroidered with pink roses, with leaves of gold and silver, and quilted with diamonds.

"Mrs. Arthur N. Welman!"

Even Alva gasped when she looked up at this well-known young society lady dressed as a cat. Her skirt was made entirely of genuine white cats' tails sewn on a dark background, with the bodice composed of rows of genuine white cats' heads. Her cap was a stiffened white cat's skin, with the cat's head hanging down over her forehead and the tail hanging behind. In case anyone didn't understand, a blue ribbon with PUSS inscribed on it, from which hung a bell, graced the young lady's neck.

"Mr. and Mrs. William H. Vanderbilt!"

Alva's mother-in-law was dressed as a lady-in-waiting to Marie An-toinette. Ordinary evening dress was absolutely prohibited, Alva had made clear to everyone invited, but William H. Vanderbilt, the head of the House of Vanderbilt, Willie's father, Alva's father-in-law, the richest man in the world, surely could wear whatever he chose, and he chose to wear his usual formal black evening clothes, as did his compan-ion. That was all right, too. Alva would make another exception to her rules for the evening, for his companion had been the great commander of the Union armies during the Civil War and the eighteenth president

of the United States, sixty-year-old Ulysses S. Grant. A man who had seen it all, Grant was nevertheless fascinated by this party. Always in financial straits, he had just joined his son's new brokerage firm, Grant and Ward, to make some money. Tonight, the hardbitten old soldier had stepped into the world of his dreams.

It was nice that the general could come, but *Ulysses S. Grant* wasn't the name Alva had been listening for all evening.

The procession of guests continued on and on: wizards, Jack and Jill, Prince Charming, Little Red Riding Hood, Russian peasants, an Indian chief, Henry IV of France, a toreador, a picador, a flower girl, Queen Elizabeth, a fairy queen, Music, Ice, every imaginable costume decorated with diamonds and rubies, precious stones, pearls, gold and silver thread, exotic feathers.

"Mrs. Astor!" the butler called out after almost all the other guests had arrived and passed through the receiving line.

Ah, *here* she is.

And there she was, like Alva, dressed as a Venetian princess, in a gown of dark velvet, embroidered with gold roses and other designs in pearls, the inside of her long flowing sleeves embroidered with more jewels. And as she entered the lair of the woman who wanted her crown, she was armed to the teeth with chains of diamonds that circled her neck and fell over her bosom, diamonds that hung from her ears, diamonds that circled her wrists and fingers, her famous Marie Antoinette diamond stomacher at her breast, her black hair crowned with a diamond tiara set with diamond stars. Some said she was wearing every jewel she owned that evening. "Borne down by a terrible weight of precious stones,"[104] as one reporter described her, Mrs. Astor bade good evening to Mrs. Vanderbilt.

After being received by Mrs. Vanderbilt and Lady Mandeville, the guests were led into the Henry II dining hall at the back of the mansion, a mammoth room, fifty feet long and thirty-five feet wide, whose walls, wainscoted with quartered oak and carved Caen stone and covered with tapestries, rose two stories. At one end of this grand dining hall, which had been turned into a ballroom for the night, was a music gallery suspended eighteen feet above the floor. From behind the wall of roses and ferns that hid the musicians, the Vanderbilts' two children, six-year-old Consuelo and five-year-old Willie, "crouching on hands and knees

behind the balustrade of the musicians gallery, looked down on a festive scene below."[105] The silvery splendor of the calcium lights that illuminated the room shone on the great stained-glass windows depicting the meeting of Francis I and Henry VIII at the Field of the Cloth of Gold. One guest remarked that these windows "gave exactly the effect of another fancy dress ball going on in another room."[106] But that scene of ancient grandeur paled in comparison with the shifting gleams of colorful costumes moving that evening through the rooms of the Vanderbilt mansion.

At exactly 11:30, the hobbyhorse quadrille began.

From behind the canopy of roses that covered the music gallery blared the circus music of P. G. Gilmore's military band—violins, violas, violoncellos, double basses, horns, trombones, and kettledrums—as lady riders, dressed in scarlet coats and white satin vests and breeches, with patent-leather boots and gold spurs and flared riding caps, rode around the dining hall astride their hobbyhorses. The hobbyhorses were actually their gentlemen partners, wearing the horse costumes delivered that evening, which had taken workmen two months to complete. Over their heads and attached around their waists were lifesize heads of horses, covered with horsehides, with large bright eyes and flowing manes and tails. The costumes, though large, were very light. The gentlemen's feet and hands, as they bent over to be ridden, were concealed by richly embroidered hangings with horse legs represented on the outside of the blankets. The appearance of these lifelike hobbyhorses "was the cause of much amusement," one guest remembered.[107] Spurred on by the laughter of the crowds, the hobbyhorse quadrille became more and more lively with two riders tossed off their mounts. The ice was broken. The party had begun.

Mrs. C. L. Perkins, Jr., wearing a high hat and carrying a large goose, then led the Mother Goose quadrille, which Ward McAllister had made a standard dance at all Patriarch costume balls. As one guest noted, "All the friends of our childhood"—Jack and Jill, Little Red Riding Hood, Bo-Peep, Goody Two Shoes, Little Miss Muffet, the Pieman, Ping Wing the Pieman's Son, Squires, the Wizard, and My Pretty Maid—"were gotten up with conscientious exactitude."[108]

For the Dresden china quadrille, four couples had dressed all in white court costume of the period of Frederick the Great. The ladies

wore gowns of ivory-white satin, their hair piled high on the backs of their heads, powdered and decked with white ostrich plumes. The gentlemen were in immaculate white waistcoats, knee breeches, hose, buckle-slippers, and powdered wigs, with white narcissus in their buttonholes. Each had the Dresden factory mark of crossed swords on the breast. "It was the whitest, purest thing possible amid all this saturnalia of colors," commented one partygoer, "and was danced with reserve, like a quadrille at court, in the presence of royalty. . . ."[109]

Alva watched with special interest the star quadrille, which had made possible her conquest. Pairing up with their partners wearing Henry III costumes of dark velvet, powdered wigs, knee breeches, and buckled shoes, with swords at their sides, were Miss Astor and Miss Beckwith in white, Miss Hoffmann and Miss Marie in yellow, Miss Warren and Miss McAllister in blue, and Mrs. Bryce and Miss Carroll in mauve. Each carried a wand tipped with stars, and above the forehead of each, nestled in her hair, was a tiny electric light. Alva smiled slightly and nodded to Mrs. Astor and Ward McAllister as Lander's orchestra began to play "Disputation" and the girls and their partners began the dance. Ward McAllister, naturally enough, declared to one and all the star quadrille to be "the most brilliant" since it contained "the youth and beauty of the city,"[110] including the daughter of his Mystic Rose and his own rather homely daughter.

Relieved when the presentation of the formal quadrilles was finally over, the guests began dancing themselves, led off by Mrs. Cornelius Vanderbilt in the "Go-as-you-please" quadrille.

It was the other side of midnight, but the partygoers were not sleepy. Like some modern-day Merlin, Alva had cast her spell and her guests had fallen under it, swept on waves of chatter and laughter into a kaleidoscope of characters from history and literature, through a swirling mass of colors and costumes to another age, far beyond March 26, 1883, at 660 Fifth Avenue. To be dancing that night through the dining hall–ballroom, into the period rooms, up the grand staircase and around the tropical rain-forest gymnasium was to be possessed by Alva's magic, to forget everything but that moment, which would never be forgotten.

The guests danced the "Ticklish Water Polka" and returned to the gymnasium in the early hours of the morning for an eight-course dinner prepared by all of the Vanderbilt family's chefs and the famed Del-

monico's pastry cooks, sipping the finest champagnes, wines, and then Madeiras.

"Every smiling face," one guest noted, testified to the "general hilarity and enjoyment of the evening."[111]

Ward McAllister, looking dashing in his costume of royal-purple velvet slashed with scarlet, and a rakish hat with a plume, reminded the Schermerhorns about an incident at their fancy dress ball some years before. "The men in tights and silk stockings, for the first time in their lives, became jealous of each other's calves," he chuckled, "and in one instance, a friend of mine, on gazing at the superb development in this line of a guest, doubted nature's having bestowed such generous gifts on him; so"—he paused dramatically, with a mischievous twinkle in his eye—"to satisfy himself, he pricked his neighbor's calf with his sword, actually drawing blood!" McAllister had caught the attention of others around him. "But the possessor of the fine limbs never winced; later on he expressed forcibly his opinion of the assault. By not wincing, the impression that he had aided nature was confirmed."[112]

"The beauty of the women was perhaps not enhanced by their costumes," one guest observed, "for American women are always beautiful. But the beauty of the men was very much improved by the glory of costume. It shows how much men lose in the ugly dress of the nineteenth century."[113]

If the men were handsome in their elaborate costumes, at least some were uncomfortable. Their clothes inspired a joke that made the rounds of the male guests. "I'm Appius Claudius," one of the guests reported to another. "Oh, are you?" came the reply. "I'm uncomfortable as Richard the Lion-Hearted."[114]

At one point during the night, Mrs. Vanderbilt and Mrs. Astor were seen deep in what appeared to be a friendly conversation. How beautiful young Carrie looked in the star quadrille! What a charming house. Who was your architect? Some guests must have been reminded of Ward McAllister's precept that "the highest cultivation in social manners enables a person to conceal from the world his real feelings. He can go through any annoyance as if it were a pleasure; go to a rival's house as if to a dear friend's; 'Smile and smile, yet murder while he smiles.' "[115]

Whatever Mrs. Astor's innermost thoughts, the guests had no doubt that they were at the greatest social event of their lives. The

investment banker Henry Clews, who came to the ball dressed as Louis XV in chocolate and gray satin, believed that the party had "no equal in history. It may not have been quite so expensive as the feast of Alexander the Great at Babylon, some of the entertainments of Cleopatra to Augustus and Mark Antony, or a few of the magnificent banquets of Louis XIV, but when viewed from every essential standpoint, and taking into account our advanced civilization, I have no hesitation in saying that the Vanderbilt ball was superior to any of those grand historic displays of festivity and amusement."[116]

A few of the older guests left after two o'clock that morning, but by six o'clock the party was still going strong. As Tuesday's sky paled above the city, Alva led a Virginia reel, her sign that the fancy dress ball had officially ended. The ball had lasted "long after sunrise, to the surprise and keen interest of passers-by who stopped in amazement on their way to work to watch my departing friends."[117]

One French courtier dressed in ruffles and powdered wig, who decided to walk home to clear his head, was hooted and chased up Madison Avenue by a group of boys on their way to school.

When Alva awoke some hours later, her maid brought into her bedroom overlooking Fifth Avenue all of Tuesday's newspapers. Propped in bed, she savored them, one by one.

The lead article on the front page of the *New York Times* set the tone: ALL SOCIETY IN COSTUME, the headline read. "Mrs. W. K. Vanderbilt's Great Fancy Dress Ball." And in column after column, the article described in lavish detail the interior of the mansion, the decorations, the costumes of society's leaders, and of course "Mrs. Vanderbilt's irreproachable taste"—Alva paused to read this phrase over several times—"Mrs. Vanderbilt's irreproachable taste was seen to perfection in her costume. . . ."[118]

MRS. VANDERBILT'S BALL: AN EVENT NEVER EQUALLED IN THE SOCIAL ANNALS OF THE METROPOLIS, blared the headline of the *New York World.* "The fancy ball given last night by Mr. and Mrs. W. K. Vanderbilt, in the new and noble house built by Mr. Richard M. Hunt, was unquestionably the most brilliant and picturesque entertainment ever given in New York."[119]

The *New York Sun* was in complete agreement. "Mrs. William K. Vanderbilt's fancy ball, which has caused such a stir and din of prepara-

tion in fashionable circles for a month and more, was gorgeously accomplished last night. . . . In lavishness of expenditure and brilliancy of dress, it far outdid any ball ever before given in this city."[120]

LIKE AN ORIENTAL DREAM, proclaimed the headline of the *New York Herald.* "Ghosts of every century, fairies, goblins and gnomes, re-embodiments of historical personages of all climes and times stole out from the pages of their annals last night for a revel in the nineteenth century at the bidding of Mrs. W. K. Vanderbilt, [and] made up a scene probably never rivaled in Republican America and never outdone by the gayest court of Europe."[121]

See, the party certainly *had* been worth the $250,000 it cost,[122] Alva told Willie, as squads of servants marched from room to room, throwing away $11,000 worth of fading roses, pulling the tangled vines down from the ceiling of the gymnasium, washing and drying and putting away the thousands of crystal glasses and gold plates and solid silver knives and forks and spoons, sweeping up the bits of gray fluff and tinsel that Mrs. Lorillard, the Phoenix, had scattered about the house.

Alva breathed a rare sigh of exhaustion: "I know of no profession, art or trade, that women are working at today," she declared, "as taxing on mental resources as being a leader of society."[123]

4

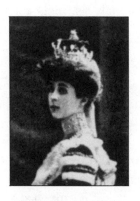

CONSUELO

1 8 8 3 – 1 8 9 5

1.

Alva's fancy dress ball changed everything.

Five weeks later, William H. Vanderbilt, either believing that his children were going to need a lot more money to maintain their new position in society, or wondering why at the age of sixty-two he was still working so hard when his children were living the good life, resigned as head of all his railroads and appointed his thirty-four-year-old son Willie, Alva's husband, chairman of the Lake Shore and Michigan Southern Railroad, and president of the Nickel

Plate road. He also named his oldest son, forty-year-old Cornelius, chairman of the New York Central Railroad and Michigan Central Railroad. "I am out of active business now." He smiled as he talked with reporters. "My interests are in the hands of trusty managers, so I give myself no concern about them. I think that I have done my share of work, and so now I am taking a vacation, and really I do not try to keep posted on what is going on."[1] After a lifetime of indoctrination by his penny-pinching father, the Commodore, William was learning from his children that it was even more fun spending money than it was saving it.

Before the ball, the Vanderbilt family "was unheard of in New York society, except occasionally when it was abused for watering stock or damning the public."[2] The old families looked at the Vanderbilts with disapproval. "The Huntingtons do not go to the Vanderbilts'," one debutante remembered her mother telling her. And Herman Rogers, the son of a Knickerbocker family, recalled as a boy that his parents had told him he could play with the Roosevelts, but to be wary of the Vanderbilts. "You may be nice to them," his mother told him, "but don't get involved."[3]

But after the ball, no social function in New York was complete without Alva and Willie, or at least some member of the Vanderbilt family. One contemporary now commented that the Vanderbilts "exhibit a high degree of refinement, showing how fast human evolution under favorable circumstances progresses in this country. . . . In this country, three generations in this instance have produced some of the best examples of nature's nobility."[4] The Vanderbilts had unquestionably secured a permanent place for themselves among the Four Hundred. Alva and Willie were, of course, invited to Mrs. Astor's next ball. In no time, Mrs. Astor and Mrs. Vanderbilt became the best of friends. And a newspaper cartoonist even created a socialite named Mrs. Astorbilt, who embodied the characteristics of Mrs. Astor and Alva Vanderbilt.

After such a spectacular social triumph, Alva became even more firmly convinced that she could accomplish just about anything to which she set her mind. She was more assertive, more obstinate, more domineering than ever, making it obvious who ruled the château at 660 Fifth Avenue.

* * *

Alva and Willie Vanderbilt's three children—Consuelo, born in 1877; Willie K., as everyone called him, born in 1878; and Harold, born a year after the ball in 1884—grew up in a very special world. They were the first generation of the Vanderbilt family to experience unlimited wealth from the day they were born.

The heirs knew no other home than the palace on Fifth Avenue, a home whose size terrified them after dusk. In it, a child could easily get lost, bumping into a terrifying carved stone gargoyle along an echoing corridor that never seemed to end. The vast spaces of the mansion hid "spirits lurking to destroy me," young Consuelo later remembered, "hands stretched out to touch me and sighs that breathed against my cheek."[5] But in the daytime, the house was a veritable playground, with its massive gymnasium on the third floor "where we used to bicycle and roller skate with our cousins and friends" and where each December "a Christmas tree . . . towered to the roof and was laden with gifts and toys for us and for every one of our cousins."[6]

There were "joyous sleigh drives" in the city after heavy snowfalls, Consuelo recalled, "the horses with their bells, the fat coachmen wrapped in furs, and Willie and myself in the back seat with our small sleigh on which we were allowed to toboggan down slopes in the Park."[7] And matinees at the Metropolitan Opera House. And Sundays after church when the children could spend "delirious hours marching armies of tin soldiers across the carpet that represented land, or sailing them over the seas of parqueted floors to fight furious battles for the possession of the forts we built out of blocks."[8]

The three children loved to spy on their parents' parties, those "gala evenings when the house was ablaze with lights" when, from behind potted plants, they could peep "down on a festive scene below—the long dinner table covered with a damask cloth, a gold service and red roses, the lovely crystal and china, the grownups in their fine clothes."[9]

Life on Fifth Avenue could be formal and stilted, and the children luxuriated in the freedom of the summer and early autumn months at Idlehour on the south shore of Long Island, where they crabbed, fished, and learned to sail. "During the hot summer days," Alva remembered, "we spent much of our time on a little side wheel yacht, delightfully comfortable. We would start in the morning with the children and friends and go over to Fire Island . . . where we would have our luncheon,

returning in the cool of the evening."[10] The children set up a playhouse at Idlehour and there, "utterly happy, we would cook our meal, wash the dishes and then stroll home by the river."[11] At the playhouse, Consuelo made preserves and cooked, while Willie K. served as carpenter and waiter. "I and my friends often went there for afternoon tea," Alva remembered. "It was prepared and served by the children and was most excellent."[12] The children also raised vegetables and grew flowers, which Alva bought from them. "My happiest memory," Consuelo reflected, "is of a farm in the surrounding country where we went for picnics and played at Indians and white men, those wild games inspired by the tales of Fenimore Cooper. Wriggling through thorns, scrambling over rocks, wading through streams, we were completely happy—though what sights we looked in torn clothes with scratched faces and knees as we drove home to the marbled halls and Renaissance castles our parents had built."[13]

Even though their games took place around "marbled halls and Renaissance castles," Consuelo, Willie K., and Harold did not perceive that their lives were different from other childrens'; but every once in a while, there were times when Consuelo pondered "with some discomfort on the affluence that surrounded me, wondering whether I was entitled to so many of the good things of life." One day young Consuelo greeted one of the gardeners mowing the endless lawns at Idlehour, and noticed how sad he seemed.

"Is anything the matter?" Consuelo inquired.

He told her that his little girl, who was ten, just like Consuelo, was crippled and would be bedridden for the rest of her life. "The sudden shock of so terrible a lot overwhelmed me; and when the next day I drove with my governess to see her, the pony cart filled with gifts, and found her in a miserable little room on a small unlovely cot, I realized the inequalities of human destinies with a vividness that never left me."[14]

When their father, affable, happy-go-lucky Willie, was with them, everything was fun for the Vanderbilt children. "He was so invariably kind, so gentle and sweet to me," Consuelo recalled, "with a fund of humorous tales and jokes that as a child were my joy."[15] But their father was often not at home; "alas, he played only a small part in our lives; it seemed to us he was always shunted or sidetracked from our occupations."[16] "Sidetracked" was an understatement, for managing the fam-

ily's railroad properties with his brother Cornelius, acquiring more rail-roads, and consolidating and streamlining them into the Vanderbilt network occupied much of his time and energy.

With Willie consumed by his work, it was the children's mother "who dominated our upbringing, our education, our recreation, and our thoughts."[17] There was no point in involving their father in their run-ins with Alva. "With children's clairvoyance we knew that she would prove adamant to any appeal our father made on our behalf and we never asked him to interfere."[18]

Alva could be a fun-loving friend to her children. "Her dynamic energy and her quick mind, together with her varied interests, made her a delightful companion," Consuelo recalled.[19] Nothing fazed Alva, nothing frightened her. Consuelo remembered with awe and admiration the day "when I, aged nine, was out driving, [and] my pony started to run away with me, making straight for a water hydrant. My cart would undoubtedly have been overturned; but without the slightest hesitation my mother who was standing near by threw herself between the hydrant and the racing pony and seized his bridle, thus preventing a serious accident."[20]

But as a mother Alva could often be more fearsome than fun. It became obvious early on that Alva was turning her prodigious energies into molding her daughter into a certain kind of person. Often, as Consuelo lay in bed, she "reflected that there was in her love of me something of the creative spirit of an artist—that it was her wish to produce me as a finished specimen framed in a perfect setting, and that my person was dedicated to whatever final disposal she had in mind."[21] Only much later would Consuelo realize that Alva, entranced by the marriage of her childhood friend Consuelo Yznaga to the duke of Manchester, envisioned the same kind of royal marriage as the happy and ultimate goal for her daughter. Alva groomed Consuelo to be a duchess, a princess, perhaps even a queen, from her earliest childhood days.

By the age of eight, Consuelo, who never attended school but was educated at home by English, French, and German governesses, had learned to read and write in three languages. She was permitted to speak only French with her parents. And every Saturday, Alva made her daughter recite long poems in French, German, and English.

CONSUELO

A young lady of Consuelo's position had to learn proper deport-ment. On the long drives to church every Sunday, Alva insisted that Consuelo "sit up very straight," and the poor child, "not allowed to relax for a moment," found these drives "frightfully tiring." "When my legs began to fidget in uncontrollable twitches, I was strictly admonished against what for some unknown reason my mother dubbed 'Vanderbilt fidgets,' as if no other children had ever been afflicted thus."[22] (It was rather surprising for Alva to term this condition Vanderbilt fidgets, for as a child she had spent her time in church "looking around or timing myself to see how many times I could take my gloves off and put them on again before the end of the sermon."[23])

Worst of all was "a horrible instrument which I had to wear when doing my lessons. It was a steel rod which ran down my spine and was strapped at my waist and over my shoulders—another strap went around my forehead to the rod. I had to hold my book high when reading, and it was almost impossible to write in so uncomfortable a position."[24] Alva designed this device to give Consuelo perfect posture and to cultivate the "measured and stately walk"[25] of royalty.

Frequently Alva applied her riding whip to her children, just as her mother had done with her. But the taste of the whip was not as devastat-ing to Consuelo as the "ridicule suffered in public" from her mother. "I remember an occasion when dressed in a period costume designed by my mother—for it was her wish that I should stand out from others, hallmarked like precious silver—I suffered the agonies of shame that the ridicule of adults can cause children." Consuelo never learned to beat up her tormentors as had Alva, who, as a child, had thrown the boys who made fun of her clothes into the gutters. "Then again I was particularly sensitive about my nose, for it had an upward curve which my mother and her friends discussed with complete disregard for my feelings. Since nothing could be done to guide its misguided progress, there seemed to me no point in stressing my misfortune."[26] And so, the oldest daughter of the richest family in America "developed an inferiority complex and became conscious not only of physical defects but also of faults that with gentler treatment might have been less painfully corrected."[27]

For all the training Alva provided her daughter, she unwittingly neglected to teach Consuelo the most important skill of all: how to think

for herself. Alva so dominated Consuelo that she grew into a shy, submissive, withdrawn, overly sensitive young lady, very much frightened of the world.

Consuelo remembered once objecting to some of the clothes her mother had selected for her. "With a harshness hardly warranted by so innocent an observation, she informed me that I had no taste and that my opinions were not worth listening to."[28]

Alva would not be contradicted.

"I thought I was doing right," Consuelo once replied to one of her mother's harangues concerning something she had done.

"I don't ask *you* to think; *I* do the thinking, you do as you are told."[29]

Such a domineering mother, Consuelo was convinced, "reduced me to imbecility."[30]

For Consuelo and her two brothers, life with these mismatched parents could be a terrifying experience. As soon as she was old enough to think such thoughts, Consuelo began to realize what her father had come to learn soon after marrying: It was all but impossible to live with Alva. "Why my parents ever married remains a mystery to me. They were both delightful, charming and intelligent people, but wholly unsuited to each other."[31] Willie's "gentle nature hated strife. My father had a generous and unselfish nature; his pleasure was to see people happy and he enjoyed the company of his children and friends, but my mother—for reasons I can but ascribe to a towering ambition—opposed these carefree views with all the force of her strong personality. She loved a fight. If she admitted another point of view she never conceded it. . . . She dominated events about her as thoroughly as she eventually dominated her husband."[32]

Perhaps Willie should have realized early on that something was wrong in his relationship with his wife when he saw the assignment of bedrooms in the Fifth Avenue château for which he had just paid $3 million. It was, of course, customary for husband and wife in this Victorian era to have separate bedrooms, but it was the difference between Alva's bedroom and Willie's that was so extraordinary. Alva had designed for herself a huge bedroom on the second floor looking out over Fifth Avenue, with an enormous four-poster canopied bed fit for royalty,

walls lined with tapestries and heavy draperies, and a marble bathroom with solid gold fixtures and an enormous alabaster tub. The bedroom Alva assigned to Willie was a tiny room on the third floor tucked next to the gymnasium. "My father's small dreary room saddened me," remembered his daughter. "It seemed a dull place for so gay and dashing a cavalier who should, I thought, have the best of everything life could give."[33]

There was no doubt in Alva's mind whose right it was to rule 660 Fifth Avenue. "The home is the woman's sphere," Alva believed, "and the higher her intelligence, the greater her appreciation of that fact that it is peculiarly her castle, where she dominates."[34]

As the years went by, Alva, the cute little plump Pekingese, matured into a stout, tightly corseted matron, a battle-ax with the fierce defiant eyes of a Confederate raider, a set, severe mouth, her prematurely gray hair dyed red. Articulate, opinionated, sarcastic, Alva ruled her family with an iron hand. If ever it seemed she was not going to get her way, she flew into a wild temper tantrum that submissive Willie found distressing, and that sent the three young children scurrying in fear to their rooms. "The bane of [Alva's] life and of those who shared it," Consuelo saw, "was a violent temper that like a tempest at times engulfed us all."[35]

Willie quickly learned that the only way to humor and appease his volatile, imperious wife was to let her spend his money. Willie's father soon made it possible for her to spend on a grand scale, the only kind of spending that could satisfy the insatiable Alva.

2.

True to his word, William H. Vanderbilt had put aside all his business interests. The family patriarch was sick and tired of it all: the twelve thousand miles of Vanderbilt railroads that now crisscrossed much of the United States, the constant misreading of his actions by the press, the attacks from state legislatures, the raids by his enemies, the death threats, the package addressed to "W. H. Wanderbilt" containing that "infernal machine" that had exploded in the post office. Let someone else assume the headaches of his empire. It had worn him out.

What would he do? "No yachts for me!" he chuckled to reporters. "No yachts for me, no sir! They are easy to buy, but they are hard to sell. When I want to go to Europe the 'Britannic' and the 'Georgic' [steamships] are good enough for me."[36]

It was almost too late for him to enjoy the fruits of a lifetime of labor. He was sixty-two, he was exhausted, he was overweight, his blood pressure was high, he had suffered from years of indigestion, he didn't feel well, and he was convinced his health was failing him. He wanted his doctor to see him constantly, often several times a week, but the doctor assured him that the attack of paralysis he had suffered in 1881, which left his right eye sightless and his lower lip occasionally trembling, was insignificant.[37]

When his doctor asked him how he felt, William Vanderbilt answered, "I feel very well, but I am not sure of myself."[38] "If I can only pass my sixty-fourth birthday!" he would tell his friends. "That seems to be a dangerous period in our family."[39] His personal physician believed that what Vanderbilt needed more than anything was rest and recreation. "I believed he had too much to think of and that under the weight of such important cares as his great interests involved, his health had been affected in such a way as only rest and freedom from thought would benefit."[40]

His doctor encouraged his love of racing trotters. Some had been cynical enough to say that William Vanderbilt had shown an interest in horses only to please his father, but even after the Commodore's death he was buying the fastest horses he could find.

June 14, 1883, was surely the brightest day of his life, the day he drove his wagon behind his prize horses, Aldine and Maud S., a mile around a track in two minutes fifteen and a half seconds, a record no professional driver had yet matched. "It is pretty good for an amateur!"[41] he told his friends, beaming, when they congratulated him. From then on he was addicted, and could be seen flying by on wild rides behind his favorite trotters, his reddish whiskers flaring in the breeze, his face ruddy from the wind, happy and at ease. "In order to see William H. Vanderbilt as he is," a contemporary wrote, "you must go, not to Wall Street, nor to the offices of the New York Central Railroad, but out to Harlem Lane, on a fine afternoon, when the fast trotters of New York are taking their exercise. Behind the fastest team on the road,

whose speed emulates that of his own locomotives, Mr. Vanderbilt is himself. His stout, sturdy figure sits firmly upright in his light wagon; his strong hands hold the reins as an expert; his broad Hollandaise face, with shrewd small eyes, and drooping 'Piccadilly' whiskers, is flushed with pleasure, sunshine and fresh air. His voice is genial, cheery and emphatic. He is enjoying himself thoroughly, and he diffuses an atmosphere of heartiness and good will as he dashes along, passing all competitors, or halts for a moment at a roadside hostelry to exchange a few words with an old friend or a road acquaintance."[42]

Several years before his retirement, William H. Vanderbilt's favorite daughter-in-law had persuaded him that a man of his stature must have a better home. Caught up in Alva's enthusiasm, he had purchased an entire block on Fifth Avenue, all the land between Fifty-first and Fifty-second streets, the site of Isaiah Keyser's farmhouse. Now, Alva told him, what this block needed was a massive granite mansion set right in the middle. She also recommended that he buy up that block across the street, tear down the orphan asylum, and create a beautiful park.

Vanderbilt was captivated by the idea until his wife put her foot down. These grandiose plans had gotten out of hand. A house occupying a block was going too far. Even if he made it known that he would leave the house to the city as a museum, it still would not quiet public opinion and he knew it. Just imagine what the press would do! Besides, she had no intention of leaving the home they were living in located at the corner of Fifth Avenue and Fortieth Street. "We don't need a better home and I hate to think of leaving this house where we have lived so comfortably," quiet Maria Louisa Vanderbilt told a friend about her husband's plans. "I have told William that if he wants a finer place for his pictures to build a wing to which he could go whenever he felt inclined; this is too good a house to leave. I will never feel at home in the new place."[43]

Throughout his married life, William Vanderbilt had never once spoken harshly to his wife, and he wasn't about to now. A compromise was in order. He retained the architect who had designed the Grand Central Depot to build him twin mansions on the lot, one of which would be his home, the other to be divided between his only two daughters who did not yet have homes on Fifth Avenue: Margaret Louisa, the wife of Elliott F. Shepard, a prominent attorney in the city;

and Emily, the wife of William D. Sloane, the well-known carpet manufacturer. (Daughter Eliza, Mrs. William Webb, lived at 680 Fifth Avenue, and daughter Florence, Mrs. Hamilton McKown Twombly, lived at 684 Fifth Avenue, in mansions their father had built for them.)

William Vanderbilt became caught up in the construction of the twin mansions. He had his heart set on red and black marble for the facade, but when he learned that the use of this imported stone would add a year or more to the completion date, he settled on Connecticut brownstone. He believed he had only ten years to live, and he was not about to waste one precious year.

Vanderbilt commissioned Herter Brothers to decorate the interior of the mansions. "We have rarely had a customer who took such personal interest in the work during its progress," noted William Baumgarten of Herter Brothers. "All the designs were submitted to him from the first stone to the last piece of decoration or furniture. Mr. Vanderbilt was at our warerooms or at our shops almost every day for a year. He spent hours in the designing rooms, and often looked on while the workmen were busy in the shops, and gave them money and encouragement in their work."[44]

With six hundred workmen and sixty sculptors laboring at full speed for two years, with William Vanderbilt throwing money at them to work faster, the twin mansions with entrances at 640 Fifth Avenue, 642 Fifth Avenue, and 2 West Fifty-second Street were completed by the end of 1881. It was obvious the grim four-story structures had been designed by the architect of the Grand Central Depot; massive square blocks of brownstone overwhelming their lots, they looked like public edifices—a "gloomy waste of rubbed sandstone," one critic called them in comparing them to Alva's masterpiece. But they were impressive in their very size. An awed observer dubbed them "the tenth wonder of the world."[45]

One afternoon, two young men from out of town drove up Fifth Avenue past these new twin mansions that filled the block.

"I suppose these are really the best residences in the city," Henry Frick commented to his companion.

"I think they are so considered," Andrew Mellon replied.

"I wonder how much the upkeep of the one on that corner would

be?" Frick asked. "Say $300,000 a year? I should think that would cover it."

"It might," Mellon agreed.

"That would be six per cent on five millions, or five per cent on six millions, say a thousand a day. That," young Frick contemplated, "is all I shall ever want."[46]

Vanderbilt was so pleased with the results that he commissioned a book about his house, *Mr. Vanderbilt's Home and Collection*, lavishly illustrated with color plates. The fifteen copies of the gilt-edged book, printed in four volumes, which measured four and a half feet by two and a half and which together weighed one hundred pounds, were dutifully purchased by Vanderbilt's business associates. "In these volumes," the obsequious author began, "we are permitted to make a revelation of a private home which better than any other possible selection may stand as a representative of the new impulse now felt in the national life." The house, with its fifty-eight rooms built around a four-story atrium, had "nothing but what a reasonable and practical family may live up to. It is as sincere a home as exists anywhere. Like a more perfect Pompeii, the work will be the vision and image of a typical American residence, seized at the moment when the nation begins to have a taste of its own. . . ."[47]

This taste fortunately never escaped beyond the walls of the typical American residence at 640 Fifth Avenue. There was a decided elegance and grandeur in the carefully thought-out period rooms of Alva's château down the street. In contrast, the baroque interior of the home of the head of the House of Vanderbilt was a tasteless hodgepodge, ostentatiously crammed with riches. Everywhere was everything: walls of red African marble, of stamped leather; walls hung with blue silk brocade, with red velvet embroidered with leaves, flowers, and butterflies, enriched with cut crystal and precious stones; ceilings of mahogany, of bronze, of colored glass, of bamboo; wainscoting of rosewood inlaid with mother-of-pearl and brass, ebony inlaid with ivory, polished ebony inlaid with satinwood; and Grecian, Oriental, Elizabethan, English, Renaissance, French, and Victorian touches in crowded rooms bursting with bronze, stained glass, marble, mosaics, and friezes. It was a stylistic mess that cost a fortune.

Taking his cue from Alva's ball earlier that year, William Vanderbilt proudly rolled out the red carpet on the evening of December 11, 1883, and, as Ward McAllister noted, "generously invited all who were in any way entitled to an invitation, to come and view his superb house, and join in the dance which was to inaugurate its completion." In the opinion of the Autocrat of the Drawing-Rooms, it was "one of the handsomest, most profuse, liberal, and brilliant balls ever given in this country."[48]

But it soon became apparent to William Vanderbilt that the life Alva and Willie were leading was not the life for him, nor was this palace the home for him. He spent more and more time in a tiny corner of the library of the fifty-eight-room mansion, sitting in an old rocker that had come from his Staten Island farmhouse. He complained of feeling suffocated in the city, and sought fresh air on weekends at his farm. During the week a wagonload of milk, produce, and flowers from the farm arrived at the service entrance at 640 Fifth Avenue to remind him of the home he loved.

The one room of his mansion in which he took continuing pride was his large art gallery situated at the back. It was jammed with purchases from his frequent trips to Europe. Vanderbilt eschewed the work of the modernists—Gauguin, Cézanne, van Gogh, Monet, Manet, Renoir—which he did not understand. "It may be very fine," he would reply to his advisers who urged him to buy one of these modern paintings, "but until I can appreciate its beauty, I shall not buy it."[49] He was determined to purchase only the very best foreign paintings that money could buy. "I like pleasing pictures,"[50] he explained. Pleasing pictures meant monumental French works of art that told a story. He was partial to paintings of Napoleon's triumphs. He also liked pastoral scenes. Constant Troyon's portrayal of a yoke of oxen appealed to him. "I don't know as much about the quality of the picture as I do about the truth of the action of the cattle. I have seen them act like that thousands of times."[51] Similarly, J. F. Millet's *The Sower* struck him as being an accurate depiction of a farmer's life. Some harsh critics suspected he valued his paintings by the square foot; one of the two hundred massive paintings that hung in his gallery, *Attiring the Bride* by Jules Lefebvre, was six feet by nine. When asked which of the paintings in his collection he liked the best, he replied, "I like them all."[52] He liked what he collected so

much that he would invite his gentlemen friends to view the paintings with him, and on certain days of the week he opened his gallery to the public, until visitors began snipping flowers in his conservatory and peeping into the family rooms.

Vanderbilt often commissioned French artists to paint a particular scene that he wanted to add to his collection, paying them more than the fee quoted, telling the artists he wanted them to do their very best work. Interviewing the French artist Rosa Bonheur through an interpreter, Vanderbilt gave her a commission for two paintings. She replied that she would have one completed within a year, but that the other would take two or three more years. "Tell her," Vanderbilt said to his interpreter, "I must have them. I'm getting to be an old man, and want to enjoy them."[53] The artist laughed, for she was the same age as Vanderbilt, and completed both paintings that year.

More and more, Vanderbilt's thoughts turned to death. Between 1879 and 1885, his lawyers redrafted his will nine times. He quietly gave money to help out his father's old friends, and provided $100,000 to be distributed among employees of the New York Central, always with the stipulation that those who benefited by a gift should say nothing of it. On October 17, 1884, he delivered to the College of Physicians and Surgeons in New York the deed for twenty-nine lots that he had purchased for $200,000, and a check for $300,000 "to form a building-fund for the erection [on the lots] from time to time of suitable buildings for the college."[54]

With an inner sense that time was getting short, in December 1884 he drove with his two oldest sons, Cornelius and Willie, to the old Dutch cemetery at New Dorp, on Staten Island, where the Commodore was buried. He said he wanted to build a family mausoleum there. The Commodore had donated fifty acres to the cemetery and William had just paid for a new chapel there, but the trustees of the Moravian Cemetery would agree to sell him several acres for the family mausoleum only at "Vanderbilt prices." He refused to pay, and purchased fourteen acres on a hilltop adjoining the cemetery, with a view of the farms of New Dorp spread out below. Aware now that Alva's and Willie's architect was more accomplished than his own, William Vanderbilt commissioned Richard Morris Hunt to design a mausoleum to be built on this hilltop.

Hunt assumed that William Vanderbilt would be as responsive a client as his favorite patron, Alva Vanderbilt, and confidently presented his sketch, a plan that rivaled the most magnificent mausoleums in Europe.

"No, Mr. Hunt," said Vanderbilt shaking his head, "this will not answer at all. You entirely misunderstood me. We are plain, quiet, unostentatious people, and we don't want to be buried in anything so showy as that would be. The cost of it is a secondary matter, and does not concern me. I want it roomy and solid and rich. I don't object to appropriate carvings, or even statuary, but it mustn't have any unnecessary fancy-work on it."[55]

The architect redrew his plans, eliminating all unnecessary "fancy-work" for these unostentatious folk, while leaving the crypt roomy, solid, and appropriately rich looking. A Romanesque chapel patterned after the Chapel of St. Gilles at Arles in the south of France won Vanderbilt's approval. Construction of the gray granite temple began early in 1885. It would be embedded in the hillside on three sides, with commanding views from its front steps all around Staten Island and of every steamship coming into New York Harbor. Frederick Law Olmsted, who had designed Central Park, was hired to direct the landscaping of the site.

At the end of the year, on December 3, 1885, Vanderbilt visited his old farm, telling the resident farmer that he had just given it to his youngest son, George, adding, "I have enjoyed more peace of mind and quietness here than I ever have in the big city yonder."[56] Driving in his carriage back to New Dorp, he visited the old Moravian Cemetery, walking up the hill to check on the construction of the mausoleum, already half completed, with twenty tons of bronze gratings being installed to protect the cells from intruders.

Five days later, on Tuesday, December 8, 1885, William Vanderbilt sat in his favorite rocker in his library, looking out on Fifth Avenue. He was talking with Robert Garrett, the president of the Baltimore and Ohio Railroad Company, the son of its founder whom the Commodore once had called "the rotten apple in the barrel" of railroading.[57] Young Garrett was interested in bringing a new trunk line into New York City through Staten Island and wanted Vanderbilt's help. In the middle of

the afternoon, a servant came in to light a brisk fire in the hearth, and in the fire's glow, Garrett noticed that Vanderbilt's face appeared flushed. Later, it seemed to Garrett that Vanderbilt was slurring his words, and he leaned closer to listen to him more carefully. Suddenly, without a sound, William Vanderbilt toppled to the floor, struck dead by an apoplectic stroke.

All evening long, newsboys cried, "Extra! Extra! Death of William H. Vanderbilt!" as carriages stopped in front of 640 Fifth Avenue bringing members of the family to the darkened home.

Three days later, the mourners gathered at St. Bartholomew's Episcopal Church on Park Avenue in Manhattan where William Vanderbilt had been a vestryman. There was nothing that indicated that this service was for the richest man in the world. The only decorations were the low black catafalque in front of the chancel and a cross of white roses. There was no pomp, no glitter, no ostentation. It was a service Billy would have liked, simple and brief. "I am the resurrection and the life, saith the Lord," chanted the pastor. "He that believeth in me, though he were dead, yet shall he live, and whosoever liveth and believeth in me shall never die. We brought nothing into the world, and it is certain we can carry nothing out. The Lord gave and the Lord taketh away; blessed be the name of the Lord."[58]

Afterward, twelve pallbearers carried the casket to the hearse. Within sight of the church, trains rumbled in and out of the New York Central's depot, adding to the world's greatest fortune. A funeral cortege of one hundred carriages made its way down Fifth Avenue to the wharf at the end of Forty-second Street. There, the old ferryboat *Southfield*, the very one that had carried home the body of the Commodore eight years before, waited.

The pilot rang his bell at 11:40, and the boat left its slip and steered over toward the New Jersey shore, and then headed straight down the river to Staten Island. In the bright, cold December afternoon, the pallbearers carried the casket up the winding road, within sight of Billy's old farmhouse, past the bare fields and leafless woods, to the cemetery.

By two o'clock, all the mourners had left. The casket had been placed in the Vanderbilt vault near the Commodore's until the mauso-

leum was finished. There remained only the guards the family had hired, who would stay there, twenty-four hours a day, punching a time clock every fifteen minutes, for the next fifty years.

Late that Friday afternoon, as the Pinkerton guards paced around William H. Vanderbilt's grave waiting for body snatchers, his four sons and four daughters, who had returned to 640 Fifth Avenue, were pacing around the library, waiting for news of the will. There was no mystery about the size of their father's fortune as there had been in January 1877, when the Commodore died. William Vanderbilt had publicly stated just how much he was worth, though few could understand the meaning of his words, "two hundred million dollars." "The ordinary human mind fails to grasp the idea of such a vast amount of wealth," wrote one of the Vanderbilt family bankers. "If converted into gold it would have weighed 500 tons, and it would have taken 500 strong horses to draw it from the Grand Central Depot to the Sub-Treasury in Wall Street. If it had been all in gold or silver dollars, or even in greenbacks, it would have taken Vanderbilt himself, working eight hours a day, over thirty years to count it. If the first of the Vanderbilts had been a contemporary of old Adam, according to the Mosaic account, and had then started as president of a railroad through Palestine, with a salary of $30,000 a year, saving all this money and living on perquisites, the situation being continued in the male line to the present day, the sum total of all the family savings thus accumulated would not amount to the fortune left by Wm. H. Vanderbilt. . . ."[59]

No. There was absolutely no question about the size of William H. Vanderbilt's estate. In eight years, the son in whom the Commodore had no confidence, the son whom he had ridiculed as a "blatherskite," a "beetlehead," a "sucker," had more than doubled the fortune his father had left him. William Vanderbilt had made as much money in eight years as it had taken his father a lifetime to accumulate. How proud the old Commodore would have been! Not only had his son proved himself a fitting successor to the archetypal robber baron, he had told off the public, too!

What concerned William Vanderbilt's eight children and their spouses was just how that $200 million would be divided. It was the Commodore's known wish that one member of each succeeding genera-

tion be endowed with the bulk of the family fortune. And it was well known that William Vanderbilt, like his father, favored primogeniture as a means of perpetuating the family dynasty. It was also known that one of the last wills William Vanderbilt had executed left the vast majority of his estate to the eldest son of the eldest son of the Commodore: Cornelius. "The opinion is universal among Mr. Vanderbilt's friends," the papers noted, "that he has bequeathed the bulk of his fortune to his eldest son, Cornelius."[60]

Judge Charles Rapallo, who had drawn up the last will of William Vanderbilt, walked into the hushed library to read the document dated September 25, 1885, to the attentive family members. The reading of the will, typewritten on nineteen pages of foolscap, began:

"I, William H. Vanderbilt, of the City of New York, do make and publish my last will and testament as follows."

To his "beloved wife, Maria Louisa," he left his mansion at 640 Fifth Avenue, an annuity of $200,000 a year, and all his works of art, "except the portrait and the marble bust of my father, which I have bequeathed to my son Cornelius."

To Alva, this was a bad sign. It looked as if Cornelius was being recognized as the new head of the House of Vanderbilt.

His four daughters received the houses on Fifth Avenue he had constructed for each of them.

To his trustees he gave $40 million of United States bonds and bonds of his railroads, to be divided into eight equal lots of $5 million each, the income from each lot to be paid to each of his four daughters and four sons. Outright to each of his eight children was bequeathed $5 million of bonds and stocks of the Vanderbilt railroads.

The thirteenth clause also struck Alva as ominous: "I bequeath unto my son, Cornelius Vanderbilt, the sum of $2,000,000 in addition to all other bequests to him in this will contained." Again, a special provision for the eldest son. And then another, a clause that gave his grandson, William H. Vanderbilt, "son of my son Cornelius," $1 million to be paid when he reached the age of thirty, with the income going to him immediately.

After a host of small gifts to various relatives, a bequest of $200,000 to Vanderbilt University and other charitable bequests to churches,

hospitals, and museums, Judge Rapallo read the twenty-second provision:

> All the rest, residue and remainder of all the property and estate, real, personal, and mixed, of every description and wheresoever situated of which I may be seized or possessed, or to which I may be entitled at the time of my decease, I give, devise, and bequeath unto my two sons, Cornelius Vanderbilt and William K. Vanderbilt, in equal shares, and to their heirs and assigns to their use forever.[61]

The rest, residue, and remainder came to $130 million. Willie and Cornelius II would each receive $65 million.

Only after his own death had William Vanderbilt dared disobey the father he feared: He had split up the family fortune.

Why? He had made clear his belief that the fortune was too great a burden for one man to assume. And he was not about to precipitate another battle over a will. But there was another important reason. "We have money enough for ourselves and for the husbands and wives you will marry," William Vanderbilt once told Willie and his other children, "but we haven't respectability enough, for no family has any to lend."[62] Alva. Alva alone had given the Vanderbilt family respectability, a respectability that both the Commodore and his son William had discovered money alone could not buy. Alva had won the heart of her father-in-law. He had therefore changed his will and divided the bulk of his estate between Cornelius and Willie, rather than leaving it all to Cornelius.

When Alva's father had died two weeks after she married Willie, William Vanderbilt had taken her by the hand and said: "My dear, you have lost your Father. You are now my daughter. I want you to come to me on any and all occasions of need." From that day on, Alva recalled, "we were boon companions." Alva's father-in-law, she once reflected, "was a great friend of mine, ever kind and generous to me."[63] Indeed he was.

Someone casually asked Judge Rapallo, as if it was the last thing on his mind, how soon the estate would be distributed. The legacies would be paid before the first of January, he told the attentive children.

Sixty-five million dollars in two weeks! Finally, Alva's dreams were so close she could reach out and touch them.

3.

The average human mind might have failed to grasp what so many millions of dollars meant, but Alva's mind regarding sums of money was anything but average.

Her beloved father-in-law had been buried but two months before Alva gave, as her daughter termed it, "full vent to her ambitions."[64] Her latest desire was for a yacht, just like the Astors'.

How do I love thee, Alva? William might have thought. *Let me count the ways:* an eight-hundred-acre country estate on Long Island, a French château on Fifth Avenue, the most spectacular ball this country had ever seen, the pearls of Catherine the Great and the empress Eugénie, the greatest art treasures of Europe, a private railroad car that was a veritable mansion on rails. It was impossible for Willie to say no to his wife, so once again he said yes, and on February 25, 1886, commissioned the Delaware shipyard of Harlan and Hollingsworth to build a three-masted schooner with steam boilers and a coal capacity of three hundred tons.

On October 14, Alva and Willie, along with a party of their family and friends, boarded their private railroad car at the Grand Central Depot for a ride to Wilmington, Delaware. There at the shipyard docks, surrounded by thousands of workers who had been granted a half holiday at Willie's expense and who had come to watch with their wives and families, Mrs. Fernando Yznaga, Alva's sister, christened the new $500,000 yacht with the name that Willie had so aptly chosen: the *Alva.*

J. P. Morgan's *Corsair* was 165 feet long. William Astor's new *Nourmahal* measured 233 feet. Jay Gould's *Atlanta* was 250 feet. The *Alva* topped them all at 285 feet: the largest private yacht ever built.

"Mrs. Vanderbilt, who is very generally accredited to be a lady of excellent taste," the *New York Times* gushed in describing the *Alva,* "deems that elaborate and ornate furnishing are out of place on a yacht.

She thinks that she is rich enough to afford simplicity in this instance, and that is what she is going to have, in a comparative sense."[65]

Comparative was the key word. All of the staterooms, each of which had a private bath, were paneled in mahogany. The French walnut walls of the library featured an oil painting of the Commodore's *North Star* over the fireplace. The dining room, of white enamel woodwork trimmed in gold, was thirty-two feet wide, eighteen feet long, and nine feet high. All of the teak decks were covered with Oriental rugs. The Vanderbilts on the high seas would not have to leave behind the comforts to which they had become accustomed on Fifth Avenue, for in addition to a captain, the ship was manned by a crew of fifty-two, including "a chief officer, a second mate, four quartermasters, two boatswains, a ship's carpenter, eighteen seamen, a chief engineer, first and second assistant engineers, six firemen, three coal passers, three oilers, a donkey engine-man, an electrician, an ice machine engineer, a chief steward, three cooks, two mess boys, and a surgeon,"[66] in addition to the French chef and servants they brought with them.

The *Alva* now made it possible for the world to become the Vanderbilts' playground. It took them to the West Indies, to Europe, around the Mediterranean, to Greece, Turkey, and Egypt. Travel to distant ports seemed as effortless as visiting a neighboring town. So imposing was the yacht that while it was sailing the Dardanelles, a Turkish warship fired two shots across its bow, believing it to be a navy cruiser of a foreign country. Officials at every port—the American consul in Cuba, the commodore of the Haitian Navy, the United States minister at The Hague, the king of Greece, the commander of the British fleet in the Mediterranean, the sultan of Constantinople—welcomed the Vanderbilts as visiting dignitaries.

Nevertheless, these cruises were "excessively boring" to the Vanderbilt children, whose tutors accompanied them. "Heavy seas provided our only escape from the curriculum of work, for even sightseeing on our visits ashore became part of our education, and we were expected to write an account of all we had seen."[67] And the three young children were terrified in rough weather. "On one occasion as we left Madeira and headed for Gibraltar a frightful storm overtook us," Consuelo later recounted. "The waves broke over the high wooden bulwarks in such rapid succession that there was not enough time for the water to drain

out through the freeing ports before the next wave hit us. I was lying in the forward deck cabin with my brother Willie and his tutor, who was both frightened and sick. 'If we have seven such waves in succession,' he informed us, 'we must sink.' Willie and I spent the rest of the day counting the waves in terrorized apprehension as the green water deepened on our deck."[68]

Alva, too, became bored with cruising the world and turned her attention to her next project.

It just wasn't fair, she pouted to Willie. All her friends had cottages in Newport to get away for the summer. Mrs. Astor went to Newport every summer. The Belmonts were there. The Cornelius Vanderbilts had just bought the Lorillards' house, The Breakers, right on the sea. For goodness' sake, even Ward McAllister summered at his farm in Newport, though it was on the unfashionable side of town. It wasn't fair. Willie thought only of himself.

From experience, Willie had become adept at discerning the distant rumble of approaching battle. To placate his wife, on her thirty-fifth birthday Willie gave Alva a special present. He commissioned the Vanderbilts' favorite architect, Richard Morris Hunt, to build for Alva in Newport, on Bellevue Avenue (which was to Newport what Fifth Avenue was to New York City), on four acres of land next to Beechwood, Mrs. Astor's summer cottage, "the very best living accommodations that money could provide."[69] Before beginning work on the house, Alva told her husband that she would not devote the long hours it would take to design and oversee the construction of the house "unless it was given to me out and out, at once. . . . I insisted that it should be put entirely in my name. This was done."[70]

On a trip to Greece aboard the *Alva,* "I made my best studies and got my inspiration for the building afterward of Marble House," Alva recalled in remembering the origins of her summer cottage. "The germ of the Marble House idea was born at the foot of the Acropolis."[71] Having worked together on Idlehour and the château on Fifth Avenue, architect and client knew everything about one another. Richard Hunt guessed that Mrs. Vanderbilt would want a house to top her other homes, and probably every other house in existence. He guessed correctly. Alva decided that for her summer cottage, set in a community that prided itself on its summertime simplicity, a temple of white marble

would be most appropriate. "Bellevue Avenue on the East, its high grounds sloping toward and mounted above the ocean, was," Alva believed, "the very spot for a reincarnation of the Greek ideal. The same siren waves which sang to Odysseus, to Alcibiades, to Sappho and to Sophocles could here be heard."[72] And so Richard Hunt began drawing plans, remarking in a letter to a friend that "it is as much as one man's brain can do to keep up with the Vanderbilt work."[73]

Hunt admired Mrs. Vanderbilt's architectural vision, but her impatience and her involvement in the most minute details of the plans for what she was calling Marble House nearly drove him mad. Every day, Alva "spent many delightful hours in his office,"[74] looking over his shoulder, making changes, researching historic precedents, refining his specifications for each room. Hunt's notes on a pair of drawings for the wainscoting in a corridor of the second floor of the mansion convey his exasperation. On one drawing he scrawled in large script: "This absolutely disapproved by Mrs. Vanderbilt." On the other he wrote with relief: "This accepted by Mrs. Vanderbilt."[75] Alva had the greatest respect for the genius of Richard Hunt, but this did not stop her for one moment from fighting with him. "We often had terrific word battles. With fiery intensity he would insist on certain things. I would, with equal eagerness, insist on the contrary. Once . . . we had had a long and heated argument over some detail of measurement. Finally he turned to me in a rage and said, 'Damn it, Mrs. Vanderbilt, who is building this house?' and I answered, 'Damn it, Mr. Hunt, who is going to live in this house?' "[76] Alva found that "the work we did together was for me always an endless delight."[77] "She's a wonder," Hunt sighed to his wife.[78]

Whatever the cost of Marble House, Willie reasoned—and the cost was escalating daily—it was worth it. Alva was busy, she was occupied, she was happy. As one of her friends, Harry Lehr, once told her, she "loved nothing better than to be knee-deep in mortar."[79] He was right. "One of my earliest recollections," Alva wrote in memoirs of her childhood in the South, "is of a big library with books piled from floor to ceiling, myself on a rug building imaginary houses with books taken from shelves within my reach. For me, this was ever a favorite amusement and great pleasure. The constructive element in my nature thus early asserted itself—the desire to create, to fashion dwellings, imaginary structures with spaces denoting rooms and halls, and openings indicating what

would be doors and windows. All took shape even under the small hands of this young child, the foreshadowing of one of my future life works."[80]

Construction began in the fall of 1889, immediately necessitating the purchase of a wharf, a warehouse, and a ten-ton derrick at Newport Harbor to handle the five hundred thousand cubic feet of white marble for the facade of the house. This was being shipped in from a quarry on the Hudson. Several tons of yellow marble from a quarry near Montagnola, Italy, would line the entrance hall. And shiploads of pink Numidian marble from a quarry in western Algeria that had not been used since Roman times were needed for the dining room. In fact, the only room lacking marble was Willie's tiny study, which would feature a wooden mantelpiece painted to look like marble.

Alva's birthday present would be used for no more than seven or eight weeks of the year. This house of brilliant white marble, its four towering Corinthian columns fashioned after those of the Temple of the Sun at Heliopolis, only larger, cost Willie $2 million. But that was just the exterior. Alva also spared nothing to create as opulent an interior. The dining room was fashioned after the Salon of Hercules at Versailles, the ballroom after Versailles's Hall of Mirrors, with carved paneling covered by hundreds of sheets of gold leaf. The rooms at once exuded classic formality, with their cool marble, gold, gilt, and bronze, and dazzling, dizzying visions of carved dragons, cherubs, cupids, satyrs, nymphs, garlands, oak leaves, acorns, and masks of Dionysus, which adorned every inch of space. "I like to think," Alva reflected, "that some of the treasures of Europe accumulated in her eras of splendid achievement have been brought to this Greek dwelling as gifts to her temple."[81] Alva's rapture with the ancien régime was evident throughout the house, with a bust of Louis XIV here, a palace-sized portrait of Louis XV there, masks of Apollo, sunbursts, and, in case anyone missed the connection, a portrait medallion of the long-suffering Richard Morris Hunt hanging next to a portrait medallion of J. Hardouin-Mansart, the chief architect of Versailles, above the landing of the grand staircase.

When the house was completed in June 1892, a niece of the Vanderbilts told of her visit: "No description can possibly give one an idea of how marvellously beautiful it is," she exclaimed. "It is far ahead of any palace I have ever dreamed of."[82] Another visitor remarked, "I am waited upon by footmen, butlers, maids and chauffeurs. I am . . .

treated with a sort of sumptuous consideration, fed delicacies by soft-moving servants, given delicious drinks when suffering from heat and generally coddled and made soft."[83]

The interior decoration of Alva's fantasy had consumed $9 million of Willie's fortune. At a total cost of $11 million, Alva's summer cottage, Marble House, had cost nearly four times as much as the Vanderbilts' Fifth Avenue residence. But it was worth it. "It was like a fourth child to me," Alva sighed.[84] And, after all, Alva was just trying to help Willie and the Vanderbilt family. "I had always had tremendous respect and great appreciation for the Medici family," she explained. "They originated as apothecaries. Later their great wealth was used to encourage art of every kind. . . . So I felt about the Vanderbilt family. These houses were not merely beautiful private residences. They were the means of expression in outward and visible terms of the importance of the Vanderbilt family. They represented not only wealth but knowledge and culture, desirable elements for wealth to encourage, and the public accepted them in that way."[85]

"Personally," Alva once said, "I'm a believer that this is a pretty good old world."[86] The fantasy she was living was, in her estimation, "an ideal life."[87]

But as glorious as Marble House was, it would not be enough to please Alva for long.

4.

Once Alva had created her visions of American aristocracy at Idlehour, on Fifth Avenue, and at Marble House, "her restless energy," Consuelo later reflected, "must have turned to other projects. It was perhaps then that plans for my future were born."[88]

So preoccupied was Consuelo with the growing tension between her parents that at first she did not even discern that she was becoming her mother's next project. By the time she reached her teens, "the continual disagreements between my parents had become a matter of deep concern to me." She found that she was "tensely susceptible to their differences, and each new quarrel awoke responding echoes that tore at my loyalties. Profoundly unhappy in my home life [because of

the] constant scenes that so deeply wounded my father and harried my mother beyond control—scenes that embittered the sensitive years of my girlhood and made of marriage a horrible mockery,"[89] Consuelo awaited the split between her parents that she now felt was inevitable.

Sailing from Bar Harbor, Maine, to Newport, the *Alva* was forced by a heavy fog to anchor off the coast of Chatham on the elbow of Cape Cod early in the morning of July 23, 1892. Two hours later, a steamship loomed out of the fog and plowed into the *Alva,* breaching the steel hull of the luxury yacht. Willie and his guests were awakened by the stewards, rushed onto the deck in their pajamas, and were lowered into a launch, as water poured into the stricken vessel. The *Alva* very quickly settled to the bottom of the sea.

Taken by steamship to Boston, Willie immediately located a telegraph operator. His first message was not to tell his wife of his safety, nor was it to his brother and business partner Cornelius to assure him that he was well; rather, his first message was to the Laird Shipyard on the river Mersey in England to arrange for the immediate construction of a new yacht to replace the *Alva.* Twenty-seven feet longer, weighing in at twenty-four hundred tons, the steamship, fully rigged for sail, could cross the Atlantic in seven days. The sleek black yacht, again the largest in the world, so large that it was at times mistaken for a man-of-war, was christened the *Valiant,* not the *Alva II,* a fact that said quite a bit about the deteriorating state of the Vanderbilts' marriage.

Alva decided that a long cruise aboard their new yacht was just what was needed to bring the family closer again, and to stop the rumors in society that their marriage was in serious trouble. "It was in such an atmosphere of dread and uncertainty," Consuelo recalled, "that our last and longest yachting expedition was undertaken in my seventeenth year."[90] Alva was then forty; Willie was forty-four. Consuelo and Harold, their younger son, would accompany them. In addition to the crew of seventy-two and a French chef, the passenger list included a doctor, a governess for Consuelo and Harold, and "three men friends who were our constant companions,"[91] as Consuelo discreetly phrased it. The three men were Willie's friends, and included Oliver Hazard Perry Belmont, the thirty-five-year-old son of the famed international banker August Belmont, as well as twenty-nine-year-old Winthrop Rutherfurd,

scion of an old New York family. Alva found Willie's friends delightful company for a long cruise and "refused to have another woman on board."[92]

The several-month cruise turned out to be one of Alva's worst ideas. It was a disaster.

Setting sail from New York on November 23, 1893, the *Valiant* plowed across the Atlantic, into the Mediterranean, through the Suez Canal, and on to the Red Sea and the Indian Ocean. Mooring at Bombay, where the heat was almost unbearable, the Vanderbilts and their friends continued across India by train. This was not the Vanderbilt railroad system, and their private sleeping car was not one of the Vanderbilt mansions on wheels. For the first time, as the train rumbled across the poor continent, "we realized what discomfort in a train could amount to. At every station angry natives seeking transportation tried noisily to force their way into our bedrooms which opened directly onto the station platforms. Luckily the doors were locked, but the din was formidable. And in the night those angry mobs seemed threatening. No one slept. . . . We knew little comfort, for it was difficult to secure bath water and the food was incredibly nasty. We lived on tea, toast and marmalade."[93]

The *Valiant* sailed around India and met the group at the port of Hooghly, reuniting them with their French chef and the luxuries of home. There the Vanderbilts spent a week as guests of the viceroy and Lady Lansdowne.

It was here that Consuelo first became clearly conscious of her mother's "admiration for the British way of life" and of "her desire to place me in an aristocratic setting."[94] What Consuelo would not learn until much later was that Alva had begun to seal her fate that week: She had decided to arrange a marriage between her daughter and their hostess's nephew—the most noble Charles Richard John Spencer Churchill, duke of Marlborough, marquess of Blandford, earl of Sunderland, earl of Marlborough, Baron Spencer of Wormleighton, Baron Churchill of Sandridge, prince of the Holy Roman Empire, and the twenty-three-year-old master of England's grandest palace: Blenheim.

It is unlikely that Alva ever mentioned her plans for Consuelo to her husband, for by the time the voyagers returned to Bombay, Willie and Alva could not stand the sight of one another. In fact, they were

not even speaking. The other passengers aboard the *Valiant* had not been drawn into the Vanderbilt squabble. Alva was growing rather fond of Oliver Belmont, and Consuelo was quite bewitched by the "outstanding looks"[95] of Winthrop Rutherfurd. Leaving the *Valiant* in India, Alva and Willie proceeded on to Paris separately.

Reunited at the Hotel Bristol in that spring of 1894, the Vanderbilts were trying to mend their fraying marriage when Alva heard a rumor that Willie had given a Parisian lady, blond twenty-six-year-old Nellie Neustretter, "a woman notorious in Europe,"[96] forty thousand francs he'd won in a bet on the Grand Prix de Paris, and that he was providing her with an apartment and servants, outfitted in the same maroon uniform as servants of the House of Vanderbilt. "The capture of the purse and affections of Mr. W. K. Vanderbilt . . . is a story of the hunting of big American game on the sunlit shores of the Mediterranean," cackled the *New York World*. "All of the employees of the New York Central," the newspaper continued, "are bound to take an interest in the fact that the fares which they collect, the freight money which they earn and any trifling reduction that may be made in their number or in their wages must pay some little tribute to Nellie Neustretter."[97]

Dutiful Cornelius Vanderbilt rushed to Paris to try to negotiate a cease-fire between his brother and sister-in-law, of course to no avail. Alva had sworn that she would never speak to that man again, and she never did. After nineteen years of married life, wonderful Willie was, she had now decided, nothing but a "weak nonentity."[98]

At the height of this Victorian age, an age when "ladies rose and left the room when divorce was mentioned and 'adultery' was an embarrassing word in the Ten Commandments,"[99] Alva decided to do what was shocking and scandalous. She demanded a divorce.

"My divorce . . . created nothing short of a sensation in New York. Women were not supposed to divorce their husbands in those days, whatever their provocation, and social ostracism threatened anyone daring enough, or self respecting enough, to do it. . . . I was the first woman of any prominence to sue for a divorce for adultery, and Society was by turns stunned, horrified, and then savage in its opposition and criticism. For a woman of my social standing to apply for a divorce from one of the richest men in the United States on such grounds, or for any cause,

was an unheard of and glaring defiance of custom. It was a shock to everyone."[100]

Alva proudly told her friends, "I always do everything first. I blaze the trail for the rest to walk in. I was the first girl of my 'set' to marry a Vanderbilt. Then I was the first society woman to ask for a divorce, and within a year ever so many others had followed my example. They had been wanting divorce all the time, but they had not dared to do it until I showed them the way. . . ."[101] Alva couldn't have cared less what anyone thought. "It's all a pack of nonsense. The Smiths of Alabama cut me dead for marrying W. K. Vanderbilt because his grandfather peddled vegetables. Then they cut me dead all over again for divorcing him. I can't be bothered with stupid prejudices."[102]

"I still feel pain at the thought of the unkind messages I was made the bearer of," Consuelo remembered half a century later, "when, in the months that preceded their parting, my mother no longer spoke to him. The purport of those messages I no longer remember—they were, I believe, concerned with the divorce she desired and with her wishes and decrees regarding custody of the children and arrangements for the future."[103]

Willie returned to New York and went to live at the Metropolitan Club. Alva remained in Paris with Consuelo to await the results of the divorce proceedings.

Consuelo was relieved that her warring parents were parting: "The sinister gloom of their relationship would no longer encompass me." But she did not realize "how irrevocably I would be cut off from a father I loved nor how completely my mother would dominate me from then on."[104]

With little else to do but wait for her divorce to be decreed in New York, Alva turned her total attention to her seventeen-year-old daughter.

First, there were trips to the great dressmakers along the rue de la Paix. Inside the small modest doors bearing the names of Worth, Doucet, and Rouff were an "array of lovely dresses, expensive furs and diaphanous lingerie" that "fairly took one's breath away. I longed to be allowed to choose my dresses, but my mother had her own view, which unfortunately did not coincide with mine."[105]

Then, Alva arranged for Consuelo to make her debut at a party given in Paris by the duc de Gramont.

Consuelo was the first to admit that at seventeen she was "still in the ugly duckling stage. . . . My lack of beauty . . . made me painfully sensitive to criticism. I felt like a gawky graceless child."[106] As an acquaintance commented, "her frailty and height made her look as if she might break in two in an adverse breeze." Her cousin Gertrude Vanderbilt's assessment of her was even more direct: Consuelo was, as she said, "nothing on looks."[108]

It was therefore with a great deal of trepidation that Consuelo prepared for her coming-out ball in Paris. Though, Consuelo thought, the terror of not being asked to dance, the humiliation of being a wallflower, "ruined the pleasures of a ball for those who were ill favored," she need not have worried for a moment, for a host of men found the wistful young heiress indescribably beautiful. "A galaxy of partners presented their respects to me and I was soon at ease and happy."[109] In June, Alva informed her daughter that five men had asked her for Consuelo's hand, all of whom Alva had refused "since she considered none of them sufficiently exalted."[110] His Serene Highness Prince Francis Joseph of Battenberg, a claimant to a Balkan throne who needed financial backing, seemed to fire Alva's imagination for a moment— Queen Consuelo—before she remembered that there would be even better hunting over in England. To all these proposals, Alva returned the same answer: "that I was much flattered, but thought it better for an Anglo Saxon woman to marry in the Anglo Saxon race."[111]

Alva and Consuelo spent that summer of 1894 in England. There Lady Paget, who as Minnie Stevens of New York had been one of Alva's dearest friends, plotted with Alva to advance her plans for the perfect marriage of Consuelo and the duke of Marlborough. At a dinner party given by Lady Paget, Consuelo was seated next to the young duke. But all Consuelo received that summer were "two or three other proposals from uninteresting Englishmen which I found slightly disillusioning. They were so evidently dictated by a desire for my dowry, a reflection that was inclined to dispel whatever thoughts of romance might come my way."[112]

Consuelo was relieved in the fall when she and her mother returned to their mansion at 660 Fifth Avenue, with Alva apparently over her obsession with the idea of a royal marriage for her daughter. Thank goodness. What Consuelo dreamed of doing was eventually going to

Oxford to study languages and, right now, spending as much time as possible with Winthrop Rutherfurd, with whom she had fallen "violently in love"[113] on their travels through India.

Winty's blood was as blue as it came. His father, Lewis Rutherfurd, a direct descendant of Peter Stuyvesant, had been among Ward McAllister's first choices to serve as one of the Patriarchs, those twenty-five "nobs" whose position in society was secure by birth. Winty had it all. He was part of the magic Four Hundred by divine right, he was wealthy, he was bright, he was a lawyer, he was a sportsman, and, as a little extra icing on the cake, he had "really breath-taking good looks."[114] So enchanted was Edith Wharton by this Adonis that she made him "the prototype of my first novels."[115]

Consuelo could no more tell her mother of her love for Winty than Alva would confess to her daughter her feelings for O.H.P. Belmont, even though the decree of divorce had been granted. But Alva was Alva, and knew of her daughter's feelings without being told.

During these winter months without her father, who had been banished from 660 Fifth Avenue, Consuelo turned more and more to Winty, whom she "loved passionately."[116] Alva was carefully monitoring this relationship. Consuelo had to render "a strict account of the few parties I was allowed to attend without her, and if I danced too often with a partner he immediately became the butt of her displeasure. She knew how to make people look ridiculous and did not spare her sarcasm about those to whom I was attracted, reserving special darts for an older man, who by his outstanding looks, his distinction and his charm had gained a marked ascendancy in my affections."[117]

Winthrop Rutherfurd, Alva agreed, was a nice boy; certainly he had a proper background, and yes, he was gorgeous. And yes, he was a lot of fun to have around. But this was *not* the man for her daughter to marry. Consuelo was much too young to have any idea of what was best for her.

5.

On her eighteenth birthday, March 2, 1895, Consuelo opened a small box that had been delivered to her and "found a perfect rose alone on

its green foliage. I instinctively knew who had sent it, though no name was attached."[118]

Later that day, Consuelo and Winty went bicycling along Riverside Drive with Alva and a group of her friends. The young couple sped ahead, and when they had lost sight of the others, Winty proposed to Consuelo, "the only proposal of marriage I wished to accept."[119]

"Of course, it was a most hurried proposal for my mother and the others were not far behind; as they strained to reach us he pressed me to agree to a secret engagement, for I was leaving for Europe the next day. He added that he would follow me, but that I must not tell my mother since she would most certainly withhold her consent to our engagement. On my return to America we might plan an elopement."[120]

Like a steamship huffing and puffing into port, Alva finally caught up with the beaming young couple and instinctively knew what had happened. This nonsense had gone far enough. It was time for her to spring into action. The bicycling party was over. There was packing to be done. They would sail tomorrow and not return home for many months.

Winty did follow Consuelo to Paris, but Consuelo never knew it. Alva had instructed her servants that Mr. Rutherfurd be "refused admittance when he called."[121] His letters were to be confiscated and the letters Consuelo wrote to him were not to be mailed by the servants, but rather given directly to Alva.

Consuelo never confided in her mother that she was engaged to Winty Rutherford. Alva never let on that she knew.

Day after day, week after week, Consuelo thought of Winty, wondering when he would come, wondering why he hadn't written, wondering if he still loved her, never suspecting that he had been in Paris and had been turned away by the Vanderbilt servants, told that Miss Vanderbilt was not interested in seeing him. "When one is young and unhappy the sun shines in vain, and one feels as if cheated of one's birthright. I knew that my mother resented my evident misery, and her complaints about what she satirically termed my 'martyrdom' did not improve our relations."[122]

Without feeling, Consuelo went through the motions of life in Paris, trying on the clothes her mother ordered for her, visiting mu-

seums, attending concerts and lectures and "a few of those deadly debutante balls which I no longer cared for," dancing "with men who had no interest for me."[123]

Soon "events began to move more rapidly, and I felt I was being steered into a vortex that was to engulf me."[124]

During their visit to England, Alva arranged through her old New York City friend Lady Paget for a visit to the duke of Marlborough's great ancestral home, Blenheim Palace.

Set in a royal park of three thousand acres in Oxfordshire, sixty-five miles outside of London, Blenheim Palace was never meant to be a home; it was a national monument to the first duke of Marlborough, given to him by a grateful queen after his victory over the French in 1704 near the Bavarian village of Blenheim in the War of the Spanish Succession. Work had begun in 1705 on a palace to rival Versailles. For two decades thereafter, fifteen hundred workmen labored over the baroque structure whose roof covered more than seven acres of grand rooms and endless halls. Indeed, Blenheim easily could have contained all of the Fifth Avenue mansions, the country homes, and the summer cottages of every member of the Vanderbilt family. Wrote a noble lady in 1721 after visiting the palace: ". . . some parts of Blenheim were so vast in ye designs that tho' they were formed by a man, they ought to have been executed by ye Gods."[125]

As Alva and Consuelo approached the park of Blenheim through a stone arch, "a porter in livery carrying a long wand surmounted by a silver knob from which hung a red cord and tassel stood at attention and the great house loomed in the distance."[126] To Alva, such pomp and ceremony was nothing short of heaven.

The Vanderbilts entered the great hall of the palace, where Consuelo "had to crane my neck to see the Great Duke dressed in a Roman toga driving a chariot" in a mural painted on the ceiling sixty-seven feet above her.[127] Everywhere murals, paintings, tapestries, statues, and busts glorified the military conquests of the first duke of Marlborough. Each was pointed out and explained to the Vanderbilts as they were led on a tour by the young ninth duke, who lived alone in the 320-room palace looked after by 200 servants.

Even for someone like Consuelo, it was obvious how impractical a residence Blenheim was. The kitchen was hundreds of yards from the

dining room, which made the serving of each meal a matter of careful strategic planning. The palace had only a few bathrooms and "they were usually installed in some inconvenient place at the end of a passage."[128] Consuelo found it strange "that in so great a house there should not be one really livable room" and judged all the rooms "devoid of the beauty and comforts my own home had provided. We slept in small rooms with high ceilings; we dined in dark rooms with high ceilings; we dressed in closets without ventilation; we sat in long galleries or painted saloons. Had they been finely proportioned or beautifully decorated I would not so greatly have minded sacrificing comfort to elegance."[129]

Consuelo was not the first to conclude that Blenheim had been "planned to impress rather than to please."[130] Wrote Alexander Pope of England's greatest palace:

> See, Sir, see here's the grand Approach,
> This way is for his Grace's Coach;
> There lies the Bridge, and here's the clock,
> Observe the Lyon and the Cock,
> The spacious Court, the Colonnade,
> And mark how wide the Hall is made?
> The Chimneys are so well design'd,
> They never smoke in any Wind.
> This Gallery's contriv'd for walking,
> The Windows to retire and talk in;
> The Council-Chamber for Debate,
> And all the rest are Rooms of State.
>
> Thanks, Sir, cry'd I, 'tis very fine.
> But where d'ye sleep, or where d'ye dine?[131]

"In a word," Pope concluded, "the whole is a most expensive absurdity and the Duke of Shrewsbury gave a true character of it when he said it was a great quarry of stones above ground."[132]

Consuelo quickly perceived what was wrong at Blenheim: The young duke was destitute, unable to maintain so monumental a home. From the days of the first duke of Marlborough, Blenheim had been an impossible burden. The first duchess of Marlborough had sighed that Blenheim was "so vast a place that it tires one almost to death to look

after it and keep it in order."[133] The sixth duke had begun to admit tourists for a shilling apiece to help defray the upkeep, and the seventh and eighth dukes had sold off the palace library, its collection of old masters, and the Chinese export porcelain to pay for essential maintenance. The Vanderbilts' host's father, the eighth duke, had divorced his wife and married Lilian Hammersley, the widow of a New York millionaire (whom the New York papers described as a "common looking and badly dressed woman with a moustache"), whose fortune he'd drained to install central heating and electric lights at Blenheim. Now, with Blenheim stripped of heirlooms, its great lawns turned to hay, the burden lay heavy on the shoulders of the ninth duke, who understood it to be his "first duty in life to preserve and embellish" this great home.[134] "To live at Blenheim in the pomp and circumstance he considered essential,"[135] Consuelo recognized, required vast sums of money. Now it was all too clear to her where she fit into the picture: Her dowry would rescue an impoverished duke; in return, he would give her the royal title of duchess, which her mother craved for her.

"I don't know what Marlborough thought of me, except that I was quite different from the sophisticated girls who wished to become his Duchess. My remarks appeared to amuse him, but whether he considered them witty or naive I never knew. . . ."[136] What was clear, at least to Alva, was that the duke was more than willing to forgo any of the "sophisticated girls" who might have been of interest to him for this shy American heiress.

The next day, the duke showed the Vanderbilts around his estate. "We also drove to outlying villages where old women and children curtsied and men touched their caps as we passed. . . . I realized that I had come to an old world with ancient traditions and that the villagers were still proud of their Duke and of their allegiance to his family."[137] By the end of the weekend, Alva was enthralled by a grandeur that surpassed even her wildest fantasies. Consuelo, on the other hand, found everything about Blenheim and the duke bizarre, and wanted nothing to do with the impossible gloom of the dreary old palace. By the end of the two-day visit, she had "firmly decided that I would not marry Marlborough." She would marry Winthrop Rutherfurd. "It would, I knew, entail a struggle, but I meant to force the issue with my mother. I did not relish the thought, but my happiness was at stake."[138]

On the voyage back to the United States that summer of 1895, Consuelo gathered the courage to tell her mother that she was not going to be forced into marrying the duke of Marlborough.

Don't be silly, Alva told her daughter. That is the most ridiculous thing I've ever heard. No one is forcing you to marry the duke. "Generously allowing [Consuelo] the choice of alternatives,"[139] Alva told her daughter that she indeed did not have to marry the ninth duke of Marlborough; she could marry his cousin, the duke of Roxburgh, if she so chose. It was up to her. Unmindful of Ward McAllister's dictum against foreign alliances—"the wealthy men of America should be ambitious to build up families composed entirely of native stock instead of importing from time to time, various broken-down titled individuals from abroad"[140]—Alva had set her heart on a noble marriage for her daughter.

Consuelo sat silently, thinking only of her return to Newport, "where I could get into touch with the man to whom I considered myself engaged."[141] Once she was with Winty again, she would tell her mother everything, of her love for Winthrop Rutherfurd, of their engagement, of their plans for marriage.

But that summer, magnificent Marble House was to Consuelo a jail. It was, she thought, just "like a prison,"[142] with the high walls surrounding the property, and its gates lined with sheet iron. "My life became that of a prisoner, with my mother and my governess as wardens. I was never out of their sight. Friends called but were told I was not at home. Locked behind those high walls—the porter had orders not to let me out unaccompanied—I had no chance of getting any word to my fiancé."[143] This was just how Alva wanted it. "Nature will have her way among any group of young people thrown together," Alva was convinced. "I was careful that my daughter should not meet men for whom she might have a youthful and passing fancy."[144]

Consuelo fell into a mood of despair and hopelessness. Joy had disappeared from her life forever, she thought; such were her feelings of despondency one night when Alva chaperoned her to a Newport ball.

There he was! There was Winty! All six feet two inches of him. Consuelo was breathing again, she was living again; the love she felt for Winthrop Rutherfurd filled her again as if they had never been apart. "We had one short dance before my mother dragged me away, but it

was enough to reassure me that his feelings toward me had not changed."[145]

It was to be quite a night, a night Consuelo would never forget. As they were driven home, Consuelo said not a word, but her mother knew that she was flying, soaring with happiness, in love.

The carriage reached Marble House. The footman swung open the ten-ton steel and gilt-bronze entrance grille to admit the two Vanderbilt women. Alva told her daughter to meet her in her bedroom at once.

Consuelo climbed the marble stairs to the second floor, emboldened by her love for Winty. She would tell her mother everything, no matter what. It was time to bring it all to a head. It was now or never. She was eighteen. She had no intention of marrying a man she cared nothing about. She was engaged to Winty and would marry him.

Consuelo entered her mother's cavernous rococo bedroom with its high ceiling and heavy tasseled curtains, rich Aubusson rug, damask walls, and cherub sconces holding shields bearing the letter A. Alva was waiting.

For the first time, Consuelo announced that she was engaged to Winthrop Rutherfurd and planned to marry him, and that "I considered I had a right to choose my own husband." These words, "the bravest I had ever uttered," released from her mother "a frightful storm of protest."[146]

At first Alva tried reason. Consuelo could not marry the Rutherfurd boy. "The marriage of youth is based almost entirely on physical attraction," Alva explained to her daughter.[147] Such marriages do not last. Marlborough is "the husband I have chosen"[148] for you, Consuelo. My decision to select a husband for you is founded on considerations you are "too young and inexperienced to appreciate."[149] Consuelo, your interest in that Rutherfurd boy is "merely the whim of a young inexperienced girl."[150] Consuelo! Wake up! Look at my dearest friend, your godmother, Consuelo Yznaga, duchess of Manchester. You will be a *duchess*—can't you see what that means? Consuelo Vanderbilt: duchess of Marlborough, princess of the Holy Roman Empire!

Seeing she was having no effect on her daughter, Alva broke into a "frightening rage."[151] Consuelo "suffered every searing reproach, heard every possible invective hurled at the man I loved."[152] Alva informed her daughter of Winty's "numerous flirtations, of his well-

known love for a married woman, of his desire to marry an heiress. My mother even declared that he would have no children and that there was madness in his family."[153] Consuelo! Are you out of your mind! He's impotent! He's mad!

Frightened by her mother's vehemence, Consuelo struggled to maintain her composure, sitting in stony silence as her mother stormed on.

No one, *no one* had ever stood up to Alva before. She was furious. "There was a terrible scene in which she told me that if I succeeded in escaping she would shoot my sweetheart and she would, therefore, be imprisoned and hanged and I would be responsible."[154] No, "she would not hesitate to shoot a man whom she considered would ruin my life,"[155] that's how strongly she felt about this. She was ready to hang for her crime.

The ninth duke of Marlborough was coming to America, Alva firmly informed her daughter. He would stay with them at Marble House as their guest. "She had already negotiated my marriage with him."[156] And that was that.

As Alva said, "I have always had absolute power over my daughter, my children having been entrusted to me entirely after my divorce. . . . When I issued an order, nobody discussed it. I therefore did not beg but ordered her to marry the duke."[157] It was as simple as that.

Numb, Consuelo walked down the hall to her bedroom "in the cold dawn of morning feeling as if all my youth had been drained away."[158]

The next morning, Marble House was ominously quiet. "I heard that my mother was ill and in her bed, that a doctor had been sent for."[159]

Later in the day, Mrs. Lucy Jay, one of Alva's sisters who was staying at Marble House, came to talk to Consuelo. "Condemning my behavior, she informed me that my mother had had a heart attack brought about by my callous indifference to her feelings." She said that Alva would never, never consent to Consuelo's plans to marry Mr. Rutherfurd, and that she was resolved to shoot him if they planned to elope.

Consuelo asked her aunt if she felt there was any hope that her mother would come around to see her position.

"Your mother will never relent," Mrs. Jay sternly told her, "and I

warn you there will be a catastrophe if you persist. The doctor has said that another scene may easily bring on a heart attack and he will not be responsible for the result. You can ask the doctor yourself if you do not believe me!"[160] If Consuelo insisted on opposing her mother's will, it would kill her. Alva would die unless the wedding was arranged.

Alone, confused, bewildered, Consuelo had no one to turn to. Her father was far away in New York. Winty was kept outside the gates of Marble House, his letters intercepted. There was no way he could reach the woman he loved. Still imprisoned in Marble House, Consuelo had no way of talking to him. "The servants had orders to bring my letters to my mother."[161] Her mother had been forever the center of her universe, someone who had always exercised total control of her life, someone who had always thought for her, always made decisions for her. Now she was kept away from her mother. She began to worry. Maybe it was wrong to question her mother's judgment; maybe she did know what was best. Maybe she should follow her wishes without question. Consuelo certainly did not want to confront her again and have her fly into another tirade. She did not want her mother to suffer another heart attack, an attack that now would be fatal.

What should she do? What could she do? Alone in her "austere" bedroom, "paneled in a dark Renaissance *boiserie,*" with its six windows through which at best "one could only glimpse the sky through their high and narrow casements," Consuelo pined the summer away. Even there, in her own bedroom, she was reminded of the control her mother had over her life. To the right of her bed "on an antique table were aligned a mirror and various silver brushes and combs. On another table writing utensils were disposed in such perfect order that I never ventured to use them. For my mother had chosen every piece of furniture and had placed every ornament according to her taste, and had forbidden the intrusion of my personal possessions."[162] Alva had done everything for Consuelo. "I don't ask *you* to think, *I* do the thinking, you do as you are told."[163] And now, she was telling her daughter to forget the man she loved; she was tearing Consuelo "from the influence of my sweetheart";[164] she was forcing her daughter to marry a man she did not love, a man she hardly knew, the ninth duke of Marlborough, to leave Marble House and Fifth Avenue and live far away from her family in a crumbling old castle in England. "How sad were those summer days of

disgrace and unhappiness, my mother turned away from me, my father out of reach, my brothers engrossed in their personal pleasures. . . . My friends who had wearied of being rebuffed no longer called, and with an ingrained reticence I kept my worries to myself."[165]

Consuelo worried all summer, but within a day of the encounter, Alva had experienced a complete recovery from her heart attack and was bustling about Marble House, preparing for the arrival of the duke of Marlborough. There was so much to be done. She would give a "Bal Blanc" on Wednesday, August 28, 1895. It must outshine every previous entertainment. It was, of course, as the newspapers noted, "in honor of her daughter, Miss Consuelo Vanderbilt, who is having her first Summer out."[166] But it was also Alva's personal "declaration of war," as she called it, against the archaic notion that a divorced woman had to be ostracized from society. "When I walked into Trinity Church in Newport on a Sunday soon after obtaining my divorce, not a single one of my old friends would recognize me. They walked by me with cold stares or insolent looks. They gathered in little groups and made it evident they were speaking of their disapprobation of my conduct. Often in the ensuing days of my new freedom I have gone to a dinner party where the only woman who would speak to me would be the hostess. When the men were left in the dining room the women would sweep away from me, leaving me standing alone so that the hostess was forced to come to the rescue."[167]

Alva sent out five hundred invitations, veritable summonses to appear at her Bal Blanc. She doubted very much if anyone would dare not come, especially since this was the first time she had thrown open the gates of Marble House for a ball, and especially with the ninth duke of Marlborough as her honored guest.

Outshine every other ball it did. It was called "the most beautiful fete ever seen in Newport."[168]

Footmen in powdered wigs and maroon Louis XIV costumes led the guests into the great hall, over floors of lustrous yellow Siena marble, past a large bronze fountain filled with floating lotus of the Nile and lilac-colored water hyacinths and pale pink hollyhocks, surrounded by swarms of artificial hummingbirds, bees, and butterflies. At the other end of the hall one could see the moonlit sea.

Standing in the dining room against the walls of rose marble that

"gleamed like fire,"[169] Alva was dressed in a gown of jade-green satin trimmed with white satin and Spanish lace, the three-foot pearl necklace of Catherine the Great casually draped over her shoulder. Consuelo wore a white satin gown trimmed with lace that had belonged to Alva's mother. The young duke of Marlborough stood with them, closely scrutinizing all the pretty women. The guests were surprised to find Marlborough "rather undersized,"[170] not "a big, strapping Englishman with a loud voice, but instead, a pale-faced frail-looking lad with a voice . . . as soft as a debutante's."[171]

Outside on the marble terrace overlooking the ocean, protected by the two projecting wings of Marble House, thirty-five dinner tables were arranged, each with a wreath of pink hollyhocks tied with pink ribbons. The "grounds were just as they used to be at Versailles, when Louis strolled across the broad terrace with his court,"[172] reporters noted. The branches of every tree twinkled in the evening sea breeze with white Chinese lanterns shaped like Marble House.

Some of the guests might have thought that Mrs. Vanderbilt had even paid for the moon to be shining on Marble House to provide, as Alva reflected, "a setting of almost unreal beauty"[173] that warm summer night, as the guests danced around the marble terrace and perfect green lawns to the music of three orchestras, while nine French chefs prepared dinner. The first dinner was served at midnight, as the lawn was kept ablaze with colored fires. A cotillion in the gold ballroom followed, capped by a larger supper served at three in the morning.

This midnight ball at Marble House outdid "any private social function ever given in the country,"[174] the papers reported the next morning, but all the guests were disappointed. That night "everybody was thinking of just one thing—would the engagement that would make Consuelo Vanderbilt the Duchess of Marlborough be announced?"[175] Alva told the reporters that "she thought it a shame that such a report had gone abroad."[176] "Miss Vanderbilt is not engaged to the Duke of Marlborough. I regret that the papers so often see fit to connect her name with different friends of ours."[177]

Alva spent the next several weeks displaying her English friend and her daughter to Newport society, driving with them in a carriage up and down Bellevue Avenue, chaperoning them at dinners, balls, luncheon

parties aboard the Astor yacht in Newport Harbor, polo games followed by tea.

The one mistake Alva made was in taking the duke to The Breakers, the just-completed Italian Renaissance villa of Willie's brother Cornelius. It was even bigger than Marble House, with more marble, more bronze, more gilt. The duke assumed that these Vanderbilts were even richer than Consuelo's parents, and reportedly proposed to Gertrude Vanderbilt, the twenty-year-old daughter of Alice and Cornelius, who flat out said no.[178]

On the last day of his visit, remembering all the expenses back at Blenheim, Marlborough took Consuelo into the Gothic Room of Marble House, "whose atmosphere," Consuelo felt, "was so propitious to sacrifice," with its "stained-glass windows from some famous church [that] kept out the light, creating a melancholy atmosphere in which a Della Robbia Madonna suggested the renunciation of a worldly life,"[179] and there asked her to become his duchess. Alva had waged so successful a campaign that Consuelo accepted.

Later that evening, when Consuelo broke the news of her engagement to her brother, he spoke the words that Consuelo felt but dared not think.

"He is only marrying you for your money," Harold told her in the matter-of-fact tone of an eleven-year-old.[180]

With that, Consuelo's careful hold of her emotions collapsed. She burst into tears and ran to her room.

Before either Consuelo or Marlborough could have a change of heart, Alva notified all the papers of the engagement and announced plans for a wedding on November 6, 1895.

6.

"It is probable," the papers predicted, "that the Vanderbilts, with their characteristic reserve, will avoid as much as possible the publicity that attaches to an international match of such importance."[181]

It was only early on her wedding morning when Consuelo looked outside to the streets of New York City that she realized her marriage

to the ninth duke of Marlborough had become a spectacle. Through the "heavy gray curtain of Indian summer mist that made all the surroundings gloomy,"[182] she saw that their mansion was being patrolled by fifty policemen and twelve detectives holding back the crowds. (This was a new mansion. In her divorce settlement with Willie, Alva had been given enough money always to live like a Vanderbilt. Alva kept Marble House in Newport and Willie kept Idlehour on Long Island. Alva had also been given the château at 660 Fifth Avenue and all of its contents. This she spurned. "I don't want this house!" she declared.[183] It had been "rendered disagreeable by unpleasant memories."[184] The only thing she took from the château was the large portrait of herself, the one in front of which she had greeted her guests. This she cut up into pieces, a gesture that seemed to say that her old life, her life as Mrs. Vanderbilt, Queen of Society, was over.[185] Alva bought a mansion on Seventy-second Street and Madison Avenue.) By 10:30 there were two thousand onlookers, mainly women, armed with opera glasses, camp stools, and lunch bags, thronging the streets around the mansion. And every window in the neighborhood from which the Vanderbilt house could be seen was filled with spectators, watching through opera glasses for a sight of the bridal party.

Move on! Move on! the policemen shouted, trying to keep the crowds at least one hundred feet back from the house. But they proved hardly a match for the women who were intent on seeing the young Vanderbilt bride. They used every subterfuge to get closer, telling the police they were going through to Fifth Avenue, but when they reached the front of the Vanderbilt house they would stop and stand there and stare until ordered to move on. One woman so strenuously resisted moving that a policeman had to "take her almost in his arms."

"How dare you lay hands on me?" she screamed.

"I wouldn't, madam," said the policeman, "if you would go where you belong."

"Beast!" she cried at the policeman and walked into the crowd.[186]

Whenever it was rumored that Miss Vanderbilt was about to appear, the women would sweep across the street in a wild rush to see the future duchess of Marlborough. For several hours, small lively battles were waged between the police and curious women, all the way down Fifth Avenue from Alva's new house past the mansion of the Cornelius

Vanderbilts at Fifty-seventh Street, with every window shuttered while the family stayed at Newport to avoid the wedding, past Alva's dream château at Fifty-second Street, where all the windows were shut and not a face was to be seen.

Outside of St. Thomas's Episcopal Church at Fifth Avenue and Fifty-third Street, three hundred policemen struggled to maintain some semblance of order. The sidewalks and streets around the brownstone church were mobbed with seven thousand sightseers, many of whom had been standing there for hours as the morning mist lifted over the church. The sidewalks, reporters noted, were "tightly packed with young women, old women, pretty women, ugly women, fat women, thin women, all struggling and pushing and squeezing to break through police lines. Then imagine all those women quarreling one with another for struggling and pushing and squeezing, and begging, imploring, threatening and coaxing the police to let them pass."[187] Many of the police "felt a strong temptation at times to club some of the women, but their commander took pains that the gentlest means possible should be employed."[188]

Two young women dressed in black with tan jackets and passé black feather boas alighted from a hansom "with an amount of dignity that would have sufficed for a dozen empresses." They haughtily paid the cabman, bade him begone, and turned with majesty to sweep past the police into the church.

"Cards?" a policeman asked.

"Sir-r-r-r! No!" they said, raising their eyebrows far aloft.[189]

The police called their bluff and herded them back into the crowds.

Only the middle of Fifth Avenue was passable, and carriages soon jammed the street as the four thousand guests Alva had invited began to arrive.

"You will have to move to the other side of the street, ladies and gentlemen, and keep this space clear," a police officer directed. His orders were met with cold glances.

"But we are guests. We have invitations for the church," the guests cried out in chorus.

"You have to wait to present them until the doors are opened."

"Who says so?" demanded one indignant guest.

"The Inspector," the officer replied.[190]

The police were able to clear the middle of the avenue in front of the church of all the onlookers except one, a well-dressed woman "upon whose face was written in unmistakable letters, 'I won't.'"

"Madam," said the Inspector, "you can't stand there."

"Why can't I?" she asked defiantly.

"Because no one else can. We can't give you a privilege that the others do not have. So please move on."

"I won't!" was her retort. "I've got a perfect right here. You don't own the sidewalks of this city."

"I don't claim to own the sidewalks," the Inspector answered courteously. "But don't you think it would be rather unfair if we allowed you to stand here and drive the others away?"

"I don't care what you do with the others. You can't get me away from here unless you use force." And she stamped her foot.

"Far be it from me, madam," he responded with a low bow, "to use force against a lady. You may remain here as long as you like. But in order that the rest of the people may not object to your receiving special privileges, I will furnish you with a guard of honor. Sergeant?"

The sergeant approached and saluted.

"Bring me ten of your tallest men."

Ten giants assembled.

"Officers," said the Inspector, "this lady is not to be disturbed. Form a tight circle around her, all facing the lady, and do not allow any one to see her."

"You won't dare . . ." the lady began.

The men formed a suffocating ring around her, all grinning at her. She begged them to go away, she threatened them, she coaxed, but not one of them said a word. Her face, which had become red as fire, now grew white, and in sheer desperation she attempted to break through the circle. She might as well have tried to break through a stone wall.

"I want to speak to the captain," she said fiercely.

The Inspector approached her.

With eyes that blazed with fury, the woman hissed, "I'll go away! Let me out and I'll go away."[191]

The circle opened, and she ran into the crowds.

Thirty policemen, their heels braced against the street, were leaning with their backs against the mob of women to hold them back. Perspira-

tion streamed down their faces, and all the time they were begging the women to stand still. A carriage rumbled down the avenue. Thinking it must be the bride, the women "seemed to become possessed of demons." Reporters watched in amazement "as they struggled like so many drowning persons, and there being such a tremendous pressure behind them, they pushed the police line further and further toward the church."[192]

At ten o'clock, the two big front doors of St. Thomas's opened, and at once there was a rush of favored persons holding the coveted invitations. They pushed their way into the fragrant church, which now looked more like a fairyland than a house of worship, through the vestibule filled with hothouse ferns and palms.

Eighty decorators and florists had been working in the church for several days, transforming it to fulfill Alva's vision. From the dome of the church, ninety-five feet above the pews, six massive garlands of greens, laurels from New Hampshire and Maine, intertwined with lilies, roses, and chrysanthemums, draped all the way down to the galleries. The columns supporting the church were entwined with pink and white chrysanthemums and ropes of white roses. Trellises of lillies of the valley and laurel, interwoven with pink chrysanthemums, banked the walls of the church and hid the chancel rail. There was scarcely an inch of stonework or woodwork that was not decorated by vines or blossoms. At the end of every fifth pew was a four-foot-high floral torch, composed of bunches of pink and white roses, with ribbons of pink and white satin tied in a bow and flowing to the floor.

The guests hardly noticed the transformation of St. Thomas's, so intent were they on claiming a seat with a view.

Within minutes, the pews were filled with wealthy members of New York, Washington, Philadelphia, and Boston society. The six ushers, dressed in black frock coats that reached to their knees, and sporting boutonnieres of lilies of the valley and large white silk ascots set with sapphire pins, gifts from the bridegroom, found it impossible to carry out Mrs. Vanderbilt's explicit directions for where each guest was to be seated. Even as the organ recital began, "many of the women insisted on taking seats in the centre of the Church, others absolutely refused to be seated in the pews assigned to them, either on the side aisle or in the galleries, and still others actually stood on the seats whenever some

well-known woman arrived so that they might catch a better glimpse of her gown."[193] There was a "great craning of necks" when Mrs. Astor, wearing "an exquisite costume of gray,"[194] was ushered to a forward pew right behind where the governor of New York and the British ambassador sat.

The chimes of St. Thomas's rang out at noon, and at that precise moment, Alva arrived. She saw that something was amiss, gave her orders, and immediately two men began to unroll a crimson carpet down the center aisle out to the curb.

Dressed in a plain gown of sky-blue satin with a border of Russian sable, and carrying a large bouquet of white roses with streamers of blue and white satin, forty-two-year-old Alva walked triumphantly into the church and up the center aisle, escorted by her two sons, Willie K. wearing a frock coat and gray trousers and carrying a top hat, and young Harold in knickerbockers and a wide white Eton collar. "Mrs. Vanderbilt looked very bright and fresh, and wore a decided expression of satisfaction on her face as she entered the church," one reporter noted.[195]

Flutters and stirs of excitement murmured through the pews. Everyone knew how Alva Vanderbilt had torn her daughter from the man she loved and, because of her own social aspirations, had forced her into a marriage to a man who, some reporters were fond of quipping, "isn't much more than one-half as big as his titles."[196] They knew how Alva had refused to invite any member of the Vanderbilt family to the wedding except Consuelo's grandmother, the widow of William H. Vanderbilt, but she had refused to attend without the others. On that wedding day, one commentator noted, "Alva Vanderbilt was perhaps the most hated woman on earth."[197]

With Mrs. Vanderbilt seated, the bridal party would not be far behind. "The bridal procession," the *New York Times* had reported several days before, "will move up the broad central aisle of the church promptly at 12 o'clock."[198]

The ministers came out of the vestry room and took their places in the chancel; the Right Reverend Codman Potter, bishop of New York; the Right Reverend Abram Newkirk Littlejohn, bishop of Long Island, who had baptized Consuelo; the Reverend Waldo Burnett, the

chaplain at Blenheim; and the rectors of St. Thomas's and St. Mark's. All were on hand to bless this international alliance.

The ushers took their stations, three on one side of the central aisle, three on the other side.

The orchestra leader stood. He raised his baton. The fifty-member symphony orchestra was poised to strike the first crashing notes of the bridal chorus from *Lohengrin*.

Nothing happened. The church was still. No one stirred.

Here and there, a guest rustled in a pew. Someone coughed. A few ventured a quick glance toward the back of the church. There stood the duke of Marlborough in his dark gray double-breasted waistcoat, with white orchid boutonniere and pale gray gloves. The duke had been scheduled to attend the rehearsal several days before, but had not, explaining to reporters as he continued his shopping spree that "that sort of thing is good enough for women."[199] In any case, no rehearsal could have prepared him for this. There he stood, "his face almost ashen,"[200] "pulling down cuffs, arranging mustache and folding arms,"[201] glancing toward the main entrance, casting "an appealing look toward Mrs. Vanderbilt,"[202] looking at the orchestra leader, shaking his head no. NO!

Alva looked neither to the right nor the left, showing no signs of emotion. Where was Consuelo? Consuelo was five minutes late. Alva felt an attack of the Vanderbilt fidgets, but composed herself. Ten minutes passed. Where the hell was Consuelo? Now Willie and Consuelo were twelve minutes late. "My heart grew pale. Now they were fifteen minutes overdue," Alva realized. "What had happened? I no longer heard the deep singing organ and the Orchestra. I sat tense and heard my heart beat. . . . I imagined everything awful in all the realm of disaster as the cause of the delay."[203]

Every few moments, the guests seated nearest the door of the church "would get up and lean out over the aisle with much rustling, whereupon everyone else would turn in his or her seat and gaze fixedly at the spot with the feeling that in a moment, even as their eyes were fixed there, the long awaited must appear."[204]

False alarms all.

Then there was a stir outside. The orchestra leader tapped sharply with his baton to call his musicians to attention.

"Here they come at last," the guests whispered.

But no one came.

A woman's voice exploded from the balcony in the sudden hush: "Oh, will she never come?"[205]

Alva felt certain that Consuelo had not at the last minute run off with that Rutherfurd boy; it would be impossible. She had made certain of that by placing a guard at the door of her daughter's bedroom so that nobody could get near, even to speak with her.

"I spent the morning of my wedding day in tears and alone," Consuelo remembered; "no one came near me."[206]

Not even her wedding gifts, which filled her room, consoled her. Not all the pearls Alva had received from Willie and now given to her daughter: the three-foot ropes of evenly matched pearls, each half an inch in diameter, that had graced the neck of Catherine of Russia, or those that had once been the empress Eugénie's. Not the diamond tiara with pear-shaped stones that her father had given her, or the diamond belt from Marlborough, or the purse of gold mesh set with turquoise and diamonds from Mrs. Astor, or the pearl brooch from Mrs. Richard M. Hunt. Not the diamond pins from her younger brothers. Not any of the gifts, which were said to be "more numerous and valuable than the entire stock carried in many jewelry stores that do business in New York City."[207] Her mother had made her return "without excuse or thanks" every wedding present she had received from any Vanderbilt relative, "and I felt hurt and pained."[208] Consuelo picked up the pair of antique silver candlesticks from Winty, held them to her, and cried, feeling she had "betrayed the love of another man."[209]

"Like an automaton," Consuelo "donned the lovely lingerie with its real lace and the white silk stockings and shoes" and slipped into the beautiful wedding dress with "its tiers of Brussels lace cascading over white satin," its "high collar and long tight sleeves," and the "court train, embroidered with seed pearls and silver," which "fell from my shoulders in folds of billowing whiteness."[210] With the unexpected arrival of the wedding dress some weeks before, Consuelo had realized that her mother "had ordered it while we were still in Paris, so sure had she been of the success of her plans."[211]

Consuelo walked downstairs to meet her father, who was to drive with her to the church. She "felt cold and numb" as if this were not

happening to her, as if she was going into shock. Willie took one look at his daughter and realized that something had to be done quickly before they could proceed to the church. "We were twenty minutes late, for my eyes, swollen with the tears I had wept, required copious sponging before I could face the curious stares that always greet a bride."[212]

Outside, down on Fifth Avenue, a great shout arose: "The bride is coming!"

Four carriages carrying the bride and her bridesmaids proceeded down Fifth Avenue.

"The bride is coming," the women shouted, waving their handkerchiefs at the carriage. Far away began a wild fluttering of white handkerchiefs, which spread and came nearer, looking like the white crest of an incoming wave.

"Hurrah! Here she comes! Look! Look!"[213]

As the driver of Willie's carriage called to the horses and stopped with a flourish in front of St. Thomas's, the church chimes were merrily pealing. The sun had broken through the morning mist.

Willie stepped out of the carriage carrying Consuelo's enormous bridal bouquet of white orchids, and then helped his daughter step down from the carriage and disentangle her fifteen-foot train. The crowds went wild. Tall, slender, erect, and graceful, her dark brown hair brushed back in a pompadour, Consuelo looked very much like the duchess her mother had so long groomed her to be.

"Hurrah for the bride!" the onlookers shouted again and again. "Hurrah for the Duchess!"[214]

The bridal party assembled inside the church. The sexton breathed a sigh of relief, and waved his handkerchief. The orchestra leader dropped his baton, and the grand notes of the Wedding March reverberated through the church.

The six bridesmaids, in white satin gowns with royal-blue sashes and Gainsborough hats of blue velvet, started down the aisle, carrying their bouquets of red bridal roses and lilies of the valley. All those in the church rose to their feet. Then came two flower girls. As Willie and Consuelo followed, Consuelo "remembered to press my father's arm gently to slow his step. So many eyes pried my defenses, I was thankful for the veil that covered my face."[215]

Before the altar, Marlborough stood waiting, noticing that Consuelo "appeared much troubled."[216]

Consuelo cringed at the irony of the hymn as the chorus of sixty voices broke into song:

O! perfect love, all human thought transcending,
Lowly we kneel in prayers before thy throne,
That theirs may be the love that knows no ending,
Whom thou forevermore dost join in one. [217]

Consuelo glanced at Marlborough shyly. "I saw that his eyes were fixed in space."[218]

Bishop Potter addressed the young couple: "I require and charge you both as ye will answer at the dreadful day of judgment, when the secrets of all hearts shall be disclosed, that if either of you know of any impediment why ye may not be lawfully joined together in matrimony ye do now confess it. For be ye well assured that if any persons are joined together otherwise than as God's word doth allow their marriage is not lawful."

Silence.

Bishop Littlejohn came forward and addressed the duke: "Charles Richard John, wilt thou have this woman to be thy wedded wife to live together after God's ordinance in the holy estate of matrimony? Wilt thou love her, comfort her, honor her, and keep her in sickness and in health, and forsaking all others, keep thee only unto her so long as ye both shall live?"

"I will," the duke replied in a low but firm voice.

"Consuelo, wilt thou have this man?"

Only those in the front row could hear the girl's faint reply: "I will."

Willie Vanderbilt stepped up to the chancel and took his daughter's hand, placing it in Marlborough's.

"Let us pray," said Bishop Littlejohn.[219]

Consuelo and the duke kneeled on a white silk cushion for the benediction, while the chorus softly sang: "God be merciful unto us and bless us, and show us the light of His countenance." The ministers recited the benediction.

And then, as the duke and duchess left the chancel to the march from *Tannhäuser,* the duke "made a slight, very slight inclination of the

head toward the seat where Mrs. Vanderbilt sat."[220] The bride and groom, followed by the father of the bride, proceeded into the vestry room.

There, the duke's attorneys showed Marlborough, Consuelo, and Willie Vanderbilt where to sign the marriage contract they had drafted to "profit the illustrious family"[221]—the illustrious family, of course, being the duke's. Dated November 6, 1895, the document began:

> Between the most Noble Charles Richard John, Duke of Marl-borough, of Blenheim Palace, in the County of Oxford, En-gland, party of the first part, and William Kissam Vanderbilt of Oakdale, in the county of Suffolk, N.Y., Esq., of the second part, Consuelo Vanderbilt, party of the third part . . .
>
> Whereas, a marriage is intended between the said Duke of Marlborough and the said Consuelo Vanderbilt, and whereas pursuant to an agreement made upon the treaty for the said intended marriage, the sum of $2,500,000 in 50,000 shares of the capital stock of the Beech Creek Railway Com-pany, on which an annual payment of 4 per cent is guaranteed by the New York Central Railroad Company, is transferred this day to the trustees. And shall during the joint lives of the said Duke of Marlborough, Consuelo Vanderbilt, pay the in-come of the said sum of $2,500,000 . . . unto the Duke of Marlborough for his life.[222]

In addition to setting aside $2.5 million for the young couple, Willie signed a separate agreement memorializing his obligation to pay both the duke and the duchess $100,000 every year for life.

Within ten minutes, the documents had been executed. His job done, Alva made it known that Willie "was to disappear."[223] Willie left the church by a side entrance. Alva did not want him around at the wedding breakfast at her home.

As the march from *Tannhäuser* resounded through St. Thomas's, and the chimes outside rang the news to the city, the bride and groom walked down the aisle and out to the waiting carriage. "People were surprised to discover that she was fully half a head taller than the bridegroom," the papers noted.[224] As the gossip sheet *Town Topics*

summed it up: "Winty was outclassed. Six-foot-two in his golf stockings, he was no match for five-foot-six in a coronet."[225]

As Consuelo and Marlborough ("Sunny" as he was called, certainly not because of a happy disposition but rather because one of his titles was earl of Sunderland) settled themselves into the carriage, Consuelo was informed by her new husband that he had no intention ever of revisiting the United States, for he despised "anything that was not British."[226] Then "my husband spoke of some two hundred families whose lineage and whose ramifications, whose patronymics and whose titles I should have to learn."[227] Consuelo understood at once that she had gone from being "a pawn in my mother's game" to what her husband was calling "a link in the chain." "To one not sufficiently impressed with the importance of insuring the survival of a particular family, the fact that our happiness as individuals was as nothing in this unbroken chain of succeeding generations was a corroding thought."[228]

Marlborough immediately informed his new wife, "tragically," that to marry her he had had "to give up the girl he loved," but that "a sense of duty to his family and to his traditions"—the preservation of Blenheim—"indicated the sacrifice of personal desires."[229] Consuelo thereupon told her new husband that "her mother had insisted on her marrying [him], that her mother was strongly opposed to her marrying Rutherfurd, that she had used every form of pressure short of physical violence to reach her end."[230]

As the carriage pulled away from the curb after the wedding breakfast, eighteen-year-old Consuelo looked back. "My mother was at the window. She was hiding behind the curtain, but I saw that she was in tears."[231] For the first time, Alva, too, had begun to understand just what she had done.

On the morning of November 16, "after the week's seclusion custom has imposed upon reluctant honeymooners"[232] as Consuelo later described her first days with Sunny at her father's Long Island estate, the newlyweds boarded a German steamship docked at Hoboken, New Jersey. The wharf was mobbed with a crowd come to catch a glimpse of the famous young couple and bid them farewell.

Willie kissed Consuelo. "We will meet again in Paris," he assured her, as she "murmured a few words of farewell and bravely kept back the tears that were ready to flow."[233]

When Alva, who had been chatting with some friends, turned to speak to her daughter, she saw Willie. She bowed her head a little and said, quietly and calmly, "Good morning, Mr. Vanderbilt."

"Mr. Vanderbilt's face flushed slightly," the reporters noted, as "he raised his hat and bowed."[234] Alva led Consuelo to another part of the deck, put her arm around her daughter's waist, and kissed her twice. "The eyes of both were moist when they said farewell."[235]

As the steamship pulled away into the harbor, Consuelo and Marlborough stood at the rail watching the crowd watching them. The duke took off his hat and bowed again and again, while the duchess waved her handkerchief.

Later, the *New York World* pictured all twenty-seven of England's dukes, with those who were still "eligible" outlined in white. "Attention, American heiresses," the caption read. "What will you bid?"[236]

5

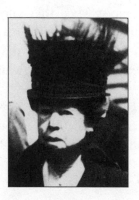

ALICE OF
THE BREAKERS

1 8 9 5 – 1 8 9 9

1.

On Consuelo's wedding day, Alva Vanderbilt might indeed have felt herself "the most hated woman on earth."[1] "As soon as my daughter's engagement was announced, very disagreeable letters began to pour in upon me from persons wholly unknown to me but who evidently disapproved of the marriage and felt called upon to tell me so . . ." Alva wrote in a draft of her memoirs. "All these letters were clearly from unbalanced people who seemed to think

they could interfere with the private lives of others. Some of them even threatened to kill the Duke, others, to blow up my house before the date set for the wedding. Many hinted at a resort to violent measures to prevent the marriage."[2]

Alva's sister-in-law Mrs. Cornelius Vanderbilt II, Alice Vanderbilt—who had insisted that her family spend the day of Consuelo's wedding in Newport, as far away from the spectacle as possible—shared the sentiments of many of these letter writers. She readily understood how Alva Vanderbilt could be the most hated woman on earth, for Alice had always hated Alva. Alice reveled in the stories New York City's *Town Topics* printed about her sister-in-law. Alva Vanderbilt was "unstable," it reported. She was "irresponsible." She was putting on weight. She had worn the same dress to several balls. She used "expletives of a character to turn all the milk in the refrigerators."[3] Alice agreed that Alva was despicable.

Cornelius Vanderbilt II was as different from his brother Willie as Alice was from her sister-in-law Alva.

A lifelong acquaintance of Cornelius Vanderbilt's remarked that he never once recalled seeing him smile. There is no evidence that this story was apocryphal.

Born in 1843, the first of eight children of William and Maria Vanderbilt, Cornelius Vanderbilt had grown up on his father's Staten Island farm long before his grandfather, the Commodore, recognized William's business acumen. The very fact that William Vanderbilt named his eldest son Cornelius should have tipped the Commodore off that perhaps Billy was not the "blatherskite" he thought. In any event, the Commodore saw more promise in serious young Cornelius than he did in blundering Billy, and took a special interest in his first grandson.

Young Cornelius attended the little country school in New Dorp until he was fifteen, and then decided it was time to earn his living, seeking employment from John M. Crane, the president of the Shoe and Leather Bank.

"I see you are a Vanderbilt," Mr. Crane said. "Are you a relative of the Commodore?"

"He is my grandfather," Cornelius replied.

"Why don't you ask him to recommend you?" Mr. Crane inquired.

"Because I don't want to ask him for anything," the young lad replied.

When the Commodore heard this story from Mr. Crane, he was pleased. He later asked his grandson why he had not come to him for employment and received the same reply, which pleased him more.[4]

Cornelius labored long hours at the Shoe and Leather Bank at a salary of thirty dollars a month, boarding in the city during the week, returning to his parents' farm on Staten Island on Saturday night to spend Sunday with his family. "Cornelius was one of the best boys we ever had and one of the most conscientious workers," Mr. Crane remembered. "If anything, he was too conscientious. Trifles that the other clerks would think nothing of would worry him half to death. He was eminently industrious, fair and square, and everybody liked him, although I believe none of the boys knew him well."[5]

One day, the Commodore came to visit his grandson at the Shoe and Leather Bank to tell him he was sailing to Europe, and to invite Cornelius to join him.

"I am going myself," said the Commodore, "and I'll take you along if you want to go."

"And give up my salary?" the bewildered young Cornelius wondered.

"Well, I don't suppose it will go on while you are gone," the Commodore replied.

"Then I guess I'd better stay," young Cornelius reasoned.[6]

The Commodore smiled with delight. What a grandson! "If a boy is good for anything," the Commodore remarked, "you can stick him down anywhere and he'll earn his living and lay up something; if he can't do it he ain't worth saving, and you can't save him."[7] In the Commodore's eyes, young Cornelius was proving worthy of the great name he bore.

Still skeptical of his son William's ability to step into his shoes, the Commodore began to groom his grandson Cornelius to play a part in the family business, making him assistant treasurer of the New York and Harlem Railroad. His punctuality, politeness, and love of hard work endeared him to his grandfather, who made him treasurer of the New

ALICE OF THE BREAKERS

York and Harlem Railroad with a hand in the management of the New York Central, all by the age of twenty-four.

After the Commodore's death, Cornelius became the vice president of the Harlem and first vice president and chief of the finance departments of the New York Central and Hudson River railroads, and upon his father's retirement in 1883 he became the chairman of the board of directors of the New York Central.

In a few brief years, Cornelius Vanderbilt's station in life had changed dramatically. It changed even more on December 8, 1885, the day his father died. As the *New York World* put it: "It is remarkable how high Cornelius stood in the estimation of men yesterday. The day before he was nobody; to-day he is a king. Everybody speaks well of him, of his conservatism and his executive ability."[8] He was now the most powerful businessman in the United States and one of its wealthiest citizens. Yet his dedication to work was just the same as it had been as a clerk at the Shoe and Leather Bank.

Forty-two-year-old Cornelius Vanderbilt was neither tall nor short. He was neither heavy nor thin. With the spectacles and slightly rounded shoulders of an accountant who had spent too many hours poring over ledgers, with his close-cropped dark brown hair that was turning gray, a Roman nose, and a high-pitched voice, he would not have made an impression on anyone who did not know who he was. Long before the first of the clerks arrived in the morning, he could be seen at his rolltop desk at the Grand Central Depot in the large office on the second floor that once had been his father's and before that his grandfather's, with a full-length oil portrait of the Commodore on the southern wall and one of William H. Vanderbilt above his desk on the northern wall. There he pored over information from all the Vanderbilt railroads, while softly humming to himself some favorite tune. An accountant by temperament and trade, he carried with him at all times a notebook in which he recorded every investment that he made, and many of the minor details of his business interests, keeping careful records of the entire Vanderbilt railroad system, not neglecting a single road. It was said that daily he knew his precise net worth.

As would be expected, he managed his inheritance cautiously and conservatively, never expanding the scope of his personal investments

outside of the Vanderbilt railroad interests to include positions in any of the emerging industries of the day, and never taking any bold steps to expand the Vanderbilt railroad empire. In 1892, for example, an officer of the Union Pacific came to Cornelius and his brother Willie for assistance in keeping the railroad out of the grasp of Jay Gould. "I told the Vanderbilts they could have this property, the control of it, for practically a few millions of floating debt. They replied that it was more and more a settled policy that they would not move their management or interests west of Chicago."[9] And so it was that the Vanderbilts blithely passed up the control of a line that would have opened up for them a transcontinental system.

An acquaintance described Cornelius Vanderbilt as "a serious man with a quiet, resolute manner. He worked harder than any of his clerks. We took luncheon at the same downtown club. Vanderbilt never spent more than twenty minutes over his light meal—could not give the time to linger and talk with the rest of us."[10] Like his father before him, Cornelius was finding that running the Vanderbilt railroads, the management of which his brothers had left largely to him, was all-consuming. "I feel tired almost all of the time," he told a colleague who urged him to take time off more often, "but I would rather be in New York where I can look in at the office, than in the country."[11] It was a full-time job being chairman of the New York Central, the president of seven companies within the Vanderbilt system, the vice president of the Beech Creek Railroad, and a director of forty-two companies. Yet Vanderbilt devoted a full quarter of his time to his charitable interests. A vestryman of St. Bartholomew's Church, a member of the finance committee of the Protestant Episcopal Board of Foreign Missions, a member of the executive committee of the International Young Men's Christian Association, a trustee of the Bible Society, chairman of the executive committee of St. Luke's Hospital, a director of the House for Incurables, a director of the College of Physicians and Surgeons, a director of the American Museum of Natural History and the Metropolitan Museum of Art, president of the New York Botanical Gardens, a trustee of Columbia University—he faithfully attended every committee meeting of each organization and spent additional hours researching and weighing the thousands of requests for assistance that crossed his desk, donating, often anonymously, hundreds of thousands of dollars each year to religious and

charitable institutions, as well as to individuals who seemed to need his help. He once noted that in a typical day's mail he received requests for contributions that exceeded his annual income.

Beyond these responsibilities, he regularly found time to visit the patients in St. Luke's Hospital, and was never too busy to help those who were aged and poor. One summer afternoon he saw an elderly lady burdened with a heavy basket, trying to make her way from one cross-town streetcar to another, scarcely able to drag herself along. He alighted from his carriage, gently took the basket out of the old woman's hands, and assisted her aboard the next car.

Chauncey Depew's office at the New York Central adjoined Vanderbilt's, with a door between the two that was always open. "He was a man who loved work for work's sake," Depew noted. "Work seemed to be his recreation. He would transact what business there was to do, attend to all the matters relating to the various philanthropic and charitable enterprises in which he was interested and finally clear up his desk. As soon as he had done so he would come into my office and fairly beg for work to do. He never seemed to tire of it."[12] And, indeed, he did little else, having no interest in horses like his father and grandfather, or in yachts like his brother Willie, or in any other sport or hobby.

Cornelius Vanderbilt was, as a contemporary well described him, "always courteous, considerate and gentle. . . . He is never heard to use a harsh or impure word and is known for his blameless, upright life."[13] He found in 1867 the perfect wife in a fellow Sunday school teacher at St. Bartholomew's: tiny, not quite five-foot Alice Claypoole Gwynne. Quiet, reserved to the point of seeming shy or cold, Alice Vanderbilt acted like the Sunday school teacher she was. The Commodore, it was said, was disappointed with this petite, plain lady his oldest grandson had married; but if he had lived to see the pluck of which she was made, he would no doubt have been proud. The couple lived unostentatiously, raising their seven children—Alice born in 1869, William in 1872, Cornelius in 1873, Gertrude in 1875, Alfred in 1877, Reginald in 1880, and Gladys in 1886—and attending Episcopal services daily, twice a day if their schedules permitted.

Only one person destroyed the quietude of their life: Alva Vanderbilt.

The trouble all began, Alice always believed, when Alva, that little

southern snippet, curried the favor of her father-in-law, William H. Vanderbilt, and wheedled her way into his will. Had it not been for Alva's influence on her father-in-law, Willie would never have received half of his father's residuary estate; he would have received $10 million just like the rest of his brothers and sisters, while Cornelius, as the oldest son, would have received the entire residuary estate. Alva and Willie therefore had cheated her husband, Cornelius, out of an extra $55 million. But even worse, in Alice's eyes, was that her father-in-law's division of the bulk of his estate between his two oldest sons—Cornelius and Willie—left it ambiguous as to exactly who was to be the next head of the House of Vanderbilt. And that was when the real trouble began.

It was to his grandson Cornelius that the Commodore had bequeathed the cherished portraits of his mother, Phebe, and his first wife, Sophia, and it was on Cornelius that he had conferred $5.5 million in railroad stocks, leaving only $2 million each to Cornelius's brothers, Willie, Frederick, and George. And it was to his son Cornelius that William Vanderbilt bequeathed the portrait and the marble bust of the Commodore, and to whom he gave an extra $2 million. Surely there could be no clearer signs that Cornelius had been crowned patriarch of the family and the Vanderbilt empire.

The problem was that Willie, spurred on by that vixen Alva, was acting like the head of the House. This impression could not be allowed to stand. And so the two Sunday school teachers from the parish of St. Bartholomew's were drawn into a race to spend money and flaunt their wealth, the likes of which the world had never seen.

When Willie's carriage was seen traveling up Fifth Avenue with two footmen on the box, Cornelius and Alice assigned two footmen to their carriage. When the Willie Vanderbilts stationed a watchman in front of their home, Cornelius and Alice stationed two of the biggest servants they could hire, dressed in Vanderbilt maroon with black silk breeches and black silk stockings, to open their front door.

And then there was the matter of Alva's French château at 660 Fifth Avenue. Until then, Alice and Cornelius had been quite content to live at their house at 72 Park Avenue, quietly raising their children. But if Alva was trying to proclaim to the world through grandiose architecture that she was Mrs. Vanderbilt, they would teach her a thing or two.

ALICE OF THE BREAKERS

It was a common belief at the time that Alice Vanderbilt set out to dwarf her sister-in-law's Fifth Avenue château, and dwarf it she did. Designed by George P. Post, a student of Richard Morris Hunt, the Cornelius Vanderbilts' own five-story French château of red brick with gray limestone trim and a red slate roof, with great stone gabled dormers, chimneys, turrets, and balconies, rose on the parcels of land they had acquired at 742–746 Fifth Avenue and 1 West Fifty-seventh Street. It was a structure that newspapers called "the largest dwelling-house occupied by a single family in the city of New York,"[14] designed to show just how millionaires should live. "The city now possesses a private house which must for a century or two elevate the standard of such houses," one paper reported, "and tend, at least, to the improvement of domestic architecture."[15]

Larger! The house must be made larger! Several years later, in 1887, Cornelius bought up adjoining land on Fifty-eighth Street for $414,000, tore down five town houses and expanded his mansion, until it and a tiny formal garden occupied the entire block of Fifth Avenue between West Fifty-seventh and Fifty-eighth streets, providing a superb view over Grand Army Plaza into Central Park. "I want to dominate the Plaza,"[16] the pious Cornelius modestly explained, as he paid hundreds of laborers extra wages to work into the night by the leaping flames of huge bonfires, so that the renovations would be completed quickly.

Alva's château was universally admired for the beauty of its design and its striking architectural elegance. The most that could be said for Alice's new home was that it was much larger than Alva's. It was a mansion of "depressing, gloomy splendor,"[17] as one of Alice's grandchildren later described it, an imposing meaningless monstrosity, but it served its purpose. Let there be no doubt about it, the house proclaimed, the Cornelius Vanderbilts are richer than the William K. Vanderbilts. The Cornelius Vanderbilts are richer than you. The Cornelius Vanderbilts are richer than anyone.

Passing through sixteen-foot-high wrought-iron gates, intimidated guests were glacially welcomed in a grand hall forty feet long, fifty feet wide, and thirty-five feet high, all of carved Caen stone, a hall that one reporter called a vestibule "larger than the Supreme Court of the United States."[18] Conspicuously opened on a table was a leather-bound book showing Alice's family lineage; Alice had tried, in vain, to trace the

Vanderbilt roots back to some appropriate nobility. ("Alice is happy at last," Alva Vanderbilt remarked. "She's found she's descended from William the Conqueror."[19]) The hall spilled into large connecting salons and a library, all of which could be opened to increase the size of the sixty-four-by-fifty-foot ballroom, with a ceiling forty feet above the dance floor.

Visitors found the mansion chilly and uncomfortable, built for social functions but not for living (though it certainly never became known for its hospitality; one socialite remembered puritanical Alice's parties "especially for their ornate dullness"[20]). A houseguest noted that the mansion "was furnished before the day of interior decorators and was done in the worst of the French and Victorian periods. Much application of gilt everywhere."[21] The dining room, which could easily seat two hundred, "was ponderous and heavy with red velvet hangings and atrocious oil paintings of pastoral scenes—badly painted cows and unnatural looking trees."[22] On the walls in other rooms hung "exceedingly bad portraits of the whole family."[23]

Two elevators took the family to their suites on the second and third floors, if they chose not to use the massive staircase. Cornelius's master bedroom had a commanding view over Grand Army Plaza. Looking out one morning, he noticed that the city had erected a fountain with a bronze statue of a nude woman bathing, the Lady of Abundance, with the back of the statue toward his mansion. Shocked and offended, he contacted City Hall and patiently explained the problem, requesting that the indecent statue be removed. When he was told the statue would stay, he moved a block away, changing his bedroom to the other side of the house. "The old boy couldn't stand the 'rear' view," one of his children chuckled.[24]

A friend of Alice Vanderbilt's called her "a woman of arrogant solemnity,"[25] and so she was, this Sunday school teacher of St. Bartholomew's Parish who made the transformation to empress of Fifth Avenue without missing a beat, preaching with her dour husband the Puritan ethic of piety, charity, and hard work while living amid visible riches that were beyond belief. To run this colossal structure of 137 rooms took more than 30 servants—butlers, valets, ladies' maids, footmen, housekeepers, a chef, assistant chefs, pantry boys, parlor maids, upstairs maids and scrubbing maids, laundresses, chauffeurs, seamstresses, and

guards. At least no additional help had to be hired when the solid gold service was brought out for a party of two hundred guests: The Vanderbilts were ready. The menservants were housed in the basement rooms, the women servants on the upper floor. Alice spoke to her servants exclusively through her head butler. The story was told of the evening she arrived late at a party because, though she knew the way to the hostess's home, she refused to speak directly to her chauffeur who had become hopelessly lost. Once a day, diminutive Alice put on one immaculate long white kid glove and ran a finger over antique furniture, carved mirrors, and heavy picture frames. If the glove was sullied by a mote of dust, the maid responsible for that room was summarily fired.

One of the Vanderbilts' small children once watched a maid shaking a rug from the window.

"Mother, what's that lady doing?"

Alice recoiled.

"That is no lady," she instructed her child. *"That's a woman."* [26]

Hardly had the work been completed on the addition to their Fifth Avenue mansion when there arose the battle of The Breakers.

In 1885, Cornelius Vanderbilt had purchased for $450,000 the Lorillard family's Newport summer cottage, The Breakers, a large wooden-frame mansion on Ochre Point, a twelve-acre headland jutting into the Atlantic. The Vanderbilts added a new wing, a greenhouse, and a playhouse for the children that was actually the size of a small house. In his spare moments, the French chef came to the playhouse and taught the Vanderbilt girls how to cook on the miniature stove, serving the meals on monogrammed plates. The children were also able to gain some practice in the playhouse for someday running The Breakers; the two rooms of the cottage each had a button, so that the children could summon the butler or upstairs maid from The Breakers to handle any unpleasant problems.

The Vanderbilts fell in love with Newport and The Breakers, which was one of the grandest houses of the resort, and often were the first family to arrive in the late spring, the last to leave in the fall. It was their purchase of this mansion that led Alva to ask Willie for a Newport cottage for her thirty-fifth birthday present in 1888. When it opened in the summer of 1892, it was obvious to Alice that Marble House far

surpassed The Breakers, as it did every other Newport mansion. Alva had won the battle again.

But the war was not yet over. On the cold, windy afternoon of November 25, 1892, a fire started in the overworked heating system of The Breakers and roared through the wooden frame structure, completely demolishing it within an hour. No one was injured in the blaze, and Cornelius was not very concerned about the loss of his summer cottage. "Nothing can be done but let it burn," he told the firemen.[27] "I don't care so much for the house; that can be rebuilt—but I hate to lose my pictures,"[28] and the priceless tapestries, furniture, linen, and silver with which The Breakers was stuffed, he might have added.

Cornelius Vanderbilt immediately summoned Alva's architect, Richard Morris Hunt, and told him he wanted a modest two-story residence to replace The Breakers. Alice had other ideas. Within a month after the fire, Hunt submitted plans for a French Renaissance château, similar to the Vanderbilts' Fifth Avenue mansion. Cornelius rejected this plan. By January 12, 1893, Hunt came back with new sketches for a mansion modeled after the sixteenth-century palace of a Genoese merchant prince. The Vanderbilts settled for this plan—a seaside palace that would occupy one full acre of the twelve-acre site.

Richard Hunt soon concluded that working with Alva Vanderbilt had been a sheer delight compared to dealing with her sister-in-law Alice. According to Hunt's wife, Alice Vanderbilt did not practice "the courtesy to which Richard had hitherto been consistently accustomed," and as a result "he chafed under [her] unconscious rudeness, and it made the work trying occasionally, not only for him but for [her] husband." She was an "exacting" lady, "insistent in [her] demands."[29]

Her first demand was that the new home, which she had already named again The Breakers, be fireproof, and fireproof it was, constructed of a steel-beam framework covered with brick, stone, and tile, with a buff Indiana limestone exterior and red tile roof. The kitchen, as large as an average home, was isolated in a separate wing. The heating plant was buried near the caretaker's cottage several hundred feet from the house, with a boiler room and storage rooms for hundreds of tons of coal, and a connecting tunnel to the mansion big enough to drive through with a team of horses.

Her second demand was that it be bigger than Marble House. And

it was, with its four stories, seventy rooms, thirty baths with hot and cold fresh water and salt water piped in from the sea, and thirty-three rooms for servants. The eleven acres surrounding the mansion were covered with sod imported from England, and numerous thirty-ton trees planted around gave the place an appropriately venerable look.

A visiting Englishman pointed to the huge structure and asked his hostess what it was.

"That is The Breakers," she replied.

"Ah, The Breakers," he repeated. "I *knew* it must be a hotel."[30]

Newport society soon dubbed Alice Vanderbilt "Alice of The Breakers," the tiny lady with the big house, to distinguish her from the resort's other preeminent builder, sister-in-law Alva Vanderbilt.[31]

Her third demand was that her new summer cottage be more luxurious than Marble House. If The Breakers didn't surpass Marble House in conspicuous extravagance, it at least equaled it.

"The Breakers," one guest noted, "was imposingly and magnificently Vanderbilt."[32] The house was constructed around a great hall, an open space forty-five feet high onto which second- and third-floor galleries opened, suggesting an Italian courtyard, with its trompe l'oeil ceiling painted like a blue sky with summer clouds. The great hall set the tone for the style of the house: huge, open, and airy, with ornate paneling, pilasters, columns, and chandeliers. Opulent Italianate interiors surrounded the great hall, including the spectacular two-story formal dining room, twenty-four hundred square feet, highlighted with twelve red alabaster columns topped with Corinthian gilded bronze capitals, a ceiling canvas of the goddess Aurora, two 12-foot Baccarat chandeliers, and royal-red damask draperies. An adjoining billiard room was paneled in twenty varieties of marble. (This room contained a ceiling mosaic of a mother and children in a Roman bath; the prudish Alice insisted that the nudes be draped before she would move into the house.) Entire rooms were constructed, carved, painted, and gilded in France, disassembled, shipped to Newport in huge packing crates, and reassembled in The Breakers by the French workmen who had constructed them, thereby helping Hunt to meet Alice Vanderbilt's overriding demand that this masterpiece be finished in record time, no matter what the cost.

Construction began in the spring of 1893. With the work of two thousand laborers and artisans and artists, some working during the day,

others at night with the aid of electric lights, The Breakers was ready for occupancy in the summer of 1895, an amazing accomplishment in a day when all work was done by hand, by pick and shovel, and with horse-drawn carts. Limitless wealth could indeed accomplish anything.

It had been worth the $7 million it cost (plus the millions more to furnish it), for the summer of 1895 would prove to be the only summer Cornelius Vanderbilt would ever enjoy his new cottage.

2.

Alice and Cornelius Vanderbilt could click their tongues and sigh to themselves about what Alva had done to their niece Consuelo; they could show their disdain for Alva's royal matchmaking by not attending the wedding; but they really could not say a word about it, for the problems they were experiencing with their own children were vexing and embarrassing.

Alice and Cornelius never knew what to make of their daughter Gertrude, who was born in 1875, a year after their first daughter, Alice Gwynne Vanderbilt, had died in childhood.

Gertrude was so strange. She idolized her two older brothers, William and Cornelius, imitating everything they did. "One of the first things I remember was how I longed to be a boy. I was four years old when unable to resist the temptation longer I secreted myself in my mother's room and proceeded to cut off my curls. This it seemed to me was what distinguished me most from my brothers; they said only girls had curls, so mine were sacrificed and all I gained was a severe punishment."[33] When a third and fourth son, Alfred and Reginald, were born to the Vanderbilts, Gertrude "longed more than ever to be a boy. But even though Fate had given me this burden to bear I certainly rebelled at it by letting my actions be entirely those of a boy."[34] While Gertrude's younger cousin Consuelo was strapped to a chair in Marble House, tutored in foreign languages, and trained to walk like a duchess, Gertrude and her brothers were gathering wild blackberries, picking strawberries in the Newport fields, climbing the rocks along the ocean, playing tennis, and swimming in the surf at Bailey's Beach.

Alice had decorated her daughter's bedroom in their palace on

Fifth Avenue in a decidedly feminine style. "She opens her eyes on the prettiest room in all New York," reporters marveled. "It is on the corner of Fifth Avenue and Fifty-seventh Street. . . . The wall is hung with white silk and so is the ceiling, where the rich material is drawn up in the center in canopy fashion. The little single bed, the dainty dressing-table, the dressing-stool, desk and some of the easy chairs are of white mahogany, inlaid with quaint wreaths and garlands of mother-of-pearl. The canopy and curtains for the snowy bed are of the filmy bolting cloth, embroidered in pink roses and blue forget-me-nots. All the brushes, mirrors, combs and toilet bottles on the dressing-table are of Dresden china, covered with roses and forget-me-nots, and with the monogram 'G.V.' in gold."[35] Gertrude would retreat to her bedroom for hours on end to write, from her youngest days filling pages of diaries and journals with the questions and problems she could not raise with her brothers, and certainly not with her distant parents. And from her earliest writings right through those of her teenage years, the thoughts and reflections she committed to paper repeatedly grappled with the torment of being the daughter of the richest parents in the world. Was a friend a true friend, or only a friend because Gertrude's father was so wealthy?

"Speaking of best friends makes me think that I always said I had none," Gertrude wrote in her diary, "and perhaps it was true. My first real friend was Alice Blight. I think she loved me as much as I loved her. Sometimes I used to imagine it was not for myself she loved me and then I think I was the most unhappy girl that ever breathed."[36]

"I look into the future," Gertrude wrote at eighteen, "and imagine I see myself, grown up and out. I meet a man. I love him. He is attentive to me for my money. He proposes, makes me believe he loves me. I accept, since I love him. We are married. Now, since money is secure, he shows me that he does not love me. I love him still and am wretchedly unhappy. We lead separate lives, he going his way, I mine. And thus we grow old."[37]

What but money did Gertrude have to offer anyone? she wondered time and again. "How anyone can see anything in you I am sure I don't know," she wrote to herself in her diary. "You are only nice looking, you are not one bit entertaining or amusing, you are stupid, you are conceited, and you are tiresome, you are weak, you are characterless, you are cold and reserved, small and narrow minded, ignorant and unwilling to

learn, you think you are always in the right, you are shy and foolish, your waist is big, your hands and arms badly formed, your features out of proportion, your face red, your legs long, now—what have you to say for yourself?

"I have something to say in spite of all that," Gertrude answered herself. "You know my hair is curly, my mouth small and red, my complexion very good, my movements graceful, my expression sweet."

But she was not yet through with her self-abuse.

"Stop, that is nothing, you exaggerate. Your hair is curly but not a pretty color, simply a dull brown. Your mouth may be small and red, but it is weak, your complexion is too red and spotty, you are not graceful, your expression, when you have any, is stupid.

"My voice, then, it is said to be silvery?

"Yes, perhaps by some idle talker who wanted to flatter you."[38]

"I cannot remember when I first realized who I was," Gertrude, when she was eighteen, wrote in a notebook she entitled "My History." "It must have been very slowly brought about, this realization, for I can put my finger on no time when it burst upon me. At any rate when I was eleven I knew perfectly that my father was talked of all over, that his name was known throughout the world, that I, simply because I was his daughter, would be talked about when I grew up, and there were lots of things I could not do simply because I was Miss Vanderbilt. That I should have to go through life being pointed at, having my actions talked about, seemed too hard. That I should be courted and made a friend of simply because I was who I was, was unbearable to me. I longed to be someone else, to be liked only for myself, to live quietly and happily without the burden that goes with riches. Of course time made all this easier to bear, and when I was eighteen I felt as if I could hold my head up under it, and that I would act my part well for God had put me there, just where I was, and if He had not meant me to have strength to go through He would never have put me where I was. So I became to a certain extent reconciled to my lot. If I was liked for my worldly possessions, why I gave nothing in return and lost the respect I might have had for the person. It was a simple arrangement and for anyone as self-centered as myself it was not such a hard one. For let me tell you I had friends in spite of the terrible obstacle which stood in our way.

There were girls who liked me for myself, I know it. I was not altogether unlovable, I think."[39]

Gertrude never doubted that Esther, the daughter of the Vanderbilts' architect, Richard Morris Hunt, liked her for herself. At nineteen, Esther, like Gertrude, was tall and attractive. Gertrude counted it among the "thrills of my life when Esther kissed me."[40]

One evening in September 1893, when Gertrude returned home late from a long drive with Esther, Alice Vanderbilt called her daughter into the parlor. There, "in a terrific tone as if very, very much provoked," Alice forbade Gertrude to go to Esther Hunt's again for a month.

Why? Gertrude asked.

"Because I don't like the way you act—with her."[41]

Gertrude ran up the great flight of stone stairs to her room, locked the door and cried, confiding to her journal the agony of having to "sit by and hear your best friend picked to pieces or the fact of your having three letters in the same week from the same girl laughed at and mockingly alluded to. Listen to your friend being called a runner after rich girls, with a knowing look in your direction . . . If I have children of my own, they will tell me everything because they know I will understand and sympathize, yes, if my prayer is granted, I will live over my youth with them."[42]

Gertrude was baffled by her feelings toward Esther. "I loved her more yesterday afternoon than I have ever done before. I felt more thrill at her touch, more happiness in her kiss."[43] "Do I love her?—that is the question. . . . I know I am perfectly happy to sit hand in hand with Esther and not say anything, but does that mean very much? I know so painfully little of love that I cannot tell you."[44]

Gertrude recorded in her diary an imaginary conversation she had with her mother, who continued her campaign to eliminate Esther from Gertrude's life. She labeled the entry "What I should like to have out and done with once and for all":

MAMA: It is enough, Gertrude, you know I cannot stand those people, they run after you, oh Esther is such a friend, she is so fond of you. Now I wish it to stop. You are not to go there any more.

I will not have it. Do you hear me? Esther has no bringing up, I will not have you running there all the time and her coming here and staying till I don't know what hour.

G.V.: Of course, you can prevent my going to see her [Gertrude defiantly responded in her diary], but if you think you can change my opinion of her you are mistaken, that's all there is about it. Because the Hunts are not quite swell enough, of course they are not worth having anything to do with. I know perfectly well that you have been trying for over a year to prejudice me against Esther. You have said as many disagreeable things about her as you dared to, and the best of it is you have imagined you were influencing me. You think you can twist me round your finger, and let me tell you that the only thing you have succeeded in making me do is in telling you less and less about myself and my affairs and something else which I think I had better not say. . . . I am old enough to make my own friends. Because I have seemed to agree with you is no sign that I did. I used to think it was my duty to do in almost everything as you wanted me to, now I think I am old enough to do more as I want and I am going to speak my opinions hereafter and not only think them. You may call me undutiful and all that sort of thing, but if you will take a child the wrong way, I think you have to suffer. I know I have no right to say that, but it is true, and I know Alfred feels the same way about it. That is why we have never told you more. Other children tell their parents almost everything, I never did. Now it's all out, it's been there so long I knew it had to come sometime. Thank goodness it is over.[45]

For her twentieth birthday, Esther gave her good friend a leather-bound album, which she inscribed inside:

To my Gertrude
To see her is to love her,
And love but her forever,
For Nature made her what she is
And never made another.
> from
> Esther.[46]

On the pages of the album, Esther had copied love poems through the ages.

Several days later, Esther wrote to Gertrude:

Gertrude dearest, I love you so entirely that if I thought you really liked anyone else more than you do me, I do not know what I should do. . . . Sweetheart, I wonder if you really know how much you are to me—Do you ever feel blue for me and does your heart ever ache for me? Gertrude, answer this letter in the evening when you have gone up to bed and keep it before you—I love you and I would give *anything* in this world if you were only Gertrude—anything but Vanderbilt—Somehow I always feel as if your Mother thought you were too good for anyone to know well because of this and yet there are many things that equal money, more than equal it, but America seems given over to nothing but this—Please take this in the right way, my Gertrude, if you are to be open with me, I am going to be entirely so with you—I want you now, all the time, I slept with your letter in my hand under my pillow.[47]

Within a day or two, Esther sent Gertrude a little book in which she had written eight love letters, one of which read:

My Darling—

It is when the lights are out and when I am all alone and all is quiet, that most I want you—Then, if you could only come to me and lie beside me and let my arms enfold you, and let me feel your dear head so near me, that to reach my heaven I only had to lean a little more towards you and draw you closer—Your mouth—Gertrude, your mouth someday will drive me crazy, I kiss it softly at first, perhaps shortly too, then for longer, then somehow I want you all, entirely, and almost I care not if I hurt you—then gently again, because I am sorry—So I love, even worship you—

Esther—[48]

Worried about their daughter's future, Cornelius and Alice Vanderbilt went to great pains to launch twenty-year-old Gertrude into society and find her a suitable husband, throwing a coming-out party for her at The Breakers with three hundred guests, including "representatives of the British and French embassies, the Belgian ministry, and the

Spanish legation"[49] perhaps in an effort to entice a foreign suitor, flooding their home with eligible young men, and sending Gertrude off to ninety-two dinners, dances, evenings, and operas that winter season of 1895. The privacy-loving Vanderbilts even did the unthinkable: They invited reporters into their home to do a feature story on Gertrude. HOW THE PRETTY HEIRESS ENJOYS LIFE was the title of one newspaper article that read like an advertisement for Gertrude Vanderbilt:

> Miss Gertrude Vanderbilt, the richest prospective heiress in America, is still a girl in skirts to her shoe tops. Her father's fabulous wealth is estimated at $150,000,000. . . . Her portion of the estate will hardly be less than $20,000,000. It must be a pleasant sensation to live in a $7,000,000 house and to have most of the good things of life without even the trouble of wishing for them. This is the goodly heritage of Miss Gertrude Vanderbilt. . . . The richest debutante in America is as sweet as a May blossom, this fortune-favored young girl, and as modest and unassuming as any little country maid. . . .[50]

The Vanderbilts' campaign worked. Gertrude was besieged by suitors and relished every minute of it, awakening after a puritanically repressed adolescence to become infatuated with a new male on what seemed a weekly basis.

There were still the nagging doubts. Even though each of the carefully selected young men to whom she was introduced was of exactly the proper background and wealthy enough not to be a fortune hunter, she sometimes wondered if each eligible bachelor "talked to me because I am Miss Vanderbilt."[51]

"If I wanted, I could make him propose in less than a week," she wrote of one suitor.[52] And then she wondered why this was so. "I am an heiress," she wrote in her diary, "consequently I know perfectly well there are lots of men who would be attentive to me simply on account of that. When I first fully realized that to be the case I was terribly unhappy and wished I might be a poor girl so that people would only like me for myself. Now I have become used to the thought and I face it boldly, as I must, and try to make the most of it. What I want to know is this—do you think it possible for anyone to love me for myself entirely? That the money would—no, could—make no difference? That

anyone in all the world would not care for the money but would care as much as his life for me?"[53]

Gertrude was sure of one thing: "I could never marry without love. I couldn't. Absolutely."[54] Gertrude would not marry "for anything except love because I have everything else."[55]

All her doubts disappeared when she was with a man who made her fall head over heels. Just in her twentieth year, there were, among others, Bobby Sands, who ordered flowers for every day of the transatlantic voyage she took with her family; Jim Appleton, "who was so nice that I believe in the whole world there is no one quite as nice. . . . He is the best looking man I have ever known and he is simply a brick";[56] "when Lispenard Stewart leaned over to speak to me and pressed his shoulder against mine, it almost undid me entirely";[57] Jim Barnes: "tonight he will be at the house—tonight I will be near him, I will hear his voice, will look in his eyes, will sit at the same table with him, will breathe the same air that he breathes."[58]

That particular night, after dinner, as Jim Barnes and Gertrude sat in the drawing room with the other guests, "something happened," Gertrude confided to her diary. "I don't know if I ought even to tell you. But still, there is no harm and I tell you he is the only man in the world I have ever allowed to do what I allowed him to. Of necessity, we were very near. He was rather restless and his foot pushed up against mine. First, I moved it away, but it happened again and this time I could not resist. I left it there. And for the rest of the evening we were thus off and on. I would have taken mine away but he always came back, not in a horrid, pushing way—but—oh my God, if I was wrong forgive me. It flashed through me that he might think less of me for it, and imagine I allowed other men to do the same, but when I looked into his face, his eyes, and saw there something that made me almost tremble, I could not resist and I let my foot rest against him to show him my life was his to make or mar, just as he chose. Well, the evening came to an end only too soon—oh God, if it could only have lasted forever—and I went home."[59]

And then there was the boy in the mansion across the street, Harry Whitney. "Harry Whitney is a brick! There is no doubt about that. Harry is bully and we are going to be friends. I was just thinking, now suppose Harry did ever care for me. I know he *likes* me *very* much now,

but there would be no reason to be nice to me if he didn't *really* care."[60]

Gertrude recorded in her journals precisely the amount of time she was with the current object of her affections. For example, one list was headed "When I have seen Mr. (Jim) Barnes":

> December 8th, 1894, Sokes dinner, introduced only.
> June 15th, 1895, Lenox Golf Links, 1¼ hours.
> July 3d, 1895, Dinner at Home, 1 hr.
> July 5th, 1895, Sokes dinner, 5 minutes.
> July 6th, 1895, Barnes lunch, 20 minutes.
> July 7th, Call, Lenox, 25 min.
> Nov. 24th, Church, 3 min.
> Nov. 30th, Sloane dinner, 1 hr.
> Dec. 2d, Home dinner, 1½ hr.
> Dec. 6th, Opera, 10 min.
> Dec. 8th, Walking from church, 15 min.
> Total 3 hrs. 23 min.[61]

"I was in 'Jim's' house today!" Gertrude exulted in her diary after a visit with Jim's sister, Charlotte Barnes. "I mean the house he lives in, and my excitement was—? I sat on the sofa I thought it most likely he sat on. Charlotte kept me waiting five minutes. . . . I wish she had kept me waiting half an hour, then I could have sat on every chair in the room so as to be sure and make no mistake. Tomorrow, thank goodness, is Sunday and I can be under the same roof with him for an hour and a half, that is if he goes to church."[62]

In January 1896, Jim Barnes invited Gertrude and her parents to his electrical laboratory to show them some of the experiments he was performing. Gertrude confided to her journal: "I am going to do nothing but read electricity from now till we go. Two hours a day. I promise it."[63] Esther sensed that Gertrude's interest in Jim was becoming all-absorbing, and invited her to dinner on a day when Esther's mother would be in Newport. ". . . I love you and want you—Dearest, we will not go upstairs unless you suggest it and you will act just as you wish—I am waiting for a letter tomorrow morning telling me when I am to see you—Ever yours, Esther."[64]

"Not so long ago," Esther wrote again when she received no re-

sponse from Gertrude, "you certainly seemed to love me and now really I might not exist—It is hardly fair to treat me in the way you do when you know how much I love you, Gertrude—You always said that if ever you stopped loving me you would tell me, and then you used to say *you* never would—What is it, dear? I want to see you so much, tell me when you will come and see me. . . . Why are you so queer to me? Someone certainly has come between us."[65]

Mamma must have voiced some criticism of Jim Barnes, for on January 17, 1896, Gertrude wrote in her diary: "I shall put it down in black and white or die—I hate her. Her! Who? My mother. Yes, ha, ha, I have never allowed myself to say it, to think it scarcely before. Now I know it is true and say it, I would say it to her if she gave me the chance. I am happy, am I not—oh yes, living in an atmosphere of worldliness and suspiciousness—no matter. Well today has made me make up my mind to one thing and that is that I will not stop my love for Jim but I will do all in my power to make him love me in return. And if he does I will marry him. I won't take a cent from the family if he can support me quietly and happily. Oh God, riches make more unhappiness than all the poverty in the world. . . . I only live at times. Most of my life is simply existence. That is what she tries to make it. There is no more sympathy between us than there is between the table and myself, perhaps less, ha ha. Perhaps less. And I am young and longing and dying for sympathy, for feeling, for human love, and there isn't any for me—none—none. . . . Tell me, why am I rich—oh if I could only be poor—very, very poor and Jim would love me. . . . I don't believe I will ever be happy in my life. I will be an old maid—but I won't live at home, and do good among the poor, oh my, such work was never meant for me. I'll do it just the same. Then some day they will say, your money does good even if you don't, and after that I suppose I will die contented. And no one will care, why should they? Not even the poor people because I will leave them my money. Money, money, money, money . . ."[66]

Gertrude felt no closer to her father. "I am sure Papa hates me. Perhaps not exactly that, but he does not like me. I don't know what I have done, but I think it is more what I have not done. He does not think anything I do is right, he thinks me still nothing but a child and—lots more, I know it, I feel it. My instinct tells me it is so, and a

woman's instinct is right. I am a woman now, I know that too. I have changed lately, perhaps Papa feels *that.* That is maybe what he does not like."67

No one, Gertrude felt, could understand her. "You don't know what the position of an heiress is! You can't imagine. There is no one in all the world who loves her for herself. No one. She cannot do this, that, and the other simply because she is known by sight and will be talked about. Everything she does or says is discussed, everyone she speaks to she is suspected of going to marry, everyone loves her for what she has got, and earth is hell unless she is a fool and then it's heaven. The few people who are not snobs, but the very ones she wants, will not be seen with her because they won't be called worldly. Her friends flatter and praise her to her face, only to criticize and pick her to pieces behind her back. The world points at her and says 'watch what she does, who she likes, who she sees, remember she is an heiress,' and those who seem most to forget this fact are those who really remember it most vividly. The fortune hunter chases her footsteps with protestations of never ending devotion and the true lover (if perchance such a one exists) shuns her society and dares not say the words that tremble on his lips. Of course, worldly goods surround her. She wishes a dress, a jewel, a horse— she has it, but not all the money in the world can buy her a loving heart or a true friend. And so she sits on her throne, her money bags, and society bows to her because her pedestal is solid and firm and she doesn't seem perhaps quite human. But she has a heart just the same and the jeers or praise thrown with bows at her feet cut her and make the hours that should be spent happily pass in dreary succession on and on. Oh! Will they ever end?"68

Her fantasies of the ideal life she would like to lead were miles from the world of privilege on Fifth Avenue and in Newport:

A big establishment is one thing I will not have. This is in case I should ever marry—

A house to which mine and my husband's friends were *always* welcome. No matter the time or place.

Our house would be rather small, or very small would suit me better, homelike in the true sense of the word, with one

delightful library with a divan and easy chairs. That would be a private room for my husband and myself *alone*.

We would travel a great deal without much baggage or any servants.

When we were at home we would ride a great deal, take long walks, have delightful times together, little sprees of all kinds.

I wouldn't care about going out, but we would see our friends in an informal way.[69]

Several days after bringing her journal up to date with the total number of hours and minutes she had been with Jim Barnes, Gertrude noted that in February 1896 the boy who lived in the ivy-covered mansion across Fifth Avenue, Harry Whitney, had stopped in. (His father was William C. Whitney, a prominent attorney who had married the daughter of a Standard Oil Company magnate. He had served as secretary of the navy and then made a personal fortune pursuing his business interests.) Soon Harry Whitney was stopping in to see Gertrude quite often, including twice the last week. He had a little dog that he let Gertrude keep while he was attending Columbia Law School. In no time she wrote in her journal that "Harry and I are having a desperate flirtation. It's splendid. We understand each other perfectly. I told Harry all about Jim. He understood. I wouldn't have told him if I hadn't cared for him even more—perhaps than Jim? Who knows? Certainly not I? This book is getting to be the outlet of a crazy mind—crazy is the only word for it."[70]

Mamma found Harry, who was tall, athletic, and intelligent, to be a fine young man. "If Harry keeps straight," she told her daughter, "[his uncle] is going to leave him all his money, and he is supposed to be worth about $30,000,000."[71]

Soon, Gertrude and Harry were sleigh riding and ice skating together, and Harry had answered Gertrude's deepest concern directly:

Dear Gertrude,

You are a brick—really you are—& you need never be afraid of an insincere "yes" from me.

Of *course* it is possible for someone to love you simply and

entirely for yourself. We have been made to go through an existence here, God knows for what—it is hard enough & unsatisfactory enough—but there is one, just one, redeeming feature & that is the possibility of love.[72]

In the winter of 1896, the Vanderbilts arranged for a trip to Palm Beach aboard their private railroad cars, a trip to include Gertrude and a number of her wealthy girlfriends and boyfriends, including Harry. They excluded Esther. "Truly to the cars which bear the Vanderbilt party southward the chariot of Midas would be but a huckster's cart," wrote the *New York Journal.* "Although not given to match making, it is shrewdly guessed that Mr. and Mrs. Vanderbilt have arranged their party with thought for the future welfare of several of these young people, and that they are willing to remove every obstacle in the course of true love if all other things are consistent and proper. That we shall have announcements of early summer weddings with June roses galore is a foregone conclusion."[73] Gertrude seemed to know exactly what she was doing on the trip south. "I am going to *make* him care for me when we are off on the trip. *Make* him by being indifferent and oh, various other little tricks that I have learnt in my career. I have been pretty successful so far—and, strange as it may seem it is not only my money!"[74]

While sitting alone on a piazza one night in Florida, Harry suddenly turned to Gertrude.

"Gertrude, shall we have an understanding?"

Gertrude felt too weak to speak.

"Shall we, Gertrude? Do you care for me?"

"Oh, Harry" was all she could say, giving him her hand, which Harry kissed "over and over again and yet over and over."

"No, no, Gertrude—it can't be. Oh, no, Gertrude!" Harry laughed in joy.

Gertrude returned to her room with "a queer swimming in my head and a strange joyful feeling at my heart."[75]

"Have you repented?" Harry asked her when he saw Gertrude the next morning.

"No, have you?"

The boy and girl next door were in love. "I suddenly looked at him

and could not take my eyes away. He looked down—I could not. He looked at me again—for the first time we looked right into each other's eyes and saw each other's soul. Then he leaned forward suddenly and pulled my hands to him. He said: 'Kiss me.' And before I knew it he had leaned over the table and kissed my mouth. A few moments later he said: 'I feel better now.' "[76]

Back in New York City a week later, the two resolved during a long walk together to tell their parents that they were engaged.

"Where did you go this afternoon?" Mamma asked Gertrude as she walked into the parlor.

"I'm engaged," Gertrude announced.

"Engaged! Gertrude! Who to?"

"Harry! Do you like it?"

"Yes. This afternoon?"

"Oh no—a long time ago [a week ago] on the trip."[77]

Harry wrote a letter to Cornelius Vanderbilt, who was out of the country:

> Dr. Mr. Vanderbilt:
>
> As you may have suspected, I am in love with Gertrude and have asked her to be my wife. She has consented and has told Mrs. V. so that I write this to tell you of it and to ask for your consent.
>
> I fully appreciate the responsibility of taking Gertrude from a home like hers but will make it my life's duty and pleasure to try to make her happy and feel certain that I shall be able to do so.[78]

By Easter Sunday, Harry had still not heard from Cornelius Vanderbilt, and the couple delayed a public announcement of their engagement, but Esther had gotten wind of it.

"Of course I am glad for you but I love you and really I want to see you," Esther wrote. "It hurts! And yet I am so glad for you."[79]

"I never thought it possible to care for anyone the way I care," Gertrude wrote to Esther, explaining her feelings for Harry. "Sometimes the way I feel reminds me a little of something *you* have said and I wonder if you ever could have cared for me anything like this way. I am sorry for you if you did. . . . Esther, you must get engaged, you don't know what it is to be absolutely happy until you are."[80]

The engagement of Gertrude and Harry, which would be regarded

by the press as "a most felicitous outcome of the long and intimate association of the two families,"[81] would be announced in June.

3.

Gertrude had been the least of the Vanderbilts' worries. Much more troubling to Alice and Cornelius was Neily, Gertrude's older brother, Cornelius Vanderbilt III. As hard as Alice and Cornelius had worked to get their daughter married, they were struggling even harder to stop their son from marrying the wrong woman.

The events that would shatter the Vanderbilt family began that warm, magical summer night of August 14, 1895, the night of Gertrude's coming-out party at The Breakers. There, twenty-two-year-old Neily had danced with Miss Grace Wilson, the charming southern Grace Wilson with her bright hazel eyes, dreamy complexion, and deep auburn hair. Like his older brother, Bill—William Henry Vanderbilt II—who had been secretly engaged to Grace Wilson at the time he died of typhoid fever in 1892 while a junior at Yale, Neily, too, was hypnotized by the beauty of this woman who was several years his senior.

Bill had been the golden boy of the Vanderbilt clan. He had, as Gertrude phrased it, "all the brains of the family."[82] Handsome, outgoing, he had been a popular student at St. Paul's and at his Psi Upsilon fraternity at Yale, bringing home gangs of his friends for post–football game dinners at his parents' Fifth Avenue mansion. The heir apparent as head of the House of Vanderbilt as the oldest son of the oldest son of the oldest son of the Commodore, he had just reached the age of twenty-one in 1892 and so had begun to receive the income from the trust fund his grandfather had established. He had joined the Knickerbocker, New York Yacht, Seawanhaka Corinthian, Racquet and Tennis, and Westchester Polo and Riding clubs, and had purchased for the summer a forty-six-foot sloop, when he was brought home from Yale in May 1892, stricken with typhoid. All the celebrated physicians that money could summon could not save him. A grief-stricken Cornelius Vanderbilt donated a dormitory at Yale in Bill's memory, Vanderbilt Hall, and the family went into mourning for two years, a period Gertrude called "a very sad time . . . which I would rather not dwell upon."[83]

Now Neily, a year younger than Bill and also a student at Yale, was the eldest son. Now he someday would rule the Vanderbilt empire. Neily was different from Bill. Plagued with bouts of chronic rheumatism, he was a quiet, studious young man, interested in science and engineering, fascinated by experiments and inventions. But like his brother he was smitten by the charms of Grace Wilson, his first love, and, much to his parents' dismay, he squired her about Newport the rest of that summer of 1895 after the ball at The Breakers. Alice and Cornelius hoped that Neily's infatuation with Miss Wilson would soon pass. Grace, who they suspected was twenty-eight, six years older than Neily, was much too old for him, too worldly. This was the first time Neily had been in love; there would be other women.

Great beauty, backed by even a little wealth, opened wide every society door. Grace was a classic beauty, with fine features, a beguiling figure, and a poised, sophisticated personality to match. She was welcomed everywhere. Each winter, she stayed in her parents' Fifth Avenue mansion for the opera season and the Patriarch and Assembly balls. Early in the spring, she sailed for Europe to select her new wardrobe in Paris, then visited with her sister and her husband on the Riviera, cruising with them on their yacht, *White Ladye.* Afterward, she would "take the cure" at Bad Nauheim in Germany to prepare for the London season, then travel on to Scotland for grouse hunting, back to Paris in the fall for more clothes, and then return to the United States for the cure at Hot Springs, West Virginia, to get ready again for the winter season in New York.

Courtly Richard Wilson, a southern gentleman who had made a small fortune as a profiteer during the Civil War and now, living in New York, oversaw his railroad and banking interests, doted on his lovely daughter, treating her like a pampered princess. "Father, what shall I do?" Grace cabled from Paris. "I'm supposed to sail on the *Teutonic,* and Worth doesn't have my dresses ready."

"What are we going to do about Grace?" Richard Wilson asked one of his employees as soon as he received her frantic cable.

"Well, Major," the employee answered, "I guess I better go bail her out again. When do you want me to leave?"

"This afternoon at three," Wilson replied.

And so the employee set sail for Europe to "take the hide off Worth's and get Grace's dresses" so that she could sail as scheduled. "Mr. Wilson just thought it was outrageous that those people should keep his daughter waiting."[84]

In September 1895, after courting charming Grace Wilson for several weeks, Neily suffered a severe attack of rheumatism. His father was so concerned that he had another bed moved into Neily's room and slept there every night until the attack subsided, then sending him to Hot Springs to recuperate.

While he was gone, Mrs. Vanderbilt paid a social call on Mrs. Wilson. Would Grace be going abroad this winter? she casually inquired. No, Grace would be in New York all winter, Mrs. Wilson replied.

Upon Neily's return to Fifth Avenue, his romance with Grace Wilson blossomed.

At first the Vanderbilts teased him about his attraction to Grace Wilson.

Walking home from church, Neily told his parents he would be going out for lunch.

"Where?" asked Gertrude.

"At the Goelets," Neily answered.

"Ah, to see Grace Wilson!" Gertrude laughed. Grace's sister had married Ogden Goelet.

That evening, at the family dinner, younger sister Gertrude persisted in having some fun at her brother's expense.

"Who was at the lunch?" she asked.

"Miss Wilson," Neily replied in a very grumpy tone.

"Is that all?"

"Yes."

Gertrude looked at her mother and smiled.

"She was afraid to have anyone else," commented Alice Vanderbilt, who saw fortune hunters everywhere, and considered Grace Wilson one of the most determined.

For the rest of the meal, Neily, according to Gertrude, was "more than usually grumpy" and said hardly a word.

After dinner, he rose from the table.

"Papa, I would like to speak to you and Mamma alone in the other room."

"I will go," Gertrude said. Terribly excited, she was convinced that her brother had become engaged to Miss Wilson.

The next morning, Gertrude could hardly wait to rush down the stone staircase to breakfast to ask her mother what had happened.

"I cannot tell you,"[85] Mamma replied in a most serious voice.

That was enough to prick Gertrude's curiosity. She spent her days thereafter lurking around the halls and doors of the 137-room mansion, trying to "keep her eyes open" and put together the pieces. Neily was not coming down to breakfasts. He left the house each morning by ten and did not return until late at night. A letter arrived for Neily, marked IMMEDIATE. Gertrude brought it to her parents, and said in her most innocent voice, "Why, that looks like Grace Wilson's handwriting." When her parents did not reply, she knew she was on to something.[86]

This situation, Alice and Cornelius Vanderbilt had concluded, was getting way out of hand. Reasoning with Neily had not worked. Sending him away for a while had not worked. Being defied was a new experience for Cornelius Vanderbilt. All his life, he had been accustomed to speaking softly and pleasantly and having his suggestions carried out with dispatch. So sure was he of getting his own way that this methodical man customarily laid out his schedule a year ahead, to the day and hour. It unsettled him to be disobeyed, and worst of all, to be disobeyed by one of his children. Fretting and worrying, he had no idea how to cope with this family crisis. At a time like this, when something had become too messy for him to handle, there was only one thing left to do: call in the Vanderbilts' personal diplomat, Chauncey Depew.

Depew sent a letter to Richard Wilson, asking for a meeting to discuss his daughter. Is this family crazy? Mr. Wilson thought. No, he would not meet with Mr. Depew. He would discuss his daughter only with Cornelius Vanderbilt.

A second letter arrived from Mr. Depew, stating that a meeting had been arranged between Mr. Vanderbilt and Mr. Wilson for November 26, 1895, at Mr. Depew's house, a neutral arena. There, a frustrated Cornelius Vanderbilt fought in the only way he knew how. He launched from his arsenal of weapons his ultimate threat, telling Mr. Wilson that

if Grace would not leave his son alone, if they ever married, it would "alter [Neily's] prospects."[87]

To move Neily out of Grace Wilson's range, the Vanderbilts arranged for him a grand tour of Europe and the Near East, and tried to persuade him to go. Finally, one morning in November 1895, Neily arrived at breakfast and told his mother he was going to sail tomorrow for Europe.

"Cornelius, come and kiss me," Alice Vanderbilt said to her son.

"Well, you needn't be so pleased," he replied. "I've told Papa."[88]

With the matter now safely contained, the Vanderbilts told their daughter what had been happening. Gertrude had been right. Neily had indeed informed his parents he was engaged to Grace Wilson. Alice took her daughter into her confidence and explained to her why Neily's marriage to Miss Wilson just could not be.

One strike against the Wilsons was that they were good friends of Alva Vanderbilt's. But that was the least of the problems. A Georgian, Richard T. Wilson had sold cotton blankets and supplies to the Confederate armies during the Civil War, had run cotton to England through the Union blockade, and had been a cotton speculator in London. After the war, he returned to New York with a profiteer's fortune, purchased Boss Tweed's Fifth Avenue mansion, and began buying southern railroads at depressed prices. Though not in the same league with the Vanderbilts, he had accumulated a fortune of about $10 million, and his children had married well. His oldest daughter, May, married Ogden Goelet, whose family's large real-estate holdings in Manhattan were second only to the Astors'. His son Orme married Carrie Astor, Mrs. Astor's youngest daughter, who had danced the star quadrille at Alva Vanderbilt's fancy dress ball. Another daughter, Belle, had married the second secretary of the British Embassy in Washington, the son of Lord Herbert and the brother of the earl of Pembroke, and so had entered one of the oldest families of the English aristocracy.

Society called the family the "marrying Wilsons." A joke that was making the rounds at this time asked: "Why did the Diamond Match Company fail? Answer: Because Mrs. Richard T. Wilson beat them at making matches."[89] "By her matchmaking skill," the papers reported, "Mrs. Wilson has brought into her family more money than the original J. J. Astor or Commodore Vanderbilt gained. That shows what may be

accomplished by a woman without resorting to the business occupations of men. No financier in the world controls as much money as Mrs. Wilson and her son and daughters. No American matron has ever approached her record as a matchmaker. Only Queen Victoria and the Queen of Denmark can compare with her."[90] There were those unkind enough to say that the only thing left for Mrs. Wilson to do was pass away so that her husband could marry Queen Victoria.

After Bill's death from typhoid in 1892, Grace had been engaged to Cecil Baring, the son of Lord Revelstoke, but she broke off the engagement when he lost most of his fortune in the crash of 1893. When she next set her sights on Neily, it appeared to Alice and Cornelius that this worldly young lady, who had been "out" for several seasons and whom the Prince of Wales called "pet," certainly was bound and determined to capture a Vanderbilt.

"There is *nothing* the girl would not do," Alice told her daughter Gertrude. "She is at least 27 . . . has had unbounded experience. Been engaged several times. Tried hard to marry a rich man. Ran after Jack Astor to such an extent that all New York talked about it. Is so diplomatic that even the men are deadly afraid of her. There is nothing she would stop at. There is no one attentive to her, she thinks. Aside from it being a Vanderbilt, it will be her last chance." It is, Alice Vanderbilt concluded, shaking her head sadly, "the most dreadful thing of its kind that has ever happened in society."[91]

Gertrude was persuaded. "Oh, I pray he has not married her yet," she wrote in her diary on November 27, 1895, the day before Neily was to sail for Europe. "I fear it is so. His eyes had such a strange look today. He was much more cheerful than he has been for a long time. I feel as if I were living in a book. It's terrible. Mamma and Papa have hardly slept the last ten nights. Everything is wrong."[92]

No wonder Neily looked so cheerful the day before he sailed. Several days after his departure, Grace would be following him to Europe aboard the *White Ladye,* the yacht belonging to her sister and brother-in-law. Alice and Cornelius Vanderbilt were furious. The Wilsons, they swore, had "behaved like liars and cheats"[93] when they had told the Vanderbilts that Grace would remain in New York that winter.

The Vanderbilts considered their options. They wrote to a friend in London and told him to meet Neily as he arrived and to take him

anywhere as long as it was far from the spell of Miss Wilson. They thought of sending one of Neily's friends to Europe to meet him, as if by accident, and to bring him home. They planned to wire him to return home immediately, but concluded that he would never comply.

Before they knew it, the Parisian papers reported that Cornelius Vanderbilt III and Grace Wilson were both in Paris and had been seen holding hands in a carriage on the Champs Elysees. Together they went on to Constantinople to visit Grace's sister Belle and her husband, Michael Herbert. The trip the Vanderbilts had planned for their son was not working out according to plan. In fact, it had backfired.

Two days after Neily's arrival, the Herberts received a telegram from Cornelius Vanderbilt: "Is my son in Constantinople?"

"Yes," the Herberts wired back, "Pera Palace Hotel."[94]

Soon cables and letters were flooding into Constantinople from Chauncey Depew and every member of the Vanderbilt family. Gertrude wrote to her brother

> Dear Neily,
> I can't say what I want to half the time—the words stick in my throat. Please, please don't announce your engagement now. You may think because I don't say much that I don't really care for you. You may think too that I am as narrow as the others and that I don't understand your point of view. That is not so. I care so much for you that if I were not absolutely sure that you would not be happy I would take your side against the family. I am not narrow and I know how hard your position is and how desperate you feel, but you are not going to do yourself any good by announcing it, and you certainly are going to do Miss Wilson harm. . . . When people are sure of their feelings it is not such a hard thing to wait. You are positive you won't change, you are positive she won't change—why can't you wait? You will say your position is a hard one. True, but not as hard as it will be if you announce this engagement. What could be my object in saying all this if I did not care for you. The family have not asked me to speak to you.
> It's four years ago . . . you came down to New York and found Willie dying. He died and you—instead of taking his place—what

are you about to do? If you have said you would announce don't think you can't go back on that. If Miss Wilson really cares for you she will not mind waiting. I tell you I know & I am a girl.[95]

"I hear a rumor that a certain young lady is paying you the most pressing attentions," Neily's bachelor uncle, George Vanderbilt, wrote to him in what Neily termed a "most monstrous letter." "I wish I could see you as I could tell you certain interesting facts about her which I cannot write. All I can say is do not commit yourself."[96]

Grace's sister wrote to her husband that Neily's "father sent him a most horrid and disagreeable cable yesterday to the effect that unless he separated himself from G., his remittances would cease, beyond honoring his letter of credit which he was obliged to do. . . . Poor fellow, he is terribly cut up and depressed." And Neily told Grace's sister that he had received a letter from his mother that "he had burned . . . at once, it was so horrible."[97]

Despite his family's pleas and his father's threats, Neily followed his heart and Grace to Cannes, and the lovers spent several weeks leisurely cruising the Mediterranean aboard the Goelets' *White Ladye.*

The Wilsons, upset themselves about what all the gossip was doing to their daughter's reputation, bombarded the Goelets with letters, wondering when young Vanderbilt would hurry up and propose. "Ogden is going to have a serious talk with the boy," Grace's oldest sister, May, wrote to her parents, "and point out to him that he has a serious trust put into his hands, and that altho he must, he believes, give in to the separation question if he still desires it, he must see that Gracie's family can no longer allow her to be talked about with him without some definite promise. He himself is getting nervous about this equivocal situation and says something must be done, but does not seem to know how to do it."[98] Just as Alice Vanderbilt had called Grace's behavior "the most dreadful thing of its kind that has ever happened in society," so Grace's sister called the Vanderbilts' efforts to separate Neily and Grace "the greatest wickedness of the nineteenth century."[99] "Grace still intends and feels it is certainly for her ultimate happiness to carry the thing out. She is really very fond of the boy and one can understand that what he proposes doing for her and all the sacrifice it involves appeals to her very much."[100]

Finally, early in 1896, Cornelius Vanderbilt sailed to Europe, rounded up his son, and brought him home. Shortly thereafter, the Vanderbilts left on their railroad trip to Palm Beach with Gertrude and her friends. Neily declined to join them on the trip. "The only really interesting item of gossip," the *New York Journal* reported of the trip, "lay in the fact that young Cornelius, Jr. [as Neily, Cornelius Vanderbilt III, was called by the papers], was not in the party. For even this young favorite of fortune has his troubles, and the stern but wise parents' swift, not to say peremptory, nipping in the bud of young love's dream, and the sudden recall home from the presence of the fair but forbidden one, has resulted in a seclusion of himself and his shattered memories in the wintry waste of Newport . . . unhappy and alone since his summary recall from Paris and the presence of his love."[101]

Neily took a job in the engineering department of his father's New York Central, resolving to give his parents one more chance to change their minds about Grace.

Grace returned from Europe a few weeks later. "If I were in your place," Grace's sister wrote to her after she arrived home in New York, "I should have one preliminary canter over the course, and then I should coolly go in to win—with or without their consent. And with no fuss and feathers. Wait a week or two to see if there is any attempt to retract their bitterly insulting conduct, and then you and Neily must realize that you have got your own lives to lead and that you have perfectly proven the fact that you are all in all to each other, and the outside world must be dismissed from your minds for some years to come. . . . Live for your-selves."[102]

For a month or two, everything was quiet. Then one June evening, Grace and Neily were seen riding down Fifth Avenue in a carriage with Mrs. Wilson.

On June 10, 1896, the *New York World* announced the engagement and forthcoming marriage of Neily and Grace, noting that as the eldest son of Cornelius Vanderbilt, Neily would be one of the richest men in the world and "that one of his wedding presents will be one of the biggest yachts afloat."[103]

The front page of the *New York Times* the next day reported quite a different story.

MISS VANDERBILT ENGAGED, read the headline of the first of two

articles, describing Gertrude's engagement to Harry Whitney. "This engagement has the cordial approval of all the members of each family."[104]

AGAINST MR. VANDERBILT'S WISH was the headline of the next article, reporting that "the marriage of Cornelius Vanderbilt, Jr., and Miss Grace Wilson, whose engagement was formally announced yesterday by her parents, Mr. and Mrs. Richard T. Wilson, will take place within two or three weeks. The date will probably be made public to-day. 'Though the time has not been fixed yet,' Mr. Wilson told the reporters, 'my daughter's wedding will not be deferred long, and will doubtless take place in the present month. Cornelius Vanderbilt, Sr., is opposed to the marriage—on what grounds I do not wish to discuss. It is untrue that my daughter is eight years older than Mr. Vanderbilt. She is twenty-five years old, and he is twenty-three.' " Cornelius Vanderbilt authorized a one-sentence statement to be published in the article: "The engagement of Cornelius Vanderbilt, Jr., to Miss Wilson is against his father's expressed wish." Grace Wilson's brother was quoted as saying that it was Neily's desire "to disregard his father's preferences."[105]

Right after the announcement of her daughter's engagement, a proud Mrs. Wilson summarized for reporters the conquests of her children. Her daughter May's marriage to Ogden Goelet had opened up a $45 million fortune. Son Orme's marriage to Carrie Astor had landed a nest egg of $15 million. Daughter Belle's marriage to Michael Herbert resulted in the Wilsons' entry into the English aristocracy. And now their lovely daughter Grace's engagement to Cornelius Vanderbilt III made the young couple heir to a Vanderbilt fortune of $110 million. "It is through her efforts that the House of Wilson, like the House of Hapsburgh, has achieved greatness through marriage," a reporter wrote, "and its social head is undoubtedly the most influential person in New York society to-day. This fact has not been generally recognized. The late Mrs. Paran Stevens was once regarded as the most powerful woman in society, but anybody can see now that Mrs. Wilson was always a greater power. Her work can be judged by its results."[106]

In an age when a proper engagement lasted at least half a year, the Wilsons arranged for their daughter's wedding to take place a week later, thereby throwing fuel on the rumors and gossip that spread about the city. What would happen, reporters asked Mr. Wilson, if Cornelius

Vanderbilt carried through with his threat and disinherited his son? "It makes no difference what Mr. Vanderbilt does," the usually polished Mr. Wilson snapped. "I am not concerning myself about his intentions. Whether he cuts his son off without a cent or not, the wedding will take place at the time and place arranged."[107]

So he thought. But that special day, Thursday, June 18, 1896, came and went with no wedding, with only a single-sentence statement signed by two doctors, one the Vanderbilts' doctor, the other the Wilsons', that was sent to the newspapers: "Mr. Cornelius Vanderbilt, Jr., has an attack of acute rheumatism and is confined to his bed and cannot safely leave his room, Thursday, the 18th inst. Dr. William H. Draper and Dr. E. G. Janeway."[108]

Ten thousand lilies of the valley, ten thousand roses, and hundreds of boxes of orchids the Wilsons had ordered for the wedding were delivered to city hospitals, and the Wilsons sent a card to everyone who had been invited: "Mr. and Mrs. Wilson are obliged to postpone their daughter's wedding on account of the serious illness of Mr. Cornelius Vanderbilt, Jr."[109] No alternate date was mentioned.

It was a hot, miserable summer in the Vanderbilt mansion on Fifth Avenue. For days on end, father and son would not speak. When they spoke, they argued endlessly. "Just how far Mr. Vanderbilt is likely to go if his son insists in opposing his wishes in marrying Miss Wilson is difficult to say, but those in a position to know assert that he is likely to go to extremes," the newspapers reported.[110] "Those in a position to know" were the household servants who, bribed by newsmen, told of the fights they overheard between father and son, and of the days of silence that summer when the two, living alone in the same house and working in the same office of the New York Central, would not speak.

Neily could be "the most evasive person in the world if he did not choose to face an issue," those who knew him realized, but "could, once forced into a corner, explode with all the violence of a volcano."[111] Explode he did on the oppressively humid summer day of July 17, 1896, when his father ordered him to go to Newport, allegedly for relief from his rheumatism, but in Neily's mind to get him away once again from Grace Wilson. Shouting at his father, Neily suddenly struck the harsh authoritarian who was trying to keep him from the woman he loved with the threat of losing a $100 million fortune.

Later that day Dr. Draper came to the mansion to discuss Neily's rheumatism. The doctor thought that Cornelius Vanderbilt himself looked ill.

"You are not well," Dr. Draper told him.

"Oh, yes, I am all right," Vanderbilt said.

"You look queer."[112]

At that moment, Vanderbilt collapsed in his chair from a massive paralytic stroke. Far from feigning the attack to keep his son from marrying the wrong woman, as Alva Vanderbilt had feigned a heart attack the summer before to force her daughter to marry the right man, Cornelius Vanderbilt was completely paralyzed on his right side, unable to speak, drifting in and out of consciousness.

Alice rushed back from Newport aboard the Vanderbilts' private railroad car to find her husband "desperately ill."[113] At one o'clock that morning, she ordered thirty workmen to spread several inches of tanbark from the Newark tanneries for three blocks in front of the mansion to deaden all noise of passing horses and carriages.

It was 98 degrees the next day. The servants struggled to keep Mr. Vanderbilt's bedroom cool with ice and fans. Finally Alice made a decision she knew her husband would have disapproved if he had been conscious: She had him moved to the cool side of the mansion, the Fifty-eighth Street side, which he had ignored after the city erected the nude statue visible from the windows. The tanbark was shoveled off Fifty-seventh Street and spread over Fifty-eighth Street.

All traffic was rerouted to avoid the Vanderbilt mansion. "I know my rights," the driver of a heavily loaded wagon yelled at a policeman. "I'll not let a sick rich man interfere with my business."[114] Threatened with arrest, he sullenly followed the rerouting.

"Is he gone yet?" someone in the crowd that had gathered around the Vanderbilt mansion called out as William Whitney, Harry's father, crossed the street to come visit Mrs. Vanderbilt.

"We know that Mr. Vanderbilt's condition is serious—dangerous—" Whitney told the onlookers, "but we do not expect that it will end fatally."[115]

Gertrude followed her mother back to New York. "I too have been through an anxious time," Gertrude wrote to her cousin Adele.

When they sent for me in Newport to go down and see Papa
two days after he had the stroke they did not think he could
live, but now he is better and though his recovery is very very
slow, the doctors say he will recover. But it will probably be
three months before he can stand again, and even then—we
don't know. And there are other troubles besides sickness.
[Though Neily] *knows* it is his behaviour (that of course is
private) that gave Papa his stroke, he refused to see him. Never
took the trouble to walk across the hall and ask how he was.
When he was told Papa's life depended on it he would not say
he would even put off the wedding. I used to feel that it would
be hard when he married her not to see him, now I don't care,
I would go out of my way to avoid him. He is inhuman, crazy.
Whatever you want to call it. I don't believe he will ever come
in the house again. He won't come without her and that is out
of the question. Of course Papa can't be told for months.[116]

The 137-room Fifth Avenue mansion was no longer big enough for
both Neily and his father. Neily left home and moved into a small
apartment.

As with a president or monarch, every three hours an official physician's bulletin was issued to the crowds outside the mansion, and published the next morning on the front pages of the daily papers. Cornelius
Vanderbilt was paralyzed on the right side and could not speak. He slept
five hours. His condition remained unchanged.

"Mr. Vanderbilt passed a restless night and his condition is less
favorable than it was yesterday." A summer storm that night had kept
him awake, the rain hardened the tanbark, and "the noise of the street
ascended to his room with harrowing intensity and bothered him."

"Mr. Vanderbilt's condition shows no material change. He has
passed a comfortable day."[117]

"Mr. Vanderbilt's improvement has steadily progressed during the
day, and he is much better this evening."[118]

A cold front that drove the heat and humidity from the city seemed
to help. "Mr. Vanderbilt passed an entirely satisfactory night, and is
doing well this morning."[119]

By July 26, he felt well enough to be taken from his mansion in an

ambulance with special rubber-covered wheels to the East River, where he was carried aboard his brother Frederick's steam yacht, the *Conqueror*, and taken to Newport. There he was carried to a room on the sea side of The Breakers to eliminate any noise from Bellevue Avenue. The tanbark that had been swept up from Fifth Avenue was spread around the gravel walks of The Breakers, and the bell on the front door was muffled. Here, in his Italian Renaissance palazzo, he could find the complete quiet and rest that, with "mild applications of electricity," his physicians prescribed.[120]

On August 3, one week after Cornelius Vanderbilt was taken to Newport, Grace and Neily were married in a simple ceremony in the parlor of the Wilson home. Not a single member of the Vanderbilt family was present, though the duke of Marlborough and his duchess, Consuelo, sent a cablegram of congratulations. The papers reported that "young Vanderbilt looked defiant, though happy."[121]

"You certainly have had more trials and sorrows than any other two people (out of a book) I have ever heard of," one of Grace's sisters wrote to the newlyweds. "I hope the present chapter is ending with 'and they lived happily ever after.' "[122]

And so it seemed it would, as the young couple set off for their honeymoon at Saratoga, with Grace stopping at a newsstand while switching trains and purchasing every copy of the different afternoon papers, which featured on the front page the story of the wedding. The press had taken the side of Neily and Grace. "Not only society but readers of newspapers all over the country have looked with interest upon the love story of the young prince of millions and his sweetheart. Cornelius Vanderbilt, Jr., the prospective heir of a fortune of something like a hundred million dollars, has expressed the prerogative of all young men, rich and poor, and fallen in love with a young society woman whose face had charmed many. . . . For some reason, Cornelius Vanderbilt, Sr., objected to his son's early marriage and has done everything in his power to prevent it. All the world loves a lover and it is doubtful if the father gets much sympathy in his objections. We cannot help setting him down with the 'cruel parents' of literary tradition."[123]

Grace reveled in the publicity and attention showered on them. "All the hotel people treat us royally and the people in the hotel run to peer at us when we pass in and out," she eagerly informed her parents.

"You have never seen such behavior. They follow us in the streets!! The number of letters we get is dismaying, most of them are from people we don't know congratulating us, etc."[124]

"I wish you could see the way people watch and follow us about," Grace wrote to her brother. "Read today's *World* and you will get quite a fair idea of it all."[125]

"The reporters flocked to the steamer and tried to photograph the staterooms we had taken," she told her parents when later in the summer the young couple decided to go to Europe to give Neily's parents an opportunity to calm down. "I expect there were any number of articles in the papers after we left. By the way, Neily has subscribed for some newspaper cuttings and we want them forwarded. I expect we shall only be a week in London, so send everything to Munroe and Co., 7 Rue Scribe, Paris."[126]

But the happiness of the young couple could not last while they were worrying about Neily's parents.

It had been ominously quiet at The Breakers the day Neily and Grace married. "It was impossible to see Cornelius Vanderbilt, Sr., this evening," the papers reported, "or to get any word to or from him concerning his son's marriage." The attending physician, Dr. McLane, allowed no one outside of the immediate family to see him. "Mr. Vanderbilt is in no condition to be informed of his son's marriage."[127]

Neily's sister Gertrude had hoped to make her wedding to Harry Whitney that summer a day of reunion to establish peace between her brother and father, but parental pressure proved too much: Mr. and Mrs. Cornelius Vanderbilt, Jr., were not invited.

On Tuesday, August 25, 1896, a clear summer morning in Newport, Neily's younger brother Alfred escorted the bride down the great staircase of The Breakers into the gold room, where a small assembly of Whitneys and Vanderbilts, minus Neily and Grace, had gathered. While guards in another room watched over the wedding gifts—the diamond tiara and necklace Cornelius had given his daughter, a diamond cluster from Willie Vanderbilt, five strands of matched pearls valued at $200,000 from Harry's father, and countless diamond and pearl brooches and pins—Cornelius reached up from his plush-covered wheelchair when it was time for him to give his daughter away, and placed Gertrude's hand in Harry's. Afterward, the orchestra leader struck up "The

Star-Spangled Banner," an obvious comment on cousin Consuelo's marriage ten months before. "It is so rarely that an American girl of fortune marries one of her own countrymen," the orchestra leader commented in approval, "that I thought the selection decidedly in keeping with the occasion."[128]

Gertrude and Harry's honeymoon was spent at Harry's father's eight-thousand-acre preserve on October Mountain outside of Lenox, Massachusetts, in a small cottage that had been quickly built while the main house was being constructed. "The little house we lived in," Gertrude wrote to her friend Esther, "the smallest and dearest you have ever seen . . . only had two rooms and a piazza, and we did not have a servant within a quarter of a mile. . . . If you ever get married, Esther (which of course you will, and probably very soon too), don't take a maid on your honeymoon. Harry and I really grew dependent on each other. More than that. There is nothing that brings you so close to a person as having to do the little necessities of life together."[129] Alice Vanderbilt knew that her daughter's enchantment with playing house would not last long. She wrote to Gertrude, sending her quarterly allowance check, which she had forgotten to give her in the excitement of the wedding, asking if Gertrude would want to use the Vanderbilts' private railroad car, instructing her to send all her laundry to The Breakers, and wondering how soon she might want Jeanne, her personal maid.

Gertrude's wedding was the first of many signals to Neily and Grace that they were outcasts. Neily grew restless, wondering how his father was, wondering why his parents wouldn't communicate with him, wondering how long they would turn their backs on him and his wife, wondering if he had caused his father's stroke. With his stroke, Cornelius Vanderbilt had been transformed from a vital man of fifty-three consumed by his business and charitable interests into an invalid confined to a wheelchair, who never regained his energy or the full use of his limbs despite endless visits to spas, physicians, and hypnotists. "Neily telegraphs to his brother Alfred every few days asking about his father and he, Alfred, answers as to Mr. V's condition, but that is all the communication we have had with them," Grace wrote to her parents during the honeymoon.[130]

The first word Neily received from his father was a terse cable that

autumn: "Your grandmother died Friday after an hour's illness. Funeral Tuesday. Father." "This is the first message of any kind Neily has had from his father," Grace wrote to her mother, "and he was *so so happy* to get even this."[131]

Neily had been one of Mrs. William H. Vanderbilt's favorite grandsons and might well have expected to receive something under her will, but his grandmother left all her fortune to her Kissam relatives and to St. Bartholomew's Church.

It was becoming increasingly difficult for Neily and Grace to live like Vanderbilts on their income. Neily received $6,000 a year from his trust fund, and Grace received $25,000 a year from a trust fund her father set up for her, but she was accustomed to spending on her wardrobe each year more than their combined incomes. Grace's wealthy sisters did not help matters, writing to her about footmen and valets and butlers they were interviewing to work for Neily and Grace, and debating the virtues of various pieces of jewelry Grace must have: "a dear little chain necklace with emerald drops," a "pear-shape diamond necklace," a "great pin with sapphire and two diamonds," or a "huge pendant of the ruby necklace."[132]

Both Neily and Grace realized how important it was to reestablish their relationship with the senior Vanderbilts. After receiving his father's cable, Neily immediately wrote to him, telling him how much he wished to see him, and reporting that he and Grace planned to sail home on December 16, and that he hoped his father would not refuse to see him.

On December 3, Neily received a cable from Dr. McLane, Cornelius Vanderbilt's personal physician, in response: "Your Father has read your letter he is doing well and making slow but steady progress he does not wish to see you at present and as his physician I must insist upon exemption from worry do not return an interview impossible have written you—McLane. December 2nd New York."[133]

When the Wilsons learned from Grace and Neily that they were not going to return to New York as they planned, they were frantic. Rumors were circulating in the city that Grace had given birth to a child in Switzerland and that this had been the reason for the sudden marriage. Richard Wilson went to see Dr. McLane. It was essential that Grace immediately return to New York to quell these vile rumors and

preserve her reputation. "I asked Dr. McLane if he could name a time when he would not object to Neily's return," Mr. Wilson wrote to his daughter. "He replied that he hoped in a few months Mr. V. would be so far recovered as that the excitement incident to Neily's return would not injure him."[134]

In the meantime, the Vanderbilts were making it quite clear to their family and friends that they would *never* have anything to do with Neily and Grace. As Alice Vanderbilt wrote to her daughter, Gertrude, who was still on her honeymoon with Harry and now was in Japan, "Your Father went to Communion—up to the chancel rail, I mean—for the first time & that made him very happy. . . . Cornelius [Neily] has written three letters to him of the sort you might expect, saying he was sorry Father was ill & that he wanted to come home & see him. Never saying, however, he was sorry he had acted as he did or anything to show contrition except that they differed. Your Father got Dr. McLane to cable him not to come home as he did not wish to see him at present & an interview would be impossible."[135]

Finally, in January 1897, pressured by the Wilsons to hurry home and clear Grace's reputation, Neily and Grace arrived in New York and moved into the Wilsons' house at 511 Fifth Avenue.

"My dear Mother," Neily wrote to Alice Vanderbilt upon his arrival:

I received yr. note a few days ago. I feel terribly that you refuse to see me. What there has been in my actions during the past eighteen months to make you refuse to see me I do not know.

I considered the question of my own happiness lay with me, and I persisted in my choice. This is all I have done during that time and you *know* I have done nothing but what is perfectly open and just.

And yet I am treated as if I were a scoundrel by my own family when there is nothing I have done that I am ashamed of, or regret, or that I would not wish to have the whole world know. My dear Mother, will you not allow me to see my sick Father? He is ill, and though you do not seem to *believe* it, I am very wretched at not seeing him.

I ask this of you, and pray you will not refuse it. As ever, Yr. Aff. son C.[136]

As usual, Neily received no response from his mother or father.

Neily set out to prove himself, commuting every day to New Haven to earn his master's degree in mechanical engineering from Yale, devoting himself to his studies, then seeking his old job with the engineering department of the New York Central. "Your Father has sent word to C[ornelius] that he may have the position he formerly filled in the Engineer's Office," Alice Vanderbilt told Gertrude, "saying that he does this, not because he & I have changed our opinion of his conduct, but because he had promised it before he was taken ill. As a promise it had to be kept & that is all."[137] There was also in this letter to Gertrude a reprimand for making the mistake of inviting Neily and Grace to a supper dance. "It was very awkward for you about the Small Dances," Alice scolded her daughter. "I think you ought not to accept anything or go on any committees where the W[ilson] family are to be & I would not attend those particular Dances if I were you. That family will do everything to make it appear that you side with them & there should be no mistake in letting people see that you do not."[138]

Grace gave birth to a baby boy on April 30, 1898. "To all appearances," *Town Topics* reported, "he looks like any other two-day-old, in flannels, snowy linen and dainty laces. When he thrust his chubby little fist towards the ceiling, his father laughed outright. . . . Society sees him only as a living question mark. Will he heal the breach between the families? If they are reconciled he will be worth many times his weight in gold."[139] Cornelius Vanderbilt IV, Neily and Grace named him, but even this did not soften the hearts of Alice and Cornelius Vanderbilt, who rushed off to Europe to a health spa rather than attend the christening. Those members of the Vanderbilt family who sided with Cornelius and Alice always referred to the new Cornelius Vanderbilt as "that Wilson baby."[140]

Six weeks after the christening, bored with Neily's ascetic life, Grace took the baby and was off to Europe by herself, while Neily finished his courses and concentrated on his job with the New York Central, working to design a new locomotive firebox that would elimi-

nate engine trouble. His invention was a success and was installed in many of the locomotives of the Vanderbilt system, saving the New York Central hundreds of thousands of dollars in repair bills. Neily was hailed as a genius in locomotive engineering. "This young man intends to win back his father's favor by showing that there is something in him," commented a New York Central executive who had served under the Commodore, William H. Vanderbilt, and Cornelius Vanderbilt. "And you may depend upon it he will make his mark. He is a worker, and he appreciates the value of a thorough understanding of the details that make the best executive. Unless I am greatly mistaken, this young Vanderbilt will be a great railroad executive before he dies."[141]

Nary a word of congratulations or acknowledgment emanated from the frigid splendor of The Breakers.[142]

Early in the afternoon of Monday, September 11, 1899, Cornelius Vanderbilt felt well enough to leave The Breakers with Alice and travel to New York in his private railroad car so that he could attend directors' meetings the next day of the New York Central, the New York and Harlem Railroad, and the Wagner Palace Car Company. They spent a comfortable several hours aboard Car No. 493, with its four mahogany staterooms, kitchen, pantry, and dining compartment, library, a main saloon of mahogany with a piano and harp and with furniture upholstered in rich blue velvet, and at the rear an observation room finished in quartered English oak. They would return to Newport on Wednesday to prepare for a dinner party they would host the next day in honor of Ulysses Grant's granddaughter and her fiancé.

At six o'clock the next morning, Alice awoke in her bedroom of the Fifth Avenue mansion hearing Cornelius shouting for her.

"Alice! Alice!"

Alice rushed into his room to find her husband writhing in pain, his face blue.

"I think I am dying," he said to his wife, falling unconscious.[143]

Servants came running in response to Mrs. Vanderbilt's cries for help, but within minutes the fifty-six-year-old head of the House of Vanderbilt was dead of a cerebral hemorrhage.

His children were summoned. Gertrude, Neily, and Reginald rushed down from Newport by special train. For the first time since his

marriage three years before, Neily, who looked tired and haggard, crossed the threshold of the Fifth Avenue mansion.

Neily and Grace were not oblivious to the importance of Cornelius Vanderbilt's will, which would not be read until brother Alfred reached home from his graduation trip "to see the entire world, or as much of it as we can."[144]

"I do so wonder what you are doing—and if it is hot, and uncomfortable, and if you are fairly well—???" Grace, who was in Newport, pregnant with their second child, wrote to her husband. "Have you seen the *Journal* and *World* of today—Do look at them. You are quoted in the *World,* and the *Journal* seems to know all about the three copies of the W[ill]."[145]

Later Grace reported to Neily that one of her friends told her that everyone was speculating about what the will would contain and some had said to her "that if you are cut off it will be *iniquitous.* . . . 'Well, what would you consider cut off?' and they responded 'Why, five millions.' " Another friend "also agreed that if it were true that you had been left very little it would be an outrage, but he would not for a moment believe any of those stories, as your father never could have done such a thing."[146]

Late in October, when Alfred returned to the United States, the family assembled at The Breakers. There, in the dark library, paneled with Circassian walnut stamped in gold, they gathered around the great stone fireplace that, for $75,000, had been ripped from the sixteenth-century Château d'Arnay-le-Duc in France and installed at The Breakers, complete with its inscription in archaic French etched on the white marble mantle: *"De gran bien me rie, et poinct no default; Il n'est qu'adresse, quant tout prevault"* (Little do I care for riches, and do not miss them, since only wisdom prevails in the end).

There was Alice, dressed in mourning. For the rest of her life, for thirty-five more years, she would wear nothing but black. There was eldest son Neily, twenty-six years old; twenty-four-year-old Gertrude; twenty-two-year-old Alfred; nineteen-year-old Reginald, the apple of his mother's eye; and thirteen-year-old Gladys. Only the rustle of a quiet fire and the boom of the autumnal surf on the cliffs disturbed the silence of the gloomy gathering.

A group of Vanderbilt lawyers looked from Neily to Alfred. And

then the senior attorney began to read the will of the late Cornelius Vanderbilt.

"I give and devise to my beloved wife Alice G. Vanderbilt, for and during the term of her natural life, my dwelling house on Fifth Avenue and Fifty-seventh Street," including all the stables, furniture, and works of art. "I except from this bequest the portrait and bust of my grandfather and the portrait of my father, and the two portraits bequeathed to me in the will of my grandfather, all of which I give to my son . . . Alfred." The Commodore's gold congressional medal, presented for his gift to the Union of the S.S. *Vanderbilt* during the Civil War, had always been passed to the new head of the House of Vanderbilt. Cornelius bequeathed the medal to Alfred.

Clause after clause was read. Alice was given The Breakers and its contents and a trust fund of $7 million. Gertrude, Alfred, Reginald, and Gladys shared a $20 million trust fund, and each of the four children received $5 million outright. Gertrude received an extra million dollars. In provision after provision, the same names appeared. To Alice, to be handed down to Alfred, to Reginald, to Gertrude, to Gladys. To Alice, to descend to Alfred. To Reginald. To Gertrude. To Gladys. The quiet in the library was complete. There was no mention of Neily, the eldest son of the testator.

There were provisions for Cornelius Vanderbilt's favorite charities. And $1.5 million of the $72 million estate was set aside for inheritance taxes, which the papers reported as being "exceptionally heavy."[147]

And then, in the ninth clause of the will, Neily was bequeathed by his father the *income* from a trust of $1 million, and $500,000 outright.

Younger brother Alfred was named to receive the residuary estate: $42,575,000.

Finally the lawyer concluded the reading of the will: "I have to this my last Will and Testament, set my hand and seal of the city of New York this 18th day of June in 1896."[148]

June 18, 1896! The will had been changed three years before, on June 18, 1896, the date Neily and Grace had set for their wedding. Cornelius Vanderbilt, whom scores of editorials and obituaries eulogized as a deeply religious man of Christian charity and compassion, had never found it in his heart to forgive his son.

6

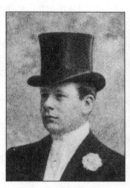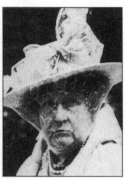

THE
COURT JESTERS

1 8 9 5 – 1 9 1 2

1.

"Thank God for Vanderbilts," the social columnist Cholly Knickerbocker once observed. *Town Topics* concurred: "The Vanderbilt family can always be relied upon in times of dullness to furnish either news or a sensation of some kind."[1] Vanderbilt births, deaths, mansions, balls, illnesses, marriages, divorces, disinheritances, extravagances, and feuds continued to fill the headlines, as the high society the family had jimmied its way into

a few short years before rolled on to the end of the century, evolving, changing, experiencing wealth and luxury unknown to ordinary mortals.

As the world had changed around him during the last decade of the nineteenth century, Ward McAllister continued strolling down Fifth Avenue each afternoon, stopping at the Union Club for an hour or two, and attending a dinner or ball in the evening. By profession a lawyer, McAllister never practiced law and had no office. "Society," he had said, "is an occupation in itself. Only a man who has a good deal of leisure and a taste for it can keep up with its demands."[2]

He found himself "assailed on all sides" by people wanting to enter society, and became, as he said, "a diplomat [who] committed myself to nothing, promised much and performed as little as possible."[3]

Every morning "mothers would call at my house, entirely unknown to me, the sole words of introduction being 'Kind sir, I have a daughter.' These words were cabalistic; I would spring up, bow to the ground, and reply: 'My dear madam, say no more, you have my sympathy.' "

McAllister would assure the mothers that he would do everything in his power to help launch their daughters into society.

"May I ask if you know any one in this great city, and whom do you know? For to propitiate the powers that be, I must be able to give them some account of your daughter."

This, McAllister found, "was enough to set my fair visitor off. The family always went back to King John, and in some instances to William the Conqueror.

" 'My dear madam,' I would reply, 'does it not satisfy anyone to come into existence with the birth of one's country? In my opinion, four generations of gentlemen make as good and true a gentleman as forty.'

"With disdain, my fair visitor would reply, 'You are easily satisfied, sir.'

"And so on, from day to day, these interviews would go on; all were Huguenots, Pilgrims, or Puritans. I would sometimes call one a Pilgrim in place of a Puritan, and by this would uncork the vials of wrath. If they had ever lived south of Mason and Dixon's line, their ancestor was always a near relative of Washington, or a Fairfax, or of the 'first families of

Virginia.' Others were more frank, and claimed no ancestry, but simply wished to know 'how the thing was to be done.' "[4]

McAllister, as social monarch, had become as well known to the public as any member of the exalted Four Hundred. As a transcontinental train carrying a party of New York society leaders steamed through Tennessee, a group of men on horseback waited at a station for the train to pass so that they could observe the passengers.

"I want to know!" said a gaunt mountain horseman. "Wal, I've rid fifteen miles a-purpus to see that dude McAllister, and I don't begrutch it, not a mite."[5]

The mountain men of Tennessee might have been fascinated by that dude McAllister, but members of society were growing weary of his pontifications and name-dropping as he courted the press. Reporters pursued him for gossip about the Four Hundred, often waiting on the sidewalk outside his house and club. They were never disappointed. For several years he teased them with scraps of information. Finally in 1892, he thought he would have some fun and consented to give the reporters his famed list. The Four Hundred consisted of an "original inner circle" of 150 who attended Mrs. Astor's dinners. Another 19 were of the "contingent inner circle," the next 26 were "star members inner circle fringe," the next 49 were "plain inner circle fringe" and 156 were "fringe to plain inner circle fringe."[6]

From then on, to the horror of the upper crust, McAllister kept refining and explaining his list to reporters: "It has raised an awful rumpus, doncherknow, an awful rumpus, d'you understand? It leads off, don't you see, with a little boy from Boston—Fred Allen, don't you understand? It puts him ahead of the Astors, doncherknow. Of course, that's an alphabetical accident. It's absurd, don't you see? The Astors are at the very front of Society. They should come first as a matter of course, doncherknow?

"People running around with the list in their hands—that is, people who are on it, doncherknow—running around, you know, with the list in their hands, I say, saying 'See here, you know, here I am, the hundred and fortieth or the hundred and forty-fifth, close to the tail end.' I say to them, 'You're very lucky, really, to be on it at all, doncherknow.' "[7] ("The first thing a reader must do with one of Mr. McAllister's state-

ments is to find out what it means," joked *Town Topics,* "since he cannot [speak] intelligible English."[8])

McAllister was committing the unpardonable sin of telling all, an error he compounded when he published his memoirs, *Society As I Have Found It,* a volume readers found almost humorous in its arrogance, and which caused the Four Hundred to writhe in embarrassment. The structure of society, which had seemed so natural, did indeed appear a bit ridiculous in cold print.

McAllister had grand plans for a Ceremonial Ball in 1889, but the committee in charge of the ball ostracized him. "The whole thing in a nutshell," said Stuyvesant Fish, the president of the Illinois Central Railroad and chairman of the entertainment committee for the ball, "is that McAllister is getting pretty well advanced in years and the committee is not one that can be bossed by any demagogue, big or little, young or old."

McAllister became perturbed at "that man Fish." "I do feel a little stronger on balls than a mere railroad president," he sniffed.

Twirling his moustache, Mr. Fish had the final word. "Who is Ward McAllister, anyway? McAllister was our *major domo,* our master of ceremonies, our caterer. As such he was not acceptable to us, and we told him his services were no longer required. McAllister is a discharged servant. That is all."[9]

Incensed, McAllister boycotted the ball and stayed in Washington, D.C., until it was over. Upon his return to New York City, he caught hold of reporters. "A young lieutenant, mind you, dancing with Mrs. Astor! I don't wonder the country laughs! And young Harry Cannon, forsooth! And, mind you, young Creighton Webb! Why as a dance of dignity the thing was a farce! I am glad that I had nothing to do with such a Fishball."[10]

The laughter over this pompous social arbiter turned into a roar when in a series of newspaper interviews in 1893 he tried to prepare Chicago for the members of New York society who would be visiting the World's Columbian Exposition that year.

"I would suggest that Chicago society import a number of fine French chefs. I should also advise that they do not frappé their wine too much. Let them put the bottle in the tub and be careful to keep the neck

free from ice. For, the quantity of wine in the neck of the bottle being small, it will be acted upon by the ice first. In twenty-five minutes from the time of being placed in the tub it will be in perfect condition to be served immediately. What I mean by a perfect condition is that when the wine is poured from the bottle it should contain little flakes of ice. That is a real frappé."

Chicago took offense that this eastern dandy, who obviously believed that west of Central Park began an endless social wilderness extending across the continent, would attempt to educate the city in social etiquette. The *Chicago Journal* assured McAllister that "the mayor will not frappé his wine too much. He will frappé it just enough so the guests can blow the foam off the tops of the glasses without a vulgar exhibition of lung and lip power. His ham sandwiches, sinkers and Irish quail, better known in the Bridgeport vernacular as pigs' feet, will be triumphs of the gastronomic art."

McAllister responded. "I never intended to convey the impression that any New Yorker as a man is necessarily superior to a native of Chicago," he began, but then could not resist continuing his lessons: "In these modern days, society cannot get along without French chefs. The man who has been accustomed to delicate fillets of beef, terrapin, pâté de foie gras, truffled turkey and things of that sort would not care to sit down to a boiled leg of mutton dinner with turnips."[11]

McAllister became the butt of a hundred jokes. "Ward Make-a-Lister" they called him, the "New York Flunky," "A Mouse Colored Ass." *Life* ran a cartoon of a policeman dragging two drunks in formal evening wear into the police station. "What's that you've got, O'Hara?" the police captain asked his officer. "Society as Oi have found it, sorr!"[12] Perhaps at last he began to perceive that he had never been the master of society, but rather its head butler.

Ward McAllister died of the grippe on the night of January 31, 1895 at the age of sixty-eight, while all society danced at the great Charity Ball. Mrs. Astor, his "true and loyal friend in sunshine and sorrow"[13] as he often commented, who was about to move to her just completed Renaissance palace at Sixty-fifth Street and Fifth Avenue, had scheduled her last dinner in her famous old brownstone for the next day. McAllister's Mystic Rose saw no reason to cancel her dinner just because her chamberlain was lying in state in the parlor of his home

several blocks away. After all, wasn't it McAllister himself who had said that "a dinner invitation, once accepted, is a sacred obligation. If you die before the dinner takes place, your executor must attend the dinner"?[14]

So the dinner went on, and perhaps Ward McAllister would have approved. And, no doubt, he would have been charmed that the pall-bearers at his service at Grace Church included an Astor and a Vanderbilt, for he was the man who had pulled together New York's old and new money to create a special world of high society. But where were the Four Hundred he had served so long and so well? Where were the Patriarchs? Where were those leaders of society for whom he prepared such wonderful fetes, such evenings of unforgettable food and wine? Only five of the Patriarchs and less than twenty of the Four Hundred came to pay their respects. The church was filled to capacity, but not with nobs or swells, not with the old Knickerbocker aristocracy or the parvenus. Rather, the common people, having heard so much about "that dude McAllister," mobbed the church for the dandy's final social event, grabbing flowers off his coffin as mementos of a famous man. The common folk were there, and the band of musicians he had hired for every social event.

And then the funeral cortege carried him slowly down Fifth Avenue past Mrs. Astor's old home, past the newer Vanderbilt mansions, past the scenes of high society that had been so dear to his heart. "Doubtless, 'other side of Styx,' " a friend wrote, "his spirit has found congenial companions. I see his shade in dignified disputation with other shades. He argues with Brummel about the tying of a cravat, with Nash about a minuet, the proper composition of a sauce is the subject of a weighty dialogue with the great Vatel."[15]

The world could change, her prime minister could fall from grace, but Mrs. Astor went on and on, invincible. She needed another Ward McAllister, and it was not long before she found one.

"I begin," said Harry Lehr, "where Ward McAllister left off. He was the voice crying in the wilderness who prepared the way for me."[16]

Harry Lehr had been born in Baltimore in 1869, just before Ward McAllister helped Mrs. Astor emerge as Queen of Society. His father was a prosperous tobacco and snuff importer and served as consul of

Portugal and Belgium. In the financial crash of 1886, when Harry was seventeen, his father lost everything and died, leaving the Lehrs penniless, shunned by their old friends. The family went to France, where Harry found a job as a bank clerk.

Harry hated every moment of living in poverty. "I must have beauty, light, music around me," he wrote in his diary. "I am like Ludwig of Bavaria, I cannot bear the cold greyness of everyday life. It withers my soul. Other clod-like people can stand it if they choose—I cannot!"[17]

He returned to Baltimore two years later, and quickly realized that to get back in "the social set I had been in in my father's lifetime, I should have to offer something in place of the money and position we had before."[18] Harry was tall, well built, and handsome, with blond hair and "eyes of vivid blue that seemed to hold the very spirit of gaiety."[19] What he had to offer was his personality, his gift of laughter. "There was something so magnetic in his gaiety that other people instinctively responded to it," a friend remarked. "All women were happy in his society. He liked them and understood them."[20] Though this charm was spontaneous, he nevertheless was quite aware of its power. "I saw," he wrote in his diary, "that most human beings are fools, and that the best way to live harmoniously with them and make them like you is to pander to their stupidity. They want to be entertained, to be made to laugh. They will overlook most anything so long as you amuse them. I did not mind cutting capers for them if I could gain what I wanted through it."[21]

Harry Lehr's radiant vitality was nothing short of infectious. His manners were impeccable, he was modest, tactful, accommodating, full of a wealth of stories and jokes, an accomplished pianist who could sit at the keyboard for hours "as he drifted dreamily from Chopin to Liszt, from Liszt to Grieg, to Schubert, to Beethoven, completely absorbed in the music."[22] He livened every party with his nonstop conversation, his wit, and his contagious braying laugh.

This debonair bachelor was invited everywhere, and soon found he could live by his charm alone. "Other men have to sweat in offices. I made up my mind I never would. I had only to be amusing to get a living, much better than working for one."[23]

One summer he was invited by Mrs. Evelyn Burden to be a guest

at her Newport mansion. It was at a Newport ball that Harry Lehr first met Mrs. Astor.

As usual, Caroline the Magnificent was aglitter in her diamonds. Harry seized a bouquet of red roses from a vase, walked up to her, and handed them to her.

"Here!" he said with his boyish grin. "You look like a walking chandelier! Put them on. You need color!"[24]

Mrs. Astor stared at him. They were standing in front of a parrot's cage. Harry looked at Mrs. Astor and put his finger to his lips.

"Don't interrupt," he said.[25]

Mrs. Astor continued to stare in disbelief. And then she laughed. Mrs. Astor, in her sixties, was charmed. Harry Lehr, in his twenties, was born.

For millionaires surrounded by obsequious servants, fawning sycophants, social climbers, and deferential friends, Harry Lehr's humorous irreverence was as refreshing as a summer breeze off Newport Harbor. Newport's *Morning Telegraph* was as captivated as Mrs. Astor:

> The seaside Valhalla of swaggerdom is dull—dull as a Presidential message, or a *Punch* joke. But what cares Newport? It can console itself with its new bona fide sensation—'Harry' Lehr's laugh. Haven't you heard 'Harry' Lehr's laugh? That shows that you have not been within a hundred miles of Newport this season. Everybody within rifle range of Newport has 'Harry's' laugh down by heart. Not that it is stentorian, clangorous or of the ten-ton gun variety. Not at all. But its vibrations, once started, have an initial velocity of a mile a second, and by the end of the third peal, the very earth is undulating in unison, the church steeples begin to wag in perfect time, and the jaded souls of Newport's 'h'inner suckles' seem acted upon by some new and potent stimulant. As Newport's court jester, 'Harry' is a wonder. He simply laughed himself into the bosom of the ultra exclusives. He has held up the town with his irresistible chuckle, and robbed it of invitations to dinners, musicales, yacht cruises, barn dances, and heavens knows what not, at his piratical pleasure.[26]

At lavish multicourse dinner parties, Harry would send the servants into a tizzy by requesting a hard-boiled egg and glass of milk. "I always love to do it at a party of this sort," he chuckled. "Champagne may flow like water, but you will see the whole staff won't be able to produce one glass of milk."[27]

Harry Lehr could get away with anything. When Alva Vanderbilt, another of his admirers, waded into the surf at Newport's Bailey's Beach, outfitted in a bathing dress, black silk stockings, and a large hat, bobbing up and down over the waves while carrying a green umbrella to preserve her complexion, Harry Lehr and her son Willie K. approached her from behind.

"You engage her in conversation, Willie," Harry instructed, "while I close the umbrella under the water."[28]

The maneuver was successfully executed, with Alva chasing both across the beach with the remains of her umbrella.

"Samson's strength lay in his hair," Harry Lehr once said. "Mine lies in the favour of women. All I have to do is keep in their good graces and everything comes to me."[29]

Mrs. Astor took him under her wing. During opera season, she reserved a seat for him in her box. He helped plan her balls, line up caterers and musicians, choose her party favors. He escorted her everywhere.

He encouraged her to add a touch of "Bohemianism" to her parties.

"I am having one of those new parties, too," she proudly told a friend.

What guests made up the Bohemian element? her friend inquired.

"Why, Edith Wharton and J. P. Morgan."[30]

One Sunday evening in 1895, Harry Lehr even persuaded her to do the unthinkable: to accompany him to Louis Sherry's new restaurant on Fifth Avenue, the first time in her life that sixty-four-year-old Mrs. Astor ever had dined in public. As she swept into the restaurant on Harry's arm, she created a sensation. "I could hardly believe my eyes," one reporter exclaimed. "I never dreamed it should be given to me to gaze on the face of an Astor in a public dining room."[31] "Harry Lehr and his legs and his piano playing and his singing and his witticisms and all the rest of it," another reporter commented, "have completely fascinated Mrs. Astor. To see that august lady . . . in a coquettish raiment

of white satin, with the tiniest hair dress, at Sherry's on Sunday last, dos-à-dos almost with Lillian Russell, I could hardly believe my eyes. And she seemed to enjoy it, and nodded her head to the rag-time tunes, and took the most gracious interest in everything."[32] "But what are we coming to? Mrs. Astor at Sherry's table d'hôte, breathing the same air as that of the 'middle classes'! But Harry Lehr, dear child, is irresistible."[33]

Harry Lehr even lived for a year in Mrs. Astor's mansion, until her granddaughter started the rumor that the wedding of Mrs. Astor and the young Harry Lehr, thirty-nine years her junior, would soon be announced.

It was after he left the Astor mansion in the spring of 1901 that he began courting Elizabeth Drexel Dehlgren, "Bessie," the recently widowed heiress of the Philadelphia Drexel banking fortune.[34]

"I have invited four of my best friends to meet you," Harry Lehr told Bessie one day after seeing her for several weeks. There at lunch, much to her surprise, were Mrs. Astor; Alva Vanderbilt; Mrs. Stuyvesant Fish, the wife of the president of the Illinois Central; and Mrs. Hermann Oelrichs, the daughter of the miner who had struck the Comstock Lode. These four ladies were *the* leaders of high society. Together, the four had become known as Newport's Social Strategy Board.

"I think she is delightful, Harry," Mrs. Oelrichs whispered to him after lunch. "We four are going to take her up. We will make her the fashion. You need have no fear. . . ."[35]

That afternoon, Harry Lehr proposed to Bessie, who quickly accepted. "He said he was not 'animal' or 'emotional,' " she confided to her diary; "(neither am I, but I thought all men were). He is the one glorious exception, the one pure and Godly man. . . . That he is honourable and high-minded I know—I am also sure that I truly admire him. I do not believe in what novelists are pleased to call 'romantic love'; it is low and bestial and not worthy of men and women, who are made in God's image. True love which lasts to the end and which strengthens with years is founded on respect, not on passion. . . ."[36]

Bessie was soon "hurt and disappointed" to discover that Harry was "infinitely more interested in the precise details of the fortune my father had left me than in anything else."[37]

"My dear," she whispered to him, "you won't have to worry over

money. You know I will give you everything, as much as ever you want. I understand perfectly that you have to provide for your mother, and we will arrange all that. . . ."[38]

Harry laughed. "I don't suppose you have any idea of the way I live. Well, I shall have to enlighten you. I live not on my wits, but on my wit. I make a career of being popular."[39]

Bessie did not understand, so Harry patiently explained to her just how he had been living so well on so little.

He received all his clothes free, his tailor having "an idea, which I naturally encourage, that it is a privilege to dress the man who according to newspapers 'sets the fashion for American manhood.' " He had the same arrangement with a shirtmaker, who asked only that he "let it be discreetly known where his underwear came from."[40] Black, Starr, and Frost loaned him a constant supply of fashionable gold watches, signet rings, and cigarette cases. His rooms over Sherry's cost him nothing; the publicity for Sherry's generated from Mrs. Astor's visit with him that Sunday evening assured him free lodging whenever he requested. He could entertain lavishly in the restaurant downstairs or at the Waldorf or Delmonico's, "for the management was perfectly aware that no better advertisement could exist than Harry Lehr's patronage. Wherever he led, the whole of the smart crowd would be certain to follow." Harry never sent letters, only telegrams. "Oh, do let Harry Lehr send his cables free," the wife of a cable magnate coaxed her husband. "He is always hard up . . . so generous . . . what that boy must spend . . . and then he's so amusing!" Wives of railroad tycoons secured free passes for him. A wine merchant paid him six thousand dollars a year to promote his champagne, which soon was filling the cellars of hostesses like Mrs. Astor, Mrs. Vanderbilt, Mrs. Fish, and Mrs. Oelrichs.

"Now you see how it is all done," Harry explained to the amazed Bessie. "But it has this one disadvantage. It can only last while I am a bachelor. People see me from quite a different angle now that they know I am going to marry a rich girl. The day after our engagement was announced everyone started bothering me. The shops won't give me things free any more. They say that now I can afford to pay for them myself. So you see, darling, I am afraid there is only one solution. You will have to realize that I am giving up a perfectly good livelihood

because I love you far more than my career . . . and you will have to supply me with all that I am losing. . . ."[41]

Bessie found that "there was something so irresistibly funny in his point of view that I could only laugh and agree."[42] Her lawyers drew up a marriage settlement.

"We had a lovely dinner," Bessie wrote in her diary that day before their wedding. "Harry was awfully clever and witty and lovely and handsome and oh! I was so proud of him! There is no other like him in the whole world. . . ."[43]

The evening after their wedding, at a hotel in Baltimore, Bessie dressed carefully for her first dinner alone with Harry, pinning a diamond brooch on her rose brocade gown, and arranging for the dining room in their suite to be filled with sheaves of red roses and the table set with caviar, quail in aspic, Harry's favorite champagne, and cigars. Next to Harry's plate was a special gold and enamel watch she had chosen for him.

As Bessie completed her preparations for dinner, her maid came in, her eyes downcast.

"Madame, I thought I had better tell you. . . . There must be some mistake. The maître d'hôtel tells me that Mr. Lehr has just given him orders to serve him dinner in his own room. He says that you will dine alone."

A few minutes later, Harry Lehr entered his wife's room. All merriment had left his eyes.

"There are some things I must say to you, and it is better that I should say them now at the very beginning so that there can be no misunderstandings between us. You have just heard my orders to the servants, I presume?"

Bessie nodded.

"Well, I intend that they shall be carried out for the rest of our life together. In public I will be to you everything that a most devoted husband should be to his wife. You shall never have to complain of my conduct in this respect. I will give you courtesy, respect and apparently devotion. But you must expect nothing more from me. When we are alone I do not intend to keep up the miserable pretense, the farce of love and sentiment. Our marriage will never be a marriage in anything but

in name. I do not love you, I can never love you. I can school myself to be polite to you, but that is all. The less we see of one another except in the presence of others the better."

Bessie's mouth was too dry to speak above a whisper.

"But why did you marry me?"

Harry Lehr laughed, and "there was such bitterness in the sound that I shrank back involuntarily."

Harry looked past her, pacing the room. "Dear lady, do you really know so little of the world that you have never heard of people being married for their money, or did you imagine that your charms placed you above such a fate? Since you force me to do so I must tell you the unflattering truth that your money is your only asset in my eyes. I married you because the only person on earth I love is my mother. I wanted above everything to keep her in comfort. Your father's fortune will enable me to do so. But there is a limit to sacrifice. I cannot condemn myself to the misery of playing the role of adoring lover for the rest of my life."

Bessie was speechless.

"After all," Harry continued, "have you so much to complain of? At least I am being honest with you. How many men in New York, how many among our own friends, if it comes to that, have entered their wives' rooms on their wedding night with exactly my state of mind? But they prefer hypocrisy to the truth. If I am never your lover when we are alone, at least I will not neglect and humiliate you in public. What is more, I believe you will actually gain by marrying me. You will have a wonderful position in society. As my wife, all doors will be open to you. Perhaps you will remember that luncheon to which I invited you to meet my four best friends?"

Bessie nodded.

"That was because I wanted to be sure that they would approve of my choice. Much as I wanted to marry you, nothing would induce me to forfeit my position in society to do so. But when I heard their decision to take you up I knew you were going to be invited to all the most important houses in New York, and therefore there could be nothing to fear."

Harry turned to look at Bessie.

"I suppose I am what novelists would call an adventurer. I am not

ashamed of it. I would do more than I have done for the sake of my mother. If you will try and accustom yourself to the position, and realize from the start that there is no romance, and never can be any between us, I believe that we shall get along quite well together. But for God's sake leave me alone. Do not come near me except when we are in public, or you will force me to repeat to you the brutal truth that you are actually repulsive to me."[44]

Harry walked out of the room, leaving Bessie sitting by the fire, "staring into the ruins of my life. Then I undressed and crept into the great bed that was to have been our marriage bed, and lay sobbing in the dark till the pillow was drenched with my tears." The next day she wrote in her diary: "My happiness is gone. Mamma must never know."[45]

Bessie determined that it was "a thousand times better [to] wear the mask of casual indifference, let him think I cared as little as he!"[46] The two set out to perfect their charade as they plunged into the social whirl.

2.

Even after his marriage, Mrs. Astor continued to fawn over Harry Lehr. "Kind motherly Mrs. Astor," Bessie noted, "would smile her approval: 'So nice to see young people so much in love. I am so glad to see dear Harry with such a charming wife.' "[47] And Alva Vanderbilt was very fond of him. Both ladies asked Harry to help them select their clothes, for which he had a special knack. "I went to Wetzel's," Harry wrote in his secret diary one day when he bought a new suit, "and had my clothes fitted on. I did the very best I could to hide how it bored me. Oh, if only I could wear ladies' clothes," he drooled in his diary, "all silks and dainty petticoats and laces, how I should love to choose them. I love shopping even for my wife."[48]

"How could anyone take me seriously, dear lady?" he would ask Mrs. Astor or Alva Vanderbilt. "I'm only your fun-maker, your jester."[49] Never were there two more kindred spirits than Harry Lehr and his best friend and fellow jester, Mrs. Stuyvesant Fish.

Mrs. Fish had married well. Her husband, the president of the Illinois Central Railroad, was a direct descendant of Peter Stuyvesant.

Yet she was an unlikely candidate to be one of high society's leaders. She could barely read or write. By the standards of the Gilded Age, her husband's fortune of just "a few million,"[50] as she described it, was little more than what Ward McAllister would call "respectable poverty." She was heavyset, of stern visage, with piercing black eyes and high-arched eyebrows; some were unkind enough to say that like her friend Harry Lehr, she sometimes pretended she was a woman. But from this corseted *grande dame* of aristocratic bearing came a constant stream of chatter, punctuated by her hoarse macawlike laugh and bursts of caustic comments, which in their directness and unexpectedness were the delight of a bored society.

"Can I get you something for your throat, my dear?" Stuyvesant Fish asked his wife, who was in the midst of a coughing fit.

"Yes," she sputtered, "you can get me that diamond and pearl necklace I saw today at Tiffany's!"[51]

Mrs. Fish was as much a part of the frivolous society that migrated between Fifth Avenue in New York City and Bellevue Avenue in Newport as anyone. Yet she liked nothing better than to poke fun at the superficialities and pretensions of her world.

She delighted in the stinginess of some of the wealthiest society matrons. Once she dropped in unannounced at lunchtime at the home of one society leader. "We had a slab of nondescript cold meat," she later complained to her social secretary, "and fried potatoes and tea. Of course all this would be served with great style by a butler and two footmen in bright liveries. It's a shame. I should have told her I was coming so the poor woman could have had a square meal."

Later in the afternoon, the lady took Mrs. Fish into her drawing room and summoned her servants to bring in the tea. The tall doors of the room opened and in came the butler followed by two footmen, one carrying over his arm an antique lace tablecloth, which he carefully positioned on the tea table, the other bearing a heavy silver tray, which he placed on the tablecloth, with the butler overseeing the entire operation to make sure everything was perfect. "And what do you think we were served?" Mrs. Fish asked her secretary. "Weak tea and soda crackers!"[52]

"I'm so tired of being hypocritically polite," Mrs. Stuyvesant Fish once grumbled to a friend. She in fact made no effort whatsoever to be

polite, and it became something of a badge of honor to be insulted by her. Her guests loved it and kept coming back for more.

"Howdy-do, howdy-do,"[53] she would brusquely greet her guests, quickly herding them on to her husband as they came through the front door of Crossways, their colonial mansion built on the hill above Bailey's Beach in Newport, or of their six-story Venetian palace at 25 East Seventy-eighth Street in New York. ("It would be an uncomfortable place for anyone without breeding," she noted.[54])

"Make yourself perfectly at home," she told her guests. "And, believe me, there is no one who wishes you there more heartily than I do."

"Oh, how do you do!" she greeted a gentleman. "I had quite forgotten I asked you."

"Well, here you all are," she announced to her guests: "older faces and younger clothes."[55]

One of her innovations was to streamline to precisely fifty minutes the customary marathon three-hour dinner orgies that Mrs. Astor had made de rigueur, to reduce, as she said, the "eight to ten courses of boresome, messy dishes to, oh, perhaps three courses—but something you really wanted to eat."[56] Each footman assigned to every two guests was under strict orders to keep the courses moving, and guests remembered having to hold their plates down with one hand while eating with the other. One guest recalled lifting his hand to take a fish bone out of his mouth and, before he could put it on his plate, seeing his plate disappear.

She encouraged her guests to call each other by their first names during the dinners, rather than the "Mr." and "Mrs." that were then the custom, and so she became Mamie.

"And what have you been doing with yourself to-day, Fred Martin?" Mamie asked one of her guests at dinner.

"Oh," Mr. Martin replied, "I've been addressing the inmates of the asylum for the blind; I spoke for over an hour, and at the conclusion I asked my audience which they would prefer to be—deaf or blind."

"Well, and the verdict?" Mrs. Fish asked.

"They were unanimous in deciding in favour of blindness."

"What! After hearing you talk for an hour!"[57]

One newcomer to society made the mistake of being so gauche as to ask Mrs. Fish about the size of her New York City mansion.

"I can't tell you how big it is," Mamie replied, "because it swells at night."

Another tried to compliment her on her Newport mansion.

"Yours is the largest small house I've ever seen," the guest said to Mrs. Fish.

"And yours is the smallest large house *I've* ever seen," Mamie replied.[58]

There was a great deal of gossip one summer about Mrs. Alice Drexel, who had a handsome male secretary to oversee the operation of her mansion. A friend of hers leaned over to Mrs. Fish.

"Mamie, have you seen Cousin Alice? I've looked everywhere in the house."

"No," Mrs. Fish replied with an icy stare. "Have you looked under the secretary?"[59]

Not even Alva Vanderbilt knew how to deal with her viper's tongue. Alva let it be known that she found Mamie's Newport mansion "ugly,"[60] but she was not prepared for Mamie's retaliation.

"I have just heard what you said about me at Tessie Oelrich's last night," a livid Alva stormed at Mamie Fish. "You can't deny it, because she told me herself. You told them I looked like a frog."

Mamie coolly looked Alva over, and then politely corrected her: "A toad, my dear; a *toad.*"[61]

Mamie Fish invariably served champagne at her dinners. "You have to liven these people up. Wine just makes them sleepy."[62] She wanted her guests to be awake for the entertainment she had planned. On her invitations she had scrawled, "There will be something besides the dinner, come." That "something besides the dinner" could be the cast of a current musical, visiting royalty, an opera singer, vaudeville actors, Indian or Japanese dancers—any celebrity, it was said, who could "hold a fork."[63] The high point of many evenings was when her friend Harry Lehr appeared after dinner, dressed to the nines as a Newport dowager, and strutted before the guests.

One of her guests began to explain to Mrs. Fish why he would have to leave the party early.

"I promised my sister that I would call for her. . . ."

"Don't apologize," she squawked like a blue jay. "No guest ever left too soon for me."[64]

Growing bored with one of her own parties, Mamie ordered the orchestra to continue playing "Home Sweet Home" until all the guests had taken the hint and gotten up to leave. One guest begged her for one more dance, just one more two-step.

"There are just two steps more for you," she told her, "one upstairs to get your coat and the other out to your carriage."[65]

Still playing "Home Sweet Home," the musicians stood up and herded the lingerers out the front door.

One furious socialite sat on the front steps of Crossways, pouting, as she waited for her carriage to arrive. Mrs. Fish's secretary saw her.

"My goodness, what are you doing out here?"

"I'm waiting for my carriage. Mrs. Fish has ordered us out."

The secretary hurried to Mrs. Fish to inform her that the lady's carriage had not yet arrived and that she was sitting on the front steps.

"Let her stay there," Mrs. Fish ordered. "She'll cool off better out there than here."[66]

Harry Lehr and Mamie Fish understood each other perfectly.

Shortly after the Lehrs' marriage, the guests at one of Mrs. Fish's parties were trying to guess each other's favorite flowers.

Harry Lehr jumped in. "I know Mamie's: the climbing rose."

"And I yours, pet," she replied. "The mari-*gold.*"

Once at a party, Stuyvesant Fish and his wife got up to leave.

"Sit down, Fishes," Harry Lehr called from down the table. "You're not rich enough to leave first."[67]

Like two mischievous schoolchildren egging each other on, Harry Lehr and Mamie Fish delighted in plotting outlandish pranks. They arranged for a baby elephant to walk through the dining room after one dinner. Another evening, boys dressed as cats distributed favors to the startled ladies: squiggling white mice. There was a dinner party for dolls given by the pair, where all conversation was in baby talk. The two pranksters caught Mrs. Campbell's dachshund, covered it with flour from the tip of its nose to the end of its tail, and set the dog loose on Newport's fashionable Casino terrace when it was filled with society matrons in their black lace dresses.[68]

One evening when Bessie Lehr came in from driving, Harry met her in the hall.

"Joseph Leiter has just rung up," he said. "He wanted to know whether he might bring a friend to our dinner party tomorrow night. I told him I was sure you would not mind as it is not to be a big, formal affair."

"Who is the friend?" Bessie asked.

"Prince del Drago, who is staying on the yacht with him. Joe says he is a charming fellow, and comes from Corsica. I asked him whether he was any relation of the del Dragos whom we met in Rome, and he said that certainly he was. They all belong to the same family, only the Prince's is a distant branch. Joe thinks we shall like him immensely, but he warned me that he is a little inclined to be wild. He doesn't want us to give him too much to drink, because he is not used to it. Anything goes to his head, and then apparently he is apt to behave rather badly."

"Of course I shall be delighted to see him," Bessie replied, "and I shall tell the butler not to fill up his glass too often."[69]

Word that an Italian prince would be at the Lehrs' party quickly spread among the guests, who were eager to meet him.

At eight o'clock the next night, the doors of the dining room opened and there was Chicago merchant prince Joseph Leiter holding the hand of his guest, a small pet monkey dressed in formal evening clothes.

The monkey was treated as the guest of honor, seated between Mrs. Lehr and Mrs. Fish in the place of honor usually reserved for Mrs. Astor.

Forgiving Bessie Lehr noted that the little prince's simian manners "compared favourably with those of some princes I have met,"[70] at least until he had slurped several glasses of champagne and then climbed to the chandelier to throw light bulbs at her guests.

Harry and Mamie were in hysterics for days about their Monkey Dinner, as it came to be called, though the papers and preachers were shocked by society's decadence and wanton extravagance; Harry Lehr and Mrs. Fish, they scolded, had "held up American society to ridicule."[71] Mrs. Astor was not amused. Mr. Fish did not care. Early on he had questioned Mamie about the amount of time she was spending with Harry Lehr. "Oh, him?" she answered her husband. "Why, he is 'just one of us girls'!"[72]

Mamie and Harry began dancing to a wilder beat, with a driving rhythm of madness. "Society wants novel entertainment," she explained. "It is like a child. It thinks it has everything it needs and cries for it doesn't know what. . . . I try to give it fillips."[73]

Another season in Newport with the same receptions, the same people, the same conversations. "Same old food, same old faces, same old cakes," Mrs. Fish complained.[74] The rarefied world of the Newport rich, Harry Lehr and Mamie Fish had decided, was vapid, silly, selfish. All the men could talk about was their boring work and making money. The women couldn't even talk about that, for most confessed to having no idea what it was their husbands did. "My dear young woman," one of the Four Hundred told a visitor, "there is no conversation in this country—none at all. No, no, no, none at all, and forgive me if I say so, madame, but here in Newport it is damn stupid."[75]

Harry Lehr decided it was time to do something different, and sent out invitations to a "dogs' dinner," inviting all of his friends' pets, accompanied by their owners, to a dinner given on his veranda, with leaves from the dining room table set on trestles about a foot high as a table for the dogs. One hundred dogs attended, some attired in fancy dress, to eat the menu of stewed liver and rice, fricassee of bones and shredded dog biscuit. One dachshund ate so much that it dropped unconscious by its plate and had to be carried home.

One day Mrs. Fish and Harry Lehr wandered into an auction in progress on Bellevue Avenue and seated themselves at the back of the auction room.

"Who will bid for this magnificent piece of furniture?" the auctioneer called out, pointing to a fire-screen. "Genuine Chinese antique."

Harry Lehr emitted a hollow groan. Mamie Fish covered her eyes with her hands and shook her head. Everyone in the audience turned to look, as the auctioneer glared at them with murder in his eyes. On he went, describing the fire screen. No one bid.

A china cabinet was next on the block. Harry's groans grew louder. Mamie seemed as if she would faint if she had to look at the cabinet. No one bid on the cabinet.

Item after item was displayed, extolled by the auctioneer, and taken away without a bid, as Mamie and Harry continued their pantomime.

The auctioneer slammed down his hammer. "The sale is suspended until the lady and gentleman in the back leave the hall!"

Mamie and Harry sat looking straight ahead, the picture of innocence, until they were all but forcibly removed from the hall.

They were not yet finished. No sooner had they walked outside than Mrs. Fish began shrieking, "Oh, oooh, look! He can't get the horse to stop! He will be killed! There's going to be a frightful accident! Oh! Oh! How terrible!"[76]

Everyone in the auction hall rushed outside, only to see Mamie Fish and Harry Lehr driving off in their carriage, doubled over with laughter.

Old Mr. James Van Alen had invited all of Newport to his home, Wakehurst, for a musicale in honor of J. Pierpont Morgan. Bessie Lehr received her invitation, but Harry was not invited.

Harry rushed to the home of Mrs. Fish to determine what the problem was. She was equally chagrined. Mr. Fish had received an invitation, but she had not been included. At Bailey's Beach, Mrs. Fish cornered Mr. Van Alen.

"Very sorry, my dear," he said, adjusting his monocle. "Upon my word very sorry, but I can't have you and Harry Lehr at this party of mine. You make too much noise."

"Oh, so that's it! Well, let me tell you, sweet pet," Mrs. Fish informed the old man, "that unless we are asked, there won't be any party. Harry and I will tell everyone that your cook has developed smallpox, and we will give a rival musicale. You will see that they will all come to it."[77]

Van Alen relented when he was promised that "the two disturbing elements" would stay on the terrace during the music.

Once Mrs. Fish sent out invitations for a dinner and ball "in honour of the Grand Duke Boris of Russia," who was then visiting Mrs. Ogden Goelet (Grace Vanderbilt's sister, May) in her Newport mansion, Ochre Court. (Grand Duke Boris, who had married the sister of the czarina, had ingratiated himself with the Four Hundred by commenting, "I have never dreamt of such luxury as I have seen in Newport. We have nothing

to equal it in Russia."[78]) Because of Mrs. Fish's refusal to invite a friend of Mrs. Goelet's to the ball, Mrs. Goelet arranged another dinner for the grand duke at her home the same night as Mamie's reception.

Mrs. Fish was frantic.

"You have got to get me out of this, Lamb," she said to Harry Lehr. "You must do something."

"Mrs. Goelet will keep her word; she won't let the Grand Duke come," Harry thought aloud. "The only thing you can do is to turn the whole thing into a joke. You must make people laugh so much that they will not be quite sure of what has really happened."

Mrs. Fish hit upon it.

"I know, Lamb, you will have to impersonate the Czar of Russia!"[79]

That evening, Mrs. Fish greeted her guests in the hall of Crossways. All two hundred who had accepted her invitation arrived, despite the later invitation each had received from Mrs. Goelet. All waited for Grand Duke Boris to appear.

He was late. The guests began whispering that maybe he was over at Mrs. Goelet's party after all.

Mrs. Fish seized the moment.

"His Majesty is a little late."

"His Majesty?" the guests around her asked.

"Yes, His Majesty! I could not get the Grand Duke Boris after all, but I have got someone better. Lambs and pets, His Most Gracious Imperial Majesty—the Czar of All the Russias!"

The door flew open. Mrs. Fish dropped in a low curtsy, followed by all the other ladies, as the gentlemen bowed, to rise "with shrieks of laughter when they realized they were paying homage to Harry Lehr."[80]

There, coming through the doors, dressed in Mamie's ermine-lined opera coat turned inside out, his chest covered with medals purchased the day before at a Newport party shop, was Harry Lehr, who took Mrs. Fish by the arm and paraded among the guests, speaking a few words to each in broken English.

The next morning at Bailey's Beach, the grand duke spoke to Harry Lehr.

"I hear you represented the Emperor last night. It's a good thing you were not in Russia, but I only wish I had been there to see it. It must

have been most amusing. Our party was poisonous. We shall have to call you King Lehr in the future!"[81]

And King Lehr it was, forevermore.

> *Oh, Harry, Harry, quite contrary*
> *How does your garden grow?*

wrote Mamie in verse for Harry.

> *With terrapins and champagne corks*
> *And magnums all in a row.* [82]

Mrs. Astor was shocked by what was happening to society. Surely Ward McAllister had been correct. "Society," he had said, "needs to be managed just as a circus is managed."[83]

"I am not vain enough to believe that New York will not be able to get along without me," Mrs. Astor opined as the twentieth century commenced. "Many women will rise up to fill my place. But I hope that my influence will be felt in one thing, and this is, in discountenancing the undignified methods employed by certain New York women to attract a following. They have given entertainments that belonged under a circus tent rather than in a gentlewoman's home."[84]

It was obvious that Mrs. Astor was referring to Mrs. Stuyvesant Fish.

"Mrs. Astor," cooed Mamie in her sweetest voice, "is an elderly woman."[85]

3.

Mrs. Astor was indeed getting old. The world might be changing, with each woman "trying to outdo the others in lavish display and mad extravagance"[86] as she said, but her own world changed not at all. Once a year, her subjects, responding to her imperial summons, came to pay homage to their dowager queen at her annual ball, with its predictable ceremonial quadrilles and stilted conversations. Elderly, bewigged, wrinkled, but still game, she dressed in a royal-purple Marie Antoinette costume and wore "a massive tiara that seemed a burden upon her head" and "was further weighted down by an enormous dog collar of pearls

with diamond pendant attachments." She wore also her celebrated Marie Antoinette stomacher of diamonds and a high diamond corsage ornament. Diamonds and pearls were pinned here and there about the bodice. She was, *Town Topics* concluded, "a dozen Tiffany cases personified."[87] Early in the evening, after greeting all her guests, Mrs. Astor slipped away from her party and went to bed.

To the press, she was still "the Queen." In January 1900 it was reported as a news item that "she drives in the park each day between the hours of 4 and 5 and . . . she one day during the week got down from her carriage and walked a long way on one of the paths while her carriage followed her slowly."[88]

The only challenge to Mrs. Astor's long reign had come not from one of the new leaders of society with their madcap amusements, but from within. Her nephew William Waldorf Astor believed that, as head of the House of Astor, his wife was the one and only "Mrs. Astor," and to prove it even went to the trouble of having calling cards engraved for her with those two magic words, MRS. ASTOR. The attempted coup to overthrow the queen of society was an utter failure, and, frustrated, William Waldorf Astor packed his bags and took his wife to England, never to return. But he would have the last laugh: He arranged for his family's mansion, which was separated by a garden from Mrs. Astor's home at 350 Fifth Avenue, to be razed, and on the site constructed the thirteen-story Waldorf Hotel, thus rendering Mrs. Astor's famous brownstone uninhabitable.[89]

Mrs. Astor had learned a thing or two over the years from her friend Alva Vanderbilt, and in 1891, soon after the noisy construction began on the Waldorf, called Richard Morris Hunt to design for her a gray limestone French Renaissance château uptown at 840 Fifth Avenue, far away from the Waldorf Hotel and above the Vanderbilts' territory on the avenue. On February 1, 1896, she moved in, and two days later opened for her annual ball her new gold and white ballroom with its rug woven of peacock tails.

And on and on she went, year after year, until 1905 when, at the age of seventy-five, she suffered a stroke and fell down a flight of marble stairs, and the bronze gates of her Renaissance palace closed forever to the faithful Four Hundred. Januaries came and went and the invitations to her annual ball were never sent. She was "quite small and shrunken

with white hair and a cap,"[90] a granddaughter recalled, as she wandered alone through the grand halls and salons of her home, checking the dining table, ordering the preparation of invitations that were never mailed, standing in front of her portrait greeting one last time "imaginary guests long dead, conversing cordially with phantoms of the most illustrious social eminence,"[91] until her death on October 30, 1908.

Alva Vanderbilt had no intention of picking up Mrs. Astor's crown as society's queen, having lost interest in it years before when she realized that it could be hers. And she certainly wasn't ready yet to lead the life above reproach required of the Queen of Society.

It had been rumored at the time Alva and Willie separated that Willie was seeing Alva's best friend, Consuelo, duchess of Manchester. With her divorce final and her daughter safely ensconced at Blenheim with the duke of Marlborough, Alva turned to Willie's best friend, Oliver Hazard Perry Belmont, as her next project.

O.H.P. Belmont was the recently divorced son of August Belmont, a German Jew who had come to the United States in 1837 at the age of twenty-one as the agent for the Rothschilds, and had immediately assumed an important role in handling the banking requirements of a growing nation. A financial genius who quickly accumulated an enormous personal fortune, a diplomat who served as American minister to the Netherlands and consul general of Austria, an urbane man of continental charm and glamour, Belmont married in 1849 the dreamily beautiful Caroline Perry, the daughter of Commodore Matthew Perry, credited with opening Japan to American commerce, and the niece of Commodore Oliver Hazard Perry, the naval hero of the Battle of Lake Erie during the War of 1812. For many years prior to the ascendancy of Mrs. Astor, the Belmonts were the leaders of New York and Newport society.

As Willie's best friend, Oliver Belmont joined the Vanderbilts on many of their long cruises aboard the *Alva* and the *Valiant*, including the voyage to India in 1893 on which Alva and Oliver fell in love.

After his father died in 1890, Oliver had commissioned Richard Morris Hunt to build a cottage for him several blocks from Marble House down Bellevue Avenue. By 1893 his massive fifty-two-room Louis XIII–style manor, Belcourt Castle, was complete.

As a new bachelor, he had designed it just as he pleased. Hunt must have swallowed hard and concentrated on his guiding architectural principle: "It's your client's money you're spending. If they want you to build a house upside down standing on its chimney, it's up to you to do it, and still get the best possible results"—for the entire first floor of the mansion was devoted to Oliver Belmont's passion: It was composed of a multitude of stables for his prize horses. Belmont could drive his carriage right through the front doors of Belcourt Castle into the house, and there his horses could be housed in the splendor they deserved, with individual tiled, upholstered stables, paneled in teak, decorated with harness fittings of sterling silver, tended by special English grooms who changed the horses' blankets of pure white linen embroidered with the Belmont crest three times a day. "Oh! To lodge horses so," sighed a guest at Belcourt Castle, Julia Ward Howe, the poet who wrote "The Battle Hymn of the Republic," "and be content that men and women should lodge in sheds and cellars!"[92]

Leaving their carriage by the stables, visitors to Belcourt Castle would climb the grand staircase to the living quarters. A ballroom that could easily hold five hundred guests was graced by two stuffed horses, Oliver's favorites with which he could not bear to part, mounted by dummies dressed in full suits of armor. More suits of armor decorated the monumental Gothic rooms with their huge thirteenth-century stained-glass windows, emblazoned with the coat of arms of Dunois, the Bastard of Orléans. "My dear Oliver," Harry Lehr once questioned when he first noticed the coat of arms, "why proclaim yourself illegitimate?"[93]

Belcourt Castle was just what Oliver Belmont wanted, right down to the solid-gold and sterling-silver door hinges and knobs. But Alva, who, like many women, found Oliver to be "one of the handsomest men . . . with his dark eyes, clear-cut profile and slender, faun-like grace,"[94] knew that the house just could not be what he *really* wanted. As soon as it was complete and he had begun to live there, she helped him remodel it, adding additional master bedrooms, one with just the sort of sunken bathroom she would like herself, a bathroom the size of a large living room.

Alva always bragged that she was one of the first to do everything: the first of her set to marry a Vanderbilt; the first society lady to divorce;

the first woman to ride a bicycle; the first to cut off her waist-length hair. ("I always thought long hair a frightful waste of time and energy. I don't think it made women lazy, but it did make us irritable. To my mind it was woman's curse and not her beauty."[95]) There was no reason why she shouldn't be the first divorced society leader to marry again, to marry a divorced man who happened to be part Jewish and, at thirty-eight, was five years her junior. To their surprise, Alva and Oliver found that no church wanted anything to do with their marriage, and so, on January 11, 1896, two months after Consuelo's marriage to Marlborough, they were married in a civil ceremony, conducted by the mayor of New York City, attended only by Alva's two sons, Willie K. and Harold. "I knew I had hungered for years, that I had existed, never lived," said Alva. "At last free, my own mistress, the great power within me to love claimed my whole being and all willing, I married that man who completed for me a life in its perfection in every sense. Few, alas, I believe have realized as I have marriage in its entirety."[96]

"Every woman should marry twice," Alva told her friends, "the first time for money, the second time for love."[97] For love *and* money, she might have added, for she was not so blinded by love to forget that "money alone has power."[98] Oliver's wedding gift to Alva was the deed to Belcourt Castle. Alva closed up Marble House, except to continue to have all her washing and ironing done there because of its superior laundry facilities, and took over as chatelaine of Belcourt Castle.

Tourists on day trips through the summer resort were brought outside of Belcourt where the driver of the sight-seeing van, speaking through his megaphone, described "one of the sights of Newport" to his passengers. One day, the tour guide stopped his van in front of the mansion as the guests at one of Alva's luncheons were finishing dessert.

"Oh, here's that dreadful man with the megaphone," Alva exclaimed. "He's going to tell all the tourists about our staircase. Do listen to what he says; it really is too funny for words."

That particular day, the tour guide did not follow his usual script.

"Here you see before you the new home of a lady who is much in the public eye," he began, as Alva's guests squirmed in discomfort. "A society lady who has just been through the divorce courts. She used to dwell in marble halls with Mr. Vanderbilt. Now she lives over the stables with Mr. Belmont."[99]

Nothing bothered Alva. She went right on blazing trails for others to follow.

Her latest "first" was a new toy she bought for Consuelo, an electric car her daughter could drive around the grounds of Blenheim. At the same time, she imported for herself a French de Dion Bouton automobile for $1,500. Soon Willie Vanderbilt, Cornelius Vanderbilt, the Fishes, the Astors, the Whitneys, and the Goelets all had their own horseless carriages, to which they gave names such as *Red Devil, White Ghost,* and *Blue Angel,* and which they drove up and down Bellevue Avenue to dinner parties. "Lewis, our coachman, was deeply disgusted when ours was brought home and he was instructed to make a place for it in the coach house," Alva remembered. "And when, as occasionally happened, our auto stalled on Ocean Drive and we had to send for Lewis to come to our rescue with the horses, he was secretly delighted. Every such manifestation of the inferiority of the automobile was a source of gratification to him, and in his eyes at least a vindication of his low opinion of our latest acquisition. No car ever replaced in his affection the horses in our stables."[100]

On September 7, 1899, Alva held the first car race in the United States, a "concours d'élégance" set up on the lawns around Belcourt Castle, an obstacle course planted with dummy nursemaids, policemen, children, and babies in carriages. Donning scarves, veils, gloves, and goggles, Oliver Belmont with Mamie Fish as his copilot of a car with a stuffed eagle on top, Ambassador James W. Gerard with Alva carrying a whip made of daisies, and Harry Lehr and Mrs. Jack Astor in a car smothered with blue hydrangeas lurched around the slalom course at ten miles an hour to the din of explosions, sputters, and coughs. The driver who struck the fewest pedestrians and navigated the course "without driving over the 'baby' "[101] won the race.

Automobiles, "bubbles" as they were called, were soon the latest fad of the rich. Willie built a garage for a hundred cars at Idlehour, where he kept his "de Dion Bouton, his Stevens-Duryea, his Hispano-Suiza, his Mercedes, his Bugatti, his Bentley, his Isotta-Fraschini, his Duesenberg, his Rolls-Royce,"[102] attended by twenty chauffeurs and mechanics. "We never dreamed," Mamie Fish commented later, "that cars would ever become popular with everybody."[103]

Despite Oliver's aversion to entertaining, Alva resumed her role as

a leader of society, throwing even more lavish parties than she had as Mrs. Vanderbilt. Pairs of servants dressed in red breeches, silk stockings, and powdered wigs (if they powdered their own hair rather than wearing wigs, the Belmonts paid them an extra five dollars, almost twice their weekly wage) and holding gold candelabra stood on either side of each of the steps as the guests climbed the grand staircase. There Azar, the Belmonts' faithful six-and-a-half-foot Egyptian majordomo (who slept each night by Oliver's bedroom door with a dagger between his teeth), "his air of conscious superiority . . . unrivalled,"[104] flanked by two English footmen in court livery, welcomed the guests "with all the pomp and ceremony of a Grand Vizier."[105] The guests would then proceed into the Gothic ballroom where Oliver and Alva, enthroned in huge carved armchairs, greeted the hundreds of guests. Mrs. O.H.P. Belmont did not object when her friends called her Lady Alva.[106]

By 1908, at the age of fifty, worn out from trying to keep up with his driving wife, Oliver died. Under his will, which did not fill a single sheet of paper, he gave everything to Alva, making her several mansions and $10 million richer.

"Let us all make the most of the hour with us," Alva wrote to a friend. "It can be done, it is hard work at times . . . but even with a broken heart and all the joys faded out of the picture believe me, we can paint anew the old canvas, put it back in the frame that held the real one, hang it on the wall a little below its old place and write in big letters above it: 'God's sun still shines for others; give to them what once was ours.' "[107] To heal the wound of Oliver's death, Alva set out to "paint anew the old canvas" by doing what she did best: building. Time and again, she proved the wisdom of Harry Lehr's insight that she "loved nothing better than to be knee-deep in mortar."[108] Her projects included an authentic Chinese teahouse built by the sons of Richard Morris Hunt on the edge of the sea cliff of Marble House; a remodeling of Belcourt Castle, removing the stables on the first floor and replacing them with reception rooms, a hall, and a library; a Georgian home at 477 Madison Avenue; Brookholt, a colonial manor at Hempstead, Long Island; Beacon Towers, a medieval castle at Sands Point, Long Island. (Alva once stayed at Blair Castle in Scotland, the ancient home of the duke of Atholl. "It's not correct," she declared, staring at the castle's

architecture. "There are a lot of mistakes. My castle at Sandy Point is far more authentic!"[109])

"I was never destined, I think, to stay in any one place," Alva observed.[110]

Her favorite housekeeper, Bridget McGowan, who was a devout Catholic, one day mustered her courage to speak up to Mrs. Belmont.

"Another house, Mrs. Belmont?" she asked in dismay. "Why don't you build your mansions in the sky?"

"Because I am going to live in *your* mansions when I get there." Bridget looked confused.

"When I get up there," the practical Alva continued, pointing heavenward, "I am going to say to St. Peter, 'Where are Miss McGowan's mansions? She has been living for years in mine and now I want to live in hers.' "[111]

Alva continued her frenetic entertaining at each of her homes. Such was her prestige that an invitation to one of her parties was, as an invitation to Mrs. Astor's had been, a social triumph.

Remembering her own beginnings, she helped others get their start in society. William Leeds, "the Tinplate King," and his wife entertained lavishly at Newport for two summers, but were never accepted by the resort's elite. When the Drexels leased their mansion to the Leedses for the summer, they were castigated by the daughter of the governor of Rhode Island, who was firmly entrenched as part of Newport's smart set. "How can you lease to those horrible, vulgar people? Why, the whole house ought to be disinfected after them!"[112]

The Leedses found a champion in Alva Belmont, who, as her friends recognized, was never happier than when "she was pitting herself against the rest of the world."[113] One summer morning she called Harry Lehr.

"I like those Leeds people, and the wife is lovely. I am going to take them up and put an end to this silly nonsense about them."

Soon invitations to Alva's ball "in honour of Mr. and Mrs. William B. Leeds" issued forth. No one dared turn down an invitation to Belcourt Castle and risk Alva's displeasure. "The light of victory shown in Mrs. Belmont's eyes," a guest remembered, as she stood in the armor gallery of Belcourt with Mrs. Leeds, greeting each of her guests.[114]

* * *

Alva had been convinced that there was "no profession, art or trade
that women are working in today as taxing on mental resources as being
a leader of society." But not long after Oliver's death, she began to
question whether "any woman, no matter what her financial condition
of life, can lead an idle existence" and whether all her "occupations, for
many years, were worthless."[115]

The catalyst of this out-of-character self-questioning was ex-
husband Willie's remarriage in 1903 to Anne Harriman Sands Ruther-
furd, the widow of the brother of Consuelo's old flame, Winthrop
Rutherfurd. Alva hated the new Mrs. Vanderbilt and banned from her
parties any friends who had invited her to their homes. It was when the
new Mrs. Vanderbilt began to devote her time to charities that Mrs.
Belmont, feeling an intense rivalry, began to perceive that there was
more to being a leader of society than entertaining.

"I must say that it took me many years to find that there was work
for me to do."[116] The good cause that sparked Alva's enthusiasm was
the emerging movement for women's suffrage.

Alva "delighted in men's company," but, strangely enough—for
she certainly had never been dominated by either of her long-suffering
husbands—she had, as her daughter Consuelo noted, a deep-seated
"hatred for the genus man"[117] and for the institution of marriage.

"You ought to be called the matchmaker, Harry Lehr," Alva once
laughed. "This is the fourth engagement you have engineered this sea-
son."

"Well, wasn't it rather clever of me?"

"You know perfectly well I don't believe in marriage. I never shall
until we have true equality of the sexes. The marriage ceremony itself
shows the unfairness of women's position. When a woman can get up
in the pulpit, mumble a lot of words over a couple and say, 'Go away
and sleep together' then I'll uphold marriage. Not before."

"But you have been married twice, dear lady," Harry said with a
smile.

"Oh, well, I have had to fall into line with the customs of my world,
but that does not mean I agree with them."[118]

Once Alva had a heart-to-heart talk with Harry's wife, Bessie
Lehr.

"You are not happy with Harry Lehr," she began. "You ought to leave him. I'll help you. I don't believe in marriage anyway."

Bessie declined. Alva shrugged her shoulders.

"You are the old-fashioned woman, Bessie. I am the woman of the future."[119]

Alva's views on marriage were shaped by what she saw around her, and perhaps primarily by Willie's infidelity. "For years I had witnessed the putting aside of wives of wealthy and prominent men after these men had secured recognition for themselves. Not by divorce. They did not want or need divorces. They left their wives to maintain the dignity of their position in the world, such as it was, and to care for their children, while they amused themselves elsewhere. That, they took it upon themselves to decide, was all that a woman was good for after they had finished with her, in ten years or less of married life. All around me were women leading these half lives, practically deserted by their husbands who not only neglected them but insulted them by their open and flagrant and vulgar infidelities. . . . If a man was rich enough and had enough to offer, there were, unfortunately, women willing and waiting to throw themselves at their heads, women who were younger and more attractive to them than the wives of whom they had grown tired."[120]

Alva was never one to accept the way things were. "I was one of the first women in America to dare to get a divorce from an influential man. I had dared to criticize openly an influential man's behavior."[121] It had not been easy. The experience focused in Alva's thoughts the great disparity of the sexes and "led up to my own rebellion against the existing order as it affected women."[122]

"Please forgive me," said James B. Haggin as he arrived late to one of Alva's receptions at Belcourt, "but my lawyer kept me. I have just been making my will."

"Oh, really?" asked Alva. "Well, I hope you are leaving a nice fortune to that sweet wife of yours."

"No, why should I? She is no relative. She is only my second wife. As a matter of fact I have left her practically nothing. I am leaving all my money to my own relations, my children by my former marriage. They have the first claim."

"What!" cried Alva. "You mean to tell me that you are going to disinherit Pearl after she has been such a wonderful wife to you, and put

up with all your moods and your bad temper for years. I have never heard of such a disgraceful thing! Now listen to me: I won't allow you to do such a dreadful injustice. You can't die with it on your conscience; why, you would not rest in your grave! Unless you change that will right away I'm going to tell everyone I know about it, and they will all take Pearl's part. You won't have a friend left. Now just think it over and send for your lawyer and have him make a new will. It is the only way you can show your wife that you have appreciated all the kindness and affection she has given you."

Mr. Haggin fell under this attack. He had a new will drawn up the next day, and sent Alva a bouquet of orchids. Pinned to the flowers was a little note: "Thank you for opening my eyes."[123]

It was not long before Alva abandoned society (a world of women with "sawdust brains" and "wax faces,"[124] she once said. "I only identify myself with this set enough to have some influence with them and to get money for causes out of them"[125]). She took up the cause of suffrage and became a militant feminist, pledging "my life, my interests, my all" to the women's movement.[126] "It was clear to me that I had always been . . . an unconscious suffragist. I was a born rebel."[127]

"Quite thoughtfully I enlisted my best in the cause of equal suffrage," Alva recalled. "I knew that any woman who is exceptional in wealth, social position, or unusual ability has many ways of achievement. I have entered into the battle for woman suffrage, fighting, as best I may, for what seems to me the most worthy cause at hand. Not all the warriors of the world who have couched a lance have been men."[128]

When Alva determined to give a cause her "all" and her "best," she *meant* her all and best. Her ferocious energy galvanized the women's movement. "The Bengal Tiger," they called her. The first suffrage meeting Alva attended was held in a small rented room of the Martha Washington Hotel in New York. In attendance were fifteen women. Alva was dismayed. "The public," she told the gathered women, "knows nothing of this agitation carried on in such an obscure way, and wouldn't be moved if it did know. Something must be done at once."[129] The time had come "to take this world muddle that men have created and . . . turn it into an ordered, peaceful, happy abiding place for humanity."[130]

She attended suffragist conventions, worked at the headquarters of the Equal Suffrage League in New York City, gave speeches, and wrote articles ("It is in the power of women to free women, the most exalted task the world has ever set, and the achievement will glorify forever the sisterhood of a new era which heralds a complete unity of the women of the future"[131]). She fostered picketing (once criticized for encouraging a picket of the White House, Alva Belmont replied that "the sentimental ladies and gentlemen who are so afraid lest we fatigue the President are urged to remember that we ourselves are very, very tired, and perhaps the sentimentalists will confer some pity on the faithful women who have struggled for three-quarters of a century for democracy in their own nation"[132]). She helped write a suffragist operetta, leased the seventeenth floor in an office building at 505 Fifth Avenue so that the National American Woman Suffrage Association could move its headquarters from Ohio to New York City, and spearheaded campaigns against congressmen who opposed suffrage ("I shall consider you false to our interests," she wrote to one congressman seeking reelection, "and shall not hesitate to make the fact known in important places"[133]). She bought a historic mansion in Washington, D.C., to serve as the headquarters for the National Woman's party and served as its president; in addition, she organized the Political Equality Association and also became its first president. A born leader, she took command of the movement. Though some were put off by her flamboyance and militancy, the women followed, even when she insisted that each agitated suffragette take a formula she called Victory Laxative Tablets once a day, the secret formula for which she had obtained from a German doctor.[134]

Alva broke with the peaceful, conservative faction of the movement, the National American Woman Suffrage Association led by Mrs. Carrie Chapman Catt, to head the National Woman's party, a group of more radical feminists who carried blazing banners of purple and gold, picketed state legislatures, Congress, and the White House, went on hunger strikes, and were happy to be arrested.

"Brace up, my dear," Alva consoled one weary lady. "Just pray to God: *She* will help you."[135]

As those who knew Alva would have expected, her strategy for furthering the cause was direct: a total women's boycott. "The time will come," she believed, "when women should and will withdraw from every

sort of activity in which they are now associated with men, form themselves into a solid phalanx, bound together with the steel cable of a common purpose, and say to the men of America: 'Until you give us the ballot, we will not marry you; we will not work in your places of business; we will have nothing to do with you, socially, industrially—any way.' Woman's nature enables her to get along better without man than man can get along without woman. She could stand the strain long enough to bring him to her just terms. . . . Let her withdraw from the church, the world's greatest civilizing influence. The church cannot stand without her. . . . Then, let her walk out of the hospitals. A man is almost of no use in attending the sick. About all he can do is to carry a stretcher. Nursing is essentially a woman's work. Let women do all of these things and I ask you, as a man, what would happen?"[136] With men unable to stand the strain, Alva believed, the battle would be over in short order.[137]

"This infusion of power into the movement that had been dragging along for half a century," the *New York Times* wrote of Alva's suffrage work, "has resulted in an astonishing extension of vigor and energy and the campaign this winter will be something the like of which has never been seen before."[138]

If Alva's society friends were shocked to see her lending her support to further the rights of women, they were horrified when they learned that she planned to open up Marble House to a suffrage conference. "Families are rather apt to make things difficult for their younger and unconventional members. Mine did . . . when I went into the woman suffrage movement. I was quite literally an outcast with my family and most of my friends." But guess what? "With me it made no difference."[139]

The last party Marble House had seen was the ball for the duke of Marlborough on August 28, 1895. At the end of that season, the mansion had been closed up and never reopened. Now, fourteen years later, Alva hung its marble walls with the great purple and gold banners of the suffrage movement declaring FAILURE IS IMPOSSIBLE, the last words of Susan B. Anthony, which Alva had selected as the battle cry of the movement. On August 24, 1909, she opened the great bronze doors to her fellow suffragettes. To raise money for the cause, she charged five dollars for admission to the mansion. For one dollar, a woman could

enter the gates and walk around the grounds and sit under the tent to hear the speeches.

Azar, Mrs. Belmont's tall, handsome Egyptian majordomo, was utterly dismayed, Bessie Lehr noticed, "as hundreds of women from New York, Boston, Chicago, every part of the country, swarmed into the house that had earned the reputation of being one of the most exclusive in Newport, and wandered in the gardens in groups of three and four. Women in shirtwaists, their jackets hanging over their arms, women carrying umbrellas and paper bags. Man-hating college women with screw-back hair and thin-lipped, determined faces; old country-women, red-cheeked and homely; giggling shopgirls. Azar had never seen such guests. What a contrast to the elegant garden parties of former years, the splendid entertainments that had been his greatest pride. It was too much for him!"[140]

And Alva's twenty-five-year-old son, Harold, was downright embarrassed by the whole affair.

Alva cornered him.

"You must help me. I want you to come on the platform and introduce the speakers."

As the youngest of her children, Harold had learned how to handle his mother. He simply walked away. As Bessie Lehr noted, "nothing would induce him to identify himself with this new departure of his mother's mental activity."[141]

Alva inveigled an appearance by Governor Pothier of Rhode Island. The governor began to get cold feet as his moment to address the delegates approached.

"How on earth shall I begin my speech?" he asked Alva.

"Only one way of course, 'Voters and Future Voters,'" she responded, and laid out for him a speech full of cries to battle.

When he rose to the podium, the governor lost his courage. "Ladies and Gentlemen," he began, reading the innocuous speech of a politician.[142]

When it was her turn, Alva held nothing back. Under the big tent on the lawn, standing on a platform in front of a VOTES FOR WOMEN banner, looking over her glasses perched on the tip of her nose, spurred on by Mamie Fish and Harry and Bessie Lehr in the front row, she began:

"Sisters, I ask you to put behind you these fallacies of the past; discard vain dreams, rely upon yourselves; have valiant aims, believing that your rights are the same as those of man. Encourage attainable possibilities. Believe that Motherhood should be no greater than Fatherhood, that the wife should not be the unpaid servant of the husband, but both must be equal.

"Women of this century, build your castles no longer in the azure skies of vanishing theories, but on earth, with wills of steel. Draw from your intellect and the wisdom of your observation the great lesson that each must stand alone. By what right do you forever cling to man? Is his road not hard enough without this? His promise to bear *your* burdens, made perhaps in all sincerity, he cannot keep."[143]

These were the kind of people who would steal anything, Azar warned his mistress after the last suffragette had left Marble House, so it was not surprising to him that Mrs. Belmont's suffrage banner—four white stars on a blue background—was missing.

Several weeks later, Alva was at one of her neighbors' receptions. The footman announced the entrance of "Mrs. Carrie Chapman Catt," the president of the National American Woman Suffrage Association. Into the room walked a very large lady draped in a blue gown whose train of blue with four white stars immediately caught Alva's eye.

"Why, it's Harry Lehr!" she cried. "And *you* were the culprit who stole my banner!"[144]

Alva Belmont was to lead the Political Equality Division of the great Women's Vote Parade down Fifth Avenue at sunset on May 4, 1912, from Fifty-ninth Street to the Washington Arch, a march of thousands of women.

"I've ordered a white pleated walking skirt and strong shoes," Alva told her friend Mamie Fish.

"My dear Alva, you'll never be able to do it. It must be all of three miles and you have scarcely walked a step in your life."

"All the more reason why I should begin now. After all, my dear, I must have something to interest me in my old age. I shall walk the whole way."[145]

And of course she did. "She looked as serene and unself-conscious as though she had been in her own drawing-room," Bessie Lehr thought

as she watched her friend heading the procession of brass bands, mounted police, and the thousands of white-clad women, regiment after regiment, who had flocked to New York City from all over the nation to take part, carrying banners that voiced their frustration: SINCE WE CAN BE EDUCATED LIKE MEN, WHY CANNOT WE HAVE A VOICE IN THE GOVERN- MENT OF OUR LAND?; THE HAND THAT ROCKS THE CRADLE RULES THE WORLD; WE PREPARE THE PEOPLE FOR THE NATION, WE WANT TO PRE- PARE THE NATION FOR THE PEOPLE; and the suffrage picket banner that was Alva Belmont's favorite: FAILURE IS IMPOSSIBLE.

Later, Alva confessed to her daughter, Consuelo, how trying such a public exhibition had been for her, as the crowds had stared and ridiculed the belligerent women, reviling them as "female pests" and "loathsome dealers in clack."[146] Hers was not a popular cause. "The situation is dangerous," the *New York Times* editorialized. "We often hear the remark nowadays that women will get the vote if they try hard enough and persistently, and it is true that they will get it, and play havoc with it for themselves and society, if the men are not firm and wise enough and, it may as well be said, masculine enough to prevent them. One does not need to be a profound student of biology to know that some women, a very small minority, have a natural inclination to usurp the social and civic functions of men."[147]

"To a woman brought up as I was, it was a terrible ordeal!"[148] But as Alva Belmont marched down Fifth Avenue, determined eyes straight ahead like a soldier, no one would have believed it.

Bessie and Harry Lehr watched from the Hotel St. Regis. Harry nodded: "The dear old Warrior has got something to fight for at last."[149]

7

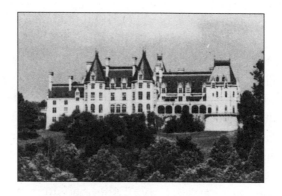

BILTMORE

1 8 9 5 – 1 9 3 3

1.

"They say, sweet Lamb," Mrs. Fish wrote to her friend Harry Lehr, who was staying in Europe, suffering from a nervous breakdown, "that you have lost your mind. If you have, come back to New York for I can assure you that the loss won't interfere with your popularity. You know quite well that you won't need any mind to go with the people in our set."[1]

Mamie Fish and Harry Lehr had sensed it coming: the mindless flight of the idle rich from the boredom of their lives by spending ever

greater sums of money in the pursuit of ever new amusements. At the same time, rapid economic expansion was creating new manufacturing, banking, railroad, oil, and mining millionaires, each trying to make his mark and break into society by increasingly lavish expenditures.

A newspaper reporter who had written that the millionaires of Newport "devoted themselves to pleasure regardless of expense" was corrected by one of the Four Hundred who explained that what they really did was "to devote themselves to expense regardless of pleasure."[2] "It is doubtful," another member of the Four Hundred complained, "whether there are more useless and empty ways of spending money in the world than can be found at Newport."[3] Bessie Lehr remembered Mrs. Pembroke Jones telling her "that she always set aside $300,000 at the beginning of every Newport season for entertaining. Some hostesses must have spent even more. A single ball could cost $100,000, even $200,000. No one considered money except for what it could buy."[4]

Mamie Fish was right; society had gone mad.

At a millionaire's dinner party in the ballroom at Sherry's all the guests ate on horseback, the horses' hooves covered with rubber pads to protect the floors. One hostess hid a perfect black pearl in each of the oysters served to her guests, and a host handed out cigarettes rolled in $100 bills. Another party featured a pile of sand in the middle of the table, and toy shovels at the guests' seats; upon command, the guests dug into the sand, searching for buried gems. A millionaire thought nothing of buying a $15,000 diamond dog collar, a pair of opera glasses encrusted with diamonds and sapphires for $75,000, a bed inlaid with ivory and ebony and gold for $200,000, a necklace for his true love for $500,000.[5]

In 1895, a visitor from France, viewing the two-mile stretch of Fifth Avenue that faced Central Park—Millionaires' Row as it was called (thirty years before, this part of the city had been nothing but flimsy wooden shacks and scrub growth)—was dumbfounded. "It is too evident that money cannot have much value here. There is too much of it. The interminable succession of luxurious mansions which line Fifth Avenue proclaim its mad abundance. No shops, unless of articles of luxury—a few dressmakers, a few picture dealers . . . only independent dwellings each one of which, including the ground on which it stands, implies a revenue which one dares not calculate. The absence of unity in this architecture is a sufficient reminder that this is the country of the

individual will, as the absence of gardens and trees around these sumptuous residences proves the newness of all this wealth and of the city. This avenue has visibly been willed and created by sheer force of millions, in a fever of land speculation, which has not left an inch of ground unoccupied."[6] To the Frenchman, the mediocre taste of the rich was suffocating. "On the floors of halls which are too high there are too many precious Persian and Oriental rugs. There are too many tapestries, too many paintings on the walls of the drawing rooms. The guest-chambers have too many *bibelots,* too much rare furniture, and on the lunch or dinner table there are too many flowers, too many plants, too much crystal, too much silver."[7]

It was the height of the Gilded Age.

Before the Civil War, there were fewer than a dozen millionaires in the United States. In 1892, the *New York Tribune* published a list of 4,047 millionaires, over 100 of them having fortunes that exceeded $10 million. It was estimated that 9 percent of the nation's families controlled 71 percent of the national wealth. As the self-indulgent old rich and new rich flaunted their wealth, paying on average $300,000 a year to maintain their city mansions and Newport cottages, $50,000 to keep their yachts afloat, and $12,000 each time they wanted to give a little party, hundreds of thousands of immigrants were jammed into tenements not far from the fabulous Millionaires' Row. Thousands of child laborers worked in sweatshops for $161 a year. Common laborers made $2 to $3 a day, with the average worker earning $495 a year. Two thirds of the nation's families had incomes of less than $900; only one family in twenty had an income of more than $3,000.[8] By now it was clear that hard work and determination alone were not enough to rise from poverty, to eliminate the overcrowding, filth, and malnutrition from their lives. The days of taking a periauger and building a fortune were a distant fantasy. The realization was coming that these people were imprisoned by circumstance. A spirit of discontent was growing. Change was in the air.

In 1894 a commentator noted that "if our civilization is destroyed, as Macaulay predicted, it will not be by his barbarians from below. Our barbarians come from above. Our great money-makers have sprung in one generation into seats of power kings do not know. The forces and the wealth are new, and have been the opportunity of new men. With-

out restraints of culture, experience, the pride, or even the inherited caution of class or rank, these men, intoxicated, think they are the wave instead of the float, and that they have created the business which has created them. To them science is but a never-ending repertoire of investments stored up by nature for the syndicates, government but a fountain of franchises, the nations but customers in squads, and a million the unit of a new arithmetic of wealth written for them. They claim a power without control, exercised through forms which make it secret, anonymous, and perpetual. The possibilities of its gratification have been widening before them without interruption since they began, and even at a thousand millions they will feel no satiation and will see no place to stop."[9]

The millionaires of the Gilded Age, the captains of industry, the merchant princes, had once been all but deified as the great builders of the country. In the Progressive Era, which began in the final years of the century, the muckrakers dismissed them as avaricious robber barons. The mansions of the rich had once been viewed in awe as monuments to the greatness of a new nation. Now they were being condemned as socially inappropriate indulgences, the most visible example of the conspicuous waste of the idle rich. When Cornelius and Alice Vanderbilt decided in the early 1890s to expand their Fifth Avenue mansion to cover an entire block, the outcry was intense. Vanderbilt was scolded by the press for spending so much on a private residence: "He has no business in a Republic to 'flaunt' his wealth so insolently. And surely it is only enlightened moral sense to maintain that the good a man incidentally does in spending a vast sum on his own self-gratification alone, ends in destruction and social dry-rot, ministering as it does to envy and the sense of social disproportion which is the very seed of revolution, and the growth of the horizontal cleavage between the 'haves' and the 'have-nots.' "[10]

Increasingly, the press was criticizing the lavish expenditure of the rich as something that was not democratic. "When we look upon the palaces planted in some of our mountain and seashore towns, the great lawns and gardens requiring the attendance of forty or fifty men, the four-in-hands whirling along the country roads, blowing horns to warn all humbler vehicles to clear the way, the great yachts with their crews awaiting the rare visits of their owners, we may not be able to formulate

the grounds for our belief, but we do believe, or feel with an instinct that amounts to certainty, that all this is out of harmony with the spirit of American institutions, and that sooner or later one or the other must go."[11]

Politicians jumped on the bandwagon. The Senate Committee on Education and Labor considered passing legislation putting a ceiling on how much a millionaire could spend on his residence. The Sherman Antitrust Act of 1890, which passed Congress by an almost unanimous vote, was an outgrowth of the growing fear of the giant monopolies and trusts and their control over the necessities of life. Between 1873 and 1879, fourteen different income-tax bills had been introduced in Congress to help redistribute wealth, but it was not until 1894 that the first income tax since the Civil War was imposed, at 2 percent of all income exceeding $4,000. This was done despite Ward McAllister's grave public warning that "our best people will be driven out of the country" and flee to Europe "where expenses of the necessaries and luxuries of life are not nearly so high as they are in this country."[12] McAllister perhaps recognized such a tax as the opening wedge that would destroy society as he knew it, but as it turned out, the rich had no reason to flee to Europe; the next year the new tax was struck down as unconstitutional by the U.S. Supreme Court.

The chasm between a bloated plutocracy and the poor was widening, deepening, becoming more visible. The worst depression since the Civil War hit the nation in the early 1890s and precipitated a number of strikes: the bloody Homestead strike at the Carnegie steel mills in 1892, during which Pennsylvania sent in its militia; the Pullman strike in 1894, which led to the burning of hundreds of railroad cars in Chicago freight yards and necessitated the intervention of federal troops; thirteen hundred other strikes in 1894 alone. The long agricultural depression dragged on, hundreds of banks closed, the stock market broke, and businesses collapsed. The Philadelphia and Reading Railroad Company, the Northern Pacific, the Union Pacific, and the Santa Fe railroads went into receivership. Unemployment in New York City exceeded 20 percent, thousands of jobless men swarmed in the cold winter streets of the city, and a band of the unemployed, Coxey's Army, marched to Washington to seek, unsuccessfully, relief. Rumors of popular unrest, insurrection, revolution, class war, were abroad. The rich were haunted by

nightmares of armies of the poor marching through the city, plundering. That pointed eight-foot-high wrought-iron fence that surrounded the Cornelius Vanderbilt mansion began to seem less ornamentation and more fortification.[13]

One winter morning in 1897 in his mansion in New York City, Bradley Martin, a wealthy descendant of an old New York family and one of the original members of the Four Hundred, had an idea about how to alleviate the plight of the poor. He turned to his wife.

"I think it would a good thing if we got up something; there seems to be a great deal of depression in trade; suppose we send out invitations for a concert?"

"And pray, what good will that do?" his wife asked him. "The money will only benefit foreigners. No, I've a far better idea; let us give a costume ball at so short notice that our guests won't have time to get their dresses from Paris. That will give an impetus to trade that nothing else will."[14]

The more the Bradley Martins thought about their idea, the more they liked it. Their old friend Ward McAllister had been right: A ball could solve all of society's problems! Seamstresses, hairdressers, florists, musicians, wine dealers, waiters, chefs—they all would be kept busy. There would be work for everyone. Everyone would benefit from their ball. And what fun it would be! For the night, they would transform the ballroom of the Waldorf into a hall of Versailles and have all their friends come dressed in costumes of the sixteenth, seventeenth, and eighteenth centuries as if for presentation at the court of Louis XV!

Invitations went out to the thousand people on the Bradley Martins' visiting list. Mrs. Bradley Martin turned on her publicity machine to interest the newspapers in her good deed. And then the trouble began.

Newspapers in editorials, politicians on the soapbox, and preachers from the pulpit expressed their outrage at such a wanton display of wealth during a period of depression and despair. The ball the Bradley Martins were planning would be an example of Roman extravagance at its worst: feasting and dancing while thousands starved.

The rector of the fashionable St. George's Protestant Episcopal Church in New York City doubted whether money of the rich spent on fancy dress costumes for the ball would really help the indigent: "This

affair will draw attention to the growing gulf which separates the rich and the poor, and serve to increase the discontent of the latter needlessly. It is hardly to the point to talk of setting money into circulation. I believe it to be a deplorable thing to do anything that will emphasize the poverty of the poor or augment their discontent. The meat of the matter is that in a time of general depression, with poverty all too prevalent, it is unwise to give to social reformers and would-be revolutionists any handle for their fanatical efforts."[15] The Reverend Dr. Rainsford advised his parishoners not to attend the ball.

"God pity the shivering, starving poor these days and send a cyclone of justice upon the ball of selfishness!" ranted a Brooklyn pastor. "Sedition is born in the lap of luxury—so fell Rome, Thebes, Babylon, and Carthage," lectured the Reverend Madison Peters in his sermon "The Use and Misuse of Wealth." "I believe that such an affair as that to be given by the Bradley Martins is an incentive to anarchy."[16]

A politician, a Republican to boot, stated that it would serve the Bradley Martins right if an anarchist did throw a bomb into the party as the papers were predicting, and blow "the dancing fops and their ladies to spangles and red paste."[17]

Nevertheless, the Bradley Martins pressed on, convinced of the soundness of their good intentions.

At 11 o'clock on the night of February 10, 1897, all of society was at the Waldorf: Mrs. Astor, Mamie Fish, Harry Lehr, Grace and Neily Vanderbilt, Mrs. O.H.P. Belmont, Winthrop Rutherfurd, Lispenard Stewart, Mrs. Orme Wilson, August Belmont in a suite of gold-inlaid armor that had cost $10,000. ("Were all the costumes ticketed with the price?" the *London Chronicle* wondered upon learning the costs of many of the gowns and costumes, down to the price of the diamond buttons.[18]) No one would have missed this ball, especially with the exciting possibility of witnessing the first skirmishes of a class war as promised by the press. Society was prepared. Bradley Martin had hired a squad of policemen to stand outside and protect his guests as they arrived. All of the ground-floor windows of the Waldorf had been boarded to repel bombs. And Pinkerton detectives dressed in period costumes mingled with the guests, looking for anarchists.

The walls of the ballroom were draped with tapestries, the room filled with six thousand orchids. There were fifty musicians, jeweled

favors, and endless quadrilles. Dinner was served by waiters in royal livery. And all evening long, Mr. Bradley Martin, dressed as Louis XV, and Mrs. Bradley Martin, as Mary Stuart, queen of Scots, bedecked in Marie Antoinette's ruby necklace, dressed in a gold-embroidered gown trimmed with pearls and precious stones, greeted their guests as they approached their thrones.

The total amount of money that the ball put into circulation, according to Bradley Martin's calculations, was $369,200. This had certainly not been the costliest ball of the Gilded Age, nor the most exclusive, nor the most original. But it was the most notorious. Fourteen years before, Alva Vanderbilt's fancy dress ball had received front-page coverage as AN EVENT NEVER EQUALLED IN THE SOCIAL ANNALS OF THE METROPOLIS. The Bradley Martin Ball received front-page coverage consisting of ridicule and satire and condemnation. The times were changing.

The Bradley Martins never understood the public outcry over their ball, which they were convinced had sprung solely from their humanitarian impulse to help the needy. The criticism would blow over, they were sure. They could withstand it. But the final straw came with a visit from New York City's tax collector, who reappraised their mansion in light of their obvious wealth and doubled their tax assessment. Enough ingratitude was enough. The Bradley Martins sold their home and moved to England, never to return.

2.

Among the most conspicuous of those indulging in conspicuous consumption were the grandchildren of Commodore Vanderbilt. The uproar over the Bradley Martin Ball bothered them not one whit, for they were believers in the types of sermons given by Bishop Paddock of New York City's Christ Church. Wealth, the bishop preached, was God-given. "He calls some men to make money, a million it may be in one case, a thousand in another. Whatever the difference may be between the men who make these sums is God-given, and the millionmen should realize that fact and live accordingly."[19] The Vanderbilt grandchildren did. "They are inveterate builders, are these American millionaires,"

wrote a historian of the Gilded Age. "What with the six or seven great New York houses of the Vanderbilt family, and their still larger number of country estates, it could be plausibly argued that among them they have invested as much money in the erection of dwellings as any of the royal families of Europe, the Bourbons excepted."[20]

The grandchildren of the Commodore had indeed done very well in the ten years since the death of their father, William H. Vanderbilt, in 1885.

As befit the eldest son, Cornelius had built himself the biggest mansion on Fifth Avenue and the biggest summer cottage in Newport.

Willie had the most elegant mansion on Fifth Avenue and in Newport, not to mention his eight-hundred-acre country estate on Long Island and the largest steam yacht afloat.

Brother Frederick lived in the mansion at Fortieth Street and Fifth Avenue that the Commodore had given his son William, and that William Vanderbilt had in turn given to his son Frederick. In the spring and fall, he could relax at his fifty-room Italian Renaissance mansion on six hundred acres in Hyde Park, New York, with commanding views of the Hudson; in the summer he could retreat to Rough Point, his mansion in Newport; and, in between, he sailed aboard his yacht, the *Conqueror.*

Sister Margaret Louisa lived with her husband, Elliott F. Shepard, in the twin mansion her father had built next to his home at 640 Fifth Avenue; at Woodlea, the couple's estate in Scarborough, New York; and in their summer cottage at Bar Harbor, Maine.

The other twin mansion, at 640 Fifth Avenue, was occupied by sister Emily and her husband, William D. Sloane, when they were not at their villa, Elm Court, in Lenox, Massachusetts, or at their mansion in Washington, D.C.

Florence Adele, the third daughter of William H. Vanderbilt, had married Hamilton McKown Twombly, who had inherited from his father an interest in several railroads, and whose business acumen the Vanderbilts relied on in overseeing their finances. The couple lived at 684 Fifth Avenue in the mansion Florence's father had built for them, as well as at Vinland, their summer estate in Newport, which adjoined The Breakers, and at Florham, their 110-room mansion set on one thousand acres in the rolling hills of Morris County in New Jersey.

In the mansion next door to Florence's on Fifth Avenue lived sister

Eliza, who had married Dr. William Webb, president of the Wagner Palace Car Company. When not in the city, they enjoyed Shelburne Farms, a sprawling mansion and thirty-five-hundred-acre estate in Shelburne, Vermont, near Burlington.

George Vanderbilt was the youngest of the eight children of William H. Vanderbilt, born nineteen years after his oldest brother, Cornelius. As the youngest child, he was his father's favorite and his father's constant companion.

George was different from his older brothers, showing no interest in the family business, in society, or in the sporting activities that occupied his brothers' free moments. To his niece Consuelo, he didn't even look like a Vanderbilt; with his dark hair and eyes, moustache, pale complexion, and slender, almost frail build, he seemed to Consuelo like a Spaniard.

As his brothers and sisters were engaging in the most frenetic mansion-building binge the United States had seen, George was quite content to live at home with his mother at 640 Fifth Avenue, haunting secondhand bookstores to buy volumes to add to his collection of old books, which he kept in a library near his bedroom on the second floor.

George had inherited $1 million from his grandfather, the Commodore; his father gave him an equal amount on his twenty-first birthday. He inherited $5 million more when his father died in 1885, as well as the income from a $5 million trust fund. But money seemed of little interest to him. Shy, introverted to the point of almost appearing simple-minded to those who first met him, he spent his time among his books, reading, studying philosophy, becoming fluent in eight foreign languages, and learning the histories of all the paintings in his father's gallery.

In the winter of 1888, three years after the death of William H. Vanderbilt, twenty-six-year-old George and his mother went to the Great Smoky Mountains of North Carolina to get away from the cold New York City winter. George was captivated by the magnificent vistas and sparkling fresh air of this mountain country near Asheville, and decided he would build a retreat so that he and his mother could visit there every winter. This was just like George, his brothers and sisters concluded when they heard of his plans. Everyone was building on the fashionable sections of Fifth Avenue and Newport, and there he went,

building a lodge in the impoverished Appalachian mountain country of
western North Carolina, miles and miles from civilization.

George bought a tract of land in 1889 and began construction of
his house later that year.

Six years later, with everything almost as he wanted it, he invited
his mother and all his brothers and sisters and their families to come
spend Christmas with him at his new home, Biltmore.

On Christmas eve, a procession of private railroad palace cars rolled
into Asheville and were switched onto the spur line George had laid from
the Southern Railway to his property. His mother arrived in her private
car, followed by Cornelius and Alice and their children, Willie in his
palace car, *Idlehour,* the Frederick Vanderbilts in their car, *Vashta,* the
Seward Webbs, Florence and Hamilton Twombly—everyone was there,
along with enough servants to take care of them for this week in the
wilderness of North Carolina, while they inspected what young George
had been up to.

George had begun with the purchase of five thousand acres in 1889,
and then had decided that he did not want any neighbors close by. He
continued acquiring land with the addition of contiguous parcels of small
farms and one-room log cabins. One old black farmer with nine acres
in the heart of the growing estate refused to sell, stating that he had "no
objection to George Vanderbilt as a neighbor."[21] But Vanderbilt money
never failed to do the trick in this impoverished countryside. Before he
finished, the estate boasted enough land to keep any neighbor far away:
146,000 acres, 228 square miles. It would have taken one week to travel
on horseback around the borders of his kingdom.

The carriage trip for George's mother and brothers and sisters and
their families from the front gates, where the railroad tracks stopped, to
his house was three more miles, but magical miles they were. When he
had first begun buying this mountain property, he had called upon the
most noted landscape architect of the day, elderly Frederick Law
Olmsted, the creator of such wonders as Central Park in New York, the
grounds around the U.S. Capitol, public parks in Boston, Chicago, and
Buffalo, and the university grounds at Stanford, Cornell, and Amherst.
Olmsted spent several days riding around this domain with George
Vanderbilt. He found Vanderbilt "a delicate, refined and bookish man,
with considerable humor, but shrewd, sharp, exacting and resolute in

matters of business,"[22] and thus was quite candid with him about the possibilities of this vast tract.

"Now I have brought you here to examine it," George said to his wise old friend, "and tell me if I have been doing anything very foolish."

"What do you imagine you will do with all this land?" Olmsted asked.

"Make a park of it, I suppose."

"You bought the place then simply because you thought it had good air and because, from this point, it had a good distant outlook. If that was what you wanted you have made no mistake. There is no question about the air and none about the prospect. But the soil seems to be generally poor. The woods are miserable, all the good trees having again and again been culled out and only runts left. The topography is most unsuitable for anything that can properly be called park scenery. It's no place for a park. You could only get a very poor result at great cost in attempting it."

"What could be done with it?"

"Such land in Europe would be made a forest; partly, if it belonged to a gentleman of large means, as a preserve for game, mainly with a view to crops of timber. That would be a suitable and dignified business for you to engage in; it would, in the long run, be probably a fair investment of capital and it would be of great value to the country to have a thoroughly well organized and systematically conducted attempt in forestry, made on a large scale. My advice would be to make a small park into which to look from your house, make a small pleasure ground and gardens; farm your river bottoms chiefly to keep and fatten live stock with a view to manure; and make the rest a forest, improving the existing woods and planting the old fields."[23]

That sounded fine to George, who told Olmsted to begin at once. Old, lame, and in poor health, Olmsted was rejuvenated by the prospect of undertaking such an enormous project. With a large staff and no limit on expenses, he immediately began the work of surveying, grading, laying out miles of roads, constructing bridges, culverts, drains, preparing nurseries and fields, planting rare and unusual flowering trees and shrubs, scouring swamps and valleys for native azaleas and rhododendrons, building a great English walled garden of four acres with formal beds of roses, tulips, perennials, and annuals. Through his cultivation and alteration of

the land, he began painting picturesque compositions with vistas and lawns, trees and shrubs.

The winding road the Vanderbilt family carriages followed that Christmas Eve took them along ravines, ever upward into the mountains, past woodland pools, springs, and streams, deep forests of majestic conifers and hardwoods, with each side of the road highly cultivated with azaleas and rhododendrons.

The road was designed so that there were no vast spaces or distant outlooks until finally the forests opened up. They were on the summit of a mountain that had been cut flat, with breathtaking views over the French Broad River where it met the Swannanoa River, over parks, pastures, hills, and beyond to the double peak of Mount Pisgah and in the distance the Great Smoky Range and the Black Mountains. George owned it all. But it was hard to focus on the view and hard for even this group of jaded millionaires to keep their jaws from dropping in wonder, for there before them stood young brother George's retreat, Biltmore, the largest house that had ever been built in the United States.

George had developed almost a father-and-son relationship with Richard Morris Hunt when he had helped his father work with the architect in designing the family mausoleum on Staten Island. Hunt shared these feelings with his youngest Vanderbilt patron, and enjoyed every moment of his work on the proposed mountain retreat. "Richard went to Biltmore full in anticipation of pleasure," Hunt's wife wrote in her journal, "for here George Vanderbilt watched over him with affectionate solicitude, and . . . even his professional work was made easy by the perfect harmony between himself and his client."[24]

With this type of close working relationship, with the grand mountain site that George had selected, and with George's desire to build a home suitable to house the monumental works of art he had been acquiring on his trips abroad and storing at his mother's home, Hunt, like Olmsted, saw the opportunity to create the masterpiece of his career.

In the spring of 1890, Hunt made his first trip to the site in Vanderbilt's private railroad car. There, everything was happening at once. The land was being cleared; trees were being planted; the site was being surveyed; thirty-two thousand bricks a day were spewing forth from the kilns that had been built on the estate; three hundred men were grading and clearing the forests. A nearby mountain with a spring of fine

water that suited George Vanderbilt's taste had been purchased and a reservoir was being built, along with a filtration plant, pumping machinery, and five miles of pipe to bring the water to his new house. "Everything is progressing rapidly and well," Hunt wrote to his wife; "certain vistas have been opened up within the last two days and a grand establishment may be expected—nothing being spared by G.W.V. If it is not a success the fault will lie with us, who are called upon to do our best."[25]

Architect and patron set out to create the finest country home in America. The thirty-five-acre leveled mountaintop, surrounded by several hundred acres of parkland Olmsted was creating from the forests, would be dominated by a great château, not cramped on a city lot on Fifth Avenue or on a few acres of windswept waterfront in Newport, but a real château set in countryside similar to France's Loire Valley. Patterned after three of the greatest of the French châteaus—Chambord, Blois, and Chenonceaux—the mansion would have a front 780 feet long, and would cover 5 acres, the same size as the Commodore's Grand Central Depot. Built of Bedford stone and Indiana limestone, with a skyline of towers and mullioned windows, the home would contain 250 rooms, including 40 master bedrooms, certainly enough if all the members of the Vanderbilt family came calling.

"The chateau is beginning to hum," Richard Hunt wrote to his wife as the work progressed. "The mountains are just the right size and scale for the chateau!"[26]

Just as the mountains seemed to be in scale with Biltmore, so the rooms of the mansion were in scale with the château, from the palm court, a sunken marble conservatory filled with flowers, palms, and ferns, to the walnut-paneled library with ceiling-high bookcases holding over twenty thousand leather-bound volumes, to the ninety-foot-long tapestry room, to the seventy-two- by forty-two-foot banquet hall with its ribbed timber ceiling arching seventy-five feet above the parquet floor, three enormous marble fireplaces, five 16th-century silk-and-gold Flemish tapestries that had belonged to King Henry VIII, a cathedral pipe organ taller than a three-story house, and seventy-six antique Italian chairs around the dining room table.

Young George Vanderbilt, accompanied by Richard Hunt and his wife, had traveled around Europe in the summer of 1889 to visit some of the historic châteaus of France and to collect treasures for Biltmore.

"G.W.V. was insatiable in his desire to see beautiful interiors and pictures," Mrs. Hunt recalled, "and I can see him now, as he surreptitiously passed historic rooms and announced with glee that the long gallery at 'Biltmore' was a few feet longer or broader. One morning we spent at the great Oriental carpet warehouse of Robinson, where G.W.V. selected three hundred rugs for the house yet to be built."[27] Every room in this magnificent château in the middle of nowhere was filled with priceless treasures, paintings by Renoir and Boldine, portraits by Sargent, Singer, and Whistler, Dürer engravings, tapestries by the score, wall hangings that had been Cardinal Richelieu's, Napoleon's chess set, not to mention the oak, marble, and limestone carvings of Karl Bitter that graced every nook and cranny of the home.

As his mother, brothers, and sisters toured the 250 rooms of the château during their Christmas visit, as they were driven over the two hundred miles of roads he had laid out, as they were shown around Biltmore Village, the town George had built on his estate for the eighty house servants and over three hundred outdoor workers that it took to run his barony—a village with a school, shops, a railroad station, sawmills, a hospital, a post office, and All Souls Church—the family realized that there was no question but that younger brother George was pure Vanderbilt. He had outdone them all, as well as every other millionaire of the Gilded Age.

It had taken one thousand laborers, each earning ninety cents a day (seventy-five cents a day more if they brought a mule with them), six years to build Biltmore, lay out the park around it, and landscape an outer area of eleven thousand acres. The work had been completed just in time, for shortly after the family Christmas reunion, George's mother, seventy-five-year-old Mrs. William H. Vanderbilt, passed away. George closed up the mansion at 640 Fifth Avenue and moved down to Biltmore.

Vanderbilt's goal at Biltmore was to promote scientific forestry and farming and to run his duchy as a self-sustaining estate. A director of forestry oversaw the improvement of timber in the acres of forest. A director of agriculture was in charge of breeding dairy cattle and European hogs. The director of landscaping, Chauncey Beadle, who came to the estate in 1890 when it was being built, stayed for the next sixty years, supervising the care of the 11 million specimens in the arboretum.

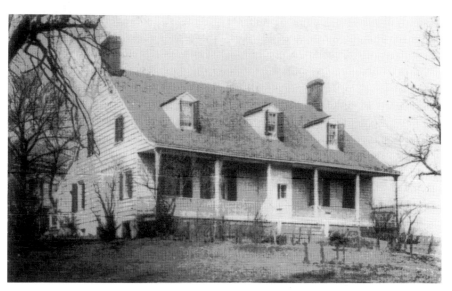

THE BIRTHPLACE OF CORNELIUS VANDERBILT.
"Cornelius had been born on May 27, 1794, in a small farmhouse at
Stapleton, Staten Island, a stone's throw from the waters
of New York Bay."
STATEN ISLAND HISTORICAL SOCIETY

CORNELIUS
VANDERBILT,
THE COMMODORE.
"The Commodore was the
first to admit that the
accumulation of money had
been a mania with him
when he was seventeen and
that he had never gotten
over it. 'I have been insane
on the subject of
money-making all my life.'"
BROWN BROTHERS

DANIEL DREW.
"The Commodore's old
steamboat rival, sun-beaten
gospel-quoting Daniel Drew,
as tightfisted and shrewd as
the Commodore"

GRAND CENTRAL DEPOT.
"The Commodore built at Fourth Avenue and Forty-second Street the
Grand Central Depot, a massive brick-and-granite structure with a glass
domed roof that covered five acres, a building that was, as he
planned it, the largest terminal in the world."

THE GRAND CENTRAL DEPOT, NEW YORK.
JOINT PASSENGER STATION AND GENERAL OFFICES OF THE
"New York Central & Hudson River," "New York & Harlem" and the "New York & New Haven" Railroad Companies. Completed in 1871.

VICTORIA WOODHULL.
"Whether Victoria Woodhull was receiving stock tips from the beyond or whether the Commodore was whispering tips into Tennessee's cute little ear, within a few months the sisters had made over $500,000."

TENNESSEE CLAFLIN.
"The Commodore began spending more and more time with the young girl, bringing her with him to his office, sitting her on his knee and bouncing her up and down as he talked railroad business with his associates and she pulled on his side whiskers."

FRANK CRAWFORD.
"The Commodore was infatuated with a relative, Frank Crawford, the thirty-year-old great-granddaughter of his mother's brother."

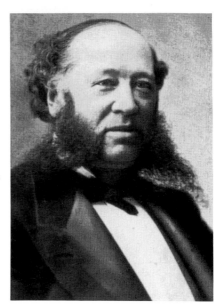

WILLIAM H. VANDERBILT.
"One fine day he must have looked up and concluded he had been doing something right. 'I am the richest man in the world.'"

CARICATURE OF WILLIAM H. VANDERBILT.
"Cartoonists had a field day portraying the heavyset executive as a rapacious brigand, intent only on satisfying his insatiable appetite for more—more railroads, more business, more money."

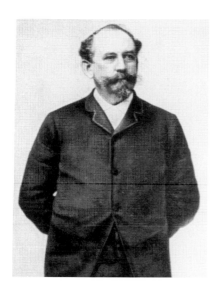

WARD McALLISTER.

"When the wealthy encountered Ward McAllister, who spoke with such authority in his affected British accent, they were relieved to let this fop assume the role of arbiter of good taste and to obey his precepts blindly."

MRS. ASTOR.

"Mrs. Astor was definitely the problem. Mrs. Astor would have nothing to do with social upstarts like the Vanderbilts, and Mrs. Astor was the undisputed queen of New York society."

MRS. ASTOR'S BROWNSTONE.

"The ballroom of Mrs. Astor's brownstone at 350 Fifth Avenue at the corner of Thirty-fourth Street could hold four hundred people. Therefore that became the magic number that constituted the cream of New York society."

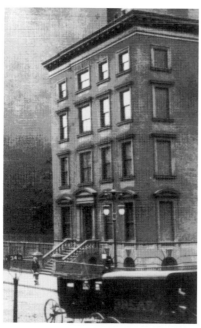

WILLIAM K.
VANDERBILT.
"Willie quickly learned
that the only way to
humor and appease his
volatile, imperious wife
was to let her spend
his money."

RICHARD
MORRIS HUNT.
"The first thing you've
got to remember is that
it's your clients' money
you're spending. If they
want you to build a
house upside down
standing on its chimney,
it's up to you to do it."

**ALVA VANDERBILT
DRESSED FOR HER FANCY DRESS BALL,
MARCH 26, 1883.**
"Alva looked very young and she looked very rich."
NEW YORK HISTORICAL SOCIETY,
THE HAROLD SETON COLLECTION

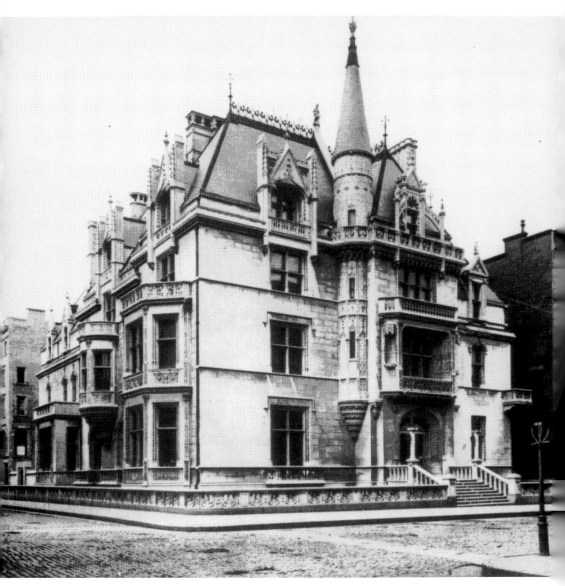

THE WILLIAM K. VANDERBILT MANSION,
660 FIFTH AVENUE.
"Everyone was entranced by this château that seemed to have been lifted
from the rolling countryside of the Loire Valley and planted
on a corner of Fifth Avenue."

THE
GRAND STAIRCASE,
660 FIFTH AVENUE.

"Down the Caen stone staircase swirled a crowd of princes, monks, cavaliers, Highlanders, queens, kings, dairy maids, bullfighters, knights, brigands, and nobles."

CULVER PICTURES

THE MUSIC ROOM,
660 FIFTH AVENUE.

"The guests proceeded into the white and gold Louis XV music salon paneled with gilded wainscoting wrested from an old French château."

CULVER PICTURES

WARD McALLISTER AT THE FANCY DRESS BALL.

"As Ward McAllister, costumed as the Huguenot count de La Môle, lover of Marguerite de Valois, embraced Alva, Alva thought that his arrival was a good omen."

NEW YORK HISTORICAL SOCIETY, THE HAROLD SETON COLLECTION

ALICE VANDERBILT AT THE FANCY DRESS BALL.

"Alice, the former Sabbath morning instructress of the children of St. Bartholomew's Parish, came as that new invention the Electric Light Torch, dressed in white satin lavishly trimmed with diamonds and with her head, Ward McAllister noted, 'one blaze of diamonds.'"

NEW YORK HISTORICAL SOCIETY, THE HAROLD SETON COLLECTION

THE WILLIAM H. VANDERBILT TWIN MANSIONS,
640 FIFTH AVENUE.

"It was obvious the grim four-story structures had been designed by the architect of the Grand Central Depot; massive square blocks of brownstone overwhelming their lots, they looked like public edifices."

MUSEUM OF THE CITY OF NEW YORK,
BYRON COLLECTION

THE LIBRARY, 640 FIFTH AVENUE.

"The baroque interior of the home of the head of the House of Vanderbilt was a tasteless hodgepodge, ostentatiously crammed with riches."

BROWN BROTHERS

THE VANDERBILT MAUSOLEUM,
NEW DORP, STATEN ISLAND.

"A Romanesque chapel patterned after the Chapel of St. Giles at Arles in the south of France won Mr. Vanderbilt's approval. It would be embedded in the hillside on three sides, with commanding views from its front steps all around Staten Island and of every steamship coming into New York Harbor."

STATEN ISLAND ADVANCE PHOTOGRAPH

THE DEATH OF WILLIAM H. VANDERBILT.

"Suddenly, without a sound, William Vanderbilt toppled to the floor, struck dead by an apoplectic stroke."

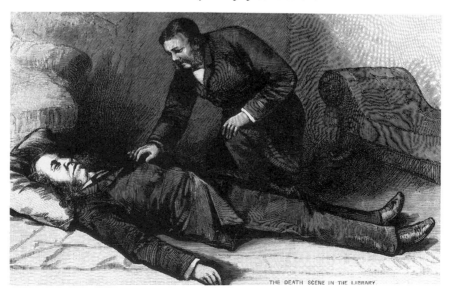

THE DEATH SCENE IN THE LIBRARY.

CONSUELO AT SIXTEEN.
"Alva groomed Consuelo to be
a duchess, a princess, perhaps
even a queen, from her earliest
childhood days."
BROWN BROTHERS

CONSUELO AS THE
DUCHESS OF MARLBOROUGH.
"She soon wearied of a life of
formal protocol, of changing
her clothes four times a day for
different occasions, of
interminable dinners during
which 'as a rule neither of us
spoke a word,' of walking on
'an endlessly spread
red carpet.' "
PHOTOGRAPH BY LAFAYETTE

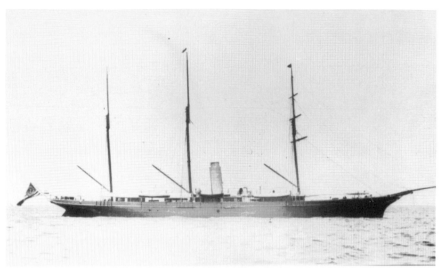

THE *ALVA*.

"The *Alva* topped them all at 285 feet: the largest
private yacht ever built."

MARBLE HOUSE.

"Alva decided that for her summer cottage, set in a community that
prided itself on its summertime simplicity, a temple of
white marble would be most appropriate."

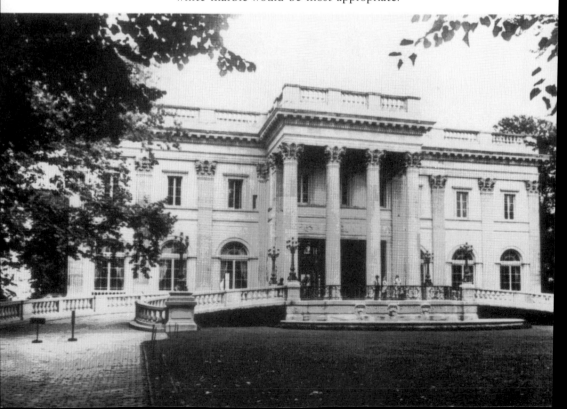

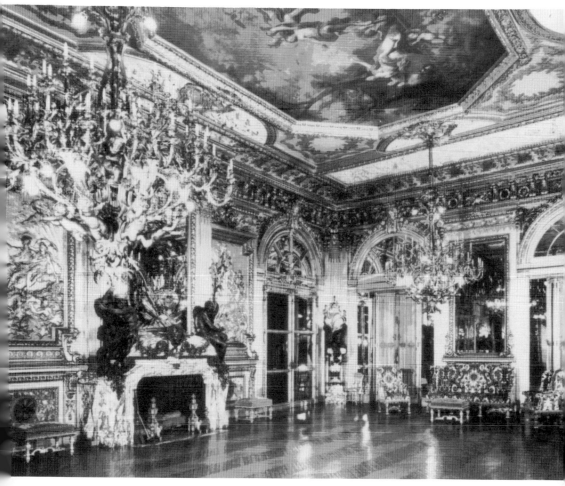

THE GOLD BALLROOM,
MARBLE HOUSE.

" 'I like to think,' Alva reflected, 'that some of the treasures of Europe
accumulated in her eras of splendid achievement have been brought
to this Greek dwelling as gifts to her temple.' "

THE DUKE OF MARLBOROUGH.
"Marlborough immediately informed his new wife that to marry her he had 'to give up the girl he loved,' but that 'a sense of duty to his family and to his traditions indicated the sacrifice of personal desires.' "

BLENHEIM PALACE.
"Consuelo quickly perceived what was wrong at Blenheim: The young duke was destitute, unable to maintain so monumental a home."

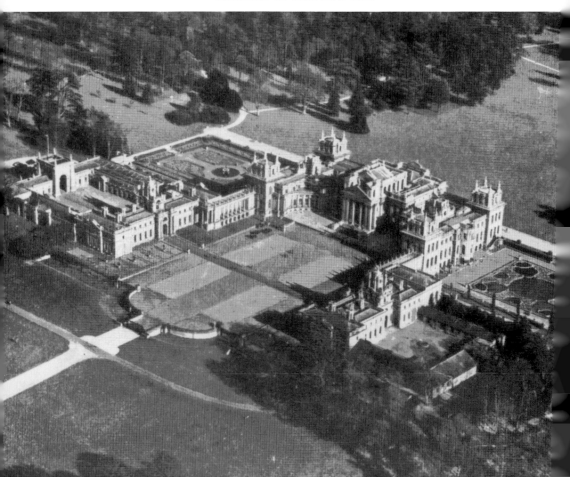

CORNELIUS VANDERBILT II.
"A lifelong acquaintance of
Cornelius Vanderbilt's remarked
that he never once recalled
seeing him smile."

ALICE VANDERBILT.
"Quiet, reserved to the point of
seeming shy or cold, Alice
Vanderbilt acted like the Sunday
school teacher she was."

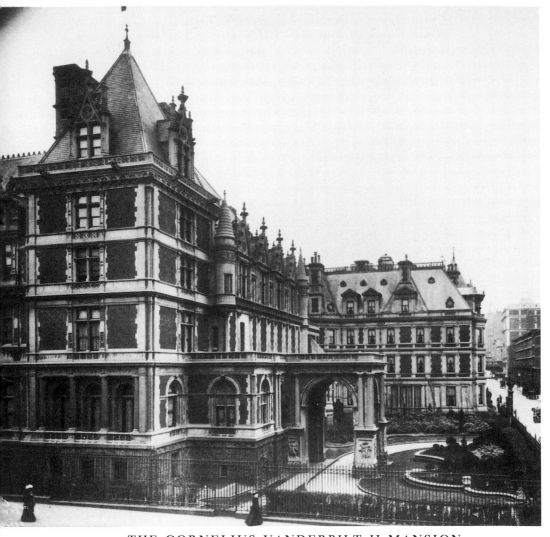

THE CORNELIUS VANDERBILT II MANSION, 742–746 FIFTH AVENUE.

"Visitors found the mansion chilly and uncomfortable, built for social functions, not for living."

MUSEUM OF THE CITY OF NEW YORK,
BYRON COLLECTION

THE LIVING ROOM OF THE
CORNELIUS VANDERBILT II MANSION.
"A houseguest noted that the mansion 'was furnished before the day of
interior decorators and was done in the worst of the French
and Victorian periods.'"
CULVER PICTURES

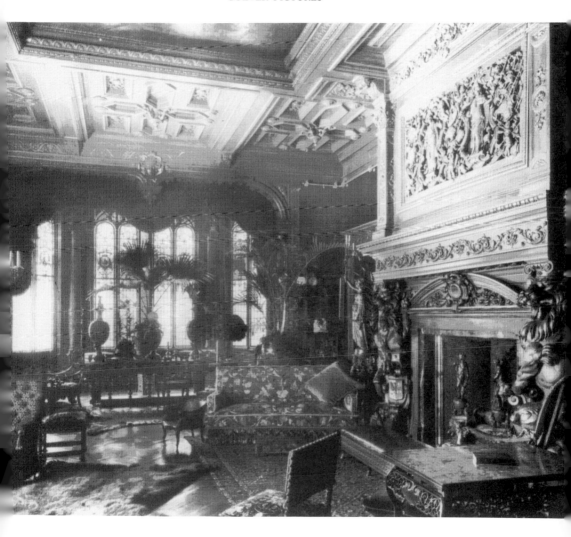

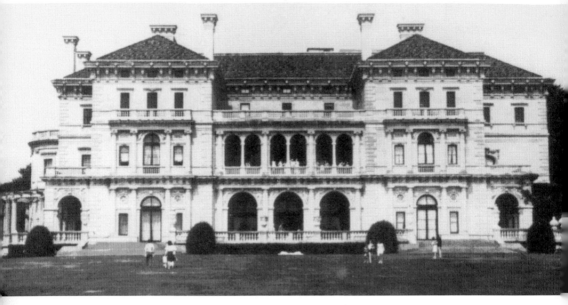

THE BREAKERS.

"Hunt came back with new sketches for a mansion modeled after the
sixteenth-century palace of a Genoese merchant prince. The Vanderbilts
settled for this plan—a seaside palace that would occupy one
full acre of the twelve-acre site."

THE DINING ROOM, THE BREAKERS.

"Opulent Italianate interiors surrounded the great hall, including
the spectacular two-story formal dining room."

COURTESY OF THE PRESERVATION SOCIETY OF
NEWPORT COUNTY

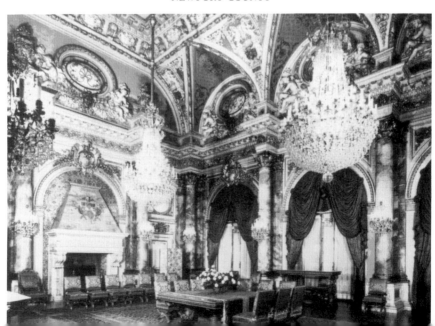

THE GREAT HALL, THE BREAKERS.

"The house was constructed around a great hall, an open space forty-five
feet high onto which second- and third-floor galleries opened,
as in an Italian courtyard."

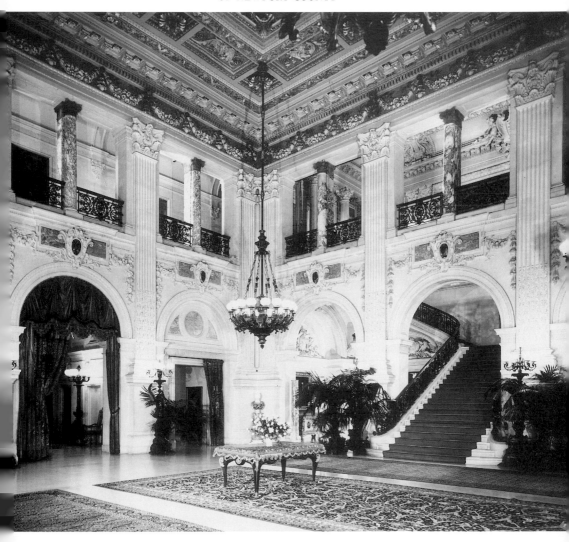

GERTRUDE VANDERBILT.
"What but money did Gertrude have to offer anyone? she
wondered time and again."
DAVID & SANFORD

BESSIE AND HARRY LEHR.
" 'Kind motherly Mrs. Astor,'
Bessie noted, 'would smile her
approval: "so nice to see young
people so much in love. I am glad
to see dear Harry with such a
charming wife." ' "
COURTESY OF
J. B. LIPPINCOTT COMPANY

ESTHER HUNT.
"Gertrude never doubted that Esther, the
daughter of the Vanderbilts' architect,
Richard Morris Hunt, liked
her for herself."
E. F. COOPER

MRS. STUYVESANT FISH.
"From this corseted grande dame
of aristocratic bearing came a
constant stream of chatter,
punctuated by her hoarse,
macawlike laugh and bursts of
caustic comments that, in their
directness and unexpectedness,
were the delight of a
bored society."

CROSSWAYS, THE NEWPORT HOME OF
MRS. STUYVESANT FISH.

" 'Howdy-do, howdy-do,' she would brusquely greet her guests, quickly
herding them on to her husband as they came through the
front door of Crossways."

BROWN BROTHERS

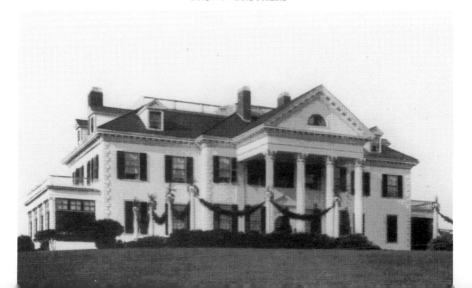

BILTMORE.

"The mountains are just the right size and scale for the chateau!"

COURTESY OF
THE BILTMORE COMPANY

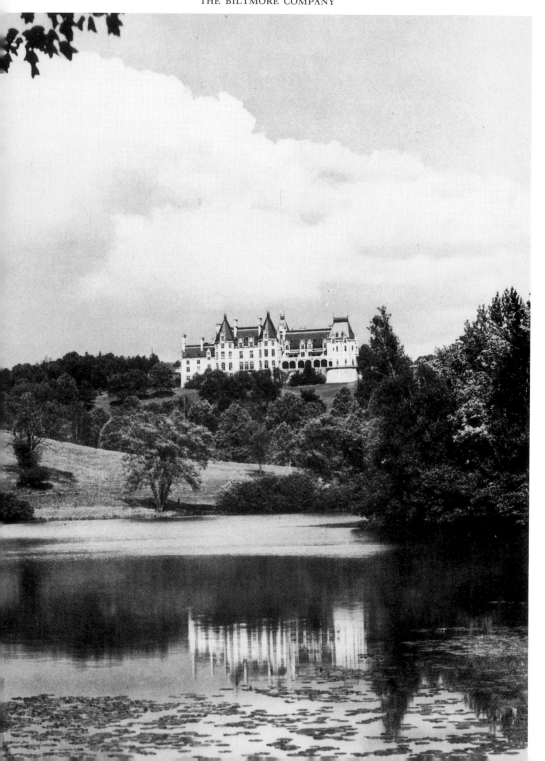

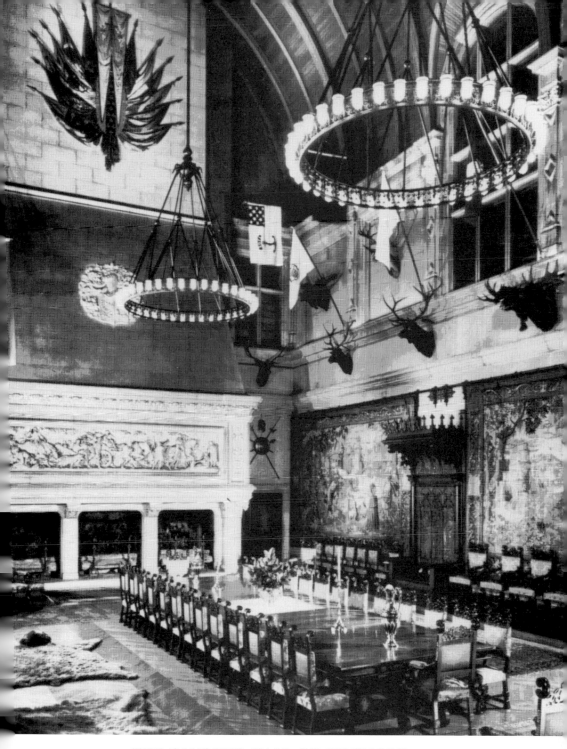

THE BANQUET HALL OF BILTMORE.

"When Henry James came to visit, he found Biltmore 'utterly
unaddressed as to any possible arrangement of life, or state of society. We
measure by leagues and we sit in Cathedrals.' "

GEORGE VANDERBILT.
"The family realized that there
was no question but that younger
brother George was pure
Vanderbilt. He had outdone them
all, as well as every other
millionaire of the Gilded Age."
PORTRAIT BY
JOHN SINGER SARGENT

BELCOURT CASTLE.
"Oliver's wedding gift to Alva was the deed to Belcourt Castle."
COURTESY OF HASTINGS HOUSE, PUBLISHERS;
PHOTOGRAPH BY MERRILL FOLSOM

MRS. O.H.P. BELMONT.

"Alva took up the cause of suffrage and became a militant feminist,
pledging 'my life, my interests, my all' to the women's movement."

GRACE WILSON.

"There, twenty-two-year-old
Neily had danced with Miss
Grace Wilson, the charming
southern Grace Wilson with
her bright hazel eyes, dreamy
complexion, and deep
auburn hair."

GRACE AND NEILY VANDERBILT.

"It had been ominously quiet at The Breakers, the day Neily and Grace married."

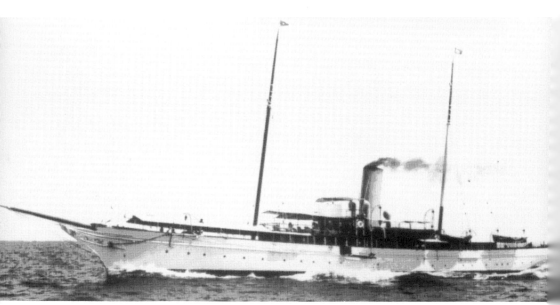

THE *NORTH STAR.*

"Each year, at Grace's urging, the Vanderbilts sailed the *North Star* to those ports where they would most likely be seen by royalty."

**GLORIA AND REGGIE
VANDERBILT.**
"Gloria appeared to Reggie a
statuesque, glamorous beauty, a
bewitching blend of European
sophistication and wistful
American innocence that stirred
his imagination. He had no idea
that she was younger than his
own daughter."
UNITED PRESS INTERNATIONAL

**REGGIE VANDERBILT
WITH LITTLE GLORIA.**
" 'It is fantastic how Vanderbilt
she looks!' Reggie exclaimed
in delight."
COURTESY OF E. P. DUTTON;
IRA L. HILL STUDIO

NURSE KEISLICH AND LITTLE GLORIA.
"Nurse Keislich had no doubt about what her job demanded: 'Watch her, guard her—every move she makes—her money, her life!' She hovered over her charge like a mother hen."
COURTESY OF NEW YORK NEWS, INC.

GERTRUDE VANDERBILT WHITNEY AND LITTLE GLORIA.
"Little Gloria arrived at the courthouse in Gertrude Whitney's Rolls-Royce, accompanied by two bodyguards. They moved through the crowds of photographers, reporters, and the curious."
COURTESY OF NEW YORK NEWS, INC.

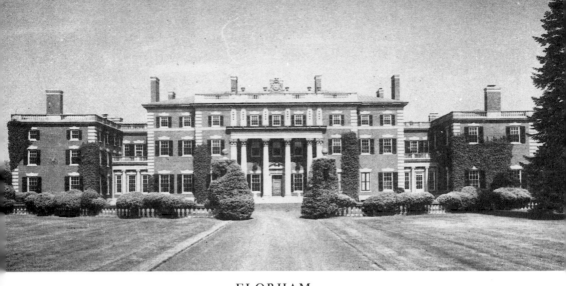

FLORHAM.

"Who could afford to live in a 110-room mansion on a 1,000-acre estate
that required a staff of over 100 to maintain?"
SOTHEBY'S

THE GREAT HALL AT FLORHAM.

"While the great hall was awash in organ music, Mrs.
Twombly invariably sat in the throne chair directly to the
left of the organ."
SOTHEBY'S

MRS. CORNELIUS VANDERBILT III
IN THE LIBRARY AT 640 FIFTH AVENUE.

"And there in the midst of this otherworldly setting was Grace Vanderbilt, dressed to the nines, sporting her jeweled bandeau and diamond stomacher."

COURTESY OF McGRAW-HILL PUBLISHING CO.;

PHOTOGRAPH BY BEATON

FLORENCE VANDERBILT TWOMBLY.

"Longer than any other member of the family, she led exactly the type of life of pomp and splendor the very rich were supposed to lead."

COURTESY OF TICKNOR & FIELDS, A HOUGHTON-MIFFLIN COMPANY

Two million young trees were sold each year from the Biltmore nurseries, which covered one hundred acres. Trees from thousands of acres of forests were selectively cut, hauled to the estate's large steam sawmill and then to the planing mill, and sold for commercial lumber. Three thousand cords of firewood were sold annually, along with fifteen hundred cords of bark from chestnut oak for the manufacture of tannic acid, fifteen hundred cords for the making of chestnut extract, tons of fresh produce from the truck farms and fruit from the greenhouses, milk and ice cream from the dairies, and pedigreed livestock from the barns. The annual income Vanderbilt received from his forest industry was great enough to offset the expense of supporting the large army of mountain men he needed to care for his domain and run it as a center of scientific forestry work. "He employs more men than I have in my charge," commented the U.S. secretary of agriculture. "He is also spending more money than Congress appropriates for this Department."[28]

At Biltmore, George led the life of a gentleman farmer, in his spare time studying the plants, birds, and animals of his principality, learning various dialects of American Indian tribes, and, for some obscure reason, translating contemporary literature into ancient Greek.

Biltmore was a monument to a young man's fantasy. When Henry James came to visit, he found it "utterly unaddressed to any possible arrangement of life, or state of society." All it was, he concluded, was "a phenomenon of brute achievement." The room to which he had been assigned, he complained, was located about half a mile from the "mile-long library. . . . We measure by leagues and we sit in Cathedrals."[29]

It could get lonely living in a 250-room house set in the midst of so vast and remote an estate, with only servants and an occasional guest. On June 2, 1898, at the age of thirty-six, George Vanderbilt married Miss Edith Stuyvesant Dresser, a descendant of Peter Stuyvesant. With their only child, Cornelia, born in 1900, they journeyed from Biltmore to their mansion in Washington, D.C., then to their summer cottage in Bar Harbor, stopping in every now and then at 640 Fifth Avenue, which George had inherited after his mother's death.

Was there no end to what Vanderbilt money could buy? Indeed there was, and for George Vanderbilt, the glimpses of the end were closer than the misty blue-gray mountain peaks he could see from his bedroom window.

Five years after the opening of Biltmore, George Washington Vanderbilt was running out of money. Suddenly, work stopped. Some of the rooms of the château were never completed or decorated, closed off forever with bare brick walls. The poultry farms, which were losing money, were abolished. Olmsted had dreamed of a road circling the entire estate with plantings on each side, a great arboretum of specimen trees and shrubs. He laid out his plans for this Arboretum Road, as he called it, and enthusiastically showed them to Vanderbilt. For the first time, his patron did not give the nod of approval. Annual expenditures for improvements and maintenance of the barony were slashed from $250,000 to $70,000. Vanderbilt's financial adviser, his brother-in-law Hamilton McKown Twombly, criticized Olmsted's son, who had continued his father's work. "The trouble with you landscape architects is that you don't protect your clients from their own ignorant impulsiveness about matters in which they rely on your experienced judgment."

"If we had known earlier," the younger Olmsted later responded, "that George Vanderbilt was spending more than his income on the Biltmore Estate and eating seriously into his capital, we could, and would, have urged methods of economizing—to any desirable degree— much more satisfactory in the net results, and less wasteful, than [what] inevitably happened when the annual expenditure was suddenly and arbitrarily cut to about a quarter of what it had been running."[30]

Not even Vanderbilt wealth could fund dreams too grand. George tried to sell 120,000 acres of forest to the United States Forest Preservation Commission at a low price, but his offer was not accepted.

When George Vanderbilt died of a heart attack on March 6, 1914, at the age of fifty-two, and his debts were paid and his estate settled, the full effect of his Ludwig-like building spree was obvious: His net estate was less than a million dollars, $929,740.98, including only $11,125 of railroad stocks and bonds. His fourteen-year-old daughter, Cornelia, received the $5 million trust fund he had inherited from his father, and his wife was left the homes at Bar Harbor, Washington, and Biltmore, with no money to run them. Within three months of her husband's death, Edith Vanderbilt had sold 86,700 acres of the Biltmore barony to the National Forest Preservation Commission for $433,500, at $5 an acre, $200,000 less than her asking price; she would sell off additional

acreage as she needed money until only a core estate of 12,500 acres remained. The executors of George Vanderbilt's estate were compelled to reduce the individual bequests made in his will because there simply were not the assets to fulfill them. "Which of you, intending to build a tower, sitteth not down first, and counteth the cost, whether he have sufficient to finish it?" Luke 14:28.

3.

Like the grand finale of a Fourth of July fireworks display, George Vanderbilt's Biltmore was the biggest and most startling of the Vanderbilt mansions. It was overwhelming. And it was the end. One by one, the mansions now would begin to fall.

"William K. Vanderbilt is in charge of everything," Chauncey Depew had told reporters that day in September 1899 when Willie's older brother, Cornelius Vanderbilt, passed away. "He is the head of the family."[31]

For a while, Willie managed the affairs of the railroad empire with a vigor that had not been seen in the family since the days of the Commodore.[32] He acquired selected railroad properties to complement the Vanderbilt railroad system, which now traversed twenty thousand miles and included seventy thousand freight and passenger cars, and concentrated on reducing the cost of haul and doubling the haul carried by each freight car by improving the track system and eliminating grades and curves. His work polished the bottom line, increasing the profits of the railroads and adding hundreds of millions of dollars to the value of New York Central stock and to the family fortune. "While many individual Americans are wealthier than any of the Vanderbilts," the *New York Times* reported, "the combined fortune of the descendants of the Commodore who inherited large fortunes and usually married into other wealthy and prominent families, is commonly rated greater than that of any single family group in the United States, and among the greatest in the world. The combined fortunes of the descendants of Commodore Vanderbilt probably reach a total today which runs into the billions."[33]

It was predicted that under Willie's directorship, the Vanderbilt lines would soon extend across the continent, from the Atlantic to the Pacific, and the family fortune would continue to swell.

But with more money than one person could ever spend, no matter how hard he tried, and try he certainly did, Willie soon tired of merely making more money and devoted himself to a life of leisure. Before he was fifty, he had all but retired from the irksome task of running the railroads, handing the management over to the Morgan interests, while he explored the world on extended cruises aboard the *Valiant*, sailing from Oyster Bay to Newport, to the races at Cowes off the English coast and at Kiel in the Baltic Sea, on to Monte Carlo and Venice, and then to the Caribbean. He defended the America's Cup with the *Defender*, and established a racing stable in France that was a phenomenal success, with his horses winning the Grand Prix and almost every important prize.

Willie indeed had it all: good health, good looks, good friends, and good fun, and an ever-growing fortune that enabled him to do anything anyone could do. He also had the intelligence to perceive that perhaps having everything left a lot to be desired. On one of his trips back to the United States from his French stables, he talked with reporters in extraordinarily candid terms about what it meant to be rich. "My life was never destined to be quite happy," he told them. "It was laid out along lines which I could not foresee, almost from earliest childhood. It has left me with nothing to hope for, with nothing definite to seek or strive for. Inherited wealth is a real handicap to happiness. It is as certain death to ambition as cocaine is to morality."

He continued lecturing the astonished reporters: "If a man makes money, no matter how much, he finds a certain happiness in its possession, for in the desire to increase his business, he has a constant use for it. But the man who inherits it has none of this. The first satisfaction, and the greatest, that of building the foundation of a fortune, is denied him. He must labor, if he does labor, simply to add to an oversufficiency."[34]

While at the races at Auteuil in France on April 15, 1920, seventy-one-year-old Willie was struck down with a heart attack, induced, his doctors believed, by his habit of smoking a box of cigars each day. He

passed away three months later, on July 22, at his home in Paris, with his children—Consuelo, Willie K., and Harold—at his bedside. "Whatever his personal suffering may have been," Consuelo recalled, "he made no complaints; not even a gesture of ill-humor troubled the serenity he seemed to emanate."[35] His body was taken to the United States. Before burial in the family mausoleum at New Dorp on Staten Island, there was a private service in Willie and Alva's château at 660 Fifth Avenue, a service that stirred poignant memories for Consuelo and her brothers "as from the gallery, where as children we looked down on festive scenes, came the haunting notes of death's dirges."[36]

Willie had lived lavishly and given money away lavishly, including $1 million to build model tenement houses in New York City, and hundreds of thousands of dollars to Columbia University, the YMCA, the Vanderbilt Clinic, and Vanderbilt University. He left an estate valued at $54,530,000: after years of spending and spending, almost exactly the amount he had inherited in 1885 when his father died. To Consuelo, he had given $15 million shortly before his death. His second wife received $109,000 under his will and the income from a trust of $8,250,000. After the state of New York had claimed an inheritance tax of $1,934,571.73, his sons, Willie K. and Harold, divided the residuary estate, each receiving $21 million. Like his father before him, Willie through his will advised his sons to invest in bonds of the New York Central system.

Willie's death precipitated the scattering of his playthings. His second wife, unable to afford the vast sums needed to maintain his renowned French racing stables, sold them within three months of his death. A year after his death, the contents of the château at 660 Fifth Avenue were auctioned by the American Art Galleries, everything from a set of twenty etched gold wineglasses to the paneling of the gilded ivory ballroom (sold to a curiosity shop for $1,400), to the great stained-glass window from the dining room depicting the Field of the Cloth of Gold. For $460,521, Harold sold Idlehour, the eight-hundred-acre estate in Oakdale, Long Island, with its three-story marble and brick manor house containing thirty master bedrooms, its large conservatory, and its tennis court under glass, all of which had cost Willie over $10 million. A syndicate purchased it and planned to convert the estate into a country club.[37]

And soon after Willie's death fell the first, and most famous, of the Vanderbilts' Fifth Avenue mansions.

When Willie and Alva's château had been completed in 1883, the nearby blocks of Fifth Avenue had been an exclusive residential neighborhood, an avenue of old-money brownstone townhouses and new-money palatial mansions, and here and there open spaces waiting for new millionaires. The Vanderbilts had not believed that business and trade would ever reach that far up Fifth Avenue. Maybe it would reach the avenue at Forty-second Street, but certainly not farther north into the two miles of fabulous mansions, Millionaires' Row. Certainly the land owned by Columbia University on Fifth Avenue and by St. Patrick's Cathedral, and the other Vanderbilt homes, would at least protect the two or three blocks of the Vanderbilt neighborhood. But it began to happen, the inevitable march of business up Fifth Avenue, led by real-estate agencies, art dealers, and brokerage firms. Willie Vanderbilt had called a family council at the first sign of the invasion of trade into the Vanderbilts' territory in the early years of the new century; the family agreed to buy the Langham Hotel at the northeast corner of Fifty-second Street and Fifth Avenue when it came on the market unrestricted against business, later snatching up other parcels for protection. When Willie learned that the old Roman Catholic Orphan Asylum across from his father's twin mansions at 640 Fifth Avenue was to be bought by a developer to construct an eighteen-story hotel, he purchased the property for $1 million and later leased it to Cartier. Finally, though, the family realized it was no use. It was like holding back the tide. Frederick Vanderbilt gave up in 1914 and sold his mansion at the corner of Fifth Avenue and Fortieth Street; it was demolished and replaced by the six-story Arnold Constable and Company building. Before too many years elapsed, the neighborhood had changed from residential to business, albeit elegant business, and the remaining Vanderbilt mansions stood as outposts in a changing world.

With Willie's château at 660 Fifth Avenue surrounded by commercial buildings and apartment houses, it, like all the period houses of the Gilded Age, seemed more than ever a ridiculous anachronism. "Must I show you this *French chateau,* this little Chateau de Blois, on this street corner, here, in New York, and still you do not laugh?" wrote a Chicago architect. "Must you wait until you see a *gentleman* in a silk hat come

out of it before you laugh? Have you no sense of humor, no sense of pathos? Must I then tell you that while the man may live in the house physically (for a man may live in any kind of a house, physically), that he cannot possibly live in it morally, mentally, or spiritually, that he and his home are a paradox, a contradiction, an absurdity, a characteristically New York absurdity; that he is no part of the house, and his house no part of him?"[38]

Several months after Willie's death, his sons, Willie K. and Harold, put the château at 660 Fifth Avenue up for sale. The land was assessed at $1,950,000, and Alva's dream home, which had cost $3 million in 1883, was assessed at only $175,000 more. It was thought that the house might be used as a restaurant.

On November 12, 1922, the Empire Trust Company purchased the château with plans to turn the dining hall into its main banking room, and to construct a connecting office building next to the mansion. These plans fell through, and ownership passed in November 1925 to real-estate developer Benjamin Winter, once a poor immigrant boy from Poland who had been a house painter, then a painting contractor, and in the boom years after the World War one of New York's wealthiest real-estate operators. Winter planned to erect two 5-story buildings and stores on the site. The mansion would be razed, but the staircase carved of Caen stone and many of the beautiful fireplaces and mantels would be used in the new offices.[39] The painting of the marriage of Cupid and Psyche that graced the ceiling of the Louis XV salon where Alva had greeted her guests was sold to the Century Theatre. For several thousand dollars Warner Brothers purchased the marble floor of one of the rooms of the mansion and some paneling, frescoes, and fixtures to be used in one of its new theaters. And the statue of Richard Morris Hunt in stonemason's garb, long forgotten on the roof, was discovered and returned to Willie K. The Caen stone carved walls, stairways, and carved wood panels were bought by a company that resold architectural pieces to millionaires building new mansions.

How could a masterpiece like Richard Morris Hunt's château be demolished? How could a wrecking ball be permitted to swing into that graceful limestone facade, into the carved fleurs-de-lis and the slender turret? Everyone thought of ways to postpone the day of destruction.

For the first time, the doors of 660 Fifth Avenue were thrown open

to the public in November 1925. Where once the guests at Alva's fancy dress ball had entered her fairyland past footmen in maroon livery, two women sat at a table inside the massive entranceway, collecting fifty cents from each of the sightseers who trooped through to attend the benefit performances and tea dances held by the Film Mutual Benefit Bureau to raise money for the poor children of New York City. Later in December, the Commission for the Blind ran in the mansion a sale of articles made by the blind. To accommodate the surprising crowds wishing to get a glimpse of this fabled Fifth Avenue monument, the mansion had to be kept open in the evening as well as during the day.

Requests came to the new owners from all over the country for a mantel, a door, a cabinet, or some other keepsake. There was some talk of removing the mansion in parts and reassembling it on Long Island as a country estate. But finally, on March 1, 1926, the wreckers' ball swung into the limestone château, and six weeks later not a trace remained.

4.

Mrs. O.H.P. Belmont had been far away when the house that had changed her life, and the standing of the Vanderbilt family, was reduced to rubble.[40] With her battle won when the Nineteenth Amendment to the Constitution became law on August 26, 1920, providing that "the right of citizens of the United States to vote shall not be denied or abridged by the United States or by any state on account of sex," Alva had decided to return to the favorite country of her youth, France.

After the Civil War, "I was broken hearted that I must leave France. I was in sympathy with everything there. Its musical language had become mine. I loved its culture, art, people, customs."[41] With Willie living there, the country had not been big enough for both of them. Now, with Willie dead and with the suffrage battle won, Alva decided she would go and live in France to be nearer her daughter, Consuelo. Despite all of Alva's vexatious suffrage activities, Consuelo recognized that her mother's life was "a lonely one,"[42] and that she welcomed the opportunity to grow closer to her daughter whose life she once had so disastrously dominated.

* * *

After their marriage in 1895, the duke and duchess of Marlborough had journeyed to England, that "land of half-tones and shades, of mists and fleecy clouds, of damp and rain,"[43] as Consuelo described it, and settled in Blenheim Palace, which, despite its breathtaking size and ancient grandeur, Consuelo found to be "devoid of the beauty and comforts my own home had provided."[44] The duke wasted not a moment in remedying these deficiencies. Growing up a Vanderbilt, Consuelo had seen how people would take advantage of her. While shopping in Newport with her governess, "when Marble House was mentioned as our address, the shopkeeper informed me he had mistaken the price he had given me and added a good 50 per cent."[45] But even Consuelo was shocked by her husband's spending spree. Although Willie Vanderbilt had told the young newlyweds to buy whatever they wanted at his expense, Consuelo "was surprised by the excess of household and personal linens, clothes, furs and hats my husband was ordering,"[46] in addition to jewels to replace the heirlooms Marlborough's family had been forced to sell over the years to maintain Blenheim, the crates of antiques and art treasures the duke was buying to replace those that had been sold, and an extravagant crimson state coach. One lord visiting Blenheim, noting the recent restoration of the grounds, turned to another guest and remarked that "there are uses for American heiresses and their money after all!"[47]

The passing years had done nothing to bring the couple closer together. After Consuelo had "done my duty"[48] and given birth to two sons, "a horrible loneliness encompassed me."[49] So far from family and friends, she soon wearied of a life of formal protocol, of changing her clothes four times a day for different occasions, of interminable dinners during which "as a rule neither of us spoke a word,"[50] of walking on "an endlessly spread red carpet."[51] Even more distressing, Marlborough insulted Consuelo "in every possible way" and came to find her "physically repulsive to him."[52] "The problem created by the marriage of two irreconcilable characters is a psychological one which deserves sympathy as well as understanding," Consuelo reflected many years later. "In the hidden reaches where memory probes lie sorrows too deep to fathom."[53]

In 1906, after eleven years of a difficult marriage, the duke and duchess separated, and Consuelo, still in her twenties, went to London

to live at Sunderland House, a Tudor mansion Willie had bought for her. "It is very sad about Consuelo, is it not?" Alice Vanderbilt coyly wrote to her daughter, Gertrude. "Of course the English will point to the example of her Mother and Father which is unfortunate as that does give M. [Marlborough] a leg to stand on. . . . It's excessively sad and, as C. will be always an object of observation under any circumstances, the outlook is unpleasant. Her Father will not listen to there being any divorce; queer is it not after his own experience! . . . The real reason seems to be that she is physically repulsive to him, and that he cannot bear to be near her. What her charges are I don't know. I heard the final break came when she said about two weeks ago she was going to Paris to get her winter things. Go and stay, he said. She came and saw her Father who went immediately to London and arranged matters. So of course this gives a chance to say that M. wants the separation, that W.K. offered untold sums to stop it. I am repeating gossip, but strange to say I have not a word to say about her charges. . . ."[54]

By this time, Alva's ideas about the oppression of women were jelling; she now realized full well that she never should have forced Consuelo into marriage, not because the marriage to the duke was a loveless one, but rather because marriage to any man would be intolerable until there was equality of the sexes.

While Alva had been spearheading the suffrage movement in the United States, Consuelo had formed the Women's Municipal party in Britain to help women get elected to municipal councils, and from these positions attempt to do something about the conditions under which women worked in sweatshops. She had also developed houses for prisoners' wives where women were given employment as seamstresses and laundresses while their husbands were in prison, and hostels to provide decent lodging for working women.

Consuelo found herself possessed by "a perverse desire to condone all men's errors" when she was with her mother, always finding the extremes of "female self-sufficiency" advocated by Alva "somewhat ridiculous," as she railed against the male sex "as if their presence in this world were altogether superfluous,"[55] but on the stump herself, Consuelo delighted her mother. "Many persons wonder why wealthy women want the ballot," Consuelo once told one of Alva's gatherings of suffragettes at Marble House. "There would be little wonder if they knew

the story of women whose sons-in-law have squandered the last penny. Legislation is the only protection for the wealthy mothers-in-law of many a young spendthrift. It is the only way in which they can save themselves from ruin. . . . Women sorely need the ballot here, or rather the country needs women voters. Votes for women is a movement for the uplift of the sex, and I am for it, heart and soul."[56]

Unlike her mother, Consuelo had not concluded that marriage was intolerable, and on July 4, 1921, married Lieutenant Colonel Louis-Jacques Balsan, a retired officer of the French Army, with whom she lived in Paris and found great happiness. Two years later, "my mother came from America to be with me; her sympathy was precious."[57] Alva and Consuelo reunited, growing closer than they had ever been, "each sharing the other's interests,"[58] spending together "many pleasant hours."[59]

Consuelo knew that her mother's decision "to live in France might be actuated by more than just the desire to be near me; always an inveterate builder, she welcomed, I knew, the opportunity to build a new home in a new country, being really happy only when thus employed."[60]

"I was never destined to stay in any one place," Alva said.[61] "Perhaps it is the Huguenot blood in us, perhaps the love most Americans feel for France, but always the members of my family seemed to drift back to Paris. Both of my sisters spent the remainder of their lives in Paris. Very likely I shall do the same. France is now my daughter's adopted country, and always it has been a second home to me."[62]

She closed up her Georgian home at 477 Madison Avenue in New York City, Beacon Towers on Long Island, and Marble House in Newport (she had sold Belcourt Castle in 1916 to Oliver Belmont's brother, Perry), and in 1923, at the age of seventy, moved to France.

Consuelo had been right; Alva divided her time among a town house in Paris, a villa on the Riviera at Èze-sur-Mer, and a fifteenth-century château at Augerville-la-Rivière, which her secretary described as an idyllic retreat with "a bright sun, a delicious breeze, and no sound here save what the breeze makes in the leaves overhead, the insects' murmur, the swans' occasional wing-flapping, and the lapping of the water."[63] Swans glided after the rowboat on the nearby quiet river and tame deer came to the château at twilight for bread and chocolates. There, Alva at last seemed to have found contentment. "There are days

when years mean nothing, the sun is so vivid, so warm, the sky so blue, the trees so strong and green and the air so full of life. We are . . . just children, careless with joy, knowing nothing, forgetting to feel, smiling not knowing why."[64] But never, of course, was she content enough to stop building. There, at her château, Alva "proceeded to let her fancy roam, creating improvements."

Walking in the garden with Consuelo, she suddenly stopped.

"This river is not wide enough," she said pointing to the watercourse that went past the château. "It should be twice as large."

The next time Consuelo visited, an army of workmen had already widened the river.

"This is all wrong," she said another time of a courtyard that was sanded rather than paved. "It should be paved."[65]

Soon paving stones were ariving from Versailles to cover the courtyard.

Alva might grow old. Her short hair, which was no longer red, was "turning gradually to the color of faded American Beauty roses and finally to a rich purple."[66] Her interests had turned from society to suffrage. But she never changed, and certainly never mellowed.

Alva was, if anything, direct. She was "not one thing to your face and another behind your back,"[67] Bessie Lehr had commented. As Mrs. William K. Vanderbilt, she had funded the Seaside Home for Children, which was located near her Long Island country estate, Idelhour, and at the request of its director, Bishop William T. Manning of the powerful Episcopal diocese of New York, had served on its board of trustees, always contributing generously to all his fund-raising efforts. As Mrs. O.H.P. Belmont, she had received a form letter from Bishop Manning requesting her usual donation. She noticed that her name no longer appeared on the letterhead as a member of the board of trustees. Why had her name been dropped? Alva demanded of the Protestant clergyman. After beating around the bush, the bishop told her that it did not seem proper for the list to be headed by a divorcée.

"I suppose it's perfectly proper, though, for you to accept my tainted money," Alva snapped. "To spare your future qualms of conscience, I'll give it to organizations more concerned with charity than appearances."[68]

Some years later, when Bishop Manning was sure she had cooled

off, he approached her again, seeking a contribution toward the completion of the Cathedral of St. John the Divine. "I am still a divorced woman," Alva huffed.[69] She at that time had just received a cable from her grandson, Consuelo's son John, the marquess of Blandford, asking her to stand with King George as godparent to her first great-grandson, who was to be christened by the archbishop of Canterbury. "Bishop Manning repudiates me and accepts my gift," Alva acidly noted, "but the Archbishop of Canterbury permits me to stand with his monarch at a christening."[70]

The first to marry a Vanderbilt. The first society lady to seek a divorce and not lose her social standing. The first to advocate the rights of women. Alva continued to do just as she pleased, adding to her long list of firsts when she was pictured in magazine advertisements endorsing Pond's Cold Cream, her accompanying testimonial signed "Mrs. O.H.P. Belmont." The money she received for these ads, and others for a Simmons bed, was donated to women's causes. Soon, other society ladies were featured in advertisements in the pages of popular magazines.

Guests at Alva's French homes learned to close their ears to her continuous bickering with her servants, as she complained constantly and upbraided them whenever a plate did not reach the table noiselessly. Once at a luncheon party she gave when she was well into her seventies, she broke into a fit of rage, picked up a plate, and threw it at Azar, her faithful Egyptian head butler. One of her guests immediately left the table and went home, determined never again to be around such a volatile hostess. Soon the guest received a bouquet from Alva and then a telephone call.

"I know there's no excuse for my behavior, but Azar drives me out of my mind. The man is a sex maniac. He keeps my maids in a constant turmoil with his advances. You didn't see it, but during lunch today he pinched the waitress while she was serving me. There are days and days I have to keep Azar locked up in a closet. If I don't he'll turn my house into a harem."

"Why don't you just fire him?" the amazed guest asked Alva.

"Oh, I couldn't do that. He was so devoted to my husband. I've soothed Azar's ruffled feelings by giving him an extra week's pay. That will hold him until the next seizure."[71]

Alva also complained about her children in front of her guests,

talking of Consuelo's "unloving attitude, her spinelessness about men, her indifference to losing her nationality, first on marriage to a British subject and later on marriage to a French subject."[72] She took a special delight in needling her youngest son, Harold—the Professor, she called him—who had invented contract bridge. "The Professor goes crazy when I'm his partner, but he cannot make me obey his hidebound rules. As long as I pay my losses, I'll bid any way I please."[73] Only her handsome, carefree son Willie K. avoided her censure, because, as she explained, "he's the only Vanderbilt in captivity who ever got over his accident of birth."[74]

Her houseguests themselves often learned to be on their best behavior when staying with Alva. After one guest had left, Alva's maids found that from smoking in bed, his sheets had several holes in them.

"Very good," Alva said. "Have them washed and then just draw the holes together with the coarsest darning cotton you can find. When he comes again, see that he gets them on his bed."

Several days into his next visit, he spoke to Alva about a problem he had encountered.

"Everything is so perfect here. You have such wonderful linen, Mrs. Belmont, that I think I ought to tell you that it is not being taken care of as it should be. You ought really to see the sheets on my bed!"

"Ah, yes, those sheets!" Alva drawled. "You're quite right. Those are the sheets you burned holes in with your cigarettes. I had them darned especially for your personal use."[75]

Alva once entertained a houseguest who did nothing but get in her way, trying to redecorate rooms in her house, and giving orders to her gardeners. By the end of the first week of a two-week visit, Alva was desperate.

"If that woman does not leave," she told a friend, "I shall go mad!"

When the guest returned from a walk, she found Alva standing in the guest room with several workmen. The rug had been rolled back, and all the furniture moved to one corner, as they stood in dismay watching water dripping from the ceiling into several buckets set on the floor.

"That leak again!" Alva cried. "And the plumber not even in town—gone to San Raphael for a funeral and won't be back for three days. We can't do a thing until he comes back!"

The guest looked around the room for her belongings.

"Your things?" Alva asked. "I have had them taken to the hotel where I engaged a room for you. I could not—I simply could not let you stay in this room. For goodness' sake, Jean," she ordered one of her servants, "get another pail!"[76]

Jean had spent the previous hour sponging water onto the ceiling, spilling it onto the floor, and positioning buckets to set the stage for the peremptory departure of the troublesome houseguest.

When she was almost eighty, Alva decided that she wanted "to take a last look around,"[77] and invited her children Consuelo and Willie K. to join her and several friends on a seven-week tour of Egypt. The group went up the Nile aboard houseboats and toured the Valley of Kings with Howard Carter, the man who had discovered Tutankhamen's tomb.

Soon thereafter, she was increasingly troubled by her loss of energy and strength, though never her spirit. "During the long hours of the night when I do not sleep, I realize what I am unable to do out here, it is dreadful to grow old, to know that the body stops the will, I never expected this. I *have been* so strong. I am timid about overdoing myself. I want to stay a little longer, so much is still to be done."[78]

Knowing that time was getting short, she finally began to yield to her children's arguments and one by one sold some of her homes. In August 1923, she sold her Georgian town house at 477 Madison Avenue in New York City for $500,000 and presented the collection of rare armor from its gallery where she had held so many receptions to the Metropolitan Museum of Art. Next to go, in 1927, was Beacon Towers, her stone castle at Sands Point on Long Island Sound, sold to the press mogul William Randolph Hearst. An auction in January of 1928 at the American Art Galleries disposed of some of her French furniture and interior decorations, with the highest prices paid for a Brussels tapestry ($5,000), a large Kermanshah carpet ($5,400), and an eleven-by-sixteen-foot Persian carpet ($1,500). A collection of her curios and jewelry was bought by John Ringling, the circus maestro, and graced Ca' d' Zan, his extravagant Venetian palazzo in Sarasota, Florida.

But she could not bear to part with Marble House, even though she had not seen it for more than a decade and had not lived in it for more than several weeks during the last twenty years. Marble House "was like a fourth child to me, and I felt, and feel, that it properly belongs to me,

and to my children after me."[79] Her children made it clear to her that none of them wanted it because of the great expense of keeping it up, but nevertheless she provided in her will that it would pass to her youngest son, Harold, who had enjoyed it for more summers than her older children. But finally she relented, and in 1932 sold it to Frederick H. Prince, the head of Armour Company, for the Depression price of $100,000—less than one hundreth of what Willie had paid for Alva's thirty-fifth birthday present.[80]

Alva began saying her goodbyes. Fellow suffragette and feminist leader Doris Stevens later remembered her last visit to Alva's château in the summer of 1931: "We parted tearfully at a final tea alone together at which she said she said she feared this would be the last time she would see me. This was the first and only time I ever saw Mrs. Belmont weep. She gave me a rose from her garden which she had picked herself. I tried to comfort her and make her feel that it would not be a final visit. She talked a great deal about death as she had done often during our last few days together, and admitted to me for the first time that she was really ill and feared the end was near. She said she felt there was no one else to whom she could say, lest they think it vain of her, that she would like me to present to her son W.K. at an appropriate time, the erecting to her of a monument. She described exactly what she wanted; a heroic figure of herself in the open air in Washington, the space to be set aside by the government, the base of the monument to contain bas relief depicting various scenes which occurred in Washington—riots by the police and by the mob, women being loaded into patrol wagons, women arrested for petitioning President Wilson—in short, she wanted cut in stone the sacrifices which so many women had made in going to prison for this idea. She said she was sure her son would cooperate in such a plan. She said that she knew I would not think this vain of her to want this, but that I would understand that this was an honor to all women in honoring her for what she had done for women. . . . We kissed each other farewell as usual, but this time with tears."[81]

Alva suffered a stroke in May 1932 at the age of seventy-nine and was confined to her wheelchair. Harold came to visit his mother frequently, working out a card game that would hold her interest and buying films for her movie projector, though his visits were usually

shorter than he planned because of the stress and trials of living in Alva's household. Alva was well cared for by round-the-clock doctors, as well as her secretaries, chef, and servants, whose main function it was to keep her entertained.

No longer able to walk, she was drawn around her estate in a carriage made from a bath chair Queen Victoria had used, so Consuelo was surprised when her mother announced that she wanted to build a bowling alley. Consuelo tried to dissuade her, but soon enough a bowling alley arrived from the United States and was assembled at her château.

She had another stroke six months later, in October 1932, but her doctors were optimistic, convinced that with all the care she was getting, it would be impossible to do anything but get better. "Dear Doris," Alva wrote to Doris Stevens, "I was so happy to receive your letter of August 4th which Miss Young read to me out of doors under the trees in the court yard of the Chateau. I am sending you a picture of how I look each morning so that you can see for yourself that I am gradually getting better. It is a long and tiresome process, however."[82]

Even after her second stroke, Alva remained Alva, scolding her nurses for letting her hair grow out gray and ordering them to bring in the hairdresser to redye it titian red.

"I don't want to die with white hair," eighty-year-old Alva told her friend Elsa Maxwell. "It's so depressing." She lay silently for a moment, and then smiled sadly. "It makes no difference now. The important thing is knowing how to live. Learn a lesson from my mistakes. I had too much power before I knew how to use it and it defeated me in the end. It drove all sweetness out of my life except the affection of my children. My trouble was that I was born too late for the last generation and too early for this one. If you want to be happy, live in your own time."[83]

Her condition was complicated by bronchial and heart ailments, and at 6:50 A.M. on January 26, 1933, conscious to the end, she passed away in her Paris town house, with Consuelo and Harold at her bedside. At the time of her death, after a lifetime of buying and building, she was down to her last million. Her estate was valued at $1,326,765. She bequeathed $100,000 to the National Woman's party and $2,000 to her long-suffering servant Azar. Consuelo was the residuary legatee.

After funeral services at the American Cathedral in Paris, Consuelo accompanied the body aboard the steamship *Berengaria* for the voyage back to New York City. After the liner docked on February 10 at Pier 54 of the North River, the casket was taken by a National Woman's party escort of honor to St. Thomas's Church on Fifth Avenue, and there placed under the folds of the old golden picket banner of the suffrage fight, with its great purple letters: FAILURE IS IMPOSSIBLE.

Representatives of twenty-two women's organizations escorted the coffin up Fifth Avenue. Harry Lehr's widow, Bessie, watched Alva's funeral procession from the St. Regis Hotel where she had stood with Harry to watch the great suffrage parade that Alva had led twenty-one years before. Now the same banners whipped around in the cold winter wind. Women who had marched behind the society leader in their youth, now gray-haired, carried her coffin all the way to Woodlawn Cemetery.

There, years before, Alva had commissioned the sons of her architect, Richard Morris Hunt, to design a burial chapel fashioned after St. Hubert's Chapel at the Château of Amboise, with stained-glass Gothic windows and a mural of Saint Hubert and the legendary stag with the crucifix in its antlers.

(Alva and a friend had once been at Woodlawn Cemetery, looking at a tomb of pink marble that an heiress had built for her husband. "Ridiculous! Absolutely ridiculous!" Alva opined. A workman who was nearby heard her. "Well," he said, "if you think this is funny, go and look at that tomb over there where the crazy woman who built it has put cats on the roof!" He pointed to Alva's mausoleum, complete with a roof decorated with stag's antlers and two cats carved of stone.[84])

At the chapel, the women formed a double column through which the casket was borne up the steps and placed in the crypt, while four women buglers sounded taps, just as Alva had ordered in her will.

"This is not the time, in the face of that great mystery of life, the passing of a soul, to frivolously chat about the gold goblets of a dinner party or the visiting cards of the mauve decade," read an editorial in the *Washington News*. "Mrs. Belmont will be known wherever the story of woman's freedom will be read."[85] But it was only after her death that anyone dared thwart Alva Erskine Smith Vanderbilt Belmont. Despite

the clear instructions in her will, a woman had not been permitted to deliver her funeral oration at St. Thomas's Church. No statue was ever erected. And the history books would ignore the fact that there once was a woman whose personality and money sparked a crusade for human equality. Instead, her lasting monument would be Marble House, a relic of a way of life that had died long before her.

8

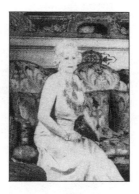

THE
KINGFISHER

1 8 9 9 – 1 9 3 1

1.

A s long as Grace Wilson Vanderbilt had anything to say about it, the Gilded Age was not over yet. She hadn't chased Neily Vanderbilt halfway around the world and sacrificed her reputation for nothing. It was her turn to reign as Mrs. Vanderbilt, and nothing would stop her.

Neily Vanderbilt's decision to marry the charming Grace Wilson against his parents' wishes had proved a very expensive act of disobedi-

ence, as he learned when his father's will was read that chilly autumn afternoon in 1899 at The Breakers. As the oldest surviving great grandson of the Commodore, twenty-six-year-old Neily was in line to assume the title of head of the House of Vanderbilt, and with that title, the bulk of the family fortune. Instead, his father's will had left him but $500,000 outright and the income from $1 million in trust, while his younger brother, twenty-two-year-old Alfred, received the residuary estate of over $42 million, as well as all the other trappings of the head of the family.

Memories of the distressing public spectacle that had surrounded the contest of the Commodore's will were fresh enough to impel the family to work to reach some amicable settlement with Neily, who seemed sullen and depressed. Several days after the will was read, Chauncey Depew, as executor of the estate, issued a statement: "When Alfred Vanderbilt returned home after his father's death he decided, from brotherly affection and for family harmony, to take out of his own inheritance and give to his brother Cornelius a sum sufficient to make the fortune of Cornelius the same as that of his brothers and sisters. This has been accepted in the same spirit." The sum sufficient was $6 million. Neily had his own statement to make to the press the next day to set the record straight. "The agreement has been made to appear as a mere gift. It is really a family settlement or adjustment of the situation, which, I am glad to say, my brother met with fairness. I have nothing further to say."[1]

Reporters asked for clarification.

"Mr. Vanderbilt, were you quoted correctly in the *World* as saying that you were to receive not less than $10,000,000 under an agreement made before your father's death?"

"It is correct," Neily replied. "That agreement was made prior to my father's death—yes, prior to my father's death."

"With whom did you make this agreement?" they asked.

"It was made between my brother Alfred and myself. The matter since then has been in the hands of my attorneys; they have full charge of my affairs."

Would he contest the will? the reporters persisted. After all, he had not received $10 million.

Neily took his hands out of his pockets. He looked at the ceiling, and then at the floor. He scratched his head. "Per-haps."[2]

Several days later, however, all the beneficiaries under the will signed a waiver, eliminating the possibility of any litigation. But thereafter, the relationship between Alfred and Neily was strained. There was, after all, Neily believed, a significant difference between the $6 million his younger brother had given him and the $8.5 million he felt he was owed to bring his share of his father's estate up to $10 million. The very day Alfred began working in the treasurer's office of the New York Central, Neily quit his job with the Central and never returned. And the brothers never again spoke, only nodding coldly when they happened to pass.

Having exiled himself from the familiar world of the family's railroads, Neily cast about for what to do with his life. The publicity surrounding their marriage had made Grace and Neily the world's best-known young couple. With this type of recognition, Neily decided he should enter politics, and in 1900, with Grace at his side, he attended the New York Republican Convention at Saratoga Springs. Their arrival made the front page of the *New York Times.*

"I find politics most interesting," he explained to reporters. "The political field offers great opportunities for practical information of value. I am not an office seeker. I have a penchant for politics, and when I was asked to be a delegate, I gladly acquiesced."

"Do you propose to take an active part in politics?" he was asked.

"Yes, I think that is the duty of every American."[3]

"Would you like to go to Congress?"

"Certainly," Neily Vanderbilt answered. "But it is not for me to pass upon that sort of question. If called, I shall respond."

At the convention, Neily was summoned into the proverbial smoke-filled back room to meet with New York's political leaders.

"Well, young Vanderbilt," an old-time political boss informed him, "if you want to go into the state legislature, we can put you there. It will cost you a hundred thousand dollars." He took the big cigar out of his mouth and winked at his colleagues.

"And how much to go to Congress?" Neily inquired.

"Oh, I guess about three hundred thousand," another of the politicians responded.

"Three hundred thousand dollars!" Neily exclaimed.

"To become a member of the lower house," he was instructed.

"And the United States Senate?" Neily asked in disbelief.

"Half a million."

Neily walked around the room, considering what he was hearing.

"Look, my name happens to be Vanderbilt, but I'm not a Rockefeller, you know."[4]

He walked out of the room as the old boys roared with laughter.

Neily filled his days tinkering with his experiments in an office jammed with ten thousand scientific books. He obtained patents on thirty of his inventions. He went along on one of the early Wright brothers' flights and exchanged wireless messages with Marconi. With August Belmont, he organized the Interborough Rapid Transit Company, serving as a consulting engineer in the building of the first New York City subway. He sat on the boards of directors of twenty corporations and joined many exclusive gentlemen's clubs. He signed up for service as a second lieutenant with the Twelfth Regiment of the New York National Guard. In his leisure time, he painted watercolors and took photographs and speculated in the stock market to try to build up his fortune to real Vanderbilt levels, or at least to levels to support the lifestyle his wife was pursuing.[5]

Just like Alva Vanderbilt, Grace Wilson Vanderbilt had something to prove and set out at once to prove it. While Neily busied himself with his inventions, Grace began to blend together their modest fortunes with her royal contacts and their worldwide notoriety. The mixture was just right. With three magic strokes, she transformed herself from Grace Wilson, the southern belle whom Alice and Cornelius Vanderbilt had felt was not good enough for their son, into Mrs. Cornelius Vanderbilt, Queen of Society.

Grace's first coup took place when the German imperial yacht, *Hohenzollern,* dropped anchor in New York Harbor in February 1902. Every society matron aspired to be asked to entertain Prince Henry, the kaiser's brother. The long-reigning Mrs. Astor assumed she would be requested to do the honors, and so postponed her trip to Europe. But at a special opera performance at the Metropolitan for Prince Henry, the prince made a beeline for Grace Vanderbilt's box. "The visit of Prince Henry to the box of Mrs. Cornelius Vanderbilt on Tuesday evening at the gala opera performance and his marked attention to her have been

matters of current discussion since that event," the papers reported the next day. "The recognition was so marked and the singling out of this young matron so obvious that it took many by surprise."[6]

Grace had received a cablegram from the kaiser, who had entertained her some years before when she had been in Germany. The cable requested her to invite Prince Henry to dinner so that he might "dine with a representative American family."[7]

This was to be the only dinner the prince attended in a private home on his trip to the United States. "The mere honor of entertaining Prince Henry . . . is a trifle," stated *Town Topics.* "The real triumph is that Mrs. CV has become *the* Mrs. Vanderbilt. She is recognized as the head of the family by the Kaiser. It is her branch of the Vanderbilt family which is to carry out its traditions. Mrs. Alfred Vanderbilt may hurry back from Palm Beach, and Mrs. Vanderbilt Senior may storm and fret in her 57th Street mansion. Young Mrs. Cornelius, in the few years of her married life, has . . . succeeded beyond cavil in establishing herself as the representative of the most powerful family in America. Mrs. Astor," *Town Topics* added, "will sail before the dinner takes place."[8]

Grace's second coup occurred in Newport that summer at Beaulieu, the three-story, faded red-brick William Waldorf Astor estate on Bellevue Avenue, between Marble House and The Breakers. Grace and Neily had rented Beaulieu for the season.

One afternoon at tea, after days of carefully considering her next campaign, Grace announced her plans to her husband.

"I think I'll have the *Wild Rose* come to Beaulieu. It's a marvelous play. I know every tune by heart," she said, softly humming "Cupid Is the Captain."

"But it's still playing in New York!" said Neily.

"Yes, I know. Won't it be fun, though! I'm so tired of amateur theatricals and clambakes and picnics and costume balls. This will be something absolutely new and different!"

"Oh, come now," Neily protested. "Why not the *Götterdämmerung*? Grand opera in July would really be new."

"August," Grace said with a distant look in her eyes, ignoring her husband's sarcasm. "End of August, I think. It's the last party of the season that's best remembered."[9]

Still infatuated with Grace, Neily gave in. He arranged for the

Knickerbocker Theater in New York to close for two days, with all performances canceled, so that the troupe could come to Newport for a special performance of the season's most popular play. Two hundred invitations to what Grace called her "at home" were distributed around Newport.

Radiant in a pale green gown accentuated by her emeralds and diamonds, Grace stood greeting her guests on the manicured lawn of Beaulieu, bright with the glow of a harvest moon and dozens of shaded fairy lamps. The guests proceeded over a red velvet carpet through a midway, an enclosed area 275 feet long covered with red calico, hung with garlands of flowers and laurel leaves, and illuminated by red calcium lights. The midway was filled with amusement park sideshows: booths for games of chance, wheels of fortune, a wooden duck-shooting gallery, strength-testing machines, Gypsy fortune-tellers, dancers and singers. At the end of the avenue stood Harry Lehr, wearing the false waxed moustache of a concessionaire, handing out reservation tickets for the hit Broadway musical, *The Wild Rose*. The tickets were replicas of those sold at the box office in New York, except that the name of the theater was not the Knickerbocker, but Beaulieu Theater.

At midnight, the guests took their tickets and were ushered into the theater that carpenters and electricians had constructed on the lawn at the edge of the sea cliffs during the past week. The star of the Broadway show came down the center aisle; Neily helped her up onto the stage. The crimson velvet stage curtain rose, the orchestra in the pit struck up the first notes of the year's most popular score, and for an hour the actors performed to the continual applause of the amazed guests.

At the end of the play, dinner was served in the house and on the large veranda, while workmen changed the theater into a ballroom, with rose petals strewn over the dance floor. The two orchestras were still playing as the sun rose over the sea and the last of the guests left their breakfast tables to say goodbye to Grace and Neily. "Isn't she wonderful?" Neily asked all the guests as he stood proudly by the side of his beautiful wife.[10]

Even by the distorted standards of the Gilded Age, it had been an extraordinary night. Like all of the other guests, Grand Duke Boris was flabbergasted. "Is this really your America or have I landed on an enchanted island?" he asked Bessie and Harry Lehr as he marveled at the

splendor of Beaulieu. "Such an outpouring of riches! It is like walking on gold."[11] Grace's unique "at home," just like Alva's fancy dress ball, had established the reputation of the young Mrs. Vanderbilt.

Grace's third coup was convincing her husband that they needed a yacht like her sister's, May Goelet's *White Ladye.* An avid sailor, Neily did not need much convincing, but the use to which the yacht would be put was probably other than what he had contemplated.

Construction began in 1901, and two years later Neily took possession of the 279-foot steam yacht, which he named the *North Star* after his great-grandfather's.[12] With its gleaming, graceful white hull, rakish bowsprit, heavy antique furnishings, seven staterooms, each fifteen feet square, a drawing room thirty feet wide and twenty-six feet long, a dining room thirty feet long, and quarters for a crew of forty, the *North Star* was rivaled by only four other ships afloat: King Edward VII's *Victoria and Albert,* Emperor Wilhelm's *Hohenzollern,* Czar Nicholas's *Standart,* and J. P. Morgan's *Corsair.*

Each season, at Grace's urging, the Vanderbilts sailed the *North Star* to those ports where they would most likely be seen by royalty, from Cowes on the north shore of the Isle of Wight—which was the resort of the British royal family and the gathering place each August of the Royal Yacht Squadron and the kings of Holland, Sweden, Norway, and Belgium, the princes of Prussia, Battenberg, and Bourbon, and Kaiser Wilhelm—on to Kiel to visit Prince Henry of Prussia, to St. Petersburg to be received by the czar and czarina, to Biarritz and San Sebastián to see King Alfonso of Spain. Along with oil paintings of yachts and frigates and sea battles, a gallery of autographed photographs of the good friends of Grace and Neily adorned the cabins of the *North Star*—photographs of the dowager queen of England, the last empress of Austria, His Imperial Majesty Kaiser Wilhelm, and the czar of all the Russias, Nicholas II. The *North Star* sported more royal pennants than any other American yacht.

After Mrs. Astor's death in 1906, there was never any question who reigned as the new queen of New York and Newport. It was Mrs. Cornelius Vanderbilt. In more respectful moments, social columnists referred to her as "Her Grace." At other times, her unabashed pursuit of royalty won her the title "the Kingfisher."

There remained for Grace one more conquest. Society might recog-

nize her as its queen, but to Neily's family, the couple were outcasts still. After all these years, Neily's brother Alfred would not speak to him and Reginald, Gertrude, and Gladys never came to visit.[13] Every once in a while, Neily would take his young children, Neil and Grace, to visit their grandmother, Alice of The Breakers, though his wife would never accompany them. "I can remember how terrifyingly huge and cold The Breakers struck me as a child," Neily's son remembered, "with its high throne chairs and suits of armor. The music salon seemed as vast as an auditorium and as lifeless as a museum. Grandmother greeted us stiffly, seated on a high-backed red velvet chair. She asked a lot of perfunctory questions about our lessons, but hardly seemed to listen to our whispered answers. At the end of the visit, she and Father drank tea while a footman in a white wig brought us children French vanilla ice cream with the thickest, richest, creamiest chocolate sauce I have ever tasted. Afterwards, as we shook hands politely and turned to leave, the food lay cold in the pit of my stomach, like the cold little chill about my heart."[14]

"We should all have luncheon together tomorrow somewhere," Alice of The Breakers announced to her daughter Gladys and future son-in-law, Laszlo Szechenyi, a Hungarian count, when they were visiting The Breakers in the autumn of 1907 and Neily had stopped by to see them.

"Why not at Beaulieu?" Neily unexpectedly asked.

The room froze in silence. Alice looked up.

"Very well. If Grace will not come to me—then," she said very softly and slowly, "I shall go to her."[15]

On October 13, 1907, for the first time since the marriage of her son eleven years before, tiny Alice of The Breakers, dressed in black velvet, still in mourning for her husband, her neck hung with ropes of pearls that almost reached her knees, came calling.

The butler escorted her into the drawing room of Beaulieu.

"Mrs. Vanderbilt," he announced without emotion.

Neily jumped to his feet and bounded over to his mother, embracing her and leading her over to where Grace sat, immobile, enthroned beneath her tapestries. As nine-year-old Neil would remember this historic scene: "Mother smiled and extended her hand with a graceful regal motion. Thus she received at her box in the Diamond Horseshoe [at the Metropolitan Opera], when important social figures trooped dutifully in

to pay their respects during the entr'actes. Never, never did she go to *them.* Yet one look at my mother's face as she greeted my grandmother that evening long ago, and I sensed, childlike, that her smile was the flash of sun on the surface of a glacier."[16]

Grace's conquests were complete.

2.

There was no doubt about it: Mrs. Cornelius Vanderbilt was the new queen. Like Mrs. Astor, Mrs. Vanderbilt adhered to the strictest protocol of the aristocracy. Her mornings were spent planning the day's affairs, her afternoons taking a carriage around the neighborhood as a footman delivered her calling cards, her evenings entertaining. She wintered in New York, traveled to Paris in the spring to replenish her wardrobe, to London for the social season, to Newport for the summer. She knew how to speak to a queen or a chambermaid, and was equally at home in a drawing room, at the opera, on a yacht, or having tea with the king of England.

To maintain her standing as Queen of Society stretched Neily's inheritance to the last penny. It was with a curious mixture of extravagance and thrift that Grace set about making ends meet. The *North Star,* for instance, was moored in England, not at New York or Newport, for if it was kept in American waters for more than a few months it would fall under American registry and the sailors' wages would be higher. Neily and Grace could justify the enormous expense of maintaining the *North Star* by subtly weaving into their conversations with the yacht's royal visitors glowing reports of Neily's latest inventions, which the monarchs frequently ordered for their countries. Neily had sold his new firebox for locomotives to the German, British, and Russian governments long before it was purchased by the New York Central, the Chesapeake and Ohio, the Illinois Central, or the Harriman railroads.

Rather than buying or building a Newport summer cottage, the Vanderbilts for many years rented Beaulieu for $25,000 a season, closing down their four-story New York City mansion at 677 Fifth Avenue,[17] drawing the blinds, covering the furniture with muslin, and hiring moving vans that carted the tapestries, the gold service, trunkloads of silver,

and the big Steinway to Newport for the summer. This piano, by the way, which was shipped back and forth each season, did not belong to the Vanderbilts; for decades it was rented for $650 a year. Each summer Grace rented fourteen pots of palms to decorate Beaulieu for $237, along with rented boxes of begonias, hydrangeas, and gloxinias. Chinese vases, large gilt candlesticks, bath towels, face towels, tablecloths, linens, crystal: They were all rented. The grandeur in which this younger generation of Vanderbilts lived was largely an illusion.

To carry out her responsibilities as Queen of Society on so tight a budget was straining even Grace's ingenuity. It was therefore a godsend when Neily's uncle George Vanderbilt passed away down at Biltmore in 1914. Uncle George had inherited his father's mansion at 640 Fifth Avenue. Under the terms of William H. Vanderbilt's will, if George died without any sons, as he had, the mansion was to pass to the oldest son of William H. Vanderbilt's oldest son, Cornelius. But Cornelius's oldest son, Bill, had died of typhoid as a senior at Yale. William H. Vanderbilt had planned for every contingency; in the event of the death of this grandson, the mansion and art works were to pass "to my grandson Cornelius, in fee, and in that event I give to my last-named grandson $1,000,000, my object being that my present residence and my collection of works of art be retained and maintained by a male descendant bearing the name Vanderbilt."[18] So it was that the family outcast inherited 640 Fifth Avenue, the family seat, and a much-needed million dollars.

"Why, it's the Black Hole of Calcutta!" forty-three-year-old Grace complained as she and Neily first entered 640 Fifth Avenue through the massive bronze doors, reproductions of the Gate of Paradise created by the old Florentine sculptor Ghiberti, into the dizzying Byzantine splendor of the mansion's interior, which had not been touched since that December day in 1885 when William H. Vanderbilt had died. "I couldn't possibly live here!"[19]

Two years and $500,000 worth of renovations, remodeling, and modernization ("For that amount," the newspapers commented, "as fine a private home as the average wealthy man would wish for could be built in the most exclusive residential part of the upper east side"[20]) made the mansion habitable for Grace. With its ballroom—a replica of one at Versailles with red velvet hangings, huge mirrors, cream and gold

woodwork, and bare glistening parquet floors—which could hold a thousand guests, and a dining room table that could seat sixty, the mansion was the perfect setting for the large-scale entertainments she was planning.

The taxes on this mansion on Fifth Avenue when Neily and Grace moved in during 1916 were $33,115 a year. The income from the extra $1 million they had received when Uncle George died was enough not only to pay the taxes, but to run 640 Fifth Avenue as Grace believed it should be run, with thirty-five servants, including Gerald, the English butler, in tails and black tie; six footmen in maroon knee pants and tail coats, white stockings, and black pumps; six maids in black dresses with frilly aprons and caps; a French chef, a second cook under the chef, a kitchen maid, a second kitchen maid, and a scullery man; as well as three laundresses, footmen to polish the silver, three upstairs chambermaids, a parlor maid, a maid to clean the servants' rooms in the basement and on the fifth and sixth floors, personal maids, window cleaners, elevator maintenance workmen, and a man who did nothing but stoke the giant furnaces.

Grace's day began at ten o'clock, when her maid drew back the curtains and her social secretary entered her bedroom with a roster of those who were presently houseguests at 640 Fifth Avenue. Grace's secretary kept a card file with important information about all of Grace's friends: their birthdays, the names of their children, their favorite drinks, flowers, cigars, and candies. Her houseguests would find on their bedside table the latest book by their favorite author, a vase of favorite flowers, their brand of cigarettes, and a thermos of their bedtime drink of choice. At dinner, Grace kept a small notebook by her side, which she filled with this data as she learned it, the next morning passing the new intelligence on to her secretary, who classified it into files: lists, for instance, of "men who will dance," "men who can play the piano," "men who can lunch," "men who will go to the theater but not the opera," and lists of eligible male dinner guests.[21]

Then, for several hours, the real work began. And the work was never ending. Grace gave two large dinner parties each week, smaller dinners or luncheons daily, and a ball at least once a month. A hundred visitors stopped in for tea each Sunday, and a thousand came each

Christmas Day to her annual Christmas party, with gifts for each guest hung on a giant tree in the center atrium.

"Telephone the Secretary of State in Washington and the Greek Ambassador and ask them to dinner some day next week," she would tell her secretary. "Call the mayor's office" or "call the governor's secretary at Albany" or "call the protocol office of the State Department in Washington. Tell them that Mrs. Cornelius Vanderbilt would like to know at once where Mr. So-and-so can be reached because she would like to ask him to a dinner party."[22]

The problems she faced every day were vexing. Once she held a dinner party for two hundred and could not decide where her friend, former president Theodore Roosevelt, should be seated. She called T.R.

"Colonel, how shall I seat the table? Which is correct? Should I put you, an ex-President, on my right, or the Mayor of New York City?"

"By all means, put the Mayor on your right," T.R. chuckled. "A live dog is better than a dead lion any day."[23]

Together, Mrs. Vanderbilt and her secretary each morning sorted through the mail, the stacks of letters asking for money, from a "less fortunate woman" in Indianapolis who had just given birth to her second set of twins and needed $400, from "a Southern California Seer" requesting funds to build the world's most beautiful tabernacle, from the president of a midwestern college asking for $200,000 for a summer course. "Has it ever dawned on you, my dear lady, that through the simple medium of sacrificing just one of your many strings of pearls you can assure a college education for a score of Indian children?" wrote a "devoted friend of the Redskin children" from Muskogee, Oklahoma.

"Enough of that, my dear."

"Yes, Madam."

On to the invitations, which the secretary summarized.

"Mrs. X. wonders if you would care to be present at the luncheon she is giving in the Colony three weeks from tomorrow."

"Mrs. X.? Isn't she that preposterous woman from Oklahoma whose husband struck oil or ran a chain of grocery stores or something?"

"It was oil, Madam."

"Do I know her?"

"Not exactly, although you met her last summer in Newport at Mrs.

Y.'s tea. Mrs. Y. has telephoned several times since and was very anxious to have you meet her friend once more. She says Mrs. X. is the most remarkable woman that ever came from the southwest."

"Write her a note, my dear, and tell her that I regret a previous engagement. What else?"

"Dinner at Mrs. Z.'s. Four weeks from today."

"Who is she? Another provincial?"

"Yes, Madam. A distant relative of a western Congressman. Divides her time between here and Washington. Made the British Embassy last spring."

"Not the *British* Embassy, my dear!"

"I am quite certain, Madam. She dined there twice."

"Hm . . . I suppose I might just as well accept her invitation. They are getting to be quite successful, those provincials, aren't they?"

"Unfortunately."

"How do you suppose they do it? When I was a young girl it used to take a provincial anywhere from five to ten years to be recognized by even a South American Legation in Washington. Who ever thought in those days that the fact of one's being related to a Congressman could impress an Ambassador?"

"The inter-allied debts, Madam. Trying to mollify the western sentiment, no doubt."

"A sad state of affairs, my dear."

"Yes, Madam. Do you recall, Madam, what Sir Cecil used to say about money?"

"Do I? Rather, my dear. That it takes at least three generations to wash off oil and two to exterminate the smell of hogs . . . Poor old Sir Cecil . . . It was a fortunate thing for him that he died when Society was still Society and not a hodge-podge of tradesmen and stock-brokers. . . . And speaking about Sir Cecil . . . this reminds me, my dear. Did you finally decide who is to be given the place of honor at dinner tonight?"

"I am afraid it will have to be the Ambassador, Madam."

"It won't do. I tossed all night long thinking about it. I am not at all sure whether he should be given preference to the Count. It is all very well to call him 'Ambassador' but don't forget that he lost his last diplomatic post more than fifteen years ago."

"I am afraid . . ."

"I know, I know. You mean that luncheon when he never opened his mouth because he was seated three places away from the hostess. I think we'd better call him up and tell him about our predicament."

"I already have."

"You have? You are taking liberties, aren't you?"

"I thought . . ."

"I forgive you this time, my dear, but it must never happen again. What was his answer?"

"That an Ambassador, even if he is a former Ambassador, ranks above all other guests except the President, the Vice-President, the Speaker of the House and the Governor of the State where the hostess resides."

"Did you point out to him that the Count's ancestors participated in the First Crusade?"

"I did."

"And?"

"He said he would much rather plead illness and stay at home. In fact, he was quite nasty about it."

"I have an idea, my dear . . ."

"He anticipated it, Madam."

"You mean he guessed that I might have two tables?"

"Quite so. He warned me that in case there is going to be more than one table he is to be put at the one presided over by you."

"The cheek of the fellow! Who is he, anyway? Just a common variety of American business man who happened to put his money on the right political horse."

"Why not let him stay at home, Madam?"

"I can't do that. I must have someone to talk foreign politics with the Count. I do not mind telling you that this sort of thing is playing havoc with my nerves. One dinner more like this and I will be in the hands of my physicians. Worry, worry, nothing but worry . . . I am all in."

"Won't you rest for an hour or so, Madam, and let me attend to the luncheon?"

"Rest? You are joking, my dear! Don't you know what I have to accomplish between now and luncheon?"[24]

And so the morning went. It was not until later in the day that Grace made her first public appearance, having spent hours dressing, selecting from among her hundreds of Paris fashions, some so heavy with pearls and embroidery that they had to be laid out in her closet on twelve-foot shelves; selecting as well from among her five hundred pairs of shoes and matching handbags, eleven white fox neckpieces, and hundreds of jeweled bandeaus, the fashionable headache bands that became her trademark.

Grace was entertaining at least ten thousand guests each year at 640 Fifth Avenue, at Beaulieu, and aboard the *North Star*. Through her drawing room and grand salon passed the greats of the day: Samuel Clemens, Theodore Roosevelt, J. P. Morgan, Russell Sage, Herbert Hoover, General Pershing, Doris Duke, the duke of Kent, Jim Farley, Ignace Paderewski, Arturo Toscanini, the Prince of Wales, Lord Balfour, John Jacob Astor, every British monarch from Queen Victoria to George VI, King Albert of Belgium, the king and queen of Spain, the crowned heads of Scandinavia and the Netherlands, the king of Siam, princes and presidents, grand dukes, emperors, czars, socialites, brokers, bankers, diplomats. (Winston Churchill was a guest on the night of December 12, 1931, when he was struck by an automobile on Fifth Avenue after leaving the mansion. Grace had warned him about mixing drinks. "To the most powerful woman in New York," he had toasted her. "She will remain thus if she does not meddle in the bacchanalian affairs of men."[25] While he was in the hospital, Grace sent him a wreath of grapes.)

The only person missing from her parties was her husband: Neily Vanderbilt.

It would have been pleasing if history had recorded that Neily Vanderbilt renounced a fortune for the woman he loved and lived happily ever after. Such was not the case. Neily realized soon after marriage how different he and Grace were. He was quiet, shy, introverted, a man who loved to tinker in a laboratory and read scientific journals. Grace was outgoing, exuberant, extroverted, completely self-absorbed. "Grace Vanderbilt," Theodore Roosevelt once observed, "sees herself in a kind of perpetual fairy tale."[26] At an opera performance in Rome in 1903, she was asked to sit in the box with the king of

England. Grace could hardly wait to tell everyone all about it. She wrote to her sister May:

> I assure you everyone in the house looked at us, with great interest, seeing all the King's party in our box. And the *dear* King himself couldn't keep his eyes off our box!! I wore my jewels, which I afterward heard from many people were much admired. . . . As soon as the King entered he looked around the house and again spied us out. He then pointed me out to the other royalties. . . . And he said how charming I was. And they all said I had the most beautiful jewels in the house that night. This same lady in waiting said the King of England had told them before this that at Naples I had looked so lovely at the opera! Is it not kind of him to recommend me to the Italian King and Queen? I hear that all the Italian papers speak of me and my jewels. I wore my tiara, my emerald collar, my pearls with the emerald piece Belle gave me, my diamond fringe across the front of my gown (they admire that extravagantly) and my other emerald piece, all this with my yellow and silver gown looked very pretty. . . . The next night we went to the British Embassy reception, arriving very late, 11:45, just as the King was starting away. He stopped and again began quite a conversation, keeping carriages and everything waiting, and he looked dead with fatigue, but his face lighted up and he said, 'I saw you, looking lovely, last night at the opera. Be sure to come to England this season,' etc. etc. On Sunday the Emperor is to be received by the Pope and on Monday His Holiness is giving us a private audience!!! . . . Did I tell you old Grand Duke Michael sent me his photo? Dearest Sister, would you mind immediately sending this on to darling Mother and Father as I can't write all this twice.[27]

Grace Vanderbilt was a woman who had to be in the limelight all the time.

"It's just like Grand Central," Neily once complained to his son about all the guests at 640 Fifth Avenue. "Your mother has become a waltzing mouse."[28]

Neily's son remembered how sometimes before a dinner his father would tiptoe down the stairs and switch the seating cards. "When the guests filed in, and Mother found the tottering, black-wigged Mrs. Astor down with the nobodies at the far end of the table, and a ravishing debutante next to Father, the light of battle really glittered for an instant in those extraordinary green eyes."[29] Bored with the perpetual dinners and endless small talk, Neily began eating his dinner alone in his sound-proof laboratory at 640 Fifth Avenue, while Grace reigned downstairs over her dinner table of guests. Soon he was finding reasons to go on frequent railroad inspection tours and to spend more time on National Guard duty, serving as a lieutenant colonel in the fight against the Pancho Villa raids on the Mexican border in 1918, and in World War I as a brigadier general in command of the Twenty-fifth Infantry Brigade in Europe.

As Neily's parents, Alice and Cornelius Vanderbilt, perhaps had realized, clashes with Grace were inevitable.

Grace and Neily had different friends. Grace would not invite Neily's business friends to the house until she learned they were socially accepted by some of her English acquaintances. Neily had no use for Grace's pretentious friends. Grace preferred Newport and New York City; Neily, his yacht. Grace loved the opera, or at least to be seen at the opera. Neily could not stand it. Grace never touched a drop of liquor and could not tolerate people who did. Neily smoked three or four packs of cigarettes a day and was drinking heavily.

In the summer of 1924, Grace wrote to one of her sisters:

Darling Sister: a thousand thanks for all your dear letters—another one this morning to cheer and help me! I am feeling so terribly disheartened this evening—and am writing to ask advice, as I am really at the *end* of my resourceful mind!

The situation is this (and very, very sad for all of us). Neily, poor darling, was *so* very *drunk* this evening (our first appearance since landing!) in the restaurant at dinner that, before we had our dessert, Reggie Pembroke very kindly put his arm into Neily's and led him through the dining room and up to our rooms where he left Neily asleep on the sofa.

Poor darling Neily is *continually* drunk—every evening.

I really do not know what to do or where to go—it is horrible.

I am frightfully grieved and feel treacherous in telling all this so frankly—so bluntly—but now that he has made this unfortunate public exhibition it will be the talk of London— and of the world. . . . I have all these years managed to get Neily straightened out by taking him along for cures and doing something—but now the devil seems to have got hold of him and I cannot combat whatever it is. . . .[30]

By the time their son, Neil, was ten, in 1908, he became conscious of his parents' quarrels and fights, of angry voices coming from their rooms, of doors slamming in the mansion, of his father angrily storming out the great bronze doors to Fifth Avenue. Sometimes, the fights were over trivial matters. Neily wanted to take showers; Grace felt a shower was "un-English" and refused to have any installed at 640 Fifth Avenue, so that Neily had to retreat to one of his clubs to take a shower. Suspicious of what her husband was doing whenever he spent time away from home, Grace opened his mail and listened in on his phone conversations until he had private wires installed in his bedrooms in New York and Newport. Most often the disputes had their origins in the role Grace felt that her husband should assume—that of the distinguished host at her multitude of parties, a role in which Neily had no interest. In the family dining room was a small elevator concealed behind the paneling, through which Neily could escape down to the 51st Street entrance when he felt a scene coming on with his wife.

"Your mother is a bully," Neily once told his son. "If she can't have her own way, there's simply no use arguing with her."[31]

3.

Grace and Cornelius Vanderbilt's English butler once commented that Mrs. Vanderbilt ran her house "with more pomp and circumstance than many of the crowned heads of Europe."[32] Six footmen in maroon livery stood at attention each time she left or entered the house, and the red carpet was always rolled out to the street for her departures and arrivals.

This world in which the Vanderbilts' two children, Neil and Grace,

grew up was certainly one of the most unusual in the United States, a world that was made even more difficult for them by the open warfare between their parents.

"We were taken downstairs to see our parents twice a day: at 9 A.M. to say 'good morning,' eat breakfast and bow gracefully; for twenty minutes at 5 P.M. to be displayed to the guests gathered in the drawing room for tea. On neither occasion were we allowed to speak until we were spoken to or beg favors."[33]

Aboard the *North Star*, the children were lectured on how to behave with royalty, and dressed in their little coats with ermine trim when the kaiser came aboard. Alice Roosevelt Longworth, a good friend of Grace's, found the Vanderbilt children "terribly repressed." As Neil later wrote: "There was no such thing as self-expression in our young lives. We were taught never to exhibit strong emotion, never to laugh or cry too loud; always to rise when a lady entered or left a room and never to sit down in a carriage until all the ladies were seated. We never broke into adult conversations, nor did we speak unless first spoken to. I bowed and sister curtsied to our elders."[34]

Andrew Carnegie came over each Sunday evening from five to seven, "accepting the flattery of the grownups and never failing to repeat to the children that the most difficult art on earth is that of holding on to money."

"Even a fool can make a million dollars, my boy, but it takes a sage to keep it," Carnegie said. "Do you hear me, Neil?"

"Yes, sir, I do," eight-year-old Neil answered obediently.[35]

Andrew Mellon and Henry Frick usually arrived at the house together. Frick, who grandfather Wilson did not believe was "a man to be permitted in the same room with children," promised Neil a job in a steel plant "if I grew up to be a 'good boy.'" Neil noticed that "no other guest in our house mentioned the word 'dollar' so often."[36]

Grace's children sometimes were permitted to join her in her bedroom in the morning, helping to arrange the cards bearing the names of that night's guests to work out the seating plans, alternating names depending on their importance and titles. "Sister and I were also given lessons in proper table settings. Followed by the butler bearing various dishes and condiments on a huge silver tray, Mother led us around and around the gleaming sixty-foot mahogany table. Before I was nine, I

knew precisely which dishes remained and which disappeared during a complete seven-course dinner. Nothing in my training as a future perfect party host was left to chance. And when I was away from home, Mother kept up a barrage of hypothetical problems, enough to furrow the brow of the most adept party giver."[37]

"Should the former Governor of New York be seated on the right of the hostess and the former Ambassador of Great Britain on her left or vice versa?" Grace quizzed her children in daily lessons on the social niceties. "Years before I had learned the Constitution of the United States, I knew that a Secretary of War should never, never be out-seated by the Secretary of Labor, that both should be shoveled down toward the middle of the table in order to vacate a spot for the Chief Justice of the Supreme Court, and that no Chairman of a New York bank, no matter how many millions in back-taxes he owed the U.S. Government, could be placed on the right of the hostess if a Congressman, no matter how small a chance for reelection he stood, were invited to break our bread. Many a time my sister and I were left without dessert for our failure to distinguish between a full-fledged Ambassador and a Minister Plenipotentiary and many a time we swore that when we grew up we would make all those frightfully important people eat in the kitchen and like it."[38]

"By the time I was sixteen," Neil remembered, "I had lunched and dined with every major crowned head of Europe and the sum of my scholastic knowledge compared most unfavorably with that of a boy of fourteen about to enter the freshman class in high school. It could not have been otherwise. Tossed among New York, Virginia and Florida in winter, I commuted between Newport and Europe in summer and had to rely upon private tutors chosen for their dignified appearance to atone for the lack of regular education. I spoke French, some German and Italian. I swam, fenced, boxed and sailed boats. I shot quail and danced with my tall English governesses, five times my age. But that was all. The rest consisted of disjointed bits and pieces of information communicated to me aboard trains, ships and motorcars. . . . I likewise went to many summer schools in Europe, perhaps to too many schools for my own good: in England, when my parents expected to enter their yacht in the Cowes Regatta; in Germany, when they accepted the Kaiser's invitation to join the *Hohenzollern* on a cruise through the Scandinavian fjords;

in Spain, when the *North Star* was to visit San Sebastian. The choice of my summer schools depended entirely on the itinerary of our yacht. I even spent two days in the Academy for boys of 'aristocratic birth' in Czarskoie-Selo. I could not speak Russian nor understand my teachers there but it so happened that the reunion of the fashionable yachtsmen of the world was held that year off the coast of Russia."[39]

On occasion Grace would take her young son for a walk through an old Newport graveyard, wandering with him among the crumbling tombstones, reading their inscriptions. "All those people in there thought themselves quite some pumpkins, darling, in their day and age. But who remembers them now? When you grow up, you'll find that life is often very difficult. So have all the good times you possibly can, just so long as you don't hurt other people."[40]

Such was life with Mother Grace. Life with Father Neily was quite a different story. Neily had grown up with a cold, distant father, yet he was if anything even colder toward his son than his father had been toward him.

One day, when Neily and Neil were rowing out to a raft, the young boy fell overboard. Believing that his son was not developing into a good swimmer, Neily kept rowing away. "Of course he thought this would teach me to swim," his son remembered. "But I nearly drowned before someone else picked me up and took me ashore, and I was ill afterward. I thought it terribly cruel and I never learned to swim until much later."[41]

Some years later, when Neil was fifteen, "my father and I went down the gangway to the float of the New York Yacht Club at Newport. The bosun with the megaphone had hailed the *North Star* and they were sending the launch for us. As we waited on the float, I saw a small dinghy alongside and stepped into it, thinking the launch would come up on its other side. But the dinghy turned turtle with me. My father promptly stepped on its upturned bottom, which forced me to go down below and come up beyond it instead of taking advantage of the air under the boat. My father said such things were the way to teach a boy to be a man, and his father had done the same things to him. But they are things which stick in a child's mind and make him think, foolishly no doubt, that the parent doesn't love him."[42]

Young Neil tried hard to be close to his father. Once Neily told his

wife that he had to go to a directors' meeting and would therefore have to miss her dinner party that evening. Grace did not believe him. Neil heard his mother telephone and hire a private detective to follow her husband.

Seventeen-year-old Neil wanted to warn his father that trouble was on the way, and tracked him to an apartment next to the New York Yacht Club. Some of his young friends at the yacht club told him that inside the apartment a group of men were watching belly dancers. There, outside the apartment, was the detective his mother had hired. Neil tried to get the detective to leave by giving him the several dollars he had in his pocket. When this didn't work, he knocked at the apartment door.

"Is Colonel Vanderbilt in there? I'm his son."

After considerable rustling inside, a woman came to the door.

"There must be a mistake," she told Neil. "There's nobody by that name here."

"I just want to tell my father that he's being followed. My Mother hired a detective and he's outside the door here."

The woman closed the door in his face.

The next morning, Neil was called to see his father. "When I went down to his bedroom, his neck was the color of a turkey gobbler's and he demanded to know what the hell I was doing following him. My father's room and my mother's were separated by their two bathrooms, but I knew that she could be listening, and so I said only that Mother had had him followed and I'd tried to tip him off."

"Well, for your information," Neily snarled at his son, "I wasn't in that apartment; I never go to those things. But I want you to know that I'm going to stop your allowance for the next six months because I don't like my son following me whether I'm going out on business or on pleasure."[43]

Neil found as he grew up that his father "seemed to grow progressively cooler toward me, until finally he seemed as prickly as a porcupine. Almost everything I said and did seemed to irritate him, and more than once he ordered me out of the room because he said I made him nervous."[44] Ironically, "there were times when I liked my father after he had been drinking better than when he had not."[45] Even as his son became a teenager, Neily still treated him like a simple child. When there was something serious to discuss, Neily would dismiss him with a

remark such as "Your mother and I want to discuss the price of peas in Denmark, so why don't you go out, Neil, and run around the block."[46]

The lives of Grace and Neily's two children were at once worldly and cloistered. Escorted everywhere by detectives, not allowed to mingle with other children, Neil until the age of twelve believed that every family lived just the way his did, with mansions and servants and yachts. Yet his parents gave him an allowance of only twenty-five cents each week, and he had no understanding that their wealth had anything to do with him.

It was not until he was away from home at prep school at St. Paul's in Concord, New Hampshire, that he began to understand what an unusual life he had lived. Several of his classmates asked him to buy them some candy.

"How could I?" Neil asked. "I have only twelve cents left of my weekly allowance."

"That's all right, just walk in the store and tell them who you are. They'll let you charge anything you want."

"Will they?"

"Sure thing. You are a Vanderbilt."

Neil looked puzzled.

"Oh, go on, stop pretending. Don't you know that your family has one hundred million bucks?"

"I see," Neil said.

But he did not. Nevertheless, to please his friends, he went with them to the store and asked for a pound of marshmallows, laying down his twelve cents and explaining that he would pay the balance later.

"What's the name?" the proprietor asked.

"Vanderbilt."

"What's the first name?"

"Cornelius. Cornelius Vanderbilt."

"Any relation to the old lady who has that fine house on Fifty-seventh Street, in New York?"

"That's my grandmother."

"Take two pounds of marshmallows," said the proprietor, "and keep your twelve cents. You'll pay me the whole thing in a heap at your pleasure."

Neil was dumbfounded.

"You see," said his classmates, "you can buy the whole town if you want to. Just give your name and tell them to charge. How about your buying bicycles for us?"

"But I have only . . ."[47]

Soon Neil's friends were riding away on their new bicycles, and soon thereafter Neil's father was at Concord to take his son back to New York, where he was given "a sound thrashing." His weekly allowance was reduced to fifteen cents a week until his debts were paid off.[48]

The same scene repeated itself some years later when Neil was at army training camp. Grace was sending her son five dollars a week.

"How about taking the boys to a swell joint and treating them to a case of Frog champagne?" one of Neil's army buddies would ask him.

"I wish I could do that."

"But what?"

"I've explained to you several times."

"Can't you sign a check?"

"I have no bank account."

"Charge it then."

"I tried it once at school and I'll never do it again. My parents would simply refuse to pay the bill."

"So, that's what we get for wasting our time with a blankety-blank millionaire."

A similar conversation took place every Saturday.

"What the hell is the matter with you rich guys?" Charlie, an Irishman who slept in the same tent, asked Neil. "You know damn well you're as popular as ground glass in coffee and still you won't budge an inch. Now, look: there's six of us here. Dave worked in a tailor's shop, Mike was a garage mechanic, Jim tended bar, Al dug sewers, I used to be a motorcycle cop. None of us was a big shot, none ever had any dough, but do we lie about our folks, do we cringe when it comes to buying drinks? Not on your life. Why, I'd rather jump in the river and say 'here goes nothing' than refuse the boys a drink. Am I right, boys?"

"Right, Charlie," the others cheered.

"So far so good, my friends. Now, then, what is the name of the guy in this here tent that has more dough than Uncle Sam's Treasury?"

"Vanderbilt!" they shouted.

"Right again. One question more and we'll be through. What is the name of the guy in this here tent that never bought a drink for his pals?"[49]

Neil's name resounded through the camp.

On duty in France during World War I, young Neil was chosen by the commander of the American Military Jail, a man who clearly held a grudge against the Vanderbilt family, to work as his orderly.

"So, the public be damned, eh?" was his first comment to Neil Vanderbilt.

Neil stared at him.

"Don't you know who said that?"

"No, sir, I do not."

"Ever heard of William H. Vanderbilt?"

"Yes, sir, that's the name of my late great-grandfather."

"Great-grandfather to you but a blankety-blank to me. Did you bring me the money my folks dropped in the market because of him and his God damn schemes?"

"Don't you think it would be better, sir," Neil quietly asked him, "if you ordered my transfer to the 27th Division Headquarters Troop?"

"I'd gladly transfer you to hell but I was told to keep you here. You can bet your life though that it won't be soft for you."

It was not. The commander paraded Neil before all visitors. "Take a good look at this specimen," he would say. "He might be God Almighty back home but he is just another lousy orderly here. It ain't such a bad war, my friends, when one can have a Vanderbilt scrub his lavatory."[50]

After returning home following the Armistice, Neil, without telling his parents his plans, set out to do something none of the Commodore's other descendants had done: He set out to find a job.

He had always been interested in being a newspaperman. "What's your ambition?" J. P. Morgan had once asked eight-year-old Neil Vanderbilt when he was visiting Grace and Neily.

"I want to be a journalist," Neil had answered.

"That's awful," Morgan had growled. "A journalist usually winds up by either becoming a chronic drunkard or by remaining a journalist. I do not know which is worse."[51]

Despite these discouraging words, when young Neil and his sister, Grace, were aboard the family steamship they printed the *North Star Weekly,* which they sold for three cents a copy to the captain and the crew of the yacht and to any guests they could corner. "The Empress of Germany must weigh at least sixty pounds more than her husband," read one story in the children's paper. "She is as big as our former wet nurse." Another told of a trip to the kaiser's ship and how he "cuts turkey much better than our cook in Newport. But it takes him longer. Because of his crippled right hand, he cuts the bird with his left, with the aid of a curious instrument which is a combination of a long fork and a carving knife. He serves himself first and the moment he finishes eating the footmen take away everybody's plates. We felt hungry after dinner and Neil said he wished he could ask for a glass of milk."[52]

Now, after the First World War, Neil spoke with several prominent publishers about how best to become a journalist. "Make, borrow or steal three million dollars," one told him. "Then shop around for a good newspaper. I know of no other way for a young man to enter the publishing business." Another advised matter-of-factly, "Bluff your parents into giving you three million dollars."[53] Still receiving a niggardly weekly allowance from his mother, Neil realized that this was out of the question. Instead, he secured a job as a reporter with the *New York Herald* for twenty-five dollars a week. Neil did not have to tell his parents the good news. The next morning every New York daily carried the story about a young Vanderbilt looking for work. Neil was summoned at once to see his parents. They informed him that he had twenty-four hours to resign, or else leave 640 Fifth Avenue.

Neil chose to leave home. Not only did he get no support from his family, but he also began to learn that his colleagues viewed him differently because his father was rich. There were rumors, all false, that he used a fast car to cover his beat, that a detective was with him at all times, that he had become a reporter just as a publicity stunt, that he had a ghostwriter whom he paid to draft his articles. Some editors were reluctant to give him difficult assignments; others took a special delight in sending him off on bizarre errands. He received hundreds of letters at the newspaper asking him for money; the requests for one year totaled $8,343,676.26. In addition, thousands of marriage proposals arrived by mail, most of which included photographs.

Once, while Neil was scouting a strike at the Grand Central Station, the stationmaster asked the pesky reporter with all the questions, "Who are you, anyway?"

"I am Cornelius Vanderbilt," Neil answered.

"And I," responded the stationmaster, "am P. T. Barnum."[54]

Although Grace had hoped that her son would marry an English lady, she was not disappointed when Neil fell in love with Rachel Littleton, the daughter of a distinguished lawyer. Perhaps now he would settle down and forget his foolish dream of being a newspaperman. Grace planned a typical Vanderbilt wedding for her only son. Three thousand of her closest friends attended the ceremony at St. Thomas's Episcopal Church, and the wedding presents filled an upstairs room at 640 Fifth Avenue: a bandeau of diamonds worth $300,000, a diamond necklace, cases of antique silver, gold coffee spoons, diamond bracelets and watches. Grace sent the young couple off on their honeymoon with a footman "who treated us like royalty—as Mother indeed thought we were."[55] But though this was a typical Vanderbilt wedding, Neil and his bride did not begin their lives together like typical Vanderbilts. There was one critical ingredient missing: money. Neily had given his son a check for ten thousand dollars. "All things considered we had hoped for a somewhat bigger check."[56] Ten thousand dollars was not bad for newlyweds in 1920, but certainly not enough to live in the manner that was expected of these newlyweds. Neil continued to support himself and his bride as a reporter, now for the *New York Times*.

Two years later, another newspaper publisher encouraged Neil to start an illustrated daily, a penny newspaper in Los Angeles. Neil explained that he had no money for such a venture.

"Get it from your parents," the publisher told him.

"I smiled sadly and informed him that my parents would rather see me burn in hell than publish a newspaper. In fact, I was asked by them to leave their house and was obliged to live on my meager salary for a while when they first found out that I was working."

"I see," said the publisher. "They are rather old-fashioned, aren't they? But what is to prevent you from organizing a corporation and selling stock in your newspaper to your would-be readers?"[57]

This is just what Neil did, founding Vanderbilt Newspapers, Inc.

Running under the slogan "The Public Be Served"—a play on his great grandfather's famous slip of the tongue, "The public be damned"—his *Los Angeles Illustrated Daily News,* which attacked vested interests, began with a circulation of 125,000, and within a month had climbed to 280,000. Soon Neil was expanding his chain, starting up the *San Francisco Illustrated Daily Herald* and then the *Miami Tab,* followed in short order by the *Vanderbilt Weekly* for Sunday readers and the *Vanderbilt Farmer* in Florida.

Losses caused by the collapse of the Florida real-estate boom, coupled with a loan Neil had guaranteed for printing presses that was unexpectedly called, threatened his growing newspaper empire to the point where Neil badly needed an infusion of capital. It was a critical moment. He was, in his estimation, "within a stone's throw of success."[58]

Neil had always assumed that in a pinch, he could rely on his family to help him out. He was dead wrong. "One of my great faults has always been counting my chickens before they are hatched. But from the time I was a little boy, my mother and father had promised me that if I didn't drink or smoke or get involved with girls up to a certain age, and did the things they wanted me to do and left undone the things they did not want me to do, I would inherit several million dollars of my ancestors' money. As I grew older the figures crystallized: I would have three million when I was twenty-six. The money was not left 'in trust'; it was my share of family funds, which they would give me, more or less, as a reward for good conduct—a sort of carrot in front of my nose to keep me on the straight and narrow, as other boys are given, with similar conditions, larger allowances of pocket money than I ever had."[59]

From what he could gather, Neil estimated that by 1920 his mother had inherited about $5 million or $6 million of Wilson money, and that his father, through his inventions and investments, had increased his original $7.5 million to about $20 million or $25 million. Yet Neil had reached and passed his twenty-sixth birthday and still had seen not a penny of the money he believed was coming to him.

"As much as I hated it, I had to call on my parents. I asked them to lend me what would have sooner or later become mine according to the terms of my grandfather's will. The negotiations were lengthy and

exceedingly painful for both sides. . . . After weeks of conferences marked by a spectacular display of irritation and resentment,"[60] Neil was told that he would be given $1,903,000 as a loan to be taken out of his inheritance, but only if he would hand over the operation of his papers to a New York attorney recommended by his father's lawyers.

Neil was shocked. His parents had always treated him as a child and now again, despite his service in the World War and his successful start-up of a number of newspapers, they had no confidence in his abilities. "Of course I was very angry indeed. I was also sorely hurt and upset. I went to my room and remained there until my father asked me to come down because he and Mother wanted to talk to me. Then I went downstairs, to find both of them flushed with anger at what they considered my bad behavior, my disobedient attitude. I made a few foolish threats to the effect that they would live to rue the day and that although I'd made up on other occasions, I would leave the house next morning, never to return.

"In spite of these dramatic statements I went over to kiss Mother good night, but she brushed me off. This probably hurt worst of all. I had always felt closer to her than to Father. In her way I suppose she spoiled me; certainly she was more generous with her smaller income than Father with his larger one. It was no surprise to find him arrayed against me, but here Mother was allied with him. That was too much to take, and I said the unforgivable: 'I wonder what you did—both of you—with my three million!'

"Then I turned and walked to the door, and downstairs and out of the house without hat or coat."[61]

Neil had nowhere else to turn. Assistance from his grandmother, Alice of The Breakers, was unthinkable. Neil had been sending complimentary copies of his newspapers to his grandmother until he received a note from her secretary. The note read: "Mrs. Vanderbilt instructed me to write to you and ask you to discontinue mailing your disgraceful newspapers to her address. She is neither amused nor interested."[62]

And so, though he "ranted and raved," he had no choice but to consent to his parents' terms. Within a year after the new management was in place, the papers had gone out of business, and Neil's inheritance had been surrendered to the creditors of Vanderbilt Newspapers, Inc.

THE KINGFISHER

Neil was shattered. For $40 a month he rented a two-room apartment over a Fifth Avenue toy shop across from his grandmother's 137-room mansion; the "chateau-annex," the newspapers dubbed it. He testified in 1931 in answer to a lawsuit that he was worth exactly $120. Cornelius Vanderbilt IV, the Commodore's namesake, his great-great-grandson, was broke.

9

REGGIE

1901–1934

1.

The days of Vanderbilts as railroad kings were past. The days of Vanderbilts as builders of monuments to the family fortune were also over. Now the days of decadent hedonism had begun.

Reginald Claypoole Vanderbilt, born in 1880, the youngest of the four sons of Cornelius and Alice Vanderbilt, was raised in a curiously mixed-up world of privilege and piety. At his parents' block-long mansion on Fifth Avenue, and at The Breakers in Newport, he was sur-

rounded by the most conspicuous extravagance of the Gilded Age. Amid this overwhelming opulence, his humorless, puritanical parents read to him from the Scriptures and preached the virtues of a stern morality.

A lot was expected of Reginald. He was, after all, a Vanderbilt, the son of a man dedicated to hard work, the grandson of the world's richest man, the great-grandson of the famous Commodore. But early on Reggie sensed that he just didn't have what it took to compete in a family of achievers. He was not an all-round golden boy like his oldest brother, Bill, whose tragic death from typhoid fever while a senior at Yale devastated the family. Nor was he as inventive as his brother Neily, who had graduated from Yale with honors. He certainly wasn't blessed with his brother Alfred's athletic prowess or good looks, having inherited more of the round, homely Gwynne features of his mother. The only way Reggie could distinguish himself was to live the life of a rich playboy. And this he did with dedication and consummate skill.

Like his brothers, he went to St. Paul's and then on to Yale, where he stayed in Vanderbilt Hall, given by his parents in memory of his brother Bill. At Yale he learned that he could be popular simply by playing polo with the horses he brought from home, leading his class-mates on drinking sprees and romantic adventures with ladies of the evening, and betting on college sporting events. He thought it great fun when he lost $3,500 on the Yale-Harvard game.

On December 19, 1901, his twenty-first birthday, Reggie inherited $7.5 million outright under his father's will, plus $5 million from another trust fund. To celebrate, he invited a group of his classmates to dinner in New York City, and then took them to Number 5 East Forty-fourth Street for some adventure.

Behind the green columns and rich bronze doors of the brownstone at Number 5, one door down from Delmonico's and a hundred feet from Sherry's, the city's most fashionable restaurants, stood the city's most elegant gambling house, patronized by a clientele of multimillionaires. The bronze entrance doors opened electrically, admitting the guests to a vestibule barred by another massive door. The first doors then swung shut and locked. If, after inspection through a peephole, the doorman found that the visitors passed muster, the second set of doors opened. A Vanderbilt always passed muster, and young Reggie and his friends were admitted instantly.

The house was designed to make its wealthy visitors feel right at home, with teak floors and walls of white mahogany inlaid with mother-of-pearl. The opulent rooms displayed antique Chippendale furniture, magnificent works of art, bronzes and Chinese porcelains. It looked like an exclusive men's club or a wealthy New Yorker's home, except for the hickory roulette wheel, the baccarat table, and the faro boxes in the big room on the second floor. It was, in fact, the home of Richard Canfield, a heavyset, florid-faced, big-jowled gentleman who also operated exclusive gambling establishments in Newport and Saratoga. Always immaculately attired in formal evening clothes, the dress required of all his patrons, Richard Canfield, who could trace his descendants back to the *Mayflower*, usually retired to his study on one of the upper floors to read the classics while his guests gambled the night away.

Canfield advised each of his guests, including Reginald Vanderbilt, that if they played at the roulette wheel or the baccarat tables or at faro too long, the only winner would be Richard Canfield. It was inevitable. Those were the odds. That was how he made his money. Reggie found this advice easy to forget as Canfield's servants laid out a magnificent buffet late in the evening, served the finest wines from the cellar, and dispersed costly cigars. By the end of his twenty-first birthday celebration, Reggie's inheritance had been depleted by $70,000. He yawned and went home.

To keep abreast of his studies, Reggie was tutored throughout his four years at Yale. At commencement, however, he did not receive his diploma for he had failed one of his exams. Instead, he left Yale with two things: a fiancée—the beautiful, chestnut-haired Cathleen Neilson, whom he married on April 14, 1903,[1] and who gave birth the next year to a daughter, Cathleen—and a diagnosed case of cirrhosis of the liver, brought on by his immoderate fondness for brandy milk punches.

Reggie was never employed and never did a lick of work. Somewhat at a loss when asked his occupation, he usually responded, "Gentleman." When in the city, he lived in a drab four-story brownstone at 12 East Seventy-seventh Street, primarily distinguished by being one of the first private homes to have a fully equipped bar installed in it. Other than in having a good time, his only real interest lay in breeding show horses and polo ponies at the 280-acre estate he bought after graduating from Yale, Sandy Point Farm in Portsmouth, Rhode Island, six miles outside

of Newport and a half mile from his brother Alfred's Oakland Farm. There at Sandy Point, around a rambling colonial home with a pillared portico, were stables for fifty horses, Reggie's pride and joy. Near the house he built a racetrack where he could watch his horses being trained, often hiring a brass band to play in the center of the ring to liven up the sessions. He built a large room overlooking the track in which he displayed all the cups, trophies, and ribbons the Vanderbilt stables had won.

Self-indulgent, lazy, lackadaisical, Reggie had absolutely no sense of responsibility or purpose other than to keep himself from being bored. His peccadilloes made good copy, and the press reveled in reporting all of his improprieties. With his pet bull terrier seated next to him, its legs fitted with leather leggings, its back draped in a leather coat, goggles over its eyes, Reggie raced his automobile over the quiet country roads of Newport. Angry farmers threw stones at him, and the police lay in wait to hand out speeding tickets. On five separate occasions in New York City he struck pedestrians, killing two men, injuring two others, and leaving one young boy severely injured. Because he was a Vanderbilt, he was never prosecuted. There were accusations of falsifying his federal income tax returns. There were stories that he lavished invaluable jewels on casual female acquaintances. Rumors persisted that a Newport gentleman had given Reggie a severe beating for seeing his wife, and when that did not seem to get the message across, shot him—rumors that the Vanderbilt family found hard to deny when the usually gregarious Reggie was absent from public sight for several months, recuperating.

And then there were the astonishing gambling losses at Canfield's, $400,000 over the course of five unlucky nights, it was said. When Tammany Hall was defeated and the city began hiring a new breed of honest men, William Tavers Jerome, the new district attorney, pledged to eradicate gambling houses from the city. His prime target, thanks to Reginald Vanderbilt, was the most infamous of the houses: Richard Canfield's.

At eleven o'clock on the night of December 1, 1902, six of Jerome's men leaned a ladder against the side of Number 5 East Forty-fourth Street, climbed it, and swung an ax through the window. The detectives entered the house with drawn revolvers.

"We understand that gambling is going on here," the detectives

informed Richard Canfield, who had come downstairs to see what all the noise was. "This is a gambling house."[2]

"A gambling house?" the urbane Canfield asked in amazement. "Gentlemen, this is my private residence, and I assure you all this is needless trouble on your part. I would have been glad to have admitted you at the reception door if you had indicated a desire to enter. I assure you that there is nothing here that needs your attention. Nor do I ask you to accept my bare word. The freedom of the house is yours—though I am sorry you have broken my windows."

Canfield led the detectives through the first two floors of the brownstone. As they searched everywhere, there was dead silence; not the whir of a roulette wheel nor the click of dice nor the shuffling of cards could be heard. Not a patron was to be seen, for Canfield had shrewdly closed down his gambling establishment with the fall of Tammany Hall. The detectives searched on.

"This is my own apartment, gentlemen," he explained when they reached the top floor; "rather comfortable, I think. I use it also as my private office."[3]

Canfield cautioned the detectives not to hammer on the walls of this room since it would hurt the mother-of-pearl inlay in the mahogany panels. One of the detectives noticed that the room was not as deep as the others. Inlay or not, hammer on the wall he did. It sounded hollow. The men swung their axes into the mahogany, and with their crowbars opened up a hole. They lit a candle and thrust it into the hole, revealing a small hidden room.

"By God!" exclaimed District Attorney Jerome. "As last we've got the stuff!"[4]

Detectives carried out five roulette tables, three wheels, a faro layout, packs of cards, thousands of ivory chips, and the IOUs from Canfield's safe, including one from Reginald C. Vanderbilt for $300,000.[5]

"I have in my possession the names of a score of your patrons, men of prominence in this city," the district attorney warned Canfield. "It is my intention to summon them as witnesses, unless you are willing to acknowledge your connection with this place, and assume the responsibility for its management."[6]

"I'll stand for the house, but I'll protect my patrons, even if it

should mean some personal inconvenience to myself," Canfield quietly responded.[7]

When Canfield maintained that Jerome had conducted an illegal search and seizure, quoting from the classics of literature to support his allegations, the district attorney found it necessary to buttress his case by summoning Canfield's wealthy patrons to testify as to exactly what had been going on at 5 East Forty-fourth Street. And the patron he most wanted to testify was Reginald Claypoole Vanderbilt. This was not really something Reggie wanted to do, so he secluded himself deep within the recesses of his mother's 137-room mansion on Fifth Avenue. When a subpoena was issued, he fled to Sandy Point Farm, outside of Jerome's jurisdiction.

Jerome knew that Reginald Vanderbilt would have to return to the city sometime, and stationed detectives around his mother's home, at his town house, at his clubs, and at the home of his in-laws in order to snare him when he finally arrived. "This house is the residence of Mrs. Frederic Neilson, who is the mother-in-law of Mr. Reginald Vanderbilt," the guide announced over a megaphone as the sight-seeing bus slowed in front of 100 Fifth Avenue. "Mr. Vanderbilt is now supposed to be in hiding. The crowd in front of the house is composed of District Attorney Jerome's detectives who seek to subpoena Mr. Vanderbilt to testify about the money he lost at Richard Canfield's gambling house."[8]

Once, on the way to a horse show in Philadelphia, Reggie stopped in New York to visit his wife's parents. The detectives got the word that he was in the house and beefed up their vigil, just waiting for him to walk out.

Reggie was trapped, no doubt about it.

There was only one thing to do: call Harry Lehr. A half hour after Harry arrived, the Neilsons' Swedish cook left the house, and a little later Harry Lehr left, but after that, all was quiet.

After several days, the Neilsons' butler came out and walked straight to the men who had been there day and night posing as loiterers.

"You might as well go," the butler told them. "He was here, but he's gone."[9]

It was only then that the detectives realized that the stout Swedish cook had been none other than Reggie Vanderbilt, dressed up by Harry Lehr in servant's clothes and a wig.

Thereafter, until January 11, 1904, when the charges against Richard Canfield were finally dropped, Reggie took the train between Newport and Philadelphia by way of Boston, Montreal, and Detroit to dodge the process servers waiting for him in New York.

No matter what Reggie did—lose hundreds of thousands of dollars at the gambling tables, run over pedestrians, or take his wife of nine years and his eight-year-old daughter to Paris in 1912 and sail back to the United States without telling them or leaving them a note or any money[10]—whatever trouble Reggie got himself into, his mother, Alice of The Breakers, always forgave him. Reggie, her youngest son, was her favorite child. Bill was dead, and Neily might as well have died by marrying Grace Wilson. Now, with the tragic death of her son Alfred, who went down on the *Lusitania* on May 7, 1915,[11] Reggie was the new head of the House of Vanderbilt. The family portraits of the Commodore and William H. Vanderbilt were now his, and along with them all the responsibilities as head of the dynasty, whether or not he chose to assume them. Stern, straitlaced, righteous Alice Vanderbilt could forgive her son any indiscretion, but she was concerned about him. "Regi had been upsetting her," Harry Whitney wrote to his wife, Gertrude, Reggie's sister. "Regi was drunk & apparently is most of the time."[12] Alice Vanderbilt went to Chauncey Depew for help. "Don't worry, my dear lady," the faithful family adviser assured her. "Young men sow wild oats. All of them do."[13]

Such was the life being led by Reginald Vanderbilt from his college days at Yale to his desertion of his wife and daughter in 1912, to his divorce in 1919, to that day in 1922 when at age forty-two, as society's best-known bachelor, he met seventeen-year-old Gloria Morgan. Gloria was one of the "Magical Morgans," as Maury Paul, who signed his well-known society column in the *New York American* as Cholly Knickerbocker, labeled her and her twin sister, Thelma. Gloria and Thelma were identical twins, so similar in appearance and personality that often their parents—Harry Hays Morgan, the American consul in Switzerland, and his wife, Laura, whose mother had been born in Chile and who traced her ancestry back to the grandees of Spain—couldn't tell them apart. The girls had grown up in Switzerland, Amsterdam, Spain, and Germany as their father, a career diplomat, received new assignments.

"You had both better marry rich men," Mamma would tell the twins. "You're extravagant, you know. You never save. You give everything away. If you want to play at being Lady Bountiful, you had better marry someone who can give you what you need."[14]

When they were sixteen, the precocious twins somehow convinced their parents to let them return to the United States, where they rented a small apartment at 40 Fifth Avenue in Greenwich Village. Maury Paul saw that these two beautiful, vibrant young ladies, living alone in New York, would make good copy, and frequently wrote about them. When Thelma, at age seventeen, married James Vail Converse, the grandson of the founder of Bell Telephone and a relative of J. P. Morgan's, Maury Paul took Gloria under his wing, referring to her as "Glorious Gloria" in his columns, and set out to find her a suitable husband.

On a snowy evening in January 1922, Reggie attended a small dinner party given by Thelma at the Café des Beaux Arts. Gloria arrived late because of the storm and was directed by her sister to her appointed table. As she approached, an older heavyset man, with a moustache and dark brown hair just turning gray, rose from the table.

"Don't tell me," he said. "This beautiful girl must be Thelma's twin sister. I've never seen two people so much alike. I'm Reggie Vanderbilt."

He looked at Gloria with what she perceived as "rather bored and weary eyes." His eyelids were heavy and turned up at the corners, which gave him a sleepy, nonchalant appearance, but there was also about him the demeanor of someone who knew he had the power to get whatever he wanted. Gloria appeared to Reggie a statuesque, glamorous beauty, a bewitching blend of European sophistication and wistful American innocence that stirred his imagination. He had no idea that she was younger than his own daughter.

Reggie began to talk to her about his horses, especially his prize horse, Fortitude. Gloria knew nothing about horses and had never heard of Fortitude, but she had heard about Reginald C. Vanderbilt and "I pretended to be enormously interested."[15]

"Do you have to do that, or do you think it intriguing?" he asked her after several minutes.

"What?" she asked him.

"Stammer. It is very charming, you know."

As he spoke, he realized that Thelma had the same speech impediment, a sort of breathless whispering voice. "We speak French like Spanish and Spanish like French, and English like—well, like something I can't mention," Gloria later explained.[16]

"I apologize," he said, laughing.[17]

Soon he asked Gloria to dance.

"Would you mind very much if we don't just yet?" she said. "I've been dashing all day, and I'm starved."

Reggie breathed a sigh of relief. As it turned out, he hated dancing.

"What a bore you must think I am," he remarked later that night. "I've been talking your ear off, and I haven't given you a chance to say a word. But promise me you'll let me take you out to see Fortitude one day, and then you'll see why I'm so proud."

Gloria told him that she would love to see Fortitude.

"Bully!" Reggie exclaimed.[18]

A friend of Gloria's came over to ask her to dance. "Well, Gloria," he whispered as they tangoed, "I see you have charmed the most eligible bachelor in town."[19]

The next day, Reggie invited Gloria to the theater.

"Don't go home," he begged her afterward, "please don't go home—let us go out somewhere. I have so much I want to say to you."

"I'm so sorry, I can't," Gloria told him. "I have to get up very early. Thelma and my mother sail for Europe tomorrow."

"I'll meet you tomorrow noon on the boat," he told her.[20]

But at noon the next day, Reggie Vanderbilt was not in the crowd of well-wishers. Well, that was that, Gloria thought. What she did not yet realize was this was Reggie, as careless as ever.

When she returned to her apartment, a great box bursting with orchids and every type of flower of the season awaited her. The phone rang.

"Gloria, this is Reggie. I'm so sorry," he apologized, making some excuse for failing to appear at the ship. "Darling, just to show me I'm forgiven, please have lunch with me. I don't care how many engagements you have to break—break them all. I'll pick you up in ten minutes."

He hung up.

"Well!" Gloria said to herself. "When this Reggie Vanderbilt

wants something, there's no doubt about it, he wants it; and, what's more, he probably gets it."[21]

For the next several days, Reggie would not leave Gloria alone, taking her to lunch, to dinner, to parties, to the theater. This was a heady, dreamlike time for a seventeen-year-old intent on marrying a rich man.

Four days after they had met, Reggie asked Gloria to marry him. Gloria accepted his proposal without hesitation, though Reggie was more than twice her age.

The following afternoon, Reggie called Gloria and asked her to come to his house for dinner, telling her that his good friend Maury Paul would be there.

Reggie seemed preoccupied and solemn as the threesome sipped drinks in the oak-paneled den.

"Maury, you know both Gloria and I value your friendship. What I am about to tell you Gloria has already heard from me."

"Please, darling," Gloria interrupted.

"No, dearest. I want Maury to know that you are entering this marriage with your eyes wide open—and what you may be letting yourself in for."

He cleared his throat.

"Most of the inheritance left to me outright by my father has long since gone. I now derive my income from a five-million-dollar trust, which, after my death, must go to Cathleen and any other children I might have. And there may well not be other children. The chances are you would be a Mrs. Vanderbilt with no money. Do you understand exactly what I am saying to you?"[22]

What he was saying was that he had squandered his fortune.

Since the age of twenty-one, he had not only been spending the income from his inheritance, $775,000 each year, he had, in addition, been spending the principal. Gone was the $7.5 million he had received from his father, gone an additional $2.5 million received in 1907 from his father's estate, gone $3 million from other kind relatives' bequests, gone $500,000 he had received when his beloved brother Alfred died. Gone, all gone. And nothing to show for it. No great house. No yacht. No art collection. Nothing. It is doubtful that Reggie could even remember where it had all gone. His senses dulled by a steady consumption of

brandy milk punches, the betting, the gambling, the women—it had all blurred into one perpetual party that had lasted for two decades.

"As my wife, you will have a big name but little money to live up to it. I've spent every cent of my personal fortune. . . . As long as I live, you will be taken care of, but I am an ill man. Should I die, the $5,000,000 trust fund goes to my daughter by my former wife, Cathleen. Your only chance of financial security in the future would be to have a child who would then share the trust fund with Cathleen. Your chance of having a child by me is one of those 100 to 1 shots, for my doctor doubts that I can become a father again."

With Reggie showering expensive gifts on her and promising her that "I'll buy you the whole of Paris" on their honeymoon, and with a nice chunk of the Vanderbilt fortune watched over by Reggie's elderly mother, a portion of which would someday replenish Reggie's depleted coffers, it was a little hard for seventeen-year-old Gloria to understand just what he was telling her.

"Darling," Gloria whispered, "all this is not necessary. I told you last night I love you. I want to marry you, and I will not hear another depressing word out of you."

"I'm the proudest and happiest man in the world," Reggie told Maury Paul, beaming. "What this angel sees in me I will never know. But I still don't believe Gloria realizes what she might be up against. Good Lord, a Mrs. Vanderbilt without any money!"

Reggie got up as Gloria and Maury laughed.

"I haven't talked this seriously in years," Reggie exclaimed. "I need a drink!"[23]

"I love you," Gloria told Reggie the next day. "I want to marry you. Nothing else matters to me. You know that. But I will not marry you unless your mother gives her consent."[24]

Reggie recalled older brother Neily's disinheritance because of his marriage to Grace Wilson, and agreed with Gloria that this was a sensible idea.

A week later, he called Gloria to tell her he would stop by to pick her up. He had arranged an audience with his mother and it was to be that afternoon.

Gloria was terrified. She put on her mother's green taffeta dress

with a mink collar, and one of her hats with a cluster of fruit on top. As they were driven to the mansion, Gloria grasped Reggie's hand.

"Don't worry, dearest, she'll love you as much as I do."

"I'm petrified," Gloria whispered, almost in tears. "If she doesn't like me, I will never marry you, Reggie. I really mean it."[25]

When a footman opened the massive front door of the Fifth Avenue château, Gloria found that "my heart beat so violently that I could hardly breathe."[26] They were led to a drawing room where seventy-seven-year-old Alice Vanderbilt was enthroned. Gloria was struck by how this tiny woman dressed in black could dominate such an imposing home.[27] There in the drawing room, Alice of The Breakers talked with Gloria about everything down to the price of eggs, everything but the subject they had come to see her about: their marriage.

When they were safely back in the automobile, Gloria turned to Reggie.

"Darling, did you tell your mother? I can't understand. She never mentioned our engagement."

"Gloria," Reggie patiently explained, taking her hands in his, "my mother is a very undemonstrative woman and will not permit herself any show of emotion. but you will find out that this reserve covers a sincere nature and a warm heart."

"But, Reggie, I don't know where I stand."

"Don't worry," said Reggie. "You'll be hearing from her."[28]

Several weeks after the visit, Gloria still had heard nothing about how she had fared.

"I haven't heard from your mother," she would tell Reggie each day.

"All the Vanderbilts move slow but sure," he laughed.

Gloria felt she knew what the problem was. No doubt the proper Mrs. Vanderbilt viewed her, Glorious Gloria, the Magical Morgan, as a young lady with a past, the same way decades before she had thought of Grace Wilson, whom the Prince of Wales had called his pet. Gloria was not about to let such nonsense interfere with her future. One day she worked up her courage and knocked at the door of the Vanderbilt mansion. Gloria asked the stunned old dowager who her personal physician was, and then left. Within several days, Mrs. Vanderbilt had re-

ceived a report from her physician verifying that Gloria was a virgin, a
report that Maury Paul published in his society column. This certifica-
tion did the trick, for a letter then arrived from Mrs. Vanderbilt: "Dear
Gloria: You will be at my house tomorrow afternoon at four o'clock to
meet your future relatives."[29]

Again Reggie and Gloria entered the great mansion. This time all
the family was there, staring at them in what Gloria perceived as "cold
disapproval." There were Neily and Grace Vanderbilt, and Reggie's
aunts Mrs. Florence Vanderbilt Twombly and Mrs. Emily Vanderbilt
White, and Reggie's sisters, Gertrude Vanderbilt Whitney and Gladys
Vanderbilt Szechenyi. Alice of The Breakers introduced Gloria to each
of the thirty assembled relatives. "Florence, I want you to meet my
future daughter-in-law, Gloria."[30] Gloria thought "they might have
been painted pictures on canvas for all the movement they made. Behind
their acid courtesy was a faint but unmistakable hostility."[31]

At last one figure from the group stepped forward. She put her arms
around Gloria and kissed her.

"I'm your Aunt Lulu," Mrs. Frederick Vanderbilt, one of Reggie's
aunts, told her. "I am so glad Reggie is going to marry you."

This a grateful Gloria remembered as "the one human thing said
to me that dreadful afternoon,"[32] as she became acquainted with the
coldest, most aloof, most distant group of strangers she had ever encoun-
tered.

Gloria awoke the morning of her wedding, March 6, 1923, feeling
terrible, her throat so sore she could barely swallow, her cheeks burning.
She took her temperature. It was 104, but she would not let herself
believe anything was wrong. "I defied whatever it was. Nothing was
going to prevent my marrying Reggie that day."[33]

She went through the wedding ceremony as if in a trance, with
what was happening around her out of focus, unreal.

"Why don't you and Reggie slip out?" Alice of The Breakers asked
her during the reception. "It will be all right."[34]

They were driven to Grand Central Station and whisked aboard the
Vanderbilts' private car where Gloria sank into a big armchair to rest,
as the train rumbled toward Rhode Island and Sandy Point Farm. "The
last thing I wanted at this time was to have Reggie know that I was ill.

What could be more devastating to a bride, more unromantic and more anticlimactic, than to be ill on her wedding night? But when dinner was served, the cumulative effect of fever, chills, pain, and nausea was too much; nothing I could do could conceal the way I felt."

"Darling," Reggie said, "you look really ill. Are you?"

Gloria broke down. "Oh, Reggie, dear, I didn't want you to know, but I really think I'm going to die."[35]

At Providence, a car met them to take them through a snowstorm out to Sandy Point Farm. At the front door, Gloria passed out. She had walking diphtheria.

For six weeks Gloria was bedridden, and it was three months more before she could walk.

When she finally recovered, the fun began.

Neither Reggie nor Gloria ever went to bed before five o'clock in the morning, with groups of friends dropping in for drinks beginning at four o'clock each afternoon and staying all night. Gloria soon found that their house "was more like a clubhouse than a private home."[36] "They want the 'palmam sine pulvere,' " Reggie would say in describing his friends, quoting a Latin phrase he had learned at Yale: "the palm without the dust," the good things of life without working for them.[37] It was an apt phrase to describe the hedonistic life he and his young wife were living.

After they had been married a year, Alice of The Breakers invited her favorite son and daughter-in-law to the Ambassador Hotel for luncheon. They had just been seated when Alice turned to Reggie.

"Has Gloria received her pearls yet?"

"Now, Mother, you know I would love to give Gloria pearls, but I do not intend buying her a cheap necklace and I cannot afford the kind I would like."

Mrs. Vanderbilt summoned the maître d'hôtel. "Please bring me a pair of scissors," she commanded.

When he returned, she took off her rope of pearls, which was so long that it wrapped twice around her neck and hung well below her waist, laid it out on the table, and cut off a third, which she handed to Gloria.

"There you are, Gloria; all Vanderbilt women have pearls." She pushed the remaining pearls into her gold mesh bag, resuming the conversation.[38]

More than anything, Gloria wanted to give Reggie "a son to be called Reginald Vanderbilt, Jr."[39] On February 20, 1924, a little girl was born to Reggie and Gloria. They named her Gloria.

"It is fantastic how Vanderbilt she looks," Reggie exclaimed in delight. "See the corners of her eyes, how they turn up?"[40]

Their happiness was to be short-lived. While in Europe the next spring, Gloria walked into Reggie's room and saw him with a blood-stained handkerchief by his mouth.

"It's only a nosebleed, dearest," he said.[41]

Gloria was horrified.

"Now, Gloria, dearest, don't get yourself all upset. I assure you this is absolutely nothing. My doctor's not worried about it, so why should you be?"[42]

Gloria insisted on taking her husband to a specialist, who advised him to take the cure at Vichy. Reggie refused. But when Gloria said she would not return to the United States with him unless he did, he gave in.

He hated every moment at the health spa. All he could drink was water, which he said was "only fit to rot your boots," and the diet he dismissed as "foul."[43] But kept away from alcohol, Reggie showed daily improvement in appearance and health.

The attending physician took Gloria aside one morning when Reggie was at the baths.

"Mrs. Vanderbilt, you must be told the seriousness of Mr. Vanderbilt's condition. He has sclerosis of the liver and if he wishes to prolong his life it cannot be done but in one way—a moderation of his living."

"And that?" Gloria asked.

"He must drink very little in the future. In fact, I would suggest not at all."[44]

"Can't he drink anything?" Gloria asked.

"A little champagne or any of the light wines with his meals. I have

explained all this to your husband, chère Madame, but he only laughs at me. I feel it my duty to tell you that I fear the consequences if he does not carry out my orders."[45]

This, Gloria knew, "was like a sentence for Reggie of almost instant annihilation."[46] Her best bet, she reasoned, was to keep him away from the United States as long as possible, far away from his drinking buddies. Reggie would hear none of that; he insisted on returning to the United States for the Newport Horse Show in August.

On their return from Europe, Alice of The Breakers invited Reggie and Gloria for dinner at 6:30 before they went home to Sandy Point Farm. Reggie, however, stopped first at the Reading Room, Newport's oldest men's club, while Gloria went on alone to The Breakers. It was not until after eight o'clock that Reggie finally arrived at The Breakers, obviously inebriated.

Nevertheless, Gloria was confident enough that Reggie had mended his ways to plan a trip in September to Chile to visit her dying grandmother. She set off for New York on September 3, 1925. Reggie would meet her the next day to see her ship off.

"I'll see you tomorrow," Reggie said as he kissed Gloria goodbye.[47]

On the train ride to New York City, Gloria looked out the window and remarked several times to her traveling companion how the trees were already changing color. Her companion told her that she was repeating herself. Suddenly, Gloria remembered a fortune-teller's prediction that a repeated conversation about autumn leaves would be an omen that something was about to change her life.[48]

That evening, when Gloria reached New York City, she called Sandy Point Farm and was told Reggie could not come to the telephone; he had a sore throat and was resting. Obsessed by her premonition that something was wrong, she called again later in the evening.

A stranger's voice answered the telephone.

"I'm Mrs. Vanderbilt," Gloria said. "Who are you?"

"I'm Mr. Vanderbilt's nurse."

"Oh, my God! What's happened?"

"Please, Mrs. Vanderbilt, don't get upset. Mr. Vanderbilt had a slight hemorrhage. I would let you speak to him, but the doctor gave him a sedative and he is now sleeping."

Gloria told the nurse to have the chauffeur meet the midnight train from New York City. She was leaving at once.

"But, Mrs. Vanderbilt," the nurse protested, "Mr. Vanderbilt told me that should you phone, I was to tell you not to worry, that he would meet you in New York as planned."

"Please, nurse, do as I ask."[49]

Gloria caught the train for Providence, where the Vanderbilt chauffeur met her. Usually a slow, cautious driver, he sped to Sandy Point Farm.

They reached the estate at five o'clock that morning. The first thing Gloria saw was her mother-in-law's maroon Rolls-Royce by the front door.

The butler came to the door.

"What is it? What has happened—how is Mr. Vanderbilt?"

"Mr. Vanderbilt died two minutes ago," the butler said.

Tiny old Alice of The Breakers appeared down the hall.

"You mustn't go in there," she whispered to Gloria.[50]

Reggie had suffered massive hemorrhaging at nine o'clock and then at three o'clock, the veins in his esophagus exploding. There was blood all over the room.

Gloria turned her face to the wall, sobbing hysterically.

"Gloria, dear," Alice Vanderbilt said to her, "you must really try to pull yourself together."[51]

Shocked, Gloria stared at her. What kind of woman was this? Her youngest son, her favorite child, dead. How could Reggie's mother be so cold, so devoid of emotion, so lacking in compassion? Eighty-year-old Mrs. Vanderbilt—who had taken that lonely ferryboat ride to the Vanderbilt mausoleum on Staten Island so many times, with the Commodore; with her father-in-law, William H. Vanderbilt; with her oldest son, Bill, dead of typhoid at twenty; with her beloved husband, Cornelius, dead of a stroke at fifty-six; for the memorial service for her thirty-eight-year-old son Alfred, lost on the *Lusitania*—eighty-year-old Mrs. Vanderbilt took her trembling daughter-in-law in her arms and held her. The grand old lady did not say a word or make a sound, but as Gloria looked, she saw great tears streaming down her ancient cheeks.

2.

When Reggie died, his twenty-year-old widow realized suddenly that "I had been living at a rate which was much greater than what I had."[52] That was an understatement. There was nothing left.

The morning after Reggie's death, Harry Whitney stopped by with a check for $12,000 to help Gloria meet expenses until the estate was settled. She needed every dollar of it. Under Reggie's will, Gloria was to receive $500,000, but Reggie had died without $500,000 to his name. All of his debts had to be paid: $14,000 to pay the butcher's bill, $5,344 for fruits and groceries, $269 for newspapers, $436 for ice, $712 to a laundress, $2,100 for gowns, $3,069 to a garage, $8,358 to Tiffany and Company, $3,900 to B. Altman and Company, $225 to an orchestra—a total of $116,671.86 to his creditors, and $106,930 to pay back taxes. Sandy Point Farm, the horses, the stables, had to be sold. The New York town house was sold. Furniture, linens, silverware, kitchen plates, trash baskets, a meat grinder, a wicker baby carriage—everything was sold at auction. When it was over, Gloria received $130,000, all that remained of the assets of the grandson of the richest man in the world.

The $5 million trust fund Reggie's father, Cornelius, had been far-seeing enough to establish, a fund whose principal could never be touched, was still of course intact, and this passed in equal parts to Reggie's two daughters: twenty-one-year-old Cathleen and one-year-old Gloria. Since the widow Vanderbilt was still a minor, her baby daughter's share of the trust fund, $2,500,000, would be administered by Justice James Aloysius Foley, the surrogate of the New York courts.

Reggie's warning to Gloria before they married had come true. Gloria was "a Mrs. Vanderbilt with no money," a woman who had "a big name but little money to live up to it." Her infant daughter was rich enough; she was not. This was a critical distinction Gloria did not yet perceive.

Several months after Reggie's death in 1925, Gloria's attorney, an old friend of her family's, George Wickersham of the prestigious New York City law firm Cadwalader, Wickersham and Taft, filed a petition with Surrogate Foley on Gloria's behalf, requesting an allowance from

the child's trust fund to cover the "monthly expenses necessarily incurred for the maintenance and support of said infant and the maintenance of the home in which said infant resides." The monthly expenses were estimated as:

Servants	$925.00
Food for servants	250.00
Food for infant and mother	400.00
Coal	100.00
Gas	20.00
Laundry	80.00
Garage and automobile accessories	300.00
Physician	50.00
Clothing for infant and mother	1,500.00
Telephones and telegrams	40.00
Incidental	500.00
	$4,165.00[53]

Surrogate Foley readily granted the petition, which allowed Gloria to draw an allowance of $4,000 each month to support herself and her baby.

Within several months of Reggie's death, Gloria was off again, resuming a life of careless extravagance on those monthly payments, crossing the Atlantic as many as twelve times a year, traveling to Paris, Biarritz, Cannes, and Monte Carlo, to Switzerland, London, New York, and Hollywood, renting a large triplex apartment in Paris in addition to residences in England and Switzerland.

Gloria hopped from country to country, from party to party, from nightclub to nightclub, moving in international high society, a group of European royalty and American millionaires that was called "the Prince of Wales Set," since it revolved around the popular young heir to the British throne. It was a time when the status of a hostess was measured by whether the prince came to her party, and the success of her party was gauged by how long he stayed.

Twin sister Thelma was at the center of this set. She had divorced her first husband soon after marrying him, and in 1926 married a fifty-five-year-old widower, Duke Furness, an English shipping magnate

known as Marmaduke. "We were blissfully happy those first few months," Thelma remarked. "I had never had so much attention showered on me. I was utterly content in his love and firmly believed it would always be that way."[54] It would not. Marmaduke was soon seen escorting other women around Monte Carlo. It was at that time that Thelma met the son of Queen Mary and King George V, David, Prince of Wales. "The Prince seemed to me to be winsomely handsome. He was the quintessence of charm."[55] As Maury Paul wrote in his society column, Thelma found herself the "fast friend" and "favorite dancing partner" of the Prince of Wales.[56] Even though, as Thelma told her close friends, "the Prince of Wales was a most unsatisfactory sexual partner," whose "primary problem was premature ejaculation,"[57] they began a love affair that would last for five years.

If Thelma could have a prince, certainly Gloria deserved one, too. One year after Reggie's death, Gloria met on shipboard His Serene Highness, Prince Gottfried Hohenlohe-Langenburg—Friedel, Gloria called him. He was a great-grandson of Queen Victoria, his mother the sister of Queen Maria of Romania, his father the first cousin of the empress of Germany. Friedel's parents were great German landowners. Their medieval castle in Bavaria, Schloss Langenburg, was larger than Buckingham Palace. The only trouble with twenty-nine-year-old Friedel was that until he inherited his parents' landholdings, he had no money of his own. He served as the secretary to a German industrialist at a salary that was less than what Gloria paid her daughter's nurse. This did not seem to bother Gloria. In her eyes, a prince was a prince, and a destitute German prince was just as good as a solvent British one.

Two months after they met, Prince Hohenlohe proposed to Gloria. "I would say yes at once," she told the prince, "if you and I were the only ones to be considered. It is not going to be easy—we must wait and see."[58]

George Wickersham advised Gloria that in his opinion, Surrogate Foley would reduce her income if she married the prince, since it would be assumed that her new husband should provide for her expenses. This was not a happy prospect. By then, Gloria long since had run through the $130,000 she had inherited from Reggie's estate and was living solely on her allowance from her baby's trust fund. "I found out," she commented, "that [an allowance of] $48,000 a year did not go as far as a

quarter of a million."[59] "No part of the infant's income can be used to finance a second marriage," Surrogate Foley ruled.[60] To avoid any reduction in her allowance, Gloria and Prince Friedel did not marry. Instead, the prince began to accompany Gloria on her wanderings, living off her largess. In truth, he was living off the unknowing generosity of Gloria's three-year-old daughter. And that was when the trouble began.

Gloria's mother—Laura Morgan, "Grandmother Morgan"—and the nurse Gloria had hired two weeks after giving birth—Emma Sullivan Keislich, "Nurse Keislich"—both of whom traveled with Gloria to take care of her baby, had long been critical of what they considered Gloria's decadent way of life, of the breathless newspaper coverage of her forays into popular nightclubs, accompanied by photographs of her in low-cut, skin-tight evening gowns on the arm of a wealthy gentleman. Both had long been critical of what they considered her neglect of her child. Gloria's affair with Prince Hohenlohe united Grandmother Morgan and Nurse Keislich as inseparable allies, and stirred them to action.

It was when Gloria sailed for Europe after Reggie's death that her mother first accused her of trying to harm the baby. Gloria had wanted to take her child up to the deck to play with the other children, but her mother insisted the seas were too rough. Gloria explained to her mother that it was a beautiful day, that all the children were on the deck playing. "This might be so," her mother reprimanded her, "but *they* are not *Gloria Vanderbilt.*"[61]

Grandmother Morgan and Nurse Keislich began treating the infant like an heiress. They saw it as their duty to serve her and fawn over her and pamper her. Nurse Keislich, for example, believed the food at the Ritz was not good enough for the baby. "Of course Mrs. Vanderbilt does not agree with me," she informed the doctor who had come to check on baby Gloria and had inquired why the nurse was cooking a chicken on a hot plate resting on the toilet seat in the bathroom, "but I for one am going to see that little Gloria Vanderbilt has the best."[62] Nurse Keislich had no doubt about what her job demanded: "Watch her, guard her—every move she makes—her money, her life!"[63] She hovered over her charge like a mother hen. Every little ache or ailment of the baby was treated as a life-threatening crisis. Little Gloria's tonsils, her sore throats, her "glands," her bowel movements, were of constant concern

to the nurse, even though frequently summoned doctors found nothing to worry about. She repeatedly urged Mrs. Vanderbilt to hire bodyguards for the baby, convinced that kidnappers were lurking everywhere. She never left little Gloria's side, sleeping in the same room with the child from the day she was hired, even declining to return to the United States when she received word that her own mother was dying.

Grandmother Morgan, a devout Catholic, had always been outspoken in her criticism of her daughter's loose lifestyle. When mother and daughter were together, the air was heavy with tension, with bickering and angry battles that flared without a moment's notice. Nurse Keislich had always kept her feelings to herself, letting them boil inside as she watched the baby's mother come home intoxicated in the early hours of the morning after an all-night party, or set out to a foreign country and leave her child for weeks, for months, at a time. Both Grandmother Morgan and Nurse Keislich, however, hated Prince Hohenlohe and were not reticent in letting their feelings be known.

Grandmother Morgan hated the prince because she was sure that all he wanted was to live off her granddaughter's inheritance. She convinced herself that he was quite intent on murdering the child to get her money. This she would tell to anyone who would listen—Gloria, Nurse Keislich, little Gloria, and the prince himself. "She objected to my marrying Mrs. Vanderbilt on the ground that I had no fortune to speak of," Prince Hohenlohe recalled, "and she accused me of all sorts of things, wanting to murder the child and such ridiculous things as that."[64]

Nurse Keislich hated Prince Hohenlohe because she was sure that if he married Mrs. Vanderbilt, they would go to live in the family castle in Bavaria and take her precious little one with them, leaving her alone. She told little Gloria about the castle in tales that embodied all of a child's primal fears—it was set deep in a dark forest, with long winding halls where little children got lost, and all of the servants were horrible dwarfs. If her mother married the prince, she, faithful Dodo, would be sent away and would never see little Gloria again. They would be separated forever. Little Gloria would be sent to a convent where all sorts of unspeakable things would happen.

It was therefore not surprising that little Gloria came to fear her mother's lover. The prince never spoke to her. He wore a monocle and

walked, little Gloria thought, "as though a rod had been rammed up his behind. Every time I saw him was scarier than the time before."[65]

On a crisp fall day in Paris in October 1928, four-year-old Gloria was preparing to go outside with her nurse. When her mother saw that she was wearing her new white kid gloves, she asked Nurse Keislich to give her an older pair of gloves for play. Little Gloria started to cry, insisting that she wanted to wear her brand-new gloves.

Hearing little Gloria crying, Grandmother Morgan rushed into the room, picking up her grandchild and putting her on her lap, telling her that she could wear whatever she wanted.

"Your mother would be in the streets were it not for you, my darling, my poor little orphan," she cooed to the child. "But I will protect you. As long as I live no one will take a penny of yours."

Grandmother Morgan, her dyed red curls shaking, her eyes narrow slits under her penciled-in half-moon eyebrows, her mouth spitting venom, turned to her daughter. "I know what you and that Boche are trying to do!" she yelled. "You are trying to kill this poor, unfortunate child! Oh, yes! I know! It will be an accident. A little push down the stairs—seeing that she is left in a draft—a million ways! and you, Gloria, will weep like a Magdalen, but just the same, the Vanderbilt millions will be yours!"[66]

Gloria was shocked. She told Nurse Keislich to take the little girl out to play, and then cornered her mother, who had thrown herself on a bed, sobbing.

"Mamma, once and for all, I want you to understand that my daughter is *not* an orphan. I don't know what you are trying to do. You are doing everything you can to alienate my daughter from me. Your insane idea that I am deliberately planning to murder my child is bad enough. But the inhuman, horrible thing is that you dare to frighten little Gloria with your evil mind. I see you now for the first time. And I realize *now* that it is not love for what you term 'that poor, unfortunate orphan,' but the Vanderbilt money which goes with her that is behind all this. You must be sick in your mind."[67]

The very next day Gloria rented a house in Paris just big enough for herself and her daughter and Nurse Keislich. She found a room for her mother at a hotel that was close to the house, and she and twin sister

Thelma agreed to give Mamma an allowance of $500 a month. All of Grandmother Morgan's children—Gloria; Thelma; their older sister, Consuelo; and their brother, Harry—gathered to break the news to her, and to warn her that if she did not behave herself, they would have her committed to an asylum. Grandmother Morgan did not take the announcement well. Little Gloria watched the spectacle of her hysterical grandmother wringing her hands as she "ran around the room hitting her head against the walls like a trapped bird."[68]

"If you think you can put me out of the house, and that I am never going to live with you," she swore to Gloria, seething in fury, *"I will see you never live with your child either! I'll drag you through every bit of mud that lies in the streets!"*[69]

Grandmother Morgan returned to the United States and rented a tiny one-room apartment on the tenth floor of the Hotel Fourteen in New York City.[70] The only thing she had to occupy her time was visiting her friend George Wickersham, Gloria's attorney, and reporting to him about her daughter's wild escapades in Europe. Her crusade against her daughter became an obsession.

When she ran out of shocking news to tell him, she arranged for more to come to her.

Nurse Keislich told little Gloria that her grandmother wanted her to send a postcard. "This is what your Naney wants you to write her," she said, leaning over the little girl. "Under 'Dear Naney,' write 'I miss you.' "

Gloria did as she was told.

"Very good darling. Now under that put 'My Mother is a rare beast.' "[71]

Gloria did as she was told.

Dear Naney—
My mother said not to write but I am not paying any attention to her. She is a rare bease—. Well, I will be in dear old New York soon. Love and kisses, Naney dear,

Gloria.[72]

Such postcards as Grandmother Morgan wished to receive began to arrive regularly at her apartment door.

Dear Naney
I love you so much and I am longing to see you. I am very unhappy
in England. . . . Momey promised me that she would take me to
a pantomime and never did so Dodo took me to see Dick Whitting-
ton and his cat. . . .[73]

Dear Naney
My mother is so bad to me I wish I could run away to New York
to you. I am very unlucky girl. . . .[74]

Dear Naney
I love you so much and I love the cards that you sent me my mother
was in Paris enjoying herself while poor me was unhappy in Englan.
My cold is better and my temp as gone to normal and the docot
let me get up for a little while. good by Naney dear

love Gloria[75]

Naney dear
We are moving again oh what a life. Well I shall soon be in my
own country in 20 days and I am thrilled about it. . . .[76]

Grandmother Morgan immediately brought each postcard to Cad-
walader, Wickersham and Taft. Look! Look! she said to George Wicker-
sham. See what I have been telling you! My poor, poor little
granddaughter! What will become of her!

Grandmother Morgan's campaign against her daughter was suc-
cessful. Wickersham sent Gloria a letter explaining that Surrogate Foley
had remarked to him, after looking over her expense report, that "you
were living at a pretty extravagant rate, and that he thought you would
be much better off, if you were living in this country."[77] Not willing
quite yet to give up the life she was leading, Gloria negotiated a compro-
mise: She would stay in Europe with her child for one more year and
then return to the United States, entering her daughter in Miss Chapin's
School.

Having accomplished the first step of her revenge against her
daughter by getting her to bring little Gloria back to the United States,
Grandmother Morgan began Step Two: to win as an ally Reginald
Vanderbilt's favorite sister, Gertrude Vanderbilt Whitney.

* * *

When Harry Whitney, the boy who lived in the mansion across the street from the Cornelius Vanderbilts, had been courting Gertrude Vanderbilt, he had told her, "You will always have a good time because even when your looks give out you will still be a great heiress."[78] He had been right.

The young girl who had written in her diary of her dream of having, when she married, a "very small" house, "homelike in the true sense of the word, with one delightful library with a divan and easy chairs,"[79] moved, when she married Harry Whitney, from the block-long mansion in which she had grown up to the Whitney mansion across the street, 871 Fifth Avenue. "The house I have stepped into after my marriage was furnished, complete and full. Beautiful Renaissance tapestries. Furniture of all the Louis. Old French and Italian paintings hung on the walls. It was the very same atmosphere in which I had been brought up, the very same surroundings." She had moved "some fifty feet from my father's house into my husband's. . . ."[80]

Harry and Gertrude bought a "summer cottage" on Bellevue Avenue in Newport, separated from Alva Belmont's Marble House only by Mrs. Astor's Beechwood. And Harry inherited from his father an eighty-five-thousand-acre camp in the Adirondacks, as well as Wheatley Hills, a Venetian palace surrounded by eight hundred acres in Old Westbury, Long Island.

Soon after their marriage, Harry's father had warned his son to be careful not to become a dilettante. It was a fair warning. "Your fears about my becoming a 'dilettante,' " Harry responded, "amuse me. I average about eight miles a day on a bicycle and two hours of golf—running this place, horse back rides, and some law thrown in."[81] Dean Keener of Columbia Law School thought Harry "one of the most brilliant students he had known,"[82] but Harry lost all interest in his legal studies, which were cutting into the time he wished to devote to polo and social activities, and he never graduated from Columbia or took the bar examination.[83]

After several years of marriage, Gertrude analyzed her husband in her journal. "His nature is a strong one and given to many impulses and combined with a brain of unusual activity he might live to do great things. However these very qualities form as well his greatest temptation. . . . Wherever he goes his boyishness, his charm, his brightness, his

cleverness insure him a warm reception. . . . His brain is marvelously quick and with discipline could yet do wonders. He has known no discipline. Life has given him all he has asked of it from the beginning. Indulgent parents provided for every wish before it was uttered; it is most wonderful of all that he retains any strength."[84] The same could have been said of Gertrude herself; having been raised as she was, it was a wonder that she retained any strength or discipline. She remained accustomed to having everything done for her. When Gertrude learned she was pregnant, she found herself "not a bit rejoiced as I should be. I don't want to be tied down but Mama has promised to take care of it, so we will be off again soon, I hope. . . ."[85]

As Harry devoted himself to business ventures, to horse racing, to polo, to his 175-foot yacht, the *Whileaway,* to his new hydroplane, to his private railroad car, the *Wanderer,* Gertrude became increasingly interested in art, in drawing, in clay modeling, in sculpting. Gertrude's interest in art seemed to Harry nothing more than an engrossing hobby, just like his interests in polo, horses, and hunting. As their interests diverged, so too did their interest in each other.

On December 4, 1913, after three children and seventeen years of marriage, Gertrude carefully composed a letter to Harry:

> It seems very obvious that we are drifting further and further apart and that the chances of our coming together are growing remote. I say this for several reasons—there is no inclination on your part to have explanations which might lead to understanding. Also our mutual indifference to the pursuits and pleasure of the other is leading us constantly to have less even to talk of and forms no bond on which we might rely to bridge our difficult moments.
>
> Of course for a very long time we have done absolutely nothing together because we wanted to. You perhaps do not realize this. We eat together as rarely as possible and from habit. We *never* go out together—perhaps because I can't do the things you want to do, perhaps because you don't want to do those I can. However this is only to show you how completely our lives are separated, not to blame you or myself. Every one of your pleasures (I don't think I exaggerate when

I say this, just think it over) is disconnected from me. Most of mine from you. You are dependent on me for nothing. Our occupations are separate, our pleasures are not the same, all the things I think essential you look down on, I look down on you because you have thrown away most all the things I admired you for. I don't trust you, you talk to your friends of the things I don't want talked of. You are a hypocrite, which I don't admire. . . .

There is one very important phase of it all that I have not yet spoken of: that is, women in your life and men in mine. I suppose that is the hardest thing of all to be honest about or to understand. You have several times behaved pretty rottenly, but I think, at least you have not been terribly open about these matters, so that they were very much discussed. But you are now behaving differently. I object to this. There is no use, I suppose, my objecting to your caring for someone else, it would simply be ludicrous, but I do object to several things which I will state. I have never been seen around all the time with *one* person. I have never been talked about with *one* person. . . .

I suppose all this is very badly expressed. It's hard to put these sort of sentiments into words. I have been really desperately unhappy, it's not a mood or a passing idea and if you will let yourself face the truth I think you will realize the truth of what I say. It makes me sick, all this superficial sort of game, and I am not going to throw the rest of my life away. I am going to face things and understand as much as I can, and then build on a solid foundation for I am tired of the sand that crumbles and will not hold my poor little house.[86]

Gertrude folded her letter to Harry and sealed it, but never addressed it and never sent it, hiding it away with her journals.

The two continued to live their own lives while living together. Gertrude's wealth allowed her to be two separate people, leading the life of a society matron in her mansion at 871 Fifth Avenue, and then— dressed in silk gauze trousers and high heels, her lips colored cranberry, her hair russet, her long nails garnet, with rings on her fingers, bracelets

on her wrists, and pearls around her neck—the life of a Bohemian artist at the art studio she had built at 19 MacDougal Alley in Greenwich Village. There she worked at her sculptures and helped promising artists who needed a patron.[87]

Grandmother Morgan knew just what she was doing in seeking Gertrude Vanderbilt Whitney as an ally. When Harry Whitney died of pneumonia at the age of fifty-eight on October 28, 1930, he left an estate of $72 million. Tall, thin, gaunt, her cheeks sunken, her face lined and hardened from years of chain smoking, Gertrude had lost her beauty, but that was all right. When Harry's estate was added to Gertrude's own fortune, she was, at the age of fifty-five, as Harry had predicted when courting her, a great heiress. In 1932, in the depths of the Depression, Gertrude's annual income included $797,000 from stock dividends, $121,000 from interest on tax-exempt bonds, and $175,000 from her trust fund. Along with income taxes of $300,000, her expenses included $200,000 to maintain her Old Westbury estate, $30,000 for her Newport home, $90,000 for her Fifth Avenue mansion, $13,500 for her garage on East 66th Street, $160,000 to maintain her studio and the Whitney Museum she had established, $20,000 for her studio in Paris, and personal expenses of $160,120.[88] Here was just the woman Grandmother Morgan knew could help her campaign against her daughter.

Gertrude Whitney had never been close to little Gloria. In fact, during the first eight years of her niece's life, she had never even sent her a birthday card or Christmas toy, and in her own recollection had seen her only half a dozen times. Gertrude did not really believe the tales of neglect with which Grandmother Morgan regaled her. But when the eight-year-old was brought back to the United States, Gertrude saw for herself a pale, thin little girl who stammered, whose facial muscles twitched, who seemed high-strung and cried easily. Maybe there was some truth to the wild stories Mrs. Morgan had been telling her. It wouldn't hurt to have little Gloria and Nurse Keislich come to Old Westbury to live with her for a little while. After all, over one hundred employees took care of the estate, which included her mansion, an art studio that looked like a Roman palace, the houses of her two daughters and son, stables with sixty-three stalls, livestock, tennis courts, swimming pools, exotic birds that roamed the gardens, an indoor riding ring, and an outdoor polo field. An extra guest or two would be no problem.

In June 1932, little Gloria had her tonsils taken out. When she was back at the Sherry-Netherland Hotel with her mother, who was about to set sail for Europe, Gertrude Whitney stopped by. She told Gloria Vanderbilt that she had spoken with the child's doctors and that both of them felt that it would do the child a world of good to spend the summer in the fresh air and sunshine.

"Why not let me take her into the country at Old Westbury?" Gertrude asked.

"That is very kind of you, Gertrude," Gloria Vanderbilt said, and directed Nurse Keislich to pack up the little girl's bags once again.[89]

When Gloria Vanderbilt returned from Europe in August and picked up her daughter at the train station, she found her in radiant good health. Gloria ordered the chauffeur to take them to the home she had rented on Seventy-second Street.

"Mrs. Vanderbilt," Nurse Keislich interrupted, "the plans are to go to Mrs. Whitney's."

"Certainly not," Gloria said. "We are going home."[90]

Soon after they arrived, the phone rang. It was Gertrude Whitney calling from her Fifth Avenue mansion, asking Gloria if Dr. St. Lawrence had called yet. She explained that the doctor was concerned about little Gloria's health. The next day, Gloria went to see Dr. St. Lawrence, who was a close friend of Gertrude Whitney's and was the doctor for all her grandchildren. Dr. St. Lawrence explained that the child was not in good health and that a winter spent in the city would be detrimental to her. What Dr. St. Lawrence did not mention was that his recommendation was colored by Gertrude Whitney's decision to keep little Gloria with her. Like Grandmother Morgan, Gertrude Whitney had concluded that Gloria Vanderbilt was not a fit mother. She would have to continue to look after her deceased brother's poor young daughter.

Gloria went from the doctor's office to Gertrude's home at 871 Fifth Avenue.

"Now don't worry, Gloria," Gertrude comforted her in her low, slow voice. "I'm sure the little one will be all right in time, and she'll surely be well enough to come to you in the spring. She can attend Greenvale School with my grandchildren and you can visit her. I know it's hard to have to be parted from your little girl, but this is the right thing and you *must* follow Dr. St. Lawrence's advice, dear."[91]

Gloria agreed, and again sent her daughter with Nurse Keislich to live with Gertrude Whitney at Old Westbury, while she continued to roam the night spots of the world, living off the income from her daughter's trust fund.

With little Gloria spending so much time with her aunt Gertrude, the obvious question was raised by Surrogate Foley: Why should Gloria Vanderbilt receive an allowance from her child's trust fund when the child was being cared for by Gertrude Whitney? He reduced Gloria Vanderbilt's allowance from $48,000 to $9,000 a year, with all of the child's expenses to be paid directly by Mr. Wickersham.

Gloria Vanderbilt only now began to perceive what was happening. She had no freedom, no life of her own. She could not marry whom she wanted; she could not go where she pleased; she could not live as she desired; she had no money of her own. She was nothing but the guardian of her daughter. "Nothing in my household ever moved but they did so first on the foundations of Gloria's desires or necessities. If it was a need for the car, she was given it and I used a taxi. . . . Whatever the demand of hers, she was given it by prior right—nothing belonged to me but the governing of her time and years."[92] Gloria reflected on what had happened: "I bore my little girl—she was bone of my bone and flesh of my flesh; I had gone down into the depths for her—and yet it seemed at times she never belonged to me. She belonged to the Vanderbilt name and the Vanderbilt money."[93]

Gloria Vanderbilt now realized just how important it was for her daughter to live with her, and tried to get her back from Gertrude Whitney. Gertrude delayed, thinking of more reasons why her niece should continue staying with her for a little while longer. Grandmother Morgan, of course, supported Gertrude Whitney.

"Gloria," Grandmother Morgan said to her daughter, "I want to talk to you and I want you to listen carefully to what I have to say. While you have been kind to me, no one knows how bitter it is to live on the charity of others. When your daughter is twenty-one you will have to live on hers, and I am telling you, you won't like it! If you will permit her to live with Mrs. Whitney, I am informed . . . I mean I feel sure Mrs. Whitney will support you for life, if you will consent to this."

"You must be mad to say such a thing to me!" Gloria responded in shock. "I am not selling my child!"

"You use such big words," Grandmother Morgan replied.[94]

She began to walk toward the door.

"Sell is not so big, Mamma—it has only four letters."[95]

"You had better reconsider, or you will be sorry."[96]

Gloria's current lover, A. C. Blumenthal, a movie theater tycoon, took her to his lawyer, Nathan Burkan. Burkan was astounded that Gloria, who had been a minor when her husband, Reginald Vanderbilt, died, had never in the intervening years been appointed guardian of her child. He began drafting the court papers needed for her to be appointed the sole guardian of her child and the joint guardian of her property, as a means to regain custody of little Gloria and some reasonable control over the trust fund.

Gloria told Mr. Burkan she would like to go to court with him when he filed the papers as she had never been inside a courthouse and was curious to see what it was like. "The less you see of courts the better," he advised her, but agreed that she could come along if she insisted.[97]

On July 3, 1934, Gloria sat in the courtroom while her attorney explained the application to Surrogate Foley. When he had finished, a lawyer in the back of the crowded courtroom rose. "I object to the petition!" he called out to the surrogate.

Mr. Burkan spun around. "On what grounds?" he asked incredulously.

"On the grounds that Mrs. Vanderbilt is unfit."[98]

"Court adjourned," Surrogate Foley ordered, banging his gavel above the sudden turmoil in the courtroom. "I will hear this case in my chambers after lunch."[99]

As she ate lunch with Nathan Burkan at a small restaurant near the courthouse, Gloria was baffled.

"Translate this to me," she said. "In plain words, what does this accusation mean?"

"In plain words, the word 'unfit' in this connection alleges that the woman to whom it is applied is unmoral and immoral."[100]

After lunch, back in Surrogate Foley's chambers behind the courtroom, Mr. Burkan was indignant. "I must refuse, Your Honor, to proceed in this case unless I am informed who is bringing the complaint objecting to the guardianship."

Well, who was it? the judge asked Walter Dunnington, the lawyer who had stood up in the back of the courtroom that morning.

"Does Mrs. Vanderbilt insist on knowing?" he hesitantly asked.

"Mrs. Vanderbilt insists on knowing," Mr. Burkan replied.

"The Complainant is Mrs. Vanderbilt's own mother, Mrs. Morgan."[101]

From the courthouse, Gloria rushed to her mother's apartment. The desk clerk told her that Mrs. Morgan was not in. When Gloria insisted on being admitted to her apartment, the clerk called the manager.

"I'm terribly sorry, Mrs. Vanderbilt," the manager told her, "but Mrs. Morgan's instructions are that if you even make an attempt to get into the elevator, I am to send for the police and have you ejected."[102]

This was getting more bizarre by the minute. Gloria left a message at the desk for her mother to contact her immediately.

Soon after Gloria reached home, her mother was knocking at the door. She stepped inside and tried to kiss her daughter.

"Don't, Mamma, I can't bear that now."

Mamma looked surprised.

"Why, why, Mamma? Why have you done this to me?"[103]

Her mother answered matter-of-factly, "What I have done, I have done only for the good of the child."

Gloria was too shocked to be angry. She was almost speechless.

"For the child's good, Mamma? How can it be for the child's good if you destroy her mother? Leave me, Mamma! You must be mad; you don't know what you're doing!"

Grandmother Morgan stood by the door, with one hand on the doorknob. "Gloria," she said calmly, "I am advising you not to fight this. I have behind me money, political influence, and the Vanderbilt family. I am telling you this for your own good. If you try to fight it, you'll regret it."[104]

Confused, Gloria hurried to Gertrude Whitney's mansion on Fifth Avenue. She ran past the butler who opened the front door, through the hall, and up the marble stairs to the drawing room, its walls hung with yellow damask and gold taffeta curtains.

"Gertrude," she blurted, out of breath, "do you know what happened today in Judge Foley's court?"

"No," Gertrude said. "What happened? Sit down and tell me."

As Gloria told her, she began to have the sinking feeling that Gertrude knew it all already.

"I'm going to ask you something that may sound to you impertinent. I have just left my mother. She told me that she will oppose my guardianship of Gloria; and she said that behind her were money, political influence, and the Vanderbilt family. You know my mother says she has no money except what Thelma and I allow her, so someone is behind this case. Is it you?"

Gertrude answered, and her voice to Gloria "acquired the steel precision of a saw blade, controlled and cutting." Gertrude said, "Gloria, if you were not so upset I would ask you to leave this house. I am going to answer that directly. And the answer is emphatically no. I have always loved you. My mother loved you. I am horrified. Why, why should your mother want to do this to you?"

Gloria realized she must have been mistaken about Gertrude.

Just then, the butler came into the drawing room.

"Mrs. Morgan is downstairs," he announced.

"That dreadful woman," Gertrude said, touching Gloria's arm. "I can't see her now. Go down, Gloria. Tell her you have been waiting for me, and that I'm not here. I'll get in touch with you later."[105]

Gloria walked out to the hall where her mother was waiting.

"Mamma, please come home quietly with me. You are causing this family quite enough trouble. Don't make it more difficult for me. I have been waiting for Mrs. Whitney; she is not here."[106]

Mother and daughter together left 871 Fifth Avenue.

In the face of this family crisis, Gloria had summoned her older sister, Consuelo, and twin sister, Thelma, both of whom immediately returned from Europe. (Before leaving England, Thelma had asked her best friend, Wallis Simpson, to take care of the Prince of Wales for the several weeks she would be gone. "You look after him for me while I'm away. See that he does not get into any mischief."[107]) Both tried reasoning with their mother.

"Mothers don't do to their children what you are doing—blacken their characters before the world," Thelma told Mamma. "Is it for money, or for hatred you are attacking Gloria? From the time she

married Reggie Vanderbilt you have lived with her, until lately. . . . She has never failed you in anything."

Gloria herself was convinced that her mother's motive in opposing her guardianship of her daughter was that "she wants it herself with the $48,000 a year," and that the reason she was doing it "was purely money—that she was money mad—her god was money—and that it had always been, and it was what made the trouble."[108]

Mamma, wringing her hands and weeping, stared at Thelma. "You have not been aware of the neglect that has been going on! This unfortunate child has been dying and Gloria has paid no attention to it!"

"That is a lie, Mamma," Thelma said, "made of whole cloth to serve some end of yours—what we do not know; but we will soon find out. The child has never been alone from the day she was born without yourself or Gloria being with her—once for six weeks in her whole life in Glion with Keislich. The child has always come first in Gloria's life—no one needs to be told that."[109]

Sister Consuelo chimed in. "As for neglect, you never considered it neglect when you left your children scattered over Europe. For months at a time you never went near Thelma or Gloria when they were little, and at sixteen years you left them alone in New York City and never came near them. . . . Neglect! Talk to me of money being the basis of this action but not of neglect."[110]

"Are you going against me, too?" Mamma wailed to Consuelo and Thelma.

"If you ask me am I on your side or Gloria's," Thelma answered, "I have only to say I am on the right side. I don't have to tell you which that is."

"You be careful, Thelma, that I don't take your child away!"

"Luckily, Mamma, my child has a father alive, and if there is any complaint it will come from him. Remember, my child has no rich aunt in England. What you do not seem to realize is that if you proceed with this case you will put a blot on this child whom you profess to love and will ruin your own."

"I can never face my God if I don't do this," Mamma whispered, dramatically clutching her rosary.[111]

* * *

A flurry of conferences were held between Gloria Vanderbilt's attorneys and Gertrude Vanderbilt Whitney's attorneys to try to resolve the dilemma of how a ten-year-old girl would be raised. With Surrogate Foley's blessing, they reached an understanding: Little Gloria would stay with her aunt Gertrude Whitney during the next school year, during which time her mother could see her any time she wanted; she would stay with her mother for a month during her summer vacation; and the next year the matter would be reconsidered by Surrogate Foley.

In September 1934, Gloria Vanderbilt insisted that, pursuant to the terms of this understanding, her daughter return from Gertrude's estate at Old Westbury to stay with her in New York City for a few days. Aunt Gertrude explained this to her niece.

"Oh, I can't go and stay with my mother," little Gloria said. "I don't want to go. I don't want to see her. I don't feel *happy* with her."

"Gloria, you *will* be back by the end of the week."

"Are you sure?"

"Yes, I am sure," Aunt Gertrude assured her.

"Are you sure?" little Gloria asked again and again, pleading with her aunt not to make her go.[112]

Finally, the young girl consented, and Nurse Keislich packed their bags for the short visit to the city.

At 10:30 on the dreary morning of Friday, September 21, 1934, Gloria Vanderbilt walked into her daughter's bedroom to tell Nurse Keislich the good news; she had just received word that she could take possession of a Long Island house right away. They would move in within the next day or two. If little Gloria needed the fresh air of the country, well, then, so be it, she would live in the countryside of Long Island, close to the school her daughter was attending. That way, there would be no reason her daughter could not live with her always.

As she spoke, Gloria noticed that the floor of the bedroom was littered with shredded wheat and toast crumbs for Gloria's puppy, Gypsy-Mitzie. "This is like a pigpen," Gloria scolded Nurse Keislich.

"I will sweep it up," Keislich snapped, fetching a carpet sweeper and tearing back and forth in silent fury.[113]

"You'll have to learn a thing or two about neatness," Gloria Vanderbilt reprimanded her, "because starting tomorrow you'll be living with me. . . . Little Gloria is not going back to Mrs. Whitney's."[114]

Little Gloria that morning had been playing a game she called "Invisible," sneaking around the house and spying on whoever was there. She hid outside her aunt Consuelo's bedroom, where her mother and her aunt were playing bezique.

"The first thing you must do," little Gloria had heard Consuelo tell her mother, "and the sooner the better, is get rid of the nurse. A German Fraülein is what she needs!"

"Maybe Friedel could help. I'm sure he would recommend someone."

"Why don't you call him? Now!"

"Let's see," Gloria heard her mother say. "In Germany it's six hours ahead . . . so now it must be . . ."[115]

Not waiting to hear the rest, little Gloria raced up the stairs to her beloved nurse.

Nurse Keislich comforted the sobbing child.

"When am I going to see Auntie Ger?" little Gloria pleaded.

"Soon," her nurse told her. "Soon."[116]

Nurse Keislich had a plan. They would pretend nothing was wrong. Together they would head for the park, but instead of going to the park, they would go straight to Mrs. Whitney's. She would know what to do. She would protect them.

Together they softly said the prayer Nurse Keislich had taught Gloria years before. "When you want something to happen, you say, 'Little Flower at this hour show me Thy power.' "[117]

Gloria picked up her puppy and her roller skates and the two tiptoed down the hall.

"Where are you going?" Gloria Vanderbilt called to the two conspirators as they passed Consuelo's bedroom.

"Just out for a bit to the park," Nurse Keislich told her.

"But it's about to rain."

"Just for a minute to get some air. Gloria hasn't been out all day."

"Have a good time," Gloria told them.[118]

Nurse Keislich directed Beesley, the chauffeur, to take them to the park.

On the way, on cue, little Gloria began crying as if in great pain.

"Take us to Larrimore's drugstore," Nurse Keislich ordered the chauffeur.

There, she went into the phone booth and called Gertrude Whitney.

"Very sick," she said to the chauffeur when she got back in the automobile. "Very sick. We're to go down to Mrs. Whitney's studio in Greenwich Village. Hurry, Beesley, hurry hurry . . . very very sick."[119]

Gloria and Consuelo had spent the afternoon playing bezique, unaware of the coming of evening.

"Good gracious, look at the time," Gloria said to her sister at six o'clock. "I wonder where Gloria is."

"No doubt she has come in with the nurse and they have gone directly upstairs."[120]

Gloria walked up to her daughter's room to see if she was there. In her room was the butler, looking through her daughter's open bureau drawer.

"What are you doing here?" Gloria demanded.

"The chauffeur is downstairs, Madam," he replied. "They have sent for Miss Gloria's clock."

Gloria ran down the stairs. Beesley, the chauffeur, was standing by the door.

"What have you done with Miss Gloria?"

"She is at Mrs. Whitney's. She's very sick."

"What do you mean by taking her to Mrs. Whitney's?" Gloria shouted at him. "Why didn't you bring her to her own home?"

But Beesley was obviously not the culprit. Gloria called for her sister Consuelo.

"Put on your hat and coat quickly. We are going to Gertrude Whitney's."[121]

Gertrude was standing in the imposing, Renaissance-style library of her Fifth Avenue mansion. She looked worried.

"This is horrible, Gloria. I can't understand the child, but she is in hysterics. The child was in the park when she became hysterical and Keislich phoned me asking if she could bring the child here. We could not quiet her, so I sent for Doctor Craig—he has installed a nurse; she is with her now."

Gloria sharply interrupted her. "I want to see my child at once."

"Of course," Gertrude answered.

She led Gloria to the bedroom where her daughter was being examined.

When little Gloria caught sight of her mother in the doorway, she shrieked in horror, "For God's sake, don't let that woman come near me. Don't let her come near, she wants to kill me!"

Screaming at the top of her lungs, the little girl ran to a window. "If she comes near me, I'll jump."[122]

"Hush!" Consuelo hissed at the child. "It's your mother!"

Little Gloria had never liked her aunt Consuelo, with her sunken cheeks and birdlike beak of a nose: "Her face never had any light in it when she looked at me or spoke to me—ever." Aunt Consuelo, "whom I feared more than anyone else,"[123] approached the child.

Little Gloria screamed, cringing as if about to be hit. "Don't let them come near me—they are both going to kill me!"[124]

Dr. Craig, his nurse, and Nurse Keislich, herself babbling hysterically, failed to calm the little girl.

"Be quiet—at once!" Gloria Vanderbilt ordered Nurse Keislich. "I will never forgive you for what you did. Get out of this room."

"What is the matter?" she asked her daughter, after her nurse stormed out.

Gloria stared at her mother, and then raced to Aunt Gertrude, throwing her arms around Gertrude's waist and holding on to her with all her might.

"Take her away. Don't let her hurt me. I'm frightened. . . . Oh, don't let her take me. . . . Don't let her come near me. She's going to kill me!"

Little Gloria would not let go of her aunt Gertrude. "I hate her. I hate her," she sobbed. "Don't let her come near me. Don't let her take me."[125]

There was nothing to do but leave the little girl alone for a while. Now Gloria Vanderbilt wanted to determine what that hateful Nurse Keislich knew about all this.

"Ask her to come to your sitting room," Gloria Vanderbilt instructed Gertrude Whitney. "I want to question her in your presence."

When Nurse Keislich appeared, Gloria demanded, "Nurse, what happened? How did you come to phone Mrs. Whitney and not me when my child became hysterical, as you say?"

"No wonder the child is in this condition in that hole you've put her in!" Nurse Keislich responded.

"What hole are you referring to?"

A flight of words, half sentences, half thoughts, a pent-up torrent of accusations came tumbling out, spilling into each other, incomplete, incoherent, but decidedly vicious, hostile. Nurse Keislich complained of the type of house Mrs. Vanderbilt was living in, a hovel, a hole she called it, of the impropriety of Mrs. Vanderbilt's guests, of the fact that Mrs. Vanderbilt did not want little Gloria to have a puppy, of her complaint that there were a few pieces of shredded wheat on the floor of Gloria's bedroom.

"It was not a few pieces, the whole room was littered with Shredded Wheat and pieces of bread. It looked like a pigsty. I am not going to have my daughter brought up in a place that looks like that. You should be neater."

"Ah, what I could say!" Nurse Keislich sneered. "And what I am going to say!"

"You can say the rest in court!" Gloria barked, summarily dismissing her.[126]

"There was nothing left for me to do," Gloria told Gertrude, after Nurse Keislich had left the room.

"You were quite right; of course there was nothing else to do. She will leave my house this evening."

"I will come back for Gloria in the morning, Gertrude."

"Yes, do so—she will be quiet by then."[127]

Aunt Gertrude, Grandmother Morgan, and Nurse Keislich went into little Gloria's room the next morning and sat around her bed. Gertrude told her that they would all drive out to Old Westbury that day.

"But you'll have to see your mother before you go," Grandmother Morgan told her.

"Do I have to? Do I really have to? Do I?"

"Oh, only for a minute, Gloria," Aunt Gertrude explained.

"Yes, Little One," Grandmother Morgan assured her, "only for a minute, and when you do—remember to . . . well, you know. . . . You don't have to say much. . . . Just pretend nothing happened. . . . You know what I mean. . . ."[128]

Gloria and her sister Consuelo returned to the Whitney mansion later in the morning. In the library, they sat talking with Gertrude over a glass of sherry.

Soon Gertrude Whitney's private maid, Hortense, knocked on little Gloria's bedroom door.

"Mrs. Vanderbilt is here now," Hortense told Nurse Keislich. "You are to go down, Mrs. Whitney said, and wait in the car with Mrs. Morgan. Miss Gloria will meet you in the car quite soon."[129]

Nurse Keislich followed her orders and went down the back stairs, while little Gloria followed Hortense down the marble corridor and the wide white marble stairs to the library. Gloria Vanderbilt and Consuelo, seated on the sofa in front of the fire, made a space for little Gloria between them. As the ladies chatted, Gloria climbed down on the floor to play with her puppy.

"Gertrude, don't you think Gloria had better go and get her coat on?" Gloria Vanderbilt said after a while.

"Oh, yes, Mummy," the little girl answered. "I won't be long. May I be excused?" she asked, staring at the fire.[130]

"Of course," said Gertrude.

Slowly, carefully, precisely, little Gloria, holding her puppy, walked out of the library and into the great hall, where Hortense met her.

"Follow me," the maid instructed, leading Gloria to the elevator. Hortense opened the door of the elevator and helped Gloria inside.

In the library the three women had another glass of sherry while they waited for Gloria to return with her coat. After what seemed like an unusually long time, Gloria Vanderbilt turned to Gertrude Whitney.

"Gertrude, dear, don't you think it would be better if you sent for Gloria? She's probably dawdling, and, really, lunch will be ruined."[131]

Gertrude rose from her chair. No longer the friendly hostess, she stared at her sister-in-law with what Gloria perceived as a "faint slow smile of triumph."

"I'm very sorry, Gloria," she stated, "but little Gloria is halfway to Westbury by now. I'm not going to let you have her."[132]

Gloria sat horrified, stunned, as the implications of what had happened became clear.

This was war. War over her little girl. The battle lines were drawn.

"All your money, all your position, all the power of your influ-

ence—use it," the dumbfounded Gloria finally uttered under her breath. "You will find it is not strong enough to kidnap a child from its mother."[133]

That afternoon, court papers were served on Gertrude Vanderbilt Whitney:

TO MRS. HARRY PAYNE WHITNEY

Greeting:
We command you that you have the body of Gloria Laura Morgan Vanderbilt by you imprisoned and detained, as it is said, together with the time and cause of such imprisonment and detention by whatsoever name the said Gloria Laura Morgan Vanderbilt is called or charged, before Honorable John F. Carew. . . .[134]

"I want my baby," Gloria Vanderbilt told the press. "I know Mrs. Whitney is one of the richest women in the world . . . but I'll fight to the finish for my child."[135]

A court appearance was set for Tuesday, September 25, 1934.

3.

Safe at Wheatley Hills in Old Westbury, little Gloria was given the big bedroom that had been Harry Whitney's, next to her aunt Gertrude's. Nurse Keislich was stationed in the room across the hall, and Grandmother Morgan in a guest room down the hall. "Inside men" and "outside men" guarded the little girl day and night.

Grandmother Morgan realized that the judge would have to be convinced that little Gloria loved her aunt, that Aunt Gertrude was like a mother to the child.

"Listen to me, Little One, you must show your Aunt Gertrude how much you love her. You must hug her more and kiss her a lot—you must show your Aunt Gertrude—"

"But how can I love her when I don't know her? I don't know her yet—"

"Hush, hush, Little One, what kind of talk is that? You do know her, you *do*, and if you don't know her yet, you will know her soon, very soon. So you see, darling—show her, hug her a lot and kiss her a lot and tell her how much you love her."[136]

So little Gloria entered a world of acting, of pretending, of making believe to everyone around her that it was dear Aunt Gertrude whom she loved so much and from whom she could not bear to be parted, while in truth it was Big Elephant, Dodo, her beloved Nurse Keislich, who had been with her since birth and had become her real mother, the one constant in a tumultuous life.

"Call your Aunt Gertrude 'Auntie Ger,'" Grandmother Morgan counseled Gloria, "to show her how much you love her. Show more excitement—a lot more, Little One—a lot more excitement when your Auntie Ger arrives here on Fridays. Keep looking out the window waiting to see her car come in the driveway, then run down the stairs as fast as you can and throw yourself into her arms the second she comes in the front door. You know what I mean, Little One. You know what your Naney means. Do it next time—show your little Naney."

Gloria did. "I got myself all keyed up looking out that window into the circle of the driveway, and when finally the car came in sight, I was raring to go. Down the stairs I went lickety-split, just like a racehorse at the sound of the bell. I almost knocked Aunt Gertrude—I mean Auntie Ger—over."

"Don't overdo it, Little One, don't overdo it," her grandmother told her later, but she was obviously pleased with her performance.[137]

The trial of the "Matter of Vanderbilt" began on Monday, October 1, 1934, a hot Indian summer day. The third-floor courtroom in the New York State Supreme Court building was stuffed with eager spectators and more than one hundred reporters.

The first witness was the dowdy Emma Sullivan Keislich, who, in a shapeless black dress and black lace-up shoes, with her short gray hair and plump figure, looked much older than her forty-three years.

From the moment Nurse Keislich was sworn in, she was ready to do battle for her little one, who was her life.

"What is your occupation?" the courtly Herbert C. Smyth, who represented Mrs. Whitney, asked her on direct examination.

"Nurse."

"Will you please tell the court what your experience has been in taking care of children?"

"My experience has been, before the ten years, that the children had loving parents instead of harsh—"

Gloria Vanderbilt's attorney, the scrappy Nathan Burkan, jumped to his feet. "I move to strike that out," he objected.

"Strike it out," the judge ruled.[138]

When Mr. Burkan tried to establish what type of people had visited Gloria Vanderbilt, Nurse Keislich testified that no good man or woman ever crossed the threshold. "They were all night life people."[139]

"Mrs. Thaw was there, was she not?" the lawyer questioned, referring to Gloria Vanderbilt's sister Consuelo.

"She calls herself Mrs. Thaw."

"What do you mean—'she calls herself Mrs. Thaw'? Do you not know this lady is married to Benjamin Thaw, then Secretary to the American Embassy in London?"

"She says she is."[140]

"You will have to advise your witness that this prejudiced manner in giving her evidence only harms her," Justice John Carew reprimanded Mr. Smyth, as he looked at the nurse through his pince-nez. "It discredits a witness when they show so partisan a spirit."[141]

But there was no stopping her vitriolic outbursts once she started.

The triplex where they'd lived in Paris, she testified, had been infested with rats, so many that in just one morning the butler had killed thirty. The tiny yard behind the apartment, which was the only place little Gloria could play, had been filled with rats. Gloria Vanderbilt's unemployed brother had lived in the apartment, supported by the child's trust fund. Each week Mrs. Vanderbilt had attended or hosted several all-night cocktail parties and never awoke until the afternoon. Nurse Keislich had seen Mrs. Vanderbilt in bed with Prince Hohenlohe. The prince had been reading to her.

"Did you notice what kind of books they were . . ." Mr. Smyth began to ask.

"Yes, the books were about. I saw them. I saw the books," Nurse Keislich blurted out, hardly able to contain her excitement.

"What kind of books did you see? You looked at them, didn't you?"

"Yes, I looked at them and as I said, I had never seen anything like it."

"I move to strike that out," Burkan interrupted.

"They were vile books!" Nurse Keislich shouted.

"Just answer the question," Smyth told her.

". . . I saw one book with . . . two women undressed, beating each other. Another day the child came in and found a picture on the table . . . of a man naked and a woman's tongue very near. It is a very embarrassing thing for me to say. . . . She saw this big red flaming thing, and the color attracted her attention."

"What did the child say?"

"The child said, 'Here is a big tongue.' "[142]

"I can't get half of this, Your Honor," the court stenographer complained, throwing his pad onto the floor in disgust. "She starts answering before the question is asked."[143]

"Woman—woman," the judge scolded her, "don't you know that God put teeth in your mouth to keep your tongue in?"[144]

Mr. Burkan began his cross-examination of Nurse Keislich.

"We are all not liars!" Nurse Keislich snapped at Mr. Burkan, bursting into tears and cringing from him. "We are not *your* kind!"[145]

When he had finished his cross-examination, Mr. Burkan rose to address the court.

"I wish to establish, Your Honor, that from this evidence alone this nurse is a dangerous woman to be around the appellant's child. Her influence for ten years accounts in a great measure for the child's attitude toward her mother."

Mrs. Whitney's attorney rose and agreed. "We will let the nurse go. She will be of no help to the child."

"Then that is settled," the judge ordered. "The nurse goes."[146]

The next witness was Gloria Vanderbilt's chauffeur, Beesley, who was called to help prove that Gloria had been the mistress of several men.

He was followed by Gloria Vanderbilt's personal maid, Maria Caillot, a twenty-three-year-old French girl, who testified that she had often seen Mrs. Vanderbilt under the influence of alcohol and that she knew when she was drunk because she always smiled when drinking excessively.

"Are you trying to imply," Mr. Burkan asked, "that Mrs. Vanderbilt never smiles unless she is drunk?"

"When she is drinking," the maid replied, "she always smiles."

Gloria Vanderbilt laughed to herself at this nonsense.

"You see Mrs. Vanderbilt smiling at you now," the lawyer said. "Would you call her intoxicated?"[147]

The courtroom laughed.

The French maid testified that she had seen "dirty books" around the house, books with pictures of nuns "doing things" with young girls.[148]

"How much money did you ask to give this evidence?" Mr. Burkan suddenly demanded.

"I did not ask for money," the indignant maid protested.

"But you were promised it," Burkan explored.

"Yes," she whispered.

At this point, her credibility was destroyed. All her testimony was worthless. Attorney Burkan then made a tactical error he would regret for the rest of his life.

"And so all these months," he concluded, "you saw nothing improper in her household?"

"No, I saw nothing."

"Mrs. Vanderbilt always conducted herself in a perfectly respectable and decent manner?" he pressed.

"Always," the maid agreed.

Now, rather than quitting while he was ahead, the lawyer went in for the finishing touch to write off this witness.

"So then, you never once saw evidence of improper conduct?"

The maid touched her hand to her forehead as if she had just remembered something. "Oh, yes," she said, "I remember now something that once happened that was very *amusant.*"

Mr. Burkan had walked back to the counsel table and was putting his papers back into his briefcase. "Oh, yes?" he said. "And what was that?"

"Yes," she continued, "there was something struck me as very funny when we were at the Hotel Miramar in Cannes in 1929. Once, one day, Mrs. Vanderbilt called me for breakfast, like she do, for breakfast she call me."

"She called you for breakfast?"

"Then I served breakfast, and I take her things up to my room, pressing them, and a few minutes afterwards I come back in Mrs. Vanderbilt's room to bring back the clothes in the closet. Then when I came, Mrs. Vanderbilt was in bed reading a paper, and there was Lady Milford Haven beside the bed with her arm around Mrs. Vanderbilt's neck—and kissing her just like a lover."[149]

For a moment no one in the courtroom stirred.

"In the interest of public decency," Justice Carew decreed, banging his gavel, "the press and the public will be barred from this courtroom!"[150]

And then, chaos.

Reporters fought to get through the doors out of the courtroom to reach the telephones to be the first to call in the scandal. FRENCH MAID BLURTS OUT SECRET, the headlines blared. LADY MILFORD HAVEN KISSED MRS. VANDERBILT. . . . EVIDENCE SO REVOLTING THAT COURT BARS PRESS AND PUBLIC. "No sooner had the testimony of an Irish nurse placed Prince Gottfried Hermann Alfred Paul Maximilian Victor zu Hohenlohe-Langenburg in the bed of Mrs. Reginald Claypoole Vanderbilt than the testimony of a French maid put the Marchioness of Milford Haven in the same place."[151] The stories branded Gloria Vanderbilt a "lesbian," with the more conservative newspapers reporting her "alleged erotic interest in women."[152]

The words of Maria Caillot hit Gloria Vanderbilt like a punch. "I heard the excitement of the courtroom being cleared—the scraping of the chairs being moved away for the people to get up—the press filing out," Gloria later recalled. "Every bit of noise was magnified to such a degree that I thought there were shells exploding over my head. I turned and looked at Gertrude Whitney, and she was smiling. She gazed at me full in the face and smiled."[153]

Baffled by the incredible testimony he was hearing and by the entire vexing case, Justice Carew was quite sure that if only Gloria Vanderbilt had a chance to be with her daughter, the normal mother-child relationship would assert itself. Perhaps there was some truth to Gloria Vanderbilt's theory that her daughter did not want to be taken from the lap of luxury she had found with her rich aunt Gertrude—who had given her

a pony and a puppy dog and eight young cousins to play with, and whose country estate was like paradise to the young child.[154] He ordered that Mrs. Vanderbilt visit her daughter at Gertrude Whitney's Old Westbury estate on Saturday, October 20, 1934.

Gertrude Whitney, in bed with a sore throat in her home at 871 Fifth Avenue, early that Saturday morning called her son-in-law, Barklie Henry, who lived in one of the houses on her Old Westbury estate. "Perhaps little Gloria will be a bit upset," she said. "Would you go over and tell her the news, please?"

Barklie Henry went over to the big house and sat down with little Gloria.

"By the way," he casually wove into the conversation, "guess who's going to see you this morning? She's on her way right now—your mother."

Instantly, Gloria began shrieking and tried to race from the room. Henry stopped her.

"Now look here, Gloria, this is all right. You are going to stay here, and you must not act this way."

Gloria raced by him, running up the stairs and into her room, locking the door behind her. Nurse Keislich had been sent away for the day, in accordance with Justice Carew's direction. A trained nurse, Miss Walsh, who was in Gloria's bedroom, saw where the girl hid the key and opened the door.

"Your mother has just called to say that she's been delayed and will not arrive until noon," Barklie Henry told Gloria. "I'll tell you what, we can go riding."[155]

The two spent the morning riding the trails through the woodlands surrounding the mansion, watched by a force of sixteen private guards that had been beefed up by several dozen Nassau County policemen due to the receipt of a kidnapping threat, as well as the growing apprehension of Gertrude Whitney and Grandmother Morgan that Gloria Vanderbilt would try that day to kidnap her daughter.

After their horseback ride, the two played cards, waiting for the arrival of Gloria's mother. When the butler announced that she was waiting outside, Barklie Henry noticed that little Gloria began shaking, breathing in shallow gasps.

Barklie Henry met Gloria Vanderbilt and her two sisters, Thelma

and Consuelo, out in the courtyard, explaining how upset little Gloria seemed to be. "Perhaps it would be better not to see her just now," he suggested.

"Nonsense!" said Gloria.

"We are here to see the child, and see her we will," Consuelo ordered.[156]

It wasn't as easy as all that. Little Gloria had again raced to her room, locked the door, and hidden the key.

Thelma was furious. She pounded on the door.

"Nurse, you must open the door. This is a court order. We are to see this little girl."

"I know it is," Nurse Walsh pleaded, "but Gloria won't give me the key."

"Why did you give her the key?" Thelma demanded.

"I didn't. . . . She took it. . . . She's thrown the key in the fire. There's a fire and she's . . ."

Consuelo had had enough. "This is Aunt Toto! Open this door!" She savagely beat the door with her fists.

"No, I won't. I don't want to see you. I hate you . . ." little Gloria cried.[157]

"Let *me* get at her!" little Gloria heard Consuelo snarl. "Listen, you listen here to me. Nobody is going to hurt you—can you hear me? Listen to me now—just open the door to me—will you do that now?—just to me. Your mother isn't even here now, she's not feeling well—she's lying down in the other room."

"Open up, Gloria," someone else said. It was Thelma again. "Open up or we will have to break the door down. Do you hear me, Gloria? Your mother has a court order to see you—a court order—so make it easy on yourself, do you hear me? Make it easy on yourself and open up—she has an order from the court! Otherwise I'll have to get one of those policemen you saw to come and I'll have to ask one of those policemen to break this door down."[158]

"Get Mr. Henry and get a carpenter," Thelma told Consuelo.

Soon Barklie Henry arrived at the scene with a caretaker who brought a ring of keys. Each was tried until the door opened. Thelma and Consuelo entered little Gloria's bedroom. Miss Walsh stood in the

middle of the room. Little Gloria was hiding behind her, holding on to her for dear life.

"What is this all about, Gloria, darling? You are not frightened of Aunt Toto, are you?"

"I am."

"Why? I haven't done anything to you."

"No."

"Then come on. Give me a kiss. Don't act like a child."

"All right," she whispered, and came out from the nurse's skirts to give her two aunts a little kiss.

"You know," Consuelo said, "your mother is crying, and you have made her very unhappy. Won't you go in and kiss her and say you're sorry?"

"No."

"Look here, Gloria. Do you realize you're hurting your mommy? You don't really want to make her unhappy, do you?"

"No."

"All right then, go and tell her you're sorry for behaving like such a silly little girl. You're grown up now and you can't behave this way."

"Will you take me?" she asked her Uncle Henry.

He took her by the hand and started to lead her out of the room. Gloria stopped dead in her tracks at the doorway.

"Why are you frightened?" Thelma asked.

"I won't tell."

"But why?"

"I'm afraid of her."[159]

"Come to me," Gloria called from the bedroom across the wide hall where she was lying on the bed, feeling faint.

Her daughter started to walk toward her and then retreated back to her room.

Thelma sat down on the floor and began playing with Gloria's puppy, Gypsy-Mitzie. Soon little Gloria joined her.

"Will you do something for me?" Thelma asked her.

"What?"

"Will you, when your mommy comes in here, kiss her?"

"Yes."[160]

Thelma left the room to get little Gloria's mother. "Pull yourself together, darling," Thelma instructed her twin sister, who was lying on the bed, sipping a glass of brandy, "and come along. The baby is perfectly willing and anxious to see you. Now fix your face up."

Thelma led her sister across the hall. Gloria handed two playing cards to her daughter, one of which had Mickey Mouse on the back.

"Oh, thank you, Mommy. Would you like to see my card collection?"

"Yes, darling. I would love it."

Little Gloria dumped all her trading cards on the floor and began showing them to her mother, one by one.

"I have a Mickey Mouse game in the car for you," her mother told her.

The nurse went downstairs to get it and brought it back. Little Gloria was fascinated.

"I wonder how it goes?" she asked.

"When I come next time, we'll play it together," her mother assured her.[161]

Justice Carew's theory appeared to be working. Given time, a reconciliation between mother and daughter seemed inevitable. What he hadn't factored into his theory was Grandmother Morgan.

The next day, Grandmother Morgan arrived at Old Westbury to make sure her granddaughter was none the worse for having had to see her mother.

"How are you feeling, darling, today?" Grandmother Morgan asked Gloria.

"Oh, fine, I feel fine fine."

"Precious One, are you sure? How can you feel fine after what happened when *They* were here, when *They* all came here? How can you? Did your stomach pains come back? You know, those pains you get in your stomach when something upsets you? *They* came here, didn't they? Right to this house. So why wouldn't you be upset, terribly terribly upset, seeing the three of them here, right on this spot, trying to take you away from your Auntie Ger, away from me, and—where do you think *Dodo* will be when the Fräulein appears? You don't think Dodo will be around then, do you? You'll never see either one of us, when they

take you back to Europe or who knows where—forever. Do you know what that means—forever?"[162]

Grandmother Morgan was right again. Gloria had pains in her stomach that night, terrible pains that kept her awake and that once again required summoning good Dr. Jessup.

"Now Doctor Jessup is coming," Grandmother Morgan told Gloria; "he is on his way here right this minute, and when he gets here you must tell him how much your stomach hurts and how you couldn't sleep last night because it hurt so much, and then when he starts poking around here and there on your little tummy, you can go like this—Oooo-ouch, um-um-um, ooooo—eeEEEEE— If you do this right, then he will be able to tell the Judge how sick it has made you knowing you may have to leave Auntie Ger and go back to your mother who will take you to Germany."

"But suppose he *knows* I'm making it up, making it up, making it up that my stomach hurts hurts hurts?"

"He won't know, if you do it right."

"But suppose he *does*?"

This was unlikely. In one six-week period, eight physicians had examined little Gloria more than fifty times, each coming away with a different diagnosis and different recommendations, though most agreed that Nurse Keislich, who had pampered the ten-year-old child, bringing her breakfast and dinner in bed on a tray and making sure she was put to bed at six o'clock each evening, was not a healthy influence.

"None of them have known so far, have they?" Grandmother Morgan asked little Gloria. "St. Lawrence doesn't know when you say you feel sick. Doctor Craig doesn't either. None of them know what's going on, so why will Doctor Jessup?"[163]

When kindly Dr. Jessup came to examine her, little Gloria made all the right noises. "I got quite carried away by my own performance," she remembered later. "But Naney came closer to me and I could sense that even she thought I might be overdoing it—and if *she* thought that, I better tone it down a bit."[164]

Puzzled more than ever by what he was hearing during the seven-week trial, Justice Carew determined that he would speak to little Gloria

himself. No one would be allowed in his chambers except little Gloria, Mr. Burkan, Mr. Smyth, and the court stenographer. No one else would be there to influence her or intimidate her. Now, the truth of what was really happening would come to light once and for all, and he would be able to fashion a fair settlement of the "Matter of Vanderbilt."

Little Gloria arrived at the courthouse in Gertrude Whitney's Rolls-Royce, accompanied by two bodyguards. They moved through the crowds of photographers, reporters, and the curious.

"You treat your mom good, Little Gloria!" people shouted. "Stick with your mom, Little Gloria! A mom's love, Little Gloria! You be nice to your mom! Nothing like a mother's love! Nothing—nothing—nothing."

"Down with Gertrude! Down with her millions! Down with the aunt, up with the mom. Down down down, Gertrude!"

Flash bulbs burst. Newsreel cameras ground away.

"Over here, Little Gloria—smile, Little Gloria, over here—just one more smile smile smile—Little Gloria, smile—"[165]

Little Gloria was well prepared to testify. Grandmother Morgan had coached her time and again. They had gone through repeated rehearsals. "So when you go there, the day you go—it won't be for long, Precious One, but it's a very very important thing you will be doing, and what you do there and what you say will decide the Judge on whether he will let you stay with Aunt Gertrude or whether he will send you back to your mother who will take you to Germany and we will never see each other again—never never never. Never! Dodo and I will never set eyes on you again. The Prince has a Fräulein waiting for you, all ready and waiting at the Schloss, just for you to arrive-aie, aie—yes he has! And *that's* where they will take you, do you hear me, darling? Are you listening to your Naney?"[166]

In the quiet of Aunt Gertrude's estate at Old Westbury, Gertrude Whitney's lawyers had reinforced these sessions. "You see," they told the young girl, "it's very simple really, the Judge wants to hear it directly from you—your feelings about your mother, about your Aunt Gertrude, and why you want to live with Aunt Gertrude here at Old Westbury instead of living in hotels here and there traipsing around all over Europe, and then maybe even having to settle somewhere—Germany, for example. Have you thought of that ever? Settling somewhere in

Germany? Your mother has always been interested in marrying a Title, so who knows what could happen in the future? Has that ever occurred to you? How would you feel about that?"[167]

With the illogic and certainty of a ten-year-old, little Gloria Vanderbilt, her bangs brushing her forehead, her legs dangling from the chair in Justice Carew's chambers, her white socks slipping into her brown laced shoes, proved a formidable adversary to the judge and Mr. Burkan.

Justice Carew began talking with her to make her feel at ease.

"I have a little girl about your age."

"Have you?"

"Are you having a good time down in the country?"

"Yes, lovely," Gloria answered. "I got a pony and a dog—everything!"

"Do you like it there?"

"Oh, I love it."

"You do not want to live in the city?"

"No. I hate the city."

". . . You don't hate the city?"

"No, I hate it. Really," the child insisted.

"You want to stay in the country?"

"Yes. I never want to live in the city."

"How would you like to live with your mother down in the country?"

"No. Never. I always want to live with my aunt."

"You lived a long while with your mother?"

"Yes, but I have hardly seen her, anything of her. She has never been nice to me."

"You wrote a lot of letters to her that said you loved her."

"No, I did not. Never. I used to write letters to her because I was afraid of her—and when she made me a sweater I just thanked her for it—and I hardly ever—"

"Don't you think you could learn to love her?"

"No."

"Oh, you could, if you did not make up your mind not to," the judge told her. "You lived with her for six or seven years over in Paris?"

"But I hardly ever saw anything of her."

"You used to write letters to her and draw little pictures of dogs and horses?"

"Well, I had to because I was afraid that she would do something to me," Gloria responded.

"She never did anything to you?"

"Yes, she did."

"What did she do?"

"Well—she never used to let me have toys, or anything, or have children to come and see me, and sometimes in the daytime she never used to see me at all. She used to just go off with her friends."

"Why, she took you to nice places, to England, where you had little boys and girls and you had a pony over there?"

"No, I did not. Never."

"Didn't you ride a pony over there?"

"No, because I never had riding lessons. Once they got me a riding suit, and I just sat on the pony and walked around."

"I think she would get you a pony now."

"No, I never want to go back to her. Do I have to?" she asked, looking at him beseechingly.

"I think you will want to."

"No," she whispered, starting to cry.

"It is not that you have to. I think you will begin to love her and want to go back."

"No, I won't" Gloria wept.

"My little girl—I used to be away a long time when I was in Washington, I used to be away all week, and I used to come home, and she used to be glad to see me."

"Yes, but probably you were nice to her."

"How was it your mother was not nice to you?"

"I don't know."

"What do you mean that she was not nice to you?"

"Once I had a little dog and I loved him very much, and she took him away from me."

"Maybe the dog had fleas."

"No. He did not."

"Was he a bad dog? . . . A nasty dog?"

"No, he was a lovely little dog."

"Didn't Miss Keislich get a little dog for you? Wasn't she nice to you?"

"Very."

"Didn't she take you out to the park and give you a good time in the park over there?"

"She did. But my mother didn't."

"But your mother paid her for doing that. Your mother told her to do that."

"I don't think she did," Gloria responded.

"Your mother told her to take good care of you and take you out to the park. All the good things Miss Keislich did for you, she did it because your mother had her there."

"I don't think so."

"Is it because you have a good time in the country that you want to stay down there with your cousins?"

"No, I love Auntie Ger, and I always want to stay with her."

"Wouldn't you like to have your mother come to see you once in a while?"

"No."

"Look at all the years you lived with your mother over in Paris."

"I don't care. I don't like her."

"You used to like her until you went down in the country?"

"No, I did not."

The judge leafed through a stack of postcards little Gloria had sent to her mother.

"Look at all the little postal cards you sent to her. . . ."

"Well, I had to, because I was afraid of her."

"Afraid of what?" the judge asked. "You don't believe in bugaboos, do you?"

"No."

"What would you be afraid of? . . . What are you afraid of?"

"I don't know. I am just afraid of her."

"Do you know your two aunts, Lady Furness?"

"Yes."

"And the other lady—what's her name?"

"Mrs. Thaw?"

"You like them?"

"No."

"You used to like them when they were over in France?"

"No, I did not. I used to like . . . Lord Furness. He was very nice to me."

"How were they not nice to you?"

"Well, they used to take things away from me. And in the morning she would not let me come in her room. She used to say she is busy."

"Whom do you mean by this?" Justice Carew inquired.

"My mother."

"They always bought you nice clothes, toys, dolls and fairy books, fairy tales and things like that, didn't they?"

"Sometimes. Hardly ever. In England, they hardly ever used to pay any attention to me. They used to go out to parties and things."

"Well, they were grown-up people, and children ought to go to bed early. 'Early to bed and early to rise makes a man healthy, wealthy and wise.' Did you ever hear that?"

"Yes."

"When you grow up you will be able to go out to parties and dances."

"She never even kissed me good night. . . ."[168]

Attorney Burkan entered the fray.

"You have a nurse, don't you?" he asked little Gloria. "A nurse whose name is Miss Keislich, but whom you call—Dodo, is it?"

"Yes."

"Has Dodo ever told you to say things or do things that—?"

"Never, never, no she never told me not to, nothing, never!" Gloria protested before the full question was asked.[169]

Mr. Burkan showed Gloria a photograph of herself smiling at her mother.

"You were smiling at your mommy, weren't you?"

"Yes, because when I was kneeling there the photographer said to smile. And I did."

"And at that time you hated your mommy?"

"Yes."

He showed her a picture of herself as an infant in her mother's arms.

"You didn't hate her then, did you?"

"Oh, well, I was a baby then."

"How old were you when you began to hate your mother?"

"As soon as I could understand things. I mean as soon as I could talk."

"You began to talk when you were about two years and a half."

"Yes, it was about then."

"So when you were about two years and a half, you began to hate your mother?"

"Yes."

"And when you were two and a half years old, you began to be afraid of your mother?"

"Yes."

The judge jumped in. "What did your mother do to you that made you feel that way when you were a little bit of a tot like that?"

"Well, for one thing she was mean to me and never used to let me see anything of her. She never used to come into my room to kiss me good night."[170]

"You were afraid?" Mr. Burkan continued.

"Yes."

"What was it? What was the thing that you were really afraid of?"

"Well, I was afraid that she would take me away."[171]

"You hate your mother," Justice Carew stated. "Why do you hate your mother?"

"Afraid."

"Why are you afraid?"

"Afraid because I don't want her to take me away. I don't want her to take me away, I am afraid that she will take me away. . . ."

"Who—who are your afraid of being taken away from?"

What little Gloria wanted to say was *Nurse Keislich, Dodo, don't let her take me away from Dodo.* But that, she knew, was the incorrect answer. She had been instructed as to the correct answer, and she recited her lines with conviction.

"Yes yes yes, from *Aunt Gertrude,* don't let them take me away from Aunt Gertrude, don't let my mother take me away from Aunt Gertrude, please please, I beg you, I beg you!"

"Now, now, there's no need for that, no need for that at all."[172]

Little Gloria's two and a half hours of testimony had done nothing to help Justice Carew determine how to decide this impossible case. The

easy solution for which he had been searching was nowhere in sight.

On November 21, 1934, he released his opinion. Mrs. Gertrude Vanderbilt Whitney was granted custody of the child. As custodian, she was to bring young Gloria to her mother each Saturday morning at 10 A.M., and pick her up at sundown on Sunday. On Christmas Day, young Gloria would be delivered to her mother at 10 A.M. and picked up at 6 P.M. And Gloria Morgan Vanderbilt would have custody of her child during the month of July. The *New York Journal American* published a jingle about this strange verdict:

> *Rockabye baby*
> *Up on a writ,*
> *Monday to Friday Mother's unfit.*
> *As the week ends she rises in virtue;*
> *Saturdays, Sundays,*
> *Mother won't hurt you.* [173]

The court battle, which Maury Paul in his society column called "as disgusting an exhibition of public laundering of soiled family linen as I've encountered,"[174] had no winners. There were only losers.

Gloria Morgan Vanderbilt had lost her child and she had lost her livelihood. The world she had known as Mrs. Reginald Vanderbilt was over forever.[175] "They've permitted Gertrude Whitney to keep Gloria because I was away from her too much," she explained in an interview. "Now if that be sound reasoning, then no mother on Park Avenue has any right to have her children. And that applies particularly to Gertrude Whitney. Anybody who knows anything about these things knows mothers and fathers in this position in life see very little of their children. When the babies are young they are taken care of by nurses and governesses. Mothers are busy with the duties that their social lives entail. You will usually find them out to lunch and then on to cocktails somewhere. They rush home to dress for dinner and away they go again. Their mornings are taken up by masseuses, fitters, hairdressers. Often personal financial affairs take them downtown to their bankers, brokers, or attorneys. When the children are old enough they are sent to private schools—often out of town. During the summer holidays they are off at camp. Now that is the life of ninety-nine children out of 100 whose parents are in the Social Register. That is exactly the way Gertrude

Whitney raised her children. She saw very little of them and she sees very little of Gloria today. During the five days of the week that my daughter is in her charge down at Old Westbury, Mrs. Whitney is usually in New York. In the fall, winter and spring, she lives at her house on Fifth Avenue. You will find her out to lunch, on to cocktails and at somebody else's house for dinner day after day. If I am unfit to have custody of my own child for the reasons that the court has given, then Gertrude Whitney is equally unfit. But of course, I have very little and Gertrude Whitney has $78 million. And $78 million couldn't possibly be wrong."[176]

Gertrude Vanderbilt Whitney had won the court battle, but the winning now meant nothing to her. "The irony," little Gloria stated years later, was ". . . that as soon as my aunt was allowed to take charge of me, she lost interest. . . ."[177]

Grandmother Morgan had lost the love of all her children.

And little Gloria, little Gloria had lost her world.

Aunt Gertrude never spoke directly to little Gloria about anything important. Whatever was on her mind was patiently presented to her niece by her lawyers. And so it was that one of Aunt Gertrude's lawyers was there one fall day when little Gloria came home from school. He told her of Justice Carew's decision and of his order that she must be freed from the pernicious influence of Nurse Keislich, that Nurse Keislich must leave just before Christmas so that Gloria would have "ample time to adjust, adjust to this little change" before the New Year when a new nurse would take charge. Gloria would not be allowed to visit Nurse Keislich or write to her or even to know where she was. Gloria ran out of the room up to her beloved nurse's room. "My heart broke and the blood of it gushed from me into the soft sweet love of her, the torrent of it sped and sped on and away, spreading on into her . . . and from that moment to this," she wrote fifty-one years later, "nothing has ever been the same again."[178]

4.

"In the beginning, a child believes that all other children are in the same world that she or he inhabits. That is how a poor child defines all others,

and that is how a rich child defines all others. Once upon a time," little Gloria recalled when she was an adult, "it never occurred to me that my situation was in any way singular or different from that of every other child in the world."[179]

The first Christmas after the custody trial, Christmas 1934, ten-year-old Gloria was being driven by her chauffeur to visit her mother when he stopped at a red light. Suddenly the car door was opened. "It was a little furry person who kneeled on the steps of the car, leaning in towards me, almost coming in but not daring to. She was grey all over from the matty fur of her squirrely coat to her hair falling out under the grey scarf on her head, right down to the grey wool socks falling down over her grey heelless shoes. The only thing about her that was not grey was the apple she held out to me in her mittened paw. She leaned in closer on her knees and shoved the apple under my face."

This gray apparition called out, "Little Gloria, help help me please, Little Gloria, please! . . . Only you, Little Gloria, you can help me help me help me please, please!"

The chauffeur jumped out of the automobile and pulled the woman back onto the street, next to the carton of apples she was selling. Slamming the automobile door shut, he sped off, as the street lady called and called for Gloria to help her.

"How could I help her?" little Gloria wondered. "What could *I* do? What? What was it about? What was any of it about? The grey bundle of her, stretching towards me with the apple, and on the pavement those other apples in their neat rows. What?"[180]

The Depression was what it was all about.

The front-page newspaper coverage of the custody battle for the "little heiress," the "gold girl" as she was called, had captivated the public's attention month after month in the dark days of the Depression. Here was a little girl, a Vanderbilt, the heir to a trust fund producing income at the unbelievable rate of over $100,000 a year, surrounded by a retinue of nurses, maids, chauffeurs, and bodyguards. And yet, here was a little girl who had nothing at all. We might not have a lot, the families hit by the Depression could reason, but we have more than poor little Gloria Vanderbilt, the proverbial poor little rich girl.

The custody battle over Gloria Vanderbilt was a bewitching reminder of an age that was suddenly over. If ever an era really did end

in a day, that era was the Gilded Age, and that day was October 29, 1929, Black Tuesday, the day the stock market crashed. "Wasn't the Depression terrible?" spoofed humorous billboards that sprang up in New York's financial district several months after the crash, when the worst seemed over. But the crumbling market presaged a broken economy. Production fell; wages were cut; workers were let go. Savings were lost, bankruptcies declared, mortgages foreclosed, banks closed. The ranks of the unemployed swelled from 3 million in 1930 to 15 million in 1933. Soup kitchens opened; bread lines formed. Hoovervilles sprang up on the outskirts of towns, colonies of tar-paper, scrap-lumber, and flattened-tin-can shacks. Beggars and panhandlers took to the streets. Hitchhikers, vagrants, hobos wandered the highways and railroad yards. Nothing got better, everything got worse, as the Depression continued year after year, day after day of numbing desperation, of disillusionment, of hopelessness and defeat.

Grace and Neily Vanderbilt's son, Neil Vanderbilt, who had bidden farewell to Fifth Avenue to become a newspaper reporter, was in a unique position to observe the effects of the Depression on his parents' wealthy friends.

To be sure, the crash had a devastating effect on their finances. Neil's father said he had lost $8 million in an hour on Black Tuesday. Taxpayers reporting annual incomes of $1 million or more fell from seventy-five in 1931 to twenty the next year. "Up to a year ago my net income amounted to three million dollars," a family friend complained to Neil. "I'll be lucky if I collect eight hundred thousand in dividends next year."[181]

"There is no point in dodging facts, Neil," Willie K., Alva and Willie Vanderbilt's oldest son, told his cousin. "In another ten years there won't be a single great fortune left in America. The country will come back—it always does; but we won't."

"What do you propose to do about it?" Neil asked him.

"Do? What can we do? Everyone for himself. . . . I personally shall spend some of the remaining time in cruising aboard my yacht, seeing the world and trying to have a good time. If I were twenty years younger, then perhaps. Oh, well, what's the use! I am not twenty years younger."[182]

The real concern of the rich was not the loss of their income or

principal, devastating though that loss may have been. Their real fear was of a coming revolution, a class war, in which they might lose everything, in which they would look outside to see the gates of their mansions being stormed by the rabble.

In 1929, right before the crash, at the height of the prosperity of the Roaring Twenties, only 2 percent of all American families had had incomes of more than $10,000; 60 percent had had incomes of less than $2,000. In the Depression years, the disparity between the haves and the have-nots was magnified. As families slept in tar-paper shacks heated by fires in grease barrels, and fed their children a broth of dandelion greens, the rich worried about their incomes falling from $3 million to $800,000.

One evening in June 1931, Neil Vanderbilt was driving through poverty-stricken Gary, Indiana, on a reporting assignment when a brick crashed through the windshield of his car. As he pulled over to the side of the road, he could see a crowd of men emerging from the shadows, gathering around him.

"What's the big idea?" he called out.

"Just to teach you, you blankety-blank millionaire, not to drive around in that bloody car of yours."

"What's wrong with my car? Anyone who wants it is welcome to it for three hundred dollars. It's five years old and it has been driven over half a million miles."

"Our mistake I guess. We thought you was a rich guy."

"And if I were?"

"All rich guys ought to be strung up."

"But who are you?"

"We're the fellows that'll do the stringing."[183]

As Neil mingled with the hitchhikers and migrants on the highways, with the unemployed and dispossessed, their common refrain was "It won't be long now. . . ." A revolution seemed just around the corner. "It won't be long now. . . ."

"Who is going to start it?" Neil would ask.

"Ever been hungry?" they answered.[184]

The rich clearly heard this refrain of the highways. They installed bulletproof steel shutters on the big windows of their Fifth Avenue mansions. They shipped their gold to Switzerland, Holland, Belgium, and France before President Roosevelt took the country off the gold

standard. Lloyd's of London did a brisk business selling riot and civil disturbance insurance to the rich. At the end of the 1931 summer season at Newport, many did not return to Fifth Avenue to face the hard winter, preferring to stay close to their waiting yachts, some of which, Neil found, were "kept under steam, day and night, ready for a three-thousand-mile jump on a second's notice."[185] Others retreated to their country homes, where they hoarded enough sugar, tea, coffee, canned soups, and fruit to last for several years.

At whatever estate he visited, he found the aristocracy preparing. "If our democracy is to survive," one gentleman told him, "we must be prepared to handle the mob in the way the mob understands. Bullets. Machine-guns. Bayonets . . . As I see it, the mob is about to fire on us. . . . If we are to retain our property—and I for one certainly do not feel like surrendering my property to a lot of hoodlums—we must begin arming ourselves."[186] And arm themselves they did. One millionaire took Neil down to the storerooms in his cellar, where there were machine guns, automatic rifles, shotguns, and wooden boxes of explosives. "If the worse comes to the worst," he told Neil, "I will meet violence with violence."[187]

The stock of the New York Central, which had closed at a high of 256⅜ on September 3, 1929, fell to 160 two weeks after Black Tuesday. The Vanderbilt family dismissed the guards at the mausoleum on Staten Island, who had been punching time clocks every quarter hour of every day since William H. Vanderbilt had been laid to rest there in 1885.

One morning in 1941 aboard Willie K. Vanderbilt's oceangoing yacht, his valet, Jenkinson, knocked on his cabin door with the morning coffee and stock market quotations.

"Central had hit 25," a new low for the stock, Willie wrote in his diary that day. "It was time to go home."[188]

10

MRS.
VANDERBILT

1 9 3 4 – 1 9 5 5

1.

"**I** feel deeply for poor, dear Marie Antoinette," Grace Vanderbilt once said during the Depression, "for if the Revolution came to America, I should be the first to go."[1]

Burrowed in her self-centered world, Grace had not noticed that a revolution had already come to America—a bloodless revolution, but a revolution nonetheless. "There isn't any New York society today any more than there is a nation called the Confederate States of America," an old man who had known Mrs. Astor, Ward

McAllister, Mamie Fish, and Harry Lehr told a friend. "There are survivors from each. And that is all."[2]

The two miles of millionaires' metropolitan mansions that had lined Fifth Avenue had vanished, razed to make way for business or converted to commercial use. Only a handful of private residences remained on the avenue and only one—on the northwest corner of Fifth Avenue and Fifty-first Street, the last of the Vanderbilt mansions on Fifth Avenue, the house William H. Vanderbilt had built in the early 1880s—was run just as it had been for decades. It was now America's last outpost of ceremonial society: 640 Fifth Avenue, home of Grace, Mrs. Cornelius Vanderbilt.

The mansion at 640 Fifth Avenue had become a shrine to a bygone century, a forgotten world that was so remote and foreign it might have been life as lived on another planet. "Her house on Fifth Avenue," Bessie Lehr recalled, "was the perfection of taste, yet in my fancy it seemed to be resisting something. It was like a citadel of another age. The ever-encroaching skyscrapers around it, the nearby Radio City were an advancing army. Modernity on the march."[3]

Nothing seemed to awaken Grace Vanderbilt to the fact that the world had changed around her; not Prohibition with its speakeasies and nightclubs, which occupied many of the buildings in the neighborhood; not the blasting of bedrock across the street with the construction of Rockefeller Center in the 1930s; not the shadowing of her home by skyscrapers on every side; not the shoppers, commuters, vendors, secretaries, and businessmen hurrying along the sidewalk outside her front door or the congested traffic on the streets around her home.

Guests ascended the ceremonial red carpet always unrolled for them on the sidewalk in front of 640 Fifth Avenue, walked up the stone steps and through the bronze doors, leaving behind the skyscrapers, the rushing shoppers and commuters, the noise and clatter of a busy city, and entered a world of footmen in livery, of a towering Caen stone hall with walls hung with seventeenth-century tapestries, of polished marble floors and rock crystal chandeliers, of Venetian velvet curtains, of French Regency chairs covered in raspberry-red silk, of fires blazing in fireplaces with green-veined marble mantels, of library tables covered with framed autographed photographs of the Queen Mother and King George VI, President and Mrs. Calvin Coolidge, King Alfonso and Queen Victoria

Eugenia of Spain, President Theodore Roosevelt, the duke and duchess of Kent, Queen Elizabeth and King Albert of Belgium.

And there in the midst of this otherworldly setting stood Grace Vanderbilt, dressed to the nines, sporting her jeweled bandeau and diamond stomacher.

Who did she think she was? Why, Mrs. Vanderbilt. These days it was rather easy to assume the title. There was no competition.

2.

Back in 1923, seventy-eight-year-old Alice of The Breakers had invited her two sons, Reggie and Neily, to dinner with their wives, Gloria and Grace.

After Neily had defied his parents' wishes by marrying Grace Wilson, and after Alfred's death aboard the *Lusitania*, Alice had always considered Reggie the rightful head of the House of Vanderbilt. That evening at dinner, she expressed these thoughts aloud.

"When I die, *you* will step into my place as Mrs. Vanderbilt," she solemnly told Gloria.

"How can you say that?" Grace Vanderbilt broke in. "Cornelius is older than Reggie and when that time comes I'll be the next *Mrs. Vanderbilt.*"

Neily shook his head in disbelief. "Really, must we quarrel about such a ridiculous subject? You are all Mrs. Vanderbilts here."[4]

Since the morning of September 12, 1899, when her husband had died of a stroke, Alice of The Breakers, the reigning Mrs. Vanderbilt, had been in mourning, wearing nothing but black, living in the past, spending her days alone in her fortress of a mansion on Fifth Avenue and in The Breakers at Newport, visiting only with her family, never seen in public.

An editorial about her husband in the *New York World* had been quite certain that "our great fortunes are now so great that it is hard work for the owners to spend the income, and only the wildest extravagance, folly and incompetence could destroy the principal."[5] This did not prove to be the case. Cornelius Vanderbilt II had built two homes befitting

the head of the richest family in the world, homes that required a commensurate fortune to maintain. When his estate was divided up, the portion left his wife, Alice, in time proved insufficient.

Several years after her husband's death, everyone noticed that Alice never opened The Breakers and the palace on Fifth Avenue the same year. So expensive had it become to run the two that Alice would use one home one year, and the other the next. The $7 million trust fund that her husband had left her produced income of $250,000 a year, which in a decade or two was just enough to pay the taxes on the two houses. The taxes on The Breakers were $83,000 a year. The taxes on the Fifth Avenue mansion, which had been $38,446 in 1899, had risen to $129,120 by 1925, the highest of any city residential property. In addition, the costs of maintaining The Breakers and the Fifth Avenue mansion were staggering. To run The Breakers took thirty-three servants, thirteen grooms, and twelve gardeners. Each winter its boilers consumed 150 tons of coal to keep the drafty rooms warm enough to safeguard its art treasures. The costs of maintaining the 137-room city house occupying a block on Fifth Avenue were even greater. When Gloria and Reggie went there to visit Alice Vanderbilt in 1922, Gloria felt that it "looked shabby and old, like a very great and elaborately mannered personage who had fallen on evil days."[6] Something had to give.

Alice bravely tried something new. She decided to economize. When she was at The Breakers, she closed off the entire mansion except one wing where she lived. She did the same in New York, living in a suite of rooms on the second floor. In later years, when she returned to New York from Newport, she didn't even bother opening her Fifth Avenue mansion, choosing instead to live at the St. Regis.

By 1925, when she was eighty, Alice Vanderbilt had concluded that she could not afford her city house: "The property is not a suitable place of residence for me in view of the changed character of the neighborhood, and the expense of its maintenance has become a real burden to me."[7] Indeed, once in the midst of New York's most fashionable residential district, the mansion had been engulfed by business. When the Cornelius Vanderbilts had acquired the land in the 1880s, it had cost $375,000 and the house $3 million more. Their new mansion had been hailed by the press as "a private house which must for a century or two

elevate the standard of such houses, and tend, at least, to the improvement of domestic architecture."[8] Now in 1925 the land, a prime site for business development, was assessed at $4.7 million and the house, worthless as a private residence, unsuitable for business, was assessed at but $100,000.

This unusual home was on the market for several years. A syndicate's contract of sale for $7.1 million fell through, as did plans to take the mansion apart, stone by stone, and rebuild it as the Harbor Hills Country Club at Sands Point, Long Island. In 1927, a real-estate operator offered $6.6 million and the deal was quickly closed. The site at 742–746 Fifth Avenue would be occupied by the new Bergdorf Goodman department store.

On several cold winter days in January 1926, with the mansion covered with snow and every window agleam with lights, Alice opened her house for tours to benefit the tuberculosis committee of the Association for Improving the Condition of the Poor. Tens of thousands of people who for years had walked by this imposing French château on Fifth Avenue wandered through its rooms, marveling at the great winding stone staircase rising from the hall; the walnut-paneled living room on the second floor; the Moorish smoking room designed by Louis Comfort Tiffany, with its rare mosaics and glass dome; the wardrobes the size of bedrooms, bedrooms as big as ballrooms, and bathrooms, one visitor noted, with enough room for a taxi to turn around.[9]

And then came the disassembling. Alice presented a mantelpiece carved by Augustus Saint-Gaudens to the Metropolitan Museum of Art. Theater tycoon Marcus Loew purchased the colonial room and Moorish smoking room and stored them in a warehouse, proudly announcing his intention to put them to use at his new Midland Theater in Kansas City. Daughter Gertrude rescued the massive gates from the ornate iron fence that surrounded the property, later giving them for the entrance to the Conservatory Gardens in Central Park.

And then the wreckers went to work. It was weeks before the mansion, built to last for centuries, had been torn down to street level so that pedestrians could get a full view of the plaza from Fifty-sixth Street.

Alice moved ten blocks up the avenue, purchasing for $800,000 the

former residence of Jay Gould's son at the northeast corner of Fifth
Avenue and Sixty-seventh Street, a six-story white marble mansion with
eight master bedrooms, fourteen servants' rooms, two elevators, and
rooms for the grand entertainments she would never give. And there she
stayed alone, rarely going out, until on April 23, 1934, at the age of
eighty-nine, she passed away.

Her net estate of $10,184,587, including $1,247,252 in cash, vari-
ous railroad securities, and real estate, was divided into three equal parts.
Gertrude received the money that had been set aside from the sale of
the Vanderbilt mansion. Gladys was given The Breakers and about two
thirds of the $7 million trust fund Cornelius Vanderbilt had left for his
wife. Neily was left the Gwynne Building in Cincinnati, which was
leased to Procter and Gamble. Reggie's young daughter, little Gloria,
was left $1 million. Servants received $1,000 for each five years of
employment. And Alice left her grandson Neil, the publisher of those
nasty newspapers, nothing but a photograph of herself.

3.

When Alice of The Breakers died, sixty-one-year-old Grace immediately
ordered new calling cards, inscribed MRS. VANDERBILT. Her time had
come. She now reigned solitary and supreme.

Unhappy with the table at which she had been seated at Ciro's in
Monte Carlo, Grace imperiously summoned the maître d'hôtel.

"Why have you given me this table? Let me have that one over
there."

The maître d' apologized and explained that that particular table
was reserved by Prince Danilo of Montenegro.

"Well, then I will have that one in the corner," Grace pressed.

The maître d' was apologetic. That table was kept for an English
duchess.

"Then see that you give me a better table than the Duchess's in
the future," Grace ordered.

She turned to an Englishman she knew who was seated at the next

table. "It is only here in France," she explained, "that I am treated in this way. In America I take a rank something like that of your Princess of Wales."

"Oh?" the Englishman responded. "Then who is your Queen?"[10]

The expense associated with maintaining her rank, whatever it was, which entailed entertaining ten thousand guests each year, was taking its inevitable toll.

The daily centerpiece of fresh flowers for the dining room cost $75, the other five vases of fresh flowers on the long dining table were filled for $35 each, and the five fruit bowls were kept full of $200 worth of fresh fruit. To stock the candy dishes cost $300 each month. Grace was spending $250,000 each year to entertain her friends and maintain her position as Mrs. Vanderbilt, $125,000 more each year than her and Neily's annual income. The expenses of running 640 Fifth Avenue and of paying taxes for the privilege of having a home on a piece of the world's most expensive urban real estate amounted to over $1,000 dollars a day. Her principal was dwindling at a rate of several hundred thousand dollars each year, yet the most she could bring herself to do to meet the crisis was to cut the number of servants in half, from twenty to ten.

Neily had been offered $9 million for 640 Fifth Avenue when it was being considered as a site for Rockefeller Center. Though he was strapped for cash, Grace had been adamant that the offer be rejected. Now the end was in sight. The fairy tale could not go on much longer. In May 1940, Neily sold the house to the William Waldorf Astor estate for $1.5 million, retaining the right for Grace to continue to live there, paying rent, until one year after his death.

"What a fool your father was to forfeit a fortune for a pretty face," William Randolph Hearst once told young Neil Vanderbilt.[11]

Neily Vanderbilt long before had come to the same conclusion himself. A pretty face didn't last very long, and when it was gone, when Grace grew older and put on weight from all the French cooking she consumed at her perpetual entertainments, what was left was two incompatible people.

"Why don't you get a divorce?" Neil would ask his mother or father when he had one of them alone.

"People in our position do not get divorces," Neily answered.

MRS. VANDERBILT

"But I love your father!" was Grace's response.[12]

As Grace continued her leading role in society, Neily, bored as always by her social affairs, horrified by the money she was spending, which was depleting their fortune at an alarming rate, became increasingly introspective, seeing himself as a failure. "Every Vanderbilt son . . . has increased his fortune except me," he once remarked, remembering the business success of his father, Cornelius, and his father's father, William.[13]

Tall, thin, his face emaciated from chain-smoking four packs of cigarettes a day, disillusioned, cynical, bitter, Neily became a wanderer, a nomad, living aboard his yacht.

At the outset of the First World War, he had donated the *North Star* to the British Red Cross to be used as an auxiliary floating hospital.[14] He later bought from Vincent Astor the *Winchester,* a 225-foot steam yacht that looked like a navy destroyer and could attain speeds of over thirty knots. It cost $7,000 a month just to keep the *Winchester* tied up at the dock, and at least twice that much on long cruises, so Neily lived at dockside. Occasionally his mother would help him with the *Winchester*'s expenses. "Dear Neily," Alice of The Breakers once wrote to her son in the early years of the Depression, "I would like to give you a present for the summer and it would be such a pleasure to me if you will put the Winchester in commission for three months. I know how you enjoy her and want you so much to have her this summer. Love, Affy yrs. Mother."[15] And sister Gertrude also found ways to give money to Neily to help cover the costs of using his yacht. But more often than not he could be found tied up at the Miami Yacht Basin, far away from Fifth Avenue and Newport, and there he died of a cerebral hemorrhage on March 2, 1942, at the age of sixty-nine.

Neily's death was significant to his wife primarily because it triggered the countdown to her departure from 640 Fifth Avenue. (It was Neily's sister Gertrude, not Grace, who made it to Florida to be with him the day he died, and it was Gertrude, not Grace, who paid for his body to be taken by private railroad car from Florida to New York.)

Neily was dead. Seventy-two-year-old Grace had one year left in her beloved home. The dowager empress still, she kept right on with her luncheons and dinner parties and balls and open houses, but the old

magic was gone. "One day I went to dinner at Mrs. Vanderbilt's and I'll never forget it," a guest recalled. "It was literally impossible to have a conversation with her. She was *without* conversation. So, during the lull, I looked down the table and I suddenly realized that the name of every one there began with an 'R.' We were all obviously her secretary's 'R' list. But as I looked closer I didn't feel too badly. At least we did spill over a bit. There were a couple of 'S's.' "[16] Hadn't Ward McAllister decreed decades before that "the success of a dinner depends as much upon the company as the cook. Discordant elements—people invited alphabetically or to pay off debts—are fatal"?[17]

Her eviction repeatedly postponed, Grace kept on entertaining until the last moment, when, in April 1945, moving men from the Parke-Bernet Galleries arrived to take out the entire art collection, as well as many of the mansion's most important furnishings. The collection of 183 paintings that William H. Vanderbilt had so proudly assembled in the early 1880s—his "pleasing pictures," the "very best foreign paintings that money could buy," which he had purchased for more than $2 million—was sold during the evenings of April 18 and 19, 1945, for a total of $323,195. An 1825 Louis XVIII Aubusson carpet went for $825, a Brussels Renaissance tapestry for $700, a Louis XV inlaid king-wood cabinet for $850. An agent from Paramount Pictures flew in and bought for $5,800 the paneling from the ballroom, dining room, and library for period set pieces.

With new construction postponed because of the war, demolition of the Vanderbilt mansion, empty and quiet at 640 Fifth Avenue, was put off. The brownstone veneer began peeling away, revealing the under-lying bricks. Rain and wind swept in through broken windows.

Early in September 1947, workmen drilled through the basement floor to test the bedrock, and at last the destruction of the mansion began. As Neil drove to see his mother at her new home a mile up Fifth Avenue (a five-story brick and limestone mansion with only twenty-eight rooms compared to the fifty-eight rooms she had left), "I saw the wreck-ing crews demolishing 640. Stone by stone they were tearing down my great-grandfather's baronial brown palace. Already my fifth-floor bed-room and Father's handsome walnut paneled study and sound-proofed engineering laboratory had vanished. Mother's famous pink boudoir still

remained on the second floor, its undraped windows staring blindly down at the Avenue Mother had dominated for fifty triumphant years."[18]

From behind the fence that had been raised around the massive structure rose the sounds of sledgehammers and creaking timbers and the clatter of falling bricks.

4.

Grace Wilson Vanderbilt considered herself *the* Mrs. Vanderbilt, and the public did, too, but to the Vanderbilt family she was nothing but a pretender to the throne. "Honestly," one Vanderbilt descendent said, "I can't ever remember meeting her. I must have, of course, at some big family things and stuff, but I can't remember it."[19] To the family, to the upper reaches of America's aristocracy, there was one and only one Mrs. Vanderbilt, and her name wasn't Mrs. Vanderbilt. It was Mrs. Twombly. Florence Adele Vanderbilt Twombly: daughter of William H. Vanderbilt, the Commodore's sole surviving granddaughter.

Her long life spanned the Gilded Age, marking its beginning and end. Longer than any other member of the family (for that matter, longer than almost any other *grande dame* of the Gilded Age), she led exactly the type of life of pomp and splendor the very rich were supposed to lead.

Florence had been born in 1854 in Billy Vanderbilt's farmhouse on Staten Island, the sixth of his eight children. When she was ten, her parents moved the family to the stone mansion at 459 Fifth Avenue that the Commodore had bought for Billy so that he could be nearby to help manage the growing railroad empire.

On November 21, 1877, Florence married Hamilton McKown Twombly, a proper young Bostonian who had parlayed a modest inheritance into a fortune in railroad holdings and whose financial acumen the Vanderbilt family tapped in managing its railroads and personal finances. The wedding took place in the midst of the trial over the Commodore's will, at a time when society viewed the Vanderbilts as a collection of rich vulgarians. An offensive account of the wedding in the

New York Times reflected this sentiment. THE MOST COSTLY WEDDING DRESS EVER WORN ON THIS CONTINENT, read the headline of the article, which described how several thousand invitations had been issued; how St. Bartholomew's Church was besieged by "an immense and exceedingly unruly crowd"; how "two rough individuals shouting 'Tickets!' " collected the invitations that admitted the guests to the church, and if a guest, like one personal friend of William Vanderbilt's, was dilatory in producing them, the pair caught the offender by the neck and flung him "backward over the curb." As a result, "men and women in evening attire were squeezed and jostled, their costumes disarranged, and their persons bruised." The *Times* noted that in the church, packed almost to suffocation, "a large number of Wall Street brokers and members of German banking houses were prominent. There were also many women of a class that would not be expected to receive invitations." The bride, the article concluded, wore silk stockings "that cost $120 the pair."[20]

That was just about the last time the public ever read anything in the papers about Hamilton and Florence Twombly.

At the time of their marriage, the combined net worth of bride and groom was $70 million, producing an annual income of $3.5 million, or $70,000 a week. In addition to their mansion at 684 Fifth Avenue, which William Vanderbilt had given to his daughter and son-in-law, and Vinland, the large English Tudor summer cottage they had purchased in Newport, next to The Breakers of Alice and Cornelius Vanderbilt, the Twomblys wanted a country house for the spring and fall seasons. They retained the prominent architectural firm McKim, Mead and White to design their home. "Twombly wants a house on the order of an English Country gentleman," architect William Mead told his partners. "I don't think he knows exactly what he means, and I am sure I don't, but as near as I can gather, his idea is that it shall be a thoroughly comfortable house without the stiffness of the modern city house. Twombly is the sort of man, who, if he gets what he wants, is willing to pay liberally for it."[21] What he wanted was the appropriate house in the appropriate setting for a family of the American nobility.

They purchased the setting in 1891, twelve hundred acres in the countryside of Morris County, New Jersey, an area where more than a hundred other millionaires had built country estates to enjoy the beauty and peace and fresh air of these quiet surroundings. Frederick Law

Olmsted was called upon to site the mansion and to landscape the several hundred acres of formal gardens and lawn that would surround the house. "You have a sweep of landscape to an infinitely remote and perspectively obscure background, an appropriate and well-proportioned foreground and middle distance being perfectly within your control, as much so as if you owned the State of New Jersey . . ." Olmstead wrote to Twombly. "You have everything screened that is desirable to be screened. Everything within twenty miles is as much under your control, so far as concerns the fitness, propriety and becomingness of the situation, as if you had the free use of it. The grand landscape is yours and nobody can interfere with your possession of it."[22] The estate would be completely secluded from public view.

Construction began in 1893, and the family first occupied Florham—its name derived from the first syllables of the Twomblys' first names, Florence and Hamilton—in the spring of 1897.

A two-mile drive winding through parklike grounds led to the imposing formal mansion of brick trimmed with Indiana limestone, whose exterior matched to scale one wing of Henry VIII's Hampton Court, designed by Sir Christopher Wren. The 110 rooms of Florham were filled with antiques and artworks, including a set of seventeen monumental tapestries executed in the royal ateliers of Paris in 1640 and presented by King Louis XIII to the cardinal-legate Francesco Barberini, nephew of Pope Urban VIII. The tapestries, woven from the finest shaded wools richly highlighted in silk, depicted the romance of the crusader Rinaldo and the beautiful Saracen princess Armida, and had hung in the Barberini Palace in Rome for two and a half centuries, until purchased for the Twomblys for $179,000 and hung in the great hall and ballroom of Florham.

The general manager of the estate, a Harvard graduate and former congressman, oversaw the operations of this self-contained dukedom: the stables with sixty teakwood stalls for sixty Thoroughbred horses and thirty more for carriage horses; an orangery for growing the oranges, nectarines, grapes, and figs that Mrs. Twombly loved; the palm house for tropical plants; the ten large greenhouses devoted to the cultivation of orchids and chrysanthemums (the greenhouses were supervised by Queen Victoria's former head gardener, whom the Twomblys had been able to lure away to Florham). The estate had a power plant to supply

electricity and steam heat for the mansion and all its outbuildings; a spring-fed 3,300-gallon water storage tower, two 1,700-gallon storage tanks, and a backup pond holding 7.3 million gallons; and a private railroad siding in a distant field on the estate, used for bringing coal to feed the generating plant and guests in private railroad cars to fill the twenty-five guest bedrooms and some of the twelve master bedrooms. On the property, Hamilton Twombly established Florham Farms for his son as a nine-hundred-acre working farm designed to be run on scientific principles, just as George Vanderbilt was doing at Biltmore. The farm included 160 Guernsey cattle, 24 of which won prizes at the St. Louis World's Fair in 1904 and brought Mr. Twombly recognition as the premier Guernsey breeder in the United States; another 400 cows that produced annually more than a million gallons of milk, which, when sold in the neighboring towns from an expensive wagon drawn by a pair of Thoroughbreds in gold-mounted harnesses, netted the estate $40,000 a year; and 100 sheep, tended by shepherds, to keep the lawns trimmed. Flowers and vegetables grown on the estate produced another $25,000, and two-day-old calves were sold for as much as $2,000 each.

Unlike other members of the Vanderbilt family, the Twomblys never courted publicity. Breathless accounts of the magnificence of Florham never appeared in the press. The papers never even published a photograph of it. The golden couple were so secure in their social position that they scorned newspaper mention. Florham was for their four children—Alice, Florence, Ruth, and Hamilton—to give them a healthy outdoor life away from the city.

The Twomblys' lives fell into a pleasing routine. Florham was their home in May and June when the azaleas and rhododendrons and wisteria and formal Italian gardens were at their peak. They traveled to Vinland in Newport for July and August, back to Florham to enjoy the autumnal splendor of the countryside in September and October, and finally to their town house on Fifth Avenue for the winter season.

The royal life the Twomblys had created for themselves was shattered, hit in the only spot where it was vulnerable: by tragedies that money could not deflect.

Sixteen-year-old Alice died of pneumonia on the eve of her society debut in January 1896.

On July 6, 1906, the Twomblys received word at Vinland that their eighteen-year-old son, Hamilton Jr., who had just graduated from Groton in June and intended to enter Harvard in the fall, had drowned in Big Squam Lake in New Hampshire while in charge of a summer camp for younger boys. The Twomblys were devastated by his death. Hamilton Twombly lost interest in everything; he withdrew from his business enterprises and social activities, resigned from his various directorships, and stayed away from Florham for two years, letting Florham Farms fall into disrepair. On January 10, 1910, at the age of sixty-one, he died of tuberculosis of the larynx; his friends said that he had never recovered from the shock of his son's death.

Alice gone. Hamilton Jr. gone. Hamilton gone. Daughter Florence married to William Burden. Fifty-six-year-old Mrs. Twombly and Miss Ruth, her twenty-five-year-old unmarried daughter, became recluses at Florham, far from the public eye. Their lives settled into a regular pattern, so set and formal that the servants knew just what they would be doing on any particular day of the year, years in advance.

In 1925, Florence Twombly sold her mansion at 684 Fifth Avenue and purchased the northeast corner of Seventy-first Street and Fifth Avenue as the site for a new home. There, at 1 East Seventy-first Street, at the age of seventy-one, she constructed a seventy-room palace, run by a staff of thirty, and she began again to entertain at her three homes.

A weekend house party—Mrs. Twombly gave five every spring and five every fall—was a formal ritual that began with the arrival at Florham of a special train from New York with private cars carrying fifteen or twenty guests. The guests arrived at the railroad siding on the estate in time for tea on Friday afternoon and a formal dinner that evening. A lady who had dined at Florham recalled that during the dinners of beluga caviar and terrapin and Mrs. Twombly's favorite dessert—Coeur à la Crème, a piece of homemade cream cheese in the shape of a heart, drenched with Florham's fresh strawberries—"Mrs. Twombly talked exactly so many minutes to the gentleman on her right, turned and gave exactly the same attention to the one on her left. Other guests, who had been surreptitiously watching her, did exactly the same. I suppose it looked like a ping pong match in slow motion."[23]

The next day the guests might play golf at the Morris County Golf Club, which Mrs. Twombly had founded, or swim or play tennis in

Florham's playhouse, stroll around the Italian gardens and manicured grounds enjoying the flowering shrubs in the spring and the avenues of blazing Japanese maples in the fall, or take motor trips around the country roads in one of the estate's maroon Rolls-Royces. Saturday night dinner was a special occasion to which scores of wealthy Morris County neighbors would be invited to join the weekend guests and indulge in a nine-course dinner.

(Joseph Donon, Mrs. Twombly's French chef, whom she had hired away from the Carlton in London for the unheard-of sum of $25,000 a year, "lives the ordered existence of a man of substantial means," the *Herald Tribune* reported. "At Newport . . . he has a separate villa of his own, his own staff of personal servants, and his own sailing boat, in which he enjoys fishing during the summer season in the reaches of Buzzard's Bay. When Mrs. Twombly entertains, and she does it frequently, there is no nonsense about economy, and the tradesmen's vans are days in advance, delivering hodsful of foie gras and whole greenhouses of orchids. There are seldom fewer than twenty for dinner, and M. Donon records that the regular daily delivery of lobsters never runs under fifty pounds."[24])

After dinner the guests would enter the ballroom, one hundred feet long, lit by three enormous chandeliers, each with two hundred lights, for music and dancing, followed at midnight by a light supper of lobster and champagne, before the houseguests retired to the thirty-seven bedrooms, each with a private bath and a room for a maid.

After a Sunday morning service at the Grace Episcopal Church several miles away, the houseguests enjoyed a five-course Sunday lunch. They were then given a little free time to prepare for Sunday evening, which started with a dinner to top Saturday's, after which the guests were escorted by liveried footmen to the great hall, 150 feet long, lined with the busts of twelve Roman emperors on marble pedestals and hung with the famous Barberini tapestries. There they were seated to hear a recital by the famed organist Archer Gibson, who for $750 would come to Florham and play the $85,000 organ, which, with its eight thousand pipes ranging in length from a small pencil to sixteen feet and its thousands of miles of wiring, was bigger than the organ at Radio City Music Hall. While the great hall was awash in organ music, Mrs. Twombly invariably sat in the throne chair directly to the left of the organ.

Later in the evening she would nod slightly to the organist, who would begin to play one of her favorite selections. At this point, like a queen, she would rise and ascend the white marble staircase to the second floor. The party, the weekend, was officially over.

Some guests invited to Florham over one Labor Day weekend were surprised to find that early on Monday morning a servant had packed their bags and piled them in the great hall near the door.

"Surely Mrs. Twombly doesn't expect us to leave today," one guest questioned the butler. "This is Labor Day, a legal holiday, and all of our offices are closed."

The butler bowed slightly and left to convey this news to Mrs. Twombly.

"Begging your pardon, Sir," he announced upon his return, "Mrs. Twombly says to tell you she has never heard of Labor Day."[25]

There must have been a time, millions and millions of years ago, when the last surviving dinosaurs wandered the face of the earth. So there was a time, deep into the twentieth century, when the last two survivors of the Gilded Age continued to live, through two world wars and the Great Depression, as if life had never changed.[26]

Twenty-five house servants ran Florham for these two elderly ladies, Mrs. Twombly and Miss Ruth, including the English butler who, in formal attire, looked like a visiting dignitary as he greeted guests and bade them farewell, the footmen, the French chef, two cooks, two scullery maids, a housekeeper in charge of all the maids, chambermaids, parlor maids, first- and third-floor maids, and Mrs. Twombly's and Miss Ruth's personal maids. One hundred more servants maintained the grounds, the greenhouses, the farm, and the stables. Every house servant was dressed in formal attire at all times. Each footman wore black shoes with buckles, black stockings, black velvet knickers, a maroon vest, and a black jacket with sterling silver buttons. Five chauffeurs and coachmen dressed in maroon livery were on duty to tend to the fifteen maroon Rolls-Royces Mrs. Twombly kept in her carriage house, including her favorite, which sported a gold and emerald vanity installed by Cartier.

"There is hardly a household left in America for a first-class butler . . ." Stanley Hudson, an English butler, once commented. "Why these days we're even supposed to *dust the furniture!*"[27] Such a shocking

state of affairs would never occur at Florham. One Morristown matron interviewed a maid formerly employed by Mrs. Twombly. The maid asked for the outrageously high salary of $125 per month. The matron was astounded. "But I understand Mrs. Twombly only paid you $65 a month." The maid drew herself up with dignity. "But that," she said, "was Mrs. Twombly!"[28]

Florham was always run the way great estates were meant to be run. Each member of the staff had an individual assignment. One white-wigged footman did nothing but open the huge mahogany front door. Several others devoted their days to taking the silver—pure silver, never sterling—from the walk-in vault and polishing it to perfection. Another was hired to care for the sand on the barn floor and to rake it into "interesting patterns." A scullery maid did nothing but prepare vegetables.

During World War II, a guest remarked to Mrs. Twombly that many of her footmen must have been drafted. She sat silently and then sighed, "This week we lost four from the pantry alone."[29]

When her grandson announced his marriage in 1935 to Flobelle Fairbanks, the niece of Douglas Fairbanks, Sr., Mrs. Twombly was anxious to attend the ceremony but not quite sure how to get to California. Her private railroad car had long been sold; the siding tracks at Florham had rusted. She would never use a public train, and at eighty-one, she was not about to try flying. The only way to get there would be by automobile, but in the midst of the Great Depression, she was concerned that her maroon Rolls-Royce would be too conspicuous and might be stopped by robbers or kidnappers. She hit upon a solution. She dressed as her maid and sat in the front seat of the Rolls next to her chauffeur. Her maid rode in the backseat, dressed as Mrs. Twombly.

At the wedding, she viewed with mild interest the large group of Hollywood celebrities, and then turned to a relative from New York. "In my day," she remarked quietly, "we had the celebrities. Now, if you please, the celebrities have us."[30]

And so it went, year after year: spring at Florham, followed by an imperial procession of Mrs. Twombly's fifteen maroon Rolls-Royces taking her and Miss Ruth and the servants to Vinland for the summer,

MRS. VANDERBILT

back to Florham for the fall, and then to the seventy-room town house on Fifth Avenue for the winter season. On and on, until August 26, 1947, when Mrs. Twombly was injured in an automobile accident in Newport, which left her bedridden. On April 11, 1953, at the age of ninety-eight, the last surviving granddaughter of the Commodore passed away.

"When Grandma died," her grandson reflected, "so did Florham. I wondered what would happen to the three men who did nothing but rake the gravel drives; to McFadyen, the head gardener, and his thirty men who nursed the orchids and manicured the grounds; to the man who always chased me and then snitched to my mother when I stole strawberries; to Allen, who was in charge of the farm, and his twelve men, who fed and milked and washed and polished the prize herd of thirty guernsey cows until they shone like gold: to Frederick, the head butler, who always greeted us at the front door at Florham; to the two men that did nothing but polish silver, and the man that washed dishes all day, and the four footmen who woke you up, served you breakfast, lunch and dinner, pressed your clothes and drew your bath; to the eight maids who cleaned and dusted the forty bedrooms and twenty-five bathrooms with woodburning fireplaces, the two dining rooms, and four living rooms, and that long hall that had no end. What would happen to Monsieur Donon, *chef par excellence,* culinary artist of the century, and his four assistants? What would happen to the full-time painters, bricklayers, and furniture repairmen who kept Florham looking like new; to the twelve men who watched over Vinland and the wonderful Belgian grapes they raised there; to Grandma's chauffeur and footman, who opened and closed the door when Grandma got in or out of the car; to Aunt Ruth's chauffeur and footman; to the man who did nothing but wash their cars? What would become of them? Then there was Miss Curry, Grandma's housekeeper, who tried to keep one hundred and twenty-six employees happy."[31]

The rising costs of fuel and labor, escalating taxes, the shrinking supply of servants: Who could afford to live in a 110-room house on a thousand-acre estate that required a staff of more than a hundred to maintain? Who in the middle of the twentieth century in the United States would want to try? It was over. The life Mrs. Twombly had lived

for almost a century was no longer possible. She left a gross estate of $22 million, but taxes took so much out of that—$18,359,807—that after other legacies were paid, not enough remained to make the gifts of $320,000 she had designated for various churches and hospitals.

Miss Ruth died a year and a half later on September 1, 1954, at the age of sixty-nine.

For two days in June 1955 before the Parke-Bernet Galleries of New York held an auction on the premises, Florham was opened to the public, its rooms filled with fresh flowers from the greenhouses as if Mrs. Twombly were presiding. Thirteen thousand sightseers from five states parked along the two-mile drive to the house and on the lawns, come to see how life had once been lived in the Gilded Age. As dealers hurried from room to room, turning over vases, examining paintings with magnifying glasses, measuring rugs, the curious sat down in chairs covered in silk brocade and felt the tapestries. They turned the solid silver knobs on the mahogany doors, tried out the bell system that once had summoned the servants, and wandered through the gardens and around the grounds, peering into the orangery, the playhouse, the stables. Who could resist a peek at how life once had been?

And then the auction.

The magnificent set of tapestries, which had hung in the Barberini Palace for 250 years and at Florham for 58, were sold as a group for $15,000. Who had a wall on which a tapestry fourteen feet high and fourteen feet wide could be displayed? Who had a home that could take a set of seventeen? How about the cut crystal palace chandelier that had graced the ballroom, eight feet high, six feet wide? Fifteen hundred dollars. The marble busts of Roman emperors perched on Siena marble pedestals looking over the great hall were sold for $225 each. A Savonnerie carpet from the great hall, twenty-seven feet long and sixteen feet wide, for $2,000. The twenty-six Regency carved mahogany dining chairs covered in crimson silk damask, for $95 each. The total contents of Florham brought $141,415, with an earlier sale of the contents of the Twombly town house on Fifth Avenue netting $110,260.

And then the massive gates set in the high brick wall by the gatehouse were closed. Save for the birds and the sound of the wind in the perfect trees, Florham was still, the mansion empty and dark. "When Grandma died, so did Florham." And so did a way of life.

MRS. VANDERBILT

5.

For all that remained, the Gilded Age might just as well have been a lost civilization, evident only to archaeologists digging and sifting to discover traces of a long-forgotten past.

The Commodore's porticoed mansion on Staten Island with its commanding view of the Upper Bay was demolished in the 1930s. The Harbor Isle Chevrolet agency now occupies the site.

The Empire State Building stands where Mrs. Astor received the Four Hundred in her brownstone at 350 Fifth Avenue.

Sixty-four years after Alva Vanderbilt's housewarming fancy dress ball on March 26, 1883, not one of the Vanderbilt family mansions that had dominated Fifth Avenue remained: 459, 640, 642, 660, 666, 680, 684, 742–746, 871, each had been demolished.

Where once expectant guests entered Alva's "little Chateau de Blois" stands the forty-one-story Tishman Building, filled with such businesses as Air France, B. Dalton, Botticelli Shoes, the Seaman's Bank, and Bantam Books, surmounted by the Top of the Sixes restaurant. In 1987, Sumitomo, the large Japanese bank, bought the building for $500 million, half a billion dollars, at that time the second-highest price ever paid for a Manhattan office building.

Alice and Cornelius Vanderbilt's block-long 137-room château at 1 West Fifty-seventh Street made way for Bergdorf Goodman.

The stronghold at 640 Fifth Avenue of Grace Vanderbilt, who died of pneumonia at the age of eighty-three in 1953, is now a fifteen-story building housing branches of the Bank of Ireland and Citibank.

An apartment building stands at the site of Florence Vanderbilt Twombly's seventy-room mansion at 1 East Seventy-first Street.

Some shards of the Vanderbilt mansions remain.

Two limestone relief panels carved for the carriage porch of Alice and Cornelius Vanderbilt's mansion were placed across the street in the Fifth Avenue entrance of the Sherry-Netherland Hotel. And the ornate wrought-iron gates that once guarded their mansion now form the entrance of the five-acre Conservatory Gardens in the northeastern corner of Central Park.

Where Gertrude Vanderbilt Whitney's mansion stood on 871 Fifth Avenue is a tall apartment building; in a corner of its lobby is her small bronze sculpture of the goddess Daphne.

Willie Vanderbilt left ten of his paintings that had hung at 660 Fifth Avenue to the Metropolitan Museum of Art, including a Rembrandt, a Gainsborough, and what has been called the "deliciously erotic" *Toilet of Venus* by Boucher, which had hung in Alva's bedroom, as well as a gold and black lacquer Louis XVI secretaire and commode bearing the cipher of Marie Antoinette, which are comparable to pieces in the Louvre's collection and which are still acclaimed today as "the finest" in the Metropolitan.[32] And an eight-foot-high Demidroff vase of green malachite, which had stood in the center of the great hall of 640 Fifth Avenue from the day in 1883 when William H. Vanderbilt moved in until the day Grace Vanderbilt was forced to move out in 1945, was given to the Metropolitan Museum of Art after her death.

The two massive black iron eagles that once perched on the Grand Central Depot were taken to flank the entrance to Willie K.'s Centerport, Long Island, estate, Eagle's Nest, and today greet the visitors to this public museum and garden.

The only remaining Vanderbilt building in New York City is, in fact, Grand Central Station, rebuilt in 1903 to replace the original structure the Commodore had erected.

The New York Central itself, for years the bluest of the blue chips, an investment as safe and secure as government bonds, has also disappeared. After peaking in the late 1920s, the freight being carried by the Central declined steadily through the years as trucks, barges, airplanes, and buses cut into its business and as the great established industries of the East grew less vigorously than those in other parts of the nation. Much of the railroad's equipment became obsolete. Any profits the Central did show were usually the result of its nonrailroad investments.

The Commodore had left control of the Central to his son Billy, and Billy had left it in the hands of his two oldest sons, Cornelius and Willie. All of Cornelius's sons had died—William, Alfred, Reggie—except Neily, who would have nothing to do with the Central. Willie and Alva's older son, Willie K., did serve as president of the Central for

MRS. VANDERBILT

one year, 1918–1919, but found that he could have more fun aboard his $3 million diesel yacht, the *Alva*. (He died in 1944 at the age of sixty-six.) His younger brother, Harold, served as a director of the Central for four decades, but devoted his real efforts to defending the America's Cup successfully three times and to originating contract bridge.

Through a proxy battle in 1954, opposed by management in a defense led by Harold Vanderbilt, Robert Young seized control of the Central with the promise of its revitalization and higher dividends. In January 1958, after a particularly disastrous year during which its stock dropped from 49 to 13, the directors of the Central suspended its quarterly dividend. Five days later, Young, suddenly aware that the eastern railroading business might never recover, shot himself in the billiard room of his Palm Beach mansion.

The only solution to the Central's problems seemed to be a merger with another line. A union between the New York Central and its arch rival from the days of the Commodore and William Vanderbilt, the Pennsylvania, was first proposed in 1957. After years of hearings and investigations by the Interstate Commerce Commission (whose mandate was that every railroad consolidation be "consistent with the public interest," a provision in the Interstate Commerce Act that might well have been a legislative reaction to William Vanderbilt's ill-advised "public be damned" remark), the merger was approved in 1968, creating the Pennsylvania New York Central Transportation Company: the Penn Central, for short.

The consolidation of the two railroad giants created the thirteenth-largest company in the United States, with assets of $5 billion, annual revenues of $1.5 billion, 21,000 miles of track crisscrossing 14 states and Canada, 4,000 locomotives, and 100,000 employees. Studies had shown that the economies and operating efficiencies that could be achieved by combining the railroads would yield savings within several years of $100 million. This did not prove to be the case. The merger of two failing roads created a larger failing company. The New York Central's earnings in 1967 plunged from the $43 million of the year before to $1 million; the Pennsylvania's from $45 million to $14 million. In its first year of operation as the Penn Central, the company lost $100 million. By 1970, the foundering giant had filed for bankruptcy. All of its railroad property

was transferred to the government's Consolidated Rail Corporation (Conrail).

The Fifth Avenue mansions, gone. The New York Central, gone. And the country homes, how did they fare? Idlehour. Marble House. The Breakers. Belcourt Castle. Biltmore. Beaulieu. Wheatley Hills. Vinland. Florham. Not one was used by the next generation.

After Idlehour, Willie and Alva's eight-hundred-acre property in Oakdale, Long Island, was purchased from Willie's estate, the plans of the new owners to convert it into a country club went awry. It was sold at foreclosure to the Royal Fraternity of Master Metaphysicians, which renamed it Peace Heaven. Among other activities, the metaphysicians adopted a five-month-old baby girl whom they planned to make immortal. Peace Heaven was purchased, again at a foreclosure sale, in September 1941 by a member of the New York Cotton Exchange, who, also finding it too big to manage, offered it in 1945 to help relieve the apartment shortage in New York City and later as a center for the "improvement of international and human relations." The estate later became the research center for the National Dairy Products corporation. Finally, in the 1960s, it was purchased for $1 million (substantially less than its asking price, $1,750,000) for Adelphi University's Suffolk campus. The mansion is used for administrative offices, while the carriage house, which at one time held one hundred automobiles, is the gym and theater, and the powerhouse is now a performing arts center.

What of those great Newport summer cottages, Marble House, The Breakers, Belcourt Castle? Writing back in 1907, Henry James had called Newport a "breeding-ground for white elephants," referring to the elephantine summer cottages that lined Bellevue Avenue. "They look queer and conscious and lumpish—some of them, as with an air of the brandished proboscis, really grotesque—while their averted owners, roused from a witless dream, wonder what in the world is to be done with them. The answer to which, I think, can only be that there is absolutely nothing to be done; nothing but to let them stand there, always, vast and blank, for a reminder to those concerned of the prohibited degrees of witlessness, and of the peculiarly awkward vengeance of proportion and discretion."[33]

He had, of course, been right; there was absolutely nothing to be done with these cenotaphs of the Gilded Age.

Marble House had been built for a world that no longer existed, if ever it did anywhere other than in Alva's imagination. In the sure knowledge that there would always be footmen to open the front door, the ten-ton steel and gilt-bronze entrance grille had been built without outside handles. The one-of-a-kind seventy-pound bronze dining-room chairs could be moved only with the help of a valet. In 1963, seven years before his death, seventy-nine-year-old Harold Vanderbilt, in memory of his mother, Alva, gave the Preservation Society of Newport County funds to purchase Marble House from the Frederick H. Prince Trust. Since then it has been open to the public, visited by hundreds of thousands of tourists each year.

Cornelius and Alice Vanderbilt's youngest child, Gladys, the widow of Hungarian Count Szechenyi, in 1948 leased The Breakers to the Preservation Society of Newport County for one dollar a year. She maintained an apartment on the third floor of the mansion, which once had housed the servants, and there she stayed for several weeks each summer, unseen as she watched the tourists walk through her parents' summer home to "view the remains," as she termed it.[34] Gladys died in 1965. In 1972, the Preservation Society purchased The Breakers from her heirs for $365,000. Today, her daughter, Countess Anthony Szapary, the granddaughter of Cornelius and Alice Vanderbilt, still lives during the summer in the apartment on the third floor of The Breakers with her son, Paul, and daughter, Gladys. "I used to feel embarrassed when people asked where I lived," said her son. "But as I got older I felt proud. It's no longer my home . . . but I feel a strong sense of continuity. The Breakers is full of happy memories. Living here was a blast. It was a great place to play hide-and-seek."[35]

Alva Vanderbilt, Mrs. O.H.P. Belmont, had sold Belcourt Castle to her brother-in-law, Perry Belmont. The mansion stayed within the Belmont family for several years and then changed hands several times. It was purchased in 1956 by Harold B. Tinney, and is now used by his family as a private residence. It is open to the public, with tours given daily by costumed guides.

After George Vanderbilt's death in 1914, part of the vast Biltmore

estate was sold to the government for the Pisgah National Forest, another part became homesites, and another was used for a section of the Blue Ridge Parkway. Since 1930, the estate, now a national historical site, has been open to the public, with a dairy and a winery, in addition to the admissions, defraying the maintenance expenses.[36]

Beaulieu, Grace Vanderbilt's forty-four-room brick mansion in Newport, set on nine acres of property by the sea, was sold by her son Neil in 1955 for $30,000. It is still a private home, though the property has been subdivided. (Several of Grace Vanderbilt's lavishly beaded and embroidered Worth dresses are occasionally exhibited by the Preservation Society of Newport County to raise money to maintain its collection of "white elephants.") Neil, who spent his life trying to live down the fact he was a rich man's son, was into his seventh marriage when he died in 1974 at seventy-six.

Gertrude Vanderbilt Whitney's Wheatley Hills estate is now the clubhouse of the Old Westbury Golf Club.

Florence Vanderbilt Twombly's Newport mansion, Vinland, is the library of Salve Regina College.

Florham Farms was demolished and became the site of the Exxon Research and Engineering Company. And in 1957, the rest of Florham was sold for $1.5 million to Fairleigh Dickinson University for its third New Jersey campus. The grass around the mansion, which had grown four feet high, was hacked down, the organ in the great hall was sold for a few thousand dollars, and desk-chairs and blackboards were arranged in Mrs. Twombly's master bedrooms for the first students arriving in the fall of 1958. The empty orangery became the reading room of the library. The carriage house where the fifteen maroon Rolls-Royces were polished to sparkling perfection is now the science building, while the playhouse where Miss Ruth swam and played tennis is part of the gymnasium.

Without a Vanderbilt fortune and 126 workers to keep it just so, Florham today is showing its age. The marble floor of the great hall is scuffed and yellowing, paint peels from around the windows and under the porch roof. Outside, Olmsted's plantings are overgrown, his vistas obscured, the outlines of the Italian garden just discernible. A bird nests inside one of the massive lighting fixtures with a broken glass panel.

MRS. VANDERBILT

From a dormitory hidden beyond the gardens, a stereo blares. Shouts and cheers echo from an autumn lacrosse game on the field where guests once arrived at the railroad siding. And in the distance, a whistle sounds as a commuter train rushes by.

Consuelo, the former duchess of Marlborough, died on December 6, 1965, at the age of eighty-eight, with about $1 million left from all the millions her father, Willie Vanderbilt, had given her. She had less trouble holding on to a photograph of Winthrop Rutherfurd, which she had kept with her through all the years.

Sometimes, Consuelo once had said, "I thought of the Commodore, what he would have made of me, and of the generations that followed him."[37] What indeed! Blatherskites all! They had certainly made a name for themselves, but at what a price!

Why had he left his fortune to one son, to Billy? To keep the wealth concentrated from generation to generation. "What you have got isn't worth anything, unless you have got the power, and if you give away the surplus, you give away the control."[38] Now look what they had done. They had divided the fortune up among themselves, time and again, until it was dissipated, one hundred years after his death, among his 787 descendants.

And the New York Central. Where did they think the money was coming from? "Keep the Central our road," he had told Billy. And what had they done? They had sold their stock and let others manage the railroad, and now the Central, their source of wealth, was gone.

And the spending! The wild, extravagant, endless spending. The Commodore had never let his expenditures rise with his income. "Something may happen," he was convinced, and therefore he kept saving.[39] "I suppose the property will go faster than ever I made it after I am gone," the Commodore once told a friend. How right he was. Those amazing châteaus on Fifth Avenue. The squads of liveried footmen. The yachts. The summer palaces. The private railroad cars. The rivers of pearls and diamonds. The tapestries, the old masters. The fleets of maroon Rolls-Royces. Now the fortune was gone.

Maybe it had all been predictable. On December 6, 1877, in the midst of the courtroom trial over the Commodore's will, the *New York*

Daily Tribune published a remarkably percipient editorial, "Founding a Family."

> The Vanderbilt case is an impressive lesson in the folly of attempting to "found a family" upon no better basis than the possession of money. The ruling idea of the Old Commodore's latter years was to amass a huge fortune which should stand for generations as a monument to the name of Vanderbilt, and make the head of the house a permanent power in American society. He chose one son out of his many children, and trained him to possess alone the inheritance of this vast wealth, as a king's first born is educated for a crown; and this favored son in turn he doubtless expected to transmit the deposit, unimpaired and perhaps increased, to the head of the next generation. American law and American customs discountenance such preferences, and have never favored the permanent confining of wealth to a single narrow channel. There is no country in the world where fortunes are made so quickly, none where so large a proportion of the men in business have succeeded in amassing a comfortable independence; yet there is none in which ancestral wealth is so rare, and none in which inherited money has done so little for its possessors. Every few years a new Croesus dazzles us with his sudden abundance; he has plundered the stock exchange, he has negotiated a railroad subsidy, he has speculated in land, he has found a silver mine, he has floated a construction company, he has gambled in rotten steamships, he has held an army contract, or he has perchance built up prosperity by shrewd adventures in legitimate commerce. What becomes of all these stupendous fortunes? Most of them vanish as quickly as they came.
>
> The Vanderbilt money is certainly bringing no happiness and no greatness to its present claimants, and we have little doubt that in the course of a few years, it will go the way of most American fortunes; a multitude of heirs will have the spending of it, and it will be absorbed in the vast circulating system of the country. The plans of the dead railway king will come to naught; and if he ever revisits the earth to look after

what he had so much at heart in his last years, he will be satisfied that the art of founding a family was one of the things that he did not know.

"It takes three generations to make an American gentleman," Ward McAllister had opined.[40] Later, Andrew Carnegie spoke of "shirt-sleeves to shirtsleeves" in three generations. Perhaps both were right.

NOTES

For further information on works cited,
see the Bibliography.

CHAPTER ONE

1. Croffut, *The Vanderbilts and the Story of Their Fortune*, pp. 142–143.
2. *New York World*, December 5, 1877.
3. Ibid.
4. *New York Daily Tribune*, December 8, 1877; March 14, 1878.
5. *New York Sun*, March 7, 1878.
6. *New York Times*, March 23, 1878.
7. Ibid.
8. *New York Herald*, April 10, 1878.
9. Andrews, *The Vanderbilt Legend*, p. 160.
10. *New York Daily Tribune*, March 20, 1878.
11. *New York Herald*, November 15, 1877.
12. *New York Mail*, December 11, 1877; *New York Sun*, November 13, 1877.
13. *The World*, December 19, 1877.
14. *New York World*, December 5, 1877; December 19, 1877; November 16, 1877.
15. *New York World*, March 9, 1878.
16. *New York Herald*, January 5, 1877.
17. His office, he said, was "the head of an upturned flour-barrel on the wharf." He kept his accounts there, "and took my cold dinner daily on that same barrel." (Croffut, pp. 106–107.)
18. Elliott, *Uncle Sam Ward and His Circle*, p. 627.
19. Parton, *Famous Americans of Recent Times*, p. 384.
20. Andrews, p. 18.
21. Vanderbilt, *Queen of the Golden Age*, p. 129.
22. Friedman, *Gertrude Vanderbilt Whitney*, p. 11.

23. *New York Tribune*, November 13, 1877.

24. Croffut, p. 41.

25. *New York Times*, April 13, 1878.

26. Lane, *Commodore Vanderbilt: An Epic of the Steam Age*, p. 201.

27. Ibid.

28. *New York World*, November 16, 1877.

29. *New York Herald*, December 13, 1877.

30. *New York Herald*, December 9, 1885.

31. *New York Sun*, December 9, 1885.

32. Lane, p. 200.

33. *New York Daily Tribune*, November 14, 1877.

34. Once when the Commodore was visiting Corneel at his farm, Corneel collapsed in an epileptic fit, with his jaw clenched, his teeth biting his lips and tongue, saliva frothing out of his mouth. The Commodore pointed to a picture of his steamer *Vanderbilt* hanging on the wall. "I would have given that ship to cure Cornelius if it had been possible," he said. (*New York Herald*, March 30, 1878.)

35. *New York Herald*, December 14, 1877.

36. Andrews, p. 27.

37. *New York Times*, December 22, 1877.

38. Andrews, p. 27.

39. *New York Herald*, December 22, 1877.

40. *New York Times*, December 22, 1877.

41. *New York Sun*, December 18, 1877.

42. *New York Times*, April 3, 1882.

43. *New York World*, April 11, 1878.

44. Andrews, p. 28.

45. Clews, *Fifty Years in Wall Street*, p. 384.

46. Croffut, pp. 118–119.

47. There was no use opposing his father. At one time he threatened to break up his family and move to Europe if his wishes were not carried out.

48. *New York World*, November 16, 1877.

49. *New York Daily Tribune*, November 14, 1877.

50. Croffut, p. 45; Lane, p. 92.

51. *New York Times*, August 14, 1861.

52. *New York World*, March 16, 1878.

53. *New York Herald*, April 29, 1853.

54. His mother died the next year, on June 22, 1854, leaving an estate of $50,000, the product of her industry and thrift.

55. *New York Post*, January 5, 1877.

56. Churchill, *The Splendor Seekers*, p. 36.

57. Amory, *Who Killed Society?*, p. 82.

58. Andrews, pp. 48–49.

59. *New York Times,* January 5, 1877.

60. Lane, p. 112.

61. During the Civil War, the Commodore's actions exhibited both patriotism and more ignoble characteristics.

On March 15, 1862, he received a telegram from Washington: "The Secretary of War directs me to ask you for what sum you will contract to destroy the *Merrimac* or prevent her from coming out from Norfolk—you to sink or destroy her if she gets out? Answer by telegraph, as there is no time to be lost." (Lane, p. 176.)

Vanderbilt immediately went to see Abraham Lincoln and the secretary of war.

"Can you stop the *Merrimac* from coming out?" the president asked him.

"Yes, I believe I can. We can sink her if she attempts to come out."

"For how much money will you undertake to do it?"

"The Government cannot hire me for anything. I will not be put on a par with the thieves who are robbing the Government in the shape of high pay."

Lincoln could not understand this response. "Well, then," said the president, "we cannot do anything with you."

"I think you can," Vanderbilt replied. "I will *give* the Government the steamer *Vanderbilt,* and fit her out, and put her at the station off Point Comfort, keep charge of her myself, and sink the *Merrimac* if she attempts to come out, provided your Navy Department shall have nothing to do with the ship. I do not want to be bothered by any navy men to accomplish this thing."

"How long before the *Vanderbilt* could be at the point named?"

"I will have her here in forty hours."

The *Vanderbilt* was there in forty hours, and Commodore Vanderbilt was skippering her, itching to blow up the *Merrimac.* The Confederates were smart enough not to venture out. (New York Genealogical Society and Biographical Library, *Laurus Crawfurdiana,* p. 93.)

Congress adopted a resolution thanking the Commodore for his *gift* of the *Vanderbilt* to the nation, a gift that he had never intended to make. He had intended rather to *loan* his prize steamship to the government for one specific mission. "Congress be *damned!*" he swore when he received a copy of the resolution. "I never gave that ship to Congress. When the Government was in great straits for a suitable vessel of war, I offered to give the ship if they did not care to buy it; however, Mr. Lincoln and Mr. Welles think it was a gift, and I suppose I shall have to let her go." (Lane, p. 179.) The steamship, which had cost the Commodore $800,000, was turned into a warship, and he was given a gold medal, inscribed "A Grateful Country to Her Generous Son." (Friedman, p. 12.) Years later, he would complain, "I was served meanly on that, meaner than ever any government served a man before or since. Why, they never gave me my vessel back." (Andrews, p. 93.)

In less noble moments during the war, he chartered or sold to the Union

a number of his ships that proved unseaworthy. A congressional investigating committee concluded that some of his ships were not fit even for a trip around New York Harbor. "In perfectly smooth weather the planks were ripped out of her and exhibited to the gaze of the indignant soldiers on board, showing that the timbers were rotten. The committee have in their committee room a large sample of one of the beams of this vessel to show that it had not the slightest capacity to hold a nail." (O'Connor, *The Golden Summers*, pp. 31–32.)

62. *New York Times*, January 5, 1877.

63. *New York Daily Tribune*, March 23, 1878.

64. *New York Sun*, March 23, 1878.

65. Twain, "Open Letter to Com. Vanderbilt," pp. 89–90.

66. Lane, p. 73.

67. Clews, p. 110.

68. *New York World*, January 5, 1877.

69. *New York Tribune*, September 19, 1879.

70. White, *The Book of Daniel Drew*, p. 180.

71. Clews, p. 113.

72. Ibid., p. 115.

73. Andrews, p. 107.

74. Depew, *A Retrospect of 25 Years with the New York Central Railroad and Its Allied Lines*, p. 5.

75. Croffut, p. 82.

76. Andrews, p. 113.

77. Croffut, pp. 83–84.

78. Andrews, pp. 116–118.

79. Minnigerode, *Certain Rich Men*, p. 85.

80. Moody, *The Railroad Builders*, p. 94.

81. Cochran, *Railroad Leaders*, p. 166.

82. Lynes, *The Taste-Makers*, p. 93.

83. Clews, p. 139.

84. Andrews, p. 132.

85. Lane, p. 251.

86. Simon, *Fifth Avenue*, p. 107; *New York Tribune*, January 5, 1877.

87. Weed, *Life of Thurlow Weed*, pp. 381–382.

88. Hendrick, *The Age of Big Business*, p. 22.

89. *New York Times*, July 7, 1873.

90. *New York Times*, April 19, 1873.

91. *New York World*, March 2, 1878. While showing a friend around his home, he turned and said, "Look at that bust. What do you think Powers [the sculptor] said of that head?"

"What did he say?"

"He said, 'It is a finer head than Webster's!' " (McAllister, *Society as I Have Found It*, pp. 251–252.)

92. In 1929, the statue of Vanderbilt was removed and placed by Grand Central Station, overlooking the top of the Park Avenue traffic ramp. The rest of the frieze was destroyed.

93. *New York World*, April 10, 1878. "I don't know whether Cornelius is as bad as some folks represent him to be," the Commodore told a friend, but then, on second thought, added that "Corneel is a damn bad fellow" and would spend all of the Commodore's money if he could get his hands on it. "Why I wouldn't let him come into my office if there was anything there he could carry away." (*New York World*, March 16, 1878.)

William's younger brother, Corneel, was envious of his success, and repeatedly pleaded with his father to give him, too, a chance to prove himself. "Here is William," Corneel wrote to his father, "to-day surrounded by his millions, with every luxury and comfort at his command, and myself persistently denied the opportunity of testing my usefulness and merit, and with a stipend enough indeed to supply the real necessaries of life, and not sufficient to enable me to sustain creditably the dignity of my position as the son of America's wealthiest and most distinguished citizen." (*New York Sunday News*, January 6, 1878.)

Corneel asked his brother to put in a good word for him with their father and see if there was a position he might have with the railroads.

William replied, "I cannot interfere between father and you; if I should he would give me a damning up and down. I dar'sn't do anything myself without he tells me to." (*New York World*, December 20, 1877.)

"I could be of some service to father on the New York Central road and also in some legislative matter," Corneel persisted.

"We really don't require any of your assistance," William haughtily told him.

Several days later, Corneel went to his father's office. William was present, and now treated his brother courteously. Corneel remarked on this change of attitude: "You don't assume such an imperious way as you did the other day."

"It is all summed up in a word," William answered. "There is the master," he said, pointing to his father, "and there is the slave," pointing to himself.

"Leatherhead!" the Commodore exploded at William, telling him that he had "been trying to learn him something for the last twenty years, but he did not know enough now to hold his gab." (*New York World*, December 19, 1877.)

94. Croffut, p. 81.

95. Harlow, *The Road of the Century*, p. 165.

96. *New York Daily Tribune*, March 16, 1878. The Commodore always treated his son like an employee. "Don't let William know anything about this plan until it is completed, else he will think that he originated it." (*New York Herald*, November 1877.) But Billy was now helping to make major policy decisions. The Commodore had no interest in extending his lines westward. "If we take hold of roads running all the way to Chicago, we might as well go to San Francisco and to China." (Croffut, p. 123.) It was Billy who convinced him to expand their lines to Chicago by buying the Lake Shore and Michigan Southern running along the south shore of Lake Erie.

97. "The Vanderbilts," *Spectator*, December 4, 1886.

98. Amory, p. 485.

99. Morris, *Incredible New York*, p. 130.

100. Ibid., p. 129.

101. Ibid.

102. *New York World*, March 9, 1878.

103. Croffut, p. 120.

104. Ibid., p. 121.

105. Churchill, p. 2.

106. *New York Herald*, December 14, 1877.

107. *New York World*, March 2, 1878; March 21, 1878.

108. Croffut, p. 122.

109. Croffut, p. 131.

110. *New York Herald*, December 14, 1877.

111. Croffut, p. 136.

112. Ibid., pp. 137–139.

113. Lane, p. 317.

114. Smith, *Sunshine and Shadow in New York*, p. 196.

115. *New York World*, March 9, 1878.

116. *New York World*, March 23, 1878.

117. *New York World*, March 9, 1878.

118. *New York World*, March 23, 1878.

119. *New York Herald*, April 10, 1878.

120. *New York Times*, April 10, 1878.

121. Ibid.

122. *New York World*, March 30, 1878.

123. Croffut, p. 134.

124. *New York World*, March 9, 1878.

125. Ibid.

126. Ibid.

127. *New York World*, November 16, 1877; *New York Herald*, April 10, 1878.

128. *New York Herald*, November 15, 1877. "A million or two is as much as anyone ought to have," the Commodore would tell his friends.

"Well, Commodore, there is a very easy way of getting rid of the rest."
"No, there ain't, for what you have got isn't worth anything, unless you have got the power, and if you give away the surplus, you give away the control." (*New York Times,* February 6, 1879.)

129. Vanderbilt, *Without Prejudice,* p. 241.

130. *New York World,* January 5, 1877.

131. *New York Tribune,* January 5, 1877.

132. *New York Times,* January 5, 1877. After Vanderbilt was dead, Dr. Henry Ward Beecher stated: "I am very glad he liked those hymns when he died; but if he had sung them thirty years ago, it would have been a good deal better for himself and many others. It is well to think that when an old man dies, he has turned to spiritual things before going, but there are plenty to say, as long as Commodore Vanderbilt could get about, he didn't care for hymns. We are glad when anyone is saved, but what we want is men in the full strength of power and life, and not the tag end." (Andrews, p. 177.)

133. Goldsmith, *Little Gloria . . . Happy at Last,* p. 80.

134. *New York Sun,* January 5, 1877.

135. *New York World,* November 17, 1877.

136. Gates, *The Astor Family,* p. 60.

137. *New York Sun,* April 14, 1878.

138. Browne, *The Great Metropolis,* p. 337.

139. Croffut, p. 290.

CHAPTER TWO

1. *New York World,* December 10, 1885.

2. *New York Times,* July 24, 1877.

3. Josephson, *The Robber Barons,* p. 378.

4. Holbrook, *The Age of the Moguls,* p. 93.

5. Ibid.

6. *New York World,* November 16, 1877.

7. *New York Herald,* November 13, 1878.

8. *New York Sun,* November 13, 1877.

9. Ibid.

10. *New York Daily Tribune,* November 14, 1877.

11. *New York Times,* May 13, 1877. Victoria married John Biddulph Martin, of a wealthy banking family. Tennessee married Francis Cook, an elderly widower who had made a fortune importing shawls from India.

12. *New York Daily Tribune,* April 10, 1878.

13. Andrews, *The Vanderbilt Legend,* p. 184.

14. *New York World,* December 22, 1877.

15. Ibid., December 29, 1877.

16. *New York Herald,* December 27, 1877.

17. Ibid.

18. *New York Times,* December 20, 1877.

19. *New York World,* December 27, 1877.

20. *New York Sun,* December 19, 1877.

21. *New York World,* December 22, 1877.

22. Clark, "The Commodore Left Two Sons," p. 92.

23. *New York Times,* September 28, 1878.

24. Clews, *Fifty Years in Wall Street,* p. 359.

25. Andrews, p. 185.

26. Bryce, *The American Commonwealth,* Vol. II, p. 515.

27. Quoted in *New York Herald,* December 11, 1885.

28. *New York Sun,* December 10, 1885.

29. Harlow, *The Road of the Century,* p. 136.

30. Jackson, *J. P. Morgan,* p. 120.

31. Allen, *The Great Pierpont Morgan,* p. 44.

32. Andrews, p. 205.

33. Allen, p. 45.

34. "I don't believe in a company organized for a specific business going out of its line. Our roads never build their own cars. They have them built for them by companies whose business it is to build cars. When I organize a railroad, I do so to run it as a railroad and not as a car-building company." (Andrews, p. 191.)

35. Hoyt, *The Vanderbilts and Their Fortune,* p. 261.

36. Hampton, *The Nickel Plate Road,* p. 165.

37. *Chicago Daily News,* October 9, 1882.

38. Harlow, p. 311.

39. Hampton, p. 69.

40. *New York Evening Post,* December 9, 1885.

41. Harlow, p. 321.

42. Jackson, p. 139.

43. Balsan, *The Glitter and the Gold,* p. 3.

44. *New York Evening Post,* December 12, 1885.

45. Clews, p. 370; Andrews, p. 194.

46. Andrews, p. 194.

47. Hampton, p. 171.

48. *New York Tribune,* October 18, 1882. Over the years, the Vanderbilt family's version of this story became quite sanitized. William had retired to his private railroad car to rest at the end of a long day. A group of reporters wanted to come aboard to interview him. He agreed to meet with one reporter, but only for a few minutes.

"Mr. Vanderbilt," the reporter exclaimed, *"your* public *demands* an interview."

William Vanderbilt chuckled. "Oh, *my* public be damned." (Balsan, p. 3.)

49. *New York Times,* December 9, 1885.

50. Fiske, *Off-hand Portraits of Prominent New Yorkers,* p. 329.

Chauncey Depew was in London as a dinner guest of the prime minister of England, William Gladstone. Mr. Gladstone turned to him.

"I understand you have a man in your country who is worth $100,000,000, and it is all in property which he can convert at will into cash. The Government ought to seize his property and take it away from him, as it is too dangerous a power for any one man to have. Supposing he should convert his property into money and lock it up, it would make a panic in America which would extend to this country and every other part of the world, and be a great injury to a large number of innocent people."

"But you have, Mr. Gladstone, a man in England who has equally as large a fortune," Depew responded.

"I suppose you mean the Duke of Westminster. The Duke of Westminster's property is not as large as that. I know all about his property and have kept pace with it for many years past. The Duke's property is worth about . . . $50,000,000, but it is not in securities which can be turned into ready cash and thereby absorb the current money of the country, so that he can make any dangerous use of it, for it is merely an hereditary right, the enjoyment of it that he possesses. It is inalienable, and it is so with all great fortunes in this country, and thus, I think, we are better protected here in England than you are in America."

"Ah, but unlike you in England, we in America do not consider a fortune dangerous." (Clews, pp. 360–361.)

51. *New York Sun,* December 9, 1885.

52. *New York Daily Tribune,* December 10, 1885.

53. *New York Sun,* December 14, 1885.

54. Croffut, *The Vanderbilts and the Story of Their Fortune,* p. 270.

55. Clews, p. 367.

56. *New York World,* December 10, 1885.

57. Ibid.

58. Croffut, p. 240.

CHAPTER THREE

1. Decies, *Turn of the World,* p. 49.

2. Churchill, *The Splendor Seekers,* p. 55.

3. William R. Perkins Library, Matilda Young Papers, Belmont Memoirs (hereinafter cited as Belmont Memoirs), p. 89.

4. Huntington Library, C.E.S. Wood Collection, Belmont Autobiography (hereinafter cited as Belmont Autobiography), p. 34.

5. Croffut, *The Vanderbilts and the Story of Their Fortune,* p. 182.

6. Balsan, *The Glitter and the Gold,* p. 6.

7. Belmont Autobiography, p. 3.

8. Belmont, "Woman's Right to Govern Herself"; biographical sketch of Mrs. Oliver H. P. Belmont.

9. Balsan, p. 6.

10. Ibid., p. 216.

11. Belmont Memoirs, p. 31.

12. Belmont Autobiography, pp. 24–25. Another story Alva liked to tell was of her governess "whose chief reason for living it seemed to me was to thwart the things I most wanted to do. Whenever I most eagerly desired to go into the Ocean for a dip, she was most emphatic in denying me this pleasure. One day she was sitting on a wooden bench in a new silk dress the folds of which were spread out all about her. 'Let me go into the water,' I coaxed but she was inexorable. When I found that it was a case of strategy, I summoned to my aid all the children of the neighborhood. 'This is what we'll do,' I explained. 'Some of us will dance before her like wild Indians, making a great noise, and the rest of us will go around behind her and quietly tack her skirts to the bench so she can't get up and then we will all go in bathing.' We carried the plan out to the last letter. The group who were to provide the distracting entertainment proved so loud in their demonstrations that the sound of the tacking was drowned in their shouts and whoops. When the job was finished we dashed for the water. The Governess tried to rise and detain us but she was held fast and every move she made endangered the precious new silk dress. These were the lawless ways in which I got results." (Belmont Autobiography, p. 25½.)

13. Belmont Memoirs, pp. 37–39.

14. Ibid., p. 5.

15. There is some evidence that Alva married William K. Vanderbilt solely as a means of saving her family from poverty. In the summer of 1917, she dictated a draft of her memoirs to Sara Bard Field in the Chinese teahouse above the sea at Marble House "to escape the curious ears of her servants as she tells me the intimate things of her life," Field wrote. The memoirs were to be published only after Alva's death. Field wrote to a friend about Alva's thoughts on her marriage to Willie Vanderbilt:

"But the chapter of her terrible marriage to Mr. Vanderbilt with its sordid selling of her unloving self but with the truly noble desire to save her Father who was slowly dying of worry and anxiety over his failing business—a pathetic mixture of good and bad—like life—and she only a baby—a girl barely seventeen who did not fully know the sex mystery—the agony of suffering—all this, the part that brings tears from her hard heart to her eyes—and to mine—this she will not let me write. She says she can't. 'The children would object, and the Vanderbilts, too, and you must not tell this to anyone not even to Frances or Janina or Kitty.' It is the sacred confidence of a woman's inner heart—a heart

that could have been loved into beauty but that has been steeled against its own finer and softer emotions. O, it is all fascinating what she is now telling me. Really, it is Life."

At another point, Alva advised Sara Field, who was divorced with children, to remarry and that "she could and would help me to a rich marriage if I would aid her in doing it." Field was shocked: "How can you cold-bloodedly advise such a thing after your experience with Mr. V?"

"I would not want you to marry such a weak nonentity as he," Alva answered, "but all men are not like that and you must bury Romance for the Cold Facts of life in which your children are bound up. You cannot help your children to advantages through sentimental romance but through money which alone has power." (Huntington Library, C.E.S. Wood Collection, Sara B. Field to C.E.S. Wood, Box 280.)

That Alva married Willie to help her family is also hinted at in the draft of her autobiography. Young Alva realized the seriousness of her father's plight and how his fear of what would happen to his daughters "haunted him and brought him to his sick bed. I saw him growing old and worn before my eyes. When I finally understood the situation, my practical nature at once wanted to help. It was while things were going from bad to worse in my father's business that I married William K. Vanderbilt. My Father was sick in bed and unable to attend the wedding. When I was all dressed for the ceremony and about to leave the house, I stole up to my Father's room. He kissed me with great tenderness and told me I was taking a great burden off his mind and that he knew if anything happened to him I would look after the rest of the family. I had been married but two weeks when my Father died. He was beyond any need of the help which the change in my fortune due to my marriage had brought to him. But this I know, the anxiety which had probably hastened his death had been much removed before he left us. Had he died sooner, the whole course of my life might have been other than it was." (Belmont Autobiography, p. 35.)

16. Croffut, p. 184.

17. Ibid.

18. Vanderbilt, *Queen of the Golden Age*, p. 44.

19. Balsan, p. 7; Martin, *Things I Remember*, p. 181.

20. Croffut, pp. 114–115.

21. Balsan, pp. 4–5.

22. Lehr, *"King Lehr" and the Gilded Age*, p. 121; Maxwell, *R.S.V.P.*, p. 104.

23. Van Pelt, *A Monograph of the William K. Vanderbilt House*, p. 10.

24. Friedman, *Gertrude Vanderbilt Whitney*, p. 16.

25. Wharton, *A Backward Glance*, pp. 54–55.

26. Thorndike, *The Magnificent Builders and Their Dream Houses*, p. 317.

27. McAllister, *Society as I Have Found It*, p. 13.

28. Ibid., p. 14.

29. Ibid., pp. 14–15.

30. Ibid., pp. 19, 17.

31. Ibid., p. 25.

32. Ibid., p. 110.

33. Ibid.

34. Ibid., pp. 111–113.

35. Ibid., p. 111.

36. Ibid., p. 118.

37. Ibid., pp. 118–119.

38. Maurice, *Fifth Avenue,* p. 242.

39. Ibid.

40. McAllister, p. 258.

41. Ibid., p. 260.

42. Ibid.

43. Ibid., p. 261.

44. Ibid., p. 282.

45. Ibid., p. 292.

46. Birmingham, *Our Crowd,* pp. 56–57.

47. McAllister, p. 349.

48. *New York Tribune,* March 25, 1888.

49. McAllister, p. 216.

50. Ibid., p. 214.

51. Ibid., p. 231.

52. Ibid., pp. 214–215.

53. Churchill, *The Upper Crust,* p. 83.

54. Lehr, p. 24.

55. Amory, *Who Killed Society?,* p. 119.

56. *Dictionary of American Biography,* Vol. 1, p. 398.

57. Cowles, *The Astors,* p. 11.

58. McAllister, p. 123.

59. Ibid., p. 222.

60. Ibid., pp. 127–128.

61. Kavaler, *The Astors,* p. 108.

62. Gates, *The Astor Family,* p. 92.

63. Advertisement quotations: Birmingham, *Our Crowd,* p. 28. "I believe in a republic," Mrs. Astor once told an interviewer, "and I believe in a republic in which money has a great deal to say, as in ours. Money represents with us energy and character; it is acquired by brains and untiring effort; it is kept intact only by the same means. (Insley, "An Interview with Mrs. Astor," p. 549.) Reference to A. T. Stewart: Lehr, p. 86.

64. *New York Tribune,* March 25, 1888.

65. Churchill, *The Upper Crust,* p. 100.

66. Ibid., p. 95.

67. Lehr, p. 85.

68. Ibid., p. 88.

69. Ibid., p. 89.

70. Morris, *Incredible New York*, p. 257.

71. Josephson, *The Robber Barons*, p. 329.

72. Lehr, p. 87.

73. McAllister, pp. 77–78.

74. Ibid., p. 73.

75. Cowles, p. 90.

76. Simon, *Fifth Avenue*, p. 65.

77. Goldsmith, *Little Gloria . . . Happy at Last*, p. 79; Birmingham, *Our Crowd*, p. 57.

78. Kavaler, *The Astors*, p. 135.

79. *New York Times*, March 27, 1883.

80. *New York World*, March 27, 1883.

81. *New York Times*, March 27, 1883.

82. Ibid.

83. Lehr, p. 84. This incident became an indelible part of the accounts of the Vanderbilts' fancy dress ball, though there is no historical record of the details of the visit. As a friend of both Mrs. Astor and Mrs. Vanderbilt, and as a man who would engage in such missions, it seems likely that Ward McAllister was the agent in this act of social diplomacy.

84. O'Connor, *The Astors*, p. 197.

85. *New York Sun*, March 27, 1883.

86. *New York Times*, March 27, 1883.

87. McAllister, pp. 351–353.

88. Sinclair, *Dynasty*, p. 15.

89. Ibid.

90. *New York Times*, March 27, 1883.

91. Ibid.

92. Ibid.

93. Ibid.

94. *New York Sun*, March 27, 1883.

95. On November 27, 1925, the *New York Times* published a letter to the editor from Leo H. Riggo: "As a young architectural sculptor I worked on the inside and outside carving of the Vanderbilt house. I laid my own private cornerstone there. In cutting a grotesque face in the panelling of the main hall, near the first landing, in cutting around the mouth back of the tongue I cut through the Caen stone into a small opening. Taking a piece of paper six or seven inches square, I wrote my name and the names of those about me and the date (I can now remember only one name, the late Robert D. Barry, sculptor for the Smith Company, Westerly, R.I.). Wrapping a few pennies with the

paper, I pushed it into the cavity, sealing it with artificial stone, never thinking I would live to see that fine residence scrapped."

96. *New York World,* March 27, 1883.

97. Balsan, p. 10

98. Balsan, p. 12.

99. *New York Times,* March 27, 1883.

100. Ibid.

101. Belmont Memoirs, p. 109.

102. Simon, p. 51.

103. McAllister, p. 354.

104. *New York Times,* March 27, 1883.

105. Balsan, p. 10. This description in Consuelo Vanderbilt Balsan's memoirs is of another ball at the Vanderbilt mansion, but it seems likely that Consuelo and her younger brother must have spied on this fancy dress ball in light of the weeks of excitement it had generated at their house.

106. Churchill, *The Upper Crust,* p. 128.

107. Ibid.

108. Ibid.

109. Ibid.

110. McAllister, p. 353.

111. Churchill, *The Upper Crust,* p. 133.

112. McAllister, p. 16.

113. Churchill, *The Upper Crust,* p. 131.

114. Churchill, *The Splendor Seekers,* p. 67.

115. McAllister, pp. 256–257.

116. Clews, *Fifty Years in Wall Street,* p. 366.

117. Belmont Memoirs, p. 110.

118. *New York Times,* March 27, 1883.

119. *New York World,* March 27, 1883.

120. *New York Sun,* March 27, 1883.

121. *New York Herald,* March 27, 1883.

122. *New York World,* March 27, 1883.

123. Andrews, *The Vanderbilt Legend,* p. 286.

CHAPTER FOUR

1. *New York Times,* August 5, 1883.

2. *New York World,* March 6, 1895.

3. Amory, *Who Killed Society?,* pp. 50–51.

4. Clews, *Fifty Years in Wall Street,* p. 387.

5. Balsan, *The Glitter and the Gold,* p. 10.

6. Ibid., p. 12.

NOTES

7. Ibid., p. 12.

8. Ibid., p. 14.

9. Ibid., p. 10.

10. Ibid., p. 14; Belmont Memoirs, p. 93.

11. Balsan, p. 14; Belmont Memoirs, p. 95.

12. Belmont Memoirs, p. 95.

13. Balsan, p. 19.

14. Ibid., p. 15.

15. Ibid., p. 11.

16. Ibid.

17. Ibid., p. 11.

18. Ibid.

19. Ibid., p. 6.

20. Ibid., p. 7.

21. Ibid., p. 25.

22. Ibid., p. 13.

23. Belmont Memoirs, p. 70.

24. Balsan, p. 13.

25. Ibid.

26. Ibid., pp. 8–9

27. Ibid., p. 9.

28. Ibid., p. 5.

29. Ibid.

30. Ibid.

31. Ibid. Soon after Alva's fancy dress ball, at a time when Willie and Alva Vanderbilt were attending every fashionable event in New York, there was gossip that Willie was rebelling at being forced to attend so many balls and dances, and to officiate at so many affairs at 660 Fifth Avenue. (*New York World*, December 10, 1885.)

32. Ibid.

33. Ibid., p. 11.

34. Belmont, "Why I Am a Suffragist," p. 1178.

35. Balsan, p. 6.

36. *New York Times*, October 14, 1883.

37. Croffut, *The Vanderbilts and the Story of Their Fortune*, p. 232.

38. *New York Sun*, December 10, 1885.

39. Croffut, p. 232.

40. *New York Times*, December 9, 1885.

41. Croffut, p. 200.

42. Fiske, *Off-hand Portraits of Prominent New Yorkers*, pp. 329–330.

43. *New York Tribune*, December 9, 1885.

44. Maher, *The Twilight of Splendor*, pp. xvi–xvii.

45. Schuyler, "The Vanderbilt Houses," p. 43; Elliott, *Uncle Sam Ward and His Circle,* p. 619.

46. Harvey, *Frick,* pp. 269–270.

47. Strahan, *Mr. Vanderbilt's House and Collection,* Vol. 1, pp. v, 9.

48. McAllister, *Society as I Have Found It,* pp. 369, 371.

49. Croffut, p. 166.

50. Churchill, *The Splendor Seekers,* p. 41.

51. Croffut, p. 170.

52. Churchill, p. 53.

53. Croffut, p. 171.

54. Ibid., p. 293.

55. Ibid., p. 213.

56. Ibid., p. 262.

57. Hoyt, *The Vanderbilts and Their Fortune,* p. 266. The shock of witnessing the death of William H. Vanderbilt, coupled with heavy drinking, caused Garrett to lose his mind. He imagined himself to be the Prince of Wales, a delusion his wife supported, transforming their mansion into a replica of the Court of St. James's and hiring actors in appropriate costumes to impersonate court officials. Harry Lehr enjoyed toying with the poor man, coming to visit him dressed as the crown prince of Germany and speaking to him in broken English, much to the delight of the befuddled Garrett.

58. *New York Herald,* December 12, 1885.

59. Clews, p. 388.

60. *New York Sun,* December 10, 1885.

61. Croffut, p. 308.

62. Ibid., pp. 181–182.

63. Belmont Autobiography, p. 33; Belmont Memoirs, p. 101.

64. Balsan, p. 15.

65. *New York Times,* October 1, 1886.

66. Hoyt, p. 282.

67. Balsan, p. 16.

68. Ibid., pp. 15–16.

69. Baker, *Richard Morris Hunt,* p. 352.

70. Belmont Memoirs, p. 110a.

71. Belmont Memoirs, p. 125; Belmont Autobiography, p. 75.

72. Belmont Autobiography, p. 41.

73. Hunt, *The Richard Morris Hunt Papers,* p. 243.

74. Belmont Memoirs, p. 92.

75. Stein, *The Architecture of Richard Morris Hunt,* p. 167.

76. Belmont Autobiography, p. 38.

77. Belmont Memoirs, p. 92.

78. Hunt, p. 243

79. Lehr, *"King Lehr" and the Gilded Age,* p. 175.

80. Belmont Memoirs, p. 1.

81. Belmont Autobiography, p. 44.

82. Baker, p. 352.

83. Huntington Library, C.E.S. Wood Papers, Sara B. Field to C.E.S. Wood, July 29, 1917, Box 280.

84. Belmont Memoirs, p. 110.

85. Ibid., p. 111.

86. Belmont, "Why I Am a Suffragist," p. 1176.

87. Belmont Memoirs, p. 162.

88. Balsan, p. 7.

89. Ibid., p. 29.

90. Balsan, p. 29.

91. Ibid.

92. Ibid.

93. Ibid., p. 30.

94. Ibid., p. 31.

95. Ibid., p. 40.

96. *New York World,* March 6, 1895.

97. Ibid. It was speculated that Nellie Neustretter was merely a decoy used by Willie Vanderbilt to hide the real object of his affections, Alva's best friend, the beautiful Consuelo Yznaga, duchess of Manchester, who at that time was a widow. (*New York World,* March 6, 1895.) It is interesting to note that in Alva's subsequent trips to England, it was not the duchess of Manchester who acted as her hostess; nor does it seem from her memoirs, *The Glitter and the Gold,* that Consuelo Vanderbilt, when she became the duchess of Marlborough, saw much of her godmother and namesake, as one might have expected for a young girl seeking a friendly face so far from home.

98. Huntington Library, C.E.S. Wood Collection, Sara B. Field to C.E.S. Wood, Box 280.

99. Vanderbilt, *Queen of the Golden Age,* p. 44.

100. Belmont Memoirs, pp. 151, 154.

101. Lehr, p. 121.

102. Maxwell, *R.S.V.P.,* p. 104.

103. Balsan, p. 6.

104. Ibid., p. 36.

105. Ibid., p. 33.

106. Ibid., p. 38.

107. Strange, *Who Tells Me True,* p. 26.

108. Friedman, *Gertrude Vanderbilt Whitney,* p. 97.

109. Balsan, p. 34.

110. Ibid.

111. Belmont Memoirs, p. 143.

112. Balsan, p. 40.

113. Andrews, p. 293.

114. Vanderbilt, *Queen of the Golden Age,* p. 45.

115. Brough, *Consuelo: Portrait of an American Heiress,* p. 58.

116. *New York Times,* November 25, 1926.

117. Balsan, p. 40.

118. Ibid., p. 41.

119. Ibid.

120. Ibid.

121. Ibid.

122. Ibid.

123. Ibid.

124. Ibid., p. 42.

125. Thorndike, *The Magnificent Builders and Their Dream Houses,* p. 191.

126. Balsan, p. 42.

127. Ibid., p. 43.

128. Ibid., p. 81.

129. Ibid., pp. 82, 83.

130. Ibid., p. 82.

131. Ibid., p. 83.

132. Ibid., p. 84.

133. Thorndike, p. 190.

134. Quote on Lilian Hammersley in Margetson, *The Long Party,* pp. 56–57. Churchill, *Marlborough,* pp. 7–8.

135. Balsan, p. 45.

136. Ibid.

137. Ibid.

138. Ibid.

139. Ibid., p. 2.

140. Eliot, *Heiresses and Coronets,* p. 46.

141. Balsan, p. 46.

142. Ibid., p. 24.

143. Ibid., p. 46.

144. Belmont Memoirs, p. 88.

145. Ibid.

146. Ibid.

147. Belmont Autobiography, p. 87.

148. *New York Times,* November 25, 1926.

149. Balsan, p. 46.

150. *New York Times,* November 25, 1926.

151. Balsan, p. 47.

152. Ibid., p. 46.

153. Ibid.

NOTES

154. Wecter, *The Saga of American Society,* p. 408.

155. Balsan, p. 47.

156. Andrews, pp. 293–294.

157. Brough, p. 218.

158. Balsan, p. 47.

159. Ibid.

160. Ibid. Alva's tactics in getting what she wanted at any cost were refined from her youth. As a child, she wrote in her memoirs, she reached a point "when I decided I was too old to longer sleep in the nursery. I wanted a room all to myself. Off of the nursery was a little room I had long coveted and for this I made petition. I was refused. I returned to the attack. Again I was refused. After argument, persuasion and attempted arbitration, all to no effect, I declared war.

"I made up my mind to be so hateful and disagreeable in that nursery that there would be a clamor from the nurse and governess to have me put out. One night my sister and I were hitting each other with a bath towel. On the mantel was an assortment of little china animals, artistic and valuable, and over them hung a large picture. I suddenly conceived the idea of militantly breaking my way out of that nursery. I took the towel and with an awful deliberateness knocked down and smashed every one of the china ornaments. Then I attacked the glass in the picture with such cool and vicious strength that it, too, was shattered. 'There, now, I've seen the last of this nursery,' I thought and went to bed. Presently my Mother came in. She had been out. As soon as she entered the house she was told of my rebellion. She grabbed up her leather riding whip and came straight to me in the nursery. Naturally I received one of the worst whippings I ever got. But I accomplished my purpose. There was a demand from the nursery authorities that I leave and I was given the little room of my heart's desire." (Belmont Autobiography, pp. 26–27.)

161. Ibid.

162. Balsan, p. 25.

163. Ibid., p. 6.

164. Andrews, pp. 293–294.

165. Balsan, p. 48.

166. *New York Times,* August 29, 1895.

167. Belmont Autobiography, p. 64.

168. Balsan, p. 48.

169. Ibid., p. 49.

170. *New York Times,* September 22, 1896.

171. Brough, p. 73.

172. *New York Herald,* August 29, 1895.

173. Belmont Memoirs, p. 146.

174. *New York Times,* August 29, 1895.

175. *New York World,* August 29, 1895.

176. *New York Times,* August 29, 1895.
177. *New York Times,* September 20, 1895.
178. Vanderbilt, *Queen of the Golden Age,* p. 46.
179. Balsan, p. 25.
180. Ibid., p. 51.
181. *New York Times,* September 22, 1895.
182. *New York Herald,* November 7, 1895.
183. *New York World,* March 6, 1895.
184. *New York World,* March 6, 1895.
185. Belmont Memoirs, p. 108.
186. *New York Sun,* November 7, 1895.
187. *New York World,* November 7, 1895.
188. Ibid.
189. *New York Herald,* November 7, 1895.
190. *New York Times,* November 7, 1895.
191. *New York World,* November 7, 1895.
192. Ibid.
193. *New York Times,* November 7, 1895.
194. Ibid.
195. Ibid.
196. *New York Times,* November 14, 1895.
197. Churchill, *The Upper Crust,* p. 179.
198. *New York Times,* November 3, 1895.
199. *New York Times,* November 8, 1895.
200. *New York Daily Tribune,* November 7, 1895.
201. *New York Herald,* November 7, 1895.
202. Ibid.
203. Belmont Autobiography, p. 92.
204. *New York Sun,* November 7, 1895.
205. Ibid.
206. Balsan, p. 53.
207. *New York World,* November 7, 1895.
208. Balsan, p. 52.
209. *New York Times,* November 25, 1926.
210. Balsan, p. 53.
211. Ibid., p. 52.
212. Ibid., p. 53.
213. *New York World,* November 7, 1895.
214. *New York Times,* November 7, 1895.
215. Balsan, p. 54, p. 53.
216. Wecter, p. 410.
217. Ibid.
218. Balsan, p. 54.

219. *New York Sun,* November 7, 1895.

220. Ibid.

221. Thorndike, p. 191.

222. Wecter, p. 410.

223. Balsan, p. 53.

224. *New York Times,* November 7, 1885.

225. Brough, p. 74.

226. Ibid., p. 218.

227. Balsan, p. 56.

228. Ibid., p. 66.

229. Ibid., p. 45.

230. Brough, p. 218.

231. Balsan, p. 54.

232. Ibid., p. 58.

233. *New York Times,* November 17, 1895.

234. Ibid.

235. Ibid.

236. Eliot, p. 79. The American press had a field day with this marriage. "Miss Consuelo Vanderbilt and the Duke of Marlborough will be married before the end of the year," wrote the *Toledo Blade;* "the date of the divorce is yet uncertain." After the marriage, the *Washington Post* noted that "the roof of the Marlborough Castle will now receive some much needed repairs and the family will be able to go back to three meals a day." (Montgomery-Massingberd, *Blenheim Revisited,* p. 116.)

CHAPTER FIVE

1. Churchill, *The Upper Crust,* p. 179.

2. Belmont Memoirs, p. 147.

3. Logan, *The Man Who Robbed the Robber Barons,* p. 243.

4. *New York Herald,* September 13, 1899.

5. *New York Sun,* September 13, 1899.

6. Ibid.

7. Croffut, *The Vanderbilts and the Story of Their Fortune,* p. 115.

8. *New York World,* December 10, 1885.

9. Pound and Moore, *More They Told Barron,* p. 116.

10. Elliott, *This Was My Newport,* p. 161.

11. *New York Times,* July 16, 1896.

12. *New York Sun,* September 13, 1899.

13. Churchill, *The Splendor Seekers,* p. 69.

14. Friedman, *Gertrude Vanderbilt Whitney,* p. 50.

15. "Mr. Vanderbilt's Expenditure," p. 128.

16. Churchill, *The Splendor Seekers,* p. 72.
17. Vanderbilt, *Farewell to Fifth Avenue,* p. 11.
18. Andrews, *The Vanderbilt Legend,* p. 347.
19. Knickerbocker, "The Vital Vanderbilts," December 1939, p. 76.
20. Strange, *Who Tells Me True,* p. 103.
21. Vanderbilt, *Without Prejudice,* p. 93.
22. Ibid., p. 94.
23. Ibid.
24. Ibid., p. 111.
25. Churchill, *The Upper Crust,* p. 230.
26. Churchill, *The Splendor Seekers,* pp. 159–160.
27. *New York Times,* November 26, 1892.
28. Elliott, *This Was My Newport,* p. 161.
29. Hunt, *The Richard Morris Hunt Papers,* p. 287, p. 298.
30. Decies, *Turn of the World,* p. 87.
31. Lehr, *"King Lehr" and the Gilded Age,* p. 290.
32. Vanderbilt, *Without Prejudice,* p. 104.
33. Friedman, p. 4.
34. Ibid., p. 5.
35. *Philadelphia Press,* March 25, 1895.
36. Friedman, p. 6.
37. Ibid., p. 48.
38. Ibid., p. 69.
39. Ibid., p. 5.
40. Ibid., p. 62.
41. Ibid., p. 46.
42. Ibid., p. 47.
43. Ibid., p. 70.
44. Ibid., p. 48.
45. Ibid., p. 55.
46. Ibid., p. 72.
47. Ibid., pp. 72–73.
48. Ibid., pp. 73–74.
49. Ibid., p. 92.
50. *Philadelphia Press,* March 25, 1895.
51. Friedman, p. 52.
52. Ibid., p. 70.
53. Ibid., p. 67.
54. Ibid., p. 83.
55. Ibid., p. 91.
56. Ibid., pp. 82–83.
57. Ibid., p. 100.
58. Ibid., p. 104.

59. Ibid., pp. 105–106.

60. Ibid., pp. 98–99.

61. Ibid., pp. 88, p. 105.

62. Ibid., p. 99.

63. Ibid., p. 108.

64. Ibid., pp. 108–109.

65. Ibid., pp. 110–111.

66. Ibid., pp. 109–110.

67. Ibid., p. 76.

68. Ibid., p. 97.

69. Ibid., p. 93.

70. Ibid., p. 111.

71. Ibid., p. 99.

72. Ibid., pp. 113–114.

73. Ibid., p. 116.

74. Ibid., p. 115.

75. Ibid., pp. 118–119.

76. Ibid., p. 119.

77. Ibid., p. 133.

78. Ibid., pp. 133–134.

79. Ibid., p. 135.

80. Ibid., p. 142.

81. *New York Times,* June 11, 1896.

82. Friedman, p. 38.

83. Ibid., p. 5.

84. Vanderbilt, *Queen of the Golden Age,* p. 37.

85. Friedman, p. 101.

86. Ibid.

87. Ibid., p. 102.

88. Ibid.

89. Vanderbilt, *Queen of the Golden Age,* p. 35.

90. Eliot, *Heiresses and Coronets,* pp. 98–99.

91. Friedman, p. 102. According to her grandson, Alice Vanderbilt "used to think that every young woman in America was trying to marry her sons," and perhaps many were, for as her grandson later found out, "There is always a great change in the attitude of the young women I meet as soon as they hear my name." (Vanderbilt, *Man of the World,* p. 293.)

92. Friedman, pp. 102–103.

93. Ibid., p. 102.

94. Vanderbilt, *Queen of the Golden Age,* p. 48.

95. Friedman, p. 137.

96. Vanderbilt, *Queen of the Golden Age,* pp. 48–49.

97. Ibid., p. 49.

98. Ibid., p. 50.

99. Ibid., p. 3.

100. Ibid., pp. 49–50.

101. Friedman, pp. 115–116.

102. Vanderbilt, *Queen of the Golden Age,* p. 52.

103. Ibid., p. 53.

104. *New York Times,* June 11, 1896.

105. Ibid.

106. Eliot, pp. 97–98.

107. Vanderbilt, *Queen of the Golden Age,* p. 56.

108. Ibid., p. 58. Compared to the time some months before when Cornelius Vanderbilt had moved his bed into his son's room during Neily's attack of rheumatism, Alice and Cornelius now evidenced no obvious concern with Neily's health. They were seen strolling down Fifth Avenue, and chatting with their friends after they had dinner at the Metropolitan Club.

109. Friedman, p. 140.

110. Vanderbilt, *Queen of the Golden Age,* p. 55.

111. Ibid.

112. Hoyt, *The Vanderbilts and Their Fortunes,* p. 306.

113. Goldsmith, *Little Gloria . . . Happy at Last,* p. 97.

114. Ibid.

115. *New York Times,* July 17, 1896.

116. Friedman, p. 141.

117. *New York Times,* July 17, 1896.

118. *New York Times,* July 18, 1896.

119. *New York Times,* July 19, 1896.

120. *New York Times,* July 18, 1896.

121. *New York Journal,* August 4, 1896.

122. Vanderbilt, *Queen of the Golden Age,* p. 74.

123. Ibid., p. 64.

124. Ibid., p. 74.

125. Ibid., p. 75.

126. Ibid., p. 77.

127. Ibid., p. 73.

128. *New York Herald,* August 26, 1896.

129. Friedman, p. 151.

130. Vanderbilt, *Queen of the Golden Age,* p. 74.

131. Ibid., p. 79.

132. Vanderbilt, *Queen of the Golden Age,* pp. 81–83.

133. Ibid., p. 85.

134. Ibid., p. 88.

135. Friedman, p. 157.

136. Vanderbilt, *Queen of the Golden Age,* p. 104.

NOTES

137. Friedman, pp. 159–160.

138. Ibid.

139. Vanderbilt, *Queen of the Golden Age*, p. 108.

140. Ibid., p. 109.

141. Ibid., p. 113.

142. In April of 1899, Neily and Grace attended the wedding of Neily's cousin Willie K. Vanderbilt and Virginia Fair, at a ceremony in Willie's mansion at 660 Fifth Avenue. Alfred and Reginald helped their father into the house, where he saw Neily but would not speak with him.

"There is no change whatever in the treatment of her by his family," Richard Wilson wrote to one of his daughters in the summer of 1899 about the Vanderbilts' attitude toward Grace, "they being as demon-like in their behavior toward her as ever. Her boy however is so charming and entertaining as to make up in a certain degree somewhat for the effects upon her of their outrageous conduct. . . ." (Vanderbilt, *Queen of the Golden Age*, pp. 118–119.)

143. *New York World,* September 13, 1899.

144. *New York Times,* July 27, 1899.

145. Vanderbilt, *Queen of the Golden Age*, p. 123.

146. Ibid., p. 125.

147. *New York Tribune,* October 28, 1899.

148. Vanderbilt, *Queen of the Golden Age*, p. 139.

CHAPTER SIX

1. Brown, *Champagne Cholly*, pp. 228–229; Vanderbilt, *Queen of the Golden Age*, p. 108.

2. "Secrets of Ball-Giving: A Chat with Ward McAllister," *New York Tribune,* March 25, 1888.

3. McAllister, *Society as I Have Found It*, p. 229.

4. Ibid., pp. 230–231.

5. Maurice, *Fifth Avenue*, p. 227.

6. Thompson, "The Man Who Invented Society," *Forbes,* October 28, 1985.

7. Churchill, *The Upper Crust*, pp. 162–163.

8. Logan, *The Man Who Robbed the Robber Barons*, p. 135.

9. Tudury, "Ward McAllister," pp. 142–143.

10. Ibid.

11. O'Connor, *The Golden Summers*, pp. 62–64.

12. Morris, *Incredible New York*, p. 247.

13. Churchill, p. 9.

14. McAllister, p. 299.

15. Maurice, p. 243.

NOTES

16. Lehr, *"King Lehr" and the Gilded Age*, p. 23.

17. Ibid., p. 51

18. Ibid., p. 53.

19. Ibid.

20. Ibid.

21. Ibid., pp. 52–53.

22. Ibid., p. 236.

23. Ibid., p. 53.

24. Amory, *The Last Resorts*, p. 191.

25. Ibid.

26. Ibid., pp. 192–193.

27. Churchill, *The Splendor Seekers*, p. 171.

28. Lehr, p. 140.

29. Ibid., p. 154.

30. Cowles, *The Astors*, p. 132.

31. Ibid.

32. Lehr, p. 82.

33. Barrett, *Good Old Summer Days*, p. 87.

34. Elizabeth Dahlgren's father was John Wilhelm Drexel, a partner of J. Pierpont Morgan in the prominent banking house Drexel, Morgan and Company.

35. Lehr, p. 36.

36. Ibid., pp. 37–38.

37. Ibid., p. 38.

38. Ibid.

39. Ibid., pp. 38–39.

40. Ibid., p. 39.

41. Ibid., pp. 40–42.

42. Ibid., p. 42.

43. Ibid., pp. 42–43.

44. Ibid., pp. 44–46.

45. Ibid., p. 47.

46. Ibid.

47. Ibid., pp. 47–48.

48. Ibid., pp. 54–55.

49. Ibid., p. 53.

50. Amory, p. 212.

51. Decies, *Turn of the World*, p. 109.

52. Barbour and Ueland, "Society Tightwads," p. 6. One author of this article, Elizabeth Barbour, was Mrs. Fish's social secretary for fourteen years.

53. Amory, p. 215.

54. Churchill, *The Upper Crust*, p. 199.

55. Morris, p. 252.

NOTES

56. Churchill, *The Upper Crust*, p. 199.
57. Martin, *Things I Remember*, p. 238.
58. Churchill, *The Splendor Seekers*, p. 173.
59. Amory, p. 217.
60. Belmont Memoirs, p. 163.
61. Churchill, *The Upper Crust*, p. 202.
62. Thorndike, *The Very Rich*, p. 23.
63. Amory, p. 217.
64. Decies, p. 107.
65. Amory, p. 215.
66. Barbour, "How to Keep House on a Million Dollars a Year," p. 8.
67. Ibid., pp. 216, 193.
68. Lehr, p. 231.
69. Ibid., pp. 150–151.
70. Ibid., p. 151.
71. Ibid.
72. Crockett, *Peacocks on Parade*, p. 78.
73. Patterson, "The Woman Who Talked," p. 9.
74. Barbour, "How to Keep House on a Million Dollars a Year," p. 8.
75. Huntington Library, C.E.S. Wood Collection, Sara B. Field to C.E.S. Wood, August 14, 1917, Box 280 (quoting Perry Belmont, brother of O.H.P. Belmont).
76. Lehr, p. 233.
77. Ibid., p. 126.
78. O'Connor, p. 21.
79. Ibid., p. 134.
80. Ibid., p. 136.
81. Ibid.
82. Churchill, *The Upper Crust*, p. 203.
83. Maurice, p. 230.
84. *Chicago Record Herald*, September 15, 1908.
85. Kavaler, *The Astors*, p. 137.
86. *Chicago Record Herald*, September 15, 1908.
87. Cowles, *The Astors*, p. 142.
88. Eliot, *Heiresses and Coronets*, p. 48.
89. Mrs. Astor's son had her mansion at 350 Fifth Avenue torn down, and there built the even more spectacular seventeen-story Astoria Hotel, which soon was joined with the Waldorf.
90. Gates, *The Astor Family*, p. 101.
91. Morris, p. 258.
92. Elliott, *This Was My Newport*, p. 203.
93. Lehr, p. 179.
94. Ibid., p. 26.

95. Belmont Memoirs, p. 32.
96. Belmont Autobiography, handwritten notes.
97. Maxwell, *R.S.V.P.*, p. 106.
98. Quoted in Huntington Library, C.E.S. Wood Collection, Sara B. Field to C.E.S. Wood, Box 280.
99. Lehr, p. 146.
100. Belmont Memoirs, pp. 158–159.
101. Ibid., p. 160.
102. Goldsmith, *Little Gloria . . . Happy at Last*, p. 62.
103. Folsom, *Great American Mansions and Their Stories*, p. 259.
104. Lehr, p. 147.
105. Ibid.
106. Belmont Autobiography, p. 1.
107. Ibid., pp. 173–174.
108. Ibid., p. 175.
109. Ibid., p. 176.
110. Belmont Memoirs, p. 166.
111. Decies, pp. 148–149.
112. Lehr, p. 121.
113. Ibid.
114. Ibid., pp. 121–122.
115. Belmont, "Why I Am a Suffragist," p. 1172.
116. Ibid., p. 1173.
117. Balsan, *The Glitter and the Gold*, p. 216.
118. Lehr, pp. 154–155.
119. Ibid., pp. 220–221.
120. Belmont Memoirs, pp. 152–154. In another draft autobiography, Alva again focused on her thesis: "A man in my class married a young and pretty woman from whom he asked nothing more than good looks, careful grooming and a readiness to serve his desires. By no chance did he turn to this petted creature for mental stimulus or high type of companionship. . . . To speak frankly, in most cases they wanted a woman for one purpose only and that was the gratification of their sex passion. . . . Then when love founded as it was on the sands of mere passion had died, I noticed with surprise and indignation that this woman was set aside, relegated to a stupid domestic sphere. Meanwhile, during these lonely, uninteresting years, what was happening to the husband? Stepping over the confining threshold of his home whose respectability he left in the hands of his discarded wife, like a young colt in a meadow he kicked up his heels and was off for a romp in the wide world field. The legalized prostitution which marriage covers is to me appalling." (Belmont Autobiography, pp. 57, 59, 65.)

NOTES

121. *Notable American Women*, Vol. 1, p. 127.

122. Belmont Autobiography, p. 65.

123. Lehr, pp. 221–223.

124. Belmont Autobiography, handwritten notes.

125. Quoted in Huntington Library, C.E.S. Wood Collection, Sara B. Field to C.E.S. Wood, Box 280.

126. *Current Literature*, December 1909, p. 599.

127. Schlesinger Library, Doris Stevens Papers, Folder 291, draft article.

128. Belmont, "Why I Am a Suffragist," pp. 1174, 1172.

129. Schlesinger Library, Doris Stevens Papers, Folder 291, draft article.

130. Belmont in *Ladies' Home Journal*, September 1922, p. 7.

131. Schlesinger Library, Jane Norman Smith Papers, Folder 103, quoted in "A Tribute" by Iris Calderhead Walter, *Washington News*, January 8, 1933.

132. *New York Herald Tribune*, January 27, 1933.

133. Schlesinger Library, Jane Norman Smith Papers, Folder 103, quoted in "A Tribute" by Iris Calderhead Walter, *Washington News*, January 8, 1933.

134. Maxwell, *R.S.V.P.*, p. 108.

135. Churchill, *The Upper Crust*, p. 182.

136. *Current Literature*, December 1909, pp. 599–600.

137. One of Alva's cohorts in the suffrage movement was none other than Lady Cook, who, before she married Sir Francis Cook, had been Tennessee Claflin, spiritualist to Commodore Vanderbilt. Her reappearance in public life after thirty years, "a small sprightly figure almost hidden by a huge Gainsboro hat, tied down with a blue veil," was an event that "set the bells of memory ringing in many a dusty belfry." Her game plan for the movement was also in character, just like Alva's. "Any man hates to be preached to. What shall we do about it then? Appeal to his sense of humor. Appeal to his fear of ridicule. Satirize the men. Laugh at them. Hold them up to public derision. Use wit, defiance, daring, love, persuasion—all a woman's armament. Trick them, bewilder them, but never lose your temper." (*Current Literature*, December 1909, p. 601.)

138. *Current Literature*, December 1909, p. 599.

139. Belmont Memoirs, p. 4.

140. Lehr, pp. 147, 224–225.

141. Ibid., p. 224.

142. Ibid.

143. There is no record of Alva Belmont's speech at this meeting, but these words, quoted from Belmont, "Woman's Right to Govern Herself," p. 666, are typical of the tone and content of all her writings and talks on her favorite subject.

144. Lehr, p. 226.

145. Ibid., pp. 222–223.

146. Simon, *Fifth Avenue*, p. 9.

147. *New York Times* editorial, May 5, 1912.

148. Balsan, *The Glitter and the Gold*, p. 215.

149. Lehr, p. 223.

CHAPTER SEVEN

1. Lehr, *"King Lehr" and the Gilded Age*, p. 284.

2. Schuyler, "A Newport Palace," p. 362.

3. Gates, *The Astor Family*, p. 180.

4. Lehr, p. 138.

5. A brother of Bradley Martin, Frederick Townsend Martin, himself a member of the Four Hundred, told of an event at "a very brilliant social function in the London social world" that astounded him. "I met at that reception a woman whose name I had heard as a household word in Society for many years. She was esteemed a brilliant woman; she was reckoned a leader in the most splendid Society of the world. She was wealthy beyond all human need. She occupied a powerful place in a political world where everything human had its part. She was a companion of princes and the equal of peers. We were talking alone, immediately after our introduction, when she said:

" 'Oh, Mr. Martin, you are an American. You are a Wall Street man. You could help me to get some of your American gold!'

"I was astounded and I showed it in my answer:

" 'Why, my dear lady, surely you have gold enough. If I am not mistaken, you rank amongst the wealthiest women of the nation. Why should you want gold? Moreover, you have social standing and are famous throughout England. Of what possible use could more gold be to you?'

"I can still see the haggard face, the quivering lips, the blazing eyes of this great Society woman as she answered me.

" 'Oh, Mr. Martin, you do not know me—I am almost ashamed to confess the truth. I dream night and day of gold. I want to have a room at the top of my house filled with it—filled with gold sovereigns. I would like to go into that room night after night, when every one else is asleep, and bury myself in yellow sovereigns up to my neck, and play with them, toss them about to hear the jingling music of the thing I love the best!' " (Martin, *The Passing of the Idle Rich*, pp. 199–201.)

6. Simon, *Fifth Avenue*, pp. 161–162. Another French visitor at the turn of the century found that the Newport scene either "revolts you or ravishes you as you are nearer to socialism or to snobbery."

NOTES

7. Lewis, *The Big Change*, p. 31.

8. Myers, *The Ending of Hereditary American Fortunes*, p. 164.

9. Quoted in Hofstadter, *The Age of Reform*, p. 141.

10. "Mr. Vanderbilt's Expenditure," p. 128.

11. Lee, "Expensive Living, the Blight on America," p. 54.

12. *New York World*, January 7, 1894.

13. The Vanderbilts' mansion in Newport, The Breakers, was surrounded by a twelve-foot fence. The bedrooms of the mansion were equipped with sliding steel grilles, as antikidnapping devices.

14. Martin, pp. 238–239.

15. Andrews, *The Vanderbilt Legend*, p. 279; *New York Times*, January 23, 1897.

16. Beebe, *The Big Spenders*, p. 118; *New York Times*, January 23, 1897.

17. Holbrook, *The Age of the Moguls*, p. 332.

18. Wecter, *The Saga of American Society*, p. 369.

19. *New York Times*, January 6, 1907.

20. Lynes, *The Taste-Makers*, p. 132.

21. Baker, *Richard Morris Hunt*, p. 413.

22. Roper, *FLO: A Biography of Frederick Law Olmsted*, p. 389.

23. Stevenson, *Park Maker: A Life of Frederick Law Olmsted*, p. 389.

24. Hunt, *The Richard Morris Hunt Papers*, p. 244.

25. Ibid.

26. Ibid., pp. 288–289.

27. Ibid., pp. 210–211.

28. *New York Tribune*, July 26, 1892.

29. Baker, p. 431.

30. Roper, p. 477.

31. *New York Herald*, September 13, 1899.

32. Willie Vanderbilt was very much the grandson of the Commodore. One day he met with the board of directors of the New York Central.

"Gentlemen," he said, "I would like to be appointed a committee of one, with power to buy the Lake Shore and Michigan roads."

The board passed a motion, unanimously giving him the authority to make the purchase. Once the votes had been cast, Vanderbilt pulled from his pocket the broker slips that showed he had already bought the line, which he then turned over to the New York Central at cost, less the interest used in buying the stock. (*New York Herald*, July 23, 1920.)

33. *New York Times*, July 23, 1920.

34. *New York Herald*, July 23, 1920.

35. Balsan, *The Glitter and the Gold*, p. 237.

36. Ibid.

37. Idlehour's furnishings, from champagne glasses to tapestries, rugs, and mantel clocks, were auctioned at the American Art Galleries in April of 1926, with a Gothic carved oak throne selling for $1,050, a nine-foot-high tapestry for $1,200, and six pairs of carved walnut chairs covered with Royal Aubusson tapestry for $6,600, the full two-day sale netting $132,962.50.

38. Sullivan, *Kindergarten Chats*, p. 140.

39. William Vanderbilt bequeathed ten of his best paintings to the Metropolitan Museum of Art. See Tomkins, *Merchants and Masterpieces*, p. 190.

40. "That too has disappeared," Alva wrote in her memoirs, "sold and torn down to make way for an apartment house. But while it stood it was one of the most beautiful houses in New York, and it will not be forgotten, for the plans, copies of which were sent by request to France, and Germany and England, have become part of the architectural history of the United States." (Belmont Memoirs, p. 105.)

41. Belmont Autobiography, p. 21.

42. Balsan, p. 238. In the summer of 1917 at the age of sixty-four, Alva had an affair with a much younger man. "I think she is desperately in love with this young man Doris told us of," Sara Bard Field, whom Alva had hired to help write her memoirs, wrote to a friend. "He arrives next Friday and I shall make my own conclusions. She talks to me freely of him, searches the whole world for contemporary women who have married much younger men, drags out the illustrations of Lady Churchill and George Cornwallis West and when I say 'Yes, but that didn't last,' she responds 'No, of course not. It was on a fleshy basis only but when she did divorce him he turned right around and married another woman older than Lady Churchill, Mrs. Pat Campbell.' You can see she is doing what we all do—rationalizing her impulse—or trying to. Poor lonely soul for she is poor in many ways and in every way lonely. My heart aches for her—selfish to the core and weighted down from babyhood with the heaviness of too much possession."

Sara Field found herself spending less time with Mrs. Belmont, "for her lover has come—Ralph Bloomer—I have only just seen him, a typical 'society man' he looked to me but Mrs. B. says no, he has some brains. Let us hope so. . . ."

"Did I tell you I met her young beau and I like him better than I first did," Field wrote later that summer. "I think he has some possibility. He is a clean looking, clean living chap, neither drinks or smokes (athletic influence while in Harvard) and with a wholesome love of outdoor life and sports and especially of flowers. He is sick of the insipid society woman and perhaps he does find a lure in Mrs. B's vigorous mentality and uncompromising selfness." (Huntington Library, C.E.S. Wood Papers, Sara B. Field to C.E.S. Wood, August 2, 13, 16, 1917, Box 280.)

43. Balsan, p. 184.

44. Ibid., p. 82.

45. Ibid., p. 28.
46. Ibid., p. 68.
47. Ibid., p. 195.
48. Ibid., p. 125.
49. Ibid., pp. 126–127.
50. Ibid., p. 77.
51. Ibid., p. 152.
52. Friedman, *Gertrude Vanderbilt Whitney,* pp. 229–230.
53. Balsan, p. 58.
54. Friedman, pp. 229–230.
55. Ibid., p. 218.
56. Brough, *Consuelo: Portrait of an American Heiress,* pp. 191–192.
57. Friedman, p. 188.
58. Ibid., p. 235.
59. Balsan, p. 239.
60. Ibid., p. 238.
61. Belmont Memoirs, p. 166.
62. Ibid., p. 141.
63. Perkins Library, Matilda Young Papers, Matilda Young to her mother, July 31, 1932.
64. Lehr, pp. 173–174.
65. Balsan, p. 287.
66. O'Connor, *The Golden Summers,* p. 196.
67. Decies, *Turn of the World,* p. 176. Alva offered to pay Sara Bard Field $1,000 a month for three months to live with her at Marble House during the summer of 1917 and to help her write her memoirs. Field needed the money and knew she would accept the offer, but wrote to a friend, "I shall pay in spiritual coin for every copper I get from her. She is a terror and I cringe at the thought of her buying me." After working with her for several weeks, Field described Alva Belmont as "hard, flinty, brutal to her inferiors. She is a queer, smart, calculating old lady." At the end of the summer, she wrote, "O, I am so tired of her. . . . She is so metallic with all her good points—so non-sensitive. I wish I were through with this job. All the money in Wall St. could not tempt me to live with her. No. No. Two hundred years from now the book [Alva Belmont's memoirs] will, I hope, have some significance as a voice from an exterminated class . . . as an inditement [*sic*] of a monstrosity—for that is what this over-rich element are. I hate them—their ideas, their psychology. Yes, yes, they are the unfortunate results of a bad system and an evil environment—so are the smelly, diseased poor. But both are loathsome. I learned of more black, black sin—(ugly living) in those six weeks in Newport than in all the rest of my life put together." (Huntington Library, C.E.S. Wood Collection, Sara Bard Field to C.E.S. Wood, undated [August or September, 1917], Box 280.)
68. Maxwell, *R.S.V.P.,* p. 106.

69. *New York Sun,* January 26, 1933.

70. *New York Herald Tribune,* January 27, 1933.

71. Maxwell, pp. 108–109.

72. Schlesinger Library, Doris Stevens Papers, memorandum of Doris Stevens, Folder 285.

73. Maxwell, *R.S.V.P.,* p. 106

74. Ibid., p. 108.

75. Decies, p. 178.

76. Ibid., p. 260.

77. Maxwell, p. 212.

78. Schlesinger Library, Doris Stevens Papers, Alva E. Belmont to Doris Stevens, April 5, 1929, Folder 292.

79. Belmont Memoirs, p. 110a.

80. Alva had sold Belcourt Castle to Oliver Belmont's brother, Perry, in 1916, and in the early 1930s saved it from a tax sale by advancing $10,000 to Perry Belmont.

81. Schlesinger Library, Doris Stevens Papers, memorandum of Doris Stevens, Folders 285, 292.

82. Schlesinger Library, Doris Stevens Papers, Alva E. Belmont to Doris Stevens, December 8, 1932, Folder 292.

83. Maxwell, p. 110.

84. Decies, p. 164.

85. Iris Calderhead Walker, "A Tribute," *Washington News,* January 8, 1933.

CHAPTER EIGHT

1. Friedman, *Gertrude Vanderbilt Whitney,* p. 166.

2. *New York World,* October 29, 1899.

3. A year before, in April of 1899, Justice Fitzsimmons of the City Court of New York had fined Neily $100 for failing to respond to a summons for jury duty, and had given him a lecture on citizenship: "As a matter of fact, I don't want men of young Vanderbilt's station. What interest have they in suits for small amounts that they would have to consider here? I might want their fathers, because they earned their money and know its value." (Friedman, p. 166.)

4. Vanderbilt, *Queen of the Golden Age,* pp. 151–153.

5. "I shopped at Tiffany's," Neily wrote to Grace in 1901 while she was at Hot Springs, Virginia, "and bought a little gold watch for Sonny's birthday and arranged with my Secretary to pay your bills. The foreign ones sum up about $13,000. Fortunately, the B and O has had a further rise and little O'Neill is about $40,000 richer than he was two weeks ago. Of course I had this on inside

information and will soon sell out of that stock." (Vanderbilt, *Queen of the Golden Age,* p. 154.)

6. Vanderbilt, *Queen of the Golden Age,* p. 170.

7. Ibid., p. 171.

8. Ibid.

9. Ibid., p. 174.

10. Ibid., p. 178.

11. Lehr, *"King Lehr" and the Gilded Age,* p. 137.

12. The *North Star* was constructed by the shipbuilder Harreshoff, who built three other yachts that year: one for William K. Vanderbilt, one for August Belmont, and one for Harry Whitney.

13. In 1902, Neily caught typhoid. For days on end, his temperature remained at 104, and he was attended by four doctors and three nurses. Grace refused to leave his room, wiping his head with alcohol and helping the nurses wrap him in rubber sheets and cover him with blocks of ice. During this siege, Grace's honey-blond hair turned white. For twenty-one days his fever persisted. Reports on his health were issued hourly by his doctors and reported in the papers, but Neily's mother, Alice Vanderbilt, saw no reason to return from her stay in Europe. When his temperature reached 105, the *New York Times* reported that if he could make it through that day, he would recover. When Alice Vanderbilt finally returned from Europe, she was asked at the dock about the possibility of a reconciliation with Neily and Grace. "No comment" was her only reply, as she headed straight to her mansion, never stopping to visit her son.

14. Vanderbilt, *Queen of the Golden Age,* p. 211.

15. Ibid., p. 214.

16. Ibid., pp. 216–217.

17. The Vanderbilts had purchased the mansion for $450,000 in 1904.

18. Croffut, *The Vanderbilts and the Story of Their Fortune,* p. 306. When a book publisher bought the mansion next to the Vanderbilts' home at 677 Fifth Avenue in 1912 and planned to build a twelve-story building there, Neily and Grace decided to move farther up Fifth Avenue, purchasing a lot between Seventy-first and Seventy-second streets for $700,000. Their intention, as reported in the press, was "to build on it one of the most elaborate homes in the city." (*New York Times,* February 19, 1912.) Those plans were aborted when Neily inherited 640 Fifth Avenue.

19. Vanderbilt, *Queen of the Golden Age,* p. 240.

20. *New York Times,* August 20, 1916.

21. Vanderbilt, *Queen of the Golden Age,* p. 285.

22. Ibid., p. 287.

23. Belmont, *The Fabric of Memory,* p. 106.

24. Vanderbilt, *Farewell to Fifth Avenue,* pp. 78–82.

25. Vanderbilt, *Man of the World,* p. 337.

26. Vanderbilt, *Queen of the Golden Age*, p. 3.

27. Ibid., pp. 193–198.

28. Ibid., pp. 296, 298.

29. Ibid., p. 172.

30. Ibid., p. 281.

31. Ibid., p. 239.

32. Ibid., p. 220.

33. Vanderbilt, *Farewell to Fifth Avenue*, p. 7.

34. Vanderbilt, *Queen of the Golden Age*, p. 165. "The President is downstairs," Grace told her children when family friend Theodore Roosevelt stopped in for a visit. "You will shake hands with him but you are not to annoy him with your silly questions." (Vanderbilt, *Farewell to Fifth Avenue*, p. 13.)

35. Vanderbilt, *Farewell to Fifth Avenue*, p. 10.

36. Ibid., p. 11.

37. Vanderbilt, *Queen of the Golden Age*, p. 248.

38. Vanderbilt, *Farewell to Fifth Avenue*, pp. 20–21.

39. Ibid., p. 23.

40. Vanderbilt, *Queen of the Golden Age*, p. 167.

41. Vanderbilt, *Man of the World*, p. 7.

42. Ibid.

43. Ibid., pp. 14–15.

44. Vanderbilt, *Queen of the Golden Age*, p. 254.

45. Vanderbilt, *Man of the World*, p. 11.

46. Ibid., p. 75.

47. Vanderbilt, *Farewell to Fifth Avenue*, pp. 18–19. It was at boarding school that Neil was first introduced to the wider world. Neily took his son to New Hampshire on the train with many of the other New York City boys attending the preparatory school. Neily insisted that, as usual, he and his son dress formally for dinner. They then made their way to the public diner. "I thought I detected a few snickers as we strolled into the crowded dining car full of business-suited New Englanders and noisy small boys," Neil recalled. "The steward, however, snapped to attention immediately and ushered us past a long line of waiting people. 'Good evening, Mr. Vanderbilt. This way, sir.'

" 'Look at the limey,' I heard a boy remark loudly across the aisle. 'And *listen* to him,' he hooted, imitating the broad English 'a' I had been taught to use since childhood, 'I cawn't make up my mind, Fawther, what to have for dinnah.' " (Vanderbilt, *Queen of the Golden Age*, p. 222.)

"Do you think," Grace wrote to her son during his second term at St. Paul's, "you would be more comfortable if I got you a short jacket lined with sheepskin and corduroy knickers lined with leather like the workmen I saw in Concord? I asked where I could get them and they said in Boston. Surely none of the boys would jump on you for this, as they are American and workmen's things. . . ." (Ibid., p. 237.)

48. Vanderbilt, *Queen of the Golden Age,* p. 229.
49. Vanderbilt, *Farewell to Fifth Avenue,* p. 35.
50. Ibid., pp. 38–40.
51. Vanderbilt, *Farewell to Fifth Avenue,* p. 8.
52. Ibid., p. 127.
53. Ibid., p. 53.
54. Andrews, *The Vanderbilt Legend,* p. 371.
55. Vanderbilt, *Man of the World,* p. 34.
56. Ibid., p. 34.
57. Vanderbilt, *Farewell to Fifth Avenue,* p. 56.
58. Andrews, p. 373.
59. Vanderbilt, *Man of the World,* p. 37.
60. Vanderbilt, *Farewell to Fifth Avenue,* pp. 68–70.
61. Vanderbilt, *Man of the World,* p. 42.
62. Vanderbilt, *Farewell to Fifth Avenue,* p. 10.

CHAPTER NINE

1. As usual, the wedding gifts from members of the Vanderbilt family were extraordinary. Mrs. Cornelius Vanderbilt gave a tiara and collar of diamonds; Miss Gladys Vanderbilt, a chain of diamonds and rubies; Mr. and Mrs. Alfred G. Vanderbilt, a stomacher of diamonds; Mr. and Mrs. Harry Payne Whitney, a diamond and emerald pin; Mr. and Mrs. Frederick W. Vanderbilt, a ring set with diamonds and emeralds; Mrs. Elliott F. Shepard, a set of twenty-four gold dessert plates; Mr. and Mrs. Hamilton Twombly, a pair of silver candelabra; Mr. and Mrs. George Vanderbilt, a set of massive silver dishes. (Friedman, p. 146.)

2. *New York American,* December 2, 1902.
3. Andrews, *The Vanderbilt Legend,* pp. 379–380.
4. Gardiner, *Canfield,* p. 222.
5. Ibid., p. 208.
6. *New York American,* December 3, 1902.
7. Andrews, p. 381.
8. Gardiner, p. 305.
9. Hoyt, *The Vanderbilts and Their Fortune,* p. 392.
10. Cathleen sued for divorce in 1919; Reggie did not contest.
11. Alfred had been a professional horseman, breeding one hundred Thoroughbreds at his Oakland Farm stables, which included regulation-size polo grounds. He held the New York–Philadelphia record for coaching, racing between two points in a hansom coach with fresh teams of horses waiting at various stops. In addition to Oakland Farms, he also built an estate in the Adirondacks, Sagamore Lodge, which included fifteen hundred acres around

Sagamore Lake, and while in New York stayed in a suite of rooms on the top floor of The Vanderbilt, his hotel on Park Avenue.

He had married Miss Elsie French in 1901. His wife sued for divorce in 1908, alleging that Alfred had been unfaithful. The allegation was that he had taken Agnes O'Brien Ruiz, the wife of a Cuban diplomat, aboard his private railroad car, *The Wayfarer*. In 1911 he married Margaret McKim, the daughter of the man who made a fortune with Bromo Seltzer.

On May 1, 1915, Alfred Vanderbilt sailed for England aboard the *Lusitania* to work for the British Red Cross. "The Germans would not dare to attack this ship," Alfred told newsmen as he boarded the *Lusitania*. "They have disgraced themselves and never in our time will they be looked upon by any human being valuing his honor, save with feelings of contempt. How can Germany, after what she has done, ever think of being classed as a country of sportsmen and of honor on a par with America, England and France?" On the afternoon of May 7, 1915, off the coast of Ireland, Germany dared to attack the ship, ramming it with several torpedoes.

"Find all the kiddies you can, boy," Alfred directed his valet after the first explosion, as he helped the women and children to the lifeboats, giving his own life belt to a female passenger. Alfred Vanderbilt went down with the liner.

"Vanderbilt was absolutely unperturbed," a survivor remembered. "He stood there, the personification of sportsmanlike coolness. In my eyes he was the figure of a gentleman waiting for a train." (Vanderbilt, *Queen of the Golden Age*, p. 243.)

"Did he wish to give it up [the seat assigned to him on the lifeboat] to someone else, or was he glad that fate had taken out of his hands the predicament of living," one of his friends wondered, "that daily, self-made fabrication of occupations and pleasures, that dreary, desperate difficulty of touching reality at any point, which has wearied so many of the very rich into forms of unconsciousness a good deal less clean than death?" (Strange, *Who Tells Me True*, pp. 134–135.)

12. Goldsmith, *Little Gloria . . . Happy at Last*, p. 229.

13. Knickerbocker, "The Vital Vanderbilts," February 1940, p. 84.

14. Vanderbilt and Furness, *Double Exposure*, pp. 20–21.

15. Ibid., p. 82.

16. *The New Yorker*, November 8, 1934, p. 36.

17. Vanderbilt, *Without Prejudice*, p. 88.

18. Vanderbilt and Furness, p. 83.

19. Ibid., p. 84.

20. Ibid., p. 89.

21. Ibid., p. 87.

22. Vanderbilt, *Without Prejudice*, p. 92.

23. Vanderbilt and Furness, pp. 90, 96; Brown, *Champagne Cholly*, p. 106.

24. Vanderbilt, *Without Prejudice*, p. 93.

25. Vanderbilt and Furness, p. 93.

26. Vanderbilt, *Without Prejudice*, p. 93.

27. Ibid., p. 94.

28. Vanderbilt and Furness, p. 94.

29. Vanderbilt, *Without Prejudice*, p. 93.

30. Vanderbilt and Furness, p. 95.

31. Vanderbilt, *Without Prejudice*, p. 95.

32. Ibid.

33. Vanderbilt and Furness, p. 97.

34. Ibid., p. 98.

35. Ibid., p. 99.

36. Vanderbilt, *Without Prejudice*, p. 12.

37. Ibid.

38. Ibid., p. 11.

39. Ibid., p. 115.

40. Ibid., p. 117.

41. Vanderbilt and Furness, p. 113.

42. Ibid., p. 136.

43. Ibid., p. 137.

44. Vanderbilt, *Without Prejudice*, p. 126.

45. Vanderbilt and Furness, p. 137.

46. Vanderbilt, *Without Prejudice*, p. 126.

47. Vanderbilt and Furness, p. 153.

48. Vanderbilt, *Once Upon a Time*, pp. 3–4.

49. Vanderbilt and Furness, p. 155.

50. Vanderbilt, *Without Prejudice*, p. 132.

51. Vanderbilt and Furness, p. 156.

52. Goldsmith, p. 497.

53. Ibid., p. 128.

54. Margetson, *The Long Party*, p. 228.

55. Ibid.

56. Goldsmith, p. 155.

57. Ibid., p. 276.

58. Vanderbilt, *Without Prejudice*, p. 149.

59. Goldsmith, p. 497.

60. Friedman, p. 586.

61. Vanderbilt and Furness, p. 179.

62. Ibid., p. 180.

63. Goldsmith, p. 31.

64. Ibid., pp. 142–143. Grandmother Morgan did everything she could to interfere with their relationship. Once Gloria left Paris for a trip to Biarritz with Prince Hohenlohe. When they arrived, there was a message from her mother waiting at the hotel. The baby had developed tuberculosis and was dying. There

was no night train back to Paris, so Gloria hired a car and had the driver race to Paris. She arrived back at her apartment early in the morning and found her daughter's room empty. Panic stricken, she was sure little Gloria had been taken to a hospital.

"Well, you're back," her mother called from down the hall.

"Where is Gloria, Mamma?"

"Why, in the park with her nurse," her mother answered without emotion. "Where else would she be at this time of day?"

"But you told me she was dying."

"She is better," her mother replied. (Vanderbilt and Furness, p. 208.)

65. Vanderbilt, *Once Upon a Time*, p. 12. One night little Gloria opened the door of her mother's room and saw "there on the bed, the long arms and legs of praying mantises battling one with the other." (Ibid., p. 15.)

66. Vanderbilt and Furness, pp. 222–223.

67. Ibid.

68. Vanderbilt, *Once Upon a Time*, p. 22.

69. Vanderbilt, *Without Prejudice*, p. 164.

70. Grandmother Morgan lived very frugally and complained constantly that she was destitute, but under the bed in a wide chest she kept an ermine cape that she was saving for the right occasion, which never came, and in her jewel box was a tiara of emeralds. When she died in 1956, she left assets of $542,677.

71. Vanderbilt, *Once Upon a Time*, p. 28.

72. Vanderbilt, *Without Prejudice*, p. 329.

73. Goldsmith, pp. 189–190.

74. Ibid., p. 190.

75. Ibid.

76. Ibid., p. 192.

77. Ibid., p. 145.

78. Friedman, p. 66.

79. Ibid., p. 93.

80. Ibid., p. 160.

81. Ibid., p. 157.

82. Ibid., p. 158.

83. Once when stopped for speeding, going eighteen miles an hour on Central Park West, Harry Whitney was asked his occupation. "I don't know what name to give that," he replied. (Friedman, p. 207.)

84. Friedman, p. 188.

85. Ibid., p. 158.

86. Ibid., pp. 329–331.

87. Gertrude Vanderbilt Whitney sponsored the Whitney Studio Club, a building next to her studio where unknown artists could exhibit their works. And when the Metropolitan Museum of Art turned down her offer of the

collection of contemporary American art she had been building, she established the Whitney Museum of American Art in 1931. All the while, she continued working at her writing, publishing a number of short stories and, under a pseudonym, a novel, *Walking the Dusk,* with themes of lesbianism, depravity, and murder.

88. Ibid., p. 569.
89. Goldsmith, p. 232.
90. Vanderbilt and Furness, p. 243.
91. Ibid., p. 244.
92. Vanderbilt, *Without Prejudice,* p. 198.
93. Ibid., p. 238.
94. Vanderbilt and Furness, pp. 245–246.
95. Vanderbilt, *Without Prejudice,* p. 223.
96. Vanderbilt and Furness, p. 246.
97. Vanderbilt, *Without Prejudice,* p. 226.
98. Vanderbilt and Furness, p. 249.
99. Ibid.
100. Ibid., p. 250.
101. Ibid.
102. Ibid., p. 251.
103. Ibid., pp. 250–251.
104. Ibid., p. 251.
105. Ibid., p. 252.
106. Vanderbilt, *Without Prejudice,* p. 237.
107. Vanderbilt and Furness, p. 306.
108. Vanderbilt, *Without Prejudice,* p. 327.
109. Ibid., pp. 245–246.
110. Ibid., p. 249.
111. Ibid., pp. 245–246.
112. Goldsmith, p. 303.
113. Ibid., p. 17.
114. Ibid., p. 34.
115. Vanderbilt, *Once Upon a Time,* p. 51.
116. Goldsmith, p. 34.
117. Ibid., p. 443.
118. Vanderbilt, *Once Upon a Time,* p. 53.
119. Ibid., p. 54.
120. Vanderbilt, *Without Prejudice,* p. 270.
121. Vanderbilt and Furness, p. 257.
122. Ibid., pp. 257–258.
123. Vanderbilt, *Once Upon a Time,* pp. 60, 66.
124. Vanderbilt, *Without Prejudice,* p. 271.
125. Goldsmith, p. 20.

126. Ibid., p. 21.
127. Vanderbilt, *Without Prejudice,* p. 272.
128. Vanderbilt, *Once Upon a Time,* pp. 57–58.
129. Ibid., p. 59.
130. Vanderbilt and Furness, p. 259.
131. Vanderbilt, *Without Prejudice,* p. 279.
132. Vanderbilt and Furness, p. 259.
133. Vanderbilt, *Without Prejudice,* p. 279.
134. Goldsmith, p. 39.
135. Ibid., p. 351.
136. Vanderbilt, *Once Upon a Time,* p. 58.
137. Ibid., p. 76.
138. Goldsmith, p. 319.
139. Ibid., p. 326.
140. Vanderbilt and Furness, p. 263.
141. Vanderbilt, *Without Prejudice,* p. 286.
142. Goldsmith, pp. 321–322.
143. Ibid., p. 332.
144. Vanderbilt and Furness, p. 263.
145. Goldsmith, p. 333.
146. Vanderbilt and Furness, p. 264.
147. Ibid., pp. 264–265.
148. Friedman, p. 595.
149. Vanderbilt and Furness, p. 266; Goldsmith, p. 343.
150. Vanderbilt and Furness, p. 266.
151. Goldsmith, pp. 345–346.
152. Vanderbilt and Furness, p. 268.
153. Vanderbilt, *Without Prejudice,* p. 291. The testimony of Gloria Vanderbilt's butler was just as damaging. He reported that Gloria threw parties at the house several times a week, noisy parties, from which the guests left early in the morning. "I saw Mrs. Vanderbilt and Mrs. Thomas naked in the library about half-past six in the morning," he reported.

Had he seen any dirty books in the house?

"I saw one, this was shown to me by her maid, and it had pictures in it from the convent with all kinds of colored pictures in."

"What were they about?"

"Women . . . some of them got slashed by the Sisters. . . . They were Sisters and they were feeling young girls. They were all naked. . . . I only saw three or four of them."

"Pictures of grown girls or little girls?" the judge asked.

"Grown-up girls, sir," the butler replied. (Goldsmith, pp. 378, 379.)

154. There was undoubtedly some truth in this theory. Gloria was enchanted by Aunt Gertrude's palace in Old Westbury: "The curve of the stairs

seemed to glide up and down. Even the space between each of the twenty steps was placed so you felt buoyed up or wafted down, without being aware that you were making yourself move at all. . . . At the foot of the stairs to the right was the dining room, where Aunt Gertrude would sit at the head of the long chestnutty table, so shiny you could see yourself reflected in it. Always, tall butler William, in swallowtail and striped vest, stood behind her chair through-out the meal, as though he were a silent guest. They had signals known only to each other. Without even turning, Aunt Gertrude would lift her finger so slightly no one else would notice, and butler William would know, without her having uttered a word, what she meant—Pass the Brussels sprouts again, or more pheasant, please. . . . Everywhere there was . . . what was it? Something . . . but whatever it was I did not know a name for it. Was it order? Maybe that's what it was—order. The more I thought about it, the more I was sure that was what it must be. . . . Everywhere order, and it was perfect. And it lived with such ease. Is that what luxury meant? So effortless! What made it so smooth, everything so perfect, as though some magic person directed it all, made it all happen?" (Vanderbilt, *Once Upon a Time*, pp. 62–63.)

155. Goldsmith, p. 409.
156. Ibid., p. 410.
157. Ibid., p. 412.
158. Vanderbilt, *Once Upon a Time*, p. 80.
159. Goldsmith, pp. 411–412.
160. Ibid., pp. 413–414.
161. Ibid., p. 414.
162. Vanderbilt, *Once Upon a Time*, p. 86.
163. Ibid., pp. 89–90.
164. Ibid., p. 91.
165. Ibid., p. 98.
166. Ibid., p. 89.
167. Ibid., p. 94.
168. Goldsmith, pp. 439–442.
169. Vanderbilt, *Once Upon a Time*, p. 101.
170. Goldsmith, pp. 450–451.
171. Ibid., p. 459.
172. Vanderbilt, *Once Upon a Time*, p. 102.
173. Vanderbilt and Furness, p. 270.
174. Brown, *Champagne Cholly*, p. 109.
175. Gloria sold all her mementos of the Vanderbilt family, all of Reggie's trophies, the bust of Reggie, the monogrammed silverware and china, and went to live in a two-room apartment, dependent on the whim of her daughter for her living expenses. Some years later, little Gloria wired her mother: "Looking through my books and accounts, owing to heavy expenses, I can no longer continue your monthly allowance. Gloria." Her mother immediately wired

back: "Dear Gloria: What you term 'monthly allowance' is my sole means of livelihood. Please reconsider. Love, Mummy." (Vanderbilt and Furness, p. 331.)

176. Goldsmith, p. 572.
177. Friedman, p. 597.
178. Vanderbilt, *Once Upon a Time,* p. 107.
179. Ibid., p. 1.
180. Ibid., pp. 115–116.
181. Vanderbilt, *Farewell to Fifth Avenue,* p. 204.
182. Ibid., p. 237.
183. Ibid., pp. 197–198.
184. Ibid., p. 206.
185. Ibid., p. 221.
186. Ibid., p. 203.
187. Ibid., p. 230.
188. Amory, *Who Killed Society?,* pp. 492–493.

CHAPTER TEN

1. "Mrs. Vanderbilt: The Echo of an Elegant Era," p. 17.

2. Gates, *The Astor Family,* p. 110. She blamed Franklin Roosevelt every time "another yacht was sold, another fleet of cars reached the auction block, another great Bellevue Avenue mansion was boarded up." One spring day as Grace and Neily sat aboard the *Winchester* to watch the Yale-Harvard boat races, Grace spotted President Roosevelt aboard Vincent Astor's yacht. As the Astor yacht passed by, Grace called out, "I don't like you, Mr. President. I don't like you at all." Roosevelt smiled. "Well, Mrs. Vanderbilt, lots of people don't like me. You are in good company." (Vanderbilt, *Queen of the Golden Age,* pp. 296, 294.)

3. Lehr, *"King Lehr" and the Gilded Age,* p. 291.

4. Vanderbilt, *Without Prejudice,* p. 112; Vanderbilt, *Queen of the Golden Age,* p. 218.

5. *New York World,* September 13, 1899.

6. Vanderbilt, *Without Prejudice,* p. 94.

7. *New York Times,* November 26, 1925.

8. "Mr. Vanderbilt's Expenditures," p. 128.

9. *New York Times,* January 10, 1926.

10. Lehr, pp. 152–153. From the time at one of her dinner parties when she had patched up a misunderstanding between William Howard Taft and Theodore Roosevelt, Grace had fancied herself something of a diplomat. While in London with her son, Neil, just before the outbreak of World War II, Grace asked, "Neil, do you think we are close to another world war?"

"Yes, Mother darling. We're very close to it. It may break out at any moment. Certainly not later than this fall, but perhaps as soon as next week or next month."

Grace summoned Franklin Roosevelt's mother and with her paid a visit to her old friend Queen Mary, with whom she had exchanged recipes for many years and whose friendship, according to Neil, even "survived Mother's nine-page letter to the Queen telling her that she wasn't fair to the Duke of Windsor!"

After their meeting with the queen, Grace and Mrs. Roosevelt had dinner with Neil. "They were so proud of themselves and so very happy and gay," Neil remembered. At dinner that night, Grace explained why: "We went over to talk to Queen Mary and tell her that we three people were not going to permit another world war to come to civilization."

"And Mother truly believed that because Mrs. Roosevelt, the mother of the President of the United States, and Queen Mary, the mother of the King of England, and she herself, a powerful person in financial circles in the United States, England, France and some other places—that because these three elderly women had got together and talked about it, they could prevent a second world war." (Vanderbilt, *Man of the World,* p. 205.) After the war, she warned Andrei Gromyko that she intended to see Stalin herself if the Reds didn't behave.

11. Vanderbilt, *Queen of the Golden Age,* p. 139.

12. Ibid., p. 303. In her own way, Grace seemed to mean it. When Grace and her daughter were in London in 1935, Grace regularly wrote to Neily. "Since our arrival I have never dreamt of anything like the wonderful times we are having. It is impossible to describe the kindness and hospitality we are having showered upon us—never have I dreamt of anything like it!!!

"I will relate today's engagements. Lunch at Lady Cunard's. A lot of very gay, amusing, clever people . . . Then a drive with Sidney Herbert who is deep in the elections. Then I went to tea at five at Buckingham Palace with the beloved King and Queen. It was all very interesting and wonderful. They received me quite alone and we sat at a small tea table, the Queen pouring tea for the King and me! They kept me with them one hour and we talked of everything and everybody—of course a great deal about you, and he said you did not like 'going out' any more than he did!!! . . . They were both so dear and kind and touching, I felt I was with very dear and true friends—more like one's family than just friends. . . . Then I rushed home, jumped into my prettiest gown and, with Grace, drove off to Crewe House for a large and beautiful and most delightful dinner where they kindly put me on Lord Crewe's left, the Turkish Ambassador on his right. There were lots of our mutual friends and we stayed until 12. I have had flowers from about thirty people. *Beautiful,* bushels, etc. etc.—it's all like a wonderful dream—only I wish I were not so dead tired all the time. You never could stand the strain—it is killing, but well worth while.

NOTES

Well, goodnight—or good morning, darling Neily. And lots of love from your devoted Grace." (Ibid., p. 300.)

13. Ibid., p. 301.

14. The heavy antique furniture and paneling were removed, the dining saloon turned into an operating room, the study into an X-ray room, and the ballroom into a ward. "This stuff will have to go," the Red Cross representatives noted, pointing to the autographed pictures of the German and Austrian monarchs hanging on the walls. "We cannot depend on the self-control of the wounded men, don't you see?" (Vanderbilt, *Farewell to Fifth Avenue*, p. 133.) The British found it quite shocking when the *North Star* was fired upon by a German submarine, for it was in bad taste to assault a ship belonging to a fellow member of the British Royal Yacht Squadron; the emperor of Germany was an honorary member, and had dined on the *North Star* on many occasions. There was only one thing to do and that was to strike the emperor's name from the Yacht Club roster and to deprive him of clubhouse privileges. This, in fact, the British did. At the end of the war, the British Admiralty tried to return the *North Star* to the Vanderbilts, but the thought of dining again in a cabin that had served as an operating room was not appealing. It was sold to King Constantine of Greece, and later to a gambling syndicate, and later still operated out of Hong Kong in the opium and hashish trade.

15. Vanderbilt, *Queen of the Golden Age*, p. 291. Neily avoided 640 Fifth Avenue like the plague, though he would occasionally stop at Beaulieu in Newport. When Neily was in failing health, Grace had an elevator installed at Beaulieu, and Grace and her son, Neil, were on hand when Neily arrived so that they could proudly show him how it worked.

Neily took one look at it and pointed his walking stick at his wife. "I suppose you put this in the house hoping it would fall and I would be killed in it—you and your son!" Grace burst into tears. Neily turned and walked out of the house, never to return to Newport. (Vanderbilt, *Man of the World*, p. 301.) Later, a committee of Vanderbilt relatives said that Neily could no longer see Grace or his son without the committee's permission because "his heart accelerated at the sight of us [Grace and Neily]." (Ibid., p. 302.)

16. Amory, *Who Killed Society?*, pp. 494–495.

17. McAllister, *Society as I Have Found It*, p. 257.

18. Vanderbilt, *Queen of the Golden Age*, p. 308.

19. Amory, p. 494.

20. *New York Times*, November 22, 1892.

21. New York Historical Society, letter to Frank Millet, July 9, 1895.

22. Wilson, *McKim, Mead & White, Architects*, pp. 156–157.

23. Kaschewski, *The Quiet Millionaires*, pp. 52–53.

24. Andrews, *The Vanderbilt Legend*, p. 341.

25. Vanderbilt, *Queen of the Golden Age*, p. 146.

NOTES

26. One Morristown lady remembered that "my grandmother and Mrs. Hamilton McK. Twombly were on calling card—but not calling—terms. Once a year, Grandmother was driven to the Twombly mansion and announced herself to the butler. After ushering her into the main drawing room, he would disappear for a discreet interval. He would return to say that Mrs. Twombly was not receiving today, which Grandmother already knew. She then left her card. Within the year, Mrs. Twombly would go through the same performance, to keep the lines of communication open, I suppose." (Kaschewski, p. 9.)

27. Vanderbilt, *Queen of the Golden Age,* p. 308.

28. Kaschewski, p. 113.

29. Amory, p. 110.

30. Ibid.

31. Burden, *The Vanderbilts in My Life,* pp. 104, 217.

32. Tomkins, *Merchants and Masterpieces,* p. 190.

33. James, *The American Scene,* pp. 216–217.

34. Amory, p. 497.

35. *New York Times,* August 19, 1988.

36. Frederick Vanderbilt's Hyde Park estate on 212 acres overlooking the Hudson, with its three-story Italian Renaissance mansion, filled with furnishings from the palace of Napoleon and the empress Josephine, is a national historic site administered by the National Park Service.

37. Plimpton, "The Voices of Two Venerable Vanderbilts."

38. *New York Times,* February 6, 1879.

39. Croffut, *The Vanderbilts and the Story of Their Fortune,* p. 133.

40. Amory, p. 46.

BIBLIOGRAPHY

MANUSCRIPT COLLECTIONS

Architects Information Center, Washington, D.C. Contains library and papers of Richard Morris Hunt.

Avery Architectural Library, Columbia University, New York, N.Y. Catherine Howland Hunt (Mrs. Richard Morris Hunt), "The Richard Morris Hunt Papers, 1828–1895" (edited by Alan Burnham), unpublished manuscript. Scrapbook assembled by Mrs. Richard Morris Hunt, July 31, 1900, on the fifth anniversary of Richard Morris Hunt's death. Susan Brendel, "Documentation of the Construction of Biltmore House Through Drawings, Correspondence and Photographs" (thesis, 1978).

Columbia University Libraries, New York, N.Y. Belmont Family Papers.

Detroit Public Library, Detroit, Mich. Mrs. Frank Crawford Vanderbilt Papers are contained in the Burton Historical Collection.

Friendship Library, Fairleigh Dickinson University, Florham-Madison Campus, Madison, N.J. Documents and clipping files relating to Florence Vanderbilt Twombly and her estate, Florham.

Melvin Gelman Library, George Washington University, Washington, D.C. Chauncey Depew Papers.

Jean and Alexander Heard Library, Vanderbilt University, Nashville, Tenn. The log of the *Alva*, 1891. Papers of Harold S. Vanderbilt.

Huntington Library, San Marino, Calif. The C.E.S. Wood Collection includes a first-draft autobiography of Alva Vanderbilt Belmont, prepared by Sara Bard Field in 1917, as well as notes for the autobiography taken while in conversation with Mrs. Belmont in July and August of 1917, and some correspondence of Alva Belmont.

Library of Congress, Manuscript Division, Washington, D.C. Papers of the National Woman's party. Frederick Law Olmsted Papers, including documents concerning Biltmore.

Museum of the City of Mobile, Reference Library, Mobile, Ala. Papers of Mrs. Frank Crawford Vanderbilt.

BIBLIOGRAPHY

Newport Historical Society, Newport, R.I. Collection on women's suffrage relating to Alva Vanderbilt Belmont's Newport rallies.

New York Genealogical Society and Biographical Library, New York, N.Y. *Laurus Crawfurdiana,* "Memorials of That Branch of the Crawford Family Which Comprises the Descendants of John Crawford of Virginia, 1660–1883" (New York: privately published, 1883). "Lines Written on the Death of Mrs. Phoebe Vanderbilt by her Granddaughter Anna V. P. Root of Staten Island."

New York Historical Society, New York, N.Y. Diary of Mrs. Frank Crawford Vanderbilt. Harold Seton Collection of sixty photographs of those who attended the March 26, 1883, fancy dress ball of the William K. Vanderbilts. Correspondence concerning the construction of Florham.

New York Public Library, New York, N.Y. "Memorial of the Golden Wedding of Cornelius and Sophia Vanderbilt, December 19, 1863." Alva Belmont, *One Month's Log of the Seminole* (New York: privately published). National Woman's party records.

William R. Perkins Library, Duke University, Durham, N.C. The Matilda Young Papers contain the incomplete typewritten manuscript memoirs of Alva Vanderbilt Belmont, and correspondence of Matilda Young, Mrs. Belmont's secretary during the last several years of her life.

Rose Memorial Library, Drew University, Madison, N.J. The Thomas Gibbons Papers include letters written by Cornelius Vanderbilt to his employer Thomas Gibbons, as well as his employment contract.

Arthur and Elizabeth Schlesinger Library on the History of Women in America, Radcliffe College, Cambridge, Massachusetts. The Jane Norman Smith, Alice Paul, and Doris Stevens collections contain suffrage movement papers of Alva Vanderbilt Belmont.

Staten Island Institute of Arts and Sciences, Staten Island, N.Y. Miscellaneous correspondence of Cornelius Vanderbilt, and records of the Supreme Court case of *Cornelius Vanderbilt* v. *New York and Staten Island Ferry Co.,* 1851.

Whitney Museum of American Art Library, New York, N.Y. Papers of Gertrude Vanderbilt Whitney.

ARTICLES, CATALOGS, AND PAMPHLETS

"American Suffragist on the Defensive, An." *Review of Reviews,* Vol. 12, January 1910.

Archer, Verley. "Commodore Cornelius Vanderbilt, Sophia Johnson and Their Descendants." Vanderbilt University (Nashville, Tenn.), 1972.

BIBLIOGRAPHY

Arnett, Frank S. "Luxuries of the Millionaires: Country Houses." *Ainslee's Magazine*, Vol. 1, No. 1, August 1902.

Baids, Peter. "My Vanderbilt Movie." *American Heritage*, Vol. 38, No. 7, November 1987.

Baids, Peter. "Poor Jacob!" *Forbes*, Vol. 140, No. 9, October 26, 1987.

Barbour, Elizabeth. "How to Keep House on a Million Dollars a Year." *Saturday Evening Post*, Vol. 199, No. 28, March 19, 1927.

Barbour, Elizabeth, and Brenda Ueland. "Society Tightwads." *Saturday Evening Post*, Vol. 199, No. 42, April 16, 1927.

Barnett, Robert N. "Captains of Industry, Part XXIII: William Kissam Vanderbilt," *Cosmopolitan*, Vol. 36, No. 5, March 1904.

Barron, Susan. "After the Ball." *New England Monthly*, Vol. 4, No. 6, June 1987.

Belmont, Alva Vanderbilt. "Woman's Right to Govern Herself." *North American Review*, Vol. 190, No. 5, November 1909.

Belmont, Mrs. O.H.P. "Are Women Really Citizens?" *Good Housekeeping*, September 1931.

Belmont, Mrs. O.H.P. Foreword to "The Story of the Women's War—by Mrs. Pankhurst." *Good Housekeeping*, November 1913.

Belmont, Mrs. O.H.P. "Why I Am a Suffragist." *The World Today*, October 1911.

Benway, Ann M. *The Chinese Teahouse on the Grounds of Marble House*. Newport, R.I.: The Preservation Society of Newport County, 1982.

Benway, Ann M. *A Guide to Newport Mansions*. Newport, R.I.: The Preservation Society of Newport County, 1984.

Biltmore Estate. Asheville, N.C.: The Biltmore Company, 1985.

"Biltmore Forest." *Harper's Weekly*, Vol. 44, July 28, 1900.

"Breakers, The." *Life*, July 23, 1951.

Burck, Gilbert. "The World's Biggest Merger." *Fortune Magazine*, Vol. 71, No. 6, June 1965; Vol. 72, No. 1, July 1965.

Burnham, Alan. "The New York Architecture of Richard Morris Hunt." *Journal of the Society of Architectural Historians*, Vol. XI, No. 2, May 1952.

Cable, May. "The Marble Cottages." *Horizon* (American), Vol. VII, No. 4, Autumn 1965.

Cherol, John A. "Historic Architecture: Richard Morris Hunt; Mr. and Mrs. William K. Vanderbilt's Marble House in Newport." *Architectural Digest*, October 1985.

Chippendale and Other Georgian and Dutch Furniture, Tapestries and Other Appointments of Florham, Convent, N.J., Estate of the Late Ruth Vanderbilt Twombly. Catalog for public auction. New York: Parke-Bernet Galleries, 1955.

Clark, Frank. "The Commodore Left Two Sons: The Great Vanderbilt Will Contest." *American Heritage*, Vol. 17, April, 1966.

BIBLIOGRAPHY

Collection of W. H. Vanderbilt. Pamphlet. New York: privately published, 1884.

"Cornelius Vanderbilt." *The Merchants' Magazine and Commercial Review,* January 1865.

Crowninshield, Frank. "The House of Vanderbilt." *Vogue,* November 15, 1941.

Dennett, J. R. "Vanderbilt Memorial." *Nation,* November 18, 1869.

"Dinner at Mrs. Vanderbilt's." *Life,* Vol. 20, No. 23, June 10, 1946.

Dunford, Timothy. "Biltmore Garden." *Southern Accents,* Vol. 5, No. 2, Spring 1982.

English and French Furniture; Oriental Rugs; Fabrics; Bronzes; Sculptures and Ivories; Tapestries; Silver; Porcelains and Glassware. Catalog for Mrs. O.H.P. Belmont sale. New York: American Art Association, 1928.

Ford, Frank Lewis. "The Vanderbilts and the Vanderbilt Millions." *Munsey's Magazine,* Vol. XXII, No. 4, January 1900.

Godkin, E. L. "The Expenditure of Rich Men." *Scribner's Magazine,* Vol. 20, No. 4, October 1896.

Hendrick, Burton J. "The Astor Fortune." *McClure's Magazine,* Vol. 24, No. 6, April 1905.

Illustrated Catalogue of Costly Antique and Modern Furnishings, Interior Decorations and Embellishments of a New York City Palatial Mansion Which Was Designed by, and Erected and Furnished Under the Direct Supervision of the Distinguished American Architect, the Late Richard Morris Hunt. For the William K. Vanderbilt residence at 660 Fifth Avenue. New York: American Art Association, October 17, 1921.

Insley, Rebecca H. "An Interview with Mrs. Astor." *Delineator,* Vol. 72, October 1908.

Johnson, Gerald W. "Dynamic Victoria Woodhull." *American Heritage,* Vol. VIII, No. 4, June 1956.

Knickerbocker, Cholly [Maury Paul]. "The Vital Vanderbilts." *Cosmopolitan,* November 1939; December 1939; January 1940; February 1940.

Lee, Joseph. "Expensive Living, the Blight on America." *New England Magazine,* Vol. XVIII, March 1898–August 1898.

"Life Visits the Vanderbilt Mansions." *Life,* January 2, 1950.

Low, Seth. "Cornelius Vanderbilt." *Columbia University Quarterly,* December 1899.

Lynes, Russell. "Chateau Builder to Fifth Avenue." *American Heritage,* Vol. 6, No. 2, February 1955.

Maconi, Carole J. "Belcourt Castle." Southborough, Mass.: Yankee Colour Corporation, 1985.

Marble House: The William K. Vanderbilt Mansion. Newport, R.I.: The Preservation Society of Newport County, 1965.

"Mr. Vanderbilt's Estate, Biltmore." *Scientific American,* February 1, 1896.

BIBLIOGRAPHY

"Mr. Vanderbilt's Expenditure." *The Spectator,* January 26, 1895; February 2, 1895.

"Mrs. Vanderbilt: The Echo of an Elegant Era." *Life,* June 16, 1941.

Mullet, Mary B. "Cornelius Vanderbilt, Jr., Tells Why He Chooses to Work." *The American Magazine,* Vol. 92, No. 2, August 1921.

Palmer, Joe H. "The Riddle of Alfred Vanderbilt." *Saturday Evening Post,* Vol. 225, No. 31, February, 21, 1953.

Patterson, Ada. "The Woman Who Talked." *Human Life,* Vol. V, No. 1, April 1907.

"Pisgah Forest Purchase." *American Forestry,* Vol. XX, No. 6, June 1914.

Plimpton, George. "The Voices of Two Venerable Vanderbilts." *Life,* Vol. 57, No. 7, August 14, 1964.

Price, Overton Westfeldt. "George W. Vanderbilt: Pioneer in Forestry." *American Forestry,* Vol. XX, No. 6, June 1914.

Private Collection of W. H. Vanderbilt, The. New York: G. P. Putnam's Press, 1879.

Queen Anne and Georgian Furniture, Tapestries, Paintings, K'ang Hsi Porcelains and Other Objects of Art, XVIII Century Colored Mezzotints, Antique Rugs, Belonging to the Estate of the Late Ruth Vanderbilt Twombly. Catalog for public auction. New York: Parke-Bernet Galleries, 1955.

"Queenly Kingfisher, The." *Life Magazine,* January 19, 1953.

Robbins, Peggy. "The Commodore and His Money." *American History Illustrated,* Vol. 19, No. 3, May 1984.

Robinson, Grace. "Pleasure Hunting in a Big Way." *Liberty,* Vol. 6, No. 19, May 18, 1929.

Schuyler, Montgomery. "A Newport Palace." *Cosmopolitan,* Vol. XXIX, No. 4, August 1900.

Schuyler, Montgomery. "The Vanderbilt Houses." *Harper's Weekly,* Vol. 26, No. 42, January 21, 1882.

"Scrapping an Architectural Masterpiece." *American Architect and Building News,* April 20, 1926.

Shearman, Thomas G. "The Coming Billionaire." *The Forum,* Vol. X, January 1891.

Shearman, Thomas G. "The Owners of the United States." *The Forum,* Vol. VIII, November 1889.

"Splendor of a Great Family, The: The Vanderbilts." *Life,* Vol. 57, No. 7, August 14, 1964.

Stein, Susan R. "Some of the New York City Houses of Richard Morris Hunt." *The Magazine Antiques,* Vol. CXXIX, No. 4, April 1986.

Thompson, Jacqueline. "The Man Who Invented Society." *Forbes,* Vol. 136, No. 11, October 28, 1985.

Tudury, Moran. "Ward McAllister." *American Mercury,* Vol. 8, June 1926.

BIBLIOGRAPHY

Twain, Mark. "Open Letter to Com. Vanderbilt." *Packard's Monthly,* March 1869.

Vanderbilt, Cornelius, Jr. [IV]. "The Blue Bloods." *Saturday Evening Post,* Vol. 249, No. 5, July–August 1927.

Vanderbilt, Cornelius, Jr. [IV]. "The Future of the American Dynasties." *Saturday Evening Post,* Vol. 199, No. 27, January 8, 1927.

Vanderbilt, Cornelius, Jr. [IV]. "It Is Hard to Be a Rich Man's Son." *Saturday Evening Post,* Vol. 199, No. 23, December 4, 1926.

Vanderbilt, Cornelius, Jr. [IV]. "The Vanderbilt Feud," *Ladies' Home Journal,* Vol. 73, No. 77, July 1956.

Walsh, E. "Biltmore Forest." *Scientific American,* September 14, 1904.

Willey, Day Allen. "Forest Conservation at Biltmore." *American Homes and Gardens,* Vol. VI, No. 7, July 1909.

NEWSPAPERS

Brooklyn Eagle
Chicago Daily News
Chicago Record Herald
New York Commercial Advertiser
New York Daily Graphic
New York Daily Tribune
New York Evening Express
New York Evening Journal
New York Evening Post
New York Herald
New York Herald Tribune
New York Journal
New York Mail
New York Star
New York Sun
New York Sunday Mercury
New York Sunday News
New York Times
New York World
Philadelphia Press

BOOKS

Adams, Charles F., Jr., and Henry Adams. *Chapters of Erie and Other Essays.* Boston: James R. Osgood and Company, 1871.

BIBLIOGRAPHY

Allen, Frederick Lewis. *The Big Change.* New York: Harper & Brothers, 1952.

Allen, Frederick Lewis. *The Great Pierpont Morgan.* New York: Harper & Brothers, 1949.

Allen, Frederick Lewis. *The Lords of Creation.* New York: Harper & Brothers, 1935.

Allen, Frederick Lewis. *Only Yesterday.* New York: Harper & Brothers, 1957.

Allen, Frederick Lewis. *Since Yesterday.* New York: Harper & Brothers, 1940.

Amory, Cleveland. *The Last Resorts.* New York: Harper & Brothers, 1952.

Amory, Cleveland. *Who Killed Society?* New York: Harper & Brothers, 1960.

Andrews, Wayne. *Architecture, Ambition and Americans.* New York: Free Press, 1964.

Andrews, Wayne. *Architecture in New York.* New York: Atheneum, 1969.

Andrews, Wayne. *The Vanderbilt Legend.* New York: Harcourt, Brace and Company, 1941.

Ashbury, Herbert. *Sucker's Progress: An Informal History of Gambling in America from the Colonies to Canfield.* New York: Dodd, Mead & Company, 1938.

Aslet, Clive. *The Last Country Houses.* New Haven, Conn.: Yale University Press, 1982.

Bailyn, Bernard, et al. *The Great Republic.* Boston: Little, Brown and Company, 1977.

Baker, Paul R. *Richard Morris Hunt.* Cambridge, Mass.: MIT Press, 1986.

Ball, Don, Jr. *America's Colorful Railroads.* New York: Bonanza Books, 1978.

Balsan, Consuelo Vanderbilt. *The Glitter and the Gold.* New York: Harper & Brothers, 1952.

Barlow, Elizabeth. *Frederick Law Olmsted's New York.* New York: Praeger Publishers, 1972.

Barmash, Isadore. *The Self-made Man.* New York: Macmillan Company, 1969.

Barrett, Richard. *Good Old Summer Days.* New York: D. Appleton-Century Company, 1941.

Beebe, Lucius. *The Big Spenders.* Garden City, N.Y.: Doubleday & Company, 1966.

Beebe, Lucius. *Mansions on Rails.* Berkeley, Calif.: Howell-North, 1959.

Beer, Thomas. *The Mauve Decade: American Life at the End of the Nineteenth Century.* New York: Alfred A. Knopf, 1926.

Behrman, S. N. *Duveen.* New York: Random House, 1952.

Belmont, Eleanor Robson. *The Fabric of Memory.* New York: Farrar, Straus and Cudahy, 1957.

Beveridge, Albert J. *The Life of John Marshall.* Boston: Houghton Mifflin Company, 1916.

Birmingham, Stephen. *America's Secret Aristocracy.* Boston: Little, Brown and Company, 1987.

Birmingham, Stephen. *Our Crowd.* New York: Harper & Row, 1967.

BIBLIOGRAPHY

Birmingham, Stephen. *The Right People.* Boston: Little, Brown and Company, 1968.

Bocca, Geoffrey. *The Woman Who Would Be Queen.* New York: Rinehart & Company, 1954.

Bradley, Hugh. *Such Was Saratoga.* New York: Doubleday, Doran and Company, 1940.

Brough, James. *Consuelo: Portrait of an American Heiress.* New York: Coward, McCann & Geoghegan, 1979.

Brown, Eve. *Champagne Cholly: The Life and Times of Maury Paul.* New York: E. P. Dutton & Company, 1947.

Brown, Henry Collins. *Fifth Avenue Old and New.* New York: Fifth Avenue Association, 1924.

Browne, Junius Henri. *The Great Metropolis: A Mirror of New York.* Hartford, Conn.: American Publishing Company, 1869.

Bryce, James. *The American Commonwealth.* London: Macmillan and Co., 1889.

Burden, Shirley. *The Vanderbilts in My Life.* New York: Ticknor & Fields, 1981.

Burnham, Sophy. *The Landed Gentry.* New York: G. P. Putnam's Sons, 1978.

Burt, Nathaniel. *First Families.* Boston: Little, Brown and Company, 1970.

Cecil, William A. V. *Biltmore.* Asheville, N.C.: Biltmore Company, 1975.

Choules, John O. *The Cruise of the Steam Yacht North Star.* Boston: Gould and Lincoln, 1854.

Churchill, Allen. *The Improper Bohemians.* New York: E. P. Dutton & Company, 1959.

Churchill, Allen. *The Splendor Seekers.* New York: Grosset & Dunlap, 1974.

Churchill, Allen. *The Upper Crust: An Informal History of New York's Highest Society.* Englewood Cliffs, N.J.: Prentice-Hall, 1970.

Churchill, Winston S. *Marlborough.* London: George G. Harrap & Co., 1947.

Clews, Henry. *Fifty Years in Wall Street.* New York: Irving Publishing Company, 1908.

Clute, J. J. *Annals of Staten Island.* New York: Press of Chas. Vogt, 1877.

Cochran, Thomas C. *Railroad Leaders: 1845–1890.* Cambridge, Mass.: Harvard University Press, 1953.

Cowles, Virginia. *The Astors.* London: Weidenfeld and Nicolson, 1979.

Cox, Archibald. *The Court and the Constitution.* Boston: Houghton Mifflin Company, 1987.

Crockett, Albert Stevens. *Peacocks on Parade.* New York: Sears Publishing Company, 1931.

Croffut, A. *The Vanderbilts and the Story of Their Fortune.* New York: Belford, Clarke & Company, 1886.

Crowninshield, Francis W. *Manners for the Metropolis.* New York: D. Appleton and Company, 1909.

BIBLIOGRAPHY

Dayton, Fred Erving. *Steamboat Days.* New York: Tudor Publishing Company, 1925.

Decies, Elizabeth. *Turn of the World.* Philadelphia: J. B. Lippincott Company, 1937.

Deems, Charles Force. *Autobiography of Charles Force Deems . . . and Memoir by His Sons Rev. Edward M. Deems . . . and Francis M. Deems.* New York: Fleming H. Revell Company, 1897.

Dennis, James M. *Karl Bitter: Architectural Sculptor.* Madison, Wis.: University of Wisconsin Press, 1967.

Depew, Chauncey M. *My Memories of Eighty Years.* New York: Charles Scribner's Sons, 1922.

Depew, Chauncey M. *Orations and After-Dinner Speeches of Chauncey M. Depew.* New York: Cassell Publishing Company, 1890.

Depew, Chauncey M. *A Retrospect of 25 Years with the New York Central Railroad and Its Allied Lines, 1866–1891.* New York: DeVinne Press, 1892.

Downing, Antoinette F., and Vincent J. Scully, Jr. *The Architectural Heritage of Newport, Rhode Island.* New York: American Legacy Press, 1982.

Dressler, Marie. *My Own Story.* Boston: Little, Brown and Company, 1934.

Drexler, Arthur, ed. *The Architecture of the Ecole des Beaux-Arts.* New York: Museum of Modern Art, 1977.

Eliot, Elizabeth. *Heiresses and Coronets: The Story of Lovely Ladies and Noble Men.* New York: McDowell, Obolensky, 1959.

Elliott, Maude Howe. *This Was My Newport.* Cambridge, Mass.: Mythology Company, 1944.

Elliott, Maud Howe. *Uncle Sam Ward and His Circle.* New York: Macmillan Company, 1938.

Fiske, Stephen. *Off-hand Portraits of Prominent New Yorkers.* New York: Geo. R. Lockwood & Son, 1884.

Flexner, Eleanor. *Century of Struggle: The Woman's Rights Movement in the United States.* New York: Atheneum, 1973.

Folsom, Merrill. *Great American Mansions and Their Stories.* New York: Hastings House Publishers, 1963.

Ford, Henry Jones. *The Cleveland Era.* New Haven, Conn.: Yale University Press, 1921.

Friedman, B. H. *Gertrude Vanderbilt Whitney.* Garden City, N.Y.: Doubleday & Company, 1978.

Friedman, Lawrence M. *A History of American Law.* New York: Simon & Schuster, 1973.

Fuller, Robert H. *Jubilee Jim: The Life of Colonel James Fisk, Jr.* New York: Macmillan Company, 1928.

Galbraith, John Kenneth. *The Great Crash.* Boston: Houghton Mifflin Company, 1955.

Gannon, Thomas. *Newport Mansions: The Gilded Age.* Little Compton, R.I.: Foremost Publishers, 1982.

Gardiner, Alexander. *Canfield: The True Story of the Greatest Gambler.* New York: Doubleday, Doran and Company, 1930.

Garraty, John A. *The Great Depression.* New York: Harcourt Brace Jovanovich, 1986.

Gates, John D. *The Astor Family.* New York: Doubleday & Company, 1981.

Girovard, Mark. *Life in the English Country House.* New Haven, Conn.: Yale University Press, 1978.

Goldsmith, Barbara. *Little Gloria . . . Happy at Last.* New York: Alfred A. Knopf, 1980.

Graham, Sheilah. *How to Marry Super Rich.* New York: Grosset & Dunlap, 1974.

Hampton, Taylor. *The Nickel Plate Road.* Cleveland: World Publishing Company, 1947.

Harlow, Alvin F. *The Road of the Century: The Story of the New York Central.* New York: Creative Age Press, 1947.

Harper, Ida Husted, et al., eds. *History of Woman Suffrage.* New York: National American Woman Suffrage Association, 1922.

Harriman, Mrs. J. Borden. *From Pinafores to Politics.* New York: Henry Holt and Company, 1923.

Harvey, George. *Henry Clay Frick, the Man.* New York: Charles Scribner's Sons, 1928.

Haywood, R. A. *Cleopatra's Needle.* Derbyshire, Great Britain: Mourland Publishing Company, 1978.

Hendrick, Burton J. *The Age of Big Business.* New Haven, Conn.: Yale University Press, 1921.

Hicks, Frederick C. *High Finance in the Sixties: Chapters from the Early History of the Erie Railway.* New Haven, Conn.: Yale University Press, 1929.

Hofstadter, Richard. *The Age of Reform.* New York: Vintage Books, 1955.

Holbrook, Stewart H. *The Age of the Moguls.* New York: Doubleday & Company, 1954.

Hoyt, Edwin P. *The Vanderbilts and Their Fortune.* New York: Doubleday & Company, 1962.

Hungerford, Edward. *Men and Iron: The History of the New York Central.* New York: Thomas Y. Crowell, 1938.

Irwin, Inez Haynes. *The Story of the Woman's Party.* New York: Harcourt, Brace and Company, 1921.

Jackson, Stanley. *J. P. Morgan.* New York: Stein and Day, 1984.

James, Edward T., Janet Wilson James, and Paul S. Boyer, eds. *Notable American Women, 1607–1950: A Biographical Dictionary.* Cambridge, Mass.: Harvard University Press, 1971.

James, Henry. *The American Scene.* New York: Harper & Brothers, 1908.

BIBLIOGRAPHY

Johnson, Allen, and Dumas Malone, eds. *Dictionary of American Biography.* New York: Charles Scribner's Sons, 1937.

Josephson, Matthew. *The Robber Barons.* New York: Harcourt, Brace and Company, 1934.

Kaschewski, Marjorie. *The Quiet Millionaires: The Morris County That Was.* Morristown, N.J.: Daily Record, 1982.

Kavaler, Lucy. *The Astors.* New York: Dodd, Mead & Company, 1966.

King, Moses. *King's Handbook of New York City.* Boston: King Publishers, 1892.

Klein, Maury. *The Life and Legend of Jay Gould.* Baltimore: Johns Hopkins University Press, 1986.

Koch, Robert. *Louis C. Tiffany: Rebel in Glass.* New York: Crown Publishers, 1982.

Lane, Wheaton J. *Commodore Vanderbilt: An Epic of the Steam Age.* New York: Alfred A. Knopf, 1942.

Lathrop, Elise. *Early American Inns and Taverns.* New York: Robert M. McBride & Company, 1926.

Lehr, Elizabeth Drexel. *"King Lehr" and the Gilded Age.* Philadelphia: J. B. Lippincott Company, 1935.

Lloyd, Henry Demarest. *Wealth Against Commonwealth.* Englewood Cliffs, N.J.: Prentice-Hall, 1963.

Logan, Andy. *The Man Who Robbed the Robber Barons.* New York: W. W. Norton & Company, 1965.

Lundberg, Ferdinand. *America's 60 Families.* New York: Citadel Press, 1946.

Lundberg, Ferdinand. *The Rich and the Super-Rich.* New York: Lyle Stuart, 1986.

Lynes, Russell. *The Taste-Makers.* New York: Harper & Brothers, 1954.

McAllister, Ward. *Society as I Have Found It.* New York: Cassell Publishing Company, 1890.

McFeely, William S. *Grant: A Biography.* New York: W. W. Norton & Company, 1981.

McLean, Evalyn Walsh. *Father Struck It Rich.* Boston: Little, Brown and Company, 1936.

Maher, James T. *The Twilight of Splendor.* Boston: Little, Brown and Company, 1975.

Mann, William d'Alton. *Fads and Fancies of Representative Americans at the Beginning of the Twentieth Century, Being a Portrayal of Their Tastes, Diversions and Achievements.* New York: Town Topics Publishing Company, 1905.

Margetson, Stella. *The Long Party: High Society in the Twenties and Thirties.* London: Saxon House, D. C. Heath, 1974.

Martin, Frederick Townsend. *The Passing of the Idle Rich.* Garden City, N.Y.: Doubleday, Page & Company, 1911.

BIBLIOGRAPHY

Martin, Frederick Townsend. *Things I Remember.* London: Eveleigh Nash, 1913.

Maurice, Arthur Bartlett. *Fifth Avenue.* New York: Dodd, Mead & Company, 1918.

Maxwell, Elsa. *The Celebrity Circus.* New York: Appleton-Century, 1963.

Maxwell, Elsa. *R.S.V.P.: Elsa Maxwell's Own Story.* Boston: Little, Brown and Company, 1954.

Minnigerode, Meade. *Certain Rich Men.* New York: G. P. Putnam's Sons, 1927.

Modelski, Andrew M. *Railroad Maps of North America: The First Hundred Years.* New York: Bonanza Books, 1987.

Montgomery-Massingberd, Hugh. *Blenheim Revisited.* New York: Beaufort Books, 1985.

Moody, John. *The Masters of Capital.* New Haven, Conn.: Yale University Press, 1921.

Moody, John. *The Railroad Builders.* New Haven, Conn.: Yale University Press, 1921.

Moore, Charles. *The Life and Times of Charles Follen McKim.* Boston: Houghton Mifflin Company, 1929.

Morison, Samuel Eliot, and Henry Steele Commager. *The Growth of the American Republic.* New York: Oxford University Press, 1937.

Morris, Lloyd. *Incredible New York.* New York: Bonanza Books, 1951.

Morris, Lloyd. *Postscript to Yesterday.* New York: Random House, 1947.

Mott, Edward Harold. *Between the Ocean and the Lakes: The Story of Erie.* New York: John S. Collins, 1901.

Myers, Gustavus. *The Ending of Hereditary American Fortunes.* New York: Julian Messner, 1939.

Myers, Gustavus. *History of the Great American Fortunes.* New York: Modern Library, 1936.

Nevins, Allan. *The Emergence of Modern America, 1865–1878.* New York: Macmillan Company, 1927.

Nichols, Charles Wilbur de Lyon. *The Ultra-Fashionable Peerage of America.* New York: George Harjes, 1904.

O'Connor, Harvey. *The Astors.* New York: Alfred A. Knopf, 1941.

O'Connor, Richard. *The Golden Summers.* New York: G. P. Putnam's Sons, 1974.

O'Connor, Richard. *The Scandalous Mr. Bennett.* New York: Doubleday & Company, 1962.

Parton, James. *Famous Americans of Recent Times.* Boston: Houghton Mifflin Company, 1884.

Phillips, Lance. *Yonder Comes the Train: The Story of the Iron Horse and Some of the Roads It Travelled.* New York: Galahad Books, 1965.

BIBLIOGRAPHY

Pound, Arthur, and Samuel Taylor Moore, eds. *More They Told Barron: Conversations and Revelations of an American Pepys in Wall Street.* New York: Harper & Brothers, 1931.

Pulitzer, Ralph. *New York Society on Parade.* New York: Harper & Brothers, 1910.

Quinn, William P. *Shipwrecks Around Cape Cod.* Farmington, Me.: Knowlton & McLeary Co., 1973.

Rae, John W., and John W. Rae, Jr. *Morristown's Forgotten Past—"The Gilded Age."* Morristown, N.J.: John W. Rae, 1980.

Ratner, Sidney, ed. *New Light on the History of Great American Fortunes.* New York: Augustus M. Kelley, 1953.

Redmond, George F. *Financial Giants of America.* Boston: Stratford Company, 1922.

Reed, Robert C. *Train Wrecks.* New York: Bonanza Books, 1968.

Roberts, Cecil. *And So to America.* Garden City: N.Y.: Doubleday & Company, 1947.

Roper, Laura Ward. *FLO: A Biography of Frederick Law Olmsted.* Baltimore: Johns Hopkins University Press, 1973.

Rousmaniese, John. *The Luxury Yachts.* Alexandria, Va.: Time-Life Books, 1981.

Sachs, Emanie. *The Terrible Siren: Victoria Woodhull.* New York: Harper & Brothers, 1928.

Saroyan, Arma. *Trio: Portrait of an Intimate Friendship.* New York: Linden Press/Simon & Schuster, 1985.

Scroggs, William O. *Filibusters and Financiers.* New York: Macmillan Company, 1916.

Simon, Kate. *Fifth Avenue: A Very Social History.* New York: Harcourt Brace Jovanovich, 1978.

Sinclair, David. *Dynasty: The Astors and Their Times.* New York: Beaufort Books, 1984.

Sirkis, Nancy. *Newport: Pleasures and Palaces.* New York: Viking Press, 1963.

Smith, Arthur D. Howden. *Commodore Vanderbilt: An Epic of American Achievement.* New York: Robert M. McBride & Company, 1927.

Smith, Matthew Hale. *Sunshine and Shadow in New York.* Hartford: J. B. Burr and Company, 1869.

Spearman, Frank H. *The Strategy of Great Railroads.* New York: Charles Scribner's Sons, 1912.

Stein, Susan R., ed. *The Architecture of Richard Morris Hunt.* Chicago: University of Chicago Press, 1986.

Stevens, Doris. *Jailed for Freedom.* New York: Liveright Publishing Corporation, 1920.

BIBLIOGRAPHY

Stevens, Frank Walker. *The Beginnings of the New York Central Railroad.* New York: G. P. Putnam's Sons, 1926.

Stevenson, Elizabeth. *Park Maker: A Life of Frederick Law Olmsted.* New York: Macmillan Company, 1977.

Strahan, Edward. *Mr. Vanderbilt's House and Collection.* New York: George Barrie, 1883–1884.

Strange, Michael. *Who Tells Me True.* New York: Charles Scribner's Sons, 1940.

Studies in Income and Wealth. Vol. 3. New York: National Bureau of Economic Research, 1939.

Tebbel, John. *The Inheritors: A Study of America's Great Fortunes and What Happened to Them.* New York: G. P. Putnam's Sons, 1962.

Tebbel, John. *The Life and Good Times of William Randolph Hearst.* New York: E. P. Dutton & Company, 1952.

Terkel, Studs. *Hard Times: An Oral History of the Great Depression.* New York: Pantheon Books, 1970.

Tharp, Louise Hall. *Three Saints and a Sinner.* Boston: Little, Brown and Company, 1956.

Thomas, Gordon, and Max Morgan-Witts. *The Day the Bubble Burst.* Garden City, N.Y.: Doubleday & Company, 1979.

Thorndike, Joseph J., Jr. *The Magnificent Builders and Their Dream Houses.* New York: American Heritage Publishing Co., 1978.

Thorndike, Joseph J., Jr. *The Very Rich: A History of Wealth.* New York: American Heritage Publishing Co., 1976.

Tomkins, Calvin. *Merchants and Masterpieces: The Story of the Metropolitan Museum of Art.* New York: E. P. Dutton & Company, 1970.

Vanderbilt, Cornelius, Jr. *Farewell to Fifth Avenue.* New York: Simon & Schuster, 1935.

Vanderbilt, Cornelius, Jr. *The Living Past of America.* New York: Crown Publishers, 1960.

Vanderbilt, Cornelius, Jr. *Man of the World: My Life on Five Continents.* New York: Crown Publishers, 1959.

Vanderbilt, Cornelius, Jr. *Queen of the Golden Age.* New York: McGraw-Hill Book Company, 1956.

Vanderbilt, Gloria. *Black Knight, White Knight.* New York: Alfred A. Knopf, 1987.

Vanderbilt, Gloria. *Once Upon a Time.* New York: Alfred A. Knopf, 1985.

Vanderbilt, Gloria Morgan. *Without Prejudice.* New York: E. P. Dutton & Company, 1936.

Vanderbilt, Gloria, and Lady Thelma Furness. *Double Exposure.* New York: David McKay Company, 1958.

Vanderbilt, W. K., Jr. *A Trip Through Italy, Sicily, Tunisia, Algeria and Southern France.* New York: privately published, 1918.

BIBLIOGRAPHY

Van Pelt, John Vredenburgh. *A Monograph of the William K. Vanderbilt House, Richard Morris Hunt, Architect.* New York: privately published, 1925.

Van Rensselaer, Mrs. John King. *Newport: Our Social Capital.* Philadelphia: J. B. Lippincott Company, 1905.

Van Rensselaer, Mrs. John King. *The Social Ladder.* New York: Henry Holt and Company, 1924.

Veblen, Thorstein. *The Theory of the Leisure Class.* New York: Modern Library, 1934.

Vidal, Gore, V. S. Pritchett, David Caute, Bruce Chatwin, Peter Conrad, and Edward Jay Epstein. *Great American Families.* New York: W. W. Norton & Company, 1977.

Warshaw, Robert Irving. *Jay Gould: The Story of a Fortune.* New York: Greenberg Publishers, 1929.

Weber, Max. *The Protestant Ethic and the Spirit of Capitalism.* New York: Charles Scribner's Sons, 1958.

Wecter, Dixon. *The Age of the Great Depression.* New York: Macmillan Company, 1948.

Wecter, Dixon. *The Saga of American Society: A Record of Social Aspiration.* New York: Charles Scribner's Sons, 1937.

Wharton, Edith. *A Backward Glance.* New York: D. Appleton-Century, 1934.

Wheeler, Daniel. *The Chateaux of France.* New York: Vendome Press, 1979.

Whipple, A.B.C. *The Racing Yachts.* Alexandria, Va.: Time-Life Books, 1980.

White, Bouck. *The Book of Daniel Drew.* Garden City, N.Y.: Doubleday, Doran & Company, 1930.

White, Dana F., and Victor A. Kramer, eds. *Olmsted South: Old South Critic/ New South Planner.* Westport, Conn.: Greenwood Press, 1979.

Williams, Henry Lionel. *Great Houses of America.* New York: G. P. Putnam's Sons, 1966.

Williams, Henry Lionel. *A Treasury of Great American Houses.* New York: G. P. Putnam's Sons, 1970.

Wilson, Richard Guy. *McKim, Mead & White, Architects.* New York: Rizzoli International Publications, 1983.

Worden, Helen. *Society Circus.* New York: Covico Friede Publishers, 1936.

Zukowsky, John, and Robbe Pierce Stimson. *Hudson River Villas.* New York: Rizzoli International Publications, 1985.

ACKNOWLEDGMENTS

I n addition to the many librarians and archivists who opened their resources to me at the institutions listed in the manuscript collections section of the Bibliography, I am indebted to a handful of friends who, in various ways, have made this book a reality. In a thirty-page proposal, my agent, Robert Lescher, instantly saw this book and understood at once where I wanted to go; his vision and guidance, in a very real sense, made everything possible. With the patience and goodwill of a saint, Katherine Moore Hickey was there from start to finish, gathering materials, typing successive drafts of the manuscript, offering insightful reactions as a first reader, and suggesting necessary changes as a perceptive critic. I was fortunate to have the research assistance of Peter M. Doiron, who brought to his work great intelligence and the ability to track down, time and again, exactly the documents I needed. Mrs. Leonard J. Panaggio, public relations director of the Preservation Society of Newport County, was ever helpful in responding graciously to endless requests. Josephine Bray of the Chicago Book Mart located scores of out-of-print books. Dr. James V. Griffo, Jr., assistant to the president of Fairleigh Dickinson University, took me on an enthusiastic attic-to-cellar tour of Florham and was the type of guide to another age that historians dream about. And last but certainly not least, it has been wonderful working with all of the professionals at William Morrow and Company: Maria Guarnaschelli, senior editor, whose impeccable touch was essential in shaping the manuscript and bringing the book to publication; Bruce M. Giffords, a copyeditor of meticulous care and clarity; Richard Oriolo, whose good taste is reflected in the jacket and book design; and Susan Halligan, director of advertising and sales promotion/marketing coordinator, and Larry Norton, sales director, the success of whose work is well evidenced by the fact that this book now is in your hands!

INDEX

INDEX

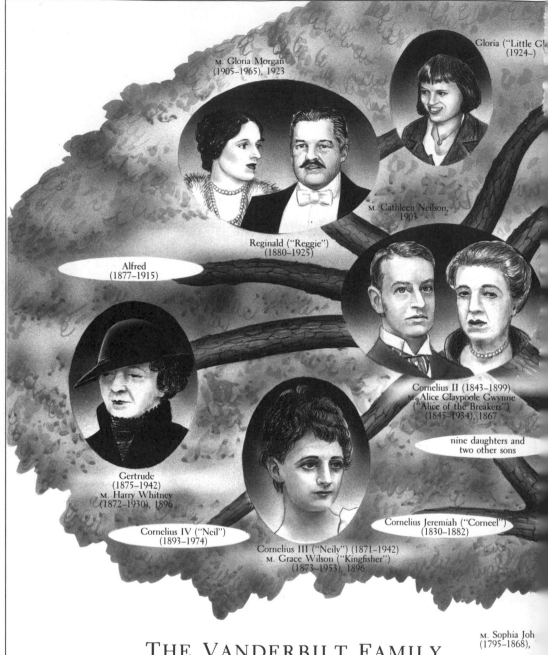

M. Gloria Morgan
(1905–1965), 1923

Gloria ("Little Gl
(1924–)

M. Cathleen Neilson,
1903

Reginald ("Reggie")
(1880–1925)

Alfred
(1877–1915)

Cornelius II (1843–1899)
M. Alice Claypoole Gwynne
("Alice of the Breakers")
(1845–1934), 1867

nine daughters and
two other sons

Gertrude
(1875–1942)
M. Harry Whitney
(1872–1930), 1896

Cornelius Jeremiah ("Corneel")
(1830–1882)

Cornelius IV ("Neil")
(1893–1974)

Cornelius III ("Neily") (1871–1942)
M. Grace Wilson ("Kingfisher")
(1873–1953), 1896

M. Sophia Joh
(1795–1868),

THE VANDERBILT FAMILY
A Simplified Family Tree